THE HARPERCOLLINS DICTIONARY OF MUSIC

THE

HARPERCOLLINS

DICTIONARY

OF

MUSIC

Third Edition

Christine Ammer

HarperPerennial

A Division of HarperCollinsPublishers

FIRST EDITION

Drawings by Carmela M. Ciampa and Kenneth L. Donlan

Library of Congress Cataloging-in-Publication Data

Ammer, Christine.
 The HarperCollins dictionary of music / Christine Ammer. -- 3rd ed.
 p. cm.
 Previously published as: The Harper dictionary of music.
 ISBN 0-06-461049-7
 1. Music—Dictionaries. 2. Music—Bio-bibliography. I. Ammer, Christine. Harper dictionary of music. II. Title. III. Title: Harper Collins dictionary of music.
ML100.A48 1995
780'.3--dc20 94-28689
 MN

95 96 97 98 ◆/RRD 10 9 8 7 6 5 4 3 2 1

AUTHOR'S NOTE

The entries in this dictionary include the most commonly used musical terms. In addition, they include considerable material on music history, with a view to explaining the background of musical practice. The biographical articles also reflect this historical orientation, including relatively little detail about composers' lives, which is readily available in books devoted entirely to this subject, but rather concentrating on the composer's works.

Additional historical information is provided in the form of charts that briefly identify the composers associated with important styles and periods, ranging from the Middle Ages to the twentieth century. At the end of the book, an *Index of Composers* lists all of the composers whose names appear in these charts, along with those who have separate entries. A second kind of chart is used to present notable examples of major musical forms, such as oratorio and opera. Further, the articles on musical instruments generally list some of the repertory for each instrument, in order to assist readers interested in hearing recordings featuring an instrument and, for those considering the study of a particular instrument, to indicate something about its repertory.

The terms in this dictionary, whether they consist of one word or of several words, are listed in strict alphabetical order, letter by letter, up to the comma in the case of inversion. In the case of identical terms in different languages and with different meanings, they are listed under a series of numbered definitions in one article, along with closely related terms. Terms mentioned in one entry but further explained in another, where the reader is advised to seek them out, are printed in large and small capital letters, as, for example, ADAGIO or AEOLIAN HARP.

Pronunciations for foreign words are as close an approximation as possible of how the words are pronounced in the respective languages, and a pronunciation key appears on page viii.

Titles of compositions are given in the original language except when that language is judged unfamiliar to most readers (for example, Russian and Hungarian) or when the English translation of a famous title has come into very common use (for example, Bach's *The Art of Fugue* and his *The Well-Tempered Clavier*). Dates usually refer to the date of first performance, unless indicated otherwise.

This considerably expanded third edition includes new developments in both classical and popular music. It incorporates recent research and discoveries in early music, as well as revised and expanded information about technological advances in sound reproduction and creation. The most important contemporary composers have been added, and the repertory for instruments and musical forms as well as all of the tables have been brought up to date.

The author is deeply indebted to the many friends and acquaintances who have unstintingly answered questions, given advice, lent musical instruments and photographs, and otherwise donated invaluable support and assistance. Special thanks are due to David Ammer for his patient explanations and knowledgeable answers to numerous detailed questions. The dictionary has been vastly improved through their help; its faults and errors and shortcomings are entirely the author's own responsibility.

ABBREVIATIONS

The following abbreviations and symbols appear in the text and in charts:

c.	circa
comp.	composed
cont.	continued
def.	definition
defs.	definitions
fl.	flourished
illus.	illustration
no.	number
op.	opus
pl.	plural
pub.	published
rev.	revised
sing.	singular
♭	flat
♮	natural
#	sharp
♭♭	double flat
×	double sharp

KEY TO PRONUNCIATION

Primary accents indicated by ', secondary accents by ".

PHONETIC
SYMBOL

PRONOUNCED
AS IN

a	*a*sh, f*a*t, c*a*rry
ā	*a*le, f*ai*th, l*ay*
â(r)	h*a*re, p*ai*r
ä	*a*rm, c*a*lm
b	*b*ell, e*bb*
ch	*ch*ild, ha*tch*et, ca*tch*
d	*d*ie, re*d*
e	g*e*t, f*e*rry
ē	*ea*t, s*ee*, hurr*y*
er	*er*ror
ēr	*ea*r, l*ee*ring
f	*f*ill, cou*gh*
g	*g*et, ri*g*
h	*h*ave, *h*ill
hw	*wh*ile, any*wh*ere
i	*i*t, ban*i*sh
ī	*i*dea, f*i*ght, sk*y*
j	*j*udge, dan*g*er, ra*g*e
k	*k*eep, ra*k*e, ra*ck*et
l	*l*ie, ca*ll*ing, fa*ll*
m	*m*an, hy*mn*, ha*mm*er
n	*n*ot, pai*n*, ru*nn*er
ng	runni*ng*
o	*o*n, b*o*x
ō	*oa*ts, ech*o*, t*o*tal
ô	*ou*ght, th*aw*, f*a*ll

oi	*oi*l, t*oy*
oo	t*oo*k, l*u*rid, p*u*ll
o͞o	*oo*ze, cr*u*el, w*oo*
ou	*ou*r, l*ou*t, t*ow*n
p	*p*eel, ta*pp*ing, la*p*
r	*r*ail, ma*rr*y, hea*r*
s	*s*it, hi*ss*, fa*s*ten
sh	*sh*all, ha*sh*, na*ti*on
t	*t*ea, hi*tt*ing, ba*t*
th	*th*ick, *th*imble, wra*th*
t͟h	*th*ese, ra*th*er, li*th*e
u	*u*nder, ab*o*ve
û(r)	*u*rgent, b*u*rst, d*i*rt
v	*v*eil, ra*v*en, do*v*e
w	*w*ill, re*w*ard
y	*y*ell, can*y*on
z	*z*odiac, ea*s*y, fu*zz*
zh	A*si*an, barra*g*e
@	*a*bout, list*e*n, cann*o*n, bon*u*s
ǝ	fin*a*l, tot*a*l, rid*d*le, di*r*e, hi*r*e

Foreign Sounds

A	French *aller* (A lä'), midway between ä and a
KH	German *ich* (iKH)
N	French *ton* (tôN), *sans* (säN), *un* (œN), *fin* (faN)
Œ	French *peu* (pŒ), German *König* (kŒ'niKH)
Y	French *une* (Yn), German *übel* (Y'b@l)
ǝ	French *digne* (dēn'y@)

THE HARPERCOLLINS DICTIONARY OF MUSIC

The Natural Sciences Quarterly

a,à For Italian and French musical terms beginning with *a* or *à*, such as *a cappella*, *à deux*, or *a due*, see under the next word (CAPPELLA; DEUX; DUE).

A 1 One of the musical tones (see PITCH NAMES), the sixth note in the scale of C major. The A above middle C is used to tune the instruments of the orchestra because, by international agreement, its pitch is set at a frequency of 440 cycles per second; this pitch is called CONCERT PITCH. (See SOUND for an explanation of pitch and frequency.) The scales beginning on the tone A are known as A major and A minor. A composition based on one of these scales is said to be in the key of A major or the key of A minor, the key signatures (see KEY SIGNATURE) for these keys being three sharps and no sharps, respectively. The note one half tone below A is called A-flat or G-sharp (see ENHARMONIC for an explanation); the note one half tone above A is called A-sharp or B-flat. For the location of these notes on the piano, see KEYBOARD. **2** An abbreviation for ALTO in choral music. Thus S A T B in a score stands for the soprano, alto, tenor, and bass voices. **3** In an analysis of compositions that have more than one section, the letter A stands for the first section, B for the second section, etc. One common musical form found in the early sonatas of Haydn and Mozart is analyzed as A A B B, which means that the form consists of two sections, each of which is repeated once. See BINARY FORM.—**A instrument** A transposing instrument, such as the A clarinet (or clarinet in A), that sounds each note a minor third lower than it is written; for example, the fingering for the written note C yields the pitch A.

Abendmusik (ä'bent mo͞o zik") *German*: "evening music." **1** In the seventeenth and eighteenth centuries, concerts held at the Marienkirche (St. Mary's Church) in Lübeck, Germany. The practice began with organ recitals but later was extended to performances of oratorios. **2** A general name for concerts held in churches.

Abgesang (äp' ge zänk") *German*. See under BAR FORM.

absolute music Also, *abstract music*. Music that exists purely for its own sake, in contrast to PROGRAM MUSIC, which tells a story. A fugue by Bach or a piano sonata by Mozart, in which the only ideas portrayed are musical ones, is considered absolute music. A song, aria, or other work having a text, on the other hand, is not absolute music, since to some extent the music is fashioned to fit the meaning of the words.

absolute pitch The ability to identify a musical tone by name, or to sing a particular tone, without the help of first hearing some other tone. Absolute pitch, which is also known

as **perfect pitch,** actually consists of the ability to remember sounds. Some persons are born with absolute pitch, but far more often it is learned in the course of musical training. A person with absolute pitch can tell immediately if an instrument is tuned correctly—a great help, for example, to a conductor of an orchestra. On the other hand, a performer with absolute pitch may have difficulty in transposing music from one key to another (see TRANSPOSE).

abstract music See ABSOLUTE MUSIC.

academy A name for various institutions connected with the study or performance of music. Some academies are chiefly schools of music, for example, the Royal Academy of Music in London, England. Other academies exist primarily to present operas, concerts, and recitals; among these are the Metropolitan Opera Association (originally called Academy of Music) in New York City and the Academy of Music in Brooklyn, New York. Still other academies are learned societies that hold meetings, publish writings about music, and offer prizes or other honors to composers and music scholars; among these are the Académie des Beaux-Arts in Paris, France, and the Académie Royale in Brussels, Belgium.

a cappella (ä kä pel'ä) *Italian:* "in church style." A term used for choral music or a vocal ensemble performing without instrumental accompaniment.

accelerando (ä chel" e rän' dô) *Italian.* A direction to speed up gradually. Abbreviated *accel.*

accent Emphasis (stress) on a note or chord. In listening to music, it is obvious that some tones stand out more than others. They may stand out because they are louder than the tones around them (**dynamic accent**), or because they are higher in pitch (**tonic accent**), or because they are held for a longer time (**agogic accent**). Sometimes, however, a tone stands out even if it is softer, lower in

pitch, or shorter than the tones around it, for example, if it follows an upbeat. In most music the first beat of a MEASURE tends to be accented, as in the 1–2–3, 1–2–3 of a waltz. In other meters (see METER), there may be a second accent in each measure, a little weaker than the first, as in the 1–2–3–4, 1–2–3–4 of a march. In many compositions, accents occur irregularly on normally weak beats (see SYNCOPATION). Irregular dynamic accents, directing the performer to produce a tone louder than the ones around it, can be marked in several ways: *sf,* which stands for the Italian *sforzando* or *sforzato,* meaning "forcing" or "forceful"; a short dash over or under the note or chord to be accented, ⌐; or a small carat over or under the note or chord, ⌄.

acciaccatura (ä chäk" kä tōo' rä) *Italian.* 1 An ornament used in keyboard music, especially from about 1675 to 1725. It is written as a dissonant note in a chord. The player strikes the whole chord but immediately releases the dissonant note or notes, so that only the consonant notes continue to sound (see CONSONANCE). In the following example, the acciaccatura is the D added to a C–E–G chord:

The player strikes all the notes together but releases the D immediately afterward. In slow music, the ornament was sometimes indicated by a short slanted dash, which meant it was to be played not as a chord (all the notes struck together) but as an arpeggio (the notes sounded one after the other). See under ORNAMENTS. 2 The term "acciaccatura" is sometimes wrongly used for a quite different ornament, the short appoggiatura (see under APPOGGIATURA).

accidentals The signs used to raise or lower the pitch of a note or to cancel such a change. Two of these signs, the

sharp and the flat, are also used at the beginning of a composition or section to show what key it is in (see KEY SIGNATURE). However, the term "accidentals" usually refers only to changes made for single notes. The signs used are: the *sharp* (#), which raises the pitch one half tone; the *flat* (♭), which lowers the pitch one half tone; the *double sharp* (×), which raises the pitch two half tones; the *double flat* (♭♭), which lowers the pitch two half tones; and the *natural* (♮), which cancels any of the other accidentals, including the sharps or flats in the key signature. An accidental applies to the note before which it appears and to all repetitions of that note within the same measure; the appearance of a bar line, marking the end of a measure, automatically cancels all the accidentals except those of the key signature. If a note is to be altered again in the following measure, the accidental must appear again. In medieval and Renaissance music accidentals were not written in the score at all but were simply played or sung in accordance with current practice (see MUSICA FICTA).

accolade (ak'əlād"). See under BRACE.

accompagnato (ä kom pän yä'tô) *Italian*: "accompanied." Also, **stromentato** (stro men tä' tô), "instrumental." Short for *recitativo accompagnato* (or *stromentato*), that is, a RECITATIVE with orchestral accompaniment.

accompaniment A term loosely used for musical material that supports the main melody or voice-part. An accompaniment may consist of chords played by the pianist's left hand while the right hand plays the melody, or it may consist of the numerous harmonies (chords) and even secondary melodies played by the orchestra along with a soloist or instrumental group carrying the main melody. Sometimes, however, the term "accompaniment" is misleading because the accompanying part or parts are just as important as the main melody; this is true in numerous art songs (see LIED, def. 1) and also in many sonatas for a solo instrument with piano accompaniment.

accordion A musical instrument that consists of two boxlike boards connected by a folding bellows. The player hangs the instrument around his or her neck. The board near the right hand is fitted with a keyboard with piano keys or buttons, on which one plays treble notes; the board near the left hand has buttons for playing chords and bass notes. Inside the boards are pairs of flat, flexible tongues, called reeds. Each reed vibrates and sounds a single tone whose pitch depends on the reed's length and thickness. Opening and closing the bellows creates a flow of air that makes the reeds vibrate and therefore produce a sound. One of each pair of reeds sounds when the bellows are pushed together, and the other sounds when they are drawn apart. The keys and buttons open valves to admit air to the desired pairs of reeds. In some accordions the two reeds of a pair are tuned to sound adjacent tones of the chromatic scale (C and C-sharp, for example), so that one note sounds when the bellows are pushed and a different one when they are pulled. In most modern accordions, however, the two reeds of a pair are tuned to the same tone. The **melodeon** is a single-row button accordion with two keys; it is often used for folk music.

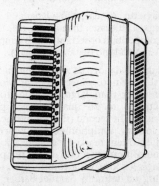

The **concertina** is a similar but much simpler instrument. It has two hexagonal (six-sided) boards, both fitted with buttons, and no keyboard. Both the accordion and the concertina were invented in Europe early in the nineteenth century.

acid rock See under ROCK.

acoustic 1 Pertaining to sound; see ACOUSTICS. 2 A term applied to traditional instruments to distinguish them from electronically altered ones, as, for example, the acoustic guitar from the electric guitar.

acoustics The science of SOUND. In music, the term "acoustics" is used mainly to describe how well musical sounds can be heard in a room or building. The acoustics of a concert hall depend largely on how (and how much) the surfaces inside the room reflect (bounce back) and absorb (soak up) sound. Both the shape of the hall and the materials used in building and furnishing it affect its reflection of sound. A hall is said to have good acoustics when there is a proper balance between sound reflection and absorption. Too much reflection is heard as echo; too little makes it difficult to hear a performance. Acoustics is also involved in recording music, in radio and television broadcasting of musical performances, and in composing music consisting of electronically generated sounds (see ELECTRONIC MUSIC).

action See under PIANO, def. 2.

adagietto (ä dä"jet'tô) *Italian*. 1 A tempo a little faster than ADAGIO, def. 1. 2 A composition or section in this tempo. 3 A short adagio (see ADAGIO, def. 2).

adagio (ä dä'jô, ə dä'zhē ō") *Italian*. 1 A slow tempo, slower than andante but faster than largo, ranging from about 66 to 76 quarter notes per minute. The second (slow) movement of sonatas, symphonies, and concertos is often marked "adagio." 2 A composition or section in this tempo. *Adagio for Strings* is a composition for string orchestra by Samuel Barber; it is based on the slow movement of his String Quartet no. 1.

adagissimo (ä" dä jēs' sē mô) *Italian*. A very slow tempo.

Adams, John, 1947– . An American composer who early in his career became associated with MINIMALISM. His minimalist works include *Phrygian Gates* (1978) for piano and *Shaker Loops* (1978) for seven stringed instruments. In the next few years Adams broadened his scope, incorporating in his music elements from numerous styles—romanticism, silent film music, jazz, rock, minimalism, and expressionism—in such works as *Harmonielehre* (1985) for chorus and orchestra, and the slyly humorous *Fearful Symmetries* (1988) for orchestra. Other important works include the operas *Nixon in China* (1987) and *The Death of Klinghoffer* (1991), both based on historical events, and *The Wound Dresser* (1989), a moving setting of a Walt Whitman poem for baritone and orchestra.

added sixth 1 A CHORD formed of a triad and the next scale note above it, such as G–B–D–E. 2 The note added to a triad to form such a chord. The INTERVAL between this note and the lowest note of the triad is a sixth.

additional accompaniment The addition of extra instrumental parts to a score by someone other than the original composer. Such additions long were commonly made to seventeenth- and eighteenth-century works for voices and instruments, particularly to frequently performed ones such as Handel's *Messiah*.

ad lib See AD LIBITUM.

ad libitum (ad lib' i təm) *Latin*. Also, *ad lib* (ad lib'). A direction that the performer is free to do any of the following: (1) vary the tempo; (2) perform or omit certain notes provided by the composer; (3) add new notes. In music for an ensemble (group of performers), "ad libitum" may further mean that the part of some instrument or voice can be included, or left

out, or performed by another instrument or voice. See also OBBLIGATO, def. 2; PIACERE.

Aeolian (ā ō'lē ən, ē ō'lē ən) **harp** A stringed instrument whose strings are made to vibrate, and therefore to sound, by the wind; it is named for Aeolus, the Greek god of the winds. The instrument consists of a long, narrow box on which are fixed a number of strings passing over two bridges. When the instrument is placed in the path of a current of air, such as an open window, the strings are made to vibrate. The strings all are of the same length and are tuned to the same pitch; however, they are of different thicknesses, causing them to produce different overtones (see HARMONIC SERIES). The Aeolian harp dates from biblical times. It became popular in Europe during the late eighteenth and early nineteenth centuries, when its mysterious, ghostly sound was found appealing.

Aeolian mode The authentic mode beginning on A. See under CHURCH MODES.

aerophone (âr' ə fōn"). Any musical INSTRUMENT in which sound is produced by the vibration of a column of air, as in woodwind instruments, brass instruments, and the organ, or by vibrations in a moving stream of air, as in the harmonica and accordion.

affabile (äf fä'bē le") *Italian.* A direction to perform in a smooth, graceful manner.

affections, doctrine of A theory proposed in the eighteenth century, especially in Germany, which held that various affections (feelings) could be expressed in music in specific ways. Thus, sorrow might be expressed through a slow, listless melody, happiness through a faster, lilting melody, etc. Ideally, a composition or section should express only one such affection. Among the composers who occasionally carried out this idea in their music are Karl

Philipp Emanuel Bach and Johann Joachim Quantz.

affettuoso (äf fet"tōō ô'sô) *Italian.* A direction to perform tenderly, with feeling.

affrettando (äf" fret tän' dô) *Italian.* A direction to perform in a hurried manner.

A-flat One of the musical tones (see PITCH NAMES), one half tone below A and one half tone above G. On the piano, A-flat is identical with G-sharp (see ENHARMONIC for an explanation). The scales beginning on A-flat are known as A-flat major and A-flat minor. A composition based on one of these scales is said to be in the key of A-flat major or A-flat minor, the key signatures (see KEY SIGNATURE) for these keys being four flats and seven flats, respectively. For the location of A-flat on the piano, see KEYBOARD.

African-American music. Also, *Afro-American music, black music.* A general name for the music of black Americans, including BLUES, GOSPEL MUSIC, JAZZ, RAP, RHYTHM AND BLUES, SOUL, and SPIRITUAL. Many of these styles tend to incorporate African elements, such as CALL AND RESPONSE, along with Western musical tradition.

after-dance See NACHTANZ.

agilmente (ä"jēl men'te) *Italian.* A direction to perform lightly and smoothly.

agitato (ä"jē tä'tô) *Italian.* A direction to perform in a restless, excited manner.

Agnus Dei (än'yōōs dä'ē) *Latin:* "Lamb of God." **1** The last section of the musical part of the Ordinary of the Roman Catholic MASS. **2** A part of the Anglican Communion service.

agogic (ə goj'ik) **accent** See under ACCENT.

agrément (A grä män') *French.* A term used for any of a number of ORNAMENTS used in French music of the seventeenth century, which came to be generally adopted in all Western

(European and American) music. Agréments are indicated by special signs or, occasionally, by small notes.

aguinaldo (ä gwē näl'dō) *Spanish.* A Venezuelan Christmas carol. The melodies, often syncopated, are in 2/4 or 6/8 meter, accented by percussion and strings.

A instrument See under A.

air 1 A simple tune or melody, used either in a song for one or more voices, or in an instrumental piece. 2 Another spelling of AYRE, def. 1. 3 Also, *ayre, aria.* One of the optional movements of the seventeenth- and eighteenth-century suite (see SUITE, def. 1). A well-known example is the second movement of Bach's Suite no. 3 in D (for orchestra), familiar in an arrangement by August Wilhelmj for violin solo with piano accompaniment entitled *Air on the G String.* 4 A French word for song. French operas and ballets of the seventeenth and eighteenth centuries sometimes included an air, either for voice or for instruments, to accompany dancing.

air column The air enclosed in the tube (body) of a wind instrument. It is the vibrations of the air column that produce the instrument's sound, and the dimensions of the column that determine the pitch and tone quality of the sound. See also AEROPHONE; BORE.

air de cour (er" də kōōr'), *pl.* **airs de cour** (er" də koor') *French.* A short song of several stanzas, sometimes with a refrain, usually for either one voice accompanied by lute or several voices without accompaniment. Such songs were written chiefly in France during the late sixteenth and seventeenth centuries.

al, à la For Italian and French musical terms beginning with *al* or *à la,* such as *al fine* or *à la fin,* see under the next word (FINE; FIN).

Albéniz (äl bā'nēth, al bā'nis), **Isaac** (ē'säk), 1860–1909. A Spanish composer and pianist who is remembered chiefly for works that reflect the rhythms and styles of Spanish folk music. His most famous piece is *Iberia,* a suite for piano. A child prodigy, Albéniz studied in various cities of Europe; among his teachers was the composer Franz Liszt. Albéniz wrote a great many compositions, but most of his life he had to continue to give concerts in order to support himself. In addition to piano music, he wrote a number of operas and numerous songs.

Alberti (äl bâr'tē) **bass** A regular pattern of broken chords (chords whose notes are played one after another instead of together) played as an accompaniment by the left hand in piano and other keyboard music. The device is named for Domenico Alberti (1710–c.1740), an Italian composer who used the pattern often but did not actually invent it. The accompanying example is from a piano sonata by Mozart.

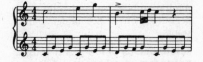

alborada (äl" bō rä'ᵺä) *Spanish:* "morning song." A type of Spanish music, particularly from the province of Galicia, played on the dulzaina, a kind of simple oboe, and accompanied by the tamboril, a small drum. Originally it was morning music, much like the French AUBADE. Ravel's *Alborada del gracioso* ("Morning Song of a Jester"), a piece for piano composed in 1905, later (1918) rewritten for orchestra, is somewhat like the Spanish type.

Albrechtsberger (äl'breᴋHts bâr"gər), **Johann Georg** (yō'hän gā'org), 1736–1809. An outstanding German organist, teacher, and composer. He wrote mainly church music, keyboard music, and other instrumental works, as well as treatises on composition and figured bass. He was greatly respected by both Haydn and Mozart

but his own music remained firmly baroque in style.

Albumblatt (äl' bŏŏm blät") *German:* "page from an album." Originally, a piece written for and in a friend's album, and then a piece dedicated to a particular friend. Eventually it became just a title used in the nineteenth century for various short compositions, usually for piano.

aleatory (ā'lē ə tôr"ē) **music** Also, *aleatoric music, chance music, music of indeterminacy.* Music that involves elements of chance. Chance may be involved in how the composer writes the music, or in how it is performed, or in both. In composition, the pitches of the notes, their duration (time values), intensity (loudness or softness), and other features may be selected by a throw of dice, by following the drawing of a design, by mathematical laws of chance, or by some similar means. In performance, chance operates by leaving some elements of the music (such as the order in which certain notes are played) up to the performer. Since different performers most likely will make different decisions, how the music is played becomes a matter of chance. Aleatory music was known during the eighteenth century and has been revived by numerous composers since 1945, among them John Cage, Karlheinz Stockhausen, Pierre Boulez, Henri Pousseur, Iannis Xenakis, Earle Brown, Pauline Oliveros, Bruno Maderna, Cornelius Cardew, and David Bedford. In Pousseur's opera, *Votre Faust* ("Your Faust," 1969), the audience decides at various points, by vote, on what course the plot will take. Also see MOBILE FORM.

all',alla For Italian musical terms beginning with *all'* or *alla,* such as *all'ottava* or *alla breve,* see under the next word (OTTAVA; BREVE).

allargando (äl" lär gän' dô) *Italian.* Also, *largando* (lär gän' dô). A direction to slow down and, usually, to perform with increasing loudness.

allegretto (äl" le gret' tô) *Italian.* 1 A tempo faster than andante but slower than allegro, lively but not too fast. 2 A composition or section in this tempo. 3 A short composition in allegro tempo (see ALLEGRO, def. 2).

allegro (äl leg'rô) *Italian.* 1 A fast tempo, faster than andante but not as fast as presto, ranging from about 120 to 168 quarter notes per minute. Originally the term was used more in the sense of its literal meaning in Italian (cheerful, joyful), so that a section might be marked "andante allegro," calling for performance in a cheerful manner at an andante tempo. The first and last movements of sonatas, symphonies, and concertos are often marked "allegro." 2 A composition or section in this tempo. *Allegro barbaro* is the name of a well-known piano composition by Bartók.

Alleluia (al"ə lōō'yə) *Latin.* An expression of praise to God that is used in various places in the Roman Catholic rites, among them the third section of the Proper of the Mass (see MASS). The chants for this section involve the alternation of a soloist and the choir. On certain sober occasions the Alleluia is replaced by the TRACT. See also HALLELUJAH.

allemande (Alᵊ mäNd') *French:* "German." 1 A dance that probably originated in Germany and came to France shortly after 1500, and then to England. Its music is moderately fast and in duple meter (any meter in which there are two basic beats per measure, such as 2/4). During the two hundred years of its popularity, the music for the allemande changed from a plain, simple style, with a melody accompanied by chords, to a more elaborate style. Usually the allemande was followed by a rapid, lively dance in triple meter (in which there are three basic beats per measure, such as 3/4 or 3/8), often the COURANTE. In the seventeenth century the allemande was no longer danced, but became a purely musical form. It was then often used as the first move-

ment of a suite (see SUITE, def. 1), becoming still more complicated and contrapuntal (with several interrelated melodic parts). **2** Also, *deutscher Tanz.* In the late eighteenth century the name "allemande" was used in southern Germany for a dance similar to the waltz, often in fast tempo and usually in 3/4 meter. It is this type that is meant in Beethoven's *Bagatellen* op. 119, for piano, marked "à l'Allemande." See also DEUTSCHER TANZ.

allentando (äl" len tän' dô) *Italian.* A direction to slow down.

alphorn Also, *alpenhorn, alpine horn.* A wind instrument used by herdsmen in the mountains for signaling and for playing simple melodies. It is always made of wood but in various shapes, either straight or bent back on itself; it may be as long as thirteen feet or as short as five feet. The alphorn can sound only the overtones of a single fundamental note (see SOUND). Sometimes several instruments tuned to different pitches are played together to give a greater number of pitches. The alphorn was known in ancient Rome, and similar instruments have been found in various places, including South America. Today it is played largely in the European Alps.

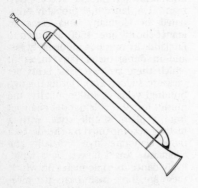

alpine horn See ALPHORN.

alt, in In vocal music, a term indicating notes above the top line of the treble staff. It comes from the Italian *in alto*, meaning "high," or *in altissimo*, meaning "highest."

alta musica (äl'tä mōō'zē kä), **bassa musica** (bäs'sä mōō'zē kä) *Italian.* Fifteenth-century terms for a loud (*alta*) instrumental ensemble, composed of shawms, sackbut, trumpet, drums, as opposed to soft (*bassa*) instruments, such as recorders, viols, harps, and psaltery. The French equivalents are *haute musique* and *basse musique.*

alteration The raising or lowering of a note by means of a sharp, flat, or natural sign. See ACCIDENTALS.

altered chord A chord in which one or more notes are raised or lowered by an accidental foreign to the key. See CHORD.

alternation In early church music, the practice of having plainsong, in which there is one voice-part, alternate with polyphony, in which there are a number of voice-parts. For a late example of this practice, see VERSET.

alternative rock See under ROCK.

althorn (ält' horn) *German.* **1** A brass instrument, usually pitched in E-flat (a fifth below the cornet). Made in numerous shapes, it is used in German, Swiss and East European bands. **2** A German name for the TENOR HORN.

alto (al'tō) *Italian:* "high." **1** Also, *contralto.* The lowest range of female voice. The normal range of the alto voice is from the F below middle C to the second D above middle C, and music for alto is written in the treble

clef. In choral music for four voice parts, the alto sings the second highest part (just below soprano). **2** Also, *male alto, countertenor.* A male voice of similar range to the female alto; the highest range of male voice, produced by using the head register (see FALSETTO; VOICE, def. 2). The male alto was especially popular in England during the sixteenth and seventeenth

centuries. **3** Among instruments that are built in various sizes, an instrument that has about the same range as the alto voice, such as the alto clarinet and the alto saxophone. **4** The French and Italian word for the VIOLA, the second highest instrument of the violin family.

alto clarinet See under CLARINET.

alto clef See under CLEF.

alto flute See under FLUTE.

alto horn A TENOR HORN in E-flat.

alto oboe See under OBOE.

alto saxophone See under SAXOPHONE.

am For German musical terms beginning with *am,* such as *am Frosch,* see under the next word (FROSCH).

amabile (ä mä' bē le") *Italian.* A direction to perform tenderly, with feeling.

Amati (ä mä' tē). The name of a family of violin makers who worked during the sixteenth, seventeenth, and eighteenth centuries in Cremona, Italy. The most famous member of the family was Niccolò Amati, who lived from 1596 to 1684; he was the teacher of both Andrea Guarneri and the most celebrated of all violin makers, Antonio Stradivari. Today Amati violins are regarded as priceless treasures, and most of those still in existence are in museums.

ambient music See SONIC ENVIRONMENT.

ambitus (am' bə təs) *Latin.* In Gregorian chant, the range of the melodies of the various chants, that is, the interval (distance) between the highest and the lowest note of each chant. In some chants this interval is only a fourth (four scale tones apart, such as C–F, or G–C), but in others it is an octave (eight tones) or more. See also CHURCH MODES.

Ambrosian (am brō' z̠hən) **chant** The collection of church chants used in the Cathedral of Milan, Italy, also called **Milanese chant.** The collection is named for Saint Ambrose, who lived from c. 340 to 397 and was Bishop of Milan. However, these chants were composed long after Ambrose's death, probably even later than Gregorian chant.

Amen (ä men') *Hebrew:* "so be it." A word found in various places in Christian church services, including the Roman Catholic Mass. In the seventeenth and eighteenth centuries, many composers, among them Bach, Handel, and Mozart, wrote long closing sections for the Amen. These are called Amen choruses or Amen fugues (since they often are in the form of a fugue), and their text consists simply of the word "Amen" repeated over and over. One of the best-known Amen choruses is the one that concludes Handel's oratorio, the *Messiah.*

American organ See under HARMONIUM.

amplifier A device for increasing a sound signal, required in any sound-reproduction system.

amplitude Loudness; see under SOUND.

amplitude modulation See MODULATION, def. 2.

anacrusis (an"ə kroo'sis). Another word for UPBEAT.

ancora (än kôr'ä) *Italian.* **1** A direction to repeat. **2** When combined with another term, ancora means "still," as in *ancora più piano* ("still more softly").

andante (än dän'te) *Italian:* "walking." **1** A moderate tempo, faster than adagio but slower than allegro, ranging from about 76 to 108 quarter notes per minute. Musicians have long disagreed as to whether andante is a slow or a fast tempo, a point that must be determined in order to understand the terms *più* (more) or *molto* (very) *andante* and *meno* (less) *andante.* If andante were a slow tempo, più andante would mean still slower and meno andante less slow; if it were a fast tempo, they would mean exactly the opposite. Today

most—but not all—musicians tend to consider andante a slow tempo. **2** A piece or section in this tempo.

andante con moto (än dän'te kôn mô'tô) *Italian.* See under MOTO.

andantino (än" dän tē' nô) *Italian.* **1** A tempo either slightly slower or, more often, slighly faster than an andante (see ANDANTE, def. 1, for an explanation of the confusion). **2** A short piece in andante tempo.

Anfang, vom (fôm än'fäṅg) *German.* A direction to repeat a composition or section from the beginning.

anglaise (än glez', äṅg gläz') *French:* "English." A dance of the seventeenth and eighteenth centuries, so called because it is based on the English country dance. In fast tempo, it could be in duple meter (any meter in which there are two basic beats per measure, such as 2/4), in triple meter (three basic beats per measure), or 6/8 meter, with an accent on the first beat of each measure. Like the allemande and many other dances, the anglaise eventually became a purely musical form and was no longer danced; as such it was sometimes used as a movement in a suite (see SUITE, def. 1), where it was always in duple meter with no upbeat and in two-part form, with each part repeated (A A B B). Sometimes the name "anglaise" was used for other dances of English origin, such as the hornpipe.

Anglican chant Harmonized music (music for several voice-parts) for the texts of psalms and canticles, which are sung during the services of the various Anglican churches (Church of England, Scottish Episcopal Church, the American Episcopal churches, etc.). The psalms and their music are found in books called *psalters* (see under PSALM). Anglican chant began to be composed in the sixteenth century soon after the Church of England broke away from the Roman Catholic Church. At that time, composers such as Thomas Tallis, William Byrd, and Orlando Gibbons began to

write long four-part settings of psalms, in imitation of the psalm tones (see PSALM TONE) used in the Gregorian chant of the Roman Catholic churches. Since the psalms used are in prose, it is not always clear how the words fit the music. This problem is solved by **pointing**, that is, marking exactly how the words and syllables go with the notes, by means of brackets, bar lines, asterisks, or other symbols.

ängstlich (eṅgst'liкн) *German.* A direction to perform in a fearful, anxious manner.

anhemitonic (an hem" i ton' ik). Lacking semitones (half tones). An anhemitonic scale is one that contains no half tones, such as the WHOLE TONE SCALE or a PENTATONIC (five-tone) SCALE.

anima, con (kon ä' nē mä) *Italian.* Also, *animato* (ä" nē mä' tô). A direction to perform in a lively, spirited manner.

animato See ANIMA, CON.

answer In a fugue, the repetition of the first theme (called the subject) in another part, transposed (moved) to another key, usually the DOMINANT but sometimes the SUBDOMINANT. If the intervals (distances) between all the notes in the answer are exactly the same as in the subject, the answer is said to be **real**; if any of the intervals is changed, the answer is called **tonal**. The accompanying example shows the first two bars of the subject and the first two bars of the (tonal) answer from a fugue by Bach. See also FUGUE.

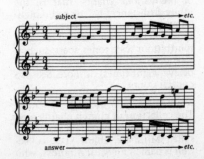

Antheil (an'tĭl), **George**, 1900–1959. An American composer who became famous for a composition called *Ballet mécanique* ("Mechanical Ballet"), scored for pianos, propellers, automobile horns, and other noisemakers. It was first performed in 1926 and created a sensation. Antheil also wrote operas, symphonies, concertos, and music for many motion pictures.

anthem A short choral piece with an English text based on the Bible or some other religious source and performed during the worship service in various Protestant churches. An anthem may either be entirely for chorus (**full anthem**) or include sections for soloists (**verse anthem**). The first anthems were composed in the sixteenth century, when the Church of England broke away from the Roman Catholic Church. At this time English became the language of the worship service, and the anthem replaced the Latin MOTET of the Roman rites. Many of England's important composers have written anthems, among them William Byrd, Thomas Weelkes, Thomas Tomkins, Orlando Gibbons, and Christopher Tye (sixteenth century), John Blow and Henry Purcell (seventeenth century), Handel (eighteenth century), and Samuel Wesley (nineteenth century). Outstanding twentieth-century composers of anthems include England's Ralph Vaughan Williams and Benjamin Britten, and the United States' Samuel Barber and Randall Thompson.

anticipation A note appearing between two chords that is dissonant to the first chord but belongs to the harmony of the second (it is so called because it "anticipates," or "looks forward to," the new harmony). For example, if chord 1 is G–B–G' and chord 2 is A–C'–F♯', the note F♯

between the two chords, dissonant with the G of the first chord, would be an anticipation.

antiphon (an'tə fon"). A plainsong (with one voice-part) setting of a religious text, from the Bible or elsewhere, that is sung both before and after a psalm or canticle in the Roman Catholic Mass (see MASS). Early in the history of the Christian church, psalms were sung by two choruses in alternation, one taking one verse, the second the next verse, and so on. This practice is called **antiphonal** singing. Later, a short text sung to a free melody by both choruses together was added at the end of each verse or pair of verses as a kind of refrain, and still later this refrain was sung only at the beginning and end of the psalm. It is this additional section that came to be called the antiphon. In some cases, the psalms were dropped entirely and the antiphon alone remained; this was the case with the parts of the Mass known as the Introit and the Communion. Thousands of antiphons survive in medieval literature, and more than one thousand are still used in Roman Catholic services. —**processional antiphon** Any of certain long, quite elaborate songs sung at processions on important Roman Catholic feast days, such as Palm Sunday. —**Marian antiphon** Any of four beautiful hymns sung in honor of the Virgin Mary. In the Roman Catholic OFFICE they are used to end the service when the choir disperses. They are *Alma redemptoirs mater* ("Gracious mother of the Redeemer"), *Salve Regina* ("Hail Queen"), *Ave Regina coelorum* ("Hail Queen of Heaven"), and *Regina coeli laetare* ("Rejoice, Queen of Heaven"). These hymns have often been given polyphonic settings (with several voice-parts, in contrast to plainsong, with a single voice-part), for voices or for organ, and the melodies also have served as the basis for many polyphonic Mass settings.

antiphonal (an tif'ə nəl) **1** Sung by two singers or groups in alternation. See under ANTIPHON. **2** The book con-

taining all the choral music sung in Roman Catholic services other than the Mass, the music for the Mass being contained in a book called the GRADUAL. Also, *antiphonale, antiphoner, antiphonary.*

anvil A percussion instrument consisting of one or two metal bars mounted on a resonating frame that are struck with a hammer. Sometimes an actual blacksmith's anvil, for which it is named, is used. Verdi's famous Anvil Chorus, in his opera *Il Trovatore*, calls for two anvils. Wagner called for one anvil in the forging song in *Siegfried* and for eighteen anvils in *Das Rheingold*. More recent uses are in Britten's *The Burning Fiery Furnace* and Walton's *Belshazzar's Feast*.

Appalachian dulcimer See under DULCIMER.

appassionato (äp päs" syô nä' tô) *Italian.* A direction to perform with intense feeling.

appoggiatura (äp pô" djä tōo' rä) *Italian:* "leaning note." A note dissonant (discordant) with the prevailing harmony that is one step above (or below) the main note and resolves by moving down (or up) on the subsequent weak beat. For example, suppose that the basic harmony is a C-major chord, such as C–E–G. One possible appoggiatura would be a D (dissonant with C and E) resolving to C:

Some authorities hold that a true appoggiatura must be preceded by a note more than one scale step away (usually two) and must resolve into a note only one scale step away. In the example above, the first condition would be met if the note just before D was B; the second condition is already met, C being one scale step down from D. (See CAMBIATA for a similar example of dissonance.)

Originally the appoggiatura was an ornament that became so common in baroque music (1600–1750) that it often was not written out but simply taken for granted in certain circumstances, especially in recitatives and arias. Later it took on somewhat different forms, each performed somewhat differently. Since about 1750, there have been two main kinds of appoggiatura, the **long appoggiatura** and the **short appoggiatura**. The long appoggiatura is played on the beat and takes away some of the time value of the main note (the note it precedes); depending on the nature of the main note, it takes on half, two-thirds, or (when the main note is one of a tied pair) all of its value. The short appoggiatura (sometimes called a **grace note**) is sounded very quickly before the main note; it is performed either on or just before the beat and gives a sharp accent to the main note. From the early eighteenth to the early nineteenth century composers sometimes distinguished between the two kinds of appoggiatura by writing the long one as a small note with the precise time value it should have (quarter note, eighth note, sixteenth note), and by writing the short appoggiatura as a note with a single or double stroke through the stem. However, this was by no means a universal practice. The accompanying examples show (*A*) a short appoggiatura from a piano sonata by Haydn and (*B*) a long appoggiatura from a piano sonata by Mozart. (See also ORNA-

MENTS.) In the nineteenth century, the long appoggiatura began to be written out in ordinary notation, as it generally is today, and the short appoggiatura was indicated as a small note with a stroke across the stem.

The short appoggiatura is sometimes mistakenly called an ACCIACCATURA, which is a different ornament altogether. See also APPOGGIATURA, DOUBLE.

appoggiatura (äp pô" djä tōō' rä), **double 1** The simultaneous occurrence of two long or short appoggiaturas in a single chord (see APPOGGIATURA). **2** An ornament consisting of two successive grace notes, one lower than the main note, and the second higher than the main note. The first note is played on the beat, so that both notes actually take away a little from the time value of the main note

(D in the example here). **3** Also, **slide**. An ornament consisting of two grace notes proceeding scalewise to a main note, for example, grace notes C and D preceding E, or E and D preceding C. See also ACCIACCATURA.

arabesque (ar" ə besk') **1** A name used by Schumann, Debussy, and other composers for a short imaginative piece. **2** An ornate figure added to a melody, in the manner of scrollwork decorating Arab architecture (with curved, unbroken lines).

arcato See ARCO.

archlute A LUTE with two pegboxes, the second housing unstopped bass strings about half again as long as the stopped strings, which run over the fingerboard to the first pegbox. It resembles the theorbo and chitarrone but has a smaller body and is higher-pitched. It was extensively used from about 1600 to 1730 for both solo pieces and continuo accompaniments.

arco (är'kô) *Italian*. Also, *col arco, coll'arco* (kôl är'kô); *arcato* (är kä'tô). A direction to use the bow (appearing after a pizzicato passage, in which the strings are plucked).

aria (är'ē ə) *Italian*. **1** An elaborate solo song, generally with instrumental accompaniment. One usually thinks of arias as part of an opera, but they are also important in cantatas and oratorios. An independent aria is called a **concert aria**. Although *aria* is the Italian word for "air," an aria differs from an air (see AIR, def. 1) in that it is longer, is not usually arranged in stanzas, and emphasizes mainly the music, often at the expense of the words. The term "aria" was used for various kinds of song during the sixteenth and seventeenth centuries. From about 1650 to 1750 the **da capo aria** was the most important type. It consists of three sections, A B A, the third being a repetition of the first; in the seventeenth and eighteenth centuries the repeated A section was often elaborately ornamented. Entire operas were made up of da capo arias—sometimes as many as twenty of them—loosely connected by recitatives (speechlike sections in which the plot of the opera progressed). The plots of such operas were fairly conventional, and the arias became so, too. Certain standard types developed, such as the **aria cantabile**, with slow, lyrical passages to express grief or longing, and the **aria di bravura**, with fast, very difficult music, to express strong feelings (joy, triumph, vengeance). After about 1750, composers such as Gluck and Mozart wrote more individualistic operas, for which the rigid da capo aria was not always suitable, and by the end of the eighteenth century arias were being written in many free forms. The aria continued to be important until the second half of the nineteenth century. Subsequently it was discarded by many composers who, influenced by Wagner, felt that the events of the plot should be continuous and not interrupted by a character stopping to sing an aria. **2** Another term for AIR, def. 3.

aria cantabile (är'ē ə kän tä' bē le) *Italian*. See under ARIA, def. 1.

aria di bravura (är' ē ə dē brä vōōr'ä) *Italian*. See under ARIA, def. 1.

arietta (ä"rē et' tä) *Italian*. A short or simple aria, frequently resembling a song.

ariette (A ryet') *French.* **1** The French word for ARIETTA. **2** In French operas up to about 1750, an aria (solo song) with an Italian text. **3** In French comic opera after 1750, an aria with a French text, sung before and after spoken sections.

arioso (ä"rē ô'sô) *Italian.* **1** A style of RECITATIVE that is more songlike and more expressive than the ordinary recitative. **2** A piece or section written in this style. (The full name for such a piece is **recitativo arioso**.) Ariosos appear in early Italian operas as well as in eighteenth-century cantatas and oratorios. **3** An instrumental piece similar in style to a vocal arioso.

Arlen, Harold, 1905–1986. An American composer best known for his popular songs, Broadway musicals, and film music. He began his career as a pianist and singer. Among his most famous songs are "I've Got the World on a String," "Stormy Weather," "It's Only A Paper Moon," "That Old Black Magic," "Blues in the Night," and "Over the Rainbow." The last was from his most famous film score, *The Wizard of Oz.*

armonica See under GLASS HARMONICA.

ARP A kind of SYNTHESIZER.

arpa (är'pä). The Italian word for HARP.

arpeggiando (är" pe djän' dô) *Italian.* A direction to perform the notes of a chord one after another, as one usually does on a harp.

arpeggio (är pe'jô) *Italian.* A broken chord, that is, a chord whose notes are performed one after another instead of together, usually beginning with the lowest note and ending with the highest. Arpeggios are either written out (with all the notes as they are to be played), or are indicated by a wavy vertical sign next to the chord. They always begin on the beat. In keyboard music an arpeggio is sometimes played at the same time by the left and right hands, in which case it is marked by a wavy line in the treble

staff and a separate wavy line in the bass. If a chord is marked with a wavy line that continues through both staves, the notes are to be played successively (one after another) by the left and right hands, beginning with the lowest note in the bass and ending with the highest note in the treble. In

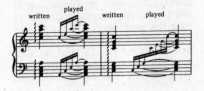

the seventeenth and eighteenth centuries, arpeggios were sometimes played in descending order (beginning with the highest note instead of the lowest), and the player could decide the number of notes, their time value, and the tempo.

arpeggione (är ped jō'ne) *Italian.* A stringed instrument, basically a six-stringed bass viol with guitar tuning and metal frets, that is bowed like a cello. Invented by J. G. Staufer in 1824, it was quite popular for a time but today is remembered mainly for the sonata Schubert wrote for it (D. 821), which is known as the Arpeggione Sonata but is now most often performed on the cello.

arrangement **1** Also, *transcription.* The rewriting of a composition for a medium (instrument, voice, group) different from the one for which it was originally written. This kind of arrangement requires considerable skill to avoid distorting the basic qualities of a piece. During the late Middle Ages, vocal pieces were quite often arranged for one or more instruments, often a lute or a group of viols. This practice continued through the Renaissance (1450–1600) and thereafter. The baroque composers (1600–1750) often arranged compositions, both their own and those of other composers. Famous examples from this period include Bach's arrangements of Antonio

Vivaldi's violin concertos for solo organ or harpsichord, and of his own violin concertos for harpsichord. In the nineteenth century, Beethoven arranged his Violin Concerto in D as a piano concerto, a version that is still occasionally played. See also ORCHESTRATION. **2** In popular music, the preparation of a song or musical theme for a particular performer or ensemble (group). Usually made by a specialist called an **arranger**, such an arrangement must take into account the song itself (melody, rhythm, harmony), the abilities of the singer or group (style, voice quality, range, etc.), and also the way in which the music is to be heard (unamplified, amplified, recorded, on a television broadcast, etc.). Some arrangers become active collaborators with the composer, taking an original simple tune and working out the entire harmonic and rhythmic shape of the piece. The American composer Robert Russell Bennett (1894–1981) was an outstanding arranger and orchestrator of Broadway musical comedies, ranging from *Rose-Marie* (1924) to *My Fair Lady* (1956) and *The Sound of Music* (1959). Another was Hershy Kay (1919–1981), who orchestrated Bernstein's *On the Town* and *Candide*. In modern popular music, where a work's recording has become as important as its written score, or more so, the arranger's job has been increasingly taken over by the engineer-producer (see EDITING). **3** See PIANO ARRANGEMENT. **4** See under SUITE, def. 2.

arranger See ARRANGEMENT, def. 2.

ars antiqua (ärz' an tēk'wə) *Latin:* "old art." A term used to distinguish the music of the late twelfth and thirteenth centuries from the music of the fourteenth century, called the ARS NOVA ("new art"). The ars antiqua includes the music of the NOTRE DAME SCHOOL and its two great masters, Leonin and Perotin (twelfth century); the period of the musician and theorist Franco of Cologne (middle to late thirteenth century); and the period of

Petrus de Cruce, also known as Pierre de la Croix (end of the thirteenth century). See also the chart accompanying MEDIEVAL MUSIC.

The Notre Dame school is known mainly for its organa (see ORGANUM), clausulae (see CLAUSULA), and CONDUCTUS. A later form, perhaps the most important of the ars antiqua, is the MOTET. The greatest advances of the ars antiqua were the establishment of strict rhythm based on specific rules called the RHYTHMIC MODES (the rhythm of earlier music was much freer) and the use of three and even four voice-parts (until the period of the ars antiqua, music had been confined to one and two voice-parts). Most probably these polyphonic pieces were sung with only one voice to a part, that is, as vocal chamber music. Along with the development of polyphony (music with many voice-parts) in church music came the rise of monophonic song (vocal music with a single voice-part) in secular (nonreligious) music, composed by the various minstrels (see MINNESINGER; TROUBADOUR; TROUVÈRE).

ars nova (ärz' nō'və) *Latin:* "new art." A term used for the music of the fourteenth century to distinguish it from that of the thirteenth century (see ARS ANTIQUA). Whereas the musicians of the ars antiqua had been active mainly in northern France and Germany, those of the ars nova worked also in southern France, Italy, and northern Spain. The principal advances of the ars nova were the use of new rhythms, new meters, and new harmonies, involving freer use of dissonance and new, very complicated methods of musical notation. The new style was described at length in two Latin treatises, *Ars nova musicae* (c. 1325) by the French composer, poet, and diplomat Philippe de Vitry (1291–1361) and *Ars nove musice* by the scholar Johannes de Muris. The most important French composer of the ars nova was Guillaume de Machaut (mid-fourteenth century), who, in addition to composing motets (see MOTET) was the

first musician to write a polyphonic (many-voiced) setting of the entire Ordinary of the Mass (see MASS). Machaut also composed ballades (see BALLADE, def. 1), rondeaux (see RONDEAU, def. 1), and virelais (see VIRELAI), all of which are polyphonic secular songs (nonreligious vocal pieces with several voice-parts). The principal Italian composers of the first half of the fourteenth century were Giovanni da Cascia and Jacopo da Bologna, who wrote chiefly madrigals and caccie (see MADRIGAL, def. 1; CACCIA); the greatest composer of the second half of the fourteenth century was Francesco Landini, who preferred the BALLATA, an Italian version of the French virelai. See also the chart accompanying MEDIEVAL MUSIC.

art ballad See under BALLAD.

articulation See PHRASING.

art rock See under ROCK; also under FUSION.

art song A term used to distinguish a serious vocal piece for one voice written by a trained composer from (1) a popular song, written mainly to make money; and (2) a folk song, whose composer usually is not known and which changes in the course of performance over the years. The art song literature ranges from the solo songs of the Middle Ages to the lute songs of the sixteenth century (see AYRE, def. 1), from the arias of the seventeenth and eighteenth centuries to the lieder (see LIED, def. 1) of nineteenth-century German composers and their French counterparts—Emmanuel Chabrier (1841–1894), Henri Duparc (1848–1933), Ernest CHAUSSON, and Gabriel FAURÉ. Other composers noted for their fine art songs include Debussy, Ravel, Mussorgsky, Grieg, Britten, Poulenc, Barber, Ives (see the separate entry for each of them), Ned Rorem, and Peter Warlock. Also see SONG CYCLE.

a.s. An abbreviation for *al segno* (see under SEGNO).

ASCAP (as′kap). The abbreviation for American Society of Composers, Authors, and Publishers, an organization of musicians. ASCAP was founded in 1914 by the composer Victor Herbert in order to make sure that the persons who wrote and published music would be paid when their works are performed.

ascending motion See under MOTION, def. 1.

ascending valve See under VALVE.

A-sharp One of the musical tones (see PITCH NAMES), one half tone above A and one half tone below B. On the piano, A-sharp is identical with B-flat (see ENHARMONIC for an explanation). For the location of A-sharp on the piano, see KEYBOARD.

assai (äs sä′ ē) *Italian:* "much" or "very." A word used in musical directions such as *allegro assai* ("very fast").

assez (A sä′) *French:* "enough" or "quite." A word used in musical directions such as *assez vite* ("fairly fast").

atonality (ā″tō nal′i tē). A style of composition in which a tonal center, or definite key (see KEY, def. 3), is avoided. Almost all the music from about 1700 to about 1900 was written in a determinable key, and while the notes and chords of other keys might be included in a piece, they were always somehow related to and were made to return to or resolve into the basic key of the piece. Such music is called **tonal**. In music composed prior to about 1700, however, this relationship of notes to a central key did not always exist, and since about 1900 many composers have deliberately avoided it. Strictly speaking, tonality and atonality (literally, "without tonality") are matters of degree. Thus, the works of Wagner and Debussy, although still tonal, show features of atonality—chords do not always resolve into the basic key, for example. The first completely atonal musical compositions were those of Schoenberg, written about 1909. Schoenberg considered all

twelve notes of the chromatic scale equally important, instead of emphasizing one or another as a tonal center. He himself disliked the term "atonal," preferring *pantonal* ("all tones"). About 1920, Schoenberg proposed the twelve-tone system as a substitute for tonality (see SERIAL MUSIC). Some prefer the term *nontonal*.

attacca (ät täk′ kä) *Italian:* "attack." Also, *attacca subito* (ät täk′kä soo′bē tô). A direction at the end of a movement or section of a composition indicating that the next movement or section is to proceed immediately, without pause.

attacca subito See ATTACCA.

attack 1 Promptness in beginning a phrase or, in a piece for an ensemble (group), the entry of the different instruments or voices at precisely the right time. **2** In electronic sound production, the time it takes a signal to build from its minimum to its maximum level. See also DECAY.

aubade (ō bʌd′) *French.* A piece of instrumental music to be played in the morning, as opposed to a SERENADE, played in the evening. In the seventeenth and eighteenth centuries, noblemen sometimes held special gatherings or receptions in the morning, during which an aubade might be played. See also ALBORADA.

audition A hearing, tryout, or test performance, at which the musician's skill is judged.

augmentation Increasing the time values of all the notes in a theme (short melody), so that, for example, all the quarter notes become half notes and the half notes become whole notes. (The opposite process, in which, for example, all the quarter notes become eighth notes and the half notes become quarter notes, is called DIMINUTION.) Both augmentation and diminution are common means of varying a theme, and they are often used in fugues, as well as in sonatas and symphonies.

augmented chord A chord that includes an augmented interval (a major or perfect interval enlarged by one half tone). Two kinds of chord are commonly altered in this way, the triad (see under CHORD) and the SIXTH CHORD.

augmented interval A major or perfect interval (see INTERVAL, def. 2) that is enlarged by one half tone, either by flatting the lower note or by sharping the upper note. Eight kinds of interval may be altered in this way: the perfect intervals of the unison, fourth, fifth, and octave, and the major second, major third, major sixth, and major seventh. Except for the augmented fourth, also known as the TRITONE, all the augmented intervals require the use of a note foreign to their key.

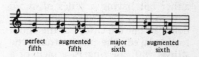

perfect fifth augmented fifth major sixth augmented sixth

aulos (ou′los), *pl.* **auloi** (ou′loi) *Greek.* A wind instrument of ancient Greece that was similar to an oboe. Like the oboe, the aulos had a double reed and a number of finger holes. It was nearly always played in pairs (that is, the performer played on two instruments at the same time, holding one in each hand), which was possible because the reed was not held between the lips, as the modern oboe's is, but inside the mouth. Many pictures show the aulos player with a

leather band tied around his head and covering his mouth; this band probably served to support the performer's cheeks, enabling him to

blow harder. The aulos is thought to have had a very shrill sound.

Auric (ō rēk'), **Georges** (zhôrzh), 1889–1983. A French composer who became one of the group known as *Les Six* (see SIX, LES). Auric studied with the composer Vincent d'Indy, and like many other French musicians of his time, he rebelled against the influence of Wagner and late nineteenth-century German romanticism. Auric's works include songs, chamber music, ballets (*Les Fâcheux, Phèdre*), and music for motion pictures (*Moulin Rouge*).

authentic cadence See under CADENCE.

authentic modes See under CHURCH MODES.

autoharp An instrument much like a zither but having a series of chord bars fixed to the strings, which hold down all but the strings of the chord to be played. The player strums the strings with the fingers, a pick, or a plectrum, and at the same time presses the proper chord bar, so that the desired chord alone sounds. The autoharp was invented in the late nineteenth century and is used mainly to accompany folk singing. It is quite easy to play. Small autoharps can produce only five chords, but larger instruments can sound as many as fifteen.

auxiliary tone Another term for NEIGHBORING TONE.

Ave Maria (ä' vä mə rē' ə) *Latin:* "Hail Mary." **1** A prayer of the Roman Catholic Church, which has often been set to music. **2** A setting of this text not intended primarily for church use, such as the setting by Gounod using Prelude no. 1 in C major from Bach's *Das wohltemperierte Clavier* ("The Well-Tempered Clavier") to serve as the harmony for Gounod's own melody. Another example is Schubert's setting of a song from Sir Walter Scott's novel, *Lady of the Lake*.

ayre (âr). **1** Also, *air*. A type of song popular in England during the late sixteenth and early seventeenth centuries. The ayre is similar in form to the French AIR DE COUR. Like the air de cour, the ayre is a solo song accompanied by lute, theorbo (bass lute), or some other instrument, and sometimes also by a bass viol; occasionally it is accompanied also by two other singers. The best-known composer of ayres was John DOWLAND. **2** Another spelling of AIR, def. 3.

B

B 1 One of the musical tones (see PITCH NAMES), the seventh note in the scale of C major. The scales beginning on the tone B are known as B major and B minor. A composition based on one of these scales is said to be in the key of B major or the key of B minor, the key signatures (see KEY SIGNATURE) for these keys being five sharps and two sharps, respectively. The note one half tone below B is called B-flat or A-sharp (see ENHARMONIC for an explanation); the note one half tone above B is called B-sharp or C. For the location of these notes on the piano, see KEYBOARD. **2** An abbreviation for BASS in choral music. Thus S A T B in a score stands for the soprano, alto, tenor, and bass voices. **3** In the analysis of compositions that have more than one section, the letter B stands for the second section (A standing for the first, C for the third, etc.). A common form for simple songs and short instrumental pieces is analyzed as A B A, which means that the form consists of three sections, the third of which is identical with the first. **4** In German, the letter B stands for B-flat, B natural being designated by H.

Babbitt (bab'it), **Milton**, 1916– . An American composer who became known for his use of mathematics in composing music and became very influential as a theorist and teacher. Babbitt studied at New York and Princeton universities, and he became a professor of both music and mathematics. In his early compositions he often used series of twelve, not only for the pitches (see SERIAL MUSIC), but also for rhythm (twelve basic rhythmic values in a theme) and for instrumentation (twelve instruments used in succession). In the 1950s he began to write ELECTRONIC MUSIC, using the SYNTHESIZER and the COMPUTER. In 1961 he became one of the directors of the Columbia-Princeton Center for Electronic Music. He is considered one of the few composers who produced outstanding compositions with the early RCA Synthesizer. His compositions include *Ensembles for Synthesizer* (1962–64), *Philomel* (1963) for soprano and tape, *Reflections* (1974–75) for piano and tape, *Images* (1979) for saxophone and tape, *Ars Combinatoria* (1981) for orchestra, and String Quartet no. 5 (1982) in one movement. Later works are *Transfigured Notes*, a set of continuous variations for string orchestra (1986; first performed 1991), and *Whirled Series* (1987), a jazzy workout for alto saxophone and piano.

baby grand The smallest size of grand piano (see PIANO, def. 2), usually about five feet long.

Bach (bäкн). The name of a family of German musicians and composers of

the sixteenth, seventeenth, and eighteenth centuries. The first important family member was Johann Christoph Bach (1642–1703), an organist and harpsichordist who wrote motets and vocal concertos. By far the most famous of them is Johann Sebastian Bach, and of his twenty children, the best known are Karl Philipp Emanuel and Johann Christian.

—**Johann Sebastian** (yō'hän si bäs'tyän) **Bach**, 1685–1750. Considered by many to be the greatest composer of all time. Born in the town of Eisenach, where his father was town musician, he began studying music as a young boy, at first with his father. When his father died, Bach went to live with his older brother Johann Christoph. At fifteen he was earning his own living, singing in a church choir. After several other musical posts, he became church organist at Arnstadt, and for the rest of his life Bach worked as organist and choir director in various German cities, his longest and last tenure being in Leipzig (1723–50). It was as an organist that he was most famous during his own lifetime. Not until the mid-nineteenth century, partly through Mendelssohn's rediscovery of his compositions, did Bach become known principally as a composer.

Bach's works represent the climax and end of the BAROQUE period. Rather than introducing new forms and styles, Bach's genius lay in taking the material of his own and earlier periods—the Lutheran CHORALE, earlier baroque organ music, the French and Italian styles of orchestral music—and creating some of the finest works of their kind. He wrote thousands of compositions, most of them for use in the churches where he was employed or for teaching purposes. In addition to church music, which includes his St. Matthew and St. John Passions (see PASSION), B-minor Mass, Christmas Oratorio, motets, and nearly two hundred cantatas, Bach wrote orchestral and chamber music (concertos, sonatas, suites) and a large number of pieces for keyboard instruments (organ, harpsichord, clavichord). Two of his most important works are *Das wohltemperierte Clavier* ("The Well-Tempered Clavier"), which consists of forty-eight preludes and fugues, two for every major and every minor key, and *Die Kunst der Fuge* ("The Art of Fugue"), which illustrates practically every possible contrapuntal treatment of a single theme. Bach also wrote easier instructive pieces, some for the use of his wife and children in studying music. Among these are his *Two-Part* and *Three-Part Inventions,* written for his oldest son, **Wilhelm Friedemann** (1710–1784; he became an outstanding harpsichordist and organist as well as composing keyboard works, trio sonatas, and cantatas). His *Clavierübung* ("Keyboard Practice") contains a number of larger pieces for keyboard instruments, among them the *Goldberg Variations* for harpsichord, a set of thirty variations on a single theme.

In 1850, a century after Bach's death, an organization devoted to publishing his huge output, the *Bach-Gesellschaft,* was formed. Its forty-six-volume edition of the works, abbreviated **BG**, was completed about 1900. It was, however, in many respects quite inaccurate, and in succeeding decades a new edition, under the direction of Wolfgang Schmieder, a German music librarian, was begun. It was published in 1950, and still further revisions were almost immediately undertaken. The numbering of Bach's compositions in these editions is usually marked either **BWV** (for *Bach-Werke-Verzeichnis,* meaning "Catalog of Bach's Works") or **Schmieder.** Their order is not chronological but by instrumentation.

—**Karl Philipp Emanuel** (kärl' fil'ip e mä' n‍oo el") **Bach**, 1714–1788. The second son of J. S. Bach. He became famous as a harpsichordist, and by the time he was twenty-six he was employed at the court of Frederick the Great. Although he also wrote vocal and instrumental works, he is

remembered mainly for his keyboard music, which includes dozens of concertos and sonatas. He also wrote a book, *Versuch über die wahre Art das Klavier zu spielen* ("Treatise on the Correct Way to Play Keyboard Instruments"), which is a valuable guide for playing the keyboard music of the eighteenth century. Unlike his father, Karl Philipp felt that mere counterpoint was not enough to make great music, and in his works he stressed the expressive qualities of the keyboard instrument, a trait that became known as *empfindsamer Stil* ("expressive style"). See also GALLANT STYLE.

—**Johann Christian** (yō' hän kris' tyän) **Bach**, 1735–1782. The youngest son of J. S. Bach. For a time after his father died in 1750 he lived and studied with his older brother, Karl Philipp Emanuel, in Berlin. He then went to study and work in Italy and, later, London, where he spent the last twenty years of his life. His music was strongly influenced by the Italian and English styles of the time, and he is sometimes called the "English" or "London" Bach. His work belongs to the preclassical period (see PRECLASSIC), and he had a direct influence on Mozart, who met him when he visited London at the age of eight. Johann Christian's compositions include church music, operas in the Italian style, English songs, chamber and orchestral music, and sonatas for the harpsichord and the piano. He was one of the first to give concerts on the piano (from the 1760s), which then was a very new instrument.

Bach trumpet A name for various kinds of trumpet made in the nineteenth century to ease the task of playing the high-pitched, elaborate trumpet parts found in some eighteenth-century music, including some of the works of Johann Sebastian Bach. Baroque trumpeters were specially trained to produce the highest available notes on their instruments, which had neither valves nor keys. This technique, called **clarino**, had all but vanished by 1810 or so.

Today players use either a piccolo trumpet or a D trumpet for these parts (see under TRUMPET for further information). Bach is also the name of a well-known American manufacturer of trumpets, making Bach trumpet a doubly confusing term.

badinage See BADINERIE.

badinerie (bA dēn ᵊ rē') *French*. Also, *badinage* (bAd ᵊ na_zh_'). A name used for a fast, gay, dancelike piece in duple meter (any meter with two basic beats per measure, such as 2/4). In the eighteenth century the badinerie was used as a movement in suites, as, for example, in Bach's orchestral Suite in B minor.

bagatelle (bA gA tel') *French:* "trifle." A title used for a short piece, usually for piano. The most familiar example is Beethoven's *Bagatellen*, three sets of piano pieces (op. 33, op. 119, op. 126), but many other composers have written bagatelles, from François Couperin (seventeenth century) to Alexander Tcherepnin (late nineteenth century).

bagpipe An instrument with one or, more often, several reed pipes, attached to a windbag that provides air for the pipes. The player holds the bag under one arm, blows air into it through a blowpipe, and works the arm as a bellows (that is, to squeeze the air out of the bag). From the bag, which is made of either goatskin or sheepskin, the air is pushed through two kinds of pipe. One pipe, called the chanter (or chaunter), sounds the melody; it has eight finger holes (seven in front and one in back, for the thumb). The other kind of pipe, called a drone, plays a single low note. There usually are one to three drones. The air reaches these pipes in a steady stream so that they sound continuously.

The bagpipe is a very old instrument, dating back at least two thousand years, and there are many variations on the kind described above, which is the bagpipe of the Scottish Highlands (the national instrument

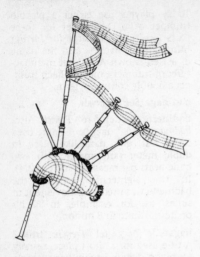

of Scotland). Most of the varieties found in Asia, North Africa, and Eastern Europe have pipes with a single reed and a cylindrical bore (the inside of the pipe does not taper). Most of the kinds found in western Europe, on the other hand, have pipes with a double reed and a wide conical bore (cone-shaped inside), producing the shrill sound associated with the Highland pipes. The chanter may be a single pipe or a double one. Like the Highland pipe, the Old Irish bagpipe, French **cornemuse**, and German **Dudelsack** all are mouth-blown. In the modern Irish bagpipe (also, *union pipes*) and French MUSETTE (def. 1), however, the wind is supplied by a small pair of bellows worked by the player's arm. Bagpipes traditionally are used to accompany folk dances, and in Britain bands of pipers also play military music.

Balakirev (bä lä′ki ref), **Mily Alexeyevitch** (mē′ lē ä″ le kse′ yᵊ vich), 1837–1910. A Russian composer, pianist, and teacher who became the leader of the group of composers known as "the Five" (see FIVE, THE). Like the other members of this group, Balakirev was interested in creating a truly national Russian music. His own works show the influence of Russian

folk music, as well as that of the romantic composers of western Europe, especially Liszt. Balakirev wrote two symphonies, two symphonic poems, and numerous songs. His best-known piece is *Islamey,* a very difficult fantasy for piano. Also well-known is his piano arrangement of Glinka's song, "The Lark."

balalaika (bä″lə lī′ kə). A kind of lute popular in Russia and other East European countries, where it is used mainly to accompany folk singing and dancing. It has a triangular body and a long neck provided with four movable frets to show where the fingers must stop the strings (see FRET). There are three strings, which the player plucks with a plectrum. The balalaika is made in at least six different sizes; one of the most common has its strings tuned E E A (above middle C).

balancement (bᴀ läns mäɴ′). French for VIBRATO, defs. 2, 4, 6.

ballabile (bä lä′ bē le) *Italian.* **1** A dance movement in a ballet or opera. For example, in Verdi's opera *Macbeth,* the song and dance of the witches is so marked. **2** Direction to perform in a dancelike fashion.

ballad 1 A solo song that tells a story in simple verse, the same music being repeated for each stanza. This kind of ballad was very popular from the sixteenth through the nineteenth centuries, especially in England. Often the text concerned actual events and was set to a familiar tune, such as "Greensleeves." Some ballads, however, even though they originally told a true story, were sung over such a long period that the event itself was forgotten and only the ballad remained, often in many different versions. A famous example of this kind, called a **folk ballad**, is "Barbara Allen." F. J. Child made an important collection, *English and Scottish Popular Ballads* (1882–1898), and pieces from it are sometimes called **Child ballads**. Sometimes composers wrote art songs in the style of a ballad—that is, telling a story, though not always using strophic form (with the same music for each stanza); one of the best-known ballads of this kind, called an **art ballad**, is Schubert's "Der Erlkönig" (The Erl King), a setting of a poem by Goethe. **2** A popular song, usually romantic or sentimental in nature. **3** A term used wrongly for BALLADE.

ballade (bA lAd') *French.* **1** A form of fourteenth-century French poetry that was frequently set to music in a polyphonic style (with several voice-parts). Probably originating as a dance-song, it came to have several stanzas, most often three, and a refrain. The first two couplets of each stanza were set to the same music, while the remaining lines and the refrain had different music. The first great writer of ballades was Guillaume MACHAUT, who composed them in three voice-parts, with the upper voice, called *cantus*, singing the words and the two textless lower parts, *tenor* and *contratenor*, supporting the melody, presumably instrumentally. (See also REFRAIN, def. 1.) **2** In the nineteenth and twentieth centuries, the name for a dramatic instrumental piece, sometimes but not always

influenced by the traditional poetic English ballad. Brahms wrote four such ballades for piano (op. 1), the first of them inspired by a Scottish ballad, "Edward." Chopin also wrote four ballades for piano, inspired by some poems of a Polish poet, Adam Mickiewicz (1798–1855). **3 Ballade** (bä lä′ də), *pl.* **Balladen** (bä lä′dᵊn) *German.* In the nineteenth century, a type of German poem similar to the English ballad but usually more elaborate and artistic. Such poems were set to music as long songs, in which the music usually changed with each stanza instead of being repeated. The most prolific creator of *Balladen* was the German composer Karl Loewe (1796–1869), who wrote seventeen volumes of them.

ballad opera A popular eighteenth-century form of English musical theater, in which spoken dialogue alternated with songs. The tunes were taken from popular ballads, folk songs, or other music by various composers, and new verses were written for them. The most important ballad opera was also one of the earliest, John Gay's *The Beggar's Opera*, produced in 1728. A modern and very successful imitation of Gay's work is Kurt Weill's *Die Dreigroschenoper* (1928), translated into English as *The Threepenny Opera* (1933) and later revived. Another twentieth-century ballad opera is Vaughan Williams' *Hugh the Drover*, which imitates the general style although it contains no spoken dialogue.

ballata (bäl lä′tä), *pl.* **ballate** (bäl lä′te) *Italian.* The most important Italian musical form of the second half of the fourteenth century, closely resembling a French form of the same period, the VIRELAI. The text of the ballata consists of three stanzas that alternate with a refrain, but it differs from ordinary strophic form (stanzas alternating with a fixed refrain) in that the refrain comes both at the beginning and at the end of each stanza, although with different words set to the same music. Originally a

monophonic song (with one voice-part), the ballata in time acquired a second and later a third voice-part. Of the many composers who wrote polyphonic *ballate,* the most important is Francesco Landini.

ballet (ba lā', bal'ā). A staged performance, generally with costumes and scenery, that is performed by dancers to music. Today ballets usually do not include either singing or spoken dialogue, relying entirely on the dancers to act out the story.

The earliest dance performances of this kind date from the fifteenth century, when they provided entertainment at weddings and other festivities at the courts of Italy, France, and Burgundy (today part of France). By the sixteenth century, what had been merely a series of dances performed in costume became much more elaborate. Stage decorations were added, and a story or plot was used to link the series of dances. In the sixteenth and seventeenth centuries the story was told with the help of words, both sung and spoken. In France this kind of entertainment was known as the **ballet de cour** (court ballet); its counterpart in England was called a court MASQUE. The ballet de cour was very popular during the reign of King Louis XIV (1643–1715), who employed great dance masters and musicians to produce new ballets. By far the most famous of the musicians was Lully, who composed many ballets; later, Lully became one of the first to include ballets within operas (see OPÉRA-BALLET). Lully's most important successor in composing ballets was Rameau.

Ballet continued to be popular during the eighteenth century, both in operas and as a separate entertainment. From France it spread to other parts of Europe, especially Austria, Russia, and, somewhat later, Denmark. The century between 1750 and 1850 saw the rise of famous ballet dancers, such as Jean-Georges Noverre (1727–1810), for whom

Gluck, Mozart, and Beethoven all wrote ballet music. However, despite the great popularity of ballet during this period, relatively little of its music has survived.

By the late nineteenth century the chief center of ballet was the Russian city of St. Petersburg, and it was there that the great ballets of Tchaikovsky —*Swan Lake, The Nutcracker,* and *Sleeping Beauty*—were first performed. It was also Russia that became the source of modern ballet, for it was the leadership of Sergei Diaghilev (1872–1929) and Michel Fokine (1880–1942) that produced the first great modern ballet troupe, the Ballets Russes. In 1909 this group began to perform in Paris, and its influence on ballet grew very quickly. Nearly all the prominent composers of the time wrote ballet music for the Ballets Russes, among them Debussy, Ravel, Richard Strauss, de Falla, Prokofiev, Hindemith, Bartók, and, perhaps most important of all, Stravinsky.

In the 1920s the Russian tradition was brought to England, whose most famous troupe was the Sadler's Wells Ballet (later called the Royal Ballet), and soon afterward ballet began to become popular in the United States. At first the American ballet followed the European models, but in time it developed its own styles, as well as its own music. The most important choreographer in this development was George Balanchine, who commissioned numerous American composers to write ballet scores. Although classical ballet continued to be an important art form during the second half of the twentieth century, companies commissioned less new music, instead relying on arrangements of existing scores, ranging from song cycles by Schubert and Mahler to transcriptions of operas, etc. Indeed, sometimes a single ballet included transcriptions of several works by quite different composers.

The chart on the following pages lists some of the more famous ballets.

SOME FAMOUS BALLETS

Composer	Ballet	First Performance
Adolphe Adam (1803–1856)	Giselle	1841, Paris
Béla Bartók	The Wooden Prince	1917, Budapest
	The Miraculous Mandarin	1926, Cologne (first revised version)
Ludwig van Beethoven	Die Geschöpfe des Prometheus ("The Creatures of Prometheus")	1801, Vienna
Leonard Bernstein	Fancy Free	1944, New York
Arthur Bliss (1891–1975)	Checkmate	1937, Paris
	Miracle in the Gorbals	1944, London
Benjamin Britten	Prince of the Pagodas	1972, London
André Campra (1660–1744)	Les Âges ("The Ages")	1718, Paris
John Alden Carpenter (1876–1951)	Skyscrapers	1926, New York
Frédéric Chopin (arranged by Alexander Glazunov)	Les Sylphides (Chopiniana)	1908, St. Petersburg
Aaron Copland	Billy the Kid	1938, Chicago
	Rodeo	1942, New York
	Appalachian Spring	1944, Washington, D.C.
Claude Debussy	Jeux ("Games")	1913, Paris
Léo Delibes (1836–1891)	Coppélia	1870, Paris
	Sylvia	1876, Paris
Werner Egk (1901–1983)	Abraxas	1948, Munich
Manuel de Falla	El Amor Brujo ("Love, the Sorcerer")	1915, Madrid
	El Sombrero de tres picos ("The Three Cornered Hat")	1919, London
Alexander Glazunov	The Seasons	1899, St. Petersburg
Christoph Willibald Gluck	Don Juan	1761, Vienna

SOME FAMOUS BALLETS *(continued)*

Composer	Ballet	Date, Place
Johan Peder Emilius Hartmann (1805–1900)	*Fjeldstuen*	1859, Copenhagen
	Valkyrien	1861, Copenhagen
Pierre Henry (1927–)	*Haut Voltage* ("High Voltage")	1957, Paris
Hans Werner Henze	*Undine* 1958, London	1938, London
Paul Hindemith	*Nobilissima Visione* (or *St. Francis*)	1920, Paris
Arthur Honegger	*Vérité-Mensonge* ("Truth-Falsehood")	1945, Paris
	L'Appel de la montagne ("The Call of the Mountain")	1942, Molotov (U.S.S.R.)
Aram Khatchaturian	*Gayane*	1926, Monte Carlo
Constant Lambert (1905–1951)	*Romeo and Juliet*	1927, Buenos Aires
	Pomona	1938, London
	Horoscope	
Jean-Baptiste Lully	*Le Mariage forcé* ("The Forced Marriage")	1664, French court
	Le Bourgeois gentilhomme ("The Middle-class Nobleman")	1670, French court
	Le Triomphe de l'amour ("The Triumph of Love")	1681, French court
Darius Milhaud	*La Création du monde* ("The Creation of the World")	1923, Paris
Wolfgang Amadeus Mozart	*Les Petits riens* ("The Trifles")	1778, Paris
Thea Musgrave (1928–)	*Beauty and the Beast*	1969, London
Luigi Nono (1924–1990)	*Der rote Mantel* ("The Red Cloak")	1954, Berlin
Walter Piston	*The Incredible Flutist*	1938, Boston
Francis Poulenc	*Les Biches* ("The Does")	1924, Monte Carlo
	Les Animaux modèles ("Model Animals")	1942, Paris
Sergey Prokofiev	*Chout* ("The Buffoon")	1921, Paris
	L'Enfant prodigue ("The Prodigal Son")	1929, Paris
	Romeo and Juliet	1940, Leningrad
	Cinderella	1945, Moscow
Jean-Philippe Rameau	*Les Indes galantes* ("The Noble Indians")	1735, Paris
	Les Fêtes de Polymnie ("The Feasts of Polyhymnia")	1745, Paris
	Pygmalion	1748, Paris

SOME FAMOUS BALLETS (*continued*)

Composer	Ballet	Date, Place
Maurice Ravel	*Anacréon*	1754, Fontainebleau
	Les Paladins	1760, Paris
	Daphnis et Chloé	1912, Paris
	Boléro	1928, Paris
Ottorino Respighi	*La Boutique fantasque* ("The Fantastic Toyshop") (based on themes by Rossini)	1919, London
Albert Roussel	*Le Festin de l'araignée* ("The Spider's Feast")	1913, Paris
	Bacchus et Ariane	1931, Paris
Eric Satie	*Parade*	1917, Paris
	Mercure	1924, Paris
	Relâche ("No Performance")	1924, Paris
William Schuman	*Undertow*	1945, New York
Dmitri Shostakovitch	*The Golden Age*	1930, Leningrad
Richard Strauss	*Josephslegende* ("Legends of Joseph")	1914, Paris
	Schlagobers ("Whipped Cream")	1924, Vienna
Igor Stravinsky	*The Firebird*	1910, Paris
	Petrushka	1911, Paris
	Le Sacre du printemps ("The Rite of Spring")	1913, Paris
	Pulcinella	1920, Paris
	Apollon Musagète ("Apollo, Leader of the Muses")	1928, Washington, D.C.
	Perséphone	1934, Paris
	Jeu de cartes ("Card Party")	1937, New York
	Orpheus	1948, New York
	Agon	1957, Los Angeles
Piotr Ilyitch Tchaikovsky	*Swan Lake*	1877, Moscow
	The Sleeping Beauty	1890, St. Petersburg
	The Nutcracker	1892, St. Petersburg
Ralph Vaughan Williams	*Job*	1931, London
William Walton	*Façade*	1931, London
Egon Wellesz (1885–1974)	*Das Wunder der Diana* ("The Wonder of Diana")	1924, Mannheim

ballet de cour (ba lā′ d³ ko͞or′) *French:* "court ballet." See under BALLET.

ballet opera See OPÉRA-BALLET.

ballet See under FA-LA.

balletto (bä let′ô) *pl.* **balletti** (bä let′ē) *Italian,* **ballett,** *English.* An Italian dance form of the sixteenth and seventeenth centuries. It was scored for lute from about 1550 to 1600, for voice from about 1590 to 1625, and for chamber ensemble during the remainder of the seventeenth century. Both the instrumental and vocal versions consisted of two repeated sections of different length, A A B B. However, in the vocal balletti each section ended with fa-la (see also FA-LA). The principal composer of vocal balletti was Giovanni Gastoldi (c. 1550–1622).

ballo (bäl′ô), *pl.* **balli** (bäl′ē). The Italian word for dance; *tempo di ballo* means "in dance tempo."

bambuco (bäm bo͞o′kô) *Spanish.* The national dance of Colombia. It is performed by two singers in close harmony (a third apart), with guitar and lute accompaniment. The lyrics are melancholy, and the music is usually in a minor key.

band 1 An instrumental group made up mainly of brass, woodwind, and percussion instruments, as distinguished from the ORCHESTRA, in which stringed instruments outnumber all the others. **2** Any of various unusual instrumental groups, such as a banjo, marimba, or accordion band. **3** In the seventeenth and early eighteenth centuries, any large instrumental group, regardless of its makeup or the kind of music it played; among famous groups to which the term was applied were the court orchestras of King Louis XIV of France and King Charles II of England. **4 brass band** A group of musicians playing brass instruments. A typical brass band consists of about twenty-four musicians playing cornets, French horns, flugelhorns, euphoniums, and trombones. Originally formed to play mili-

tary music, the modern brass band dates from about 1830, when the use of valves made brass instruments more practical, and it soon became popular among the civilian population as well. **5 symphonic band** or **concert band** A band including woodwinds, brasses, percussion instruments, and occasionally some cellos and double basses. The purpose of a symphonic band is more purely musical than that of bands performing at athletic events or military parades, since such bands generally perform at concerts. Numerous composers have written music for symphonic band, among them Holst, Hindemith, and Vaughan Williams. **6 marching band** A band that generally performs during parades and therefore cannot include instruments too large or too heavy to carry while being played. The most famous nineteenth-century American bandmaster was Irish-born Patrick Gilmore (1829–1892), who led his Grand Boston Band with the Union Army in 1861. The most famous American composer of marching band music is John Philip Sousa. (See also DRUM AND BUGLE CORPS; MARCH.) **7 jazz band** A band that performs jazz and other popular music, and generally includes some stringed instruments (usually double bass or guitar). **8 big band** A jazz band that has a total of twelve to fifteen or more instruments: four or five rhythm instruments (piano, bass, drums, guitar), four or five brasses (trumpets and trombones), and four or five woodwinds (mostly saxophones but perhaps also clarinet or flute), plus a male or female vocalist (or perhaps a vocal group) and sometimes also a string section. See also under JAZZ. **9 dance band** A band similar in composition to a jazz band that provides music for ballroom dancing. **10 jug band** A folk string band, with guitar, fiddle, and perhaps mandolin, and sometimes also piano. Its name comes from a homemade instrument, a one-gallon glass bottle or earthenware jug; the player half-vocalized and half-blew

across the opening, producing a tuba-like sound.

bandola (bän dō'lä) *Spanish*. A flat-backed lute used mainly in Colombia and Venezuela. Derived from the BAN-DURRIA, it has a similar teardrop shape, concave back, and six pairs of strings, which, however, are tuned in descending fourths, G D A E B F♯. It generally performs the melody and is accompanied by guitar.

bandora (ban dôr'a). Another name for PANDORA.

bandura (bän dōōr' ä). Also, *bandoura*. A lutelike instrument with a very short neck, round body, and forty or more steel strings, eight attached to tuning pins in the neck and the rest to tuning pins distributed around the edge of the instrument's body. A folk instrument of the Ukraine, it is plucked with a plectrum and is used alone or in ensembles of two or more instruments.

bandurria (bän dōōr' rē ä) *Spanish*. A kind of lute, used especially in southern Spain and Latin America. It has six pairs of strings tuned G♯, C♯, F♯, B, E, and A, which are plucked with a plectrum. The bandurria is often used in bands along with several other kinds of guitar.

banjo A stringed instrument widely used in American popular and folk music. It has a long neck and a body consisting of a round, shallow frame covered with parchment on one side. The banjo may have from five to nine strings, made of gut, nylon, or metal, and plucked with either a plectrum or the fingers. The most common variety of banjo has five strings, which are tuned D, B, G, C, G and plucked with the fingers. Frets indicate the stopping places. The banjo was brought by slaves from West Africa to North America, where for a time it became the traditional folk instru-

ment for American blacks. At first used for folk songs, it soon came to be used by minstrel troupes and in vaudeville performances. The banjo was also used by early jazz musicians but was later replaced by the guitar. It is quite easy to play and remains a popular instrument, especially among amateurs, chiefly for accompanying singing.

bar 1 Another term for MEASURE. **2** Another term for BAR LINE. **3 Bar** (bär). See under BAR FORM.

Barber (bär'bər), **Samuel**, 1910–1981. An American composer whose works are mostly traditional in style, although often original in content. Barber studied music from an early age and then attended the Curtis Institute in Philadelphia. Later he won the much coveted Prix de Rome, and in both 1935 and 1936 he won the Pulitzer Prize in music. His works include songs, symphonies, choral music, concertos, a fine piano sonata, and numerous short pieces, as well as the operas *Vanessa* and *Antony and Cleopatra*. Among his most frequently performed works are *Adagio for Strings*, the song cycle *Knoxville: Summer of 1915, Hermit Songs*, and *Dover Beach* for baritone and string quartet.

barbershop quartet See under QUARTET.

barcarola See BARCAROLLE.

barcarole See BARCAROLLE.

barcarolle (bAr kA rôl') *French.* Also, *barcarole;* Italian, *barcarola* (bär"kä rôl'ä). A type of song sung by the gondoliers of Venice, or a musical composition imitating this type of song. In 6/8 or 12/8 meter, the barcarolle usually has a regular, monotonous accompaniment that suggests the steady rocking of a boat. Barcarolles for piano have been written by many composers, among them Chopin, Mendelssohn, and Fauré. Vocal barcarolles appear in a number of operas; perhaps the most famous is the duet from Offenbach's *Les Contes d'Hoffmann* ("The Tales of Hoffmann").

bard A poet-musician of the Celtic peoples of the British Isles, the Irish, Scots, and Welsh. The bard composed and sang songs, often written in honor of the nobleman who employed him, and accompanied himself on the CRWTH, a kind of lyre. Later, bards also used the harp. During the early Middle Ages the bards had considerable political power and influence in the royal households that employed them. After 1284, however, when King Edward I of England conquered Wales, the bards were persecuted (because their power was felt to threaten that of the throne), and thereafter they were much less influential. There continued to be bards, however, until the end of the seventeenth century in Ireland and until the middle of the eighteenth century in Scotland. The Welsh bards used to hold an annual meeting, called Eisteddfod, and in the early nineteenth century, when interest in old music revived, the Eisteddfod began to be held again. It still is held in Wales today, although none of the ancient bards' music, which was not written down, has survived.

Bar form An old musical form, very important in the Middle Ages, which consists of three sections, A A B. It was based on a type of medieval German poem (**Bar**), which consisted of three or more stanzas, each divided into two **Stollen** (A, A) and an **Abgesang** (B). The music for each of the Stollen was the same, with different music being used for the Abgesang. This form was used by the troubadours and later by the trouvères, who called such a poem a BALLADE. Still later the form was adopted by the minnesingers and Meistersinger. A variation of the Bar form, A A B A, in which the Stollen is repeated again after the Abgesang, is the basic structure of many songs today.

baritone 1 The middle range of male voice, lower than tenor but higher than bass. The baritone range is roughly from low G (an octave and a half below middle C) to the E above middle C. (For bass-baritone, see BASS, def. 1.) **2** An instrument smaller in size and higher in pitch than one of bass size, such as the baritone saxophone and baritone saxhorn; its range roughly corresponds to that of the baritone voice. **3** See BARITONE HORN. **4** The British name for a TENOR HORN in B-flat.

baritone horn 1 In American terminology, a brass instrument of the saxhorn family, very much like the EUPHONIUM but with only three valves and a narrower bore. It is pitched in C or B-flat and may be shaped either like a trumpet, with the bell pointing up, or with the bell turned back. (The French call this instrument *baryton,* and the Germans call it *Barytonhorn.*) **2** The British name for a TENOR HORN in B-flat. (See also BRASS INSTRUMENTS.)

baritone oboe See under OBOE.

bar line A vertical line through a musical staff (or group of staves) that separates two measures. In addition, a bar line is used at the beginning of a piece, before the clef and key signature, and a double bar line marks the end (see DOUBLE BAR). The use of bar lines dates from the late fourteenth

century, but until the seventeenth century they were used only to help the player's eye follow the music on different staves. Only in the seventeenth century did bar lines come to indicate the musical METER, marking

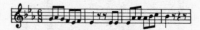

off its regular pattern. In the twentieth century, composers sometimes change the meter many times within a composition and therefore either omit bar lines completely or use them, as in earlier times, simply to help the performer read the score.

baroque (bə rōk'). A term borrowed from architecture to describe the style of music written in western Europe from about 1600 to about 1750. (The period preceding the baroque is called RENAISSANCE; the period following the baroque is called PRECLASSIC or ROCOCO.) In the baroque period many new forms and styles were developed by French, German, Italian, and English composers. Among the outstanding figures are Monteverdi and Frescobaldi in the early baroque; Vivaldi, Couperin, and Purcell in the middle baroque; and Handel and Bach at the end of the period. (See the accompanying chart of major baroque composers; see also BOLOGNA SCHOOL.)

The beginning of the baroque period is marked by a rebellion against the polyphonic style of the Renaissance, with its music in many voice-parts, all of equal importance. In its place came MONODY, in which one voice-part carries the melody and a basso continuo (see CONTINUO) supplies the accompaniment. Polyphony was not wholly discarded, however; indeed, in the form of counterpoint (in which the individual melodic lines are subordinate to the harmony they produce) it remained very important, especially in keyboard music. This resulted in the development of such forms as the FUGUE, organ chorale (see CHORALE PRELUDE), and TOCCATA. Another important concept in baroque music was the use of contrasting effects between slow and fast, solo and full chorus, and loud and soft, which is particularly evident in such forms as the TRIO SONATA, CONCERTO GROSSO, SINFONIA, and CANTATA. During the baroque period performance was almost as important as composition; indeed, much of the music was not fully written out and required improvisation and ornamentation on the part of the performer. (See also FIGURED BASS.)

barrelhouse A blues style of piano playing favored by black performers in the 1920s and persisting into the 1930s. In regular 4/4 time, it featured a heavy left-hand vamp called "stomping," or, sometimes, a walking bass.

barrel organ Also, *hurdy-gurdy*. A mechanical musical instrument in which a wooden cylinder (the barrel) is turned, either by hand or by clockwork, thereby causing organ pipes to play a particular tune. Pins and staples are driven into the surface of the barrel, and when the barrel is rotated, the pins act against levers that force air through the organ pipes at the proper times and for the desired duration. Since the positions of the pins are fixed, only a single tune or series of tunes can be played with one barrel.

Mechanical organs date as far back as the sixteenth century, and by the eighteenth century they were quite common, especially in England. They were used for home entertainment and also in small churches that could not afford a large pipe organ or the salary of an organist. Such organs were ordinarily provided with a number of interchangeable barrels, one for each hymn to be played. One form of barrel organ, in France called **orgue de barbarie** and in England **bird organ**, was used to teach canaries and other songbirds to sing popular tunes of the day. Early in the nineteenth century, portable barrel organs were made; they were mounted on carts and wheeled through the street by

IMPORTANT BAROQUE COMPOSERS

Composer	Country	Noted for
Tomaso Giovanni Albinoni (1671–1750)	Italy	Instrumental ensemble music (especially for strings), operas, solo cantatas.
Felice Anerio (c.1560–1614)	Italy	Madrigals, motets, other sacred music.
Giovanni Francesco Anerio (c. 1567–1630)	Italy	Masses, motets, some of earliest oratorios in Italian.
Jean-Henri d'Anglebert (c. 1628–1691)	France	Harpsichord music.
Johann Sebastian Bach (1685–1750)*	Germany	Keyboard, instrumental, and church choral music.
Heinrich von Biber (1644–1704)	Germany	Violin virtuoso; violin music; sacred and secular instrumental and choral works.
John Blow (1649–1708)*	England	Church choral music, songs, a masque; teacher of Purcell.
Georg Böhm (1661–1733)	Germany	Organ and harpsichord music.
Giovanni Bononcini (1670–1755)	Italy, England	Many operas, Masses, oratorios; rival of Handel.
Dietrich Buxtehude (c. 1637–1707)*	Germany	Organ music, church choral music.
Giulio Caccini (c. 1546–1618)*	Italy	Solo madrigals, one of the first operas.
Antonio Caldara (1670–1736)	Italy	Operas, oratorios, cantatas, Masses, arias, madrigals.
Giacomo Carissimi (1605–1674)*	Italy	Cantatas, oratorios.
Jacques Champion de Chambonnières (c. 1602–1672)*	France	Harpsichord music; teacher of d'Anglebert.
Marc-Antoine Charpentier (c. 1648–1704)	France	Oratorios, operas, church choral music.
Arcangelo Corelli (1653–1713)*	Italy	Concerti grossi, chamber music, violin music.
François Couperin (1668–1733)*	France	Harpsichord and organ music, chamber music.
Johann Kaspar Ferdinand Fischer (c. 1665–1746)	Germany	Harpsichord and organ music.
Girolamo Frescobaldi (1583–1643)*	Italy	Harpsichord and organ music.
Johann Jakob Froberger (1616–1667)*	Germany	Harpsichord and organ music.
George Frideric Handel (1685–1759)*	England	Oratorios, operas, orchestral and chamber music, harpsichord music.
Johann Philipp Krieger (1649–1725)	Germany	Operas, trio sonatas, church choral music.

IMPORTANT BAROQUE COMPOSERS (continued)

Composer	Country	Description
Johann Kuhnau (1660–1722)	Germany	Harpsichord and organ music, church cantatas.
Pietro Locatelli (1695–1764)	Italy	Violin and cello sonatas, concertos, concerti grossi.
Matthew Locke (c. 1630–1677)	England	Masques, incidental music for plays.
Jean-Baptiste Lully (1632–1687)*	France	Operas, ballets, orchestral music.
Marin Marais (1656–1728)	France	Bass viol virtuoso (over 550 works for viol); also first known French trio sonatas, operas.
Biagio Marini (c. 1597–1665)	Italy	Violin music, sinfonias, canzonas, sonatas.
Claudio Monteverdi (1567–1643)*	Italy	Operas, madrigals, church choral music.
Georg Muffat (1653–1704)	Germany	Harpsichord and organ music, orchestral music; brought influence of Lully and Corelli to Germany.
Johann Pachelbel (1653–1706)	Germany	Organ and harpsichord music; famous canon from Canon and Gigue in D for three violins and continuo.
Jacopo Peri (1561–1633)*	Italy	Composed one of the first operas.
Henry Purcell (c. 1659–1695)*	England	Incidental music for plays, an opera, church choral music, chamber music, harpsichord music.
Jean-Philippe Rameau (1683–1764)*	France	Operas, harpsichord music.
Alessandro Scarlatti (1660–1725)*	Italy	Operas.
Domenico Scarlatti (1685–1757)*	Italy	Harpsichord sonatas.
Samuel Scheidt (1587–1654)	Germany	Organ and harpsichord music, church choral music.
Johann Hermann Schein (1586–1630)	Germany	Organ music, church choral music, madrigals, instrumental suites.
Heinrich Schütz (1585–1672)*	Germany	Church choral music.
Jan Pieterszoon Sweelinck (1562–1621)*	Netherlands	Harpsichord and organ music, church choral music; teacher of Scheidt, other North German organists.
Giuseppe Tartini (1692–1770)*	Italy	Violin music.
Georg Philipp Telemann (1681–1767)*	Germany	Operas, oratorios, orchestral and chamber music.
Giuseppe Torelli (1658–1709)*	Italy	Concerti grossi, violin music.
Giovanni Battista Vitali (c. 1644–1692)	Italy	Violin music.
Antonio Vivaldi (c. 1675–1741)*	Italy	Concertos, concerti grossi, church music.

*See separate article on each of these composers for additional information.

street musicians popularly called organ grinders. In this kind of organ, called a **street organ**, the cumbersome barrel was replaced by perforated and folded cardboard strips. See also MECHANICAL INSTRUMENTS.

Bartók (bär'tok), **Béla** (bā'lə), 1881–1945. A Hungarian composer and pianist who became famous for his studies of East European folk music and for the use of folk elements along with modern devices in his own highly original compositions. Bartók began his studies as a young boy, first being taught piano by his mother and later attending the Budapest Conservatory. In his early years, he was strongly attracted to the music of the French impressionist composers. He also became very interested in folk music, and soon discovered that what people generally thought of as Hungarian folk music was quite different from the music actually sung by country people in remote places. Together with his countryman, Zoltán Kodály, Bartók began to collect real folk music, first in Hungary and then in Rumania, Slovakia, and other East European areas. This newly discovered music contained new rhythms, new harmonies, and even scales totally different from those with which musicians were generally familiar. When Bartók used some of these devices in his own compositions, in such traditional media as the string quartet, he met opposition and even ridicule. Gradually, however, the Hungarians came to regard this type of music as their own and to consider Bartók a great national composer. In 1940 Bartók came to the United States, where he spent the remaining few years of his life.

Bartók wrote hundreds of compositions. Among the most important are his six string quartets and several violin sonatas; numerous piano works, including *Mikrokosmos*, a set of 153 pieces for children, ranging from very easy to quite difficult; many orchestral works, including suites and rhapsodies and a Concerto for Orchestra

(but no symphonies); *Music for Strings, Percussion, and Celesta*; and three stage works, the opera *Bluebeard's Castle*, the ballet *The Wooden Prince*, and the pantomime-ballet *The Miraculous Mandarin*.

baryton 1 (bar' i ton"). An eighteenth-century stringed instrument played with a bow and having six or seven melody strings made of gut, and from eight to thirty or more sympathetic strings made of metal. A member of the VIOL family, it somewhat resembles a long-necked tenor viol. The sympathetic strings sound (without being touched) when the melody strings are bowed. The melody strings were usually tuned A D F A D F (from low A to F above mid-

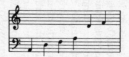

dle C), which is roughly the range of the baritone voice. The instrument's neck is carved out under the fingerboard, so that the sympathetic strings

can be plucked by the player's left thumb if desired to provide an accompaniment to the tune played on the bowed strings. A number of well-known composers wrote for the baryton, notably Haydn, whose patron, Prince Nicolaus Esterházy, was particularly fond of it and who therefore wrote more than 175 pieces for it. Nevertheless, the instrument soon dropped out of use. 2 (bᴀ rē tôn'). The French word for the baritone voice and the baritone size of instrument (see BARITONE, defs. 1, 2). 3 (bᴀ rē tôn'). The French name for the BARITONE HORN (def. 1). 4 (bä' rē tōn"). The German word for the EUPHONIUM.

Barytonhorn (bä' rē tōn horn"). The German word for BARITONE HORN (def. 1).

bass (bās). 1 The lowest range of male voice. Its range is roughly from low E (an octave and a half below middle C) to middle C. In four-part choral music it is the lowest of the parts.

Bass singers are sometimes classified according to the particular quality of their voices: **basso profondo** (deep bass), with a very low range and a powerful voice; **basso cantante** (singing bass), with a light, sweet quality; **basso buffo** (comic bass), a very agile voice well suited for comic roles in opera; **bass-baritone**, a voice with a strong upper register in the baritone range but resonance in the bass range. 2 The lowest (and therefore largest) instrument of most families, such as the bass drum, bass clarinet, and bass recorder. (A few instrument families have instruments pitched an octave lower than the bass size; these are known as contrabass or double-bass instruments.) 3 In musical compositions, the lowest part, the upper part being called treble. In Western (European and American) music of the seventeenth to nineteenth centuries, the bass is the line on which

the harmony is built. It was particularly important in the baroque era (1600–1750), when the entire harmony was built on a basso continuo. 4 A name for DOUBLE BASS. 5 In German, abbreviation for KONTRABASS. 6 **electric bass** See under ELECTRONIC INSTRUMENTS.

bassa (bäs'sə) *Italian:* "low." The phrase **ottava bassa** (or **8va bassa**) is a direction to play the notes indicated an octave lower than written.

bassadanza (bäs"sä dän' tsä). The Italian name for BASSE DANSE.

bassa musica See ALTA MUSICA.

bass bar A strip of wood, tapering at both ends, that is glued to the underside of the belly (top, or soundboard) of instruments of the viol and violin families. The bass bar is placed under the left foot of the bridge. It serves to spread the vibrations of the strings over the whole belly and to support the belly against the downward pressure of the strings. (See illustration at VIOLIN.)

bass clarinet See under CLARINET.

bass clef See under CLEF.

bass drum The largest of the orchestral drums, consisting of a wooden shell, almost three feet in diameter, which is covered with skin. The bass drum is nearly always held vertically when it is played, and although it may have one or two heads, usually only one head is actually struck. The bass drum is played with a single stick, called a bass-drum beater or tampon. Either end of the beater is used, the ends being padded with wool or felt (although occasionally all-wood beaters are employed). For ordinary drumbeats the head is struck midway between its center and edge; it is struck in the center only for short quick strokes (staccato) and special effects. Although the deep sound of the bass drum is a familiar one in every concert band and symphony orchestra, the instrument was intro-

duced to Europe only in the late eighteenth century, along with other percussion instruments used in Turkish military bands (see JANISSARY MUSIC), and was used exclusively to imitate military sounds until the middle of the nineteenth century.

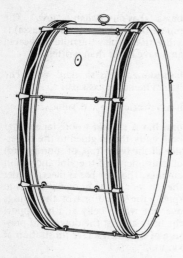

basse (bAs). The French word for BASS.

basse danse (bAs' däNs') *French*. A slow, stately dance of the fifteenth and sixteenth centuries. Its name, meaning "low dance," probably comes from the fact that the dance was performed with gliding steps (feet close to the floor) rather than with jumping or leaping ones. The basse danse was often followed by a quick, lively dance, such as the saltarello in Italy or the pas de Brabant in France. The basse danse melodies that survive consist of a series of fairly long-held equal notes that correspond to the dance steps. They appear to have served as a cantus firmus (fixed melody) over which players improvised one or more counterpoints. By the sixteenth century the basse danse consisted of a number of well-defined tunes in several short sections with considerable repetition. The basse danse is thought to be the source of various later dances, which developed into the movements (not intended for dancing) that comprise the eighteenth-century suite.

basset (bas'it) **horn** An eighteenth-century type of tenor clarinet that is still occasionally used. Invented about 1770, the basset horn has the same mouthpiece and bore as the ordinary B-flat clarinet but is longer and usually has an upturned metal bell. It is usually pitched in F, its range being from low F to the E above middle C, and it has a low, pleasantly

somber tone. Two composers in particular have been attracted to the instrument. Mozart used it in his Requiem Mass, in several operas, and in such chamber works as three Andantes for two clarinets and three basset horns and the Serenade in B-flat for thirteen wind instruments. Richard Strauss used the basset horn in six of his operas. In addition, Beethoven called for it in *Prometheus*, Mendelssohn wrote two works for clarinet, basset horn, and piano (op. 113 and op. 114), and Stravinsky's *Elegy for J. F. K.* (1964) is scored for baritone voice, two clarinets, and basset horn.

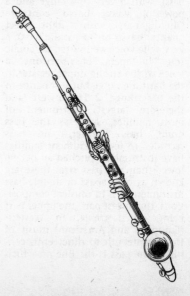

bass fiddle A familiar name for the DOUBLE BASS.

bass flute See under FLUTE.

bass horn See under SERPENT.

Bassklarinette (bäs′ klä rē net″ ə). The German word for bass clarinet (see under CLARINET).

basso (bäs′ sô). The Italian word for BASS.

basso buffo (bäs′sô bōōf′fô) *Italian.* See under BASS, def. 1.

basso cantante (bäs′sô kän tän′te) *Italian.* See under BASS, def. 1.

basso continuo (bäs′sô kôn tēn′ ōō ô) *Italian.* See CONTINUO.

basson (bA sôN′). The French word for BASSOON.

bassoon (ba sōōn′). The bass member of the oboe family. The bassoon has a very large range, from the third B-flat below middle C to the second D

above middle C. Because of the low pitch of its lowest notes, it requires a tube about nine feet long; due to this great length the tube is doubled back on itself. The bassoon has a conical bore and is made in four sections.

Like the oboe, the bassoon is played with a DOUBLE REED and consists of a wooden pipe, usually of maple, into which are bored a number of finger holes, some of which are opened and shut by means of keys. The bassoon developed sometime during the seventeenth century from the CURTAL and changed several times during the course of its development, mainly through the addition of more keys. Since the early nineteenth century there have been two quite separate schools of bassoon building, one French and the other German. German bassoons are now used in virtually every part of the world except in France itself.

Nearly every major composition for orchestra written since the eighteenth century includes a part for the bassoon, which is also required in virtually all compositions for wind ensemble. Important compositions for solo bassoon include concertos by Vivaldi, Stamitz, Mozart, Weber, and Amram; Prokofiev's *Humorous Scherzo* for four bassoons; Arcady Dubensky's Prelude and Fugue for Four Bassoons; sonatas for bassoon and piano by Hindemith and Saint-Saëns; Wellesz's Suite for unaccompanied bassoon; and Alvin Brehm's *Colloquy and Chorale* for bassoon quartet. Prominent parts for the bassoon are found in Dukas's *The Sorcerer's Apprentice,* which also has an important part for double bassoon, in Grieg's "In the Hall of the Mountain King," from his *Peer Gynt* Suite no. 1, and in Penderecki's *Adagio* (from his Fourth Symphony). —**double bassoon** or **contra-bassoon** The lowest member of the oboe family, the double bas-

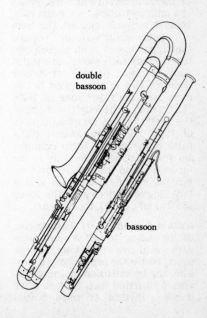

double bassoon

bassoon

soon is pitched an octave lower than the bassoon and sounds an octave lower than the music for it is written. It has a tube almost eighteen feet long, which is doubled back on itself four times.

basso ostinato (bäs' sô ô"stē nä' tô) *Italian.* See under OSTINATO.

basso profondo (bäs'sô prô fôn'dô) *Italian.* See under BASS, def. 1.

bass trombone See under TROMBONE.

bass trumpet See under TRUMPET.

bass tuba 1 See under TUBA. **2** A name sometimes used for the bass size of the SAXHORN.

bass viol 1 Name sometimes used for the DOUBLE BASS. **2** Also, *viola da gamba.* The bass member of the viol family (see VIOL).

baton (ba ton'). A slender stick used by conductors to beat time and to help indicate loudness, phrasing, etc. Some conductors use both hand and baton, others the baton only, and still others use only their hands.

battle music A general term for musical compositions in which the sounds of a military battle—cries, drum rolls, fanfares, etc.—are imitated. This form of program music was quite popular from the sixteenth to nineteenth centuries. Many such pieces are entitled *Battle, Battaglia* (Italian), or *Bataille* (French). One of the earliest is Clément Janequin's part song of 1529, "La Guerre" ("The War"), and one of the latest is Liszt's symphonic poem of 1857, *Die Hunnenschlacht* ("The Battle of the Huns"). Other examples are Franz Kotzwara's *Battle of Prague* for piano, and Beethoven's *Wellingtons Sieg oder die Schlacht bei Vittoria* ("Wellington's Victory or The Battle of Victoria"), op. 91, for orchestra.

battuta (bät tōō'tä) *pl.* **battute** (bät tōō'te) *Italian:* "beat." A word originally used with reference to the strong beat at the beginning of a measure, and by extension meaning MEASURE. A direction such as *ritmo di tre battute* ("rhythm of three beats")

means that the measures are to be grouped together in threes, the tempo being so fast that the main accent should come at the beginning of every three measures instead of at the beginning of each individual measure. —**a battuta** (ä' bä tōō'tä). A direction to the performer to return to strict tempo after some change. —**senza battuta** (sen'dzä bä tōō'tä). A phrase meaning "without beat," used as a direction to perform a piece or section in very free rhythm.

baya See under TABLAS.

Bay Psalm Book The first book printed in British North America, published in 1640 in Cambridge, Massachusetts. Its exact title is *The Whole Booke of Psalms Faithfully Translated into English Metre,* the psalms being paraphrased in rhymed English verse for singing in Protestant worship services. The first edition of the book contained no melodies, but there were numerous later editions, and the ninth edition, published in 1698, contained thirteen tunes. This edition was the first book of music printed in North America.

Bayreuth (bī'roit) See under WAGNER.

BB-flat bass (dub'əl bē' flat' bäs'). **1** A valved bugle with a very wide conical bore and a baritone range, from D to A. It is used mainly in bands. **2** A name for the orchestral tuba (see

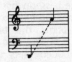

TUBA, def. 2; also see HELICON). **3** A name sometimes used for the contrabass SAXHORN.

b.c. An abbreviation for *basso continuo* (see CONTINUO).

Beach, Amy Marcy Cheney (Mrs. H.H.A. Beach), 1867–1944. An American pianist and composer, the first American woman to produce a symphony. Her *Gaelic Symphony* was performed by the Boston Symphony

Orchestra in 1896. The most successful of her other instrumental works, which are in a late romantic style that has been likened to that of Brahms, include a piano concerto, violin sonata, and piano quintet. She also wrote about 100 songs, the best of which, such as "Ecstasy," "The Year's at the Spring," and "Ah, Love But A Day," show her melodic inventiveness and fine craftsmanship.

beam Any of the thick, horizontal lines used to connect the stems of groups of eighth notes, sixteenth notes, etc. Eighth notes are connected by a single beam, sixteenth notes by two beams, etc.

beat The unit used to measure musical time, indicated by the up-and-down movements of a conductor's hand or by tapping one's foot in time to the music. Beats tend to fall into groups of twos or threes. It is these groups that are the basis for dividing music into the most common meters. The number of beats in a measure of music depends on both time signature and tempo. A piece with a 4/4 time signature (indicating that there are four beats per measure and each beat falls on a quarter note) will have four beats to the measure only when it is played in moderate tempo, neither very fast nor very slow. The song "Yankee Doodle" has four beats to the measure, the first and third of which are stronger than the second and fourth (one tends to sing *Yan*-kee *Doo*-dle, the syllables in italics being slightly emphasized). If the song is played fairly fast, one tends to miss the second and fourth beats—there isn't enough time to emphasize them—so that there are, in effect, only two beats per measure. When the song is played at the fastest possible tempo, the third beat is skipped too, leaving only one beat per measure, the first. Alternatively, if the piece is played very, very slowly, one tends to give each of the four beats an extra beat (Ya-an-kee-ee Doo-oo-dle-le), making eight beats per measure. See also RHYTHM.

beating reed A term used to distinguish single and double reeds, which vibrate against another surface, from free reeds. See under REED.

bebop (bē'bop). See BOP.

Bebung (bā' bo͞onk) *German.* See under CLAVICHORD; VIBRATO.

Becken (bek'ən). The German word for CYMBALS.

Beethoven (bā'tō vən), **Ludwig van** (lo͞od' vig vän), 1770–1827. A German composer whose nine symphonies and numerous piano and chamber compositions mark him as one of the outstanding composers of Western music. Beethoven's father was a musician, as was one of his grandfathers, and he studied the piano, violin, viola, harpsichord, and organ. He was playing in the court orchestra in his native city of Bonn by the time he was thirteen. He then studied in Vienna with Haydn and with a lesser composer, Johann Georg Albrechtsberger (1736–1809), giving his first public piano concert there in 1795. Beethoven remained in Vienna for the rest of his life. When he was about thirty years old he began to lose his hearing. Gradually forced to give up his career as a pianist, he devoted himself more and more to composing. Although he was totally deaf by about 1824, this handicap did not prevent him from composing some of his greatest works during the remaining three years of his life. Unlike many composers, Beethoven was almost as highly regarded during his lifetime as he was after his death.

Beethoven's work—a large body of compositions in virtually every form—bridges the classic and romantic periods of music history. Some authorities consider him primarily a classicist and others a romanticist, but few deny that he was very original in all he undertook. His work is often divided into three periods. To the first period, in which Beethoven largely followed the classical models of Mozart and Haydn, belong the compositions written up to about 1800,

the most important of which are his first two symphonies, the first three of his five piano concertos, twelve of his thirty-two piano sonatas, six of his sixteen string quartets, and the *Kreutzer* Sonata for violin. In his second period (c. 1800–c. 1815) Beethoven pushed the classical forms to their furthest extreme, especially in his methods of development of themes. To this period belong his symphonies nos. 3 through 8, the opera *Fidelio*, the four *Leonore* overtures, incidental music for the play *Egmont*, Piano Concertos nos. 4 and 5, his Violin Concerto, fifteen piano sonatas, the *Eroica* Variations for piano, and five string quartets. The last period (c. 1815–1827) saw the composition of his Symphony no. 9 (called the *Choral Symphony*, because of its choral finale), the *Missa Solemnis* (Mass), five piano sonatas, the *Diabelli Variations* for piano, and the last five string quartets. In these last works, especially in the string quartets, Beethoven took more and more liberties with the classic structure, using six or seven movements instead of the traditional four, exploring changes of harmony, transforming the formerly playful scherzo movement into a serious mockery, and foreshadowing the coming romantic style with more songlike, emotionally expressive melodies. (See also CONCERTO; QUARTET; SONATA.)

bel A unit for measuring the relative intensity (loudness) of sound. One bel is the difference in loudness produced by a tenfold increase in sound energy. Because the bel (named for Alexander Graham Bell) represents a very large change in loudness, it is more usual to employ the **decibel**, which is equal to one-tenth of a bel. The smallest change in loudness that can be detected by the average person's ear is about one decibel.

It is also customary to state the actual intensities of sounds in decibels by comparing their loudness to a very soft reference level. On this scale, the loudness of musical sounds ranges from about twenty-five decibels (the softest violin tone) to about one hundred decibels (the full orchestra playing very loudly).

bel canto (bel kän' tô) *Italian:* "beautiful singing." A term for a style of singing that emphasizes a beautiful, even tone and brilliant, agile technique. This style is associated with Italian opera of the eighteenth and early nineteenth centuries, and is still used for Italian vocal music of that time, such as operas by Bellini, Donizetti, and Rossini. However, the term itself is employed quite loosely and is open to varying interpretations, so it is of limited usefulness.

belebend (be lā'bənt) *German.* Also, *belebt* (bə lābt'). A direction to perform in a lively, animated manner.

belebt See BELEBEND.

bell 1 A musical instrument made of wood or metal and consisting of a hollow body that is struck either by a clapper placed inside it or by a mallet or hammer from the outside. Bells have been used since ancient times by peoples all over the world, for magic, religious purposes, signaling, and other uses. Their main use in modern times is as church bells. A bell can sound only one pitch (which depends on its size, weight, and other physical characteristics) and the overtones of that pitch, which in bells of the highest quality are accurately tuned to the basic pitch and account for the instrument's ringing quality. The church bells used today tend to be very large, weighing anywhere from 5,000 to 15,000 pounds. The largest bell ever made was the "Tsarina Kolokol" of Moscow (*kolokol* is the Russian word for bell), which was cast in 1734 and destroyed in a fire only three years later; it weighed about 432,000 pounds and was 22 feet in diameter.

Hand bells, equipped with a handle so they can be shaken (or stationary, so they can be tapped with the hand), are made in tuned sets. Ranging from six to sixty or so in number,

they can sound anywhere from a short scale to a full five chromatic octaves. Hand bells are used by a group of four to fifteen ringers, each of whom holds one or two bells (and may switch to still other bells). Handbell ringing has been popular in Europe off and on since the thirteenth century. It is especially popular in England, and has come from there to North America.

Small hand bells are sometimes used in the percussion section of the orchestra for special effects. Mahler in his Symphony no. 4 called for sleighbells, and in Symphony no. 6 for cowbells. More often, however, the bells used in the orchestra are actually metal tubes hung from hooks, which are struck with a hammer. (See CHIMES; GLOCKENSPIEL; CARILLON, def. 1.) 2 The bell-shaped, flaring opening of wind instruments, such as the clarinet, oboe, and trumpet. The shape of the bell affects the instrument's tone quality. A wide opening, as in a French horn, makes for a mellow tone, while a narrow opening, as in a trumpet, creates a more brilliant (shrill) tone.

bell chime A set of bells tuned to various pitches and suspended on a rack. Used in the Middle Ages and still popular in Asia, they resemble the tubular bells of the modern orchestra (see under CHIMES, def. 1) but are bell-shaped and may be sounded from the inside by a clapper or from the outside with a mallet.

Bellini (bel lē′ nē), **Vincenzo** (vin chen′dzō), 1801–1835. An Italian composer remembered mainly for three of his eleven operas, *Norma, La Sonnambula* ("The Sleepwalker"), and *I Puritani di Scozia* ("The Puritans of Scotland"). His music is noted for its lyrical expressiveness, well suited for the bel canto style of singing so popular in the early nineteenth century.

bell lyre See GLOCKENSPIEL, def. 2.

bells 1 See CHIMES. **2** See GLOCKENSPIEL.

belly Also, *soundboard, table, top.* The upper surface of the body of a stringed instrument, such as the guitar, violin, or lute, over which the strings are stretched.

ben (ben) *Italian:* "well." A word used in such directions as *ben marcato* (ben′ mär kä′tô; "well accented"), and *ben sostenuto* (ben′sôs″ te nōō′tô; "well held" or "well sustained").

Benedictus (be″ne dik′tŏŏs) *Latin:* "blessed." **1** The second part of the Sanctus of the Roman Catholic Mass (see MASS), which is set to the text *Benedictus qui venit in nomine Domini* ("Blessed is he who comes in the name of the Lord"). Composers often treat this section as a separate movement. See also SERVICE. **2** The concluding canticle of the Roman Catholic OFFICE of Lauds, *Benedictus Dominus Deus Israel* ("Blessed be the Lord God of Israel," from the Gospel of St. Luke).

berceuse (ber sœz′) *French:* "lullaby." A title often used for an instrumental piece (for piano, some other instrument, or orchestra) that suggests the smooth, regular rhythm of a rocking cradle. Such pieces are generally in 6/8 meter and moderate tempo. A notable example is Chopin's Berceuse op. 57, for piano. See also LULLABY.

Berg (berg), **Alban** (äl′bän), 1885–1935. An Austrian composer who became known, along with Anton Webern, as one of Schoenberg's chief disciples. From his teacher, Berg learned to compose atonal music, that is, music in which a tonal center is avoided. The principal method developed for atonal music was the twelve-tone technique, in which all twelve tones of the chromatic scale are treated as equally important (see SERIAL MUSIC). Berg, however, tended to apply these principles much less strictly than Schoenberg, never allowing them to interfere with his concern for emotional expressiveness. Berg's most famous works are his Violin Concerto and two powerful expressionist operas, *Wozzeck* (1921) and *Lulu;* he never completed *Lulu,* but it is performed with endings based on

his notes. His other compositions include a piano sonata, songs, and numerous chamber works.

bergamasca (ber″ gä mäs′ kä) *Italian.* **1** A general name for dances and songs from Bergamo, a region in northern Italy. From the seventeenth to nineteenth centuries, composers often used the name as a title for pieces resembling such music. **2** In the late sixteenth century, a piece containing the harmonic pattern I–IV–V–I (that is, a sequence of chords on the tonic, subdominant, dominant, and tonic), repeated over and over. (See HARMONIC ANALYSIS for further explanation.) During the seventeenth century, hundreds of pieces based on this pattern were written, mostly for guitar or lute. In time a particular melody came to be associated with this harmonic pattern, and sometimes it was used independently. Bach, for example, used it in the last variation of his *Goldberg Variations.* **3** In the nineteenth century, a quick, lively dance in 6/8 meter, similar to the TARANTELLA.

Berio (ber′ē ô), **Luciano** (lōō chyä′ nô), 1925– . An Italian composer who became known first as one of the pioneers of electronic music and later for his theatrical works, sometimes called music theater, which integrate sound, text, and ideas in dramatic and often very entertaining fashion. The son of an organist and composer, Berio was taught organ and piano as a boy. After World War II he helped found an important electronic music studio in Milan. During the 1960s and early 1970s he spent a number of years in the United States, composing and teaching. Much of Berio's music aims at presenting poetic, dramatic, and philosophical ideas; to this end he combined live voices and instruments, dramatic action, and taped sound. Notable among his works are *Epifanie* ("Epiphany") for voice and orchestra, in which he used quite different styles for setting the texts of Joyce, Proust, Brecht, and other writers; the *Sequenza* series of solo pieces

for various instruments (and one for voice), involving ALEATORY elements and exploiting the resources of the respective instrument; *Passaggio* ("Passage"), a stage work for soprano, two choruses (one on stage, one in the audience), and orchestra, in which the protagonist is hounded by the chorus, which represents society's crass materialism; *Sinfonia,* for orchestra and eight amplified voices, which includes poetry and prose, and fragments of works by Mahler, Debussy, Bach, and other composers; *Coro* ("Chorus"), for forty individual singers and forty-four solo instrumentalists, a complex work in several languages using folk idioms and techniques from all over the world but without literally quoting actual songs; the opera *La Vera Storia* ("The True Story"), intended to epitomize the struggle of the masses against constituted authority and dedicated to the Polish movement, Solidarity; the music theater work *Un Re in Ascolta* ("A King in Audition"), about the rehearsal of a theatrical performance based on Shakespeare's *The Tempest;* and *Rendering (Sketches from Schubert's Symphony no. 10)*, which orchestrates the extensive passages Schubert left for this work and bridges them with Berio's own (combining the two composers' styles).

Berlin, Irving, 1888–1989. An American composer famous for his musical comedies, motion-picture scores, and popular songs, and considered by many to be the most successful songwriter in history. Born in Russia, he came to the United States at the age of five. He began his musical career as a singing waiter in cafés, and then sang in vaudeville shows and theatrical performances. A self-taught pianist, he never learned to read music. Among his best-known songs are "Alexander's Ragtime Band," "God Bless America," "White Christmas," "Always," "Blue Skies," and "Easter Parade." His musical comedies include *This Is the Army, Annie Get Your Gun,* and *Call Me Madam.*

Berlin school See under PRECLASSIC.

Berlioz (bâr′lǝ ōs″), **Hector** (ek tôr′), 1803–1869. A French composer and conductor who is remembered principally for his large-scale programmatic symphonies and for his contributions to orchestration and the development of the modern orchestra. Berlioz's father taught him a little music, but he did not learn to read music or play an instrument until he was about twelve. His father sent him to Paris to study medicine, but he secretly studied music; when his father found out, he made Berlioz support himself, which he managed by writing about music, giving lessons, and singing in a chorus. In 1830 Berlioz won the Prix de Rome, his first important recognition. By then he had already composed his first major work, the *Symphonie fantastique* ("Fantastic Symphony"), which differed considerably from the conventional symphony. For one thing, it had five movements instead of the usual four. It also had a program, that is, a story told by the music. Further, the music featured an **idée fixe**, a single short theme used throughout the work to unite the different sections. Finally, in addition to using meter and rhythm in a more flexible way than was usual, the *Symphonie fantastique* illustrates Berlioz's masterful technique in writing for orchestra. The instruments of the orchestra are used in an original and meaningful fashion, and how they are used is as much a part of the music as the notes they play. The symphony was a remarkable success. It was followed by other successes, but they came only occasionally, and eventually Berlioz turned to conducting, both to earn money and to make sure that his own works were performed properly. He also wrote a book on orchestration (*Traité de l'Instrumentation*, 1844) that is still considered one of the outstanding works in this field, as well as numerous articles on music and his autobiography.

For decades after his death Berlioz's reputation rested on his skill in orchestration rather than on his compositions, but since about 1920 the value of his works has been recognized. Among them are the operas *Les Troyens* ("The Trojans") and *Béatrice et Bénédict* (based on Shakespeare's *Much Ado About Nothing*), his program symphony *Harold en Italie* ("Harold in Italy") for viola and orchestra, the overtures *Le Corsaire* ("The Corsair") and *Le Carnaval romain* ("The Roman Carnival"), and, perhaps most important, a number of great choral works: *Roméo et Juliette* (a "dramatic symphony"), *La Damnation de Faust* (which includes the famous "Rákóczi March"), *Grand Messe des Morts* ("Requiem Mass"), Te Deum, and the lovely oratorio *L'Enfance du Christ* ("The Childhood of Christ").

Bernstein (bûrn′stīn), **Leonard**, 1918–1990. An American conductor, composer, and pianist. Bernstein studied music at Harvard University and the Curtis Institute in Philadelphia. He learned conducting under Sergey Koussevitzky (longtime conductor of the Boston Symphony Orchestra) at Tanglewood, Massachusetts, later becoming Koussevitzky's chief assistant. After Koussevitzky's death in 1951, Bernstein succeeded him at Tanglewood, and in 1958 he was appointed conductor and music director of the New York Philharmonic. The first American-born musician to hold this post, he remained there for eleven years, until he resigned to devote himself to more varied activities and to composition. Teaching continued to be an important part of his work, and he inaugurated a highly successful series of televised Young People's Concerts. Bernstein's own compositions include both serious and popular works. Among the former are the *Jeremiah Symphony,* the ballet *Fancy Free,* the oratorio *Kaddish, Mass* for singers, instrumentalists, and dancers, and the operas *Trouble in Tahiti* and *A Quiet Place.* His popular works include the film score *On the Waterfront* and

several successful musical comedies, *On the Town, Wonderful Town, Candide,* and, most popular of all, *West Side Story.*

beruhigend See BERUHIGT.

beruhigt (be rōō' iḵht) *German.* Also, *beruhigend* (be rōō'i gənt). A direction to perform in a calm, quiet manner.

bestimmt (be shtimt') *German.* A direction to stress a note, phrase, or section.

bewegt (be vākt') *German.* A direction to perform in a lively, animated manner.

B-flat A musical tone one half tone below B and one half tone above A (see PITCH NAMES). On the piano, B-flat is identical with A-sharp (see ENHARMONIC for an explanation). The scales beginning on B-flat are called B-flat major and B-flat minor. A composition based on one of these scales is said to be in the key of B-flat major or B-flat minor, the key signatures (see KEY SIGNATURE) for these keys being two flats and five flats, respectively. For the location of B-flat on the piano, see KEYBOARD —**B-flat instrument** A transposing instrument, such as the B-flat clarinet (or clarinet in B-flat), that sounds each note one whole tone lower than it is written; for example, the fingering for the written note C yields the pitch B-flat. The B-flat tenor saxophone, however, sounds a major ninth lower than the written note (that is, an octave plus a whole tone lower.)

BG See under BACH, JOHANN SEBASTIAN.

bible regal See under REGAL.

big band See BAND, def. 8.

Billings (bil'ingz), **William,** 1746–1800. An American composer who was among the first in America to produce music not based directly on European models. A tanner by trade, Billings treated music as a sideline. He wrote mostly hymns, anthems, and songs, especially patriotic songs, and published six books of his works, the best known of which is *The Continental Harmony.* Prominent in these books are fuging tunes, songs in which different voice-parts enter one after another and to some extent imitate one another. Billings also made free use of dissonance, often with humorous intent.

binary form A basic musical form, consisting of two sections, A and B; usually they are repeated, creating the form A A B B. The popular ballad "Clementine" illustrates this structure. The two sections (A and B) are always related to one another in that the first section modulates (changes from one key to another), usually from the tonic to the dominant, and the second section modulates back, from the dominant to the tonic. If the A section is in a minor key, it generally modulates to the relative major key rather than to the dominant; the B section then returns to the original minor. In this respect binary form differs from TERNARY FORM (A B A), in which the A and B sections are not necessarily so related. (For explanation of these terms, see under CHORD; KEY, def. 3.)

Most songs, both folk songs and art songs, and many short instrumental works, such as dances and marches, are in binary form. Not all of these types are in simple binary form (A A B B), in which A and B are the same length. Sometimes the sections differ in length, in which case B is nearly always longer than A. Sometimes part or all of A is repeated at the end of B, so that the form becomes A A B A B A. This design is sometimes called **rounded binary form.** Originally used for short pieces, such as dances, it was this rounded binary form that, during the late eighteenth century, developed into SONATA FORM.

bind See TIE.

bird organ See under BARREL ORGAN.

bis (bēs) *Italian, French:* "again." **1** A request for a performer to repeat a selection or to present an encore. **2** A

direction to repeat certain notes or passages.

bitonality (bī"tō nal'i tē). The use of two keys at the same time, even if they are not indicated by the key signature. In piano music, the left hand might play in one key and the right hand in another, although the two keys need not be separated in this way. Unless a distinctly dissonant sound is desired, the different keys must be combined with care. A melody in the key of G with an accompaniment in the key of A-flat, for example, would sound dissonant. The keys of C and F-sharp, on the other hand, have some closely related chords and therefore do not sound so dissonant. This particular combination was used by Stravinsky in his ballet *Petrushka* (1911), and the chord shown in the accompanying example has come to be known as the **Petrushka chord**. Other twentieth-

century composers who have used bitonality to obtain special effects are Milhaud, Bartók, and Ives (in his *67th Psalm* the men's voices sing in B-flat and the women's in C major). Before 1900, bitonality was used rarely, and then usually with comic intent, as in Mozart's *Ein musikalischer Spass* ("A Musical Joke"), K. 522. See also POLYTONALITY.

biwa (bē'wä) *Japanese*. A Japanese lute with a short neck and four strings that are plucked with a plectrum. The melody is usually played on the highest string. Somewhat neglected since the westernization of Japanese music following World War II, the biwa later was taken up by several composers, notably Takemitsu. The biwa is derived from the Chinese PYIBA.

Bizet (bē zā'), **Georges** (zhôrzh), 1838–1875. A French composer who wrote one of the most popular of all operas, *Carmen*. The son of professional musicians, Bizet began his musical studies early. By the time he was 9 he entered the Paris Conservatory, studying with the opera composer Jacques Halévy, whose daughter he eventually married. Bizet's first important opera was *Les Pêcheurs de perles* ("The Pearl Fishers"), which was first presented in 1863 with little success. His incidental music for a play, *L'Arlésienne* (1872), was also largely ignored by the critics, but an orchestral suite based on the music won some praise. Bizet's next major work was his masterpiece, *Carmen*, which was produced a few months before his death. It, too, was not especially successful at first, but it remained in the repertory and soon became immensely popular in all of the world's great opera houses.

Bloch (blôk), **Ernest**, 1880–1959. A Swiss-American composer, who is known especially for those of his works that reflect his Jewish heritage. Bloch was born in Geneva, where his music teachers included Émile Jaques-Dalcroze. After studies in Brussels, Frankfurt, and Munich, he settled in New York in 1917 and pursued a career of teaching and conducting. During the 1930s he lived mostly in Switzerland, but from 1939 until his death he remained in the United States, devoting himself largely to composing. Some of Bloch's best-known compositions are specifically Jewish, such as his *Sacred Service*, or *Avodath hakodesh*, intended for a Jewish worship service; *Schelomo* ("Solomon") for cello and orchestra; and the symphony *Israel*. However, other of his works have no religious or ethnic associations of any kind, notably his Violin Concerto, his Concerto Grosso no. 2 for string orchestra, and his second, third and fourth string quartets.

block See WOOD BLOCK.

Blockflöte (blok' flœ te). The German name for RECORDER.

Blow (blō), **John**, 1649–1708. An English composer and organist who is remembered principally for his masque, *Venus and Adonis*, his songs, and his church anthems. Blow began his musical career as a choirboy, and he also studied organ. In 1668 he became organist at Westminster Abbey. Among Blow's pupils was Henry Purcell, who replaced Blow as organist until his death in 1695, whereupon Blow resumed the job until his own death. One of Blow's loveliest compositions is his "Ode on the Death of Purcell."

bluegrass A fast, two-beat style of COUNTRY MUSIC that originated in Kentucky. The basic instruments used are the banjo, fiddle, mandolin, and guitar.

blues 1 A kind of American folk music that developed from black spirituals and work songs and became popular in the early 1900s. Blues are usually slow, quiet solo songs with instrumental accompaniment and a steady, syncopated rhythm. They are so called because of the frequent presence of **blue notes**, that is, half-flatted notes (somewhere between natural and flat) on the third, fifth, or seventh degrees of the scale (in the scale of C major, E, G, or B). The use of these notes gives an effect of wavering between the major and minor modes. Most blues songs are made up of groups of twelve measures (though eight- or sixteen-measure groups are also found), and the main melody is in short phrases, separated by pauses. The text is arranged in three-line stanzas, the second line of text being a repetition of the first. Originally the pauses between phrases were used by the singer to make up the next phrase; in time, however, they were filled in by the accompanying instruments, answering with a sort of second melody (see CALL AND RESPONSE). The harmony tends to follow the chord structure I/IV–I/V–I (see SCALE DEGREES for further explanation). The earliest published blues, which are still performed today, are Jelly Roll Morton's "Jelly Roll Blues" and W. C. Handy's "Memphis Blues." Blues became very popular during the 1920s through recordings made by black women singers, among them Ma Rainey (1886–1939) and Bessie Smith (1894–1937). A somewhat different version, sometimes called **country** or **Delta blues**, was developed about the same time by black men musicians in the Mississippi Delta area. They played guitar, and sometimes also harmonica, and sang with a high-pitched nasal twang. The outstanding blues performer Leadbelly (Huddie Ledbetter, 1885–1949) performed Delta blues, often working with Blind Lemon Jefferson. Others of note were Son House (so-called "father of the Delta blues"), Robert Johnson, Charlie Patton, and Fred McDowell. The Depression of the 1930s brought on a large-scale migration from the rural South to northern cities. The blues musicians who moved north, especially to Chicago, in time developed a style called **urban blues**, in which the piano replaced the guitar as accompaniment and the texts focused on the tribulations of city life. Guitarist B.B. King was an outstanding performer in this style. In the 1940s a version of urban blues acquired a strong dance beat and became RHYTHM AND BLUES. Blues influenced the development not only of other popular music, such as jazz and rock, but also appeared in serious music; a notable example is George Gershwin's *Rhapsody in Blue* for piano and orchestra. **2** An instrumental work having typical blues features (twelve-measure structure, blue notes, short phrases, etc).

blues harp See under HARMONICA, def. 1.

blues rock See under ROCK.

Boccherini (bôk"kə rē'nē), **Luigi** (lōō ē'jē), 1743–1805. An Italian composer remembered mainly for his chamber music—chamber symphonies, hundreds of string quartets and quintets, string trios, etc.—written in a style

much like that of his contemporary, Haydn. In his own day Boccherini was famous as a cellist. His compositions are not especially original but are notable for their pleasing, expressive melodies and fluent instrumental writing. One of his best-known pieces is the Minuet from his String Quintet op. 13, no. 4.

Böhm (bœm) **system** An arrangement of the keys and finger holes in woodwind instruments that closely corresponds to the order of notes in the chromatic scale yet keeps them within easy reach of the player's fingers. It is named for its inventor, Theobald Böhm, a German flutist who lived from 1794 to 1881. Earlier methods of keying and fingering had fit either the chromatic order of sounds (the scale) or the player's fingers, but not both. Böhm, working first with the flute, made the finger holes larger and as close as possible to chromatic order; he also changed the closed keys that had been used earlier to open keys controlled by rings. The first flute of this kind was built about 1832. Later Böhm further altered the instrument, giving it a cylindrical (straight) bore, instead of a conical (tapered) bore; he also enlarged the finger holes still more and replaced the rings with padded plates. This type of flute, first built about 1847, is the kind still played today. Böhm's system was also used for oboes and bassoons, but with less success. However, about 1867 it began to be used for clarinets, for the first time enabling clarinetists to perform music in any key.

Boito (bō ē′ tô), **Arrigo** (är rē′gô), 1842–1918. An Italian poet, critic, and composer remembered less for his music than for the librettos he wrote for operas by other composers. Boito's masterpieces in this field are the librettos for Verdi's *Otello* and *Falstaff* and for Ponchielli's *La Gioconda*. Boito's own most important composition is the opera *Mefistofele*, in which he combined elements of traditional Italian opera with the dramatic ideas of Wagner.

Bolcom (bōl′kəm), **William**, 1938– . An American pianist and composer who became known for incorporating both popular and serious idioms in his music. A student of Milhaud and Messiaen, among others, he was well schooled in serial music and other important styles. He and his wife, soprano Joan Morris, gave many concerts of both nineteenth- and early twentieth-century salon music, as well as popular songs. These varied influences appear in such works as *14 Piano Rags* (1967–70), *Dark Music* (1970) for timpani and cello, *Open House* (1975) for tenor and chamber orchestra, *12 New Etudes for Piano* (1988), which won the Pulitzer Prize, and a piano concerto (1995).

bolero (bō ler′ ō) *Spanish.* **1** A Spanish dance dating from the late eighteenth century, performed as a solo or by a couple and usually accompanied by castanets. The music, in 3/4 meter, is moderately fast and includes the characteristic rhythmic patterns shown in the accompanying example. The bolero has frequently been used by composers, the best-known example being Ravel's ballet, *Boléro* (1928). In this piece, Ravel repeats a single theme over and over, each time a little louder than the time before, beginning with only a few instruments and ending with the whole orchestra (the piece lasts about twenty minutes). **2** A Cuban dance in

moderate tempo and duple meter (with two basic beats per measure), similar to the habanera.

Bologna (bô lôn′ yä) **school** A group of composers who worked in the Italian city of Bologna during the seventeenth century, the most important of whom are Giuseppe Torelli (1658–1709), Giovanni Battista Vitali (c. 1644–1692), Giovanni Battista Bassani (c. 1657–1716), and Domenico Gabrielli (c. 1650–1690). These com-

posers, who wrote mainly instrumental music, are notable for contributing to the development of several important musical forms, particularly the trio sonata and the concerto grosso. Their music is elegant, restrained, and formal in structure.

bombarde (bôn bΛrd'). 1 A French name for a large SHAWM. 2 In organs, a powerful reed stop.

bombardon (bom' bar d°n). See under TUBA. Also, in organs, a chorus reed stop.

bones A percussion instrument consisting of two rods of ivory, wood, or, originally, animal bone (whence the name), which are held between the fingers of one hand so that a flick of the wrist makes them click together. Often used in pairs (one pair per hand), they have been known since ancient times.

bongo drums Also, *bongos*. A pair of small barrel-shaped drums, of the same height but usually of slightly different diameter, that are joined together. The frames of the drums, made of thick wood, are covered with skin at only one end. They are played with the hands. Originating in Cuba, bongo drums are occasionally used in dance bands, principally for playing the music of Latin America and the

Caribbean islands, but a few composers have included them in scores, among them Boulez (*Le Marteau sans maître*) and Varèse (*Ionisation*).

bongos See BONGO DRUMS.

boogie-woogie (boog"ē woog'ē). A style of piano playing popular in the United States in the 1920s, in which the pianist played a kind of music

very similar to vocal blues. While the left hand plays a steady, rhythmic bass accompaniment, often in the form of an eight-to-the-bar ostinato (repeated figure) or a "walking bass" of broken octaves, the right hand plays a melody, using dotted eighth and sixteenth notes, heavy chords, riffs, tremolos, and similar devices. Like blues, boogie-woogie often consists of twelve-measure sections, the melody tends to be in short phrases, and the relationship of the rhythm and harmony of the melody with that of the bass is very free. In the 1930s and 1940s the boogie-woogie style was adopted by swing bands (see under JAZZ), some vocal groups such as the Andrews Sisters, and some country-music performers.

bop Also, *bebop, rebop*. A jazz style of the 1940s, named for the nonsense syllables sometimes sung by its performers. Bop differs from earlier jazz in its fast-moving, highly intricate melodies, complex rhythms, and dissonant harmonies. It is performed principally by a soloist, to whom all the other players are subordinate. The outstanding leader in developing bop was the alto saxophonist Charlie ("Bird") Parker. Others who played in bop style, at least for a time, were trumpeters Miles Davis and Dizzy Gillespie, pianist Thelonious Monk, and drummers Art Blakey and Max Roach.

bore In wind instruments (flute, oboe, trumpet, and others), the interior of the tube that encloses the air column inside the body of the instrument. Bores are differentiated according to their shape and size. There are two main kinds, conical and cylindrical. A conical bore is cone-shaped, beginning to widen at the mouthpiece and continuing to widen all the way down to the bell; this type of bore occurs in the oboe, saxophone, tuba, cornet, bugle, bassoon, and French horn. A cylindrical bore maintains the same diameter for most of its length, becoming wider only near the bell; this type of bore is found in

the clarinet, trumpet, and trombone. The length of the bore determines the lowest pitch obtainable (the longer it is, the lower the pitch). Also, a tube closed at one end produces a pitch one octave lower than one that is open.

Borodin (bor o dēn'), **Alexander** (ä"le ksän'dr⁹), 1833–1887. A Russian composer who became one of the so-called Five (see FIVE, THE), the group of composers who devoted themselves to founding a school of distinctly Russian music. Borodin's music reflects the Oriental, exotic side of the Russian tradition, mainly through its rhythms and colorful orchestration. His best-known works are the symphonic poem *In the Steppes of Central Asia* and the opera *Prince Igor* (which contains the popular "Polovtzian Dances," often performed as a separate orchestral work). He also wrote three symphonies. Borodin's full-time occupation was teaching chemistry, to which he was devoted. Consequently he never managed to complete a number of his works, including *Prince Igor,* which was finished by Alexander Glazunov and Nikolay Rimsky-Korsakov.

bossa nova (bos'sä nō'vä) *Spanish*. A Brazilian dance music, a blend of the samba and cool jazz. Saxophonist Stan Getz helped popularize it in the United States in the 1960s.

bouché (bōō s̲h̲ā') *French*: "stopped." See STOPPING, def. 2.

bouche fermée (bōōs̲h̲ fer mā') *French:* "closed mouth." A direction to sing without words (by humming, or in some other fashion), employed chiefly in choral music to obtain special effects.

Boulanger (bōō läɴ z̲h̲ā'), **Nadia** (nA' dyə), 1887–1979. A French musician who became one of the most highly regarded teachers of composition of the twentieth century. She taught at several French conservatories but perhaps her widest influence was at the American Conservatory at Fontaine-bleau, a summer school founded in 1921, where she taught a host of American composers (Aaron Copland, Virgil Thomson, Elliott Carter, Roy Harris, Douglas Moore, Walter Piston, and others) and countless composers of other nationalities as well. Although she herself preferred the neoclassic style (she greatly admired Igor Stravinsky) and was one of the first to use the performance and analysis of Renaissance and baroque music as a teaching tool, she allowed her pupils to develop their own individual styles.

Boulez (bōō lez'), **Pierre** (pyer), 1925– . A French composer who developed new, very complicated methods of composition. A pupil of Olivier Messiaen, Boulez first based his method on the twelve-tone technique (see SERIAL MUSIC) but combined it with very original treatment of rhythm and dynamics (loud-soft effects), which was generally worked out according to mathematical formulas. Although his music continued to be based on fairly strict forms, from the late 1950s on Boulez (who by then had begun to make a name for himself as a conductor) did not neglect the expression of emotions and of poetic ideas in his music. He also made use of aleatory techniques; his Third Piano Sonata (1957) gives the performer various options as to what to play next. Unlike many composers of the time working with new devices and idioms, Boulez often revised and rewrote his works. His compositions include a Quartet for four ondes Martenot; *Structures,* two books of works for two pianos; *Le Marteau sans maître* ("The Hammer Without a Master"), a suite for alto voice, five instruments, and percussion; and *Pli selon pli* ("Fold along Fold") for voice and orchestra. In 1971 Boulez became director of the New York Philharmonic, a post he retained until 1977. He then returned to Paris to direct a new electronic music center, Institut de Recherche et de Coordination Acoustique/Musique

(IRCAM) and resumed composing, especially electronic music involving the use of computers. For example, his *Répons* ("Response") calls for thirty instrumentalists and a sophisticated real-time digital synthesizer that responds during performance to the sounds produced by the live musicians. In 1992 he retired as director of IRCAM.

bourdon (*French* boor dôn'; *English* boŏr'd°n). **1** In music of the seventeenth century, a bass part that imitates the low, steady sound of bagpipe drones. A bourdon usually consists of two or three notes that are sounded continuously. **2** French for PEDAL POINT. **3** An organ stop with a droning sound.

bourrée (boo rā') *French.* A French dance in rapid tempo and duple meter (any meter having two basic beats per measure, such as 2/2 or 2/4) with a single upbeat. Originating in the early seventeenth century, bourrées later came to be used purely as a

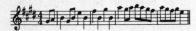

musical form in the eighteenth-century suite. Particularly well-known examples are found in Bach's Orchestral Suite No. 1 and his French Suite No. 6 (part of the latter is shown in the accompanying example).

bow (bō). A thin wooden stick, along which is stretched a flat band of horsehairs, which is drawn over the strings of the violin, viola, cello, double bass, viol, and various other stringed instruments, causing them to sound. Like the instruments themselves, the bow has changed considerably over the years. Originally it had a deep outward curve, like the type of bow used to shoot arrows, which accounts for its name. The modern violin bow dates from about 1780. It was designed by François Tourte, a Frenchman who is still considered the finest of all bow makers. This bow

has a long, tapering stick, curving slightly inward. The stick is usually made of Pernambuco wood (a kind of brazilwood). It is either round or octagonal and measures about 29-¼ inches from end to end. The band of hair, which has a playing length of about 25-½ inches (for the violin), is about ⁷/₁₆ inch wide. It comes from the tails of white horses and is rubbed with rosin so as to provide friction when it is drawn over the violin strings (without friction between the bow and the strings, the strings would not be made to vibrate and therefore would not sound). The hair is fastened directly to the bow at one

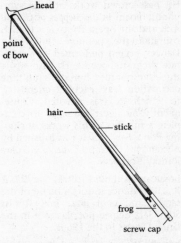

end and to a movable frog at the other end; the tension of the hair can be adjusted by turning a screw that moves the frog. At the frog, the hair passes through a metal ferrule, which keeps the hair evenly spread.

The viola bow is slightly heavier than the violin bow, and the cello bow is both heavier and shorter. The double bass bow is the heaviest and shortest of all; it also is somewhat thicker and more curved than the cello bow.

bowing (bō'ing). The technique of playing a stringed instrument with a bow, the most important of such

modern instruments being the violin, viola, cello, and double bass. There are many ways of using a bow, some of which are indicated in scores by special signs. The two most important are ⊓ (**down-bow**), which indicates that the bow is to be drawn from the frog toward the point, and V (**up-bow**), which indicates that the bow is to be drawn from the point to the frog. In general, the down-bow is used on accented notes and the upbow on unaccented notes. (For special bowing techniques and directions see DÉTACHÉ; FLAUTATO; JETÉ; LEGATO; LEGNO, COL; LOURÉ; MARTELÉ; PIQUÉ; PONTICELLO, SUL; PUNTA D'ARCO, A; SAUTILLÉ; SLUR; SPICCATO; STACCATO; STEG, AM; STRASCINANDO; TALON, AU; TASTIERA, SULLA; TREMOLO. See also DOUBLE STOPPING; PIZZICATO; PORTAMENTO; STOPPING; TRIPLE STOPPING; VIBRATO.)

Boyce (bois), **William**, 1710–1779. An English composer and organist who edited a three-volume collection of Anglican church music by many important composers (*Cathedral Music,* published 1760–1778). Boyce himself wrote both religious music and incidental music for plays, as well as sonatas, overtures, organ voluntaries, and eight short symphonies.

boy soprano See SOPRANO, def. 2.

brace In keyboard music, a bracket connecting two or more staves to show that they are to be read (and played) together (see A in the accom-

panying illustration). A similar sign (B in the accompanying illustration) is the **accolade**, which is used with the same meaning for chamber music and choral music, and in orchestral scores to connect the staves for instruments of the same family (woodwinds, brass, percussion, etc.).

Brahms (brämz), **Johannes** (yō hän'əs), 1833–1897. A German composer, one of the outstanding figures in nineteenth-century music. Born in Hamburg, Brahms became an accomplished pianist as a child, and by the age of twenty had become the accompanist for Eduard Reményi, a noted violinist of the time. During this period he began a lifelong friendship with Robert and Clara Schumann, who later did much to publicize Brahms's music. Another close friend was the violinist Joseph Joachim, for whom Brahms wrote his only violin concerto. In 1863 Brahms settled in Vienna, Austria, which remained his permanent home until his death.

Brahms carried on the classical tradition of Mozart and Beethoven, particularly in following strict rules of musical construction. However, his music is even more notable for its expressive, songlike melodies and original use of rhythms. The new romantic trends of the nineteenth century, on the other hand, which tried to free music from rigid forms, were represented by the music of Liszt and Wagner, and throughout Brahms's lifetime his supporters and those of Liszt and Wagner formed two strongly opposed camps.

Brahms composed in nearly every musical form except opera and theater music. His major orchestral works include four symphonies (written during the last decade of his life), two piano concertos, the Violin Concerto, a Double Concerto for violin and cello, numerous *Hungarian Dances,* two frequently played concert overtures (*Academic Festival* and *Tragic*), and the well-known *Variations on a Theme by Haydn.* His outstanding choral works are *Ein deutsches Requiem* ("A German Requiem"), *Rhapsodie* for alto, men's chorus, and orchestra ("Alto Rhapsody"), and *Schicksalslied* ("Song of Destiny"). In addition, Brahms wrote a large number of pieces for piano, which include *Variations on a Theme by Paganini,* and hundreds of lieder, some of which rank among the finest of their kind.

branle (brän′lə) *French.* Also, *brawl.* A sixteenth-century dance popular in France, England, Italy, and elsewhere. It was performed with swaying movements, and was often accompanied by singing. There were many varieties of branle, some in duple meter (any meter in which there are two basic beats per measure, such as 2/2 or 2/4), and others in triple meter (with three basic beats, such as 3/8 or 3/4). The branle was sometimes used as a movement in eighteenth-century instrumental suites.

brass band See BAND, def. 4.

brass instruments A family of metal instruments that have cup-shaped or funnel-shaped mouthpieces. Together with the woodwinds, the brass instruments make up the still larger family of the wind instruments. The names of these two groups are misleading, since some brass instruments are made of metals other than brass, and some woodwinds, such as the flute and the saxophone, are nearly always made of metal. The main difference between brass and woodwind instruments lies in the way in which they are made to sound. In the brasses, it is the vibration of the player's lips, pressed against the rim of the mouthpiece, that causes the air column inside the tube of the instrument to vibrate. (See also TONGUING.) When the lips are fairly slack the fundamental note is sounded. As the lips are tightened more and more, the successive notes of the harmonic series (overtones) are produced. In addition, the player must produce more and more air pressure, supported by the diaphragm and other muscles. To produce notes other than those of a single harmonic series, the length of the air column must be changed. In eighteenth- and early nineteenth-century trumpets and horns, this was accomplished by means of crooks (pieces of tubing added or taken away between the mouthpiece and the main tube). Other early brass instruments, such as the cornett, used finger holes, as do most modern woodwinds. In present-day brass instruments, the length of the air column is changed either by finger-operated valves that open up extra sections of tubing permanently attached to the main body of the instrument, or by a movable slide (as in the trombone).

The most important brass instruments of the modern orchestra are the French horn, trumpet, trombone, and tuba; the cornet and Wagner tuba are also used occasionally. Modern marching bands also may use such instruments as the flugelhorn, baritone horn, euphonium, various kinds of helicon (large bass tubas, among them the sousaphone), and various sizes of saxhorn. In addition, there are many kinds of bugle, used mainly for military or signaling purposes. The brass instruments of ancient times include the Jewish shofar (still used), the Roman lituus, and the Scandinavian lur. Brass instruments used in Europe after the fifteenth century but no longer used today (except for performing early music) include the cornett, serpent, key bugle, and ophicleide.

brass quintet See under QUINTET.

Bratsche (brä′chə). The German word for VIOLA.

bravura (brä voo̅′ rä) *Italian:* "skill." A term applied to a musical passage or a style of performance that requires considerable technical skill from the performer. Also see ARIA.

brawl The English name for BRANLE.

break 1 In jazz and other popular music, a short improvised solo that displays the performer's skill, much like a CADENZA. **2** A change in register (see REGISTER, defs. 3 and 4), which both singers and instrumentalists try to negotiate so that listeners are not aware of it.

breit (brīt) *German:* "broad." A direction to perform in a broad, measured manner.

breve (brēv, brev). A note equivalent in time value to two whole notes (see BREVIS).—**alla breve** (äl′lä bre′ve) *Ital-*

ian. Also, *cut time.* A term used for the time signatures 2/2 and 4/2 (often marked ₵), in which each half note receives one beat. Originally, the term meant that the brevis was to be the unit of time instead of the semibrevis, and that the music was to be per-

A migh-ty for-tress is— our God, A bul-wark

formed twice as fast, with only two beats per measure instead of four. Today, it means that the half note is the unit of time in place of the more commonly used quarter note.

brevis (brā'vis, brev'is) *Latin:* "short." The name of a note value that was, in medieval music (thirteenth century), the shortest note value used. Later a number of still smaller note values were introduced, such as the semibrevis and minima (literally, "half-brevis" and "smallest"), and the brevis eventually became the longest note value in use. Its modern equivalent, which is rarely used, is the double whole note (with a value of two whole notes), indicated by the sign ⊨.

bridge 1 In stringed instruments, such as the violin, cello, guitar, etc., a small piece of wood on the instrument's belly that supports the strings and carries their vibrations to the body of the instrument. In guitars, lutes, and other plucked stringed instruments, the bridge is glued to the belly and the strings are attached to it. In the violins and viols the bridge is held in place by the pressure of the strings, which are attached to a tailpiece. The bridge of a violin or viol

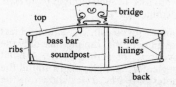

has two feet. The right foot (the one near the highest-pitched string) rests almost over the soundpost, which greatly restricts its vibrations. It is the left foot, therefore, that passes most of the strings' vibrations to the belly of the instrument. The vibrations of the left foot are amplified (strengthened) by the bass-bar, which helps transmit them to the entire belly. The accompanying drawing is a cross-section view showing the bridge and soundpost of a violin. **2** A musical passage that connects two themes (melodies), often including a modulation (change of key) from the key of the first theme to that of the second. The first and second themes of a movement in SONATA FORM are commonly connected by a bridge. **3** In popular music, the third, contrasting eight-measure section of a thirty-two-measure chorus.

brillante (bril län'te) *Italian.* A direction to perform in a showy, brilliant manner.

brindisi (brin' dē zē) *Italian:* "health, toast." A drinking song, usually set as a solo with a choral refrain. It is commonly found in nineteenth-century opera, for example, in Mascagni's *Cavalleria Rusticana* and in Verdi's *Macbeth* and *La Traviata.*

brio, con (kôn brē'ô) *Italian.* Also, *brioso* (brē ô'sô). A direction to perform in a vigorous, spirited manner.

brioso See BRIO, CON.

Britten (brit'°n), **Benjamin,** 1913–1976. An English composer who became known particularly for his operas and other vocal music. Britten began his studies in both piano and composition at an early age. Although his earliest works are mainly instrumental and one of his most popular compositions is *The Young Person's Guide to the Orchestra,* which helps the listener identify the various instruments, most of his finest works are vocal. Among them are the operas *Peter Grimes* (considered his best), *The Rape of Lucretia, Albert Herring, Billy Budd, The Turn of the Screw, A Midsummer Night's Dream,* and *Death in*

54

Venice; Serenade for tenor voice, horn, and string orchestra; *Spring Symphony,* for soloists, chorus, and orchestra; *A War Requiem,* to the text of the Roman Catholic Requiem Mass and nine poems by the English poet Wilfred Owen; *A Ceremony of Carols*; and many settings of folk songs as well as many original songs. His instrumental works include a cello sonata and piano, violin, and cello concertos. Britten's music is largely traditional in rhythm and melody but makes free use of dissonant harmonies.

broken chord A group of notes played one after another that would make a chord if they were played simultaneously. For example, the notes C–E–G make up the tonic triad in the C-major scale; played together, they form a chord; played in succession (in any order) they form a broken chord. A common kind of broken chord is the arpeggio, in which the notes are

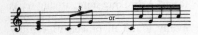

played in order, beginning with the lowest pitch. Another kind of broken chord is the ALBERTI BASS. Broken chords appear most often in music for keyboard instruments, especially in accompaniments. See also ARPEGGIO.

broken consort See under CONSORT.

Bruch (br o͞o ᴋʜ), **Max** (mäks), 1838–1920. A German composer remembered primarily for the first of his three violin concertos (Concerto no. 1, in G minor, op. 26), *Scottish Fantasy* for violin and orchestra, and *Kol Nidrei,* op. 47, a setting of a Hebrew melody for cello and orchestra. A renowned teacher, Bruch also wrote three symphonies, two operas, and numerous choral and chamber works. His music is quite traditional and technically sound. His pupils included Vaughan Williams and Respighi.

Bruckner (br o͞o k'n°r), **Anton** (än' tōn), 1824–1896. An Austrian com-

poser and organist whose symphonies and choral works won widespread recognition only after his death. Born in the village of Ansfelden, Bruckner earned a living by teaching and playing the organ. In 1867 he went to Vienna as court organist and taught organ and theory at the Conservatory there for the next twenty-four years. Most of his major works—nine symphonies (the last unfinished), a Requiem Mass, three Masses, and a Te Deum—were written quite late in life and were not well received by the public. Bruckner greatly admired Wagner, whose methods of orchestration and harmony he tried to apply in his own works. Bruckner's symphonies, which tend to be very long, contain some simple, charming melodies reminiscent of peasant songs and also give evidence of the composer's profound religious sentiment.

bruscamente See BRUSCO.

brusco (br o͞o s' kô) *Italian.* Also, *bruscamente* (br o͞o s"kä men'te). A direction to perform in a brusque, abrupt manner, with harsh accents.

B-sharp One of the musical tones (see PITCH NAMES), one half tone above B and one half tone below C-sharp. On the piano, B-sharp is identical with C (see ENHARMONIC for an explanation; for the location of B-sharp on the piano, see KEYBOARD).

Buchla (buk'lə). A kind of SYNTHESIZER.

buffa (bo͞o'fä) *Italian:* "comic." A word used in such terms as OPERA BUFFA ("comic opera").

buffo (bo͞o'fô) *Italian:* "comic." A word used in such terms as *basso buffo* ("comic bass").

bugle (byo͞o'gəl). A simple brass instrument that can produce only the overtones of a single tone. A B-flat bugle, for example, might sound the notes Bb-bb-f'-bb"-d", as shown in the accompanying example. It could not, however, sound any of the notes in between. For this reason, bugles long

were used largely for signaling (bugle calls) in the armed forces, although sometimes they were included in brass bands. In the United States today, however, this simple bugle has been largely replaced by a more trumpetlike instrument pitched in G and

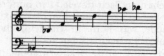

provided with one valve or piston and one rotary valve, enabling it to produce almost all notes from the A below middle C to the G above high C. (See also DRUM AND BUGLE CORPS.) Further, such bugles are available in numerous sizes.

Like the other brass instruments, the bugle is made of metal, usually

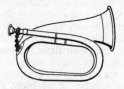

brass or copper but sometimes silver, and has a cup-shaped mouthpiece; its bore is conical. Most bugles are keyed in B-flat or C. In the early nineteenth century the bugle was given valves or keys (see KEY BUGLE) in order to permit playing the complete scale.

bugle à pistons (by' gl³ A pēs tôn'). The French term for FLUGELHORN.

Bull (bo͞ol), **John**, c. 1562–1628. An English composer who, like Sweelinck, whom he knew, had great influence on the development of contrapuntal keyboard music (in which several melodies or fragments of melodies are played at the same time). Bull lived in the Netherlands from 1613 on. His music for organ and harpsichord reflects his own great virtuosity (technical skill) as a performer, with its cross rhythms, rapid runs and scales, arpeggios, and wide leaps from note to note.

burden 1 In the fifteenth and sixteenth centuries, the refrain of a song or hymn. **2** A pedal tone, especially on the bagpipe. **3** Another spelling of BOURDON.

Burgundian (bər gun'dē ən) **school** A group of composers who, during the first half of the fifteenth century, were associated with the court of the Duchy of Burgundy. Today a province in northern France, Burgundy at that time included all of what is now eastern France, Belgium, and the Netherlands. The court, located at the city of Dijon, was one of the most powerful in Europe, and it had a strong influence on the arts as well as politics. Other important Burgundian cities were Cambrai and Liège, which had outstanding choir schools. The leading composers of the Burgundian school were Gilles Binchois and Guillaume DUFAY; possibly they were influenced by their English contemporaries, John DUNSTABLE and Leonel Power, who worked along similar lines (although it is not certain if there was direct contact between them). See also the chart of composers accompanying the entry RENAISSANCE.

Although Dufay in particular wrote very fine Masses and motets, the Burgundian composers are noted principally for their secular (nonreligious) music, especially their chansons (songs with several voice-parts). For texts they relied largely on three conventional forms of French poetry, the RONDEAU (which they used most frequently), the BALLADE, and the VIRELAI. The music was commonly in three voice-parts, all of fairly high range (soprano, alto, tenor). One new technique they used was FAUXBOURDON, a formula whereby two lesser voice-parts move at prescribed distances from the main melody. Another new development was the cantus firmus Mass, a Mass composition in three or four voice-parts based on a fixed melody, the cantus firmus. This melody, usually in the tenor, was generally in longer time values (longer-held notes) than the other parts,

which wove their harmony around it. The Burgundians were also noted for their lovely, songlike melodies.

The Burgundian composers are considered the first composers of the period called the RENAISSANCE. They were followed by the FLEMISH SCHOOL.

burlescamente See BURLESCO.

burlesco (boॅor les'kô) *Italian.* Also, *burlescamente* (boॅor les" kä men' te). A direction to perform in a comical, jesting manner.

Busnois (by nwA'), **Antoine** (äN twAn'), c. 1430–1492. A composer who worked at the Burgundian court for most of his life and is remembered principally for his chansons, polyphonic settings of the principal poetic forms of his time, and also some polyphonic arrangements of popular tunes. About one-third of his works are for four voice-parts, a texture that later (about 1500) replaced the earlier standard three-voice settings. They are notable especially for the long, elaborately shaped melodic lines in each voice-part.

Busoni (boॅo sô' nē), **Ferruccio** (fe roॅo' chē ô), 1866–1924. An Italian-German pianist and composer who coined the term NEOCLASSICISM but whose own approach to composition, although more intellectual than emotional, was more traditional than his theories. A child prodigy, Busoni won worldwide fame as a pianist, and later he also did some conducting. In addition, he wrote a number of pieces about music and aesthetics, most notably his essay *Entwurf einer neuen Aesthetik der Tonkunst* ("Outline for a New Aesthetics of Music"), published in 1907. His compositions, however, which include several operas, orchestral suites, chamber music, a piano concerto, *Fantasia contrappuntistica* ("Contrapuntal Fantasy") for piano, as well as numerous arrangements and transcriptions and other works for piano, are largely in traditional nineteenth-century style. Only a few of the late piano works and the opera *Doktor Faust* (which many consider

his best) use the expressive chromaticism and dissonance he advocated in his writings.

Buxtehude (boॅoks'tə hoॅo"də), **Dietrich** (dē'triKH), c. 1637–1707. A German organist and composer who was so famous as an organist that Johann Sebastian Bach traveled two hundred miles on foot to hear him play. Buxtehude was born in Holstein, then ruled by Denmark but today part of Germany. Little is known about his early life. In 1668 he succeeded the composer and organist Franz Tunder at the Marienkirche (St. Mary's Church) in Lübeck, Germany. There he established the practice of *Abendmusik* ("evening music"), a series of public concerts held every year for five Sundays before Christmas. For these concerts Buxtehude wrote both organ music and choral works, mainly cantatas for soloists, chorus, and orchestra, and directed the performances as well. Of the many kinds of organ music he wrote, his chorale preludes are particularly outstanding; also, his toccatas, preludes, and fugues are noteworthy for their virtuoso pedal parts. In addition, Buxtehude wrote music for harpsichord and for various instrumental ensembles.

buzuki (bə zoॅo'kē) *Greek.* A plucked stringed instrument of present-day Greece, where it is used mainly for folk music. Very much like the tanbur, it has a pear-shaped body and a long neck with two triple courses (sets of three strings tuned to the same pitch) of metal strings. Similar instruments are the Turkish bozuq, which has eight strings, and the Near Eastern (Arab) buzuq, with three double courses. These, too, are largely folk instruments.

BWV See under BACH, JOHANN SEBASTIAN.

Byrd (bûrd), **William**, 1543–1623. An English composer and organist who excelled in writing church music (Latin Masses and motets, English anthems and services), as well as con-

sort songs, madrigals, and music for
consorts of viols and for keyboard. He
is considered a great master of
polyphony in the Renaissance tradi-
tion. Byrd studied music from an
early age, and at twenty became
organist at Lincoln Cathedral. Later
he became organist for the Chapel
Royal, and Queen Elizabeth I granted
Byrd and his fellow composer,
Thomas Tallis, a monopoly on print-
ing and selling music and music
paper in England. The first book they
published was the *Cantiones sacrae*
("Sacred Songs") of 1575, which con-
tained motets by both men. Byrd
himself was a Roman Catholic, but he
wrote both Catholic and Anglican
church music. In addition to his vocal
music he composed a great many
pieces for the harpsichord and organ,
which appeared in such collections as
Parthenia, the *Fitzwilliam Virginal
Book,* and his own *My Ladye Nevells
Booke.* (See also VIRGINAL.)

Byzantine (biz′ən tēn″, biz′ən tin, bi
zan′tin) **chant** The chant used in the
religious services of the Christian
church of the Byzantine Empire,
founded about 330 by Constantine
the Great and conquered in 1453 by
the Turks. The music of the Byzantine
hymns is written in a special nota-
tion, called **ekphonetic,** which
resembles the neumes of Gregorian
chant but is not exactly the same. The
signs used indicate intervals rather
than pitches, and ascending signs dif-
fer from descending ones. Like Grego-
rian chant, Byzantine chant is unac-
companied and monophonic (having
only one voice-part) and it is based
on a system of modes, called, in the
Byzantine chant, *oktoechos* ("eight
echoes" or "eight modes"). These simi-
larities indicate that very likely both
Gregorian and Byzantine chant are
derived from older Jewish models.
Byzantine chant had considerable
influence on the chant of the various
eastern Christian (Orthodox) churches,
especially those in Greece, Serbia, Bul-
garia, and Russia. The extent of its
influence on Gregorian chant is dis-
puted.

C

C 1 One of the musical tones (see PITCH NAMES), the first note in the scales of C major and C minor. A composition based on one of these scales is said to be in the key of C major or C minor, the key signatures (see KEY SIGNATURE) for these keys being no sharps or flats, and three flats, respectively. The note one half tone below C is C-flat or B, the note one half tone above C is C-sharp or D-flat (see ENHARMONIC for an explanation; for the location of these notes on the piano, see KEYBOARD). **2** Two ornamented versions of the letter C are used as time signatures. One is the C used to indicate common or 4/4 meter. The other has a vertical line drawn through it to indicate either 2/2 or 4/2 meter (see the accompanying example). **3** An ornamented version of the letter C is used to form a

family of clefs (see tenor and alto clefs, under CLEF). —**C instrument** An instrument that sounds at the pitch of the music written for it (in contrast to a transposing instrument), especially one of a group such as the trumpets, containing instruments that do not sound at the written pitch.

cabaça (kä'bä sä) *Portuguese*: "gourd." A Brazilian gourd-rattle (adapted from African versions) used in dance bands. It consists of a gourd covered with a bead-strung netting, and sometimes also filled with pebbles or bits of shell. It is sounded by shaking.

cabaletta (kä bä let' ä) *Italian*. **1** Originally, in operas of the eighteenth and early nineteenth centuries, a short aria with a persistent rhythm that was repeated with improvised ornamentation. A famous example is Rosina's aria in Act I of Rossini's *Il Barbiere di Siviglia* ("The Barber of Seville," 1816), "Una voce poco fa" ("One voice does little"). **2** In mid- and late nineteenth-century Italian opera, the term was used for the concluding section of a long aria or duet, usually in rapid tempo and with mounting excitement, whereas the first section of such a piece, in moderately slow tempo, was called CAVATINA. An example is the final section of Violetta's aria "Sempre libera" ("Always free") from Act I of Verdi's *La Traviata* (1853).

Cabezón (kä be thôn'), **Antonio de** (än tô' nē ō" de), 1510–1566. A Spanish composer and organist who is remembered chiefly for his keyboard music, which had enormous influence on the composers for organ and harpsichord who followed him. Blind from infancy, Cabezón nevertheless became court organist by the age of sixteen. He first served the Emperor Charles V and then his son, Prince Philip (later Philip II), with whom he

traveled all over Europe. More than a decade after Cabezón's death, his compositions were collected and published by his son, Hernando, who also succeeded Cabezón at Philip's court. The collection, entitled *Obras de música para tecla arpa y vihuela* ("Musical Works for Keyboard, Harp and Vihuela"), contained both church music—arrangements of hymns, motets, and *tientos* (preludes)—and *diferencias* (sets of variations) on popular songs of the time.

caça (kä'sä, kä't̲h̲ä). The Spanish name for CACCIA.

caccia (kät'c̲h̲ä) *Italian:* "chase." An early fourteenth-century Italian musical and poetic form. The poem usually dealt with everyday subjects (hunting, fishing, or street scenes) and often a chase (after animals or women). It was set to lively music in the form of a two-part canon, that is, one part repeating the exact melody of the first but following it by a number of measures like the parts of a round. (As implied by the original meaning of the word, the second voice-part actually "chases" the first.) There is usually a third part as well, lower in range and in longer note values; it does not imitate the melody of the upper parts, and it was probably performed by an instrument rather than a voice. Following the main canon, there is generally a shorter concluding section called a RITORNELLO (def. 1), which may also be in the form of a canon.

A similar kind of composition is the French **chace**, dating from a somewhat earlier period and consisting of a three-part vocal canon at the unison. A Spanish version, possibly an imitation of either the Italian or the French form, was the **caça**. Along with the ballata and madrigal, the caccia was one of the most important forms of fourteenth-century secular (nonreligious) music in Italy.

Caccini (kät c̲h̲ē' nē), **Giulio** (jōō' lyô), c. 1546–1618. An Italian composer remembered chiefly as the com-

poser of one of the earliest operas, *Euridice* (1600), and a collection of lovely madrigals for solo voice and basso continuo entitled *Le nuove musiche* ("The New Music"). Born in Rome, Caccini went to Florence about 1565 and was a singer at the court there. He became one of the CAMERATA, a group of scholars and artists who wished to revive the classical art of ancient Greece. In his madrigals, Caccini tried to make the music suit both the meaning and the sound (accent, inflection) of the words, creating a kind of "musical speech" that came to be called recitative, although Caccini himself called it *stile rappresentativo* ("representational style"). See also MONODY, def. 1.

His daughter, **Francesca Caccini** (1587–c. 1640), a celebrated singer, lutenist, and harpsichordist, wrote music for court entertainments in Florence, as well as songs and duets that exploited the capabilities of the voice. Her most important work was the opera *La Liberazione di Ruggiero dall'isola d'Alcina* ("Ruggiero's Liberation from the island of Alcina"; 1625). However, most of her other works have been lost.

cadence (kād'əns). The series of notes or chords that ends a melody or a section, giving the listener a sense of partial or complete finality. During the course of the eighteenth and nineteenth centuries, certain sequences of chords came to be used for cadences, the most important of which are described below. However, these cadential formulas (patterns of cadences) were by no means the ones current in earlier periods, and, toward the end of the nineteenth century, as composers experimented with new harmonic ideas, the traditional formulas began to give way to totally different ones. (See HARMONIC ANALYSIS for explanation of the Roman numerals.) —**authentic cadence** Also, *final cadence, full cadence, complete cadence*. A cadence that gives a sense of complete finality: the next-to-last chord is the DOMINANT (V), the last chord is the TONIC (I). In the **perfect**

authentic cadence, the tonic note is in the soprano. For example, in the key of C major:

V I

—plagal cadence A cadence that also gives a sense of complete finality: the next-to-last chord is the SUBDOMINANT (IV), the last chord is the tonic (I). In the **perfect plagal cadence**, the tonic note is in the soprano. For example, in the key of C major:

IV I

—imperfect cadence Also, *half cadence*. A cadence that gives the feeling that more is to come and therefore is used in the middle of a section: the next-to-last chord is the tonic (I), and the last is the dominant (V) or, occasionally, the subdominant (IV). For example, in the key of C major:

I V I IV

—deceptive cadence Also, *false cadence, interrupted cadence*. A cadence that the listener expects to end on the tonic but that surprises one with a different chord: the next-to-last chord is the dominant (V), the last some other chord, often the SUBMEDIANT (VI). For example, in the key of C major:

V VI

—Phrygian cadence A cadence that gives the impression that more is to follow, and that is often found in seventeenth- and eighteenth-century music at the end of a movement that is followed by another movement:

the next-to-last chord, often the subdominant (IV), belongs to the key of the movement, which is major, and the last chord is the dominant (V) of the relative minor key (see KEY, def. 3). For example, in the key of C major:

IV V

—masculine cadence Also, *masculine ending*. Any cadence in which the final chord falls on a strong or accented beat in a measure. **—feminine cadence** Also, *feminine ending*. Any cadence in which the final chord falls on an unaccented beat in a measure. (See also HARMONY; LANDINI CADENCE.)

cadenza (kä den' dzä) *Italian*. A musical passage that gives soloists a chance to show off their technical skill in performing difficult runs, arpeggios, and the like. Cadenzas usually appear toward the end of a movement or composition, or between sections of a movement, and are performed by the soloist alone, the orchestra joining only in the initial and closing chords of the passage. The cadenza is associated particularly with the solo concerto, where it appears in the first and sometimes also the last movement. At first (late eighteenth century) the cadenza was inserted just before the closing cadence of the first movement, and the soloist improvised it (made it up) on the spot, usually basing it on the themes of the movement. In the nineteenth century composers began to write out cadenzas, a custom that has become virtually standard. For older music the missing cadenzas are usually supplied by editors.

The accompanying example is from Vaughan Williams' Oboe Concerto (1944). The indication "Tempo" at the end of the cadenza directs a return to normal tempo, the tempo of the cadenza being free and up to the performer's discretion.

The practice of including cadenzas

in solo concertos was taken over from eighteenth-century Italian opera, where singers often inserted an improvised passage just before the final cadence (end) of an aria in order to display their skill.

caesura (si zōōr'ə). A brief pause in a musical phrase, which is indicated in the score by a comma, apostrophe, or other sign (' or " or ∨). In music for voice or a wind instrument it may tell the performer to take a breath, or it may simply call for a brief break in the music. Also, *pause, breath mark.*

Cage (kāj), **John,** 1912–1992. An American composer who became known for his experimental methods, among them the use of a **prepared piano** (a piano altered in special ways for a particular performance, as by applying bottlecaps or other objects to some of the strings), music of indeterminacy (in which the performer decides what to play and how to play it; see ALEATORY MUSIC), various special kinds of notation, and live electronic music. He also wrote some interesting books and articles on music, among them the book *Silence* (1961). Cage was born in California and studied with such notable composers as Henry Cowell, Arnold Schoenberg, and Edgar Varèse. Among his works are *Imaginary Landscapes* for twelve radios, in which the performers turn the radio dials to obtain particular wave lengths (which may or may not coincide with radio stations) and various degrees of loudness, and *Four Minutes and 33 Seconds* (1954), in which a performer sits silent before an instrument for exactly that period of time and ends after playing nothing. From the 1950s on, Cage also worked with musique concrète, collecting sounds (both real-life and musical) on tape and putting them together in a kind of cut-and-paste operation. Occasionally Cage combined all these techniques. His *Indeterminacy: New Aspect of Form in Instrumental and Electronic Music* is a set of ninety stories, each told (fast, slow, or otherwise) so as to fit into the space of one minute and accompanied (or interrupted or drowned out) by piano and electronic sounds taken from an earlier aleatory work for piano and orchestra (*Piano Concert*). *HPSCHD.* (1969), produced by Cage and Lejaren Hiller, involves the simultaneous playing of one to fifty-one prerecorded tapes and one to seven live harpsichordists, each over a separate loudspeaker, in a large hall, in which the audience moves around; the music, including chance, computer composition, and other techniques, is accompanied by special film projection and lighting effects. *Europera 5* (1987–1991) juxtaposes nineteenth-century operatic arias, instrumental pieces by Cage, radio broadcasts, and silent television pictures. Cage was profoundly interested in Oriental philosophy and mysticism as well as in avant-garde Western writers such as James Joyce. His ideas and experiments have influenced many of his contemporaries, especially through his work as music director of the Merce Cunningham dance company, and he is said to have opened the door to minimalism, performance art, and other new styles.

Among the composers he influenced are Karlheinz Stockhausen, Morton Feldman, David Tudor, Earle Brown, Christian Wolff, Philip Glass, and Frederic Rzewski.

caisse claire (kes klâr'). The French term for SNARE DRUM.

caisse roulante (kes rōō länt'). Also, *caisse sourde* (kes sōōrd'). The French term for TENOR DRUM.

calando (kä län'dô) *Italian.* A direction to perform more softly and usually also more slowly.

calcando (käl kän'dô) *Italian.* A direction to speed up the tempo.

call and response A feature of African vocal music that was incorporated by American blacks in their spirituals and work songs, and later in blues and gospel music. The soloist sings or chants a line that is repeated or answered by the other singers. In traditional blues, the soloist sings a two-bar line that is echoed by the accompanying instrument, either guitar or harmonica, and this sequence is followed in each of the four-bar units of the overall twelve-bar structure.

calliope A steam-driven organ named for the Greek muse of eloquence and invented by Joshua C. Stoddard in 1845. The original model consisted of a steam boiler, a set of valves, and fifteen graded steam whistles. It was played from a pinned cylinder, but a later keyboard model played 37 notes from both keys and barrels. It was very loud and used only outdoors, on river showboats, in circuses, and on fair grounds. After 1900 compressed-air calliopes were constructed, played either from a keyboard or paper roll and obtaining as many as 58 notes (but most were smaller).

calmando (käl män' dô) *Italian.* Also, *calmato* (käl mä'tô). A direction to perform in a quiet, calm manner.

calmato See CALMANDO.

calore, con (kôn kä lô' re) *Italian.* Also, *caloroso* (kä"lô rô' sô). A direction to perform with warmth.

caloroso See CALORE, CON.

calypso (kə lip'sō). A type of popular song sung throughout the Caribbean Islands, particularly in Trinidad, where it originated. The text, using slang, invented words, and ordinary words pronounced so that the accent falls on a usually weak syllable (for example, doll-AR instead of DOLL-ar), generally pokes fun at a real-life event, situation, or person. The music, in 2/4 meter, is highly syncopated and repetitious, the accompaniment being provided by guitars, drums, and other percussion.

cambiata (käm byä'tä) *Italian.* 1 Also, *changing tone.* A shortening of the term *nota cambiata,* used for a pair of notes appearing between two chords and dissonant with both. The first note of the cambiata is usually one scale step away from one of the notes in the first chord, and the second note is more than one scale step (usually a third) away from the first note. For example, if chord 1 is G–D–G'–B and chord 2 is G–B–D–G', the notes F-sharp and A appearing between the two chords constitute a cambiata.

Many authorities distinguish between a pair of dissonant notes moving in the same direction as the chords (either up or down in pitch), and a pair of dissonant notes that move in the opposite direction from the chords (as in the accompanying example: the notes move up, from F# to A, the chords move down, from B to G); they reserve the term cambiata for the former and call the latter **échappée** or **escaped note.** 2 A name sometimes used for an accented PASSING TONE.

camera (kä'me rä) *Italian:* "chamber" or "room." A word used in such terms as *musica da camera* ("chamber music") and *sonata da camera* ("chamber sonata," a baroque form contrasted with the *sonata da chiesa* or "church sonata"; see under SONATA).

Camerata (kä"me rä'tä) *Italian.* A group of influential Italian intellectuals of the sixteenth century, including the composers Vicenzo Galilei (father of Galileo), Jacopo PERI, and Giulio CACCINI, who sought to revive the art of the ancient Greeks, particularly with respect to arousing human emo-

tions through dramatic expressiveness, and instead revolutionized the madrigal and invented opera.

camminando (käm mē nän' dô) *Italian*. A direction to proceed, to push on.

campana (käm pä'nä). An Italian word for bell (see BELL, def. 1; CHIMES).

campanella (käm"pä nel'lä) *Italian*: "small bell." A term used both for actual bells and as the title of pieces in which the sound of bells occurs or is imitated. Examples include the last movement of Niccolò Paganini's Violin Concerto in B minor, called *Rondo alla campanella,* and a piano work by Franz Liszt based on Paganini's rondo, called "La Campanella."

campanelli (käm pä nel' lē). The Italian word for GLOCKENSPIEL.

canarie (kA nA rē') *French*. A lively seventeenth-century dance, named for the Canary Islands, which was occasionally used in operas and as a movement in instrumental suites by French, German, and English composers. In 3/8 or 6/8 meter, the canarie is similar to the GIGUE but has a characteristic rhythm with a dotted note occurring on each strong beat (as shown in the accompanying example).

cancan (*English* kan'kan"; *French* käN käN') *French*: "gossip" or "scandal." A nineteenth-century dance, generally performed in music halls and nightclubs. The cancan's music, in 2/4 meter, is based on another dance, the quadrille. The cancan was considered extremely daring because it involved very high kicks by the dancers (all women). The best-known example of the cancan occurs in Offenbach's operetta *Orphée aux enfers* ("Orpheus in the Underworld," 1858).

cancel The use of a natural sign to counter a previous accidental; see under ACCIDENTALS.

canción (kän thyôn', kän syôn') *pl.* **canciones** *Spanish*. 1 In the fifteenth century, a particular type of poem that was often set to music. It was similar to the contemporary villancico (see VILLANCICO, def. 2) except that it had a more regular rhyme scheme, and the musical meter was always made to conform to the poetic meter. 2 In modern Spanish, a song of any type.

cancionero (kän"thyô ner' rō, kän" syô ner' ō) *Spanish*. 1 Originally, from the fifteenth century, a collection of poems without music, whether or not they were intended to be sung. 2 Also, a fifteenth-century book of polyphonic songs (songs with several voice-parts) with music, similar to the French chansonnier. For example, the *Cancionero musical de Palacio* (c. 1500) contains more than 450 songs. Most are villancicos similar to the Italian frottola, that is, short, for three or four voice-parts, mostly chordal in style, with the main melody in the top voice. In addition, it contains a number of romances, long narrative poems with many stanzas, each of which is sung to the same music. 3 In modern Spanish, a collection of folk songs.

canon (kan'ən). A musical composition, or section of a composition, in which a melody in one voice-part is imitated in one or more other voice-parts. Each part (except the first) enters before the preceding part has finished the melody, so that the melody and its repetitions overlap. The most familiar kind of canon is the **round,** such as the children's songs "Three Blind Mice," "Row, Row, Row Your Boat," and "Frère Jacques." This kind of canon is also called a **perpetual canon** because each part, when it comes to the end of the melody, begins again and repeats the melody, over and over. Other types of canon usually end with a short coda (concluding section) in which all the voice-parts come together.

The canon has been a popular form for hundreds of years. One of the old-

est, "Sumer is icumen in," dates from the thirteenth century. In the fourteenth century canonic imitation was used in the forms called CACCIA and *chace,* and in the fifteenth century it was widely employed in Masses and motets. In later periods the problems of writing canons continued to fascinate composers. Among the most famous canons are those in Bach's *Goldberg Variations* for harpsichord. Interest in the canon revived in the twentieth century. Serial composers such as Schoenberg and Webern applied the various canonic treatments described below to the twelve-tone series (see SERIAL MUSIC for a specific example). Some composers, such as Olivier Messiaen, have used rhythmic canon, that is, canonic devices applied to the rhythm (time values) instead of the melody (pitches). —**strict canon** A canon in which, as in a round, the imitation of the melody is exactly the same as the melody itself. —**free canon** A canon in which the imitation of the melody differs in some way from the original, such as the addition or leaving out of sharps and flats. —**mixed canon** A canon accompanied by one or more independent voice-parts, which do not take part in imitating the melody. —**double canon** A composition or section in which two independent canons (canons on two different melodies) occur simultaneously.

Other types of canon are distinguished by the way in which the imitation differs from the basic melody. —**canon at the unison** A canon in which the imitating part begins on the same pitch as the original melody, as it does in a round. If it begins on some pitch higher or lower than the original, it is called a **canon at the fifth, canon at the third,** etc., depending on the interval between the two beginning pitches (fifth, third, etc.). —**canon by inversion** Also, *canon in contrary motion.* A canon in which the imitation consists of the same intervals as the melody but upside down (if the melody were D E F# D, the imitation might be D C B♭ D,

that is, moving down in pitch the same distance as the melody moves up, and vice versa). —**canon by augmentation** A canon in which the imitation repeats the melody in longer note values (for example, half notes instead of quarter notes, quarter notes instead of eighth notes, etc.). —**canon by diminution** A canon in which the imitation repeats the melody in shorter note values (exactly the opposite of augmentation). —**retrograde canon** Also, *crab canon, canon cancrizans.* A canon in which the imitation repeats the melody backward, beginning at the end and ending at the beginning (if the melody were D E F# D, the imitation would be D F# E D). —**canon by retrograde inversion** A canon in which the melody is repeated both upside down (moving up where it originally moved down in pitch, and vice versa) and backward (beginning at the end and ending at the beginning).

Sometimes two techniques are combined, as for example, in a *canon by augmentation and inversion,* or in a *canon by diminution and inversion.*

canso (kᴀn'sō) *Provençal.* A TROUBADOUR love song.

cantabile (kän tä'bē le) *Italian.* A direction to perform in a melodious, singing manner.

cantata (kän tä'tə) *Italian.* Today, a composition for voices (soloists, chorus, or both) and instrumental accompaniment, consisting of several movements, among them arias, duets, recitatives, and choruses. The modern cantata is like an ORATORIO but is generally shorter and not necessarily confined to a religious subject. Indeed, the secular (nonreligious) cantata as it has existed since the late eighteenth century might be described as an opera in concert form, performed without costumes, scenery, or action. Originating in Italy about 1630, and developing alongside the earliest operas, the cantata was an outgrowth of the late madrigal, becoming the most important vocal form of the

baroque period (until about 1750). Musically it was similar to early opera, consisting of two or three da capo arias (see under ARIA) connected by narrative recitatives (speechlike sections); this form is sometimes called "solo cantata" to distinguish it from the modern form.

During the course of the seventeenth century the cantata was taken up by French, German, and English composers, and it began to be used for religious as well as secular texts. In addition, like opera, the cantata gradually became more elaborate, including sections for chorus and also for full orchestra. Notable composers of cantatas during the seventeenth and eighteenth centuries include Alessandro Stradella, Alessandro Scarlatti, and Niccolò Jommelli of Italy; André Campra and Jean-Philippe Rameau of France; George Frideric Handel of England; Dietrich Buxtehude, Franz Tunder, Johann Philipp Krieger, Johann Kuhnau, Johann Adolf Hasse, and Georg Philipp Telemann of Germany. The German composers favored the sacred or church cantata almost exclusively, and in it they often incorporated the Lutheran CHORALE. The cantata, like most other baroque forms, reached a high point in the works of Johann Sebastian Bach, who wrote about 300 cantatas; of these some 215 have survived, most of them religious. Bach's larger church cantatas usually consist of an opening chorus, often in the form of a fugue, followed by a number of recitatives and arias for the soloists, and ending with a harmonized chorale. He used the same scheme for his large secular cantatas.

By the late eighteenth century the cantata had achieved its modern form, that is, the religious cantata was identical to a small-scale oratorio, and the secular cantata was in effect a short opera presented in concert form. Though never regaining the importance it had in baroque times, the form continued to attract some composers in the periods that followed, among them a considerable number of important twentieth-century composers, such as Bartók (*Cantata profana*, 1930), Webern (op. 29, op. 31), Britten (*Rejoice in the Lamb*, 1943; *Cantata Misericordium*, 1963), Schoenberg (*A Survivor from Warsaw*, 1947), Hindemith (*Apparebit repentina dies*, "Suddenly Shall the Day Appear," 1947), Honegger (*Cantate de Noël*, 1953), Vaughan Williams (*Epithalamion*, 1953), Stravinsky (*Canticum sacrum*, "Sacred Canticle," 1956), and Daniel Pinkham (*Christmas Cantata*, 1958; *Ascension Cantata*, 1970).

canticle (kan' ti kəl). A Biblical song of praise other than a psalm. In the Roman Catholic liturgy, canticles are important in certain Offices (see OFFICE). Like psalms, the canticles are sung to recitation tones, melodic formulas that correspond to the eight church modes, and they are generally preceded and followed by an ANTIPHON. For some the standard psalm tones are used, while others have their own set of eight tones, and the MAGNIFICAT, the canticle of Vespers, has two sets, one for ordinary days and one for special feast days. In the Anglican service the term is used for the hymns of Morning Prayer and Evening Prayer (see under SERVICE).

cantiga (kän tē' gä) *Spanish*. Also, *cántiga* (kän' tē gä) *Galician*. An Iberian song of the thirteenth century, similar in form to the French VIRELAI and with a text in Galician. King Alfonso X of Castile and León (1221–1284), who loved art and composed music himself, had a beautifully illustrated collection of more than four hundred cantigas made, *Cantigas de Santa Maria*, dedicated to the Virgin Mary and including many thought to have been composed by him. This is the only surviving collection of its kind written in mensural notation, enabling transcription of the songs into modern meters and note values. Although many cantigas honor the Virgin Mary, others deal with secular subjects. Most consist of stanzas with a refrain that is repeated before and after each verse.

cantilena (cän ti lä′nä) *Latin, Italian*: "song," "melody." **1** In the Middle Ages, a term applied to various kinds of song, ranging from monophonic secular songs to polyphonic sacred music. **2** In the nineteenth century, a lyrical vocal line or an instrumental passage of a similar nature.

cantillation (kan″ t³ lä′ s̠hen). See under JEWISH CHANT.

canto (cän′tô), *Italian, Spanish*. **1** Singing. **2** A melody or song. **3** The treble (highest) part of a polyphonic composition. **4** The treble string of an instrument.

cantor (kan′tər). **1** Also, *chazzan*. In Jewish worship, the solo singer, who chants the sacred liturgy during Sabbath and holiday services. Also see JEWISH CHANT. **2** Also, *chanter, precentor*. In some Protestant churches, such as the Lutheran Church, the name for the music director; for example, Bach held the post of cantor of the Thomaskirche (Church of St. Thomas) in Leipzig. **3** *pl.* **cantores** (kan tôr′āz) *Latin*. In Roman Catholic services, a singer (usually one of two) who performs the solo portions of the chants, the rest being performed by the chorus (called the *schola*).

cantus (kan′təs) *Latin*. **1** In the twelfth century, the first (usually the lowest) voice-part to be written in a composition having more than one part. (The second part to be written was called the DISCANTUS.) **2** Also, *superius* (sə pēr′ ē əs). In the fifteenth and sixteenth centuries, the highest voice-part in a composition having more than one part.

cantus firmus (kan′təs fûr′ məs) *pl.* **cantus firmi** (kan′təs fûr′mē) *Latin*: "fixed song." An already existing melody that is used as the basis of a composition with other voice-parts. The composition may be for voices (with or without instrumental accompaniment), for an instrumental ensemble, or for a single instrument (usually organ or harpsichord). The melody used as the cantus firmus

may come from Gregorian chant, from a Lutheran chorale (hymn), from a popular song, or from practically any other melodic pattern, including a fragment of a scale. From the thirteenth century through the baroque period (ending about 1750), when COUNTERPOINT was basic to nearly all musical composition, the use of a cantus firmus was very common. The organa, clausulae, and motets of the thirteenth and fourteenth centuries were almost always based on a cantus firmus, taken either from Gregorian chant or from well-known songs of the time. The English composers of the early Renaissance, especially John Dunstable and Leonel Power, are credited with being the first to use a single cantus firmus to unify all the movements of a Mass. During the fifteenth and sixteenth centuries most Masses and organ music came to be constructed in this way. For example, Masses based on the tune of the song *L'Homme armé* ("The Armed Man"), shown in the accompanying example, were written

by many of the major composers of the time, including Dufay, Ockeghem, Busnois, Obrecht, Josquin, and Palestrina. (A more recent use is Peter Maxwell Davies's *Missa super l'homme armé*, 1968, rev. 1971.) By the seventeenth century, Lutheran

chorales were used as cantus firmi by many German composers, particularly in organ chorales and in the choruses of cantatas, oratorios, and Passions. Another favorite cantus firmus was the hexachord *ut re mi fa sol la* (the six-note scale C to A). Until about 1650 the cantus firmus was most often found in the tenor (lowest) voice-part and, from the fifteenth century on, it frequently was set in long notes of equal value. In organ music of the seventeenth and eighteenth centuries these long notes usually appeared in the bass. Occasionally, however, the cantus firmus formed the descant (highest voice-part), in which case the simple basic melody was ornamented (shorter, decorative notes were added).

canzona (kän tsô' nä) *pl.* **canzone** (kän tsô'ne) *Italian:* "song." **1** A medieval Italian or Provençal poem of several stanzas given a polyphonic setting similar to that of a FROTTOLA (def. 2). **2** A sixteenth-century Italian composition for voice similar to the madrigal (see MADRIGAL, def. 2) or to the VILLANELLA. **3** In the sixteenth and seventeenth centuries, a lyric poem in stanza form that was often given a polyphonic setting by Italian madrigal and frottola composers of the time. **4** From the seventeenth century on, any solo song with keyboard accompaniment, the Italian counterpart of the French CHANSON (def. 1) and the German LIED (def. 1). **5** In the sixteenth and seventeenth centuries, an important instrumental form, written for a keyboard instrument or instrumental ensemble and based on the style of the contemporary French polyphonic chanson (see CHANSON, def. 2). Because it generally included sections in contrasting style, the instrumental canzona is considered a forerunner of the sonata. The most important composers of such canzonas were Giovanni Gabrieli and Girolamo Frescobaldi.

canzonetta (kän tsô net' tä) *pl.* **canzonette** *Italian:* "little song." Also, English *canzonet* (kan zo net'). **1** From the sixteenth to eighteenth centuries, a short secular song either for solo voice or for two to six voices, with or without instrumental accompaniment. Such pieces were written by Thomas Morley (1597), Claudio Monteverdi (1619), and Franz Joseph Haydn (1794), among others. **2** In the sixteenth and seventeenth centuries, an instrumental piece similar to a short CANZONA (def. 4), such as the organ canzonette of Dietrich Buxtehude. The name has also been loosely used for instrumental pieces of similar nature; for example, the second movement of Mendelssohn's String Quartet in E-flat, op. 12, is marked Canzonetta: Allegretto.

capo See CAPOTASTO; also CAPO, DA.

capo, da (dä kä'pô) *Italian:* "from the beginning." A direction to repeat a section or whole composition from the beginning. (Also see REPEAT, def. 1.) The phrase is often abbreviated D.C. (or d.c.). —**da capo al fine** A direction to repeat from the beginning to the end or to the point marked "fine." —**da capo al segno** A direction to repeat from the beginning to a point marked by the sign (𝄋) —**da capo aria** See under ARIA, def. 1.

capotasto (kä pô täs' tô) *Italian:* "principal fret." Also, *capo* (kä'pô). A device used in lutes, guitars, and other fretted stringed instruments to shorten the vibrating length (thereby raising the pitch) of all the strings at the same time so as to permit playing in keys that would ordinarily be difficult to finger. The capotasto usually consists of a short bar of wood, metal, or some other material that is placed across the fingerboard directly over one of the frets.

cappella, a (ä kä pel'ä) *Italian:* "in church style." A term that has come to mean choral singing without instrumental accompaniment, in the manner of Gregorian chant.

capriccio (käp prē'chē ô") *Italian:* "caprice" or "whim." **1** In the seventeenth century, an instrumental piece

resembling a fugue but based on fanciful themes, such as the cuckoo's song or a part of a scale (both were so used by Frescobaldi). **2** In the eighteenth century, a composition that did not belong to any of the more usual forms of the period, for example, Bach's *Capriccio sopra la lontanza del suo fratello diletissimo* ("Capriccio on the Departure of His Beloved Brother"). **3** In the nineteenth century the term was used both for short piano compositions of a light nature (by Schumann, Mendelssohn, Brahms, and others) and for orchestral works that included popular melodies (Tchaikovsky, *Capriccio italien*, op. 45; Rimsky-Korsakov, *Capriccio espagnol*, op. 34). **4** A technical exercise or study, for example, Paganini's twenty-four capriccios for unaccompanied violin, op. 1.

capriccioso (kä prē" chē ô'sô) *Italian:* "capricious" or "fanciful." A term meaning in the manner of a CAPRICCIO (def. 3), used in such titles as Saint-Saëns's *Introduction et Rondo Capriccioso.*

carillon (kar′ ə lon″). **1** Also, *chimes.* A set of tuned bells hung in a church tower and played automatically or by means of a keyboard and pedals. Carillons were developed at least as early as the thirteenth century and achieved great popularity in Europe during the fifteenth century. Early carillons consisted of as few as four bells. Some writers distinguish between chimes and carillons, confining the term "carillon" to a set of twenty-three or more chromatically tuned bells, spanning at least two octaves, and using "chimes" for smaller sets. The average modern carillon has thirty to fifty bells, giving a range of three to four octaves, and can sound not only a melody but two-, three- or even four-part harmony.

Some churches have an electronic carillon, a set of small bells played from an electronic keyboard and deepened and amplified by means of loudspeakers. The world's largest carillon, at Riverside Church in New York City, has seventy-four bells, giving a range of five octaves. Like all traditional carillons, it is played from a keyboardlike arrangement of levers and pedals and is touch-sensitive. A complex system of levers and counterweights carries the performer's phrasing directly to the clappers, which strike the fixed bells. The highest-pitched bells, which are relatively small, can be played two at a time with one hand, but going down the scale to the largest bells, more and more force is required to move the clappers, and the lowest notes call for the performer's full weight on a pedal. **2** (kʌ rē yòn′). The French word for GLOCKENSPIEL.

Carissimi (kä rēs′ sē mē), **Giacomo** (jä′ kô mô), 1605–1674. An Italian composer remembered chiefly for his contributions to the development of the ORATORIO. Shortly after 1600, religious themes, such as Bible stories, were made the subjects of operas and performed on the stage. Carissimi treated such themes as concert works, which were not staged and were usually performed in church. The music still resembled that of early opera, but Carissimi included more sections for the chorus and added one or more narrators who told the story in recitatives (speechlike sections). His oratorios, all with Latin texts, include *Jephte, Judicium Salomonis* ("The Judgment of Solomon"), *Jonas,* and *Baltazar.*

carol **1** A song for Christmas, the English counterpart of the French NOËL and German *Weihnachtslied.* In England the term was originally applied to any song having a fixed refrain, called a *burden,* and sung by the entire group, that alternated with a series of more or less uniform stanzas sung by soloists; this form grew out of one or more medieval dances. Most carol texts were religious; some were in English, others in Latin, and still others combined both languages and occasionally also included French. The music was polyphonic (with several voice-parts), a feature that differentiates the carol from the ballad,

another kind of popular song derived from dance and having stanzas and a refrain. A famous carol was the so-called Agincourt carol, *Deo gratias Anglia* ("England thanks God"), that celebrated the English victory of 1415. During the sixteenth century, carols came to be associated with Christmas. Today, Christmas carols come from a variety of sources, chiefly folk songs and other secular (nonreligious) music. Some, such as *Stille Nacht* ("Silent Night") by Franz Gruber (1787–1863), were especially composed as Christmas carols. Others, such as "God Rest You Merry, Gentlemen," are based on older music (in this case, a sixteenth-century hymn). **2** A similar song associated with another religious holiday, such as Easter.

Carter (kär'tər), **Elliott**, 1908– . An American composer who until about 1951 wrote music in a neoclassic style (see NEOCLASSICISM), largely tonal and with hints of jazz influence, but then turned to a variety of newer techniques, culminating in atonal, densely textured music, most of it instrumental. Carter was especially concerned with the dramatic contrasts and interplay of different kinds of instrument, and also with the complex interaction of rhythms, tempos, dynamics, pitches, and other elements. One of his favorite techniques, which he called **metric modulation**, superimposes opposing rhythms, such as triplets on quintuplets, and shifts the basic pulse from one to another. Works from Carter's early period include Symphony no. 1 and the ballets *The Minotaur* and *Pocahantas*. His Piano Sonata and Sonata for cello and piano indicate a transition to his later style, which emerges in String Quartet no. 1 and *Variations for Orchestra* and is fully realized in later chamber works and especially such orchestral works as the Double Concerto for harpsichord and piano, Piano Concerto, Concerto for orchestra, and *A Symphony of Three Orchestras*. In 1975 Carter returned to writing his first vocal music since the

1940s, setting poems by Elizabeth Bishop (*A Mirror on Which to Dwell*, 1975), John Ashbery, and Robert Lowell. Other outstanding works of his are the Brass Quintet (1974), Triple Duo (1983) for violin, cello, flute, clarinet, piano, and percussion, String Quartet no. 4 (1986), and Oboe Concerto (1988).

cartridge 1 In a record player, a voltage-generating device with a stylus (needle) assembly. **2** In a tape player, a prepackaged reel of magnetic tape designed for use on a compatible machine.

cassa (käs'sä). The Italian word for DRUM.

cassa rullante (kä'sä rōō län'te). The Italian term for TENOR DRUM.

cassation (ka sä' shən). An eighteenth-century instrumental composition in several movements that is designed for outdoor performance, particularly during the evening. A cassation is usually scored for wind instruments but otherwise it is identical to the SERENADE and DIVERTIMENTO.

cassette (ka set'). A small plastic housing containing magnetic tape and two reels for supply and takeup.

castanets (kas"tə nets'). A pair of shell-shaped wooden clappers, used as a rhythm instrument, mainly by

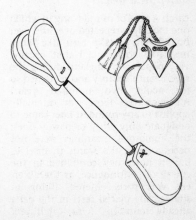

dancers but also in the orchestra. In the castanets used by dancers, the two halves are joined by a cord that passes over the player's thumb and forefinger. Usually two sets are used, one in each hand, and they either are clicked rhythmically or are made to sound a long, continuous roll. Castanets are used mainly in such Spanish dances as the bolero and fandango. For use in orchestras and bands, the two halves are usually attached to a long handle. Although today castanets are associated almost exclusively with Spanish and Latin American music, the instrument is a very old one and was known in ancient Egypt and Rome.

castrato (käs trä'tô) *pl.* **castrati** (käs trä'tē) *Italian.* A boy or man who was operated upon (castrated) in order to keep his voice from changing, so that it would remain in the soprano or alto range throughout his life. Castrati were much admired in Italy in the seventeenth and eighteenth centuries. Operas of the period contain numerous roles for castrati, which today are usually sung by women or by countertenors, although they are sometimes transposed to a lower range (tenor or baritone). The most familiar such role in opera that is still frequently performed is that of Orfeo in Gluck's *Orfeo ed Euridice;* many of Handel's operas and oratorios include such parts as well.

catch A type of round (song in which one melody is repeated over and over by different parts in turn, like "Row, row, row your boat") that became very popular in England during the seventeenth century and remained so for about two hundred years. Although the term was originally applied to any round, it later came to designate only witty or bawdy ones; the humorous meanings were not necessarily in the words themselves but in how they combined in the course of performance, as the different voice-parts entered, filling in strategically placed rests in the parts already sounding. (One catch text

even points this out, beginning "Mark how these knavish rests/Good earnest make of jests.") Catches were particularly popular during the reign of King Charles II (1660–1685). During the eighteenth century societies called catch clubs were formed for the purpose of performing catches and glees (short unaccompanied songs in simple chords). One of the oldest such organizations, the Noblemen and Gentlemen's Catch Club, founded in 1761, still holds regular meetings in London.

cavatina (kä vä tē'nä) *Italian.* In eighteenth- and nineteenth-century opera and oratorio, a solo song in slow tempo and simpler in structure than the conventional da capo aria, usually without repeated sections. Examples appear in Haydn's oratorio, *Die Jahreszeiten* ("The Seasons"), and Act II of Mozart's *Le Nozze di Figaro* ("The Marriage of Figaro"), in the Countess's *Porgi d'amor* ("Bearer of love"). It was often followed by a CABALETTA (def. 2). By extension, the term has been used for an instrumental section or movement of a similar nature, for example, the fifth movement of Beethoven's String Quartet in B-flat, op. 130, marked *Cavatina: Adagio molto espressivo.*

C clef See under CLEF.

CD Short for compact disk. See under DIGITAL RECORDING.

cédez (sā dā') *French.* A direction to slow the tempo.

celere (chel'ə re) *Italian.* A direction to perform quickly.

celesta (sə les' tə). An orchestral percussion instrument consisting of a series of tuned steel bars that are struck by hammers connected to a keyboard. Its bell-like tone is amplified by a resonator. The celesta looks like a small upright piano and even has dampers for the bars that are controlled by a pedal, just as in a piano. The celesta's range is from middle C to four or five octaves above middle C, but for convenience its music is

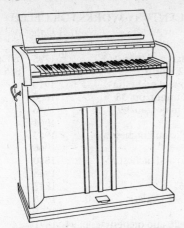

written an octave lower than it sounds. Invented in 1886 by Mustel of Paris, the celesta was first called for by Tchaikovsky in the "Dance of the Sugar Plum Fairy," in his ballet, *The Nutcracker*. It also has a prominent part is Bartók's *Music for Strings, Percussion, and Celesta* (1937).

cell A small group of pitches, functioning as a building block in serial music and other modern styles.

cello (chel'ō). The common name for the *violoncello* (the full name is less often used), the bass instrument of the violin group. About twice the size of the violin, it rests on the floor when played, supported by a spike at the lower end, and the player performs seated. The cello's shape is almost the same as the violin's, except that its neck is shorter and its ribs are deeper in proportion to its length. (See under VIOLIN for a drawing.) The cello is tuned an octave and a fifth below the violin (exactly an octave below the viola), C G d a, and it has a range of almost four octaves, from low C to the A two octaves above middle C.

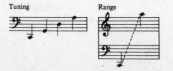

Tuning Range

The cello was developed in the sixteenth century, during the same period as the violin and viola. One of the oldest cellos still in existence was built by Andrea Amati about 1572. The early cello often had five strings, but eventually the lowest string was omitted. Until the twentieth century the cello rarely had an end-pin, the instrument being leaned against the player's legs or supported by a small footstool.

During the seventeenth century the cello was used principally together with the harpsichord, organ, or lute to provide the bass accompaniment (see CONTINUO) required by so much music of this period. Only in the late 1600s were solo pieces for cello written. Among the first are some works by Domenico Gabrielli of Bologna, dated about 1680. Soon afterward Pietro Locatelli wrote some virtuoso works for cello, and Antonio Vivaldi produced both sonatas and concertos. By the end of the baroque period (1750) the cello was coming into its own as a melody instrument, valued for its expressive, velvety tone. Johann Sebastian Bach produced six suites for unaccompanied cello, outstanding works in the cello literature. Other eighteenth-century works for cello include concertos by Leonardo Leo, K. P. E. Bach, Franz Joseph Haydn, and Luigi Boccherini, himself a renowned cello virtuoso. Important treatises on cello playing were written by the French cellist Jean-Louis Duport (1749–1819) and the German virtuoso Bernard Romberg (1767–1841).

Along with the violin and viola, the cello is a basic member of the STRING QUARTET, as well as being included in virtually all other chamber music for strings and in every symphony orchestra. Outstanding cellists of the twentieth century include, first and perhaps foremost, Pablo Casals (1876–1973), along with Emanuel Feuermann, Gregor Piatigorsky, Pierre Fournier, Leonard Rose, Janos Starker, Mstislav Rostropovich, and Yo-Yo Ma. The accompanying

NINETEENTH- AND TWENTIETH-CENTURY WORKS FOR CELLO

Composer	Work	Date
Samuel Barber	Sonata, op. 6	1932
Ludwig van Beethoven	Five Cello Sonatas: op. 5, nos. 1, 2;	c. 1795–1800;
	op. 69; op. 102, nos. 1, 2	1807; 1815
Ernest Bloch	*Schelomo* for cello and orchestra	1916
Johannes Brahms	Sonata no. 1 in E minor, op. 38	1866
	Sonata no. 2 in F major, op. 99	1886
Benjamin Britten	Sonata, op. 65	1961
	Symphony for cello and orchestra	1964
	Suite, op. 80	1968
Max Bruch	*Kol Nidrei* for cello and orchestra	1880
Elliott Carter	Sonata	1948
Frédéric Chopin	Sonata in G, op. 65	1847
Luigi Dallapiccola	*Ciaccona, Intermezzo, e Adagio*	1945
Claude Debussy	Cello Sonata	1915
Antonin Dvořák	Rondo in G for cello and orchestra, op. 94	1891
Gabriel Fauré	*Elégie* for cello and piano, op. 24	1883
	Two Cello Sonatas: op. 109; op. 117	1917; 1921
Edvard Grieg	Sonata in A minor, op. 36	1883
Hans Werner Henze	*Serenade*	1949
Paul Hindemith	Sonata for cello solo, op. 25, no. 3	1923
	Sonata	1948
Arthur Honegger	Cello Sonata	1920
Leoš Janáček	*Podháka*	1910
Zoltán Kodály	Sonata for unaccompanied cello, op. 8	1915
Bohuslav Martinu	Two Cello Sonatas	1940; 1941
Felix Mendelssohn	Sonata in B-flat, op. 45	1838
	Sonata in D, op. 58	1842
Krzysztof Penderecki	*Capriccio per Siegfried Palm*	1968
Sergey Prokofiev	Sonata, op. 119	1954
Sergey Rachmaninoff	Sonata in G minor, op. 19	1901
Maurice Ravel	Sonata for violin and cello	1922
Max Reger	Four Sonatas: op. 5, 28, 78, 116	1892–1910
	Three Suites, op. 131c	1915
Camille Saint-Saëns	Sonatas, op. 32; op. 123	1872; 1905
Robert Schumann	*Fünf Stücke im Volkston*, op. 102	1849
Dmitri Shostakovitch	Cello Sonata, op. 40	1934
Richard Strauss	Sonata, op. 6	1882
John Tavener	*The Protecting Veil* for cello and orchestra	1989
Piotr Ilyitch Tchaikovsky	*Variations on a Rococo Theme*, op. 33	1876
Heitor Villa-Lobos	*Bachianas Brasileiras* no. 1,	
	for eight cellos	1932
	Bachianas Brasileiras no. 5, for eight	
	cellos and voice	1939
Anton Webern	*Three Little Pieces*, op. 11	1914
Iannis Xenakis	*Nomos alpha*	1966
Bernd Alois Zimmermann	Sonata	1960

See also list of cello concertos under CONCERTO.

chart lists some of the many works for cello written after 1800; see also the chart of cello concertos under CONCERTO.

cembalo (<u>c</u>hem'bə lô"). 1 An Italian word for HARPSICHORD, also used in Germany. 2 The Italian word for DULCIMER.

cent A unit of measure for musical intervals. One cent stands for 1/100 half tone of the equal-tempered scale; thus one octave is 1200 cents. Measurements of intervals are useful in comparing various systems of scales and tuning (see TEMPERAMENT).

C-flat One of the musical tones (see PITCH NAMES), one half tone below C and one half tone above B-flat. On the piano, C-flat is identical with B (see ENHARMONIC for an explanation; for the location of C-flat on the piano, see KEYBOARD).

chace (<u>sh</u>AS) *French.* See CACCIA.

chaconne (<u>sh</u>A kôn') *French.* A moderately slow, stately dance in triple meter (any meter in which there are three basic beats per measure, such as 3/4 or 3/8) with a stress on the second beat, which became a popular instrumental form during the baroque period (1600–1750). Some chaconnes so closely resemble works given the title PASSACAGLIA that it is not clear exactly how the two forms differ. Like the passacaglia, the chaconne consists of a series of variations, either on a harmonic pattern (a pattern of chords related to one another in a particular way), or on a constantly repeated bass pattern (see OSTINATO). The most famous chaconne is that found in Bach's Partita in D minor for solo violin; its thirty-two variations are based on a harmonic pattern.

chair organ See CHOIR ORGAN; POSITIVE ORGAN.

chalumeau (<u>sh</u>A lУ mō') *French.* See under CLARINET.

chamber music Music for an instrumental group in which each part is played by a single instrument, as opposed to orchestral music, in which there may be numerous instruments to a part.

The different types of chamber music are distinguished according to the number of performers: trio (three players), quartet (four), quintet (five), sextet (six), septet (seven), octet (eight), nonet (nine). Some authorities regard the sonata for one instrument (usually with piano accompaniment) as chamber music, but others feel that in such works the emphasis is on the individual instruments rather than on how they perform together. Moreover, in many sonatas the piano accompaniment is subordinate to the part played on the other instrument (violin, cello, flute, etc.), whereas the essence of chamber music is the equal importance of all the parts.

By far the most popular kind of chamber ensemble is the string quartet, which consists of two violins (each playing its own part), a viola, and a cello. A string trio consists of one violin, a viola, and a cello; if the viola is replaced by a piano, the form is called a piano trio. Similarly, a string quintet consists of five stringed instruments (usually a string quartet plus a second viola or cello); if one of the stringed instruments is replaced by another instrument, such as a piano, horn, etc., the work is called a piano quintet, horn quintet, etc.

Chamber music is so called because originally it meant any music to be played outside the church, and it included both vocal and instrumental music. The old meaning persists in that chamber music is usually more intimate and personal than works of a larger scale, whether performed in a living room or in a concert hall. Although some of the sixteenth- and seventeenth-century forms (trio, sonata, ricercar, and others) have most of the characteristics of chamber music, the modern repertory is usually considered to begin with the string quartets of Haydn and Mozart, written in the late eighteenth century. Among the finest nineteenth-century

composers of chamber music are Beethoven, Schubert, Mendelssohn, and Brahms. In the twentieth century chamber music has continued to attract many composers, among them Bartók, Debussy, Fauré, Hindemith, Schoenberg, Stravinsky, Webern, Shostakovitch, and Carter. (Outstanding examples of quartets, quintets, trios, etc., are mentioned in the respective articles on these forms.)

The term "chamber music" is also occasionally used for the large body of vocal part music in which there is one voice to a part and the parts have more or less equal importance, although to avoid confusion such music is generally called "vocal chamber music." The literature ranges from examples of the earliest polyphony from medieval times to what many consider the outstanding form of vocal chamber music, the Renaissance MADRIGAL (def. 2), to the vocal duets, trios, quartets, etc., of present-day composers. (See also DUET, QUARTET, etc.)

chamber orchestra An orchestra of eighteen to forty players, as opposed to the hundred or so that make up a modern symphony orchestra. Before 1800 all orchestras were small, and today chamber orchestras frequently are used to perform orchestral music of earlier periods, as well as modern works written expressly for small groups. See also STRING ORCHESTRA.

Chambonnières (s̲h̲än bôn yer'), **Jacques Champion de** (z̲häk' s̲h̲än pyôn' də), c. 1602–1672. A French composer and harpsichordist, the founder of the French school of harpsichord playing. Employed at the court of King Louis XIV, Chambonnières was the teacher of Jean-Henri d'Anglebert (c. 1628–1691) and Louis Couperin (c. 1626–1661). He was also influential in Germany, where his style was imitated by Froberger and other composers of the time. His own compositions for harpsichord rank among the finest of the period.

chance music See ALEATORY MUSIC.

changing tone See CAMBIATA, def. 1.

chanson (s̲h̲än sôn') *French.* **1** A French word for SONG. **2** A type of polyphonic song (with several voice-parts) that was popular in the fifteenth and sixteenth centuries. It usually has a French text, which may concern practically any subject but most often treats of love. The early Renaissance composers wrote mostly chansons in one of the FORMES FIXES for one or two voices and instruments. Later Renaissance chansons are often in a free form with an imitative, four-part texture, and some of these were for unaccompanied voices.

chansonnier (s̲h̲än sôn nyā') *French.* **1** A manuscript collection of songs of the thirteenth-century troubadours and trouvères (SEE TROUBADOUR; TROUVÈRE). **2** A manuscript containing fifteenth-century polyphonic chansons (see CHANSON, def. 2) and other vocal compositions. See also under LIED, def. 2. **3** A singer-songwriter, especially of satirical topical songs.

chant (c̲h̲ant). **1** Also, *plainchant, plainsong.* The music of various Christian churches. This music is unaccompanied and monophonic (with only one voice-part). See also AMBROSIAN CHANT, BYZANTINE CHANT, and GREGORIAN CHANT. **2** In the Anglican churches, the music to which psalms and canticles are sung, which is not monophonic but in four-part harmony (see ANGLICAN CHANT). **3** (s̲h̲än). A French word for SONG. **4** (s̲h̲än). A French word for singing. **5** (s̲h̲än). A French word for VOICE.

chanter (c̲h̲an'tər). **1** Also, *chaunter* (c̲h̲ôn'tər). In a BAGPIPE, the pipe with finger holes, on which the melody is played. **2** See CANTOR, def. 2.

chantey (s̲h̲an'tē, c̲h̲an'tē) *pl.* **chanteys** Also, *chanty, pl. chanties.* Another spelling for SHANTY.

chanty Another word for SHANTY.

Charleston (c̲h̲ärlz' tən). A popular American dance of the 1920s. Its name comes from a song with that

title composed by James P. Johnson and Cecil Mack for the musical comedy *Runnin' Wild* (1923). It is in rapid tempo and characterized by a basic rhythmic feature that creates an odd syncopated effect:

Charles- ton

chaunter (c̲h̲ôn′tər). Another word for CHANTER, def. 1.

Chausson (s̲h̲ō SÔN′), **Ernest** (ârnest′), 1855–1899. A French composer who is remembered for a small number of compositions, chief among them *Poème* (1897) for violin and orchestra. A pupil of Jules Massenet and César Franck, Chausson developed a style that shows the influence of both Franck and Wagner, especially in his treatment of harmony. His other works include the Symphony in B-flat major, several operas, chamber music, and many fine art songs.

Chávez (c̲h̲ä′ves), **Carlos** (kär′los), 1899–1978. A Mexican composer who became the most important figure in his country's musical life. He founded Mexico's first symphony orchestra, which he also conducted; he served as director of the National Conservatory, which he reformed completely; and he made a point of performing Mexican music in his many appearances as a conductor abroad. Chávez's early music combines elements of native Mexican music—both of the original Indian music and that influenced by Spain during its long rule of Mexico—with a rhythmically strong and dissonant style. In his later works, especially those in symphonic form, he returned to a more traditional romantic style. His works include six symphonies, ballets, choral music, chamber music, an opera, and many piano compositions.

chazzan (K̲H̲ä zän′) *pl.* **chazzanim** (K̲H̲ä zä nēm′). The Hebrew name for CANTOR (def. 1).

Cherubini (ke″r\overline{oo} bē′nē), **Luigi** (l\overline{oo} ē′jē), 1760–1842. An Italian composer who lived mostly in Paris and wrote more than two dozen operas as well as a great deal of church music (Masses, cantatas, motets, etc.). Although Cherubini had considerable influence as a teacher at the Paris Conservatory and was much admired by his contemporaries, including Beethoven, his music is seldom performed today. Perhaps his best opera is *Les deux journées* ("The Two Days"; an English version is entitled *The Water-Carrier*); it is a "rescue opera," (in which the hero is rescued at the last minute from a dire fate; see RESCUE OPERA). Outstanding among his other operas is *Médée* ("Medea"). Of Cherubini's church music, which shows superb mastery of counterpoint, his Mass in F is the single best work. Cherubini also wrote chamber music (sonatas, string quartets, etc.) and a book on counterpoint.

chest of viols Another name for consort of viols. See under VIOL.

chest voice See under VOICE.

chevalet, au (ō″s̲h̲ə VA lä′) *French.* A direction to bow the strings of a violin or other stringed instrument at a point very close to or over the bridge, producing a nasal, brittle tone.

chiaramente (kyä″ rä men′ te) *Italian.* A direction to perform clearly and distinctly.

chiesa, sonata da See under SONATA.

Child ballad See under BALLAD, def. 1.

chimes (c̲h̲īmz). 1 Also, *orchestral chimes, tubular chimes, tubular bells.* A percussion instrument used in the orchestra. It consists of a set of metal tubes (usually eighteen in number) that hang in a frame and are struck with a mallet. They are ordinarily tuned chromatically, sounding all the half tones from middle C to the F two octaves above, and there is a damping mechanism, usually pedal-operated, to silence them. There also is an electronic version of tubular chimes,

which produce a greatly amplified sound like that of large church bells (used in the operas *Tosca* and *Boris Godunov,* and elsewhere). Chimes are generally used whenever the score calls for the sound of bells, as, for example, in the fifth movement of

Berlioz's *Symphonie fantastique* ("Fantastic Symphony"). 2 Another word for bells (see BELL, def. 1). 3 Another name for GLOCKENSPIEL. 4 Another name for CARILLON, def. 1. 5 Another name for BELL CHIME.

ch'in (<u>ch</u>ēn). Another spelling of CHYN.

Chinese block See WOOD BLOCK.

chitarra (kē tär' rä). The Italian word for GUITAR.

chitarrone (kē tär rô' ne) *Italian.* 1 A bass guitar. 2 In the sixteenth and seventeenth centuries, a large LUTE, more than five feet long and sometimes as long as six and one-half feet. It had eleven to sixteen melody courses (strings), often single but sometimes double (in pairs), and usually eight strings that did not pass

over the fingerboard and provided only single bass notes. The chitarrone was developed along with a somewhat shorter bass lute, the THEORBO, to provide accompaniments for singing and in instrumental works, often playing the CONTINUO part in baroque music.

chiuso (kyoo'zô) *Italian:* "closed." 1 A direction for horn players to stop their instrument, that is, to insert a hand in the bell to muffle its tone or alter its pitch (see FRENCH HORN; STOPPING, def. 2). 2 A direction for singers to hum, with the mouth closed.

choir (kwī'ᵊr). 1 A group of singers, most often a group that performs in church. 2 The part of the church where the singers are seated. 3 A shortening of CHOIR ORGAN. 4 Also, *section.* A group of related instruments, such as the brass instruments (brass choir), woodwind instruments (woodwind choir), or stringed instruments (string choir).

choirbook See under SCORE.

choir organ The British name for the POSITIVE ORGAN, which is played from the third manual (keyboard) of the organ. The name comes from **chair organ** (in German, *Rückpositif,* "back positive"), which was actually a small separate organ, originally played by itself and later placed behind the organist's seat in a separate case. Choir organs were used from the fifteenth to the eighteenth centuries. In time, however, they became enclosed in the main instrument. In some modern organs there may be both a positive organ and a choir organ, the former incorporated in the main case and the latter in a separate case of its own, as in earlier times.

C-hole A SOUND HOLE in the shape of a C.

Chopin (<u>sh</u>ô paN'), **Frédéric** (frā dā rēk'), 1810–1849. A Polish composer and pianist, remembered both for his romantic life and for his highly individual compositions for piano, which have had a lasting influence on music

for that instrument. A child prodigy, Chopin became a famous concert pianist, performing all over Europe. He never married but had a number of stormy love affairs, including one with a Frenchwoman, the novelist George Sand. His two hundred or so compositions for piano include études (studies), nocturnes (short reflective pieces), two sonatas, two piano concertos, ballades, preludes, and dances (especially mazurkas, waltzes, and polonaises). Although his rhythms often are those of Polish folk music, Chopin never actually used folk tunes. His music is particularly notable for unusual harmonies and sweet, songlike melodies (most of which cannot actually be sung because they include wide intervals and have ranges exceeding that of the human voice).

choral 1 (kôr'əl). Pertaining to music sung by a chorus. Beethoven's Symphony no. 9 is often called his *Choral Symphony* because a chorus is used in the last movement. **2** *Choral* (kə räl'). German name for the Lutheran CHORALE.

chorale (kə ral', kə räl'). A kind of hymn that was first sung in the Protestant (Lutheran) churches of Germany early in the sixteenth century, replacing the Gregorian chant of the Roman Catholic services. In keeping with the Protestant idea that the people should understand and take part in church services, chorales were sung not by the choir but by the congregation, and their text was in German, not Latin. The music of some chorales was adapted from Latin hymns, others were based on German hymns or even secular (nonreligious) songs, and still others were original compositions expressly written for the church. Martin Luther, founder of the denomination bearing his name, wrote numerous chorales, and one of them, *Ein' feste Burg ist unser Gott* ("A Mighty Fortress Is Our God"), is still frequently sung in Protestant churches. Here is the beginning of this chorale as harmonized by Bach in the eighteenth century.)

The form of the chorale that is best known today dates from the time of Bach (1685–1750). Unlike the earlier chorales, it usually has a four-part harmony and a steady, even rhythm, marked by sustained (long-held) notes at the end of phrases. Though Bach wrote the original music for only thirty or so chorales, he created harmonies for about four hundred others, which he used mainly in his church cantatas (see CANTATA) and also as the basis for his chorale preludes for organ (see CHORALE PRELUDE).

chorale prelude Also, *organ chorale*. A composition for organ based on a chorale melody (see CHORALE). Originally designed to be played by the organist as an introduction to the congregation's singing of the chorale, the chorale prelude gradually became more elaborate, and eventually it became a separate form. There are various kinds of chorale prelude, which are distinguished by the way in which the chorale melody is used. Some present the melody in decorated form over free harmonies, others use fragments of the melody as the subject for a chain of short fugues, others present the melody in long notes accompanied by fragments of itself, and still others consist of variations on the chorale melody. Many keyboard composers of the baroque period (1600–1750) wrote chorale preludes, among them Dietrich Buxtehude, Johann Pachelbel, and others, but the ones best known today are those of Bach.

choral music Music for a chorus, that is, a group of singers with more than one singer to a voice-part, with or without instrumental accompaniment. The music may be monophonic (with only one voice-part) as in Gregorian chant, or it may be polyphonic (with several voice-parts). It may be performed by a dozen singers or fewer, or by a huge group of several hundred singers. Much of the choral music written over the centuries has been for worship services. Among the principal forms of religious choral music are the ANTHEM, CANTATA, CHORALE, HYMN, MASS, MOTET, ORATORIO, PASSION, and TE DEUM.

choral symphony A symphony that includes some choral music. The most familiar example is Beethoven's Symphony no. 9. Others are Mahler's Symphony no. 8 and Vaughan Williams's *A Sea Symphony.*

chord (kôrd). A group of two or more notes sounded at the same time. The different kinds of chord and the ways in which they are related to one another make up the study of HARMONY. Chords are made up of intervals (see INTERVAL, def. 2), which in turn are based on the degrees of the scale (see SCALE DEGREES).

The simplest chord is the **triad**, which is the building block of classical harmony. The triad is made up of two thirds. The bottom note of the triad is called the **root** (or *fundamental*), the middle note a third above the root is called the **third**, and the top note, a fifth above the root, is called the **fifth**. Thus, in the triad C–E–G, C is the root, E the third, and G the fifth.

In a given scale, such as C major, there are different kinds of triad, depending on the intervals between the other tones and the root. The triad C–E–G is a **major triad**, since the middle note is a major third above the root and the top note is a perfect fifth above the root. The triad D–F–A is a **minor triad**, since the middle note is a minor third above the root and the top note again is a

perfect fifth above the root. The triad B–D–F is a **diminished triad**, since the middle note is a minor third above the root and the top note is a diminished fifth above the root. In a fourth type of triad, the **augmented triad** (for example, C–E–G#), the middle note is a major third above the root and the top note is an augmented fifth above the root. (The top note is not actually in the scale of C major, which contains no sharps or flats.)

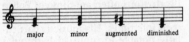

major minor augmented diminished

Triads can also be classified in another way, as diatonic or chromatic. A **diatonic triad** contains only notes that belong to a particular key (appear in its scale). Of the triads above, all but the augmented triad are diatonic since they can be formed from the notes of the C-major scale. The augmented triad uses a note foreign to the key (G-sharp), and is therefore called a **chromatic triad** or, also, an *altered chord*. (Of course, a triad diatonic in one key may be chromatic in another.) These classifications are based on the classical concepts of harmony and key signatures, which do not necessarily apply to music written before 1700 or to much of the music written since about 1910.

The key of C major, like all other major keys, has seven possible diatonic triads, based on each of the seven notes from C to B. Like the scale degrees, these triads are identified by Roman numerals, the same ones that mark the scale degree of their roots. Thus the triad built on F (the fourth degree in the key of C) is called a **IV chord**, that on G (the fifth degree in the key of C) a **V chord**, and so on. Chords I, IV, and V all are major triads, II, III, and VI are minor triads, and VII is a diminished triad. (There is no augmented triad in a

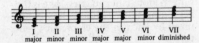

I II III IV V VI VII
major minor minor major major minor diminished

major scale.) A minor key, such as C minor, has more possible triads, since the minor scale includes certain scale degrees in two forms (for example, in the C-minor scale, both A natural and A-flat and both B natural and B-flat can be used). Again, various kinds of triad are possible, as shown here:

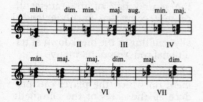

The notes of a triad need not appear in the conventional order, with the root at the bottom. When they do appear in this arrangement, for example with C as the lowest note of a C–E–G chord, the triad is said to be in **root position.** (The order of the other two notes, E and G, does not affect this terminology, which depends entirely on the position of the root, C.) When the third is the lowest note (for example, E–G–C'), the triad is said to be in the **first inversion** and is referred to as a 6_3 chord (pronounced "six-three chord") because the upper notes are a sixth and a third above the lowest note of the chord. (It is also called simply a *sixth chord*.) When the fifth is the lowest note (for example, G–C'–E'), the triad is said to be in the **second inversion** and is referred to as a 6_4 chord ("six-four chord") because its upper notes are a sixth and a fourth above the lowest note. Another kind of sixth chord is the **added sixth,** formed simply by adding a sixth to a triad, such as A to the triad C–E–G.

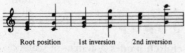

Root position 1st inversion 2nd inversion

Naturally, not all chords are made up of only three notes. In four-part writing for voices or instruments (such as music for soprano, alto, tenor, and bass voices, or a string quartet) the chords may either contain more notes than a triad or they may be triads with one of their notes doubled (repeated) in another octave (for example, C–E–G–C').

If still another third is added above a triad in root position, the result is a **seventh chord,** so called because the highest note is a seventh above the root. Again, there are various kinds of seventh chord, depending on what kinds of interval they contain (major, minor, diminished). Among the most important are the **dominant seventh chord,** consisting of a major triad with a minor third above it (in the key of C major, G–B–D–F), and the **diminished seventh chord,** a diminished triad with a minor third above it (in the key of C minor, B—D—F—A). With a four-note chord, not two but three inversions are possible, since any of the four notes may be used as the root.

If a third is added above a seventh chord, a **ninth chord** results. Similarly, the addition of a third to a ninth chord produces an **eleventh chord,** and still another third above an eleventh chord produces a **thirteenth chord.** All of these chords, consisting of five, six, and seven notes respectively, can be inverted. The thirteenth is the largest chord that can be built from thirds, since it contains seven notes. Any additional note would simply be a repetition (doubling) of a note already present in another octave.

Chords built up from fourths instead of thirds are known as **fourth chords.** (See also FOURTH CHORD; SIXTH CHORD.) In addition, chords may be constructed from seconds; these are sometimes called *tone clusters.*

chordophone (kôr' də fōn"). Any musical INSTRUMENT in which the sound is produced by the vibration of one or more strings, which are bowed (as in the violin, hurdy-gurdy, crwth, etc.), or plucked (as in the guitar, harp, harpsichord, etc.), or struck (as in the piano, dulcimer, etc.).

chord organ See under ELECTRONIC INSTRUMENTS.

chorister (kôr′ i stər). Any member of a choir, but the term is most often used for a boy singer in an English church choir.

chôro (shô′rô) *Portuguese*: "weeping," "tears." Music for an urban Brazilian instrumental ensemble in which one performer acts as soloist. Heitor Villa-Lobos wrote fourteen such works.

chorus (kôr′ əs). 1 A group of singers large enough so that there is more than one singer to a voice-part. The most common kind of chorus includes four types of voice—soprano, alto, tenor, and bass. However, there are numerous special combinations, including the men's chorus, with parts for first and second tenor, baritone, and bass, and the women's chorus, with parts for first and second soprano, and first and second alto. An **a cappella chorus** is one that performs without instrumental accompaniment. See also GLEE CLUB. 2 A composition or section written for or sung by a chorus. 3 The refrain of a song. In many folk songs and in operettas, the verse is sung by a soloist and the REFRAIN (def. 1) by a group (chorus). In popular music, this part of a song is far more important than the verse, and most familiar popular song tunes are actually the melody of the chorus. Such choruses usually consist of four eight-bar sections, the third of which is the contrasting BRIDGE (def. 3).

chorus reed A class of organ stops; see under ORGAN.

Christmas carol See CAROL, def. 1.

chromatic 1 Pertaining to or containing notes not belonging to a given major or minor key. See CHROMATIC NOTE. 2 Proceeding by two or more consecutive half tones, as in the CHROMATIC SCALE. 3 Using CHROMATIC HARMONY.

chromatic chord A chord that includes one or more notes foreign to the key of the passage in which it appears.

chromatic harmony Harmony that employs many chromatic chords. The title of Bach's *Fantasia cromatica e fuga* ("Chromatic Fantasy and Fugue") refers to the considerable use of chromatic harmony in the fantasy. During the second half of the nineteenth century, composers greatly extended the use of chromatic chords, eventually resulting in the breakdown of traditional concepts of harmony.

chromatic instrument An instrument on which the player can produce all the notes of the chromatic scale. The modern French horn, with its valves, is a chromatic instrument, whereas the older natural horn was not (see HORN). Although the modern harp is chromatic in that all the chromatic tones are available, they cannot be played quickly one after another; this would require a chromatic harp having a separate string for each half tone (see HARP).

chromaticism 1 The use of chromatic notes. 2 The frequent use of half-tone progressions, such as C to C-sharp to D or B to B-flat to A. 3 The use of chromatic harmony.

chromatic note A note that does not belong to the key (scale) in which a composition or section is written. For example, in the key of C major, which contains no sharps or flats, any note with an accidental (sharp or flat, such as F-sharp or B-flat) is said to be chromatic. (Notes that belong to the key are called DIATONIC.)

chromatic scale A scale made up of twelve half tones in an octave (on the piano, all the white and black keys from C to C).

church modes A system of scales on which all church music and most secular (nonreligious) music was based throughout the Middle Ages. These scales were supposed to have been

Authentic modes			*Plagal modes*	
I. Dorian	D E F G a b c d	II. Hypodorian	A B C D E F G a	
III. Phrygian	E F G a b c d e	IV. Hypophrygian	B C D E F G a b	
V. Lydian	F G a b c d e f	VI. Hypolydian	C D E F G a b c	
VII. Mixolydian	G a b c d e f g	VIII. Hypomixolydian	D E F G a b c d	

based on those used by the ancient Greeks. However, the medieval theorists misunderstood the Greek system, and the church modes thus have little in common with those of the Greeks except for their names. Unlike the modern major and minor modes, the church modes prescribed patterns of intervals that made it difficult to move a melody to different pitches (to accommodate a singer, for example). Until the sixteenth century there were eight church modes, each with a range (called AMBITUS) of about one octave. Each mode consisted of the eight tones of the present C-major scale. Four of them, called the **authentic modes**, began and ended on D, E, F, and G, respectively; this note, called the **final**, was the note on which melodies in these modes had to end. In the other four modes, called the **plagal modes**, which started on A, B, C, and D, melodies ended on the note a fourth above the starting note, that is, on D, E, F, and G. As can be seen in the accompanying chart (in which the final is printed in bold type), the plagal and authentic modes differed from one another only in the position of their ambitus; otherwise they were identical. (Later writers identified the church modes by Roman numerals, which are also shown in the chart. The underlined note is the tenor of the PSALM TONE for that mode.)

In the sixteenth century four more modes were added, two authentic modes (the **Aeolian mode** beginning on A and the **Ionian mode** beginning on C, identical to the MINOR and MAJOR modes respectively), and two plagal modes (the **Hypoaeolian mode** beginning on E and the **Hypoionian mode** beginning on G). There was also a mode based on B, the **Locrian mode**, but it was not used in composition because the interval between the final and the fifth note was a diminished fifth instead of a perfect fifth, the so-called *devil's tritone*, a practice not permitted.

By 1800 the church modes had been wholly replaced in art music by the major and minor modes (derived from the Ionian and Aeolian modes), but they reappeared in the nineteenth century when composers began to take an interest in various kinds of folk music, much of which is based on scales other than the present major and minor scales.

church sonata Another term for *sonata da chiesa* (see under SONATA).

chyn (chēn) *Chinese*. Also, *ch'in*. An ancient, seven-stringed zither of China that dates back at least two thousand years and is still played today. The chyn consists of a long, narrow, hollow board, over which are stretched a number of strings made of silk, which are all the same length but vary in thickness. The instrument is held flat, on the ground or in the player's lap. The player uses the fingers of the right hand to pluck the strings, while the left hand stops (holds down) the single melody string. The stopping positions are marked not by frets as in lutes and guitars but by thirteen small studs (disks) inlaid in the soundboard under the melody string. Music for the chyn is written in a kind of shorthand that tells the player which string, stopping position, hand, finger, and direction of plucking to employ.

cimbalom (<u>ch</u>im' bə lom). A kind of dulcimer (see under DULCIMER).

cinelli (<u>ch</u>ē nel' lē). The Italian word for CYMBALS. Also see PIATTI.

ciphers See under PITCH NAMES.

circle of fifths A circular arrangement of the key signatures (see KEY SIGNATURE) of the major and minor keys. The number of sharps in the signatures of the keys increases in order as one ascends clockwise by fifths from C major (no sharps or flats) to G major (one sharp), to D major (two sharps), and so on, up to C-sharp major (seven sharps). Similarly, the number of flats increases in order as one descends counterclockwise by fifths from C major to F major (one flat), to B-flat major (two flats), and so on to C-flat major (seven flats). However, on the piano and numerous other instruments, F-sharp is identical to G-flat, and the key of F-sharp major (with a signature of six sharps) is identical to the key of G-flat major (with a signature of six flats). Consequently, one arrives at the same point whether one proceeds by upward or downward fifths from C. The key signatures for the minor keys are also related by ascending and descending fifths, starting at A minor (no sharps or flats) and ascending by fifths to A-sharp minor (seven sharps) or descending by fifths to G-flat minor (seven flats). In the accompanying

diagram, the major keys are shown outside the circle and the minor keys having the same key signatures are shown inside the circle.

cister See CITTERN.

cistre (sēs' trᵊ) *French.* See CITTERN.

cithara (sit<u>h</u>'ərə). The British spelling of KITHARA.

cither See CITTERN.

cithern See CITTERN.

citole (si' tōl, si tōl'). One of the earliest forms of medieval instrument of the cittern family, a favorite of the troubadours and widely used from the thirteenth to fifteenth centuries. It had a flat, pear-shaped body, a short neck with wooden frets, and four metal strings that were plucked with a quill. In the sixteenth century its stringholder was abandoned for rib-fastened strings, and a bridge was added to raise the strings off the soundboard, resulting in a CITTERN.

cittern (sit' ᵊrn). Also, *cister, cistre, cither, cithern.* A fretted stringed instrument that was very popular in England in the sixteenth and seventeenth centuries. The cittern resembled the lute but had a flat back and four to twelve double courses (pairs) of metal strings, which were plucked with either the fingers or a plectrum. The most common kinds of cittern

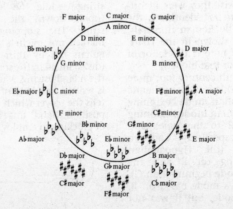

had either four or five courses, which were tuned in various ways. Used both as a solo instrument and in ensembles, the cittern was easier to play than the lute and consequently was very popular. In the seventeenth century it was often used in barbershops, both by clients waiting their turn and by the barbers.

clapper A rhythm instrument consisting of two or more objects like sticks or shells, which are banged together. They may be separate, like BONES, or hinged at one end, like CASTANETS, or attached to a stationary piece. The instrument was used by the ancient Egyptians and has long been important all over the world. In Western music it has been used since the baroque period.

clarinet (klar"ənet'). An important woodwind instrument having a single reed (in contrast to the oboe and its relatives, which have a double reed). Made of wood, ebonite (a very hard rubber), or (occasionally) metal, the clarinet has a beaklike mouthpiece and a cylindrical bore (not tapered inside) that ends in a bell-shaped opening. The reed, a shaped piece of cane, is attached to the mouthpiece by means of a clamp called a ligature. When the player blows air through the space between the reed and the mouthpiece, the thin tip of the reed vibrates, setting into vibration the column of air inside the tube of the instrument. A series of holes drilled through the sides of the tube are covered and uncovered by means of keys. These serve to shorten the vibrating air column by the proper amount to produce the various pitches in the instrument's three and one-half octave range. There are various arrangements of keys, but the most popular in the United States today is the BÖHM SYSTEM, a variation on the arrangement originally created for the flute in the nineteenth century.

The most common variety of clarinet is the B-flat clarinet, whose range extends from the D below middle C

8va higher

to the B-flat above high C (see the accompanying example). Like all modern clarinets, the B-flat clarinet is a TRANSPOSING INSTRUMENT, and it sounds one whole tone lower than the music is written. Almost as popular today is the A clarinet, which sounds a minor third lower than its music. The smaller E-flat clarinet is used mostly in bands, although it is sometimes required in orchestral scores; it sounds a minor third higher than its music is written.

The clarinet dates from the early 1700s. It is descended from an older instrument called the **chalumeau**, which also had a cylindrical bore and a single reed. The lowest octave of all modern clarinets is still called their chalumeau register. The early clarinets had a few finger keys and a speaker key, used to produce a tone a twelfth higher than the usual one. Instruments were built in a variety of keys in order to be used for music written in different keys. Among them was a tenor clarinet that was popular in the eighteenth century, the BASSET HORN.

Nearly every composition for orchestra written since the 1770s includes parts for clarinet. A few of the many compositions for solo clarinet (or with major parts for solo clar-

inet) are: Mozart's Concerto for clarinet, K. 622, and Quintet for clarinet and strings, K. 581; Weber's two clarinet concertos; Spohr's two clarinet concertos; Glinka's *Trio pathétique* for clarinet, bassoon, and piano; Brahms's Quintet for clarinet and strings, op. 115; Bartók's *Contrasts* for violin, clarinet, and piano; Ives's *Largo* for violin, clarinet, and piano; Hindemith's Sonata for clarinet and piano; Copland's Concerto for clarinet and string orchestra; Nielsen's Concerto for clarinet and orchestra; Stravinsky's *Ebony Concerto;* Stockhausen's *Harlekin* for solo clarinet; Corigliano's Clarinet Concerto; and Carter's *Gra (To Play)* for solo clarinet. The clarinet has also been important in jazz ensembles since the earliest history of jazz. Outstanding jazz clarinetists include Woody Herman and Benny Goodman. The latter also played classical clarinet and commissioned the clarinet concertos of Copland and Hindemith, and Bartók's *Contrasts.* —**bass clarinet** A larger member of the clarinet family having an upturned metal

bell and pitched an octave below the B-flat clarinet. The bass clarinet is fre-

quently used in orchestral music. —**alto clarinet** A medium-sized member of the clarinet family, pitched in E-flat, a fifth below the B-flat clarinet. It sounds a major sixth lower than its music is written. —**contrabass clarinet** Also, *pedal clarinet, double-bass clarinet.* A still larger member of the clarinet family pitched two octaves below the B-flat clarinet.

clarinette (klA rē net'). The French word for CLARINET.

clarinette basse (klA rē net' bAs'). The French term for bass clarinet (see under CLARINET).

clarinetto (klä"rē net' tô). The Italian word for CLARINET.

clarinetto basso (klä" rē net'tô bäs'ô). The Italian term for bass clarinet (see under CLARINET).

clarino (klä rē'nô) *Italian.* 1 The trumpet on which the very high-pitched trumpet parts in some eighteenth-century music were played. (See also BACH TRUMPET.) Also, such a part itself. 2 The special technique for playing such parts.

classic Also, *classicist, classicism.* A general term for the style of music written between about 1785 and 1820 by Haydn, Mozart, and Beethoven. Some authorities also include the music of Schubert, whereas others hold that it, along with Beethoven's later works, belongs more to the style of the period of romanticism. (For other classic composers, see the accompanying chart.) The chief characteristics of classicism in music are elegance, formality, and restraint, as opposed to the emphasis on expressing individual feelings that is associated with romantic music. On the whole, instrumental music was more important than vocal music in the classic period. The favorite forms were the overture, divertimento, and theme and variations, and the various types associated with the SONATA—the concerto, the symphony, and various kinds of chamber music (trio, quartet, quintet, etc.). The instruments for the most part were those of the PRECLASSIC

period just preceding, the orchestra being largely that of the MANNHEIM SCHOOL. One major change was the piano's replacement of the harpsichord, clavichord, and organ as the favorite keyboard instrument. (The music written for piano reflected to some extent the heritage of the GALLANT STYLE.) Except in chamber works, the musical texture tended to consist of a single line of melody, carried in the top part (treble, soprano), accompanied by harmony (chords) in the other voice-parts; in quartets, quintets, and other chamber music, the different voice-parts were more nearly equal in importance, although the texture was seldom truly contrapuntal (see COUNTERPOINT). Despite the greater importance of instrumental music, some very fine vocal music was written, particularly Haydn's oratorios and Masses and Mozart's operas.

classical music A term sometimes used to distinguish serious or art music from popular and folk music. The distinction tends to be arbitrary, and the term itself is too vague to be useful. See also CLASSIC; SERIOUS MUSIC.

clausula (klô' ẕhə lə) *pl.* **clausulae** (klô' ẕhə lā) *Latin.* In the compositions of the late twelfth and early thirteenth centuries called organa (see ORGANUM), a brief section in regular rhythm that is based on a melisma (section with several notes to a single syllable of the text) taken from Gregorian chant. Clausulae thus do not have a full text but are sung to only one or two words, or even to a single syllable. Later, in the course of the

IMPORTANT CLASSIC COMPOSERS

Composer	Country	Noted for
Ludwig van Beethoven* (1770–1827)	Germany	Symphonies, piano works, chamber music.
Luigi Boccherini* (1743–1805)	Italy	Chamber music.
Muzio Clementi* (1752–1832)	Italy	Piano music, études.
Carl Ditters von Dittersdorf (1739–1799)	Austria	Many symphonies (c. 120), Singspiele, 40 solo concertos (most for violin); also noted violinist.
André Grétry (1741–1813)	France	Operas; instrumental and choral works.
Franz Joseph Haydn* (1732–1809)	Austria	Symphonies, keyboard works, chamber music, choral works.
Michael Haydn (1737–1806)	Austria	Symphonies, choral works. (Brother of Franz Joseph.)
Johann Hummel*(1778–1837)	Austria	Piano works, chamber music.
Padre Giovanni Battista Martini (1706–1784)	Italy	Writer on music, teacher (pupils included J. C. Bach, Grétry, Jommelli, Mozart); sacred music (Masses, oratorios), instrumental sinfonias, keyboard sonatas.
Vicente Martín y Soler (1754–1806)	Spain, Austria	Operas, especially comic.
Étienne Méhul (1763–1817)	France	Operas.
Wolfgang Amadeus Mozart* (1756–1791)	Austria	Instrumental music, operas, choral works.
Ignaz Pleyel (1757–1831)	Austria	Symphonies, piano music, chamber music.
Antonio Salieri (1750–1825)	Italy, Austria	Operas, sacred music concertos, chamber music, songs; taught Beethoven, Schubert, Liszt.
Giovanni Battista Viotti* (1755–1824)	Italy	Concertos and other works for violin.

*See separate article on each of these composers for additional information.

thirteenth century, Perotin and other composers wrote clausulae to be substituted for sections in already existing organa. Sometimes a text was added to the upper voice-part of a clausula, and this practice gave rise to a new and very important musical form, the motet, whose name comes from the French *mot,* meaning "word." See also ARS ANTIQUA; MOTET.

clave (klä've) *Spanish.* See under SON.

clavecin (klAV saN'). The French word for HARPSICHORD.

claveciniste (klAV sē nēst') *French.* **1** A harpsichord player. **2** A composer of harpsichord music.

claves (klä' väs) *Spanish.* A percussion instrument consisting of a pair of hardwood sticks, eight to ten inches long. The player holds one stick in one hand, which is cupped to create more resonance, and strikes it with the second stick, held in the other hand. Claves are used mainly in Latin American music.

clavicembalo (klä"vē chem'bä lô). An Italian word for HARPSICHORD.

clavichord (klav' ə kôrd"). A stringed keyboard instrument that was widely used from the sixteenth through the eighteenth centuries and has been revived in the twentieth century for playing old music. The clavichord is shaped like a rectangular box, with a keyboard set into one of the long sides. The strings are stretched lengthwise, parallel to the keyboard. At the back end of each key is a brass tangent (a small blade). When the player presses down on a key, the tangent rises and strikes a string, causing it to vibrate. The strings' vibrations pass through a bridge to the soundboard, which makes them audible. When the player lets go of the key, the tangent drops back from the string, and a strip of cloth damps the string so that it immediately stops sounding. In the earliest clavichords several notes were sounded by each string or by each pair of strings tuned in unison (sounding the same pitch); such instruments were called **fretted clavichords.** At some time in the seventeenth century builders began making unfretted clavichords, which had a pair of strings for every note of the keyboard. The accompanying illustration shows an unfretted clavichord of the eighteenth century.

The sound of the clavichord is so soft that almost any other instrument can drown it out. For this reason, the clavichord was almost always used as a solo instrument. It was the first keyboard instrument in which dynamics (changes in loudness) could be produced by striking the keys with greater or less force, as in the piano. A

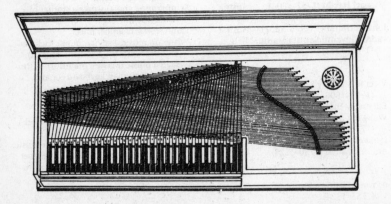

skilled performer can also obtain a special effect called **Bebung**, a VIBRATO obtained by varying the pressure with which a key is held down. In scores it is indicated by a series of dots covered with a slur.

The clavichord appears in a number of pictures dating from the middle of the fifteenth century. At that time, its range was no more than three octaves. By 1500, some were made with a range of four octaves, and in the eighteenth century five-octave clavichords were not uncommon. The instrument's greatest popularity came in Germany during the seventeenth and eighteenth centuries, when it was the most usual keyboard instrument for home use. Presumably a great deal of music was written specifically for it, although the only pieces definitely for clavichord were written in the second half of the eighteenth century by such composers as Karl Philipp Emanuel Bach just before the clavichord was replaced by the piano.

clavier 1 (klA vyā'). The French word for KEYBOARD. **2 Clavier** (klä vēr') *German.* **a.** A word that, from about 1600–1800, meant any keyboard instrument. For example, *Clavierübung* is the title of a large collection of keyboard pieces by Bach, which contains works specifically for organ and harpsichord as well as some that may have been intended for clavichord. In the second half of the eighteenth century, the term usually referred to the clavichord, but sometimes referred to the SQUARE PIANO as well. **b.** Also, *Klavier.* In the nineteenth century, the German word for piano (see PIANO, def. 2).

clef A sign at the beginning of a musical staff that locates the pitch (note) of one line on the staff, and therefore the pitches of all the other lines and spaces as well. **—treble clef** Also, *G clef, violin clef.* A sign that identifies the second line of the staff (counting from the bottom) as the G above middle C and is used for the upper staff (right hand) in piano music, for such high-pitched instruments as the flute

and violin, for the alto and soprano voices, and (with an implied downward transposition of an octave) the tenor voice. **—bass clef** Also, *F clef.* A sign that identifies the fourth line of the staff (counting from the bottom) as F below middle C and is used for bass and baritone vocal parts, the lower staff (left hand) in piano music and for such low-pitched instruments as the cello and bassoon. **—alto clef** Also, *viola clef, C clef.* A sign that identifies the middle line of the staff as middle C and is used principally for the viola. **—tenor clef** Also, *C clef.* A sign that identifies the fourth line of the staff (counting from the bottom) as middle C and is used for the tenor trombone and upper register of the cello and bassoon.

treble bass alto tenor

Clementi (kle men' tē), **Muzio** (mŌŌ' tsyô), 1752–1832. An Italian pianist, composer, and teacher who is remembered mainly for his keyboard compositions, which include sonatas, duets, variations, caprices, and preludes. His most famous work is a book of one hundred piano études (studies) of increasing difficulty, *Gradus ad Parnassum* ("Steps to Parnassus," Mount Parnassus being the home of the Muses in Greek mythology), which is still used by many piano students.

close (klōz). Same as CADENCE.

closed key See KEY, def. 2.

close harmony Harmony made up of chords whose notes are close to one another, that is, not separated by wide intervals. In four-part close harmony, for example, the four notes for a chord might all lie within an octave

My coun-try, 'Tis of thee, Sweet land of lib-er-ty,

(C–C') or perhaps within a twelfth (C–F'). In the accompanying example of close harmony, the largest interval is an eleventh (C#–G', on the second syllable of "liberty").

cluster Also, *tone cluster*. A group of adjacent notes played simultaneously, selected either specifically or at random. A cluster is most easily produced on the piano by pressing down a group of white or black keys with the palm, forearm, or another body part. The term *tone cluster* was invented by Henry Cowell, who may have been the first to use the technique in piano works (c. 1912). It has since been used by Ives, Cage, Ligeti, and numerous other twentieth-century composers. In the 1950s Stockhausen and Ligeti extended it to orchestral music.

coda (kō'dä) *Italian:* "tail." A passage added to the closing section of a piece or movement in order to give the sense of a definite ending. A coda may be quite short, consisting of only a measure or two, or it may be so long that it almost becomes an additional section. Although codas had been used since the fifteenth century and are found in many fugues of the baroque period (1600–1750), they gained new prominence in the sonatas, symphonies, concertos, and shorter forms of the eighteenth and nineteenth centuries. In SONATA FORM it follows the recapitulation. In some scores it is marked by a sign consisting of a cross superimposed on a circle.

codetta (kō det'ä) *Italian:* "little tail." A brief CODA in a fugue or in sonata form. In a fugue it is a passage in the exposition linking two entries of the subject and/or answer. In sonata form it is material that concludes the exposition.

cog rattle See under RATTLE, def. 2.

col, coll', colla For Italian musical terms beginning with *col, coll', colla,* such as *coll'arco* or *colla voce,* see under the next word (ARCO; VOCE).

colascione (kō lä s̲h̲ô'ne) *Italian.* A long-necked lute, the only European instrument directly derived from the Middle Eastern long lute. It has a long narrow neck, either two or three strings, and a small, pear-shaped body. Developed in the sixteenth century, it was used throughout the 1600s and 1700s.

collage (ko läz̲h̲'). See under QUOTATION, MUSICAL.

Collect (kol' ekt). 1 In the Roman Catholic rite, the first spoken item of the Proper of the Mass (see MASS). 2 In the Anglican rite, a short prayer, generally one used for a particular day in the church calendar, such as Christmas.

color 1 See TONE COLOR. 2 The quality of a sound as related to visual color. Some composers, notably Scriabin and Messiaen, have assigned colors to specific keys or sections, while others have used such associations more loosely.

coloratura (kô lô rä tōō'rä) *Italian.* 1 A passage, sometimes for instruments but more often for voice, that contains many elaborate musical ornaments, such as rapid runs, arpeggios, and trills. Many operas of the eighteenth and nineteenth centuries, particularly those written in the Italian style, contain very difficult arias of this kind. Famous examples include the Queen of the Night's arias in Mozart's *Die Zauberflöte* ("The Magic Flute") and the "Bell Song" from Delibes's *Lakmé.* 2 A voice, nearly always soprano but occasionally a mezzo-soprano, that is very flexible and is especially suited for performing coloratura passages.

combination tone See under TARTINI, GIUSEPPE.

combo organ See under ELECTRONIC INSTRUMENTS.

come (kô'me) *Italian:* "as." Used in directions such as *come prima* ("as at first"), *come sopra* ("as above"), *come retro* ("as before"), and *come sta* ("as it stands").

comédie-ballet See under LULLY, JEAN-BAPTISTE.

comic opera An opera on a light, sentimental subject, often taken from everyday life, with humorous elements and a happy ending. This general description applies to a large variety of forms, among them the musical comedy, ballad opera, Singspiel, opéra-comique, opera buffa, vaudeville, zarzuela, and operetta. (For a general history of the development of comic opera, see OPERA.)

commodo See COMODO.

common chord A term referring to a major triad or minor triad in root position, such as C–E–G or C–E♭–G (see CHORD).

common meter Also, *common time*. Another name for 4/4 meter, which is frequently indicated on the staff by the letter C (see illustration at C).

common time See COMMON METER.

Communion In the Roman Catholic rite, the last sung item of the Proper of the Mass (see MASS). See also SERVICE.

comodo (kôm'mô dô) *Italian*. Also, *commodo*. A direction to perform at an easy, comfortable tempo, neither very fast nor very slow.

compact disk Also *CD*, *disc*. See under DIGITAL RECORDING.

compass The range of a voice or instrument (see RANGE).

complete cadence Another name for authentic cadence (see under CADENCE).

Compline See under OFFICE.

composition 1 Any piece of music. 2 The process of creating a musical work.

compound form See under FORM, def. 2.

compound interval An interval (see INTERVAL, def. 2) that is larger than an octave, so called because any such interval is a combination of two or more simple intervals (intervals smaller than an octave). For example, the compound interval of a twelfth is the same as an octave plus a fourth.

compound meter Any METER in which there are three basic beats to a bar (or the number of beats is a multiple of three). The most common examples are 6/8, 9/8, and 12/8. See also SIMPLE METER.

compound stop Another name for MIXTURE; see also ORGAN.

computer music A composition in which a computer has been or is being used to determine any characteristics of the musical sound. The earliest computer programs merely helped decide the choice and arrangement of musical events, which then had to be recorded in a written score or tape. The development of sound synthesizers enabled composers to give precise instructions concerning all aspects of a musical tone—pitch, loudness, attack, duration, decay, timbre (tone color)—which the computer converts into a series of electrical pulses that are filtered and emerge through a loudspeaker as sounds. (See also SYNTHESIZER.) The computer is not limited by the ordinary capabilities of real instruments or human performers, and so can produce a far greater variety of sounds and much more difficult music. For example, it can deal with virtually any number of musical lines at one time. Computer music also may be combined with live performance; thus in Paul Lansky's *As If* (1982), for string trio and computer-synthesized tape, the tape echoes and amplifies the sounds of the live string players. (See also LIVE ELECTRONIC MUSIC.) Many composers of computer music work at universities or other institutions that house the sophisticated (and often very costly) equipment they need. Among the most important centers for computer music are the Institut de Recherche et Coordination Acoustique/Musique (IRCAM) in Paris, France, and Stanford University, the University of California in San Diego, California Institute of Arts near Los Angeles, and the

Massachusetts Institute of Technology in the United States. In the 1990s IRCAM became active in developing new software for computers.

The first musical work programmed on a computer was *Illiac Suite* (1957) for string quintet, created by Lejaren Hiller and Leonard Isaacson at the University of Illinois. Other composers of computer music include BABBITT, XENAKIS, HENZE, BOULEZ, Charles Dodge, Morton Subotnick, Paul Lansky, Tod Machover, and John M. Chowning. Also, jazz and rock artists are increasingly using onstage computer equipment. Furthermore, software can turn a home computer into a composing and music editing console and generate a printed score. Indeed, it has made possible desktop music publishing and eliminated the need for manual copying and similar chores. See also DIGITAL RECORDING; ELECTRONIC MUSIC; LIVE ELECTRONIC MUSIC; SYNTHESIZER.

con For Italian musical terms beginning with *con*, such as *con brio* or *con slancio*, see under the next word (BRIO; SLANCIO).

concert A public performance of music, other than opera or church-music. A concert usually involves more than two performers, a performance by a soloist or by a duet often being called a recital. (Performances of popular music, however, usually are called concerts regardless of the number of performers involved.) An opera is said to be performed in concert form when it is presented without scenery, costumes or action.

concertante (kôn" cher tän' te) *Italian.* 1 Another term for CONCERTINO, def. 2. 2 Short for SINFONIA CONCERTANTE.

concert aria See under ARIA.

concertato (kôn"cher tä' tô) *Italian.* A composition for an instrumental ensemble featuring one or more soloists (see CONCERTINO, def. 2).

concert band See BAND, def. 5.

concert étude See under ÉTUDE.

concert grand The largest size of grand piano (see under PIANO), usually about nine feet long.

concertina (kôn" ser tē'nǝ). See under ACCORDION.

concertino (kôn" cher tē'nô) *Italian.* 1 A short concerto. 2 Also, *concertato, concertante.* The small group of soloists that alternate with the full orchestra in a CONCERTO GROSSO.

concertmaster Also, *concertmistress;* British, *leader.* In an orchestra, the leader of the first violin section. The concertmaster usually assists the conductor at rehearsals, directs the orchestra's tuning, and plays solo violin passages when they occur if no guest soloist is performing.

concerto (kôn cher' tô) *pl.* **concerti** *Italian,* **concertos** *English.* 1 A composition for one or more solo instruments and orchestra, in which the parts of the soloist and of the orchestra are about equal in importance. Occasionally composers have written a concerto for orchestra alone, in which they contrast different instruments much as soloist and orchestra are contrasted in the solo concerto. Examples include Carter's Concerto for Orchestra (1970) and Sessions's Concerto for Orchestra (1981).

Most concertos are made up of three movements. The first movement is usually in SONATA FORM and often includes a CADENZA near the end. The second movement is generally in slow tempo, and the third is most often a lively RONDO, although it may be in the form of a THEME AND VARIATIONS or even in sonata form. (This, in general, is the structure of the classical concerto, dating from the late eighteenth century.) 2 solo concerto. The most common type of concerto, scored for a single soloist and orchestra. Solo concertos are classified according to the solo instrument: piano concerto, cello concerto, violin concerto, oboe concerto, etc. The solo concerto was developed in

IMPORTANT VIOLIN CONCERTOS

Composer	Concerto	Date
Johann Sebastian Bach	Concerto in A minor	both comp. 1717–1723
	Concerto in E major	
Béla Bartók	Concerto	1939
Ludwig van Beethoven	Concerto in D major, op. 61	1809
Alban Berg	Concerto	1936
Ernest Bloch	Concerto	1938
Johannes Brahms	Concerto in D major, op. 77	1878
Max Bruch	Concerto in G minor, op. 26	1868
Elliott Carter	Violin Concerto	1991
Alberto Ginastera	Concerto	1963
Philip Glass	Concerto	1987
Alexander Glazunov	Concerto in A minor	1905
Édouard Lalo	Symphonie espagnole, op. 21	1875
Nicholas Maw	Violin Concerto	1993
Felix Mendelssohn	Concerto in E minor, op. 64	1845
Wolfgang Amadeus Mozart	Concerto in G major, K. 216	1775
	Concerto in D major, K. 218	1775
	Concerto in A major, K. 219	1775
Niccolò Paganini	Concerto no. 1 in D major	c. 1813
Sergey Prokofiev	Concerto no. 1 in D major, op. 19	1923
	Concerto no. 2 in G minor, op. 63	1935
Camille Saint-Saëns	Concerto no. 3 in B minor, op. 61	1881
Arnold Schoenberg	Concerto, op. 36	comp. 1934–1936
Gunther Schuller	Second Violin Concerto	1993
William Schuman	Concerto	1947; rev. 1954, 1958
Roger Sessions	Concerto	1935
Jean Sibelius	Concerto in D minor, op. 47	1904; rev. 1905
Igor Stravinsky	Concerto in D major	1931
Giuseppe Tartini	Six Concertos	1734
Piotr Tchaikovsky	Concerto in D major, op. 35	1878
Antonio Vivaldi	*La Stravaganza* (12 concertos), op. 4	pub. c. 1712–1713
	Le Quattro Stagioni (4 concertos), op. 8	pub. 1725
William Walton	Concerto	1939
Henryk Wieniawski	Concerto in D minor	pub. 1870
	Concerto in F# minor	1853

the early eighteenth century by such composers as Torelli and Vivaldi. Until 1750 the most important kind of solo concerto was the violin concerto. However, Vivaldi wrote concertos for oboe and for bassoon, Bach wrote concertos for harpsichord (most of which appear to have been transcriptions of earlier violin concertos), and Handel wrote concertos for organ. In the classical period (1785–1820) the piano concerto became the most important type, and remained

so for the next 150 years. The accompanying charts list some of the more famous piano, violin, and cello concertos. Outstanding solo concertos for other instruments are cited in the articles on the respective instruments. **3 double concerto** A concerto scored for two solo instruments and orchestra. The instruments may be different, as in Brahms's Concerto in A minor for violin and cello, op. 102, and Mozart's Concerto in C major for flute and harp, K. 299, or the same, as

IMPORTANT PIANO CONCERTOS

Composer	Concerto	Date
Béla Bartók	Concerto no. 2	1933
Ludwig van Beethoven	Concerto no. 1 in C major, op. 15	1797
	Concerto no. 2 in B♭ major, op. 19	1795; rev. 1798
	Concerto no. 3 in C major, op. 37	1803
	Concerto no. 4 in G major, op. 58	1809
	Concerto no. 5 in E♭ major, op. 73	1809
	(Emperor Concerto)	
William Bolcom	Piano Concerto	1995
Johannes Brahms	Concerto no. 1 in D minor, op. 15	1854; rev. 1856
	Concerto no. 2 in B♭ major, op. 83	1881
Elliott Carter	Concerto	1967
Frédéric Chopin	Concerto no. 1 in E minor	1830
	Concerto no. 2 in F minor	1830
George Gershwin	Concerto in F major	1925
Edvard Grieg	Concerto in A minor, op. 16	1868
Franz Liszt	Concerto no. 1 in E♭ major	1857
Witold Lutoslawski	Concerto	1988
Edward MacDowell	Concerto no. 2 in D minor, op. 23	1889
Felix Mendelssohn	Concerto no. 1 in G minor, op. 25	1831
Wolfgang Amadeus Mozart	Concerto no. 9 in E♭ major, K. 271	1777
	Concerto no. 15 in B♭ major, K. 450	1784
	Concerto no. 17 in G major, K. 453	1784
	Concerto no. 19 in F major, K. 459	1784
	Concerto no. 20 in D minor, K. 466	1785
	Concerto no. 23 in A major, K. 488	1786
	Concerto no. 24 in C minor, K 491	1786
	Concerto no. 25 in C major, K. 503	1786
	Concerto no. 26 in D major, K. 537	1788
	(Coronation Concerto)	
	Concerto no. 27 in B♭ major, K. 595	1791
Sergey Prokofiev	Concerto no. 2 in G minor, op. 16	1913; rev. 1924
	Concerto no. 3 in C major, op. 26	1921
Sergey Rachmaninoff	Concerto no. 2 in C minor, op. 18	1901
	Concerto no. 3 in D minor, op. 30	1909
Maurice Ravel	Concerto in D major for left hand	1931
	Concerto in G major	1932
Max Reger	Concerto in F minor, op. 114	c. 1910
Camille Saint-Saëns	Concerto no. 4 in C minor	1875
Arnold Schoenberg	Concerto, op. 42	comp. 1942
Robert Schumann	Concerto in A minor, op. 54	1845
Dmitri Shostakovitch	Concerto no. 1 in C minor, op. 35	1933
Igor Stravinsky	Concerto	1924
Piotr Tchaikovsky	Concerto no. 1 in B♭ minor, op. 23	1875
Charles Wuorinen	Second Piano Concerto	1974

in Bach's Concerto in D minor for two violins or Mozart's Concerto in E-flat major for two pianos, K. 365. More recent examples are Hans Werner Henze's Concerto for oboe, harp, and string orchestra (1966); Poulenc's Concerto for two pianos and orchestra (1932); Elliott Carter's Concerto for piano, harpsichord, and two chamber orchestras (1961); Roger Sessions's Concerto for violin, cello, and orchestra (1971); Ligeti's Double

IMPORTANT CELLO CONCERTOS

Composer	Concerto	Date
Stephen Albert	Cello Concerto	1990
Luigi Boccherini	Concerto in B-flat	c. 1745
Johannes Brahms	Concerto in A minor for violin and cello, op. 102	1887
Benjamin Britten	Cello Symphony	1963
	Suite no. 3	1971
Frederick Delius	Concerto	1921
Antonín Dvořák	Concerto in B minor, op. 104	1895
Edward Elgar	Cello Concerto, op. 85	1919
Alexander Glazunov	Concerto-Ballata, op. 108	1931
John Harbison	Cello Concerto	1994
Franz Joseph Haydn	Concerto in D	1783
Paul Hindemith	Concerto no. 1	1940
	Concerto no. 2	1945
Karel Husa	Cello Concerto	1993
Dmitri Kabalevsky	Concerto	1949
Aram Khatchaturian	Concerto	1946
Édouard Lalo	Concerto	1876
György Ligeti	Cello Concerto	1966
Witold Lutoslawski	Concerto	1970
Darius Milhaud	Concerto no. 1	1935
	Concerto no. 2	1946
Georg Matthias Monn	Concerto in G minor	c. 1745
Krzysztof Penderecki	Concerto no. 1	1971
	Concerto no. 2	1982
Hans Pfitzner	Concerto in G, op. 42	1935
Sergey Prokofiev	Concerto in E minor, op. 58	1938
	Concerto in E minor, op. 125	1952
Camille Saint-Saëns	Concerto no. 1 in A minor	1873
Robert Schumann	Concerto, op. 129	1850
Dmitri Shostakovitch	Concerto, op. 107	1959
	Concerto, op. 126	1966
Heitor Villa-Lobos	Cello Concerto no. 2	1955
William Walton	Cello Concerto	1956

Concerto for flute and oboe (1972); and Arvo Pärt's *Tabula Rosa* for two violins, prepared piano and strings. **4 triple concerto** A concerto scored for three solo instruments and orchestra, such as Bach's Concerto in A minor for violin, flute, and harpsichord; Beethoven's Concerto in C major for piano, violin, and cello, op. 56; or Mozart's Concerto in F major for three pianos, K. 242. **5** In the late sixteenth, seventeenth, and early eighteenth centuries, a work for one or more voices with instrumental accompaniment (in contrast to an unaccompanied vocal work). The term was used in this sense by various Italian composers and by Schütz and Bach in Germany in the titles of works that today would be called church cantatas. **6** See CONCERTO GROSSO.

concerto grosso (kôn cher' tô grôs' sô) *pl.* **concerti grossi** (kôn cher' tē grôs' sē) *Italian.* An important type of instrumental composition of the baroque period (1600–1750), in which a small group of solo instruments, called the *concertino, concertato,* or *concertante,* alternates with the full orchestra, called the *tutti, ripieno,* or *concerto grosso.* Most often the

concertino consisted of two violins and a cello, accompanied by a basso continuo part (see CONTINUO) played on a keyboard instrument, usually a harpsichord. However, numerous other combinations were used, including such solo instruments as the trumpet, recorder, oboe, and flute. The tutti at first consisted only of stringed instruments with their own harpsichord or organ continuo, but toward the end of the baroque period various wind instruments were included as well.

A concerto grosso always consists of several movements, but their number and kind vary considerably. The chief distinguishing feature of the form is the contrast of concertino and tutti, which are constantly pitted against one another. The most important composers of concerti grossi were Corelli, Torelli, Vivaldi, Handel, and Bach; Bach's six *Brandenburg Concertos* are among the finest examples of the form. Some twentieth-century composers have written works modeled on the baroque concerto grosso. Among them are Ernest Bloch (two concerti grossi), Paul Hindemith (*Concerto for Orchestra,* op. 38), Béla Bartók (*Concerto for Orchestra,* 1944), Samuel Barber (*Capricorn Concerto*), Stravinsky (*Dumbarton Oaks*), and Alfred Schnittke (five concerti grossi, 1977–1991).

concert overture An orchestral composition that resembles the overture to an opera but is meant to be played in a concert hall and generally can stand alone (with nothing following it). Such pieces may have a title or program to which the music supposedly conforms (see PROGRAM MUSIC), or they may have been written in honor of a special occasion. The concert overture dates from the nineteenth century and was quite popular with romantic composers. Examples include Mendelssohn's *Hebrides Overture (Fingal's Cave),* Brahms's *Tragische Ouvertüre* ("Tragic Overture") and *Akademische Festouvertüre* ("Academic Festival Overture"), Rimsky-Korsakov's *Russian Easter Overture,* and Tchaikovsky's *1812 Overture.*

concert pitch The PITCH of all notes that results from tuning A above middle C to a frequency of 440 cycles per second. (For an explanation of pitch and frequency, see SOUND.) In actual practice, orchestras tune to an A as low as 435 cycles per second (Russia) or as high as 449 (Berlin). Most American orchestras range 440–442.

concitato (kôn"chē tä'tô) *Italian.* A direction to perform in an excited, agitated manner.

conducting The art of directing a group of musical performers (singers, instrumentalists, or both). It is the conductor's job to make the group perform together, at the correct tempo (speed) and with the proper expression (dynamics, phrasing, articulation, etc.). Moreover, he or she must bring into balance the different instruments or voices, so that, for example, no one group or voice sounds too loud in relation to the others. The conductor's primary objective is to present a composition as a unified whole, in a manner as close as possible to the composer's intentions.

Naturally, various conductors' interpretations of a composer's intentions may differ; nevertheless, no matter what their particular interpretation, conductors must be able to tell the performers how they want them to perform. They do so in a variety of ways, the best known of which are their hand motions. Some conductors use only their hands, others use a BATON, and still others use both. In addition, conductors may use movements of the face, head, and even the whole body in order to indicate their wishes.

Until the early nineteenth century, there was no separate leader for an orchestra. Instead, a violinist, organist, harpsichordist, or pianist led the group, at the same time playing their own instrument. The first conductors who did not play an instrument while conducting were composers

who in the late seventeenth century led musicians in performances of their own works. Today the job of conductor is nearly always independent of playing, and it requires a very advanced degree of musicianship. Conductors must be familiar with many different musical styles and periods (a work by Mozart requires quite different treatment from a work by Bach or Schoenberg), they must know every minute detail of the work they conduct, and they must be able to communicate their knowledge to the performers.

conductus (kən duk' təs) *Latin*. A type of song of the eleventh to thirteenth centuries. Its text was a poem in the Latin language, religious or secular (nonreligious) in subject, which was set to music that, unlike most other medieval forms, was not usually based on a preexisting melody. The earliest examples were monophonic (with one voice-part), but the conductus of the thirteenth century was polyphonic, having two, three, and occasionally even four voice-parts. However, unlike other polyphonic compositions of this time, such as the MOTET and CLAUSULA, the polyphonic conductus was written in strict note-against-note style, with all the voice-parts moving in exactly the same rhythm.

conjunct motion See under MOTION, def. 1.

conservatory A school that specializes in musical instruction.

console 1 The case or cabinet that houses the keyboard, pedals, and stops of an ORGAN. In organs with electric action, the console may be separate from the rest of the instrument (mainly, the pipes), to which it is connected simply by wiring. Sometimes the console is mounted on wheels so that it can be moved about easily. 2 An upright piano (see under PIANO), forty to forty-two inches high.

consonance A musical INTERVAL or CHORD that sounds pleasant (a chord or interval that sounds harsh is called a DISSONANCE). A consonant interval or chord seems restful compared to a dissonant interval or chord, which appears to call for a RESOLUTION into a following consonant interval or chord. However, it is important to realize that what one listener regards as pleasant may sound harsh to another listener. In different periods of music history, certain intervals have been judged consonant and others dissonant, so that people's ears have become accustomed to some and dismiss others as "wrong." In the Middle Ages, the fourth was considered a consonance, but by the Renaissance it had come to be thought of as a dissonance, and from about 1500 to about 1900, the intervals traditionally regarded as consonant were the unison, the major and minor third, the perfect fifth, the major and minor sixth, and the octave; the other intervals were classed as dissonant. From about 1900 on, composers began to use any and all intervals.

consort (kon' sôrt). 1 In English music of the sixteenth and seventeenth centuries, a small instrumental ensemble. 2 A composition written for such an ensemble. 3 Also, *whole consort.* An ensemble made up of instruments from a single family in different sizes, for example, a consort of viols. —**broken consort** An ensemble made up of instruments of different kinds, for example, lutes, viols, and recorders. A typical broken consort consisted of treble and bass viols, CITTERN and PANDORA (both plucked), lute, and recorder. —**consort song** In late sixteenth-and early seventeenth-century England, a solo song accompanied by a consort, most often of viols. Usually the vocal part was a relatively straightforward melody to which the instruments played an intricate counterpoint. The chief composers of consort songs were William Byrd and Orlando Gibbons.

contemporary music See TWENTIETH-CENTURY MUSIC.

continuo (kôn tēn' nōō ô") *Italian.* Also, *thoroughbass.* **1** A shortening of *basso continuo* (literally, "continuous bass"), in seventeenth- and eighteenth-century music, an accompaniment played on a keyboard instrument (usually harpsichord or organ), almost always assisted by a bass melody instrument. Instead of being written out in full, the continuo part usually consisted of the bass line, played by the cello, viola da gamba, or bass viol, in unison with the keyboard player's left hand, while a chordal instrument (organ or theorbo) played the harmonies above the bass. Numbers written over or under the notes indicated the chords to be played (see FIGURED BASS). The use of a basso continuo is one of the characteristic features of both vocal and instrumental music of the baroque period (1600–1750). **2** The bass line that is being played.

contrabass (kon' trə bās"). **1** Another name for the DOUBLE BASS. **2** Also, *double-bass.* A term used to distinguish instruments pitched lower than the bass instrument of the same family. Thus, the contrabass clarinet is pitched an octave below the normal bass clarinet. (For contrabass clarinet, contrabass trombone, contrabass tuba, etc., see under CLARINET, TROMBONE, TUBA, etc.)

contrabasso (kôn" trä bäs' sô). The Italian word for DOUBLE BASS.

contrabasson (kôn" trə bə sōōn'). Another name for double bassoon (see under BASSOON).

contradanza (kôn" trä dän' tsa). The Italian word for CONTREDANSE.

contrafagotto (kôn" trä fä gôt' tô). The Italian word for *double bassoon* (see under BASSOON).

contralto (kən tral' tō) *pl.* **contraltos** Another word for ALTO, def. 1.

contrapuntal (kon" trə pun' t'l). Pertaining to or in the form of COUNTERPOINT.

contrary motion 1 In music with more than one voice-part, the movement of two voice-parts in opposite directions (see MOTION, def. 2). **2** Another term for melodic inversion (see INVERSION, def. 3).

contrebasse (kôn trə bAS'). The French word for DOUBLE BASS.

contrebasse à pistons (kôn trə bAS" A pēs tôn'). The French term for bass tuba (see under TUBA).

contrebasson (kôn" trə bAS ôN'). The French word for double bassoon (see under BASSOON).

contredanse (kôn trə däNS') *French.* A very popular dance in France and Germany during the late eighteenth century. The contredanse apparently developed from the English COUNTRY DANCE, and it later became the basis of the française and the QUADRILLE. Beethoven wrote twelve contredanses for orchestra.

cool jazz See under JAZZ.

Copland (kōp' lənd), **Aaron,** 1900–1990. An American composer who became known particularly for works reflecting various aspects of American life. Among them are his three ballets, *Billy the Kid, Rodeo,* and *Appalachian Spring;* his opera *The Tender Land;* and a patriotic work called *A Lincoln Portrait* (scored for speaker and chorus). In addition, Copland did much to help his fellow American composers, largely through music festivals and the formation of organizations through which their work could be performed.

Copland was born in Brooklyn, New York, and began to study music during his teens. In 1921 he went to Paris, where he became the first full-time American pupil of Nadia BOULANGER. Copland's early works reflect a variety of influences, mostly neoclassical (see NEOCLASSICISM), but after his return to America in 1924 he began to be interested mainly in producing truly American music. During this period he also wrote a very successful work based on his travels in Latin America, *El Salón México* for

orchestra. In the 1950s Copland became interested in serial techniques (see SERIAL MUSIC), which he used in such works as his Piano Fantasy and *Connotations* for orchestra. Among his many chamber pieces, *Vitebsk* (1928), for piano, violin, and cello, is often performed.

cor (kôr). 1 The French word for HORN. 2 The French term for FRENCH HORN.

cor anglais (kôr än gle'). The French term for ENGLISH HORN, also used in Britain.

corda (kôr' dä) *pl.* **corde** (kôr' de) *Italian.* The Italian word for string, used to refer to the string of a piano, violin, or other stringed instrument. —**una corda** (ōō'nä kôr' dä). In piano music, a direction meaning "one string" that instructs the performer to depress the left (soft) pedal. In grand pianos, this pedal makes the hammer strike only one or two of the strings for a note, instead of the complete set of two or three (see PIANO, def. 2 for further explanation). Abbreviated *u.c.* —**tre corde** (tre' kôr' de). A direction meaning "three strings" that instructs the performer to release the soft pedal. —**tutte le corde** (tōōt' te le kôr'de). A direction meaning "all the strings" that also instructs the performer to release the soft pedal. —**corda vuota** (kôr'dä vōō ô'tä). In music for stringed instruments (violin, cello, etc.), a direction to use an open (unstopped) string. —**due corde** (dōō'e kôr'de). A direction meaning "two strings." **a.** In music for stringed instruments (violin, cello, etc.) it instructs the player to sound a note on two strings at the same time, to obtain more volume. **b.** In Beethoven's piano music it instructs the player to depress the soft pedal halfway, midway between *una corda* and *tre corde.*

corde (kôrd), *pl.* **cordes** (kôrd) *French.* The French word for the string of a piano, violin, or other stringed instrument. —**corde à vide** (kôrd A vēd'). In music for stringed instruments (vio-

lin, viola, cello, etc.) a direction to use an open (unstopped) string. —**cordes** The French term for STRINGED INSTRUMENTS.

Corelli (kô rel' lē), **Arcangelo** (är kän' je lô"), 1653–1713. An Italian composer and violinist who lived mostly in Rome, and who is remembered both for being the founder of modern violin technique and for helping develop one of the most important musical forms of his time, the CONCERTO GROSSO. A famous violin virtuoso and teacher, Corelli taught such composers as Francesco Geminiani (1687–1762) and Pietro Locatelli (1695–1764). His own compositions, though relatively few in number, had great influence and are still frequently played. They include several sets of twelve trio sonatas (see TRIO SONATA) and solo violin sonatas (see SONATA, def. 1), as well as a number of concerti grossi, the best known of which is the so-called *Christmas Concerto.*

cornemuse (kor nᵃ mYZ' *French.* See under BAGPIPE.

cornet (kôr net'). A brass instrument that looks like a small trumpet and is used mainly in military and brass bands. It should not be confused with the now obsolete CORNETT. The cornet has a cup-shaped mouthpiece and a conical bore (cone-shaped inside). It originated in the early nineteenth century, when, shortly after the invention of valves, two valves were added to the formerly plain, circular POST HORN. Soon afterward, this instrument was built in the form generally used today. The cornet usually is

pitched in B-flat and has a range of slightly more than two octaves, from the E below middle C to the B-flat below high C. However, it is a transposing instrument, its music being written one tone higher than it actually sounds (see TRANSPOSING INSTRU-

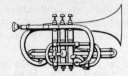

MENTS). The cornet can be played with more agility than the trumpet but has a less brilliant tone than the larger instrument. It has been especially important in jazz in the hands of such artists as Bix Beiderbecke, Joseph "King" Oliver, Wild Bill Davison, and Louis Armstrong.

cornet à bouquin (kôr nā′ A bōō kaN′). The French term for CORNETT.

cornet à pistons (kôr nā′ A pēs toN′). The French term for CORNET.

cornett (kôr net′). Also, *cornetto, Zink*. A wind instrument used from the fifteenth to nineteenth centuries. Its name is spelled with two *t*'s to distinguish it from the modern CORNET. The cornett was made of wood covered with leather and was straight or slightly curved in shape. It had a conical bore (cone-shaped inside), cup-shaped mouthpiece, six finger holes, and, usually, a thumb hole. Cornetts were made in a number of sizes. The soprano cornett, about two feet long, had a range of two and one-half octaves, from the G below middle C to the D above high C. Alto and tenor sizes were also made (the accompanying illustration shows a tenor cornett). With its clear, bright tone, the cornett blended well with voices and was often used in choral music, particularly church music. Bach scored for it in eleven of his church cantatas. A similar instrument of bass range is the SERPENT.

cornetta (kôr net′ tä). The Italian word for CORNET.

cornetto (kôr net′tô). The Italian word for CORNETT.

corno (kôr′ nô). 1 The Italian word for HORN. 2 The Italian term for FRENCH HORN.

corno inglese (kôr′ nô ēn glā′ ze). The Italian term for ENGLISH HORN.

coro (kô′rô). 1 The Italian word for chorus (see CHORUS, def. 1). 2 The Italian word for CHOIR (def. 1).

corrente (kôr ren′te) *Italian*. The Italian variety of COURANTE, in 3/8 or 3/4 meter and quick tempo, generally having a melody of running scale figures and a simple bass accompaniment. Examples appear in the works of Frescobaldi, Corelli, Bach, and others.

counterpoint The technique of combining two or more independent melodies to make up a harmonious texture (one in which the chords produced by the melodies sounding together are pleasant to the ear). Counterpoint is actually identical to polyphony, the use of more than one voice-part (a "voice-part" being the same as a "melody"). However, the term "polyphony" is usually used to refer to music of the Middle Ages (ninth century until about 1500), and the term "counterpoint" is applied to the music of the sixteenth to eighteenth centuries. Some musical forms are essentially contrapuntal, that is, their very structure is based on counterpoint. Among these are the CANON and the FUGUE. Other musical forms may or may not involve counterpoint, and even then counterpoint may be present either throughout or only in certain portions.

Counterpoint was well developed by the thirteenth century, and it reached a high point in the sixteenth-century motets, madrigals, and Masses of such composers as Byrd, Palestrina, Lasso, and Victoria. There were strict rules governing its use, concerning how the different parts

moved relative to each other. One system predominant in the sixteenth century was that of PALESTRINA, and another that set forth by Johann Joseph Fux in his *Gradus ad Parnassum* ("Steps to Parnassus," Mount Parnassus being the home of the Muses in Greek mythology). Fux's text, first published in 1725, still influences the present-day teaching of counterpoint.

Later in the eighteenth century, a different type of contrapuntal writing, in which the overall texture was more strongly influenced by harmonic considerations, came into being. The greatest composer of this type of counterpoint was Bach, and his mastery of contrapuntal technique is evident in all his works, notably such keyboard works as his *Art of Fugue*, the *Two-Part* and *Three-Part Inventions*, and the forty-eight preludes and fugues of *The Well-Tempered Clavier*. **—strict counterpoint** Counterpoint composed in accordance with the rules laid down by Fux, especially counterpoint that can be readily fitted into five basic classes that he set up. Strict counterpoint is now largely an exercise for students. **—free counterpoint** Counterpoint that (like Bach's) does not obey Fux's rules. **—invertible counterpoint** Counterpoint in which the parts are interchangeable, so that the upper part can become a lower and vice versa. In the accompanying example, from Bach's *Two-Part Invention* no. 6, the opening four measures are inverted in the next four measures, the upper and lower parts changing places (the original statement and its inversion are marked A and B, respectively). **—double counterpoint** Invertible counterpoint involving two parts. **—triple counterpoint** Invertible counterpoint in which three parts are interchangeable. Since each part can be in one of two positions, there are six possible arrangements in all. **—quadruple counterpoint** Invertible counterpoint involving four interchangeable parts and yielding twenty-four possible arrangements of the parts in a four-

part texture. **—quintuple counterpoint** Invertible counterpoint involving five interchangeable parts and yielding 120 possible arrangements of the parts. **—dissonant counterpoint** See under CRAWFORD SEEGER, RUTH.

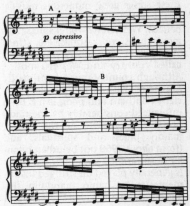

countersubject 1 In a FUGUE, a theme that follows the main theme (the subject) and forms a counterpoint to it. For example, in a three-part fugue, the first voice-part presents the subject; then, while the second voice-part enters with the answer (the melody of the subject transposed to a different key), the first voice-part may continue with a countersubject. When the third voice-part takes up the subject the second voice-part takes up the countersubject. Not all fugues contain a countersubject, and some fugues include more than one. **2** In one type of double fugue, the second of the two subjects (see under FUGUE).

countertenor Another term for male alto (see ALTO, def. 2).

country dance A type of traditional English folk dance, danced by a group and employing a large variety of steps and gestures. Country dances were especially popular during the seventeenth and eighteenth centuries. The music for country dances, often a JIG or a REEL, featured gay, lilting tunes with a marked rhythm. (See also CONTREDANSE.)

country music A type of American popular music, mostly vocal, that developed from old English and Scottish ballads brought to the Appalachian mountain areas during the late eighteenth century. From these songs grew numerous musical forms and styles, including mountain ballads, Western (cowboy) songs, religious songs, work songs, etc. (Until World War II country music was called **country and Western** music.) Although country music is primarily associated with white people, especially Southern and poor, it has been influenced considerably by the traditional black music of the South, mainly blues and spirituals, and (from about 1950 on) by urban popular music and by jazz. Country music is generally played on stringed instruments (guitar, banjo, mandolin, fiddle, autoharp) instead of the wind and percussion instruments that predominate in jazz. It stresses sincerity, a close rapport between audience and performer, a relatively simple musical structure, down-to-earth subject matter, and danceable rhythms. The lyrics, often quite sentimental, uphold such virtues as hard work, patriotism, and self-sacrifice. They often are melancholy, but purely instrumental country music, with its lively dance beat, is more cheerful. Outstanding country performers include Jimmy Rodgers, the Carter family, Hank Williams, and Johnny Cash. Famous Western (cowboy) performers were Gene Autry and Roy Rogers.

Originating in the isolated communities of the mountain areas and kept alive by community social activities such as quilting parties, hoedowns, and barn raisings, country music began to become more widespread (and commercial) with the advent of radio and phonograph music in the 1920s. One of the most important factors in its growth was a single radio station, WSU in Nashville, Tennessee, which began broadcasting in 1925 and became the national headquarters for country music with its weekly music program *Grand Ole Opry*. The show attracted the attention of large record companies, which during the 1930s sent their representatives throughout the rural South to record local music. As Nashville became commercially successful, the older style of country folk music, with its harsh twangy sound, was softened and given more sophisticated arrangements, and there was increasing emphasis on sentimental ballads. In the mid-1970s some musicians rebelled against these stock formulas and attempted to restore the vigor of earlier country instrumentation combined with, in some instances, the energy of rock or, in others, the revival of harmony singing. This new wave included such musicians as Willie Nelson, Emmylou Harris, Ricky Skaggs, and the White family. (See also ROCK; RHYTHM AND BLUES.)

Couperin (kōō pə̄ raN′), **François** (fräN swa′), 1668–1733. A French composer who is remembered mainly for his keyboard and instrumental music. An organist and harpsichordist employed at the court of King Louis XIV, Couperin came from a renowned musical family, and he is sometimes called *le Grand* ("the Great") to distinguish him from his relatives. Couperin wrote several hundred harpsichord works, which he arranged in groups called **ordres**, comparable to the instrumental suites favored by German composers of the time (see SUITE, def. 1). His pieces usually have descriptive titles, such as "Regrets," "The Rose Bushes," and "Sister Monica," leading to the belief that Couperin (who referred to them as "portraits") may have meant to convey particular ideas in the manner of program music. His elegant, refined, and formal style exemplifies the French rococo, or GALLANT STYLE. In addition to harpsichord music, Couperin composed chamber music, songs, church vocal music, and two organ Masses of exceptional beauty. He also wrote a treatise on harpsichord playing, *L'Art de toucher le clavecin* (1716), which is a valuable record of the keyboard technique of his time.

coupler (kup'lər). In organs and harpsichords, a mechanism that makes one key or pedal automatically bring into play pipes or strings ordinarily controlled by another key or pedal. The use of couplers on organs dates from the fifteenth century and on harpsichords from the seventeenth century. —**manual coupler** A coupler that makes the resources of one manual available on another, so that when the keys of one manual are played the pipes or strings normally controlled by another manual sound at the same time. On older organs and on harpsichords, the coupler operates by causing the keys of the second manual to move when the keys of the first are played. —**pedal coupler** A coupler that makes the resources of one of the manuals of an organ available on the pedal keyboard. —**octave coupler** A coupler that brings into play the note one octave higher than the note played in addition to the note itself. —**suboctave coupler** A coupler that brings into play the note one octave lower than the note played, besides the note itself.

courante (ko͞o ränt') *French.* A lively dance in triple meter (any meter in which there are three basic beats in a measure, such as 3/4 or 3/8) that dates from the sixteenth century and became, in the seventeenth century, a standard movement of the instrumental suite (see SUITE, def. 1). The French courante is much slower in tempo than the related Italian CORRENTE and alternates between 3/2 and 6/4 meter. Its texture and rhythm are more complex; the melody sometimes shifts from the treble (soprano) to one of the lower parts, and there is frequent use of HEMIOLA. Examples of the French courante appear in the works of such composers as Chambonnières, d'Anglebert, Couperin, and Bach.

course In certain stringed instruments, such as lutes and guitars, a term for two or more strings that are tuned in unison (to the same pitch) and sounded at the same time. Their purpose is to increase the volume (loudness) of the note. —**double course** A set of two such strings tuned in unison. —**triple course** A set of three strings tuned in unison. —**octave course** A pair of strings tuned an octave apart, such as one of the pairs of bass strings on certain lutes.

Cowell (kou' əl), **Henry**, 1897–1965. An American composer, pianist, teacher, and writer who became known for his innovative compositions but is remembered even more for publishing and writing about new music. He founded and edited *New Music Quarterly,* which published compositions by Ives, Schoenberg, Webern, Ruggles, and Crawford Seeger, among others. As a pianist and composer, he began to explore the inside of the instrument, asking players to pluck, brush, or beat the strings directly. He also frequently used the tone cluster, a group of adjacent notes played by pressing down the keys with the fist, palm, elbow, or forearm. Though he was not the first to use this device, he gave it its name (in the 1920s) and used it frequently in his early music. In 1931, together with Leon Theremin, Cowell invented the **Rhythmicon**, an electrical instrument that could produce different rhythms at the same time. About this time he began to call for free improvisation in his compositions; in his *Mosaic Quartet for Strings* the performers choose the order of the sections. From about 1936 on he wrote mostly tonal music, abandoning the dissonant counterpoint of his earlier works. In all he composed more than a thousand works, including sixteen symphonies. In keeping with his belief that composers should draw on material from all possible sources, he wrote *Hymns and Fuguing Tunes,* modern versions of pieces written by William Billings in colonial times, used Irish folk music in his *Irish Suite* for chamber orchestra and *Celtic Set* for band, and scored music for such non-Western instruments as the Japanese koto.

crab canon Another term for retrograde canon (see under CANON).

cracovienne (krA kō vyen'). The French term for KRAKOWIAK.

crash cymbal See under CYMBALS.

Crawford Seeger (krô'fərd sē'gər), **Ruth,** 1901–1953. An American composer who wrote a relatively small number of highly individual works, using techniques that anticipated by several decades the experiments of postserial composers after World War II. Nearly all of her compositions were produced between 1924 and 1932. They include Five Preludes for piano (1924–25), without key signatures; Suite for Small Orchestra (1926), with tone clusters used as pedal tones; Suite for strings and piano (1929), which features brief, interwoven chromatic motifs of a few notes each (instead of conventional melody or theme) that are reworked in each movement; Five Songs (1929), which use panchromatic harmony (the simultaneous sounding of chromatic notes) and tone clusters; and String Quartet (1933), with **dissonant counterpoint** (dissonant individual lines for each instrument) and special patterns of dynamics (loud-soft) and rhythms. After her marriage to musicologist and composer Charles Seeger in 1931 she devoted herself mainly to raising a family, teaching music to children, and transcribing some 1,000 folk songs from field recordings for the Library of Congress American Folk Archive, for many of which she also wrote piano arrangements. Crawford Seeger was long unrecognized except for her work with folk music, but from about 1970 on she began to win acclaim, and she has come to be recognized as one of the most original American composers of the first half of the twentieth century.

Credo (krā'dō) *Latin:* "I believe." The third section of the Ordinary of the Roman Catholic Mass (see MASS).

cresc. The abbreviation for CRESCENDO.

crescendo (kre shen'dô) *Italian.* A direction to perform with increasing loudness, often indicated by the sign ◁ . (The opposite of crescendo is DECRESCENDO or DIMINUENDO.) Often abbreviated *cresc.*

cromorne (krô môrn'). The French word for CRUMHORN.

crook 1 A curved piece of metal tubing that connects the reed of a woodwind instrument, such as a bassoon or an English horn, with the body of the instrument, making it possible to hold the instrument in a more comfortable or convenient position. **2** A length of tubing inserted between the mouthpiece and the body of a brass instrument in order to lower the basic pitch of the instrument by a desired amount. In the eighteenth and early nineteenth centuries, before the development of valves and pistons, horn players and trumpeters had to insert and remove crooks of various sizes as they were needed in order to play music in different keys. In most modern instruments, crooks are built into the instrument (usually two, F and B-flat for the French horn, B-flat and A for the trumpet), and a special valve brings one or the other into play.

cross relation Also, *false relation.* In harmony, the jarring effect of two pitches a half-step apart (D natural and D-flat in the accompanying example) when they appear in different voice-parts (the D in the alto, D-flat in the tenor) of adjacent chords or of the same chord. This device has been used since the Renaissance as a means of heightening expressiveness; William Byrd and his English contemporaries were particularly fond of it. J. S. Bach and others occasionally used it to effect key changes.

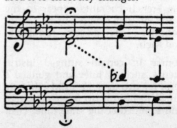

cross rhythm. Also, **polyrhythm.** The use of two different rhythms at the same time, as when triplets are performed against eighth notes (see the accompanying example from a Mozart piano sonata). Cross rhythm is frequently used by twentieth-century composers and also is a common feature of jazz.

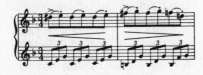

crotchet (kroch'it). The British term for QUARTER NOTE.

crouth (krōōth). Another spelling for CRWTH.

crowd (kroud). Another spelling for CRWTH.

cruit (krōōt). Another spelling for CRWTH.

Crumb (krum), **George Henry,** 1929– . An American composer and teacher of composition who became known for works that evoke a mysterious poetic atmosphere. Most of his compositions are cast in simple musical forms such as song form or theme and variations but explore new sonorities by novel means, such as producing a rapid tremlo on piano or violin strings with a thimble-capped finger, or raising and lowering a gong in a bucket of water, as well as using exotic instruments. In some of his works the musicians march about the stage, thereby shifting the balance of instrumental sound, and in others they help create a mood by wearing black masks. Crumb frequently quotes other composers (see QUOTATION, MUSICAL). His major works include *Echoes II* (1967) for orchestra; *Night of the Four Moons* (1969) for mezzo-soprano, banjo, alto flute, piccolo, cello, and percussion; *Black Angels* (1970) for electric string quartet; *Ancient Voices for Children* (1970) for mezzo-soprano, boy soprano, oboe, mandolin, harp, electric piano, and percussion; *Voice of the Whale* (1971) for flute, cello, and antique cymbals; *Makrokosmos I, II, III,* and *IV* (1972–1979) for amplified piano; and *A Haunted Landscape* (1984) for amplified piano and orchestra (including such instruments as Chinese temple gong, steel drum, and Appalachian dulcimer).

crumhorn Also, *cromorne, Krummhorn.* A woodwind instrument of the sixteenth and seventeenth centuries that was shaped like the letter J, that is, a long narrow tube with a hooked end. (The name comes from the German name, *Krummhorn,* literally "crooked horn.") The crumhorn had a cylindrical bore (straight inside), a double reed, and six finger holes and a thumb hole. The reed was covered by a reed cap with a small opening in the top, through which the player blew. Because the player's lips and tongue never touch the reed, the instrument's range is only a ninth, and the player cannot vary the tone, which is quite buzzy. The instrument was built in various sizes, ranging from a small soprano to a four-foot-long great-bass crumhorn.

crwth (krōōth). Also, *crowd, crouth, cruit.* An ancient bowed lyre of Wales that was played throughout the Middle Ages and in Wales survived until

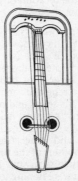

the early nineteenth century. In its earliest form the crwth was a simple wooden instrument with two pairs of

strings tuned a fourth apart, the strings being plucked rather than bowed. By the thirteenth century, however, the crwth was bowed and, soon after, acquired a fingerboard against which the player stopped the strings. About this time the crwth had six strings, which were arranged in three pairs tuned an octave apart. Two of these pairs of strings could be stopped against the fingerboard and were used for playing melodies. The third pair were drone strings, which were struck either with the thumb or with the bow to provide a continuous bass accompaniment.

csárdás (c͟här'dä͟sh") *Hungarian.* also, *czardas*. A lively Hungarian dance in 2/4 meter and rapid tempo that is sometimes preceded by a slower section. A famous example is found in Liszt's Hungarian Rhapsody no. 2.

C-sharp One of the musical tones (see PITCH NAMES), one half tone above C and one half tone below D. On the piano, C-sharp is identical with D-flat (see ENHARMONIC for an explanation). The scales beginning on C-sharp are known as C-sharp major and C-sharp minor. A composition based on one of these scales is said to be in the key of C-sharp major or the key of C-sharp minor, the key signatures (see KEY SIGNATURE) for these keys being seven sharps and four sharps, respectively. For the location of C-sharp on the piano, see KEYBOARD.

Cui (KY ē'), **César** (sā zAr'), 1835–1918. A Russian composer, one of the group called the Five (see FIVE, THE). Though he wrote a number of operas (including several for children) and numerous orchestral and chamber works, it is his songs and piano compositions that are most played today. In these Cui's style is closer to that of Schumann and other German and French composers of the time than to the typically Russian style he and his compatriots were hoping to develop.

cuivré (kwē vrā') *French.* A direction for French horn players, indicating

they are to produce a forced, brassy tone.

cuivres (kwē' vr°). The French term for BRASS INSTRUMENTS.

cumbia (ko͞om'byä) *Spanish.* Colombian dance music that is an amalgam of Andean Indian, African, and European musical styles.

curtal (kûr't°l). Also, *dulcian, fagotto.* A low-pitched wind instrument of the sixteenth and seventeenth centuries, a forerunner of the modern bassoon. It had a double reed and a conical bore (cone-shaped inside) that was, owing to its length, doubled back on itself. It was built in several sizes.

cut time Another term for alla breve (see under BREVE).

cymbales (saN bAl'). The French word for CYMBALS.

cymbals A percussion instrument that consists of a pair of thin metal plates, usually made of brass and about fourteen to twenty inches in diameter, used either singly or in pairs. For playing in pairs, cymbals

are held by leather handles and are struck or rubbed together. For playing singly, a cymbal is suspended from its center and is struck with one or two hard- or soft-headed drumsticks. The kinds and volume of tone that cymbals can produce varies greatly. The ordinary orchestral and band cymbals are not tuned to a definite pitch. In military bands one cymbal is usually fixed to the side of the bass drum; the

bass drummer plays it by clashing the other cymbal against it (at the same time playing the bass drum with a two-headed stick). Along with several other percussion instruments, the cymbals were introduced into the European orchestra by eighteenth-century composers seeking to imitate Turkish military music (see JANISSARY MUSIC). —**finger cymbals** In ancient Egypt, Greece, and Rome, much smaller cymbals, about two inches in diameter and made of thicker metal, were used. A pair was usually held by the finger and thumb and played in the manner of castanets. Unlike the orchestral cymbal these ancient cymbals were tuned, the members of each pair usually being pitched about one half tone apart to produce a characteristic clashing sound. Finger cymbals are still used by Greek, Turkish, and North African dancers. —**hi hat cymbals** A pair of small cymbals, set one above the other on a stand, and struck together by means of a pedal.

The lower cymbal is stationary, the upper movable. They are used in jazz and other popular music. —**ride cymbal** A single free-hanging cymbal, used in jazz and other popular music, mainly to outline the basic rhythmic patterns. —**crash cymbal** A single suspended cymbal that is struck with a drumstick.

czardas (chär'däsh). Another spelling of CSÁRDÁS.

Czerny (cher'nē), **Carl**, 1791–1857. An Austrian composer and pianist remembered principally for his piano études, which are carefully designed to build up the student's technique. Although Czerny also composed a great deal of church music and made hundreds of piano arrangements of instrumental works, it is mainly his teaching pieces that have survived. Czerny himself studied with Beethoven, and his own most famous pupil was Liszt.

D

D 1 One of the musical tones (see PITCH NAMES), the second note in the scale of C major. The scales beginning on the tone D are known as D major and D minor. A composition based on one of these scales is said to be in the key of D major or D minor, the key signatures (see KEY SIGNATURE) for these keys being two sharps and one flat, respectively. The note one half tone below D is called D-flat or C-sharp (see ENHARMONIC for an explanation); the note one half tone above D is called D-sharp or E-flat. For the location of these notes on the piano, see KEYBOARD. **2** An abbreviation for DISCANTUS, the treble part in choral music of the late Middle Ages and Renaissance. **3** An abbreviation for the term DOMINANT, used in analyzing the harmony of a composition. **4** An abbreviation for either DROITE or DESTRA, meaning "right" and referring to the right hand. —**D instrument** A transposing instrument such as the D trumpet (or trumpet in D) that sounds each note one whole tone higher than it is written; for example, the fingering for the written note C yields a pitch of D.

da, dal For Italian musical terms beginning with *da* or *dal,* such as *da capo* and *dal segno,* see under the next word (CAPO; SEGNO).

Dalcroze See JAQUES-DALCROZE, ÉMILE.

Dallapiccola (däl″ lä pik′ kô lä), **Luigi** (lo͞o ē′jē), 1904–1975. An Italian composer whose works combine the use of the twelve-tone technique (see SERIAL MUSIC) with a love for melody and for the song and dance forms of early Italian music. Among Dallapiccola's most important compositions are *Variazioni per Orchestra* ("Variations for Orchestra," 1954); the operas *Volo di notte* ("Night Flight") and *Il Prigioniero* ("The Prisoner"), which are more expressionistic (see EXPRESSIONISM); *Tartiniana* for violin and orchestra, based on themes by the eighteenth-century composer Tartini; and numerous pieces of vocal chamber music.

d'amore (dä môr′e) *Italian:* "of love." Describing an instrument lower in pitch than the standard member of the family. See OBOE D'AMORE; VIOLA D'AMORE.

damper A mechanism for silencing one or more notes on certain instruments by stopping their vibrations. The dampers of the piano are small pieces of felt-covered wood that rest on the strings. Striking a key raises the damper from the strings for that note, allowing them to sound when the hammer strikes them. When the key is released, the damper returns to its original place, stopping the sound. The strings can be made to continue vibrating after the key has been released by means of the DAMPER PEDAL. See also MUTE.

damper pedal Also, *loud pedal, sustaining pedal.* The right-hand pedal on a piano, which raises all the dampers

and holds them up for as long as the pedal is depressed. This permits the strings to continue vibrating, creating a rich tone.

dance An instrumental composition written as an accompaniment for dancing or in a similar style. Dance music is probably the earliest form of purely instrumental music. Hundreds of musical forms are based on dances; some, such as the POLKA and WALTZ, are still used to accompany dancing, whereas others, such as the PAVANE and GALLIARD, survive only as individual works or as movements in instrumental suites. See also BALLET.

dance band See BAND, def. 9.

dancehall A style of popular dance music that originated in Jamaican dance clubs, an offshoot of both reggae and rap. With bouncy, heavy-hitting rhythms, it draws on the basic structure of reggae, but its lyrics are less socially conscious and its instrumentation is lighter and largely computer-generated. The dancehall disk jockey is the counterpart of hip-hop's rapper, rhyming over the rhythms with lyrics steeped in Jamaican patois. Dancehall was transplanted to the American mainland in the late 1980s and was very popular there by the mid-1990s.

danse (däNs). French for DANCE.

danza (dän'tsä). The Italian word for DANCE.

danza tedesca See under TEDESCA.

danzón (dän tsōn') *Spanish.* A syncopated version of the eighteenth-century French CONTREDANSE that developed in the late nineteenth century in Cuba's Oriente Province. It soon became the island's most popular form of ballroom dance and remained so until the 1930s.

DAT Abbreviation for digital audio tape; see under DIGITAL RECORDING.

Davies (dā'vēz), **Peter Maxwell**, 1934– . An English composer who became known for his highly dramatic music, which includes sym-phonies, operas, film scores, and music for small ensemble, much of the latter composed for his own chamber ensemble, the Fires of London (founded 1970). Davies's earlier works, particularly his MUSIC THEATER pieces of the late 1960s and early 1970s, are expressionist in style (see EXPRESSIONISM). Both *Eight Songs for a Mad King* (1969) and *Miss Donnithorne's Maggot* (1974), for solo voice and small instrumental ensemble, feature a crazed, obsessive individual; in the former work the king screams and wheezes and mumbles his way through a four-octave span. Similarly *Missa super l'homme armé* (1968; rev. 1971) and *Vesalii Icones* (1969), for soloist (singer in the former, dancer in the latter) and instrumental ensemble, represent violent attacks on religious hypocrisy. Both these compositions show Davies's frequent borrowing of music from the past, particularly from the Middle Ages and Renaissance, which he sometimes quotes directly and at other times simply alludes to or imitates stylistically, using plain-song, church modes, or hocket. Occasionally Davies also used magic squares—medieval puzzles of mystically or mathematically related numbers—to determine the formal structure of pitches or rhythms. Other important works are *Shakespeare Music* (1964); the operas *Taverner* (1972), *The Lighthouse* (1980), and *Resurrection* (1988); *Ave maris stella* (1975), *A Mirror of Whitening Light* (1977), and *Image, Reflection and Shadow* (1982), all for chamber ensemble; symphonies; concertos; and the music theater piece *Le Jongleur de Notre Dame* (1978), a setting of the old story for voice, juggler, chamber ensemble, and a children's band.

db. The abbreviation for decibel (see under BEL).

d.c. Also, *D.C.* The abbreviation for da capo (see CAPO, DA).

death metal See under ROCK.

Debussy (dœ bɪ sē'), **Claude** (klôd), 1862–1918. A French composer who, as the founder and main representative of the style called IMPRESSIONISM, had great influence on the development of twentieth-century music. Debussy began his musical studies on the piano, for which he later composed some of his best works. He attended the Paris Conservatory and in 1884, after several unsuccessful attempts, won the Prix de Rome with his cantata, *L'Enfant prodigue* ("The Prodigal Son"). During the next ten years his growing interest in the work of the impressionist painters and, even more, in the poetry of Paul Verlaine, Pierre Louÿs, and Stéphane Mallarmé, led Debussy to a completely new style of music, first exemplified in his famous *Prélude à l'aprés-midi d'un faune* ("Prelude to the Afternoon of a Faun"), after a poem by Mallarmé. In this work Debussy tried to create a kind of music based on a single uninterrupted theme rather than on shorter, more conventional themes or motifs (melodic figures). In such music, the evocation of mood, atmosphere, and color are all-important. Debussy achieved quite subtle effects by means of various technical devices, including careful choice of instruments for their particular tone colors, and the use of an Oriental five-tone scale, the whole-tone scale, dissonant harmonies, parallel chords, and, perhaps most important, unusual shifting harmonies. Among Debussy's notable works are the orchestral pieces *Nocturnes, La Mer,* and *Images* (which includes the well-known "Ibéria"); a string quartet; the opera *Pelléas et Mélisande;* the ballet *Jeux;* more than fifty songs; and his piano music, especially *Estampes, Images, Children's Corner,* two books of *Préludes,* two books of *Études,* and the *Suite bergamasque,* which contains his single most famous piece, "Clair de lune" ("Moonlight").

debut The first public performance of a musician. (See also PREMIÈRE.)

decay In electronic music, the time it takes a signal to drop from its maximum to its minimum level. See also ATTACK, def. 2.

deceptive cadence See under CADENCE.

decibel (des'ə bel"). See under BEL.

deciso (de chē'zô) *Italian.* A direction to perform forcefully, boldly, and with decision.

decresc. Also, *decr.* An abbreviation for DECRESCENDO.

decrescendo (de"kre ṣhen'dô) *Italian.* Also, *diminuendo.* A direction to perform more and more softly, often indicated by the sign ⟩. (The opposite of decrescendo is CRESCENDO.) Often abbreviated *decresc.* or *decr.*

deejay Also, *D.J.* Short for disk jockey; see under REGGAE.

de Falla See FALLA, DE, MANUEL.

degree A term used when referring to a note in a particular scale or a note in relation to others in a scale (see SCALE DEGREES).

dehors, en (än də ôr') *French.* A direction to perform with emphasis, so as to make a note or passage stand out.

delicato (de"lē kä'tô) *Italian.* A direction to perform in a delicate, refined, elegant manner.

Delius (dē'lē əs), **Frederick,** 1862–1934. An English composer whose music combines features of both romanticism and impressionism, as well as making use of native English materials. Delius's best works are short pieces portraying the English countryside, such as his "On Hearing the First Cuckoo in Spring" and "The Walk to the Paradise Garden" (from his opera *A Village Romeo and Juliet*). He was also very successful in adapting various folk elements to his music, as in *Appalachia* (he lived in the United States for a year), *Brigg Fair,* and *North Country Sketches.* Although the forms he used were those of the romantic period, Delius employed a number of devices made popular by the impressionists (see IMPRESSIONISM), notably dissonant harmonies and the whole-tone scale.

Delta blues See under BLUES.

demisemiquaver (dem" ē sem' ē kwā" vər). The British term for THIRTY-SECOND NOTE.

déploration (dā plô rä syôn') The French term for LAMENT.

derb (derp) *German.* A direction to perform in a rough, bold manner.

descant (des'kant). **1** In polyphonic music (music with more than one voice-part), an upper part. Today, a descant is often a melody added to an already familiar hymn, carol, or folk song, the familiar part being sung by the congregation or one section of a group, and the higher melody being sung by a choir or simply another section of a group. (See also DISCANTUS.) **2** Also, *discant.* In the seventeenth century, particularly in England, the highest-pitched instrument of a family of instruments, for example, descant viol or descant recorder. **3** For English descant, see under MEDIEVAL.

descending motion See under MOTION, def. 1.

descending valve See under VALVE.

descort (de kôr') *Provençal.* See under LAI.

descriptive music Another term for PROGRAM MUSIC.

desk In the orchestra, a music stand used for a stringed instrument (violin, viola, cello, or double bass). In practice each desk is shared by a pair of performers, so by extension the term refers to each pair of violinists, violists, etc. The term **first desk** refers to the leader and assistant leader of a string section, in the case of the first violins, the concertmaster and assistant concertmaster.

Des Prez, Josquin See JOSQUIN DES PREZ.

destra (des' trä) *Italian:* "right." Also, *colla destra* (kôl' lä des' trä). A direction to play a note or passage with the right hand.

détaché (dā tA s̠hā') *French:* "detached." A direction to perform a series of notes slightly separated from one another. On the violin, this effect is produced by short, vigorous strokes of the bow, alternating the direction of each stroke (up, down, up, down, etc.). The effect is indicated in written music by placing dashes over or under the notes to be treated in this way. —**grand détaché** A direction to use long, vigorous bow strokes in alternating directions.

deutlich (doit'lik̠H) *German.* A direction to perform clearly and distinctly.

Deutsch (doic̠h). Abbreviation for the thematic catalog of Schubert's works in chronological order of composition, compiled in 1928 by the Austrian musicologist Otto Erich Deutsch (1883–1967) and subsequently revised several times.

deutscher Tanz (doi'c̠hər tänts) *German:* "German dance." A dance in 3/4 meter (waltz time) of the late eighteenth and early nineteenth centuries. Mozart, Beethoven, and Schubert all wrote dances of this kind. Some of those by Schubert (*Deutsche Tänze*, op. 33) are like slow waltzes (for example, no. 10) and others are brisk and lively (nos. 1, 6, and 9). See also ALLEMANDE, def. 2.

deux, à (A dœ') *French:* "for two." **1** An indication that a part is to be played by two instruments or two groups of instruments together, for example, the first and second violins playing in unison. **2** An indication that a composition or section is written for two voice-parts.

development **1** The process of changing a musical theme or musical idea. A theme may be broken up into smaller sections, or it may have its notes grouped differently (rephrased), or its harmony changed, or its rhythm altered. Moreover, such changes may be made singly or in combination, resulting in an enormous variety of possibilities. Development is a basic procedure of com-

position, particularly in longer works.
2 The second section of a movement
in SONATA FORM, in which the themes
presented in the first section (called
the EXPOSITION, def. 2) are reworked.

D-flat One of the musical tones (see
PITCH NAMES), one half tone below D
and one half tone above C. On the
piano, D-flat is identical with C-sharp
(see ENHARMONIC for an explanation).
The major scale beginning on D-flat
is known as D-flat major. A composi-
tion based on this scale is said to be in
the key of D-flat major, the KEY SIGNA-
TURE for this key being five flats. For
the location of D-flat on the piano,
see KEYBOARD.

di For Italian musical terms begin-
ning with *di*, such as *di nuovo*, see
under the next word (NUOVO).

diapason (*English* dīʹ″ ə pāʹ zən; *French*
dyA pA zôn ʹ). 1 A group of organ pipes
that provide the basic tone of the
instrument (see ORGAN; PRINCIPAL, def.
1). 2 The French word for TUNING FORK.
3 The range of a voice or instrument.

diapason normal (dyA pA zôn″ nôr
mAlʹ). The French term for CONCERT
PITCH, which in 1859 was established
as the A above middle C at a fre-
quency of 435 cycles per second.

diatonic (dīʺə tonʹik). 1 Pertaining to
or containing the notes that make up
an octave containing five whole
tones and two half tones. Both the
major and minor scales are diatonic,
as are the CHURCH MODES. For example,
one such arrangement is F, G, A, B♭, C,
D, and E, constituting the scale of F
major; the remaining notes, which do
not belong to this scale, are termed
chromatic. Naturally, the terms "dia-
tonic" and "chromatic" apply only
when a specific key (scale) is in ques-
tion. In music where no particular
key is used (see ATONALITY) the terms
have no meaning. 2 Proceeding by
scale degrees. 3 Using DIATONIC HAR-
MONY.

diatonic chord A chord made up
only of diatonic notes, for example,
F–A–C in the key of F major; the
chord F–A–C♯, on the other hand, is
called a chromatic chord, since it
contains a chromatic note (C-sharp).

diatonic harmony Harmony that
consists chiefly of diatonic chords (it
is rarely possible to exclude all chro-
matic notes).

didgeridoo Also, *didjeridu* (didʹjer i
dōōʺ) *Australian aborigine*. An end-
blown straight natural trumpet, with-
out a separate mouthpiece, that is
used by Australian aborigines. The
average instrument is 1 to 1.5 meters
(39 to 59 inches) long, with a bore of
3.5 to 7.5 centimeters (1.3 to 2.9
inches) but exceptionally large ones,
2.5 meters long, are used in special
ceremonies. It sounds a bass drone
with waves of high overtones. Among
the aborigines the didgeridoo may be
played only by men. In addition to
ceremonial functions, it is used to
accompany singing and dancing, sup-
ply rhythm and tone color as well as
being used as a drone. Western com-
posers use it occasionally, as Annea
Lockwood does in *Thousand Year
Dreaming* (1993) for ten instruments.

Dies irae (dēʹās ērʹe) *Latin:* "day of
wrath." A section of the Roman
Catholic Requiem Mass (the Mass for
the dead) whose text and music date
from the thirteenth century. Although
early composers of Requiem Masses
used the original monophonic (with a
single voice-part) music for this sec-
tion as a SEQUENCE, later composers,
among them Mozart and Verdi, set the
words to more dramatic music of their
own. The original music has also
been used to suggest the idea of death
in some secular (nonreligious) com-
positions, as by Saint-Saëns in his
Danse macabre ("Dance of Death")
and by Berlioz in his *Symphonie fan-
tastique* ("Fantastic Symphony").

diferencia (dē fe renʹthē ä) *Spanish:*
"variation." A musical form consist-
ing of THEME AND VARIATIONS. Many fine
diferencias for lute and keyboard

diatonic chromatic

instruments were written by Luis de Narvaez, Antonio de Cabezón, and other sixteenth-century Spanish composers. Narvaez was one of the first to use the form of theme and variations, which he developed to an extent extraordinary for his time.

differential tone See under TARTINI, GIUSEPPE.

digital piano See under PIANO.

digital recording Also, *laser recording*. A means of recording sound that uses computer technology to translate musical or other sounds into a multitude of binary digits (hence "digital"), or bits, which are then reconverted into sounds by means of a laser and converter and can be amplified and played through loudspeakers. Earlier recording methods all are based on analog principles, that is, the grooves on a record are replicas ("analogs") of the actual sound waves, and their fidelity (faithfulness to the original sounds) depends on how closely they correspond to it. To play back sounds the grooves are tracked with a needle or stylus, which further distorts the sound to some degree. Digital recording, developed in the late 1970s, uses neither groove nor stylus. Each sound, defined by its basic characteristics of pitch, loudness, timbre, and so on, is encoded as a binary number, and it is these numbers rather than the wave forms of the sounds that are recorded as a series of bits—strings of 1 and 0. The numerically defined sounds are immune to distortion. The bits are etched, in the form of tiny pits, into a **compact disk**, or *CD,* which looks like a shiny aluminum disk with a clear plastic cover. To play the sounds back, a digital audio system, in which the pickup is not a stylus but a small laser, is used. The laser shines a fine beam of light on the tiny pits and, by registering changes in reflected light, counts them. The count, interpreted by a special circuit called a digital-to-analog converter, spells out the musical wave form into its original shape, which can then be amplified and played through speakers. Compared to analog records, the digital technique produces more clarity of sound, greater depth and definition of the low bass (no longer constrained by the limited width of the record groove), total absence of scratch, hiss, and other background noise, and no record wear. The compact disks are almost infinitely durable; since nothing but weightless laser beams touches them during play, there is no abrasion. The coating of durable plastic prevents corrosion. However, because digital sound is so close to the original, it clearly shows up any errors on the part of record producers. Further, listeners accustomed to the extraneous noises of the concert hall and the distortions of analog recording may at first find the very clarity and fidelity of digital sound quite strange.

The original compact disk was designed mainly for classical music (its playing time of 70 minutes was based on the duration of Beethoven's Symphony no. 9). Subsequently different digital formats were designed for popular music, a *minidisk* (*MD*) of 2.5 inches and a *digital compact cassette* (*CDD*). Still another format is the *digital audio tape* (*DAT*), a smaller than conventional cassette that can accommodate more detail than compact disks and consequently is widely used by recording companies to make professional tapes.

Digital technology also has been extended to telecommunications techniques, enabling compact-disk sound to be transmitted over special telephone lines. First used for film soundtracks, this technology enables musicians to collaborate on a "live" recording even when they are physically separated by thousands of miles.

diluendo (dē"lōō en'dô) *Italian*. A direction to perform more and more softly, so the music seems to fade away.

dim. Also, *dimin*. An abbreviation for DIMINUENDO.

diminished chord A chord that con-

tains one or more diminished intervals. The most important kinds of diminished chord are the diminished triad (for example, B–D–F) and the diminished seventh chord (a diminished triad plus a minor third, such as B–D–F–A♭). See CHORD for an explanation of these terms.

diminished interval An interval that is one half tone smaller than the corresponding perfect or minor interval (see INTERVAL, def. 2, for an explanation of these terms). In practice, the most important diminished intervals are the diminished fifth (one half tone smaller than the perfect fifth) and diminished seventh (one half tone smaller than the minor seventh.)

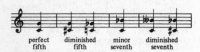

perfect diminished minor diminished
fifth fifth seventh seventh

diminuendo (dē mē"noō en'dô) *Italian*. Another word for DECRESCENDO. Often abbreviated *dim.* or *dimin*.

diminution Decreasing the time values of all the notes in a theme (short melody), so that, for example, all the quarter notes become eighth notes and the half notes become quarter notes. (The opposite process, in which, for example, all the quarter notes become half notes and the half notes become whole notes, is called AUGMENTATION.) Both diminution and augmentation are common means of varying a theme, and they are often used in fugues, as well as in sonatas and symphonies.

D'Indy, Vincent See INDY, D', VINCENT.

disc Another spelling for *disk*; see DIGITAL RECORDING.

discant (dis'kant). Another spelling of DESCANT.

discantus (dis kan'təs) *Latin:* "different song." **1** Originally, a melody that was added to an already existing melody. The main part was called CANTUS and usually lay in the tenor, while the added part was generally

above it, in the treble (soprano). **2** Music in which one or more such parts were added, and, since such music in the twelfth century was in note-against-note style, the term also came to mean music in strict rhythm. **3** In the fourteenth century, when most polyphonic music was contrapuntal, the term was occasionally used as a synonym for COUNTERPOINT.

disco A style of dance music of the late 1970s and early 1980s, usually recorded. It is characterized by a relentless 4/4 beat, instrumental breaks, and erotic lyrics or rhythmic chants. An outgrowth of nonstop music played by disk jockeys who remixed records by boosting the bass and sequencing them into continuous music, it was gradually superseded by FUNK.

discord Another term for DISSONANCE.

disinvolto (dēs" ēn vôl' tô) *Italian*. A direction to perform in a free, easy, spontaneous manner.

disjunct motion See under MOTION, def. 1.

disk jockey Also, *disc jockey, deejay, D.J.* A person responsible for selecting, sequencing and presenting recorded popular music in a discotheque or radio broadcast, as well as acting as master of ceremonies. Also see RAP; REGGAE.

dissonance (dis'ə nəns). Also, *discord.* A musical interval or chord that sounds harsh or unpleasant (a chord or interval that sounds pleasant is called a CONSONANCE). A dissonant interval or chord seems restless and appears to call for RESOLUTION into a subsequent consonant interval or chord. From about 1500 to about 1900, all intervals except the unison, the major and minor third, the perfect fifth, the major and minor sixth, and the octave were classed as dissonances. Although these intervals and chords containing them could be employed, there were strict rules governing their use and the ways in which they had to be resolved into

consonances. In most twentieth-century music, these rules are largely ignored, and the traditional distinction between consonance and dissonance is no longer made.

dissonant counterpoint See under CRAWFORD SEEGER, RUTH.

div. The abbreviation for DIVISI.

divertimento (dē ver"tē men'tô) *pl.* **divertimenti** (dē ver" tē men' tē) *Italian.* In the late eighteenth century, a composition in several movements (usually more than four) scored for a small instrumental group and intended chiefly to be entertaining (occasionally even humorous). The best-known composers of divertimenti are Haydn and Mozart, each of whom wrote numerous works of this kind. Closely related to the divertimento in form are the SERENADE and CASSATION.

divertissement (dē ver tēs män'). **1** The French term for DIVERTIMENTO. **2** A composition based on familiar tunes. **3** A ballet, dance, or instrumental piece inserted between the acts or elsewhere in a French opera of the baroque period (1600–1750), having no connection with the plot but serving purely to entertain.

Divine Office See OFFICE.

divisi (dē vē' sē) *Italian:* "divided." A term used in scores to indicate that a group of instruments that normally play one part are to play two or more separate parts, often written on the same staff. The direction is most often given to a string section, such as the first violins. The end of the divisi section, when the instruments are to resume playing one part together, is usually marked TUTTI or UNISONO. Often abbreviated *div.*

division 1 In seventeenth- and eighteenth-century English music, a variation on a *basso ostinato* or ground bass (see OSTINATO), that is, a pattern of notes or chords that is repeated over and over in the bass. The divisions might be written down by a composer or improvised (invented on the spot) by a performer. The variations were most often played on a bass viol (viola da gamba), although some sets exist for recorder and other treble instruments. The ostinato part was played on a second bass viol, or a lute, organ, or harpsichord. **2** During the Renaissance, one of several names for the manner of free embellishment, which consisted of winding around the written notes, filling in leaps, and jumping to other notes. The name comes from the fact that the embellishments most often were made around long-held notes, which in effect were divided into series of shorter note values.

division viol A bass viol of slightly smaller size than the normal bass and often used for playing divisions (see DIVISION, def. 1).

Dixieland One of the earliest styles of JAZZ, established in New Orleans, Louisiana, in the early 1900s and later taken over by white jazz musicians in Chicago in the 1920s. The Original Dixieland Jazz Band was formed about 1911 by five black musicians from New Orleans, and their instrumentation—cornet, clarinet, trombone, piano, and drums—also came to be identified as Dixieland. Also abbreviated *Dixie.*

D.J. Abbreviation for DISK JOCKEY.

do (dō). Also, *doh.* In the system of naming the notes of the scale (see SOLMIZATION), the first note of the scale (the others being *re, mi, fa, sol, la,* and *ti*). —**fixed do** A system of solmization in which *do* always stands for C. —**movable do** A system of solmization in which *do* stands for the first note of any scale (D in the scale of D, E-flat in the scale of E-flat, etc.). See also TONIC SOL-FA.

dodecaphonic (dō dek" ə fon' ik). Also, *dodecuple* (dō dek' yū pəl). Another term for twelve-tone (see TWELVE-TONE TECHNIQUE; SERIAL MUSIC).

dodecuple See DODECAPHONIC.

doh (dō). Another spelling for DO.

Dohnányi (dô<u>KH</u> nyä' nyē), **Ernö** (er'nœ), 1877–1960. A Hungarian pianist and composer whose music carried on the late romantic tradition of Brahms. A highly influential figure in the musical life of his country (even more so than his famous contemporaries, Bartók and Kodály), Dohnányi is known outside his native land chiefly for his *Variations on a Nursery Song* for piano and orchestra, first performed in 1916.

Dolby (dôl'bē). A noise-reduction system for recording equipment named for its inventor, Ray Dolby, and used since about 1966 to eliminate recording-tape hiss. It originally consisted of a series of aluminum boxes containing more than five hundred resistors, transistors, and capacitors. Since then several improved versions have been developed, and today similar noise-reduction systems are available from other manufacturers as well.

dolce (dôl'<u>c</u>he) *Italian.* A direction to perform in a soft, sweet manner.

dolente (dô len'te) *Italian.* Also, *doloroso* (dô lô rô'sô). A direction to perform in a slow, sorrowful manner.

doloroso See DOLENTE.

dominant The fifth degree of the diatonic scale, that is, the fifth note in any major or minor scale (see SCALE DEGREES). In the key of C major the dominant is G, in the key of D major the dominant is A, in the key of A minor the dominant is E, etc. The dominant is so called because of its powerful role in melody and harmony, where it is second in importance only to the tonic, or keynote (C in the key of C, D in the key of D, etc.). In analyzing the harmony of a composition, the Roman numeral V or the letter D is used to indicate the dominant or a chord built on it. — **dominant chord** A chord built on the dominant. The most important dominant chords are the dominant triad—the major triad whose root is the dominant (in the keys of C major

and C minor, G–B–D); the dominant seventh chord—the dominant triad with an added third (in C major and C minor, G–B–D–F); and the dominant ninth chord—the dominant seventh chord with an added third (in C major and C minor, G–B–D–F–A). — **secondary dominant** The fifth degree above a note other than the tonic of a composition or section, or a chord based on such a degree. If the normal dominant (the fifth degree of the tonic) is indicated as "V of I" or "V/I" (dominant of tonic), then the dominant of the second degree (supertonic) is indicated as "V of II" or "V/II," etc. Thus, a D–F♯–A chord appearing in a piece in C major might be called "V of V," since the D-major triad is the dominant triad in G major, which in turn is the dominant of C.

Donizetti (dô"nē dzet'tē), **Gaetano** (gä"ē tä' nô), 1797–1848. An Italian composer who wrote a large number of operas, some of which are still regarded as outstanding examples of Italian opera of this period. Donizetti's works are notable for their lovely melodies. A very fast worker, he produced some seventy operas in all. Of them, the best known are *Lucia di Lammermoor* and the comic operas *L'Elisir d'amore* ("The Elixir of Love"), *La Fille du régiment* ("The Daughter of the Regiment"), and *Don Pasquale*.

doo wop A style of African-American popular music that originated in the 1950s and early 1960s, and was revived in the 1980s. Originally it consisted of unaccompanied close-harmony singing by four or five men's voices, similar to a barbershop quartet. The music had a simple blues structure, and the lyrics were either nonsense syllables or simple love songs. Later the style was imitated by white vocal groups.

doppel (dô'pəl) *German:* "double." Used in musical terms such as *doppel-Be* ("double flat") and *doppelkreuz* ("double sharp").

doppelt (dô'pəlt) *German:* "twice."

Used in directions such as *doppelt so schnell* ("twice as fast") and *doppelt so langsam* ("twice as slow").

doppio (dôp'pyô) *Italian:* "double." Used in musical terms such as *doppio bemolle* ("double flat"), *doppio diesis* ("double sharp"); or in directions such as *doppio tempo* and *doppio movimento* ("double speed" or "twice as fast").

Dorian mode The authentic mode beginning on D. See under CHURCH MODES.

dot 1 A dot above or below a note indicates that it is to be performed as lightly and quickly as possible, that is, STACCATO. **2** A pair of dots, one above the other, next to a double bar line indicates that the section or piece is to be repeated (see also DOUBLE BAR). **3** A pair of dots, one above the other, appears to follow the sign for the bass clef; however, they are actually part of the sign. **4** A dot after a note indicates that the note has half again its normal time value, that is, it is to be held half again as long as normally. A dotted quarter note, therefore, is to be held as long as one quarter note plus one eighth note, a dotted half note as long as one half note plus one quarter note, etc. —**double dot** A second dot placed after the first means that the note should be held three-fourths again as long as normally, that is, with three-fourths of its time value

♩. = ♪♪ ♩. = ♩♩ ♩.. = ♩♪♪ ♩.. = ♩♪♪

added to it. Thus, a double-dotted quarter note should be held as long as one quarter note plus one eighth note plus one sixteenth note, a double-dotted half note as long as one half note plus one quarter note plus one eighth note, etc.

dotted rhythm A rhythm in which long notes alternate with one or more short notes, the long notes usually being dotted (see DOT, def. 4). From the sixteenth through eighteenth

centuries, the precise relationship of the long–short values varied, as did the performance of the rhythms so notated. For example, the long notes were sometimes lengthened and the short ones delayed for expressive purposes or to exaggerate the effect.

double (dub'əl). **1** To play a second instrument in addition to one's regular instrument. Thus a flutist may be called upon to play the piccolo (in which case one is said to "double on piccolo"). Oboists normally double on English horn, and clarinetists may double on saxophone. **2** To play in unison with another instrument. Thus, the bassoons in an orchestra may double the cellos, or all the horns may play in unison, in which case the second and third horns are said to be doubling the first horn. **3** To play an octave higher than another instrument. Thus, the piccolo often doubles the flute in an orchestra. **4** To play or sing at some other fixed interval (usually a third or a sixth) from another instrument or singer. **5** (do͞o o'bl⁾) *French.* In seventeenth- and eighteenth-century suites, a term meaning VARIATION. A double may be an elaborated repeat section of a dance movement, as in the courante of Bach's English Suite No. 1, or one of a series of variations, as in Handel's "Air with Doubles," familiarly known as "The Harmonious Blacksmith."

doublé (do͞o blā'). The French word for turn (see under ORNAMENTS).

double appoggiatura See APPOGGIATURA, DOUBLE.

double bar A pair of parallel vertical lines that mark the end of a composition or section. A double bar differs from a single BAR LINE in that it can occur within a measure. Two lines of the same width mark the end of a section; a thin line followed by a thicker one marks the end of a composition. If the double lines are preceded by a pair of dots, one above the other (as in the accompanying example), the section immediately before the double bar is to be repeated. If the lines

are followed by dots, the section immediately following the double bar is to be repeated. If dots appear both before and after the double bar, both the preceding and succeeding sections are to be repeated. In the accompanying example, the first four measures are to be repeated before the final four measures are performed.

double bass Also, *contrabass, bass, string bass, bass viol.* The largest and lowest-pitched member of the violin family. The double bass is more than six feet high and therefore is rested on the floor to be played. The performer either stands or perches on a high stool. Unlike the violin, viola, and cello, the double bass has a flat back, and its shoulders slope downward instead of being rounded. In addition, its four strings are tuned a fourth apart, instead of being tuned in fifths. All three of these features, which make the instrument somewhat easier to play, are characteristics of the VIOL, from which the double bass is descended. In fact, some authorities do not consider the double bass a true member of the violin family at all.

The strings of the double bass are tuned E A D G, and the music is written an octave higher than it sounds in order to avoid the continuous use of ledger lines below the bass clef (the accompanying example shows how the music is written). Occasionally, a fifth string, tuned to C, is added, or the E string is lengthened and a mechanism is added to the neck of the instrument that makes it possible to play the C below. This permits the double bass to play an octave below

the cello at all times. A skilled performer can greatly exceed the instrument's natural upper range through the use of harmonics (see HARMONIC SERIES), which, owing to the great length of the strings, are more readily available on the double bass than on other stringed instruments. Today, two kinds of bow are used for the double bass. One is quite similar to the cello bow but is thicker, heavier, and more curved. This type is generally preferred by French, English, and American players. The other, preferred in Germany and hence known as the German or Simandl bow (named for a nineteenth-century Viennese, Franz Simandl, who introduced it), has a longer, slenderer stick, a much wider frog, and is held with the hand under the stick (palm up), in the manner of a viol bow. The double bass is more frequently plucked than any of the other bowed instruments, and a large variety of effects can be obtained in this way. This feature has made it an important rhythm instrument in dance bands and jazz ensembles, in addition to its role in the orchestra. (The bass of rock groups is usually an electric bass; see under ELECTRONIC INSTRUMENTS.) One of the greatest jazz bassists was Charlie Mingus (1922–1979).

Although the double bass is used in every symphony orchestra, important solo passages for it are rare. One well-known one is found in Saint-Saëns's *Le Carnaval des animaux* ("The Carnival of the Animals"), in the section "The Elephant." The double bass is not often called for in chamber music, although there are a few important exceptions, among them Schubert's "Trout" Quintet (for violin, viola, cello, double bass, and piano), and Dvořák's Quintet in G major (for two violins, viola, cello, and double bass). Two famous double-bass players of the past who wrote outstanding compositions for their instrument are Domenico Dragonetti (1763–1846) and Giovanni Bottesini (1821–1889). More recent works include a quartet for double basses by the Russian violinist and composer Arcady Dubensky

(1890–1966); Concertos for double bass and chamber orchestra by Gunther Schuller (1968); Hans Werner Henze (1966); and a Concerto by the eminent conductor and bassist Serge Koussevitsky (1874–1951).

The double bass developed during the sixteenth century from the six- or seven-string contrabass member of the viol family and over the years has varied considerably in size, shape, and stringing. During the nineteenth century a three-string instrument (tuned A D G, or G D A, or G D G) was highly regarded, and in parts of Europe three-string basses are still used for folk music.

double-bass Also, *contrabass*. A term used to distinguish instruments pitched lower than the bass instrument of the same family. Thus, the double-bass clarinet is pitched an octave below the normal bass clarinet. (For double-bass clarinet, double-bass trombone, etc., see under CLARINET, TROMBONE, etc.)

double bassoon See under BASSOON.

double B-flat bass See BB-FLAT BASS.

double canon See under CANON.

double chorus A composition or section for a choir that has been divided into two sections, each of which usually has the full complement of soprano, alto, tenor, and bass voices. Composers of the VENETIAN SCHOOL particularly favored this form.

double concerto See under CONCERTO.

double counterpoint See under COUNTERPOINT.

double course See under COURSE.

double dot See under DOT.

double escapement See under ESCAPEMENT.

double euphonium See under EUPHONIUM.

double flat An accidental that lowers the pitch of a note by two half tones, indicated by the sign ♭♭. On a key-

board instrument a double flat sounds the same as the note one whole tone below it (B♭♭ equals A, A♭♭ equals G, etc.). See also ACCIDENTALS.

double fugue See under FUGUE.

double horn See under FRENCH HORN.

double instrument An instrument that combines features of two instruments. Examples are the double horn, which combines the French horn in F with the French horn in B-flat by means of an additional valve and tubing, and the double euphonium, which has both the bell of a euphonium and that of a saxtromba, the player choosing one or the other by means of a valve.

double mordent See illus. under ORNAMENTS.

double quartet See under OCTET, def. 2.

double reed A specially shaped strip of cane, folded in half and bound so that its free ends will vibrate against each other when a stream of air passes between them. The vibration of a double reed produces the sound in the oboe, English horn, bassoon, and several other wind instruments, including some kinds of bagpipe. In most double-reed instruments, the player places the reed just inside the mouth, controlling it with the lips and tongue. The accompanying illustration shows an oboe reed at the left and a bassoon reed at the right.

double sharp An accidental that raises the pitch of a note by two half tones, indicated by the sign ✗ On a keyboard instrument, a double sharp

sounds the same as the note one whole tone higher (C✕ equals D, D✕ equals E, etc.). See also ACCIDENTALS.

double stopping In violins and other bowed stringed instruments, the playing of two notes at the same time, either by stopping (holding down) two strings with the fingers so that the bow passes over them in one stroke, or by passing the bow across two open strings at the same time. In either case, the two strings must be adjacent. Double stopping is one of the most important techniques in string playing. See also STOPPING, def. 1.

double time An indication that a section is to be played in a tempo twice as fast as some previous tempo.

double tonguing See under TONGUING.

double whole note See BREVIS.

doucement (dōōs män') *French.* A direction to perform in a sweet, singing manner.

douloureux (dōō lōōr rœ') *French.* A direction to perform in a slow, sorrowful manner.

doux (dōō) *French.* **1** A direction to perform in a sweet, singing manner. **2** A direction to perform softly.

Dowland (dou' lənd), **John,** 1562–1626. An English composer and the most celebrated lutenist of his day. Of his compositions, his solo songs with lute accompaniment, in the form called AYRE, are among the finest of their kind. The melodies often are characterized by elaborate chromatic development, and the accompaniment is treated as a separate entity, resulting in unusual harmonies. Born in Ireland, Dowland lived not only in England but in France, Italy, and Denmark, and he served at the Danish and English royal courts. In addition to songs, Dowland wrote numerous lute pieces and music for instrumental groups.

downbeat The first (accented) beat of a measure, so called because a conduc-

tor ordinarily moves his or her hand or baton downward at the beginning of a measure. Also see UPBEAT.

down-bow See under BOWING.

drag On a snare drum, a beat in which the accented stroke is preceded by two quick, light, unaccented strokes.

dramatic soprano See SOPRANO, def. 2.

drammatico (dräm mä' tē kô) *Italian.* A direction to perform dramatically, or in a slightly exaggerated manner.

drängend (dreng'ənt) *German.* A direction to perform in a hurried manner, as though pressing on to the end.

droite (drwAT) *French:* "right." A direction to play a note or passage with the right hand.

drone **1** Any of the low pipes of the bagpipe, which produce only one note each and sound continuously. **2** Also, *drone string.* One or more strings that sound only a single note each. In some instruments, such as the dulcimer, the drone strings are played along with stopped strings (that is, strings whose pitch is altered by being held down at various points). In other instruments, such as the baryton and sitar, the drones are not actually touched by the performer but vibrate sympathetically along with the played strings (see also SYMPATHETIC STRINGS). **3** An instrument, such as the Indian tambura, used to produce a single continuous sound as an accompaniment to other instruments or to voices. **4** Another name for PEDAL POINT.

drone bass A bass part consisting of one or a few low, long-held notes, creating an effect similar to a bagpipe's drones. See also BOURDON; PEDAL POINT.

drone string Another name for DRONE, def. 2.

Druckman (druk'mən), **Jacob,** 1928 – . An American composer who

became known for both his acoustic and electronic music which, while carefully crafted and meticulously written out, is also very dramatic and demands expressive and imaginative execution by the performers. In some of his works, notably his *Animus* series, Druckman sets one or more live performers against a tape, contrasting virtuosity with the vast possibilities of electronic sound; in *Animus I* (1966) it is a solo trombonist, and in *Animus IV* (1977) it is a tenor and six instrumentalists. A number of Druckman's compositions have been used for ballets. A respected teacher of composition, he joined the Yale University faculty in 1976. Other notable works of Druckman's are *Antiphonies I, II,* and *III* (1963) for two mixed a cappella choruses; *Synapse—Valentine* (1970) for double bass and tape; *Windows* (1972) for orchestra; Concerto for viola and orchestra (1978); String Quartet no. 3 (1981); *Vox humana* (1983) for chorus, soloist, and orchestra; and *Reflections on the Nature of Water* (1986) for marimba.

drum A percussion instrument consisting of a frame or container (hollowed-out log, half a shell, kettle, or tube) over which is stretched a piece of thin material (cloth, paper, skin, or plastic). Drums are made to sound by being struck, either with the hands or with one or two mallets (sticks) or rattles. Thought to be among the first instruments invented (perhaps the very first), drums of one kind or another are found among every people, all over the world. Although they exist in many sizes and shapes, all drums belong to either of two types, those of indefinite pitch and those that can be tuned to sound a particular note. The most important drums in modern bands and orchestras are the SNARE DRUM, BASS DRUM, and TENOR DRUM, all of indefinite pitch, and the TIMPANI, which are tuned to a definite pitch. Drums are a necessary part of every symphony orchestra and of bands of all types, but it is in jazz

and rock that drummers may have the best chance to display their skill. Outstanding jazz drummers include Gene Krupa, Buddy Rich, Sid Catlett, and Milford Graves. See also BONGO DRUMS; TABLAS; TAMBOURINE; TOMTOM; TRAPS. For special effects produced on drums, see DRAG; FLAM; ROLL.

drum and bugle corps A marching band that includes bugles in various sizes—soprano, flugel bugle, mellophone, French horn, baritone, contrabass, double contrabass—and a percussion section consisting of a snare drum, pitched bass drums, cymbals, **tri-toms** (three drums—tenor, baritone, and bass—carried by one drummer), and five sizes of marching (portable) timpani. The precise instrumentation varies, depending on the group's size. Drum and bugle corps are traditionally associated with the armed services; civilian drum and bugle corps are mostly for young people in high school or college.

drum machine Another name for drum synthesizer. See under SYNTHESIZER.

D.S. Also, *d.s.* The abbreviation for dal segno (see SEGNO, DAL).

D-sharp One of the musical tones (see PITCH NAMES), one half tone above D and one half tone below E. On the piano, D-sharp is identical with E-flat (see ENHARMONIC for an explanation). The minor scale beginning on D-sharp is known as D-sharp minor. A composition based on this scale is said to be in the key of D-sharp minor, the KEY SIGNATURE for this key being six sharps. For the location of D-sharp on the piano, see KEYBOARD.

dub A recording technique originally used in REGGAE. The first side of a recording is remixed so that the singers are eliminated ("dubbed out"), leaving only the instrumental portion of a song. The disk jockey plays first the entire song and then the dub, with only the instruments, over which he improvises his patter (see RAP). Some-

times, one or more live vocalists sing over the dub. In other popular music heavily dependent on recording, such as rap, dub became an essential element as disk jockeys took records and, for example, boosted the bass, added extramusical noise, and/or phased parts of the vocal line in and out, totally revising the music. See also DUBBING.

dubbing Also, *overdubbing.* In electronic music, the process of combining and mixing together prerecorded and new material. This process, attempted by early electronic composers with simple equipment, has been greatly assisted by the development of multitrack recorders. On an eight-track recorder, for example, each voice-part of an octet can be recorded on its own track, either at different times or simultaneously in isolation (that is, each performer listens to the others over headphones while playing his or her own part). If one performer makes a mistake, only that track needs to be rerecorded. After all the parts are recorded, the various tracks are mixed down to a stereo (two-track) tape that gives the illusion that all were played simultaneously. Dubbing also permits a single performer to play several parts. An extreme instance is Daniel Werts's *Symphony for Large Ensemble* (1984), in which the composer himself plays every instrument: four oboes, two English horns, two bass clarinets, flutes, electric guitar, piano, synthesizers, trumpets, and chromatic wind chimes.

A major problem in early dubbing was tape hiss. When a tape is recorded, some noise is generated by the interaction of the recording head with the tape. As each successive track is recorded, tape hiss builds up at a geometric rate; thus, 16-track tape generates 256 times as much noise as one track. This problem eventually was alleviated by the introduction of DOLBY.

Dudelsack (dōō' dəl zäk) *German.* See under BAGPIPE.

due, a (ä dōō'e) *Italian:* "for two." 1 An indication that a part written on one staff is to be played by two instruments or two groups of instruments together, for example, the first and second violins playing in unison, or, sometimes, DIVISI (the score makes clear which is meant). 2 An indication that a composition or section is written for two voice-parts.

due corde See under CORDA.

duet A composition for two performers, with or without accompaniment, in which the soloists are equal in importance. —**vocal duet** A composition for two singers, with or without piano accompaniment. —**piano duet** A composition for two pianists, playing either on one piano (often marked "piano, four hands") or on two pianos. However, the term *duo-pianists* nearly always means two pianists playing on two instruments. See also PIANO DUET. —**instrumental duet** A composition for two instrumentalists, for example, a sonata for two violins, which may or may not have piano accompaniment. Furthermore, the instruments need not be the same; a sonata for flute and oboe, for example, is also termed an instrumental duet. See also DUO.

Dufay (dY fä ē'), **Guillaume** (gē yōm'), c. 1400–1474. The principal composer of the BURGUNDIAN SCHOOL. He was among the first of many northern composers to work for long periods in Italy, but his later life was spent in France, especially Cambrai, to which he attracted so many students that it became an important musical center. Although Dufay wrote music in all the forms of his time, he was most famous for his motets, cantus firmus Masses, and chansons. He was probably the first composer to use a secular tune as the basis for a Mass (see CANTUS FIRMUS). His chansons, songs in three and sometimes four voice-parts, were in the standard forms of French poetry, the virelai, ballade, and rondeau, but the last was by far his favorite form. Dufay helped develop a technique of

three-part writing that gave harmonic formulas for the voice-parts (see FAUXBOURDON, def. 1).

Dukas (dʏ kA'), **Paul** (pôl), 1865–1935. A French composer who achieved lasting fame with a single work, his scherzo for orchestra, *L'Apprenti sorcier* ("The Sorcerer's Apprentice"). A friend of numerous notable composers (among them D'Indy and Debussy), an influential music critic, and the teacher of such important musicians as Piston and Messiaen, Dukas is remembered also for his impressionist opera *Ariane et Barbebleue* ("Ariadne and Blue-beard") and a number of instrumental works.

dulcian Another name for CURTAL.

dulcimer (dul'si mûr). A stringed instrument of the Middle Ages, similar to a PSALTERY but with a flat, shallow soundbox, often three-sided but existing in a wide variety of shapes, over which ten or more courses (pairs or larger groups of strings) are

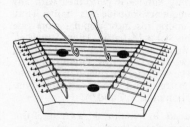

stretched. The strings are struck by a pair of small hammers, however, whereas in the psaltery the strings are plucked. Originating in western Asia, the dulcimer came to Europe about the twelfth century. Versions of it are still used in East European (Hungarian, Rumanian, Greek, Czech Slovak) folk music, where it is known by such names as **cimbalom**, **santouri**, and **Hackbrett**. It also is occasionally used in contemporary serious music, as, for example, in Peter Maxwell Davies's chamber work *Image, Reflection, and Shadow* (1982), which emphasizes the instrument's dusky,

twangy tone. —**Appalachian dulcimer** A plucked stringed folk instrument of the zither family that is used in the southern Appalachian mountain areas of the United States. Originally made in the late eighteenth century by mountain people of Scottish origin, it consists of a long, narrow, oval frame about three feet long and nine inches wide, over which are stretched three (usually) metal strings. One of the strings is a melody string, which produces various pitches when stopped (held down) at various points along its length, and the others are drones that sound a single note more or less continuously. The player holds the instrument flat, in the lap or on a table, and plucks the strings with the right hand, using the left hand to stop the melody string with a small stick or quill. Quite soft in tone, it is generally used to accompany a singer.

dumka (dōōm'kä) *pl.* **dumky** (dōōm'kē) *Czech.* A lament, originally a vocal piece. In the nineteenth century it was used as a name for melancholy instrumental pieces or movements by numerous Czech composers. Dvořák used it in his *Slavonic Dance* no. 2 and in several chamber works (his *Dumky Trio*, op. 90, is a set of six dumky).

Dunstable (dun' stə bəl), **John**, c. 1390–1453. Also spelled *Dunstaple*. An English composer, the leading figure in English music of his time, who is remembered particularly for his motets and his Masses. Many of Dunstable's motets are distinguished by the fact that the rhythm of the words governs the musical rhythm, that the different voice-parts are equal in importance, and that the parts move together in chords. Dunstable was one of the first to use double structure in portions of Masses, that is, building a single, long composition on two melodies, one in the tenor and the other in the highest part. (See also BURGUNDIAN SCHOOL.)

duo 1 A composition for two soloists, most often an instrumental duet (see

under DUET), and only seldom a piano or vocal duet. The term implies that the two soloists are equal in importance. **2** The French, German, and Italian names for duet.

duolo, con (kôn dwô'lô) *Italian.* A direction to perform in a sorrowful, grieving manner.

duple (dōō'pəl) **meter** Any METER in which there are two basic beats in a measure, such as 2/2 or 2/4.

duplet (dōō'plit). Two notes of equal time value (such as two quarter notes, or two eighth notes) that are played in the time normally taken to play three notes of that value. Duplets are used in a composition (or section of a composition) in triple meter—that is, any meter in which there are three basic beats per measure, such as 3/4 or 3/8. They are ordinarily indicated by a small figure 2 above or below the notes, or, occasionally, by dotted notes. As shown in the accompanying example, one of the two notes of a duplet may be replaced by a rest.

dur (dōōr). The German word for MAJOR; thus *C-dur* means C major.

duramente (dōō" rä men' te) *Italian.* Also, *duro* (dōō' rô), *con durezza* (kôn dōō ret' tsä). A direction to perform in a firm, bold manner.

durchkomponiert (dōōrкн' kom pô nērt"). The German word for THROUGH-COMPOSED.

durezza, con See DURAMENTE.

duro See DURAMENTE.

düster (dʏs' tər) *German.* A direction to perform in a gloomy, mournful manner.

Dvořák (dvôr' zhäk), **Antonin** (än' tôn yin), 1841–1904. A Bohemian (Czech) musician who became his country's greatest composer. Dvořák

began his musical career as a violinist and violist. In 1873 a patriotic composition of his, *Hymnus* for orchestra and chorus, proved a huge success, and he was able to devote himself to composing and teaching. Dvořák became known throughout Europe. His fame spread to America, and he came to the United States as artistic director of New York City's National Conservatory (1892–1895). During this period he wrote the best known of all his many works, his Symphony no. 9 in E minor (*From the New World*). Although some of the melodies in this work sound like black spirituals, Dvořák claimed that he did not plan this resemblance.

Dvořák's music is notable for its fresh, lilting melodies, its intense and interesting treatment of harmony, and his adaptation of Bohemian folk music. He was one of the leading nationalist composers (see NATIONALISM), and he wrote music in nearly every form—choral, chamber, symphonic, opera, songs. Of his operas, only *Rusalka* is performed with any frequency outside his native land. Among his most popular works are his Stabat Mater, Te Deum, *Symphonic Variations,* three *Slavonic Rhapsodies,* two cello concertos, Violin Concerto, Piano Concerto, piano trios, string quartets, and two of his nine symphonies (nos. 7 and 9).

dyad In serial music, a group of two pitch classes (see PITCH CLASS).

dynamic accent See under ACCENT.

dynamics The gradations of loudness or softness with which music is performed. The most important of the signs and abbreviations whereby they are indicated, called *dynamic marks,* are listed in the chart on page 123. Also see the separate entries for these terms. Dynamic indications were not generally used until the early seventeenth century, but by the middle of the eighteenth century all the present-day marks were in common use. Today most composers are quite specific about all

DYNAMIC MARKS

	Abbreviation or Sign	Meaning
pianissimo	pp, ppp	very soft
piano	p	soft
mezzo piano	mp	moderately soft
mezzo forte	mf	moderately loud
forte	f	loud
fortissimo	ff, fff	very loud
forte piano	fp	loud, then soft
sforzando, sforzato	sf, sfz	sharply accented
forzando, forzato	fz	sharply accented
crescendo	cres., cresc. <	gradually louder
decrescendo	decr., decres. >	gradually softer
diminuendo	dim., dimin.	gradually softer

directions for performance, including dynamics.

Dynamophone Another name for the Telharmonium (see under ELECTRONIC INSTRUMENTS).

E

E One of the musical tones (see PITCH NAMES), the third note in the scale of C major. The scales beginning on the tone E are known as E major and E minor. A composition based on one of these scales is said to be in the key of E major or the key of E minor, the key signatures (see KEY SIGNATURE) for these keys being four sharps and one sharp, respectively. The note one half tone below E is called E-flat or D-sharp (see ENHARMONIC for an explanation); the note one half tone above E is called E-sharp or F. For the location of these notes on the piano, see KEYBOARD.

early music A term generally referring to Western music of the Middle Ages and Renaissance, that is, up to about 1600, but sometimes extended to include the baroque period as well (to 1750). Since about 1950 there has been increasing interest in performing such music in what is believed to have been the style of the period, and using the instruments of the time, either surviving ones or reproductions. Groups devoted to this effort are frequently called **early music ensembles**. See also MEDIEVAL; RENAISSANCE; BAROQUE.

ear training The process of learning to recognize musical pitches, intervals, and rhythms, and reproduce them correctly. One of the most widely used methods of ear training is SOLFÈGE (def. 1).

échappée (ā s͟ha pā') *French*. See CAMBIATA, def. 1.

echo 1 In music, the repetition of a phrase or theme quite softly, as though coming from a distance, as a real echo does. This effect has intrigued numerous composers since the Middle Ages. Some of the polychoral compositions (compositions that use two choirs, usually in different parts of the church or hall) of the sixteenth and seventeenth centuries feature highly intricate echo effects, one chorus echoing the other. A common device in nineteenth-century music is the soft repetition of a trumpet signal or hunting call. **2** In electronic music, the imitation of a natural echo—that is, the repetition of a sound as it is reflected off a nonabsorbent surface—by electronic means, such as a tape recorder, use of an echo chamber, or a computerized delaying device. See also REVERBERATION.

echo organ A set of organ pipes designed to resemble the sound of an echo (see also ORGAN).

éclatant (ā klA tän') *French*. A direction to perform brilliantly, with dash.

écossaise (ā kô sez') *French*: "Scottish." A type of lively dance in 2/4 meter that was popular in France and England during the late eighteenth and early nineteenth centuries. Both Beethoven and Schubert wrote écos-

saises. The source of the name is not known, since the dance is not Scottish, does not resemble an actual Scottish dance, and is not the same as the SCHOTTISCHE.

editing The process of regulating the balance of thirty-two or so simultaneous tracks of recorded sound into the two or four used for stereophonic or quadrophonic reproduction. In this process, the engineer-producer must choose what instruments to emphasize, where on the stereophonic or quadrophonic field to place them, and the various sound levels for each. This combination is called the **mix,** and developing the proper mix can be very complicated. Editing also includes speeding up or slowing down a tape (or, sometimes, running it backward) for special effect, introducing electronic devices, deleting mistakes and inserting corrections, and the like. In the hands of a sophisticated editor, the final tape may sound nothing like what actually was produced in the recording studio.

E-flat One of the musical tones (see PITCH NAMES), one half tone below E and one half tone above D. On the piano, E-flat is identical with D-sharp (see ENHARMONIC for an explanation). The scales beginning on E-flat are known as E-flat major and E-flat minor. A composition based on one of these scales is said to be in the key of E-flat major or E-flat minor, the key signatures (see KEY SIGNATURE) for these keys being three flats and six flats, respectively. (For the location of E-flat on the piano, see KEYBOARD.) —**E-flat instrument** A transposing instrument, such as the E-flat clarinet (or clarinet in E-flat), which sounds each note a minor third higher than it is written, or the alto saxophone, which sounds each note a major sixth lower than it is written; in each case, the fingering for the written note C yields the pitch E-flat.

egualmente (e" gwäl men' te) *Italian.* A direction to perform evenly, with equal stress on each note.

eighth note British, *quaver.* A note, ♪, equal in time value to (lasting as long as) one-eighth of a whole note. Thus, eight eighth notes equal one whole note, four eighth notes equal one half note, and two eighth notes equal one quarter note. When eighth notes are written in succession, their flags are joined together into crossbars, called *beams:* ♪ ♪ = ♫.

eighth rest A rest, ♁, indicating a silence lasting the same length of time as an eighth note.

eilend (ī' lənt) *German.* Also, *eilig* (ī' liКH). A direction to perform in a hurried manner.

eilig See EILEND.

einfach (īn' fäКH) *German.* A direction to perform in a simple, unadorned manner.

Einleitung (īn' lī tōōng̃) *German.* An introduction or prelude.

élargissant (ā lАr zhē säN') *French.* A direction to perform more and more slowly and broadly.

electric guitar See under ELECTRONIC INSTRUMENTS.

electric organ Another name for electronic organ (see under ELECTRONIC INSTRUMENTS).

electric piano Another name for electronic piano (see under ELECTRONIC INSTRUMENTS; PIANO, def. 2).

electro-acoustic music Another name for ELECTRONIC MUSIC.

electronic instruments Musical instruments in which the sound is either produced by means of electronic devices or is changed (in volume, tone, etc.) by electronic devices. In order that the electronically produced vibrations of such instruments can actually be heard, there must be an amplifier to strengthen the rather weak signals and a loudspeaker to convert them from electric impulses into sound waves. Most of the instruments in which the sound is produced electronically are keyboard instruments, but electronic winds

and percussion are also available. See also SYNTHESIZER. The first to become well known, however, was the electronic organ (also called the electric organ or Hammond organ after the American inventor, Laurens Hammond [1895–1973], even though numerous companies besides the one bearing his name make such instruments). In the electronic organ a number of rotating wheels or electronic oscillators each produce an alternating electric current of a certain frequency to provide the basic pitches of the instrument's range (see SOUND for an explanation of pitch and frequency). These currents are modified by amplifiers and other circuits to produce a wide variety of tone colors. The instrument itself looks much like a small upright piano with two keyboards (called manuals), one above the other, and a set of pedals (pedalboard) for playing bass notes. The upper keyboard, called swell or solo manual, is used largely for melody, and the lower keyboard, called great manual, is used for accompaniment (chords). However, solo and accompaniment passages can be played on either manual; also, both hands can play on one manual at the same time. The general sound somewhat resembles that of a small pipe organ, with some additional effects (mostly orchestral flute, string, and reed sounds). Some models are provided with various special effects, such as percussion, guitar, or piano. Another type, invented in the 1930s, uses vibrating brush reeds as its sound source. Its manufacture was taken over by the Wurlitzer Company and it became known as a Wurlitzer organ.

A special type of electronic organ is the chord organ, which has only one manual and often lacks a pedalboard. The chord organ can, along with a melody, produce the most frequently used chords, chord buttons being provided for this purpose. Such organs are used largely for popular and folk music, as well as some church music (mostly simple hymns).

Another variation is the so-called combo organ, a lightweight model designed for use with popular "combo" groups, together with guitar and drums. In the late 1970s more sophisticated and quite inexpensive portable electronic or digital keyboards, with preprogrammed sounds stored in microchips, began to be widely marketed.

Two other early keyboard instruments with electronically produced sound are the ondes Martenot and novachord. The ondes Martenot (also called *ondes musicales*) is named after Maurice Martenot, who invented the instrument and first demonstrated it in 1928. It uses a single oscillator to produce the pitches of about seven octaves, and can produce MICROTONES. However, it can produce only one pitch at a time, and thus can be used only for playing melodies (it cannot play chords). It is used most often in the orchestra, principally by such French composers as Honegger, Messiaen, and André Jolivet, who wrote a concerto for ondes Martenot and orchestra; also, Pierre Boulez wrote a quartet for four ondes Martenot. Nevertheless, the instrument has not won a wide following. The novachord, which looks like a large square piano, has a separate oscillator for each of the twelve notes of the chromatic scale. It can produce both single notes and chords, and also has special controls for varying tone color and pedals for controlling volume.

One of the earliest innovators was Thaddeus Cahill, an American inventor who in 1902 exhibited his Telharmonium (also called Dynamophone), an instrument that weighed 200 tons and was designed to be broadcast over telephone wires. A working version was installed in New York City in 1906. The sounds were generated by inductor alternators, and specific pitches were obtained by rotating cogged wheels that contained the same number of poles as the frequency required. The Telharmonium provided different frequen-

cies and the means to mix them so as to obtain different tone colors, but because electronic means of amplifying the sounds had not yet been invented, it took enormous amounts of power; each fundamental note of the scale required a 200-horsepower motor. The instrument was played from an organ keyboard with thirty-six notes to the octave, making it quite cumbersome to finger. Moreover, the Telharmonium's operation interfered with the commercial telephone system and so had to be halted.

A more successful electronic instrument was the **theremin**, invented in St. Petersburg in 1920 by Leon Theremin (1896–1993). Its sound is produced by two oscillators, one of fixed frequency and the other of variable frequencies. The sound produced is determined by the difference between the two frequencies, which is controlled by the player's hands moving near an antenna that controls the variable oscillator. Like the ondes Martenot, the theremin is capable only of playing melodies. A few composers wrote music for it, but its widest use was in film music. The **Trautonium**, invented about 1930 by Friedrich Trautwein, a German professor of acoustics, used a neon tube instead of a vacuum-valve oscillator, thereby producing a sound much richer in harmonics. Different tone colors were obtained by using filters and other devices to reduce the number of overtones. There was no keyboard. Pitches were selected by means of a ribbon device operated by the performer's right hand, and higher harmonics were added by operating a series of pushbuttons with the left hand. Hindemith wrote a Concertino for Trautonium and strings (1931), and Richard Strauss used it in *Japanese Festival Music* (1940). The instrument survived into the 1950s, when an improved form, the Mixtur-Trautonium, was used in electronic studios.

Numerous instruments in which sound is generated in the ordinary way—by the vibration of strings or of a column of air—have been fitted with electronic devices. In most cases the tone is first converted into electrical vibrations by a pickup (microphone) and then is made louder or is changed in some other way by an amplifier. Such equipment not only can make a small instrument produce very loud sound, but it can greatly alter the tone produced. For example, harmonics (overtones) may be changed or eliminated, thus changing the tone color (see SOUND for an explanation), or the sound of tones building up may be changed from sudden attack (as when a finger strikes a piano key) to a very gradual buildup (as when a bow is drawn across a violin string).

The most important electronic instrument of this type is the **electric guitar.** There are two main kinds of electric guitar. One kind, which can be played without an amplifier, has a hollow body and six steel strings whose vibrations are reinforced somewhat by the wooden soundboard but still are too soft to be used in combination with other, louder instruments. Thus, for ensemble performance an amplifier is used. The second kind of electric guitar has a body of solid wood, whose only purpose is to hold the six strings and electrical equipment. One to four pickups placed under the strings convert their vibrations into electric impulses, which are then strengthened by an amplifier (which may also include such modifying devices as wah-wah and fuzz tone) and are reconverted into audible sounds by a loudspeaker. (See also HAWAIIAN GUITAR.)

Developed about 1948 by Leo Fender and others, the electric guitar helped create the new sound of rhythm and blues, and later rock, which also adopted its cousin, the **electric bass.** Also invented by Leo Fender and first used in 1953, the electric bass is very similar in structure and electronics to the electric guitar but has, like the acoustic double bass, only four strings. Although available from numerous manufac-

turers, it still is often called a **Fender bass**.

Electronic flutes and **electronic saxophones** usually have a small microphone mounted on the body of the instrument. The microphone converts the sound of the instrument to an electrical signal which is then amplified and fed to a loudspeaker. **Electronic violins, electronic violas**, and **electronic cellos** usually have a pickup attached to the bridge. In a popular type of **electronic piano**, the hammers strike reeds instead of strings. Because such pianos are much lighter in weight than ordinary pianos, they have been found useful for class instruction in piano playing; for this purpose they are usually fitted with earphones, so that only the player can hear the sounds he or she produces. (See also under PIANO.) One kind of **electronic harpsichord** has, instead of a soundboard, pickups leading to an amplifier and a series of special switches that change the instrument's usual tone color into sounds like those of a vibraharp, guitar, or banjo.

The **hyperinstruments** developed by composer Tod Machover and his associates involve linking an instrument with an interactive computer program that analyzes the performer's musical decisions and responds to them with additional, computer-generated music. The response can also be controlled by the conductor by means of a special glove that can change the computer's tempo, dynamics, tone color, etc. Between 1991 and 1993 Machover wrote three concertos, for hypercello, for hyperviola, and for hyperviolin. Also see SYNTHESIZER.

electronic music Music made up of sounds created or manipulated by electronic devices, which are recorded and reproduced on magnetic tape or a digital storage medium, or are created and performed live at virtually the same time (and may simultaneously be recorded). A tape recording or floppy disk or circuit diagram thus corresponds to the written score of traditional music, and playing a tape or compact disk may correspond to a musical performance. Its early heavy reliance on tape led electronic music to be called **tape music**. Strictly speaking, electronic music differs from MUSIQUE CONCRÈTE in that the sounds themselves are generated electronically by a device called a synthesizer. In practice this distinction is not always maintained, for many composers of electronic music combine taped or live natural sounds (both musical, such as singing, and nonmusical, such as street noises) with electronically generated (synthesized) sounds. (See also LIVE ELECTRONIC MUSIC.)

Electronic music grew out of experiments with Thaddeus Cahill's Telharmonium, the Hammond organ, and other early ELECTRONIC INSTRUMENTS. It developed about 1950 in both Europe and the United States, and its origins as well as its subsequent development are directly related to technological advances in sound equipment. With TAPE RECORDING, which first became generally available about 1950, it became possible to manipulate sounds by changing speed, reversing, splicing, mixing, filtering, and similar means. The development of the OSCILLATOR and related electronic devices made it possible to create wholly new sound material. Because the earliest equipment was large and costly, electronic composers worked in either a broadcasting studio or a laboratory, and so they are linked with particular places: radio studios in Paris, France (Edgar Varèse, Pierre Boulez, Philippe Manoury); Cologne, Germany (Herbert Eimert, Karlheinz Stockhausen); Milan, Italy (Luciano Berio, Bruno Maderna, Henri Pousseur, Luigi Nono); and the Columbia-Princeton Electronic Center in New York City (Vladimir Ussachevsky, Otto Luening, Milton Babbitt, Bulent Arel, Mario Davidovsky). Other important electronic music studios established in the 1950s include those of Tokyo, Warsaw, Munich, Eindhoven, Brus-

sels, Toronto, London, and Stockholm, and these attracted composers from other countries as well (Xenakis to Paris, Varèse to Eindhoven, Pousseur to Brussels, etc.). In the United States significant centers were established at Ann Arbor, Michigan; Urbana, Illinois; and San Francisco, California.

Although electronic music is still changing rapidly, certain basic principles continue to be valid. Perhaps the single most important one is that virtually every aspect of musical sound can be controlled by the composer: tone color, amplitude (volume), tempo (speed), frequency (pitch), and so on. Not only can the sounds be created as desired, but by DUBBING and mixing (see also EDITING) they can be combined in any way the composer wishes. In early electronic music the composer manipulated an oscillator, an electronic circuit that produces a signal at a given frequency. The oscillator was set to the desired frequency, recorded on tape, shut off, and reset for the next sound. This cumbersome process was replaced in the early 1960s by a system whereby an electrical voltage was used to set the frequency of the oscillator. This **voltage-controlled** (or v-c) **oscillator** in turn could be controlled in various ways, including by another oscillator. Another important new device was the noise generator, which could be used to add realistic effects, such as breath noise when the synthesized sounds resembled those of wind instruments, or effects like crashing surf, roaring wind, or an explosion (see also NOISE). In addition to v-c oscillators and noise generators that create sounds with pitches and harmonics never produced in nature or by conventional instruments, the composer today can use various filters to boost or minimize harmonics or other frequencies; microphones to pick up acoustic signals from virtually any source (an electric guitar, human heartbeats, etc.); envelope generators to manipulate the sound's time of attack, sustention, and decay; time

delays that, by delaying part of a sound signal, can create special effects such as echo or reverberation; polyphonic sequencers, which can store long series of notes and also offer various splicing and dubbing capabilities; and still other devices.

The early machines were huge assemblies of components, but beginning in the 1960s, with the invention of v-c oscillators and the development of ever smaller electronic components, smaller and much more efficient machinery became available. First were the Buchla and Moog synthesizers, primarily used for creating music on tape, and soon afterward synthesizers designed especially for live performance (see also SYNTHESIZER). Although tape recorders also had been used for some live performance, a great deal more could be done with microphones, amplifiers, and electronic modulators encompassed in a single machine. Another important advance, dating from the late 1960s, was the use of computers in sound synthesis. At first composers used a computer program to stipulate minute details of the sounds to be created, with precise instructions for every element of pitch, duration, and tone color. (This method was a direct outgrowth of applying the principles of SERIAL MUSIC not only to pitch but to all aspects of sound.) Once the computer was used to store and manipulate control voltages, it was a short step for it to be used in performance, that is, as a digital sequencer to play an entire synthesizer. (See also COMPUTER MUSIC.)

The rapid development of new equipment from a variety of sources raised a new problem: one piece of equipment could not necessarily interface with another without a computer program or other specialized equipment. In the mid-1980s, however, came a new industry-wide standard called **MIDI** (for "musical instrument digital interface"), a performance information exchange system that enables different makes and models of equipment—synthesizers,

computers, mixers, etc.—to communicate with each other. MIDI equipment can receive music played on traditional instruments and change it in predetermined ways. For example, added or subtracted "grain" alters dominance; frequent shifts change tone color; the "comb filter" broadens texture; etc. Not only does MIDI make it possible for a single control device (typically a keyboard) to handle several synthesizers, a lighting panel, and video equipment all at once, but when the necessary data are beamed by satellite to electronic instruments in another location several musicians can perform as a single group, even if they are on different continents at the time. Moreover, some sophisticated computer programs can connect MIDI equipment with a personal computer using a composition program, permitting performers to record all performance data and have them converted into a score in conventional (or other) notation on the user's screen.

There are several important differences between electronic and acoustic (nonelectronic) music. Once recorded, electronic music is fixed, that is, there is no opportunity for different performances to provide different interpretations of the same material (unless the recording itself is somehow changed). Second, in electronic music the quality of sound reproduction becomes extremely important. A poor sound system can so distort the effect of the new sounds being heard, for which the listener has no standard of comparison (in contrast to hearing a familiar symphony on a poor-quality tape) that the experience is ruined. Further, in concert halls both a good sound system and good acoustics are essential. Finally, because most electronic composers use sounds rather than conventional pitches as the building blocks of music, electronic music requires some organizing principle to give it coherence. Composers have dealt with this problem in various ways: by organizing sounds rhythmically, by confining them to a single instrument or kind of sound source, and by imitating speech patterns, to name but a few. Some composers, however, prefer to present a musical composition as work-in-process, as it were, showing the actual techniques used in its creation by effecting a series of changes in the sounds produced (see MINIMALISM). See also SONIC ENVIRONMENT; SYNTHESIZER.

electronic organ See under ELECTRONIC INSTRUMENTS.

electronic piano See under ELECTRONIC INSTRUMENTS; PIANO.

electrophone (ē lek' trə fōn"). Any musical INSTRUMENT that produces sound by electric or electronic means. See ELECTRONIC INSTRUMENTS.

elegante (e" le gän' te) *Italian*. Also, *con eleganza* (kôn e" le gän' dzä). A direction to perform in a graceful, refined manner.

eleganza, con See ELEGANTE.

élégie (ā lā z͟hē') *French*: "elegy." A piece of music, vocal or instrumental, expressing sorrow, often written in memory of someone who has died. Examples include Stravinsky's *Élégie* for solo viola and Fauré's *Élégie* for cello and piano.

eleventh The interval of an octave plus a fourth. (See also INTERVAL, def. 2.)

eleventh chord See under CHORD.

Elgar (el'gär), **Edward,** 1857–1934. An English composer who became the first English-born composer of international importance since the death of Purcell in 1695. Elgar's most successful works are his *Pomp and Circumstance* marches (no. 1 is among the best known of all marches), the oratorio *The Dream of Gerontius,* the *Variations on an Original Theme* (also called *Enigma Variations*), and his Cello Concerto. His other works

include the symphonic poem *Falstaff,* two symphonies, a violin concerto, and chamber works. His music in general follows the forms and harmonic traditions of the nineteenth-century romantic composers, which he used with technical skill and a fine gift for melody.

Ellington (el' iñg tən), **Edward Kennedy** ("Duke"), 1899–1974. An American pianist and composer who became one of the most important figures in the development of JAZZ. Ellington began his career as a pianist in ragtime bands. By the 1930s he was a leader in the big band movement, that is, a trend toward using a jazz band of ten to twenty players instead of the small "combo" of five or six. In contrast to the big bands of other musicians, Ellington's bands were still groups of soloists, and in his arrangements he always left room for improvisation by the individual players. The term "swing," describing the jazz style most popular in the 1930s, was coined by Ellington in one of his songs ("It don't mean a thing if it ain't got that swing"). Among Ellington's most famous songs are "Mood Indigo," "Solitude," and "Sophisticated Lady." He also wrote film scores and some sacred music.

embellishment 1 Another word for ornament (see ORNAMENTS). **2** Another word for NEIGHBORING TONE.

embouchure (*English* äm' bŏŏ shŏŏr"; *French* än bŏŏ shyr'). **1** The mouthpiece of a wind instrument, such as the flute or trumpet. **2** The positioning and shaping of the mouth, lips, and tongue in order to play wind instruments with good tone, true pitch, and proper attack.

empfindsamer Stil (em pfint'zäm ər shtēl'). German for "expressive style"; see KARL PHILIPP EMANUEL BACH, under BACH.

Empfindung, mit (mit em pfin' dōōnk) *German:* "with feeling." A direction to perform in a sensitive, expressive manner.

emphase, avec See EMPHATIQUE.

Emphase, mit (mit em fä' zə) *German.* Also, *emphatisch* (em fä' tish). A direction to perform with emphasis and decision.

emphatique (än fA tēk') *French.* Also, *avec emphase* (A vek' än fAz'). A direction to perform with emphasis and decision.

emphatisch See EMPHASE, MIT.

empressé (än pre sā') *French.* A direction to perform in a hurried manner, pressing on to the end.

ému (ā mY') *French.* A direction to perform expressively, with feeling.

enchaînez (än she nā') *French.* A direction to continue to the next section without pause.

encore (*French* än kôr'; *English* än' kôr). **1** A direction to repeat. **2** An additional piece (either repeating a piece already presented or a wholly new piece) performed in response to the audience's enthusiastic applause. **3** A request to perform such a piece. (See also BIS.)

en dehors (än də ôr') *French.* A direction to perform with emphasis, so as to make a note or passage stand out from the rest.

energico (e ner' gē kô) *Italian.* Also, German, *energisch* (e ner'gish). A direction to perform in a vigorous, decisive manner.

energisch See ENERGICO.

Enesco (e nes'kô), **Georges** (zhôrzh), 1881–1955. Also, *Enescu* (e nes' kōō). A Rumanian composer, violinist, and teacher who lived much of his life in Paris, and who used the melodies of his homeland in his most popular works, two *Rumanian Rhapsodies* (1901, 1902). His later works, which include the opera *Oedipe* ("Oedipus"), three piano sonatas, five symphonies, and some fine chamber music, were less successful but are still played occasionally.

Enescu See ENESCO, GEORGES.

englisches Horn (eng' li shes hôrn').
The German name for ENGLISH HORN.

English descant See DESCANT, def. 2;
also under MEDIEVAL.

English flute In the eighteenth century, a name for the RECORDER, used to distinguish it from the ordinary transverse flute (which was sometimes called German flute).

English horn An alto oboe, pitched a fifth below the normal oboe. Like the oboe, it is a double-reed instrument, and it has the same number of keys and fingering, so that it can be played by any oboist (as in practice it is). The English horn is a transposing instrument, its music being written a fifth higher than it sounds. It came into being during the eighteenth century and was originally built in a curved shape. In 1839 a French instrument builder, Henri Brod, made it in the shape used today, that is, straight, about forty inches long, and ending

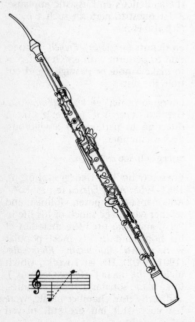

in a small, bulb-shaped bell. Thus, it is about eight inches longer than the oboe (which has a slightly flared bell), and a slightly bent crook is required to bring the instrument into a comfortable playing position. The tone of the English horn is somewhat softer, mellower, and more muted than the oboe's. Its range is a little more than two octaves, from the E below middle C to the second A above middle C.

The English horn is a standard member of the symphony orchestra, and is also used in chamber music for wind instruments, as well as a substitute for the OBOE DA CACCIA in baroque music. Outstanding compositions for solo English horn include Donizetti's Concerto in F and Concertino in G, Honegger's *Concerto da camera* for flute and English horn, Hindemith's Sonata for English horn, and Rorem's Concerto for English horn and orchestra. Prominent parts for English horn are found in the second movement of Franck's Symphony in D minor, in Dvořák's Symphony no. 9 (*From the New World*), and in Berlioz's *Roman Carnival Overture*.

enharmonic (en" här mon' ik). A term used for notes, intervals, and chords that are written differently but that, on a keyboard instrument, are played (and sound) as if they were the same. For example, on the piano the key for B-sharp and C is one and the same, and the two notes have the same pitch. This is also true for C-sharp and D-flat, D-sharp and E-flat, etc. (see the accompanying example

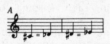

A). Such pairs of notes are said to be enharmonically equivalent. Singers and string- and wind-instrument players may distinguish between enharmonically equivalent notes, generally playing sharps at a slightly higher pitch than their enharmonically equivalent flats. This practice

has become less and less common, however, and is deliberately avoided in performing most twentieth-century music. Moreover, in some tuning systems the sharps are lower in pitch than their enharmonically equivalent flats. —**enharmonic change** Use of the same note in two different ways, for example, causing a D-sharp to act as an E-flat by moving to D natural or F natural instead of moving to E natural or C-sharp as would normally be expected. —**enharmonic interval** An interval that sounds the same as another interval but is written differently. For example, the interval called a diminished fifth (C–G♭) is, on the piano, exactly the same as the interval called an augmented fourth (C–F♯); similarly, the diminished seventh (C♯–B♭) sounds the same as the major sixth (C♯–A♯) (see the accompanying example *B*). See INTERVAL, def. 2, for an explanation of these intervals.

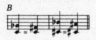

—**enharmonic chord** A chord that can be written in two or more ways. Each of the four notes of a diminished seventh chord, for example, can be written in two ways so that each note can function as the leading tone of a major and minor key. In the accompanying example *C,* the same chord is written so as to serve as the diminished seventh chord in the keys of C major and C minor, E-flat major and E-flat minor, F-sharp major and

F-sharp minor, and A major and A minor. (See CHORD for an explanation of these chords.) —**enharmonic modulation** A change of key accomplished by using an enharmonic chord, such as a modulation from C minor to F-sharp major by use of a diminished seventh chord. —**enharmonic key** Three of the major keys

having scales that can be notated in either sharps or flats. They are B major (5 sharps) and C-flat major (7 flats); F sharp major (6 sharps) and G-flat major (6 flats); and C-sharp major (7 sharps) and D-flat major (5 flats); see the accompanying example *D*.

ensalada See under QUODLIBET.

ensemble (*English* än säm' bəl; *French* äN säN' bl⁹). **1** A group of musical performers, consisting of instrumentalists (instrumental ensemble), singers (vocal ensemble), or both. **2** A term used to describe how well the members of a group play or sing together, in the sense of having equal musical ability, or of balance of the different parts and unity of presentation. In this sense, "good ensemble" means playing together well, and "poor ensemble" means playing together poorly (which may occur even when the individual players of the group perform well). **3** In opera, a piece for several soloists, either with or without the chorus.

entr'acte (äN trAkt') *French:* "between the acts." Also, *interlude, intermezzo.* Music, usually instrumental, that is performed between the acts of a play or opera.

entschieden (ent shē' dᵊn) *German.* Also, *entschlossen* (ent shlôs' ən). A direction to perform in a decided resolute manner.

entschlossen See ENTSCHIEDEN.

envelope The attack-sustain-decay-release pattern of a sound signal. In physical terms this is the amplitude (loudness) of a sound from start to finish. An **envelope generator** is a circuit that allows manipulation of the characteristics of an envelope, that is, attack time, sustention time, decay time, release time; it is an important component in the SYNTHESIZER.

environmental music See SONIC ENVIRONMENT.

épinette (ã pē net'). A French word meaning "spinet" (see SPINET, def. 1) or HARPSICHORD.

episode 1 In a FUGUE, a passage occurring between expositions of the subject by the different voice-parts. The music of the episode may or may not be based on a portion of the subject or answer, and often it will modulate to another key, in which the subject is to be presented next. Not all fugues contain episodes. **2** In a RONDO, a name for sections that appear between repetitions of the first main section. Thus, a rondo might consist of sections A B A C A, in which A is the main section and B and C are episodes.

Epistle (i pis' əl). In the Roman Catholic rites, the second section of the Proper of the Mass (see MASS.)

equal temperament A system of tuning keyboard instruments so that all the half tones are equal, that is, the difference in frequency (pitch) between C and C-sharp, for example, is exactly the same as the difference between C-sharp and D, D and D-sharp, D-sharp and E, etc. (see SOUND for an explanation of frequency), so that D-sharp and E-flat, for instance, are identical on keyboard instruments. In equal temperament, all the intervals except the octave are slightly out of tune. However, the modern listener is so accustomed to this phenomenon that the tones sound perfectly normal to the ear. Although there are other systems of tuning (see TEMPERAMENT) in which the intervals are perfectly in tune, the system of equal temperament has one major advantage that outweighs its drawbacks: with equal temperament, intervals have the same value in all keys. Thus, music may be played in any key, and one may modulate (change from one key to another) with complete freedom. (In other systems, some keys are favored at the expense of others, and modulation may be difficult or impossible.)

Although equal temperament was known much earlier and came into general use in lutes and other fretted instruments, most musicians before 1800 favored systems that provided better-tuned intervals in those keys that were more commonly used, and the system was not universally adopted until about 1850. It is often stated that Bach strongly favored equal temperament and composed *The Well-Tempered Clavier*, with its preludes and fugues in all of the major and minor keys, to show the advantages of the system, but there is no concrete evidence for this view.

equal voices 1 Voices of the same kind, that is, men's voices or women's voices (as opposed to MIXED VOICES). **2** Voices of the same range, for example, all tenor or all soprano.

ergriffen (er grif' ən) *German*. A direction to perform in a highly expressive, emotional manner.

erlöschend (er lœ' shənt) *German*. A direction to perform more and more softly, as though the music were fading away.

ermattend (er mä' tənt) *German*. A direction to perform more and more softly and gently, becoming gradually weaker.

ernst (ernst) *German*. Also, *ernsthaft* (ernst' häft). A direction to perform in a sober, serious manner.

ernsthaft See ERNST.

ersterbend (er shter' bənt) *German*. A direction to perform more and more softly, as though the music were dying away.

escaped note See CAMBIATA, def. 1.

escapement In pianos, the mechanism that permits the hammer to fall an appreciable distance away from the strings after striking them, even when the key is still held down. Many early pianos had no escapement at all, which made it impossible to play them very loudly or very softly. Instruments with a single escapement

were easier to play, but it was difficult to play rapidly repeated notes. This problem was eliminated in the early 1820s by a French builder, Sébastien Érard, who invented the **double escapement**, in which the hammer does not fall all the way back to its original position. This enables the player to strike the same key again and again, very rapidly.

esercizio (e" ser c̲h̲ē' tsyô) *Italian:* "exercise." A piece designed to improve the performer's technique.

E-sharp One of the musical tones (see PITCH NAMES), one half tone above E and one half tone below F-sharp. On the piano, E-sharp is identical with F (see ENHARMONIC for an explanation). For the location of E-sharp on the piano, see KEYBOARD.

espr. Also, *espress.* Abbreviation for ESPRESSIVO.

espressione, con See ESPRESSIVO.

espressivo (es" pres sē' vô) *Italian.* Also, *con espressione* (kôn es" pres syô' ne). A direction to perform in an expressive manner, with feeling.

estampida The Spanish name for ESTAMPIE.

estampie (es tän pē') *French.* Also, Spanish, *estampida* (es" täm pē' t̲h̲ä); Italian, *istampita* (ē" stäm pē' tä), *istanpita* (ē" stän pē' tä). An instrumental dance form of the thirteenth and fourteenth centuries. The estampie consisted of stanzas called **puncta**, each of which was repeated, but with a different ending. There were numerous puncta, usually four or five, and often the same pair of endings was used throughout, a pattern like that of stanza and refrain. The estampies that survive all are monophonic (have one voice-part).

estinto (e stēn' tô) *Italian.* Also, French, *éteint* (ā taN'). A direction to perform as softly as possible.

éteint See ESTINTO.

ethnomusicology (et̲h̲" nō myoo̅' zi kol'ə jē). The study of music in rela-

tion to the culture that produced it. The subject of such studies is frequently outside the Western (European and American) tradition, such as the music of China, Japan, the Arab countries, or various peoples of Africa. Until the nineteenth century the music of non-Western cultures was regarded mainly as a curiosity and was not taken seriously; indeed, for many years all such music, despite its enormous variety, was lumped together into one category called "exotic music." Toward the end of the nineteenth century, however, scholars began to apply to non-Western music the same careful methods of study they had been using for music of their own culture. One result has been the increasing influence of non-Western music on Western music, seen both in popular music—for example, raga, ROCK, and REGGAE—and in serious music, as in the use of various non-Western scales, instruments, and rhythms.

étouffez (ā too̅ fā') *French.* A direction to players of French horns, violins, harps, cymbals, drums, and some other instruments that a particular note or group of notes is to be damped or stopped (silenced) immediately after being sounded.

étude (ā tvd') *French:* "study." An instrumental piece designed to improve the player's technique. Études usually contain technically difficult material—arpeggios, trills, octaves, double stops, etc. Although some études, such as finger exercises, are principally technical studies, others give the material artistic form, that is, they are pieces in which musical substance and technical difficulty coincide. Chopin's piano études were among the first to accomplish this unity of beauty and technique. Also outstanding are Liszt's *Paganini Études,* which are transcriptions of violin studies, and his very difficult *Transcendental Études,* which he revised several times, creating new textures and tone colors from the technical complexities.

Études in the form of finger exercises, mainly for keyboard instruments, were written as far back as the sixteenth century. Études with genuine musical interest were written by Johann Baptist Cramer, Muzio Clementi (especially his *Gradus ad Parnassum,* 1817–1826), and Carl Czerny. The Czech pianist Ignaz Moscheles wrote études specifically intended for concert performance, so-called **concert études.** None of these, however, approaches the stature of Chopin's and Liszt's piano études. Outstanding violin études were written by Rodolphe Kreutzer, Jacques Rode, Niccolò Paganini, Charles Auguste de Bériot, and others. (See also FINGER EXERCISE; RICERCAR, def. 3.)

etwas (et′ väs) *German:* "somewhat." Used in musical directions such as *etwas bewegt* ("somewhat lively").

euphonium (yo͞o fō′ nē əm). A valved instrument of baritone range that is used largely in bands and only occasionally in orchestras. Some authorities consider it a kind of saxhorn, and others a tuba with a higher than normal range. The euphonium resembles the BARITONE HORN but usually has four valves instead of three, and a wider, conical bore (cone-shaped inside), ending in a wide bell.

Like the baritone horn, the euphonium may be shaped either like a

trumpet or bugle, with the bell pointing forward or with the bell turned back and up, like a tuba (the latter variety is shown in the accompanying illustration). The euphonium usually is pitched in B-flat (but sometimes in C) and has a range of three octaves, from the B-flat two octaves below middle C to the B-flat above

middle C. It is a transposing instrument, its music being written a ninth (an octave plus a second) higher than it sounds. —**double euphonium** A euphonium that has, in addition to the regular bell, the bell of a saxtromba. The player chooses one bell or the other by means of a valve.

eurhythmics (yo͞o riᵗħ′ miks). A system of musical training through body movements. Although he was not the first to think of body movements to express musical rhythms, the Swiss composer and teacher Émile Jaques-Dalcroze is largely responsible for making eurhythmics a method of learning music. Not only can rhythm be taught in this way, but intervals and pitches can be translated into physical movement (using the rungs of a ladder for the scale, for example), as can other aspects of music. Eurhythmics is used mainly to teach young children the basic elements of music; classes and schools of eurhythmics are widely established in Europe and America.

Evangelist In a Passion (an ORATORIO dealing with the crucifixion of Jesus), the narrator who recites the story from the Bible.

Evensong (ē′ vən sôn͡g″, ē′ vən son͡g″). In Anglican church services, the sung form of the Evening Prayer.

exercise See ÉTUDE; FINGER EXERCISE.

exposition 1 In a FUGUE, the presentation of the subject, or main theme, by each of the voice-parts. **2** In SONATA

FORM, the first section, which consists of the statement of the main themes. Usually there are at least two themes, the first in the tonic key and the second in the dominant key, the two being connected by a bridge that modulates (changes) from the first key to the second. If there is a third (closing) theme, it is usually also in the dominant key.

expressionism A term borrowed from painting to describe certain kinds of twentieth-century music written as though to express the innermost feelings of the composer or, in stage works, of the characters. Like expressionist paintings, which use distortion and exaggeration to picture a kind of inner reality, expressionist music often seems harsh and discordant, as well as emotional and dramatic. Outstanding examples are Schoenberg's *Verklärte Nacht* ("Transfigured Night"), *Pierrot lunaire* ("Pierrot by Moonlight"), and *Erwartung* ("Expectation"), Berg's two operas, *Lulu* and *Wozzeck,* and, more recent, Harrison Birtwistle's *Punch and Judy* (1966) and Peter Maxwell Davies's *Eight Songs for a Mad King* (1969). As might be expected, both the texts and music of these stage works concentrate more on the psychology of the characters than on external events. (See also MUSIC THEATER.)

expression marks In music, directions, either written out or in the form of signs, that tell the performer what the composer intended. The most basic kinds of expression mark are those used to indicate tempo (speed) and dynamics (loudness or softness). Others indicate technique (bowing, touch, use of pedals, etc.), phrasing (groups of notes), and the mood to be expressed (gentle, lively, passionate, grieving). Often the terms used for this purpose are in Italian, which has become the international language of music. However, many composers prefer to write in their own language, and editors and publishers do not always translate their directions into Italian. The use of expression marks dates from the seventeenth century. Earlier music rarely contains directions for the performer. Interpreting older music thus requires considerable knowledge of the musical practices of different periods.

eye music See under MADRIGAL, def. 2.

F **1** One of the musical tones (see PITCH NAMES), the fourth note in the scale of C major. The scales beginning on F are F major and F minor. A composition based on one of these scales is said to be in the key of F major or F minor, the key signatures (see KEY SIGNATURE) for these keys being one flat and four flats, respectively. The note one half tone below F is called F-flat or E (see ENHARMONIC for an explanation); the note one half tone above F is called F-sharp or G-flat. (For the location of these notes on the piano, see KEYBOARD.) **2** An ornamented form of the letter F is used as the sign for the bass clef, or F clef (see under CLEF). **3** Abbreviation for FORTE, usually written in lower case (f). —**F instrument** A TRANSPOSING INSTRUMENT, such as the F trumpet (or trumpet in F), that sounds each note a fourth higher than it is written, or the French horn, which sounds each note a fifth lower than it is written; in each case, the fingering for the written note C yields the pitch F.

fa (fä). In the system of naming the notes of the scale (see SOLMIZATION), the fourth note of the scale (the others being *do, re, mi, sol, la,* and *ti*).

faburden (fab′ ər dᵊn). **1** In early fifteenth-century English music, a form of vocal improvisation in which a plainsong cantus firmus (fixed melody) is accompanied by a voice in thirds and fifths below it and another voice in fourths above it. This formula enabled singing three-part harmony at sight, reading only the notes of the chant melody. Although the term faburden appears to be a translation of the French term FAUXBOURDON, the techniques are not identical. In the latter half of the fifteenth century faburden came to mean any technique of three-part harmony. **2** In sixteenth-century English music, a special way of setting hymns for organ. First a tenor part was written at a distance of sixths and octaves below the plainsong melody (which was moved up an octave if it lay in the tenor range). The plainsong itself was then discarded, and the new tenor, called the faburden, replaced it as a cantus firmus, to which additional voice-parts were added. This sort of setting was intended to alternate with the stanzas sung in plainsong.

facile (fä′ c̱hē le) *Italian.* A direction to perform in an easy, fluent manner.

fado (fä′dô) *Portuguese.* A form of urban solo song performed in cabarets and cafés. Its origin is disputed, some saying it comes from Arab music, others from rural Portuguese folk music. The songs, strophic in form (with several stanzas), may be in either a major or a minor key (or, sometimes, shift from one to the other), and are usually in

duple meter (with two basic beats per measure). A guitar accompaniment plays the bass line in simple harmonies; there may also be a lute, which improvises a melody against the singer's line.

Fagott (fä gôt'). The German word for BASSOON.

fagotto (fä gôt'tô). Today, the Italian word for BASSOON. Formerly, the CURTAL.

faiblement (fe blᵊ mäɴ') *French.* A direction to perform softly, feebly, or weakly.

fake book A collection of standard popular and jazz tunes that are used by musicians as the basis for improvisation. The tunes are reduced to key and time signatures, melody, and chord symbols. Their use is perfectly legal because the publisher pays a royalty to the original copyright owners. Some fake books, however, pirate the songs. One of these, *The Real Book*, has been widely available in the United States since the 1960s, to the distress of legitimate music publishers, and is highly regarded by many professional pop musicians.

fa-la (fä lä'). Also, *fa-la-la* (fä" lä lä'). A type of song popular in England during the late sixteenth and early seventeenth centuries, consisting of several stanzas alternating with the refrain "falala, fa la la" or similar nonsense syllables (such as "hey nonny nonny," or "tan tan tarira"). The fa-la was also called **ballett**, after the Italian BALLETTO, on which it was modeled. The Christmas carol "Deck the Halls with Boughs of Holly" does not belong to this type, since the "fa-la-la-la-la" refrain is repeated both in the middle and at the end of stanzas and the music for it varies slightly, depending on its position in the stanza.

fa-la-la See FA-LA.

Falla, de (de fä' yä), **Manuel** (mä nwel'), 1876–1946. The foremost Spanish composer of his time. He is particularly known for his use of traditional Spanish music, much of it very old, in his own music. His first great success was the opera *La Vida breve* ("Life Is Short"), which won first prize in a contest held in Madrid in 1905. Beginning in 1915, de Falla began his most productive years with the ballet *El Amor brujo* ("Love, the Sorcerer") and a work for piano and orchestra, *Noches en los jardines de España* ("Nights in the Gardens of Spain"); both combine Spanish folk elements with some of the methods of the French impressionist composers. Before 1915, de Falla had used the folk music and highly colorful rhythms of the province of Andalusia, elements of which are found in the highly successful ballet, *El Sombrero de tres picos* ("The Three-cornered Hat"). His *El Retablo de Maese Pedro* ("Master Pedro's Puppet Show"), an opera for marionettes, reflects the more formal and elegant elements of the folk music of Castile. Other important works of de Falla's are the Concerto for harpsichord and chamber ensemble (1926), and his earlier *Siete Canciones populares españolas* ("Seven Popular Spanish Songs," 1914), in which he used not only the rhythms and style of folk music but actual folk melodies.

false cadence Another name for deceptive cadence; see under CADENCE.

false relation Another name for CROSS RELATION.

falsetto (fôl set' ō). A method of singing used, especially by tenors, to extend the upper end of a singer's normal range. Falsetto is occasionally used for comic effect, as when Falstaff imitates the women in Verdi's opera, *Falstaff*. In earlier times, however, it was deliberately cultivated by men so as to sing in the alto range, the so-called countertenor or male alto (see ALTO, def. 2). Today it is still so used for early music, as well as occasionally by both men and women for singing blues, country music, and other popular genres.

falsobordone (fäl" sô bôr dô' ne). The Italian term for the fifteenth-century fauxbourdon (see FAUXBOURDON, def. 1).

fancy See FANTASIA, def. 2.

fandango (*English* fan dang' gō; *Spanish* fän däng' gö). A lively Spanish dance, in triple meter (any meter in which there are three basic beats per measure, such as 3/4 or 3/8), performed by one couple with castanets to music provided by guitar and castanets.

fanfare Also, *flourish.* A tune for trumpet or horn, used to announce the arrival of royalty, the beginning of a parade, or for a similar purpose. Such melodies generally consist of only the notes of a simple chord, such as C–E–G–C', since they were originally intended for (or imitate the sound of) the older brass instruments, on which only a single note and its overtones are available. Numerous composers have used fanfares in program music, operas, etc. The accompanying example is from Act III of Wagner's opera *Lohengrin,* announcing the arrival of the King.

fantaisie See FANTASIA.

fantasia (*English* fan tā' zhə; *Italian* fän"tä zē'ä). Also, French, *fantaisie* (fän te zē'); German, *Fantasie* (fän tä zē); English, *fantasy*. 1 A composition that is written according to the composer's fancy, rather than following a strict formal scheme. An example is Beethoven's Fantasia, op. 80 (1808), also called Choral Fantasy, a work for piano, chorus, and orchestra that does not fit the conventional scheme of either piano concerto or cantata. 2 Also, *ricercar, tiento, fancy*. In the sixteenth and seventeenth centuries, a piece for lute, a keyboard instrument, or an instrumental ensemble, in which the composer treated a theme in free counterpoint, with frequent use of imitation, the different voice-parts each taking up the theme in turn. In form such fantasias differed little from the instrumental or organ ricercar. Among the sixteenth-century composers of fantasias were Luis Milán and Miguel de Fuenllana (who wrote for the vihuela), Francesco da Milano (for lute), and Hans Kotter, Leonhard Kleber, Andrea Gabrieli, William Byrd, John Bull, and Giles Farnaby (for keyboard instruments). In the seventeenth century, although keyboard fantasias were still written by such great masters as Sweelinck, Frescobaldi, and Froberger, English composers wrote such pieces chiefly for instrumental ensemble, among which are some of the finest examples of early chamber music. In addition to Byrd, important composers of instrumental fantasias include Morley, Gibbons, and Purcell. 3 In the baroque period (1600–1750), the keyboard fantasia became virtually the same as the toccata and prelude (in contrast to the much stricter fugue). Well-known examples are Bach's *Chromatic Fantasia* for harpsichord, and his even freer Fantasy in G major for organ. 4 In the second half of the eighteenth century, a free version of the sonata. Thus Beethoven's op. 27, two piano sonatas marked *Sonata quasi una Fantasia* (literally, "Sonata, almost a Fantasia"), the second usually called *Moonlight Sonata,* differ somewhat from the conventional sonata. Mozart's Fantasia in C minor for piano (K. 396) is a long movement in SONATA FORM in which the development section is very freely treated. 5 In the nineteenth century, a title for a short piece in a particular mood; examples include Schubert's great *Wanderer Fantasie* in C, op. 15; Schumann's *Fantasiestücke* ("Fantasy Pieces"), op. 111; and Brahms's *Fantasien,* op. 116, all for piano. 6 A title for a work that freely treats themes from another composition, as in Vaughan Williams's *Fantasia on a Theme by Thomas Tallis.*

Fantasie see FANTASIA.

fantasy See FANTASIA.

farandole (fᴀ rän dôl') *French.* An ancient dance of Provence in which dancers join hands to form a long chain, following musicians who play the pipe and tabor. The farandole, which is usually in 6/8 meter, is still danced today. Bizet includes a farandole in his incidental music for the play *L'Arlésienne* ("The Woman of Arles," Arles being a town in Provence), but his dance, though based on a Provençal song, is in 2/4 meter.

fasola See under SHAPE-NOTE NOTATION.

fastoso (fä stô' zô) *Italian.* A direction to perform in a dignified, stately manner.

Fauré (fô rā'), **Gabriel** (gᴀ brē el'), 1845–1924. A French composer and teacher whose music represents a transition from nineteenth-century romanticism to the idioms of the twentieth century. For many years a church organist and for fifteen years director of the Paris Conservatory, Fauré taught such outstanding musicians as Ravel, Enesco, Florent Schmitt, and Nadia Boulanger. His own compositions are noted for a highly original treatment of harmony, careful use of counterpoint, and, in his songs, the meticulous fitting of words to music. Although he made free use of dissonance, Fauré never abandoned tonality. His best-known work is a Requiem Mass (1887). He also wrote nearly a hundred songs (some of which may well be his finest works), numerous piano pieces (preludes, nocturnes, barcarolles, impromptus), and a large amount of chamber music, of which the best examples are two quartets for piano and strings, two piano quintets, and a string quartet composed shortly before his death.

fauxbourdon (fô bo͞or dôn') *French.* **1** In the fifteenth century, a kind of three-part harmony used by Guillaume Dufay and other French composers. A plainsong melody is in the top voice, somewhat embellished and in free rhythm. The bottom voice moves at the interval of a sixth (or sometimes an octave) below the melody, and a middle improvised part is sung at the interval of a fourth below the melody. The term, which means "false bass," is thought to come from the fact that the plainsong melody is in the soprano, and not, as was usual during this period, in the tenor. By the sixteenth century this type of harmony was being used for psalm tones (see PSALM TONE), especially by Italian composers, and the Italian term **falsobordone** therefore was used for any simple four-part harmony written for a plainsong melody. In England, on the other hand, a similar technique was used for organ hymns (see FABURDEN, def. 2). **2** In present-day British usage, a DESCANT melody added above the highest part of a hymn, the choir singing the descant and the congregation the hymn melody.

F clef Another term for *bass clef,* the sign for which is derived from the letter F (see under CLEF).

feedback A shrill, high-pitched, squealing sound that is produced when a microphone is placed so close to a speaker that the electric signal loops back and forth. Produced electronically, it is used as a special effect by some performers of rock music.

feierlich (fī'ᴇr liᴋʜ) *German.* A direction to perform in a stately, solemn manner.

feminine cadence Also, *feminine ending.* See under CADENCE.

feminine ending See under CADENCE.

Fender bass See under ELECTRONIC INSTRUMENTS.

fermamente (fer"mä men'te) *Italian.* A direction to perform firmly, with decision.

fermata (fer mä' tä) *Italian.* Also, *hold.* Prolonging a note or rest longer than its time value indicates, marked by the sign ⌒. A fermata placed over a bar line directs the performer to pause

briefly before beginning the next measure.

fern (fern) *German:* "distant." Also, *wie aus der Ferne* (vē ous der fer'nə, "as if from a distance"). A direction to play or sing softly.

feroce (fe rô' c̲h̲e) *Italian.* A direction to perform with vehemence and passion.

festival A series of concerts held regularly, usually once a year, to promote interest in a particular kind of music, or simply music in general. The idea of music festivals dates from the Middle Ages, when various kinds of minstrel—the Provençal troubadours, German minnesingers, Welsh bards, and others—held regular series of concerts, sometimes featuring contests among the musicians. There have been music festivals of one kind or another ever since. A few of the more famous ones of the present day, most of which are held annually, are: the Bayreuth Festival at Bayreuth, Germany, for the performance of operas by Richard Wagner; the Festival of Two Worlds at Spoleto, Italy, and a related one at Charleston, South Carolina, for the performance of both traditional and contemporary music; the Edinburgh Festival at Edinburgh, Scotland; the Glyndebourne Festival at Glyndebourne, England, for the performance of operas; the Berkshire Festival at Tanglewood, near Lenox, Massachusetts; the Newport Festival at Newport, Rhode Island, for the performance of jazz and other popular music; the Salzburg Festival at Salzburg, Austria, originally for the performance of Mozart's works but also including works by other composers; and the International Society of Contemporary Music Festival, held in various European cities, for the promotion of contemporary music.

festoso (fe stô' zô) *Italian.* A direction to perform in a gay, festive manner.

Feuer, mit See under FEURIG.

feuille d'album (fœ yə dÅl bôm') *French:* "page from an album." A title

used in the nineteenth century for various short compositions, usually for piano. See also ALBUMBLATT.

feurig (foi' riкн) *German.* Also, *mit Feuer* (mit foi'ər). A direction to perform in a fiery, spirited manner.

ff Also, *fff.* The abbreviation for FORTISSIMO.

F-flat One of the musical tones (see PITCH NAMES), one half tone below F and one half tone above E-flat. On the piano, F-flat is identical with E (see ENHARMONIC for an explanation). For the location of F-flat on the piano, see KEYBOARD.

f-hole A SOUND HOLE in the shape of the letter *f.*

fiddle 1 A popular name for the violin. **2** Any bowed stringed instrument similar to the violin, particularly one used for folk music or dancing. In country music and the folk music from which it is derived, the name is used for the violin, and "fiddling" denotes the special techniques for playing it in this genre.

fiero (fyer' rô) *Italian.* A direction to perform in a bold, vigorous manner.

fife A small flute, slightly lower in pitch than the piccolo but shriller in tone, which today is used mostly in military bands. Originally a fife had five or six finger holes and no keys (see illus.), but in modern form it has six finger holes and one or more keys, making a greater number of notes available. Bands made up of fifes and

drums (fife and drum corps) date back as far as the fifteenth century, when the Swiss used them to accompany foot soldiers. The fife is still an important folk instrument.

fifteenth The interval of two octaves, for example, from middle C to high C.

fifth Also, *perfect fifth*. The interval made up of the first and fifth tones (in rising order of pitches) in any major or minor scale, for example, C–G in the scale of C major (*do* and *sol* in solmization syllables).—**augmented fifth** The interval one half tone larger than a perfect fifth, such as C♭–G or C–G♯. —**diminished fifth** The interval one half tone smaller than a perfect fifth, such as C♯–G or C–G♭.

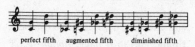

perfect fifth augmented fifth diminished fifth

figuration A rhythmic or melodic pattern that is repeated over and over again. This practice was very common in the music of the seventeenth and eighteenth centuries. (See example at ALBERTI BASS.)

figure Also, *motive* (mō′tiv), *motif* (mō tēf′). The shortest possible musical idea, sometimes consisting of only two notes, like the call of the cuckoo. A figure may be striking because of its rhythm, or its melody, or both. Its importance in a composition stems from how it is treated—for example, repeated again and again, reappearing in the same or in different forms, or reappearing in different voice-parts. Figures are often parts of a larger musical idea, called a subject or theme. See also LEITMOTIF.

figured bass In the baroque period (1600–1750), numbers placed above or below the notes of the bass part to show the accompanist (usually playing a harpsichord or other keyboard instrument) the intervals required for the harmony. Using these, one then would improvise the actual chords. Often a cello, viola da gamba (bass viol), or bassoon was played along with the keyboard instrument to reinforce the bass line. The accompanying example shows a portion of the first tenor recitative from Bach's Cantata no. 140, *Wachet auf* ("Awake"). The figure 5 under the first bass note,

C, calls for a G (the note a fifth above C); the ⁶₄ calls for the intervals a sixth and a fourth above C, which in this key (E-flat) are F and A-flat. The 7 with a slash through it means that the seventh above C should be raised a half tone, from B-flat to B natural. Although sharps are occasionally called for in this way, at other times they are indicated simply by a sharp sign (♯), and natural and flat are nearly always indicated by their respective signs (♮, ♭), although a flat could be canceled by a sharp sign and vice versa. The figure 6 under the G in the third measure, although it stands alone, implies not only a sixth (here, E-flat) but also the third (B-flat). Similarly, 3 or 4 also calls for 5, and 7 also calls for 3. A bass note without any figures implies both the fifth and the third, as well as the octave above it. Other details of figured-bass practice were less standardized and varied somewhat from composer to composer.

film music The music serving as accompaniment for most motion pictures. For early silent films, a live pianist or orchestra was often employed, both to cover the noise of the projector and to illustrate the film's action. Most often the musicians played adaptations of classical music, although occasionally new

scores were used for major motion pictures. With the advent of talkies, live music became unnecessary but it was at first difficult to synchronize recorded music with the action. By the mid-1930s, however, major composers were being commissioned to write film scores, and by 1940 or so film music was recognized as a specialized form. Among the scores written by notable composers are Prokofiev's *Lieutenant Kije, Alexander Nevsky,* and *Ivan the Terrible*; Virgil Thomson's *Louisiana Story*; Copland's *Our Town*; Walton's *Henry V* and *Hamlet*; Vaughan Williams's *Scott of the Antarctic*; Cage's *Works of Alexander Calder*; Auric's *Moulin Rouge*; Arlen's *The Wizard of Oz*; Bernstein's *On the Waterfront*; and John Williams's *Star Wars, Close Encounters of the Third Kind,* and *Schindler's List*. Other outstanding scores produced by composers famous mostly for their film music include Max Steiner's *King Kong, Gone with the Wind,* and *Casablanca*; Erich Korngold's *The Adventures of Robin Hood*; Bernard Herrmann's *Citzen Kane, Jane Eyre, Psycho, Vertigo, Fahrenheit 451,* and *Taxi Driver*; Walter Murch's *Acopalypse Now*; and Miklos Rosza's *The Thief of Baghdad* and *Lust for Life*.

A specialized area of film music is the production of scores for animated films. Of these, perhaps the most famous of all is Walt Disney's film, *Fantasia* (1940), a cartoon dramatization of eight classical works played by the Philadelphia Orchestra under Leopold Stokowski, ranging from Bach's *Toccata and Fugue in D minor* to Dukas's *The Sorcerer's Apprentice* and Schubert's *Ave Maria*. A similar use of pre-existing music in films was made for Stanley Kubrick's *2001* (1968), quoting from scores by Richard Strauss, Johann Strauss the Elder, and György Ligeti.

filter A frequency-sensitive electronic circuit that will allow only a specific portion of an applied complex signal (sound) to pass through. It passes some frequencies and attenuates (reduces in amplitude, or loudness) others. Filters are grouped according to their **passbands**, that is, the frequencies they allow to pass with little or no attentuation. Some filters block high frequencies, others low frequencies, and some pass only a selected range of frequencies.

fin (FAN) *French:* "end." Used in musical terms such as *à la fin* ("to the end").

final See under CHURCH MODES.

final cadence Another term for authentic cadence (see under CADENCE).

finale (*English* fi nal'ē; *Italian* fē nä' le). 1 In operas, the last part of an act, often consisting of a number of connected arias and ensembles involving several soloists along with the chorus. 2 The last movement of a concerto, sonata, or other composition containing three or more movements. During the classical period (1785–1820) the finale tended to be a rapid, cheerful movemént, but thereafter it was often of any character or tempo the composer wished.

fin' al segno (fēn äl sen' yô) *Italian:* "as far as the sign." A direction that the performer is to repeat from the beginning to the sign ꞩ.

fine (fē'ne) *Italian:* "end." A term generally used to indicate the actual end of a piece or section when, in order to save space, repeated sections are not fully written out. In such cases, the music appears to go right on, and, at what appears to be the end, there is an indication such as *da capo al fine,* directing the performer to go back to the beginning (*capo*) and repeat the music up to the point marked "fine."

fingerboard A long narrow piece of wood attached to the neck of a stringed instrument, over which the strings are stretched. The fingerboard normally is made of a hardwood, often black ebony. It is against this piece of wood that the player stops (holds down) the strings, thereby

shortening their vibrating length and changing the pitches they sound. In some instruments, such as the lute, guitar, and ukulele, the fingerboard is provided with frets, strips of wood or metal placed at the stopping positions. Instruments without frets, such as the violin, viola, and cello, are more difficult to play in tune, since the player must memorize the correct stopping positions.

finger cymbals See under CYMBALS.

finger exercise A composition designed solely for the purpose of improving the player's manual dexterity. It differs from an étude in that it rarely has musical value. Scales, octaves, arpeggios, and the like may be considered finger exercises. A well-known collection of finger exercises for the piano was written by the French teacher Charles-Louis Hanon (1820–1900).

finger hole One of a series of holes in the tube of a woodwind instrument, which, when left uncovered by the player's finger, shortens the vibrating air column inside the instrument and thereby raises the pitch. The lowest pitch of a woodwind is sounded when all the finger holes are covered; each hole shortens the air column slightly, raising the pitch a little. In older instruments, such as the recorder, the finger holes are covered and uncovered directly by the player's fingers. In modern woodwinds, such as the flute and clarinet, most of the holes are opened and closed by a system of keys and levers operated by the player's fingers.

fingering The order in which the fingers are used in playing an instrument. In music for modern wind instruments, the fingering for the holes, keys or levers is rarely indicated, being left up to the player. However, in advanced modern works requiring unusual techniques, the score may show the fingering by picturing the instrument's keys and holes, an open circle marking the

open ones and a black circle the closed ones.

Further, in music for older wind instruments, such as the recorder, as well as for piano and stringed instruments, fingering is often marked on the music, either by the composer or by an editor. Often such indications help the performer determine the phrasing (grouping of notes). Fingering is indicated by numbers. For piano and other keyboard music, 1 stands for the thumb, 2 for the index finger, and so on, with 5 standing for the little finger. For normal fingering, involving only five notes (which in turn occupy five fingers), the numbers often are omitted. Whenever more than five tones appear in a single direction (up or down in pitch), the thumb must be passed under another finger (or a finger must pass over the thumb) in order to reach the required number of notes (see the accompanying example for the right hand, from the last movement of a piano sonata by Haydn). In violin and viola music, the figure 1 stands for the forefinger, 4 for the little finger, and 2 and 3 for the middle and fourth fingers. In cello music the thumb, used in the higher positions, is indicated by the symbol ϙ

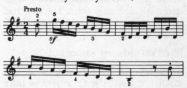

fioritura (fyô" rē tōō' rä) *Italian:* "flowering." A term used for any embellishment or ornamentation of a melody, whether written out or improvised (invented on the spot) by the performer.

fipple (fip' əl) **flute** Also, *whistle flute.* Any flute blown from one end, like a whistle, in which a small plug or block, called a fipple, closes the upper end of the pipe, leaving open only a narrow slit. A small hole with a sharp edge is cut in the wall of the pipe just below the fipple. When the player

blows the flute, the breath passes through the slit and strikes the sharp edge of the hole, producing vibrations in the air column inside the body of the instrument. Both the flageolet and the recorder are fipple flutes.

first 1 A term used in choral music for the higher-pitched of two parts, as in first soprano (higher than second soprano) or first tenor. **2** A term for orchestral instruments that play either the more important part or the higher-pitched of two or more parts, for example, first violin, first oboe, first trombone, etc.

first desk See under DESK.

first inversion See under CHORD.

first-movement form See under SONATA FORM.

Five, the Also, *the Mighty Handful.* A group of five Russian composers who in the 1870s worked together toward developing a national style of Russian music, in opposition to the more international Moscow school headed by Tchaikovsky. The Five, based in St. Petersburg, were César Cui, Alexander Borodin, Mily Balakirev, Modest Mussorgsky, and Nikolay Rimsky-Korsakov. They frequently helped with and criticized each other's works, and in fact often worked on one another's compositions.

fixed do (dō). See under DO.

flageolet (flaj" ə let', flaj" ə lā'). A small FIPPLE FLUTE with a narrow bore and six finger holes, four in front for the fingers and two in back for the thumbs. In range and tone it is similar to the PICCOLO. The flageolet, dating from the late sixteenth century, became quite popular in France and England during the next hundred years. Versions continued to be made through the nineteenth century, among them a French type with keys.

flageolet tone See HARMONIC, def. 3.

flam (flam). A drumbeat in which the accented stroke is preceded by one quick, unaccented stroke. It is usually performed on the snare drum.

flamenco (flä men' kô) *Spanish.* A type of music from Andalusia, in southern Spain, that is thought to date from the nineteenth century. Although it may be used to accompany dancing, flamenco usually consists of singing with guitar accompaniment, assisted by castanets to punctuate the rhythm. The mood of flamenco music ranges from sad and plaintive to fiery and brilliantly accented. The flamenco style of guitar playing is more dramatic than the classical style, and it employs different fingerings. Frequently a slightly different kind of guitar is used, one that is somewhat narrower, has fourteen to nineteen frets (in contrast to the twelve of the classical guitar), and has a sharper, more brilliant tone (owing to the use of cypress wood for the back and sides). The flamenco guitar often has one or two plastic or wooden plates next to the sound hole, which the guitarist taps with the fingernails for a percussive effect.

flat 1 An accidental that lowers the pitch of a note by one half tone, indicated by the sign ♭. **2** A term used to describe a tone, either sung or played, that is slightly below the correct pitch, as well as for instruments tuned slightly below normal pitch.

flautando See FLAUTATO.

flautato (flou tä' tô) *Italian:* "flutelike." Also, *flautando* (flou tän' dô). A light tone, produced by bowing gently but rapidly over the fingerboard (see also TASTIERA, SULLA).

flautist British term for flutist (flute player).

flauto (flou'tô) *Italian:* "flute." **1** After about 1750, the side-blown orchestral FLUTE. **2** Also, *flauto dolce.* Before about 1750, the RECORDER, the side-

blown flute being called *flauto traverso*.

flauto piccolo (flou'tô pē'kô lô). The Italian term for PICCOLO.

flauto traverso (flou'tô trä ver'sô) *Italian:* "transverse flute." An Italian term for the side-blown orchestral flute, used to distinguish it from the RECORDER.

flebile (fle'bē le) *Italian.* A direction to perform in a plaintive, mournful manner.

Flemish school A large group of composers who worked from about 1450 to 1600 and are considered the successors of the BURGUNDIAN SCHOOL. Although called "Flemish," these men came from a region much larger than present-day Flanders, consisting at that time of all of present-day Belgium, central and southern Holland, and the adjoining portions of northern France. (It therefore is also called the **Franco-Flemish school** or **Netherlands school.**) The Flemish school, together with the Burgundian school, includes nearly all of the important composers of the Renaissance, since many of the Flemish composers traveled and worked throughout Europe. (See the chart of composers accompanying RENAISSANCE.) The first great master of the Flemish school was Johannes Ockeghem (c. 1420–1495), known for his church music, especially Masses and motets. Among his contemporaries were Antoine Busnois (died 1492), known for his chansons and other secular (nonreligious) compositions, and the theorist Johannes Tinctoris (1436–1511), whose treatises include the first printed dictionary of music, *Terminorum musicae diffinitorium* ("Definition of Musical Terms"), written in the 1470s and printed about 1494. The next generation brought Jacob Obrecht (c. 1450–1505), Heinrich Isaac (c. 1450–1517), and Pierre de La Rue (1455/60–1518), as well as one of the greatest masters of all time, Josquin des Prez (c. 1445–1521). The main achievement of these two generations of musicians was the development of polyphonic music, in which all the voice-parts had equal importance instead of one part (the CANTUS FIRMUS) being the leader to which all the other parts were subordinate. Josquin and his followers made considerable use of imitation, the device whereby one musical theme (melody) is taken up by each of the parts in turn. They also extended the range of music downward, adding a baritone or bass voice-part to the customary soprano, alto, and tenor. Further, their music served to establish the major and minor modes to such an extent that they eventually replaced the older CHURCH MODES. Like the Burgundian composers, Josquin and his contemporaries wrote mainly Masses, motets, and secular songs, although for the last category they relied less on the established poetic forms (rondeau, ballade, virelai) and tended to make more use of the freer chanson. Another development of this period was a greater concern for writing vocal music that was appropriate to the words of its text.

The periods following Josquin's saw the further development of secular vocal music, particularly the polyphonic chanson and the Italian madrigal, as well as continued interest in polyphonic church music. Although fine instrumental music was written, especially for the lute and for keyboard instruments, vocal music remained more important. The chanson was cultivated by Clément Janequin (c. 1480–c. 1560), Nicolas Gombert (c. 1495–1556), Jean Richafort (c. 1480–1548), Jacobus Clemens (c. 1510–c. 1556; called "Clemens non Papa" to distinguish him from a contemporary Flemish poet), and to some extent by Adrian Willaert (c. 1490–1562) and Cipriano de Rore (1516–1565). The last two, however, are remembered more for their madrigals than for chansons, as are Jacob Arcadelt (c. 1505–c. 1568) and Philippe Verdelot (died c. 1550). The madrigal composers all spent consid-

erable time in Italy; by the end of the sixteenth century Italy had become the principal musical center of Europe. The last of the great Flemish masters was Orlando di Lasso (or Roland de Lassus; 1532–1594), who to some extent combined the Flemish and Italian styles.

flexatone A percussion instrument consisting of a small, flexible metal sheet suspended in a wire frame with a handle. On either side of the sheet are a series of wire-strung wooden knobs, which, when the instrument is shaken, strike the sides of the sheet. The sound created is like a mysterious tremolo. Patented in 1922 as a jazz instrument, the flexatone has attracted a number of composers and appears in orchestral scores by Honegger, Schoenberg, Khatchaturian, Henze, Davies, and Penderecki, among others.

flicorno (flē kôr' nô). The Italian word for FLUGELHORN.

fliessend (flē' sənt) *German.* A direction to perform in a smooth, flowing manner.

florid 1 Elaborately decorated with musical ornaments, as, for example, some of the arias in seventeenth- and eighteenth-century Italian opera. **2** Describing a type of counterpoint in which the added voices move in shorter note values against the longer notes of the main voice.

Flöte (flœ'tə). The German word for FLUTE.

flott (flôt) *German.* A direction to perform briskly, without hesitation.

flourish 1 Another term for FANFARE. **2** In seventeenth- and eighteenth-century England, a short improvised prelude.

flüchtig (flYкH' tiкH) *German.* A direction to perform in a light, nimble manner.

flue pipe The principal kind of organ pipe (see under ORGAN).

flugelhorn (floo'gəl hôrn"). A brass instrument of the SAXHORN group that is used principally in bands. It is generally built in a folded form. Like the cornet, it has a conical bore (cone-shaped inside) and three valves. The flugelhorn is built in several sizes, the most common of which is the soprano pitched in B-flat (or sometimes C), with the same range as the cornet, from the E below middle C to the B-flat below high C. Frequently used in nineteenth-century bands, the flugelhorn today is often replaced by the cornet but is still used in jazz, and occasionally in the orchestra (by Stravinsky, Vaughan Williams).

flüssig (flY'siкH) *German.* A direction to perform in a smooth, flowing manner.

flute Any of a large group of wind instruments consisting of a hollow tube and sounded by blowing a stream of air against the sharp edge of an opening at or near one end of the tube. Flutes of one kind or another have been found among practically every people, ancient and modern, ranging from ancient Mesopotamia and Egypt to ancient Mexico and Peru. In many respects these differed from the modern orchestral flute, which is closed at one end, is blown from the side, and is normally made of metal. Some were open, some were blown from the end like a whistle, some were made of clay, and some shaped like a globe rather than a tube. The side-blown ancestor of the modern flute dates back at least to the twelfth century. It was used mainly as a military instrument throughout the Middle Ages, the RECORDER (which is end-blown) being used for art music. During the sixteenth and seventeenth centuries the flute was improved and gradually replaced the

recorder in importance, probably owing to its greater range and the greater variety of tone colors and dynamics (degrees of loudness) that it could produce. Numerous improvements continued to be made, many of them by the Hotteterres, a French family of woodwind manufacturers and instrumentalists at the French court. The most famous of them, Jacques Hotteterre (1674–1763), wrote the first important treatise on flute playing (published in Paris in 1707) and also composed works for the flute. By 1750 the flute's importance was established. However, the term "flauto" (Italian for "flute") still meant, until the eighteenth century, the recorder, the terms "German flute" and "transverse flute" being used for the side-blown flute.

One of the main problems of the flute was its complicated fingering system, made worse by the awkward placement of holes and keys. This problem was finally solved in the 1830s by Theobald Böhm, whose system of fingering and keys is still used today. In 1847 Böhm improved the instrument's tone by redesigning the top section, giving it a slightly tapering convex shape and conical bore (cone-shaped inside).

The modern orchestral flute consists of a tube about two feet long, made of wood or metal, usually silver. It is made in three sections: a head joint (which contains the mouthpiece), body joint, and tail joint. The body joint has a cylindrical (straight) bore and is closed at one end. Both it and the tail joint are pierced with a number of holes that are opened or closed by means of keys. The player holds the instrument sideways and produces sound by blowing across an opening, called the embouchure, near the closed end of the tube. The flute has a range of three octaves, from middle C to an octave above high C. The tones of the first octave

are produced naturally by blowing fairly softly while raising the fingers from the keys, one after another; the tones of the next octave are produced by OVERBLOWING and employing the same fingering; the tones of the third octave are produced by blowing still harder and also using a different fingering. The tone quality of the flute varies considerably from the low notes to the higher ones. The lower tones are breathy and dense, but the high ones are clear, silvery, and penetrating. The instrument is very agile, and a skilled player can readily produce rapid trills, runs, and other ornaments.

The flute is one of the four basic woodwind instruments of the modern orchestra (the others are the oboe, clarinet, and bassoon), and nearly every composition for orchestra written since 1800 contains a part for flute. A few of the many important works for solo flute (or with major parts for solo flute) are: Bach's Orchestral Suite no. 2; Cimarosa's Concerto in G for two flutes; K. P. E. Bach's Concerto in D minor, and numerous sonatas for flute; Handel's numerous sonatas; Vivaldi's six concertos for flute, strings, and continuo, op. 10; Pergolesi's Concertos in D and in G; Haydn's Sonata in G for flute and piano; Mozart's Concerto no. 1 in G major for flute (K. 313); Friedrich Kuhlau's numerous chamber works for flute; Ravel's *La Flûte enchantée* (from *Shéhérazade*); Debussy's *Prélude*

à l'aprèsmidi d'un faune ("Prelude to the afternoon of a faun"), *Syrinx,* and Sonata for flute, viola, and harp; Prokofiev's Sonata in D, op. 94; Griffes's *Poem* for flute and orchestra; Ibert's Concerto for flute; Barber's *Capricorn Concerto* for flute, oboe, and trumpet; Hindemith's Sonata for flute and piano (1936); Milhaud's Sonata for flute, oboe, clarinet, and piano (1918); Piston's *The Incredible Flutist;* Nielsen's Concerto for flute; Varèse's *Density 21.5* (1935); and concertos by Foss (1986) and Zwilich (1990). (See also PICCOLO.)

—**alto flute** Also, British, *bass flute.* A flute pitched in G, a fourth below the orchestral flute; its range is also three octaves, and it is a transposing instrument, its music sounding a fourth lower than it is written.

—**bass flute** Also, British, *contrabass flute.* A flute pitched in C, an octave *below the orchestral flute.*

flûte (flyt). The French word for FLUTE.

flûte à bec (flyt″ ä bek′). The French term for RECORDER.

flute pipe An important class of organ pipes (see under ORGAN).

Flutophone (floo′ tə fon″). The trade name for a small wind instrument used mainly for teaching young children. The Flutophone, made of plastic, has a beaked mouthpiece like the recorder's and a flared bell. It has seven finger holes, giving it a range of a ninth, from the C above middle C to the D above high C. A similar instrument is the TONETTE.

flutter tonguing See under TONGUING.

fois (fwA) *French:* "time." Used in musical terms such as *une fois* ("once"), *deux fois* ("twice"), *encore une fois* ("once again"), *à la fois* ("at the same time").

folia (fô lē′ä) *Italian.* A pattern of bass harmonies (chords) that was used by many composers of the seventeenth and eighteenth centuries. (See the accompanying example for the exact pattern; the square-shaped notes are double whole notes, each having the

time value of two whole notes.) The folia was usually employed as a bass for continuous variations. As with the BERGAMASCA (def. 2), over the years a single melody came to be associated with the bass. Variations on the folia bass were written by such composers as Jean-Henri d'Anglebert, Alessandro Scarlatti, Arcangelo Corelli, and both Johann Sebastian and Karl Philipp Emanuel Bach. Even a few nineteenth- and twentieth-century composers used the pattern, among them Liszt and Rachmaninoff.

folk ballad See under BALLAD.

folk music Music that is learned mainly by word of mouth and therefore changes somewhat in the course of time. Most often the original composer is not known, the song or piece was written down only many years after it was first heard, and most of the people who play or sing it do not follow a written version. There are, however, exceptions. Some of the songs by such composers as Stephen Foster, John Jacob Niles, and Woody Guthrie, although written down by a known person, are folk songs in spirit, and eventually they come to be considered folk music. Folk music differs from so-called popular ("pop") music in that its principal purpose is not commercial but to express feelings, often the feelings of a group of people and not just those of an individual. (However, in the 1960s in the United States, music in folk style was being composed by urban singer-songwriters who called themselves "folk singers" and their compositions "folk songs." See also below.) Folk music includes a huge variety of types—lullabies, nursery songs, battle songs, love songs, dances, work songs, ballads about historical events, religious songs (spirituals), and some Christmas carols. Despite this great variety, folk songs tend to have certain common features. Principally,

they tend to be simple and direct, both in music and words; they rarely are sophisticated or subtle, and often, since they express feelings, they tend to be sentimental. Some folk music is strictly regional, expressing the tradition of a particular group of people living in a particular place, such as the cowboy songs of the American West. Other folk music is national in character, as, for example, the ballads of Scotland or Ireland, many of which relate historical events. Many American folk songs originated in the homelands of the different peoples who settled in America—England, Ireland, Scotland, France, Germany, Scandinavia, Poland, etc. (though by far the greatest number are British in origin). However, most of the folk songs that are still sung today date back only a few hundred years.

During the nineteenth century, many composers became interested in creating what they thought of as national music (see NATIONALISM), and they used the folk music of their countries—both actual folk melodies or, more often, tunes and rhythms resembling those of folk songs—in their serious music. Eventually this growing interest led to scholarly studies and collections of folk music, particularly when it was realized that as more and more people moved from remote country areas to the cities, their musical tradition was in danger of being lost. Among the composers who took a serious interest in preserving folk music (by writing it down and recording it) were Vaughan Williams of England; Bartók and Kodály of Hungary; Joseph Canteloube of France (famous for his *Chants d'Auvergne*); and John A. and Alan Lomax, and Charles and Ruth Crawford Seeger of America. There the revival of interest in folk music saw the rise to fame of numerous folk singers, who created their own new versions of old songs and also wrote entirely new songs in folk style. In the 1950s and 1960s folk festivals and hootenannies (concerts of folk music in which the audience participates)

became popular, especially among young people. Sometimes folk music has merged with other kinds of popular music. Thus, old mountain folk songs have been combined with newer hillbilly music, and modern folk songs, many of them songs of protest against racial discrimination, war, and similar evils, have been combined with ROCK. See also COUNTRY MUSIC; HOOTENANNY.

folk rock See under ROCK.

folk song 1 A song originating among the people of a country or region and passed on, usually without being written down, from one generation to the next. Such songs usually consist of several verses sung to the same melody, with or without a refrain between the verses. **2** A song of similar character written by a known composer. (See also FOLK MUSIC.)

forlana (fôr lä′ nä) *Italian.* Also, French, *forlane* (fôr lᴀn′). A lively dance in 6/8 or 6/4 meter, somewhat like the GIGUE, which originated in Friuli, northeast Italy, and was occasionally used by seventeenth- and eighteenth-century composers in ballets or as a movement in instrumental suites. An example of a forlana is found in Bach's Orchestral Suite no. 1 in C major.

form 1 Musical structure, that is, the way the elements of a musical composition are put together. The basic elements of music are individual pitches (notes), how they sound in sequence (melody), how they sound together (harmony), and how much time they take up in relation to one another (rhythm). A note or recognizable series of notes (melody) can be sounded again and again (repetition), or it may be repeated in slightly different ways (variation), or it can be followed by a totally different series of notes (contrast). These basic techniques are used to organize the larger units of a composition. Some of the most important patterns used in Western (European and American) music are: binary (two-part) form,

ternary (three-part) form, sonata form, rondo form, variation form, and strophic form. **2** Also, *compound form.* The larger structures created by combining various separate forms into compositions consisting of two or more movements or sections. Such forms include the sonata, symphony, concerto, string quartet, oratorio, cantata, and suite.

formes fixes (fôrm fēks') *French:* "fixed forms." A term used for three important forms of fourteenth-century French poetry, the BALLADE (def. 1), RONDEAU, and VIRELAI, that were often set to music.

forte (fôr'te) *Italian.* A direction to perform loudly. Often abbreviated *f.*

forte piano (fôr"te pyä'nô) *Italian.* **1** Direction to perform first loudly, then softly. Often abbreviated *fp.* **2** Also, *fortepiano.* An early piano with Viennese action (enabling a light, shallow touch for rapid passages), leather-covered hammers, and a knee-operated damper mechanism. Its sound is much softer than the modern piano's, both less loud and with a gentler tone color. The hammer is mounted on the key itself, not on the frame, and the escapement is mounted on the frame, not on the key. As the key is pressed down, the tail of the hammer is arrested by a notch in the escapement, so that the hammerhead swings up and strikes the string. Further pressure on the key pushes the escapement aside and allows the hammer to return. (For a comparison of this action with a modern piano's, see PIANO, def. 2.) The fortepiano was invented in Vienna in the late 1760s or early 1770s by Johann Andreas Stein (Mozart first encountered one in 1777), was perfected by 1780, and was very highly regarded until about 1820, when it was replaced by the improved double-escapement pianos of Érard and other builders. For the next 150 years the fortepiano was largely considered a primitive form of the modern piano, but in recent years it has been recognized as a fine

instrument in its own right, and an increasing number of builders are reproducing it (few original instruments survive) for the growing number of performers who use it to play the keyboard music of Haydn and Mozart and the early works of Beethoven.

fortissimo (fôr tēs'sē mô) *Italian.* A direction to perform very loudly. Often abbreviated *ff,* occasionally *fff.*

forza, con (kôn fôr'tsä) *Italian.* A direction to perform vigorously, with emphasis.

forzando (fôr tsän' dô) *Italian.* Also, *forzato* (fôr tsä'tô). A direction to perform with a strong accent, often abbreviated *fz.* Same as SFORZANDO.

forzato See FORZANDO.

Foss (fos), **Lukas,** 1922– . A German-born American composer, pianist, and conductor, whose music combines a variety of styles, among them neoclassicism, romantic lyricism, and American folk elements. Foss's works include two operas, *Griffelkin* and *The Jumping Frog of Calaveras County* (a one-act opera based on a short story by Mark Twain); two piano concertos; several cantatas (most notable, *A Parable of Death*); and *Symphony of Chorales,* based on some of Bach's chorales. In the late 1950s, Foss began to use various new styles, experimenting with improvisation (in his suite, *Time Cycle,* 1960), aleatory music, serial techniques, and quotation and collage (*Baroque Variations,* 1967, borrows from Handel, Scarlatti, and Bach). More recent works include *Brass Quintet* (1978), *Quintets for Orchestra* (1979), and Flute Concerto (1986). After 1970 Foss devoted himself increasingly to conducting.

Foster (fô'stər), **Stephen Collins,** 1826–1864. An American composer, who wrote both words and music for nearly two hundred songs. About a dozen of them are still well known today, and some are even considered American folk songs. The most famous of Foster's songs are "Old Folks at

Home" (often called "Swanee River"),
"Oh, Susanna," "My Old Kentucky
Home," "Massa's in de Cold, Cold
Ground," "Old Black Joe," "De Camp-
town Races," "Jeanie with the Light
Brown Hair," and "Beautiful Dreamer."

foundation stop See under ORGAN.

fourteenth The interval of an octave
plus a seventh, for example, from
middle C to the B below high C.

fourth Also, *perfect fourth*. The inter-
val made up of the first and fourth
tones (in rising order of pitches) in
any major or minor scale, for exam-
ple, C–F in the scale of C major (*do*
and *fa* in solmization syllables). —
augmented fourth The interval one
half tone larger than a perfect fourth,
such as C♭–F or C–F♯. See also TRITONE.
—**diminished fourth** The interval
one half tone smaller than a perfect
fourth, such as C♯–F or C–F♭. On key-
board instruments this interval is
identical to the major third (see
ENHARMONIC for an explanation).

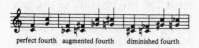

perfect fourth augmented fourth diminished fourth

fourth chord A chord that is made
up of two fourths (for example,
C–F–B♭), or one that contains a fourth
in addition to other intervals (for
example, F–B♭–C–E♭). Alexander Scri-
abin was one of the first to use a har-
mony based on fourths, which until
then had been rejected because such
chords are dissonant, and in several
compositions he used a chord made
up of five fourths (see under SCRIABIN).
Other composers who have made
considerable use of harmony based
on fourth chords are Bartók, Berg,
Hindemith, and Schoenberg.

four-three chord The second inver-
sion of a seventh chord (see INVERSION,
def. 1).

four-two chord The first inversion of
a seventh chord (see INVERSION, def. 1).

fox trot A ballroom dance that origi-
nated in the United States about 1912
and was the only one of approxi-
mately 100 popular dance forms of
that period to survive. In duple meter,
usually 2/4 or 4/4, it could be either
slow or fast. The 2/4 version of the
fox trot is also called the **two-step**.

fp The abbreviation for FORTE PIANO,
def. 1.

Franck (fränk), **César** (sā zar'), 1822–
1890. A Belgian composer and organ-
ist, remembered mainly for instru-
mental compositions that he wrote
late in his life, after about 1876.
Franck studied both in Belgium and
in Paris, where he lived and taught.
His compositions are for the most part
in traditional romantic style, but they
are notable for their free use of chro-
matic harmonies. Franck invented a
form he called *sonate cyclique* ("cycli-
cal sonata," usually translated as
"cyclical form"), in which one or
more themes appear again and again
throughout a composition, with few,
if any, changes. During his lifetime
Franck was renowned more as a
teacher than as a composer; among
his pupils were Vincent d'Indy, Ernest
Chausson, and Henri Duparc. In a
time dominated by vocal music, espe-
cially opera, Franck concentrated
largely on instrumental music, espe-
cially organ music in the contrapun-
tal tradition of Bach and other
baroque masters; his three *Chorales*
for organ are fine examples. Also out-
standing among his works are the
symphonic poem *Le Chasseur maudit*
("The Accursed Huntsman"), *Varia-
tions symphoniques* ("Symphonic Vari-
ations") for piano and orchestra, his
oratorio *Les Béatitudes*, a violin
sonata, and his masterpiece, the Sym-
phony in D minor.

free canon See under CANON.

free counterpoint See under COUN-
TERPOINT.

free jazz See under JAZZ.

free reed See under REED.

free rhythm See under RHYTHM.

frei (frī) *German.* A direction to perform in a free, unrestrained manner.

French horn A modern brass instrument of the orchestra, originally so named because it came to England from France and was thought to have been invented there. It is often simply called *horn*. The French horn consists of a conical (cone-shaped) tube, about eleven feet long, that is coiled into a spiral shape and ends in a widely flared bell. At the other end is a funnel-shaped mouthpiece. The classical French horn is pitched either in F or in B-flat. It has three valves, each of which lowers the pitch of the horn's natural HARMONIC SERIES (in the F horn, the F and its harmonics, or overtones) by making available extra lengths of tubing. The valves make it possible to play all the notes from low B to high F. The horn is a TRANSPOSING INSTRUMENT, its music being written a fifth higher than it sounds except for very low notes which are written in the bass clef, a fourth higher than they sound.

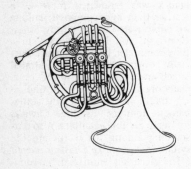

Many players today use a **double horn**, shown in the accompanying illustration, which combines the F and B-flat horns. In effect, it is a horn pitched in F but provided with a fourth valve, which enables the player to convert the instrument to a B-flat horn, with a somewhat lower range. The valve makes available an extra four feet of tubing, so that the double horn is somewhat larger and heavier than the single horn.

The French horn is difficult to play. Played well, it has a rich, mellow tone, somewhat penetrating in the high range. Played poorly, the notes tend to crack. The highest and lowest notes are particularly hard to play. Horn players use some special techniques to obtain certain effects. By increasing the wind pressure (blowing harder) the player produces a brassy, loud tone (often called for in scores by the French term *cuivré* or the German term *schmetternd*). By placing the hand inside the instrument's bell, a procedure called *stopping,* the horn player can produce a somewhat muffled tone that is also one half tone higher in pitch. One can obtain the same muffled tone by placing a pear-shaped mute inside the bell, but the mute does not alter the pitch. This effect is called for in scores by the sign + over a note or passage, or by the directions *stopped, sons bouchés* (French), *gestopft* (German), or *chiuso* (Italian).

The French horn is descended from a coiled hunting horn that originated about 1650, probably in France, though its further development took place largely in Germany. Each horn could produce only the harmonic series of a particular note (depending on the size of the tube). About 1715 the introduction of crooks (additional lengths of tubing) made different keys available on a single instrument, and by about 1800 the horn had been given a separate crook for each key. About 1750 a German horn player, Anton Hampel, had discovered that stopping produced different pitches as well as making the horn's rather brassy tone smoother and more velvety. This discovery, plus the addition

of a tuning slide and crooks that could be fitted into the center of the coil of tubing (instead of at the mouthpiece), resulted in the so-called **hand horn**, used by the great horn players of the eighteenth century (among them Giovanni Punto, 1748–1803), for whom Mozart, Beethoven, and others wrote specific compositions. Nevertheless, the crooks were hard to handle, and there was a distinct difference in tone quality between stopped and unstopped notes. These drawbacks were overcome with the invention of piston valves (c. 1815) and later (1830s) the rotary valves preferred by most builders today. The valve horn in F was the favorite instrument until about 1900, when it began to be replaced by the newly invented double horn.

Since 1835, when the valve horn was first called for (in Halévy's opera *La Juive*), nearly every composition for orchestra has included French horn parts, and the instrument is often used in wind ensembles. In addition, the repertory includes outstanding eighteenth-century works originally written for the hand horn. A few of the outstanding compositions for solo French horn (or with major parts for solo horn) are: Bach's *Brandenberg Concerto* no. 1 (originally the parts were played by hunting horns); Haydn's Concerto in D for horn and orchestra; Mozart's four concertos for horn and orchestra; Beethoven's Sonata for French horn and piano, op. 17; Schumann's *Konzertstück* for four horns and orchestra, op. 86; Brahms's Trio in E-flat for piano, violin, and French horn, op. 40; Richard Strauss's two concertos for French horn and orchestra; Hindemith's Concerto for horn; Chávez's Concerto for four horns and orchestra; Britten's Serenade for tenor voice, French horn, and string orchestra; Wuorinen's Horn Trio; Ligeti's Horn Trio; Davies's *Sea Eagle for Solo Horn*; Babbitt's *Around the Horn* for solo horn; and Zwilich's Concerto for horn and strings.

French overture See under OVERTURE.

French sixth See under SIXTH CHORD.

frequency The number of vibrations per second of a sound, which determines its pitch. See also SOUND.

frequency modulation See MODULATION, def. 2.

Frescobaldi (fres kô bäl' dē), **Girolamo** (jē rô' lä mô), 1583–1643. An Italian composer and organist, remembered mainly for his keyboard music (toccatas, ricercars, fantasias, canzonas). The most famous organist of his day, Frescobaldi played at the church of St. Peter's in Rome for about thirty years. Pupils came from all over Europe to study with him, the best known of them being Johann Jakob Froberger. It is said that at Frescobaldi's first concert in Rome, in 1608, some 30,000 persons came to hear him play. He also wrote motets and madrigals.

fret One of a series of strips of metal, gut, ivory, or wood fastened to the fingerboard of certain stringed instruments, such as the lute, guitar, and banjo, which help the fingers to stop the strings at the proper points for sounding the correct pitches. The number of frets varies according to the instrument.

frettoloso (fret"tô lô'zô) *Italian*. A direction to perform quickly, hurriedly.

freudig (froi'diĸн) *German*. A direction to perform in a happy, joyful manner.

frisch (frish) *German*. A direction to perform in a brisk, lively way.

Froberger (frō' ber gər), **Johann Jakob** (yō'hän yä'kôp), 1616–1667. A German composer and organist who is remembered for his keyboard works, which include toccatas, fantasias, canzonas, ricercars, and fugues, as well as some of the earliest suites of the baroque period. A pupil of Frescobaldi in Rome, Froberger was

renowned as an organist and made a number of concert tours. He is generally credited with establishing the order of movements within the suite (see SUITE, def. 1).

frog Also, British, *nut*. In bows for violins, violas, etc., a device that holds the hair and is used to tighten it.

fröhlich (frœ′likH) *German*. A direction to perform in a gay, joyous manner.

Frosch, am (äm frôsh′) *German*. A direction to play with the part of the bow nearest the hand.

frottola (frôt′tô lä) *pl.* **frottole** (frôt′tô le) *Italian*. 1 A general name for various types of nonreligious song popular in Italy from about 1470 to about 1530. Mostly they are four-part songs, with the melody in the treble (soprano), supported by simple harmonies in fourths and fifths. In some frottole, all the parts were sung; in others only the melody was sung, the harmony being supplied by a lute or other instrument. The frottola is considered a forerunner of the madrigal (see MADRIGAL, def. 2). 2 A particular variety of the song described above but in strophic form (consisting of stanzas and a refrain).

F-sharp One of the musical tones (see PITCH NAMES), one half tone above F and one half tone below G. On the piano F-sharp is identical with G-flat (see ENHARMONIC for an explanation). The scales beginning on F-sharp are known as F-sharp major and F-sharp minor. A composition based on one of these scales is said to be in the key of F-sharp major or the key of F-sharp minor, the key signatures (see KEY SIGNATURE) for these keys being six sharps and three sharps respectively. For the location of F-sharp on the piano, see KEYBOARD.

fuga (fōō′ gä). The Italian word for FUGUE.

fugato (fōō gä′tô) *Italian*. A musical passage or section written in the style of a fugue, occurring in a composition that is not itself a fugue.

Fuge (fōō′ge). The German word for FUGUE.

fughetta (fōō get′tä) *Italian*. A brief FUGUE.

fuging (fyōō′gĭng) **tune** Also, *fuguing tune, fugue tune, fuge tune*. A type of hymn popular in New England in the late eighteenth and early nineteenth centuries, so called because it contains a section in which the voices enter one after another, as in a FUGUE. Based on an older English form, fuging tunes were written specifically for use in singing schools. Among the composers of fuging tunes were William Billings (1746–1800) and Daniel Read (1757–1836).

fugue (fyōōg). A composition in which two or more voice-parts (most often three or four) take up a short theme according to a set of fairly strict rules. The fugue is a form of **imitative counterpoint**, that is, a musical fabric in which different melodies or different parts of the same melody sound simultaneously and, at the same time, the different voice-parts imitate one another, repeating the material of the first voice-part in either the same or a slightly different form. A round, such as "Three Blind Mice," is a simple form of imitative counterpoint; the fugue is much more complicated. Although not all fugues follow all the rules governing the form, many of them have the following features, here described for a three-part fugue (a fugue with three voice-parts) in the key of C major:

 a At the beginning, a short melody or theme, called the **subject**, is presented by the first voice (Voice 1). It is usually in the tonic (here C major, the main key of the composition).

 b The subject is then repeated by Voice 2, this repetition being called the **answer**. The answer is generally in the dominant (here, G major), at the distance of a fifth from the subject, and it may differ slightly from the subject.

c The subject is next taken up by Voice 3, usually in the same key as Voice 1 (C major) but an octave higher or lower.

d While Voice 2 is repeating the subject, Voice 1 fills in with a counterpoint to the subject—a melody that sounds well with the notes of the subject. (If this counterpoint is taken up throughout the fugue—by Voice 2 when Voice 3 is repeating the subject, etc.—it is called a **countersubject**.) Subject, answer, and countersubject are sometimes called the **exposition**.

e During the rest of the fugue, the subject is repeated again in the various voices, usually alternating with sections called **episodes**, which are based on material derived from the subject or the various counterpoints to it that have already been presented. The subject now is varied in a number of ways besides change of key. It may undergo augmentation or diminution (lengthening or shortening of the note values), inversion (be turned upside down), or stretto (be taken up so quickly by the different voices that answer overlaps subject).

f At the end, there is usually a **coda** (closing section), frequently containing a very close STRETTO over a pedal point (a long-held bass note, usually the tonic).

There are numerous variations on this scheme. For example, some fugues lack episodes; others lack a countersubject.

The fugue is thought to be descended from vocal music of the Renaissance, especially the motets of the Flemish masters (see FLEMISH SCHOOL), which often made use of different voices entering in succession and overlapping. In time these devices came to be used in instrumental music, especially in the sixteenth-century ricercar for organ, which had subjects (usually several) that were repeated again and again, and also in the organ canzona. Eventually, in the course of the seventeenth century, the fugue emerged, largely as a result of developments taking place in Germany. The first great master of the fugue was Sweelinck, who wrote fugues for organ and was an enormously influential teacher. Almost all the major keyboard composers of the baroque period (1600–1750) contributed to the development of the fugue, most notably Dietrich Buxtehude (c. 1637–1707), Johann Kasper Ferdinand Fischer (c. 1665–1746), and Johann Pachelbel (1653–1706). Some of their works foreshadowed the fugues of Bach, who was the greatest master of the form. Especially famous are Bach's keyboard fugues in *The Art of Fugue,* which illustrate almost every conceivable contrapuntal treatment of a single theme, and in *The Well-Tempered Clavier,* with its forty-eight preludes and fugues, two for each of the major and minor keys.

Fugues may be written for almost any vocal or instrumental combination—for voices, either accompanied or not; for an instrumental ensemble; or for a keyboard instrument. They may be independent compositions or portions of a larger work (sonata, symphony, oratorio, opera). Although the fugue is most commonly thought of as a baroque form, there are outstanding examples by such later composers as Mozart, Beethoven, and Brahms. Among the twentieth-century composers who have written outstanding fugues are Hindemith (*Ludus tonalis,* twelve fugues for piano), Stravinsky (in his Concerto for two pianos and the Symphony in C), Shostakovitch, and Webern.

—**double fugue: a** A fugue in which two subjects (themes) are introduced at the beginning and are developed together throughout the composition. An example of this type is found in the opening Kyrie of Mozart's Requiem Mass, K. 626, where one theme is begun by the basses in measure 1, and a second theme is begun by the altos in measure 2; the two themes then continue together throughout the movement. (Some authorities call the second theme in a double fugue of this type a countersubject.) **b** A fugue having

two subjects that are developed separately before being combined. This type of double fugue has three sections: first a fugue on the first theme, then a fugue on the second theme, and finally a fugue on the two themes contrapuntally combined.

—**triple fugue** A fugue with three subjects (themes), which are introduced and developed either in turn or together. The method is essentially the same as that in a double fugue.

—**quadruple fugue** A fugue having four subjects, usually developed together.

fugue tune Another name for FUGING TUNE.

full anthem See under ANTHEM.

full cadence Another term for authentic cadence. (See under CADENCE.)

full orchestra 1 The entire orchestra (in contrast to just a section of it, such as strings, woodwinds, or percussion). **2** The total number of players normally used in a large orchestra (in contrast to a chamber orchestra or other smaller group).

full organ A direction to the organist to play at full strength, using all or nearly all the stops.

full score See under SCORE.

fundamental 1 The first, lowest note of the HARMONIC SERIES. **2** Also, *root.* The basic note on which a chord is built.

funèbre See FUNERALE.

funerale (foō"ne rä'le) *Italian.* Also, French, *funèbre* (fy ne'br²). A direction to perform in a stately, mournful manner.

funk A style of African-American popular music originating about 1960. It resembles RHYTHM AND BLUES but is characterized by a high-volume bass, heavy syncopation with extended vamping over one or two chords, and free use of special effects from synthesizers. The lyrics are brash and often boastful. Later funk

was taken over by white performers as well. Offshoots were the even more explicit **street funk** of the 1970s and, in the 1980s, the revived DOO WOP. The name "funk" is also a black slang term for the odor of sexual excitement, and by extension "funky" is sometimes used to describe any blatantly sensual song, whether rock, jazz, or disco.

fuoco, con (kôn fwô'kô) *Italian.* A direction to perform in a brilliant, flashy manner.

furia, con See FURIOSO.

furiant (foōr'ē änt) *Czech.* A lively Bohemian dance, in rapid tempo and alternating 2/4 and 3/4 meter, often syncopated (with accents shifted to normally unaccented beats). Both Dvořák and Smetana used the furiant in their works.

furioso (foō"rē ô' sô) *Italian.* Also, *con furia* (kôn foō'rē ä). A direction to perform in a wild, passionate manner.

fusion A combination of two different genres of music. The term is most often used for a mixture of JAZZ and ROCK, which generally combines the improvisational quality and complexity of jazz with the driving beat and electronic amplification of rock. The term also has been applied to mixtures of jazz and classical music (also called **third stream**), and of rock and classical music (sometimes called **art rock**).

fuzz tone Also, *fuzztone.* A distortion device that produces a blurred sound, which also can be made rough and rasping. The device, often controlled with a foot pedal, cuts off the peaks and troughs from sound waves, so that the tones sounded are not sharp or distinct. Electronically fuzz tone is produced by adding overtones and increasing vibrations to the original tone. It is much used on electric guitars by rock artists and other popular musicians.

fz The abbreviation for FORZANDO.

G

G 1 One of the musical tones (see PITCH NAMES), the fifth note in the scale of C major. The scales beginning on G are known as G major and G minor, and a composition based on these scales is said to be in the key of G major or G minor, the key signatures (see KEY SIGNATURE) for these keys being one sharp and two flats, respectively. The note one half tone above G is called G-sharp or A-flat (see ENHARMONIC for an explanation); the note one half tone below G is called G-flat or F-sharp. (For the location of these notes on the piano, see KEYBOARD.) **2** An ornamented form of the letter G is used as the sign for the treble clef (see under CLEF). **3** An abbreviation for *gauche*, meaning "left" and referring to the left hand. **—G instrument** A transposing instrument, such as the alto flute, which sounds each note a fourth lower than it is written; for example, the fingering for the written note C yields the pitch G.

Gabrieli (gä" brē el' ē). The family name of two important Italian composers and organists of the Renaissance, related as uncle and nephew.

—Andrea Gabrieli, c. 1520–1586. Wrote madrigals, motets, and Masses; ricercars and other compositions for organ; and works for various instrumental ensembles. He introduced the polychoral style, with its use of separate groups of voices or instruments, performing in turn and then together, which became an important technique of the VENETIAN SCHOOL. A pupil of Adrian Willaert, Gabrieli in 1566 replaced his teacher as chief organist of St. Mark's Cathedral in Venice. Of his pupils, the best known are his own nephew, Giovanni, and Hans Leo Hassler (1564–1612).

—Giovanni Gabrieli, c. 1557–1612. Introduced a number of new ideas in his choral and instrumental music. He was one of the first composers to appreciate the special qualities of brass instruments, and he wrote a number of pieces for brass ensemble. Among his instrumental canzonas and sonatas is the first piece with marked dynamic (loud-soft) contrasts, his *Sonata pian e forte*. His vocal music, especially his motets, are notable for their elaborate use of the polychoral style introduced by his uncle, Andrea, whom he succeeded as organist at St. Mark's. Giovanni Gabrieli also wrote noteworthy organ music, including ricercars, toccatas, and canzonas. His influential teaching attracted pupils from all over Europe, among them Praetorius and Schütz.

gagaku (gä gä kōō') *Japanese* The traditional court music of Japan, which flourished from the seventh to twelfth centuries and is believed to be the oldest surviving orchestral music. It is played alone or to accompany singing or dance. In modern times gagaku ensembles have been orga-

nized outside the court. The basic melody instrument of the gagaku orchestra is the **hichiriki**, a short, double-reed wind instrument. It is joined by transverse bamboo flutes, called **ryūteki**, a **sho** (mouth organ; see under SHENG), and various drums. For concert presentations KOTO (zither) and BIWA (lute) are sometimes added (they are omitted when there are dancers). The individual instrumental lines are heard separately, as in chamber music, rather than merged as in the Western orchestra. The old gagaku repertory has been preserved in partbooks that give instrument fingerings and some other details but not precise pitches. Moreover, the rhythms often are not a series of regular beats, as in most Western music, but are more like human inhaling and exhaling, so that the performers must listen carefully to one another in order to coordinate the ensemble.

gagliarda (gä lyär′ dä). The Italian word for GALLIARD.

gaillarde (gī yArd′). The French word for GALLIARD.

gallant style Also, French, *style galant* (stēl gA län′). The light, graceful, elaborately ornamented style of some eighteenth-century music, especially harpsichord music, as distinct from the solid contrapuntal style of the German baroque composers. The chief composers associated with the gallant style, which is sometimes called "rococo" after its counterpart in the visual arts, are François Couperin and Domenico Scarlatti, and it was adopted by some of their German contemporaries, notably Telemann and Bach's sons, Karl Philipp Emanuel and Johann Christian. To some extent the gallant style is considered a bridge between the baroque and the classic style of Haÿdn and Mozart. See also PRECLASSIC.

galliard (gal′yərd). A lively dance popular in the sixteenth century. Usually in triple meter (any meter in which there are three basic beats per measure, such as 3/4 or 3/8) and frequently using HEMIOLA, the galliard often was preceded by a slow stately dance, at first usually a pavane and later a passamezzo. A very similar fast dance paired with a slow dance was the SALTARELLO. In the seventeenth century the galliard often appeared in suites, and by the end of the century it was often quite slow in tempo.

galop (*English* gə lop′; *French* gA lō′). A popular nineteenth-century ballroom dance in very fast tempo and 2/4 meter. The galop was a round dance (the dancers were placed in a circle), and it was performed with hopping steps, not unlike a horse's gallop. The famous "Dance of the Hours" in Ponchielli's opera *La Gioconda* is a galop.

galoubet (gA loo bā′) *French*. See under TAMBOURIN.

gamba (gäm′bä) *Italian*. A shortening of VIOLA DA GAMBA.

gambang (gom′bong) *Javanese*. A wooden xylophone used in GAMELAN ensembles. It is played with two mallets in very fast tempos and provides a gentle rippling sound.

gamelan (gom′ə lon″) *Javanese*. A general name for a classical Indonesian orchestra, of which there are many different kinds, as well as for its music. Indeed, a gamelan may be unique, made up not just of certain kinds of instrument but of specific instruments that have been played together for many years; such a group is often given a proper name, just as a person is. Some of the gamelan still used in Java today are a thousand years old. Javanese music uses two kinds of scale system, a five-tone system called **sléndro** and a seven-tone system called **pelóg**. Within each system are different tunings, and a gamelan can often be distinguished by its own particular combination of tunings. A complete gamelan consists of two sets of instruments, one set of pelóg and another of sléndro. All together there may be as many as

eighty instruments, played by about thirty performers. The most important are the percussion instruments, consisting of gongs, drums, xylophones, and kettles. The texture of gamelan music is extremely dense, with a main melody, countermelodies, punctuations, and rhythms occurring simultaneously. The central melodic theme is played by sarons, which are metal xylophones, and the units of time are marked by gongs. There are two leaders within the ensemble, one who plays the largest drum and determines tempo changes, and another concerned with melodic variations, who generally plays a fiddle called the RABAB. Both male and female voices are used but they do not predominate, merely serving as one of numerous melodic components.

Some twentieth-century Western composers have shown interest in the gamelan. Messiaen scored for similar groups of vibrating metal instruments in many of his works from the mid-1940s on, and composers as diverse as Boulez, Stockhausen, and Britten were influenced by this kind of sound. More directly, Lou Harrison wrote a Double Concerto for violin, cello, and Javanese gamelan (1981). Also, numerous gamelan ensembles have been formed in America and Europe.

gamut (gam'ət). The entire RANGE of a voice, instrument, or scale, that is, all the notes it can produce or includes. The term comes from a contraction of *gamma* and *ut; gamma* was used to represent the lowest note in the medieval scale and *ut* the first note (later changed to *do*).

gapped scale Any scale that is made up of only a selection from the notes of a larger scale and therefore containing at least one interval larger than a whole tone. For example, the pentatonic scale is a gapped scale, since it is made up of only five of the seven tones of the diatonic (major or minor) scale. (See also SCALE.)

garbato (gär bä' tô) *Italian.* Also, *con*

garbo (kôn gär'bô). A direction to perform in a graceful, elegant manner.

garbo, con See GARBATO.

gauche (gōsh) *French:* "left." A direction to play a note or passage with the left hand. Abbreviated *g.*

gavotte (gA vôt') *French.* A popular seventeenth-century dance, which in the eighteenth century came to be used as a movement in instrumental suites. It is normally in 4/4 meter, in moderate tempo, and tends to begin on the third beat of a measure. Bach used the gavotte in several suites, among them his English Suites nos. 3 and 6, and his Orchestral Suite no. 1. Sometimes two gavottes were used, one after another (marked Gavotte 1 and 2), in which case the first was usually repeated after the second. The second gavotte frequently was in the form of a musette, having a bass part that imitated the drone of a bagpipe.

G clef Another name for treble clef, the sign for which is derived from the letter G (see under CLEF).

Gebrauchsmusik (gə broukHs' moō zēk" *German:* "music to be used," "utility music." A term invented in the 1920s for music to be played ("used") at home by amateurs instead of in a concert hall by professional performers. (The term was first coined for dance music to dance to, as opposed to dance music to be listened to.) To make home performance easier, such compositions call for small groups of players and are not too lengthy or technically difficult. Moreover, they often allow for substituting different instruments when the ones called for are not available. Among those who wrote such works was Paul Hindemith, whose Gebrauchsmusik compositions include a children's opera, *Wir bauen eine Stadt* ("We Are Building a City," 1930); *Spielmusik* ("Music for Playing") for strings, flutes, and oboes, op. 43, no. 1; and a set of easy duets for two violins.

gebunden (gə boōn' dən) *German.* A direction to play a series of notes in a connected, legato fashion.

gedämpft (gə demft') *German*. A direction to produce a muted, muffled tone. In wind instruments such as the French horn, this can be effected by using a mute.

gedehnt (gə dānt') *German*. A direction to perform in a slow, stately manner, drawing out each note.

Gefühl, mit See GEFÜHLVOLL.

gefühlvoll (gə fyl' fôl) *German*. Also, *mit Gefühl* (mit gə fyl'). A direction to perform expressively, with feeling.

gehalten (gə häl' tᵊn) *German*. A direction to hold (sustain) each note to its full value.

geheimnisvoll (ge hīm' nis vôl) *German*. A direction to perform in a mysterious, secretive manner.

gehend (gā' ənt) *German*. A direction to perform at a moderate tempo, roughly at walking speed. (See also ANDANTE.)

Geige (gī' gə). The German word for VIOLIN.

gelassen (gə läs'ᵊn) *German*. A direction to perform in a quiet, easy manner.

gemächlich (gə meкн'liкн) *German*. A direction to perform at a comfortable tempo, neither very fast nor very slow (see MODERATO).

gemässigt (gə mäs' iкнt) *German*. Also, *gemessen* (gə mes' ən). A direction to perform at a moderate tempo.

gemessen See GEMÄSSIGT.

Geminiani (je" mē nyä' nē), **Francesco** (frän ches'kô), 1687–1762. Italian violin virtuoso, composer, and teacher. He wrote *The Art of Playing on the Violin* (1751), which was the first treatise on violin playing addressed to advanced violinists and was enormously influential. A pupil of Corelli and Alessandro Scarlatti, he spent most of his life in London and Dublin. His contributions to violin technique include freer use of shifts in position and double stopping. Geminiani's compositions include violin sonatas, concerti grossi, string trios, and cello sonatas.

gemshorn (gemz' horn) *German*. A medieval recorder originally made from the horn of a chamois (*Gemse* in German) and, from the late fourteenth century on, from the horn of an ox. With six finger holes and a thumb hole, it was made in many sizes, ranging from sopranino to bass, but was abandoned early in the sixteenth century. Its name and sound survive in an important organ foundation stop with a soft husky tone that carries well.

gemütlich (gə mʏt' liкн) *German*. A direction to perform at an easy, comfortable tempo, neither very fast nor very slow.

gender (gen'dər) *Javanese*. A percussion instrument consisting of tuned metal bars amplified by bamboo resonators. Made in various tunings, it is used in the GAMELAN, where it provides a mellow, nonpercussive sound.

Generalpause (ge ne räl' pou" zə) *German:* "general rest." A term used in scores for a silence lasting one or more measures for all the performers. It often occurs after a loud climax and is usually abbreviated *G.P.*

German flute In the eighteenth century, a name for the ordinary transverse flute (see under FLUTE), used to distinguish it from the recorder (which was called "English flute").

German polka The British term for SCHOTTISCHE.

German sixth See under SIXTH CHORD.

Gershwin (gûrsh' win), **George**, 1898–1937. An American pianist and composer, the first to succeed in combining American popular and serious music. Gershwin's earliest success was the immensely popular song "Swanee," which he wrote at the age of nineteen. His first important serious composition was *Rhapsody in Blue* for piano and jazz orchestra, first performed (with the composer as soloist) in 1924. Gershwin wrote both musi-

cal comedies and popular songs on the one hand, and serious concert pieces on the other. To his popular music he brought the craftsmanship of a trained musician; to his serious music he brought elements from ragtime, jazz, the black tradition of spirituals and blues, and the Latin American dance rhythms so popular during the 1920s and 1930s. Gershwin's best-known works are the symphonic poem *An American in Paris,* the Concerto in F for piano, the folk opera *Porgy and Bess,* and the musical comedies *Lady Be Good, Strike Up the Band, Funny Face, Girl Crazy,* and *Of Thee I Sing.*

His brother, **Ira Gershwin** (1896–1983), an outstanding lyricist, wrote the words for *Lady Be Good* and *Of Thee I Sing,* as well as about half the lyrics for *Porgy and Bess.* He also collaborated with other composers, among them Jerome Kern, Vincent Youmans, and Kurt Weill. His best-known songs include "Fascinatin' Rhythm," "Embraceable You," and "Someone to Watch over Me."

gesangvoll (gə zäṅg'fôl) *German.* A direction to perform in a sweetly singing manner.

geschwind (gə s̱hvint') *German.* A direction to perform in rapid tempo.

gesteigert (gə s̱htī' gərt) *German.* A direction to perform with gradually mounting intensity.

gestopft (gə s̱htôpft') *German.* A direction to use the stopped notes of the French horn (see STOPPING).

geteilt (gᵊ tīlt') The German term for DIVISI.

getragen (gə trä' gᵊn) *German.* A direction to perform in a slow, sustained manner.

G-flat One of the musical tones (see PITCH NAMES), one half tone below G and one half tone above F. On the piano, G-flat is identical with F-sharp (see ENHARMONIC for an explanation). For the location of G-flat on the piano, see KEYBOARD.

Gibbons (gib' ənz), **Orlando,** 1583–1625. An English composer and organist who is remembered mainly for his anthems and madrigals. He was among the first to write verse anthems, that is, anthems with sections for soloists and instrumental accompaniment, alternating with sections for the full choir. A famous musician during his day, Gibbons served as organist for the Chapel Royal from the age of twenty-three until his death. In addition to anthems and madrigals, he wrote motets, keyboard music, and some chamber music, consisting mostly of fantasias and dances scored for consorts (ensembles) of viols.

His son, **Christopher Gibbons** (1615–1676), also served as organist of the Chapel Royal and Westminster Cathedral. He wrote numerous anthems and instrumental works.

gig Musicians' slang for a professional booking or job.

gigue (zẖēg) *French.* A very lively dance, probably based on the sixteenth-century Irish or English jig, that became the concluding dance movement of the standard four-movement eighteenth-century suite (the first three were the allemande, courante, and saraband). The gigue in a suite is nearly always in 6/8 or 12/8 meter and has two sections, each of which is repeated. In one form, the second section presents the subject of the first section inverted (the melody is turned upside down).

Gilbert and Sullivan (gil'bûrt, sul' ə vən). The creators of a series of comic operettas, librettist William Schwenck Gilbert (1836–1911) and composer Arthur Seymour SULLIVAN (1842–1900). The operettas generally have humorous plots and are a rare combination of good-natured satire, lilting melody, and brilliant parody, both textual and musical. Through exaggeration, they poke fun at personal and social foibles, as well as at hackneyed musical conventions. They are usually performed in a highly stylized

manner that is based directly on the original productions of the operas at the Savoy Theatre in London by Richard D'Oyly Carte (1844–1901), the manager who first thought of having Gilbert and Sullivan collaborate on a musical play. Every word, gesture, and piece of action was carefully chosen to contribute to the overall effect, with the result that the actors have an almost marionettelike quality. However, the total result was so successful that the same gestures and stage actions are still copied by most performers today, both amateur and professional. The first of the Gilbert and Sullivan operettas was the one-act *Trial by Jury* (1875), followed by *H.M.S. Pinafore, The Pirates of Penzance, Patience, Iolanthe, Princess Ida, The Mikado, Ruddigore, The Yeomen of the Guard, The Gondoliers, Utopia Limited,* and *The Grand Duke* (1896). With the exception of the last two, the Gilbert and Sullivan operettas were enormously successful in their day and are still popular in every English-speaking country of the world. (The fact that the humor of the librettos is generally lost in translation has limited their popularity elsewhere.)

gimel See GYMEL.

gioco, con See GIOCOSO.

giocoso (jô kô′ sô) *Italian.* Also, *con gioco* (kôn jô′ kô). A direction to perform in a merry, lively manner.

gioioso (joi yô′ sô) *Italian.* A direction to perform in a gay, joyful manner.

Gitarre (gi tä′ re). The German word for GUITAR.

gittern (git′ ərn). An early type of GUITAR, played to accompany singing and dancing during the Middle Ages and surviving in some places until the sixteenth century (elsewhere it was replaced by either lute or guitar). The gittern had a boxlike body and, usually, four pairs of gut strings, played with a plectrum. During the fifteenth and sixteenth centuries the name was used not only for this instrument but also for the CITTERN and for the Span-

ish guitar, so that in some sources it is not always certain which instrument is meant. No music for gittern has survived.

giusto (jōōs′ tô) *Italian:* "correct." A word appearing in such directions as *tempo giusto* ("correct time"), meaning either that one should return to playing in strict tempo or that a tempo should be chosen that is appropriate to the music.

Glass, Philip, 1937– . An American composer who was strongly influenced by his study of Indian music and first became known for his MINIMALISM, based on extensive repetition, rhythmic regularity, and conventional tonal harmony. In the late 1960s Glass founded his own eight-member ensemble of electric keyboards (synthesizer, organ, piano), amplified wind instruments, and voices, for which most of his compositions were written. In the mid-1970s Glass also began writing operas. The first was *Einstein on the Beach* (1976), in collaboration with playwright-director Robert Wilson, who contributed the scenario and assisted with staging and sets. Well received in Europe, it received its American premiere at the Metropolitan Opera and shocked audiences with its text of solfège syllables, numbers that limned the rhythmic structure of the music, and interior monologues. The music of this four-and-one-half-hour work was more complex than Glass's earlier pieces; he used more chords and keys and richer tone colors and textures, although the harmonies were still tonal and the melodic patterns were relentlessly repeated. His next opera, *Satyagraha* (1980), is a series of tableaux about the life of Mohandas Gandhi in Africa, scored for orchestra, soloists, and chorus. The action is not realistic, and the libretto, in Sanskrit, is based on the *Bhagavad-Gita.* It was followed by the opera *Akhnaten* (1984), a series of meditations (in Egyptian, Hebrew, and Akkadian) on the Egyptian pharaoh, linked by a

narrator who speaks in the language of the audience. Other theater works of Glass's include the film score *Koyaanisqatsi* (1982); the music theater piece *Photographer* (1982); the operatic fifth act of Robert Wilson's twelve-hour-long multinational theater epic, *Civil Wars: A Tree Is Best Measured When It Is Down* (1984); the opera *The Juniper Tree* (1985), in collaboration with Robert Moran; and the operas *Orphée* (1993) and *La Belle et la Bête* (Beauty and the Beast; 1994), both based on films by Jean Cocteau. Glass also continued to compose smaller-scale works, such as the suites *North Star* (1977) and *Glassworks* (1981) for his ensemble, which often performed for rock and jazz audiences as well as for listeners interested in experimental serious music.

glass harmonica An instrument consisting of a series of tuned glass bowls fixed to an axle, which is made to turn by means of a treadle. The player makes the bowls sound by touching their rims with the fingers as they rotate. The glass harmonica was invented in 1761 by the American statesman Benjamin Franklin, who named it **armonica**. It is based on an older instrument, **musical glasses**, which consists simply of a series of glasses filled with water to different levels and sounding different pitches when struck or rubbed. Franklin's contribution was, in effect, to mechanize the musical glasses. The glass harmonica became very popular,

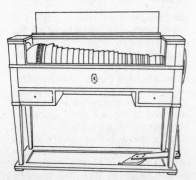

both in Europe and America, during the next century or so. In 1784 a keyboard was added, making it much easier to play (this type is sometimes called **keyed harmonica**), but no keyboard mechanism could render the subtle effects for which the instrument was most highly prized. Mozart and numerous other composers wrote pieces for glass harmonica, usually in combination with other instruments, and Richard Strauss used it in his opera, *Die Frau ohne Schatten*. Since the middle of the nineteenth century, however, it has usually been replaced by the harmonium.

Glazunov (glä zōō nôf'), **Alexander** (a" le ksän' dər), 1865–1936. A Russian composer whose works are noted for reflecting the musical tradition of his country (see NATIONALISM). His best-known composition is the ballet *Raymonda*. He also wrote nine symphonies, seven string quartets, concertos for violin, cello, and piano, and many choral works. In addition, he helped Rimsky-Korsakov to complete Borodin's unfinished opera, *Prince Igor,* and reconstructed the opera's overture from memory, having heard Borodin play it on the piano.

glee Originally, an unaccompanied song for men's voices, a form that became very popular during the eighteenth and nineteenth centuries in England and America. Glees are usually quite brief, have three or four voice-parts (often including one for male alto), and are set in simple chords. The texts may be serious or humorous. The most famous composer of glees was Samuel Webbe (1740–1816), who is said to have written at least three hundred. By the late 1700s some glees were being written for mixed voices (men and women) as well.

glee club Originally, a type of English club founded for the purpose of singing glees, catches, and, eventually, various other short choral compositions. In the course of the nine-

teenth century this type of club was formed in numerous American high schools and colleges so that students might take part in choral singing. Until about 1920, school glee clubs performed mostly popular music, but since that time they have been devoted more and more to serious music. The glee club may be for girls only, for boys only, or for both.

gleichmässig (glīḴH′ mä siḴH) *German.* A direction to perform in an even, steady manner.

Glière (glyer), **Reinhold** (rīn′hôlt), 1875–1956. A Russian composer and teacher who is remembered mainly for his symphonic music, written in a largely traditional nineteenth-century style. His best-known work is his Symphony no. 3, entitled *Ilya Murometz* (after a legendary Russian hero). Glière also wrote five operas, numerous songs, ballets, a cello concerto, French horn concerto, chamber music, and many piano compositions. His most famous pupil was Prokofiev.

Glinka (glēn′kä), **Mikhail** (mi ḴHä ēl′), 1804–1857. A Russian composer who was one of the first to use Russian subjects and Russian musical material. (He is sometimes called "the father of Russian music.") Glinka's most famous works are two operas. *A Life for the Tsar,* first produced in 1836 under the title *Ivan Susanin,* tells the true story of a simple peasant who saved the life of the first Tsar of the Romanov family. *Russlan and Ludmilla,* produced in 1842, is based on a fairy tale by the Russian poet Pushkin. Though both operas are in the standard form of nineteenth-century Italian opera, which Glinka studied in Italy, the music contains elements of traditional Russian music, and the subjects are Russian. Glinka also wrote piano and chamber works, orchestral compositions, choral music, and more than eighty songs.

gliss. The abbreviation for GLISSANDO.

glissando (glēs sän′dô). The device of moving up or down over a scale very quickly. This effect is obtained in different ways, depending on the instrument used: piano—drawing one fingertip (usually the third finger) or a thumbnail rapidly over all the white or black keys; violin, viola, cello—quickly sliding a finger up or down one string; trombone—moving the slide while blowing; other wind instruments (mainly clarinet, trumpet, horn)—increasing the lip pressure so that each note rises in pitch until it becomes the next higher note; timpani—playing a roll with the drumsticks and at the same time changing the tension on the drumhead with the aid of pedals; harp—sliding one finger rapidly across all the strings. A glissando sounds quite different on different instruments. On the harp it has a smooth, almost liquid sound and the separate pitches are discernible, whereas on the trombone it has a comic effect and the pitches are indistinct.

Glissando is indicated either by the word or its abbreviation, *gliss.,* or by a stroke or wavy line between the highest and lowest of the notes to be played. On the harp, where a number of tunings are available, the exact notes usually need to be indicated. See also PORTAMENTO.

ascending descending

Glocke (glô′kə). The German word for BELL.

glockenspiel (glok″ ən s̱hpēl′). 1 A tuned percussion instrument of the orchestra, which consists of a series of flat steel bars of different lengths that are attached to a frame. The bars are tuned to sound chromatically and are arranged like the keyboard of a piano, with one row representing the white keys and a second row, above the first, representing the black keys. The player strikes at the center of the bars with a pair of hammers, producing a sweet, clear tone. Most glockenspiels have a range of two and one-half

octaves, from the second G above middle C to the C two octaves above high C, but to avoid ledger lines the music is written two octaves lower than it sounds. Occasionally a glockenspiel with piano action is used; in this type, the bars are struck by hammers activated by a keyboard.

The glockenspiel is rarely called on for solos, being used mostly with other instruments, where it serves to supply a light, tinkling effect. One well-known glockenspiel solo is found in Mozart's opera *Die Zauberflöte* ("The Magic Flute"), where it provides the sounds of Papageno's magic bells. **2** Also, *bell lyre.* A glockenspiel in which the metal bars are attached in a lyre-shaped frame, as shown in the accompanying illustration. The instrument is portable and is used largely in marching bands, the player holding the frame by the handle and using a single beater.

Gloria (glô′ rē ä). **1** Also, *Gloria in excelsis deo* (glô′ rē ä in eks c̲h̲el′ sēs dä′ō) *Latin:* "Glory to God in the highest." The second section of the Ordinary of the Roman Catholic Mass (see MASS). Also called *Greater Doxology* (Latin, *Doxologia magna*), it is omitted on ordinary weekdays, during Lent, Advent, and on certain other sober occasions. Composers have made separate settings of the Gloria; a well-known example is that of Vivaldi and, more recently, those of Poulenc (1959) and John Rutter (1974). The Gloria is also sung in the Communion service of Anglican churches. **2** Also, *Gloria patri* (glô′ rē ä pä′ trē) *Latin:* "Glory to the Father." A short hymn in Anglican and other Protestant church services, and at the end of a psalm or canticle in Roman Catholic services. It is also called *Lesser Doxology* (Latin, *Doxologia parva*).

Gluck (glo͞ok), **Christoph Willibald** (kris′ tôf vil′ i bält″), 1714–1787. A German composer, remembered both for his operas and for his theories and musical style, which influenced many later composers of opera. His studies in Italy at first made him an admirer of eighteenth-century Italian opera seria, which consisted mostly of arias intended to show off star singers, connected by fairly unimportant music (see NUMBER OPERA). Gluck wrote numerous operas of this type, which are rarely performed today. Later, as a conductor, he was influenced by the French OPÉRA-COMIQUE, which was very popular at the time, and he wrote several works of this kind, complete with French texts. In time, however, Gluck decided that in an opera the music should serve the story; it should express the feelings of the characters and be generally in keeping with the plot. Together with the poet Ranieri di Calzabigi (1714–1795), who wrote the librettos (texts), Gluck composed his best works in this new style (sometimes called **reform opera**). The first and finest of their joint efforts was *Orfeo ed Euridice* (1762). It was followed by *Alceste,* which had a preface expounding Gluck's ideas about opera. In Paris, where Gluck conducted, his ideas touched off a quarrel between his fol-

lowers and the admirers of Italian opera, who were represented at the French court by Niccolò Piccinni (1728–1800). During this period Gluck wrote French versions of *Orfeo* and *Alceste,* which were immensely successful. His other works include the operas *Iphigénie en Aulide* ("Iphigenia in Aulis") and *Iphigénie en Tauride* ("Iphigenia in Tauris"), set to French librettos, and the ballet *Don Juan,* one of the few pieces of ballet music from this period that is still in the modern repertory. The opera composers influenced by Gluck include Mozart, Cherubini, Beethoven, and Berlioz.

gondoliera (gön" dô lye' rä). An Italian word for BARCAROLLE.

gong Also, British, *tam-tam.* A large bronze disk, three to four feet in diameter, having a shallow rim and struck at the center with a mallet. The gong originated in East Asia and today is widely used in the percussion section of the orchestra. Three kinds —Burmese, Chinese, and Turkish— are used, which vary slightly in shape, the metal used, and similar details. The gong has no definite pitch, but it sounds for a long time after being struck. Struck softly, its sound is somewhat mysterious, that is, subdued and very resonant; struck hard, it has a crashing effect, often used at the climax of a musical passage. Stockhausen wrote a composition for a gong (*Mikrophonie I,* 1964) which is made to sound by six players in every conceivable fashion, including the rubbing of microphones against it to pick up its most minute vibrations. In British usage the unpitched gong is called "tam-tam," and the term "gong" refers to a flat disk that sounds a specific pitch.

In the GAMELAN and other Asian ensembles, gongs are a vital element, and in some places (Borneo, some parts of China) may make up an entire orchestra. Either flat-surfaced or knobbed, and varying in size from quite small to very large, they often are used in tuned series, either hanging in a frame or stand, or cradled (supported from below). In Indonesian music they serve to phrase or punctuate the music.

gospel music A kind of highly emotional religious music that developed in black American churches during the 1930s. Gospel songs tell of Jesus, of learning religion, of life's trials, of being saved. The tunes and harmonies, usually four-part, are simple and straightforward, and may involve CALL AND RESPONSE, but the performance may involve hand-clapping, foot-stamping, shouts, ringing tambourines, and other special effects. The so-called "father of gospel song" is Thomas A. Dorsey, whose "Take My Hand, Precious Lord" is one of the best-known gospel hymns. An outstanding gospel singer was Mahalia Jackson (1911–1972), who regarded blues as the devil's music and would sing only gospel, the music of the Lord. Other famous gospel performers include Marion Williams (1927–1994) and the Rev. James L. Cleveland (1932–1991), who organized the Gospel Singers Workshop Convention (a large national organization). About the same time that rhythm and blues developed into rock, gospel, which had helped shape rhythm and blues, developed into SOUL. Today gospel music is still sung in devotional services in churches, often arranged for choirs ranging

from a handful of singers to fifty or more voices, but there also are gospel singers who perform mainly in theaters and night clubs, purely for entertainment. See also SPIRITUAL.

Gounod (goo nō'), **Charles François** (sharl frän swa'), 1818–1893. A French composer who wrote principally sacred music and operas. During the early part of his career Gounod served as an organist and choir director, and he wrote mainly church music, including Masses, Requiem Masses, a Te Deum, and motets. After 1850 he devoted himself entirely to operas, of which his best by far is *Faust* (1857). Of his other operas, the best known is *Roméo et Juliette* (1867). Late in life, Gounod returned to church music, producing such works as his oratorio, *La Rédemption*. Although they are sometimes criticized as being overly sentimental, Gounod's works are notable for their lovely melodies as well as for skillful treatment of voices and instruments, which influenced such later composers as Bizet and Fauré.

G.P. The abbreviation for GENERAL-PAUSE.

grace In sixteenth- and seventeenth-century England, any musical ornament (see ORNAMENTS).

grace note An ornament played very quickly just before a main note; it is performed just before the beat and gives a sharp accent to the main note. The grace note is usually printed in small type. Its time value is not counted in the rhythm of the measure, being borrowed from the duration of a note either immediately before or immediately after it. (See under APPOGGIATURA.)

gradevole (grä dä' vô le) *Italian.* A direction to perform in an easy, pleasing, agreeable manner.

Gradual 1 In the Roman Catholic rite (see MASS), the second sung section of the Proper of the Mass. The chants for this section consist of verses and responses, the former sung by a soloist, the latter by the choir, and their melodies are quite elaborate. **2 gradual** Any book that contains the musical sections of the Roman Catholic Mass, both of the Ordinary and of the Proper, which are sung by the choir. The music sung by the choir for all services other than the Mass is in a book called the ANTIPHONAL (def. 2).

Grainger (grān' jər), **Percy,** 1882–1961. An Australian-born composer who is remembered chiefly for his arrangements of English folk songs. Grainger settled in the United States in 1914, where he lived, except for his travels as a concert pianist, until his death. In addition to many choral works and short instrumental pieces, Grainger wrote band music, marches, chamber music, and numerous piano pieces. Among his best-known compositions is "Country Gardens," for orchestra. Less well known was Grainger's role as a pioneer of live electronic music. In 1935 he wrote *Free Music,* using four theremins (see under ELECTRONIC INSTRUMENTS), and in 1948 he built a machine using oscillators.

Granados (grä nä thôs), **Enrique** (en rē' ke), 1867–1916. A Spanish composer and pianist, remembered mainly for his piano compositions, which reflect the traditional rhythms and melodies of his native land. His finest work is a suite for piano, *Goyescas.*

gran cassa (grän käs' sä). An Italian name for the BASS DRUM.

grand détaché See under DÉTACHÉ.

grandezza, con See GRANDIOSO.

grandioso (grän" dē ô' sô) *Italian.* Also, *con grandezza* (kôn grän det' tsä). A direction to perform in a dignified, stately manner.

grand opera Also French, *grand opéra* (grän" dô pä ra'). A term originally

used to distinguish operas with serious subjects and with texts entirely set to music from works that include spoken dialogue. Today the term refers not only to serious operas with tragic plots that are sung throughout, but also to operas that are produced in an elaborate, lavish manner, or simply to any musical drama of high artistic value, as opposed to an operetta or a musical comedy.

grand piano A piano with a horizontal, wing-shaped case (see under PIANO).

gran tamburo (grän täm bōōr′ô). An Italian name for the BASS DRUM.

graphic notation Musical notation that uses symbols other than the conventional notes and rests placed on a staff. As twentieth-century composers experimented with new sounds, they had to develop new ways of instructing performers to produce them. The symbols they devised range from simple indications of rising or falling pitch (upward- or downward-slanted lines, or even arrows) to complex directions for ALEATORY MUSIC in which a performer's choice of what to play next may depend wholly or in part on what the other performers have just played. In one kind, called *time-space notation* and used mainly for the taped portions of music combining tape and live performance, duration is indicated by means of horizontal lines related to a fixed scale. Still other kinds of graphic notation do not represent meaningful symbols but rather are intended to inspire the performer's imagination. The accompanying example below is from Cornelius Cardew's *Treatise* (1960).

grave (grä′ve) *Italian*. A direction to perform slowly and solemnly, in a stately manner.

grazioso (grä″ tsē ô sô) *Italian*. A direction to perform in a graceful, elegant manner.

great organ The most important keyboard of a pipe organ, and the stops (groups of pipes) associated with it. The great organ includes mainly the loud, full-sounding stops, which give the instrument its characteristic tone. On large organs with three or four manuals (keyboards played on by the hands), the great organ is the second from the bottom. See also ORGAN.

great service See under SERVICE.

Gregorian (gre gôr′ ē ən) **chant** Also, *plainchant, plainsong*. The vocal music used in the services of the Roman Catholic Church. Although this music is named for Pope Gregory I, who reigned 590–604, his exact contribution is not known, and the pre-

sent-day form of the chant probably dates from several hundred years after his death. The oldest manuscripts containing chant melodies date from the tenth century, and, like all other chant music until about 1200, are notated in neumes. After about 1200, they were written down in notes derived from the neumes and placed on a four-line staff, a notation that is still used today.

The Gregorian chant is an enormous body of music, made up of about three thousand chants. Each chant consists of a single melody, sung either by a soloist or by the choir. It is sung without accompaniment (although in practice the choir is sometimes accompanied by the organ), and the choir sings in unison. The music is in free rhythm, and there are no bar lines and no time signatures. Instead, the music follows the rhythm of the words. The words themselves most often (but not always) come from the Bible, especially from the Book of Psalms. Until the 1960s, when the Church began to permit translations, the chant was always sung in Latin. The music of the chants is based on the medieval church modes, rather than on the modern major and minor scales.

Gregorian chant developed over a period of many centuries. It was most likely based on JEWISH CHANT, a view supported by the large number of texts from the Old Testament of the Bible as well as the fact that its early development took place largely in Palestine and Syria. In the fourth century, as the Bishop of Rome (the Pope) emerged as the leader of the Christian churches, the development of the chant also shifted to Rome. During the next few centuries, a number of Popes, including Gregory I, influenced this development, assigning different chants to each church rite and feast, and preserving the musical tradition. In the early Middle Ages the center of development shifted to what came to be called the Holy Roman Empire, and it was probably under its early rulers,

Pépin and then Charlemagne (ninth century), in their capital city of Metz, that the chant assumed what is today considered its traditional form. However, from about the fourteenth century on, currently popular styles of music were applied to Gregorian chant. Thus, in the Renaissance, with vocal polyphony at its height, polyphonic versions of the chant (with more than one voice-part) were composed. Some attempts were made also to fit the chant into rhythmic forms. In later eras, other fashionable innovations were attempted, such as adding various ornaments to the melodies. In the nineteenth century, in the midst of raging controversy over what Gregorian chant should really be, the Benedictine monks at the Abbey of Solesmes, in France, began a century-long labor of restoring the chant to its medieval tradition. Working with original manuscripts found all over Europe, they established the proper interpretation of hundreds of chants.

Grieg (grēg), **Edvard** (ed'värt), 1843–1907. A Norwegian composer remembered mainly for songs and instrumental music in which he combined the nineteenth-century romantic style of Mendelssohn and Schumann with various aspects of his own country's native musical traditions. Grieg's first great success came in 1869, when he played the solo part in the first performance of his popular Piano Concerto in A minor. A few years later he wrote his most famous composition, the incidental music to Henrik Ibsen's play *Peer Gynt,* which was later arranged into two instrumental suites. Grieg was at his best in short compositions, such as the sections making up the *Peer Gynt* suites, songs, and piano pieces. A master of melody and rhythm, he did not use actual Norwegian folk music in his works but, rather, created original melodies containing folk elements.

Griffbrett, am (äm grif' bret) *German.* A direction to bow over the fingerboard of a violin or other stringed

instrument, resulting in a light, pure tone, with few overtones.

Griffes (grif′əs), **Charles Tomlinson,** 1884–1920. An American composer remembered for a relatively small number of works, in which he combined elements of late romanticism, impressionism, Asian music (especially Japanese and Javanese), and unusual harmonies much like those used by Scriabin. A brilliant pianist, Griffes wrote a fine Piano Sonata (1919), as well as *Roman Sketches* (1917) for piano (which includes *The White Peacock*), *Three Preludes* (1920), and the symphonic poem *The Pleasure Dome of Kubla Khan* (1919).

grosse caisse (grôs kes′). The French term for BASS DRUM.

grosse Trommel (grō′ se trô′ məl). The German term for BASS DRUM.

ground See OSTINATO.

ground bass Also, *ground.* Another term for *basso ostinato* (see OSTINATO).

group 1 An assemblage of instruments or musicians with a common function or purpose, for example, an orchestral section of one class of instruments, or a small ensemble that performs or records together. **2** In the music of Stockhausen and others, a brief musical figure unified in some way — harmony, rhythm, etc. —that is used as a compositional unit.

growl The utterance of a guttural sound by a wind-instrument player that is transmitted through the instrument, producing a growling sound. Trumpeter Louis Armstrong was one of the many jazz performers who used it extensively.

G-sharp One of the musical tones (see PITCH NAMES), one half tone below A and one half tone above G. On the piano, G-sharp is identical with A-flat (see ENHARMONIC for an explanation). For the location of G-sharp on the piano, see KEYBOARD.

Guarneri (gwär ne′ rē). Also, *Guarnieri.* The name of a family of violin makers who worked during the seventeenth

and eighteenth centuries in Cremona, Italy. The most famous of them was Giuseppe Guarneri (1698–1744), whose violins, usually labeled *Guarnerius* (the Latin form of his name), today are considered priceless treasures, exceeded in value only by those made by Antonio Stradivari. Both Stradivari and Giuseppe's grandfather Andrea Guarneri (c. 1625–1698) were pupils of Niccolò Amati.

Guarnieri See GUARNERI.

Guido d'Arezzo (gwē′ dô dä ret′ tsô), c. 997–c. 1050. An Italian musician and teacher, famed for the invention of SOLMIZATION (a system of assigning syllables to the different pitches) and of the musical staff. Guido, a Benedictine monk, taught at the choir school of Arezzo (whence his name). The basic musical scale adopted by Guido was the six-tone HEXACHORD, def. 1. To help choirboys remember the scale, Guido assigned a syllable to each note of the hexachord. The syllables he chose are from the first words and pitches of each phrase of a hymn to John the Baptist. The accompanying example shows the hymn in modern notation and, at the end, Guido's scale. (Guido's first syllable, *ut,* is today generally replaced by *do.*) Guido used a four-line staff, which is still used for writing Gregorian chant, and he added lines above or below the staff as needed. His *Micrologus* was the first comprehensive treatise on musical practice and was used throughout the Middle Ages in monasteries and universities.

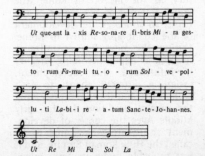

Ut que-ant la - xis Re-so-na-re fi-bris Mi - ra ges-

to - rum Fa-mu-li tu - o - rum Sol - ve-pol-

lu - ti La-bi-i re - a-tum Sanc-te-Jo-han-nes.

Ut Re Mi Fa Sol La

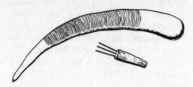

güiro (gwē′rô) *Spanish.* A percussion instrument used in Cuba, Puerto Rico, and other Caribbean islands, consisting of a hollowed-out gourd into which are cut a series of deep scratches. The player holds the gourd in one hand and, with the other, brushes forklike tines against it, producing a soft, rasping sound.

guitar A stringed instrument with a flat back, inward-curved sides, and a long, narrow neck. It has six strings, which are plucked with the fingers or with a plectrum, and which are stopped against a fingerboard provided with frets. The strings, which may be of nylon, gut, or steel, are tuned E A D G B E, as shown in the accompanying example, but the

music is written one octave higher than it sounds. In Spain, where the guitar is the national instrument, it is built in various other sizes, the size described here being the largest.

Like the lute, the guitar is thought to have come to Spain from Asia, brought there by the Moors during the Middle Ages. The guitar was easier to play than the lute, and it remained popular in Europe—especially in Spain —throughout the Renaissance (1450– 1600), even though the lute and vihuela were the principal instruments for art music during this period. After about 1600 the lute's popularity began to decline, giving way to the violin and to keyboard instruments, but the guitar continued to be played. There were several important types, of which the five-course *guitarra española* ("Spanish guitar") was the most important. It is this instrument that is the ancestor of the modern guitar, a sixth string having been added sometime during the eighteenth century.

Although many think of the guitar mainly as a folk instrument, used to accompany folk singing and dancing, the instrument has a long history in serious music. Virtuoso guitar playing attracted considerable public attention even in the nineteenth century, and almost all the great guitarists of the period between 1800 and 1850 wrote books on how to play the guitar and numerous pieces for it. With the possible exception of the compositions of Fernando Sor (1778–1839), however, much of this music is mediocre. Moreover, although the virtuosos' technical feats won wide admiration, the guitar was too soft an instrument to be heard in the larger concert halls being built. It remained for Francisco Tárrega (1852–1909) to give the guitarist still more effective technique, and for Andrés Segovia (1893–1987) to acquaint the public with its lovely tone and the fine music it could produce. Segovia revived not only music specifically written for guitar but compositions for the old vihuela and for the lute, and made arrangements of works originally written for harpsichord, piano, violin, and cello. He also encouraged twentieth-century com-

posers to write for the guitar, among them Manuel de Falla, Albert Roussel, Alexander Tansman, Mario Castelnuovo-Tedesco, Manuel Ponce, and Heitor Villa-Lobos. Also of interest are compositions for guitar by Tárrega, Joaquín Turina (1882–1949), Bolcom (*Seasons*, 1974), Henze (two sonatas, 1976, 1979; a concerto, 1986), and Carter (*Changes*, 1983).

Along with the revival of the so-called classical guitar, interest in the flamenco style of guitar playing has grown outside Spain (see FLAMENCO). In Spain and throughout Latin America, the guitar is still the main folk instrument, and there are many regional varieties of the instrument. In the United States, it has been adopted—frequently with electronic amplification (see under ELECTRONIC INSTRUMENTS)—for all kinds of folk music and blues, as well as for jazz, rock, and other types of popular music. See also HAWAIIAN GUITAR; UKULELE.

guitare (gē tAr'). The French word for GUITAR.

guitarra (gē tär' rä). The Spanish word for GUITAR.

gusle (gōos' lə). A one-stringed bowed instrument used by folk musicians, mostly in the Balkans. The gusle has a long neck and a body carved from a single block of wood. The body is shaped like a pear, a heart, or a bowl, the hollow part being covered with skin. The string, attached to the neck by a peg, is made of horsehair, as is the bow. There is no fingerboard, and the string must be stopped from the side instead. The gusle is played by a singer (called a guslar) while singing traditional epic songs.

Guthrie (guth' rē), **Woodrow Wilson** ("Woody"), 1912–1967. An American singer and composer, remembered for songs that have become, by virtue of their popularity, folk songs. Some of Guthrie's songs were new arrangements (with new words) of older folk songs. Many of them celebrate the greatness of America, whereas others include bitter comments on America's social and economic problems. Among Guthrie's best-known songs are "This Land Is Your Land," "So Long, It's Been Good to Know You," "Hard Traveling," "Roll On, Columbia," "Pastures of Plenty," and "Union Maid."

gymel (ji'məl) Also spelled **gemell**, **gimel**. A fifteenth- and sixteenth-century term for counterpoint that results from the splitting of one voice-part into two voice-parts of equal range. Each part so produced is marked "gymel" in the score. The name comes from the Latin *gemellus*, for "twin."

H The German term for the note B natural.

habanera (ä bä ner′ ä) *Spanish.* A Cuban dance, named for the city of Havana. The habanera became very popular in Spain during the nineteenth century, and inspired a number of composers, among them Debussy, Emmanuel Chabrier (1841–1894), and Ravel. Perhaps the most famous habanera of all is the aria "L′amour est un oiseau rebelle" (Love is a rebel bird) in Bizet′s opera *Carmen*, which actually is an adaptation of a song by another composer. The habanera is in 2/4 meter and has characteristic syncopated rhythms (see the accompanying example), much like those of the TANGO.

Hackbrett (häk′bret) *German.* A kind of dulcimer (see under DULCIMER).

Halévy (A lä vē′), **Jacques** (zhäk), 1799–1862. A French composer, today remembered for a single opera, *La Juive* ("The Jewess," 1835). During his lifetime, however, many of his thirty-eight other operas, which are in the conventional OPERA SERIA form of the time, were highly successful. Halévy taught at the Paris Conservatory, where his pupils included Gounod and Bizet (who became his son-in-law).

half cadence Another term for imperfect cadence (see under CADENCE).

half note British, *minim.* A note, ♩, equal in time value to (lasting as long as) one-half of a whole note. Thus, two half notes equal one whole note.

half rest A rest, ▬, indicating a silence lasting the same length of time as a half note.

half step See HALF TONE.

half tone Also, *half step, minor second, semitone.* The smallest interval used in traditional European and American music. On the piano, a half tone is the interval between any two adjacent keys—either two white keys, such as B and C or E and F, or a black key and a white key such as C and C-sharp or C-sharp and D.

Hallelujah (hal′′ e lōō′ yə) *Hebrew:* "praise the Lord." A vocal composition in which the text consists entirely or almost entirely of the word "Hallelujah" repeated over and over. The most famous example is the "Hallelujah" Chorus in Handel′s oratorio, *Messiah.* (See also ALLELUIA.)

halling (hä′lĭng, hal′ĭng) *Norwegian.* A lively dance in 2/4 meter, usually accompanied on a typical Norwegian folk instrument, the HARDANGER FIDDLE. Grieg used the halling in several of his instrumental compositions.

Hammond organ Another name for

electronic organ (see under ELEC-TRONIC INSTRUMENTS).

hand bells See under BELL, def. 1.

Handel (han'dəl), **George Frideric** (jorj frē'drik), 1685–1759. A German-born composer who lived in England after 1712, and, together with Johann Sebastian Bach, is considered one of the two leading composers of the late baroque period. Although a large proportion of Handel's hundreds of compositions are operas, he is remembered more for his oratorios and other choral music, as well as for a relatively small number of instrumental works (harpsichord suites, concerti grossi, *Water Music, Royal Fireworks Music*). His most famous work is the oratorio *Messiah,* which many consider the finest oratorio ever written. In this work Handel succeeded in combining the contrapuntal art of the German baroque style with the dramatic style of Italian opera and the choral tradition of his adopted country, England.

Handel was born in Halle (as Georg Friedrich Händel), where he studied law and music. After a year at the university there he left for Hamburg, where he worked as a violinist at the opera. Handel's first two operas were produced there. From 1706 to 1710 he visited Italy, where he produced his first Italian-style operas as well as two oratorios and other works. By 1712 Handel had decided to settle in England, where he anglicized his name. He soon received a lifetime pension from Queen Anne that permitted him to devote himself to composition even if he should lack a patron. In 1717 he became musical director for the Duke of Chandos, and in this post he wrote the first of his works still famous today, the cantata *Acis and Galatea,* the *Chandos Anthems,* and a work that later became the oratorio *Esther.* During the next decades he wrote twenty new operas as well as an enormous amount of instrumental music, including eight suites for harpsichord. By 1741 the English public

was turning away from Italian opera, and Handel, encouraged by the earlier success of *Esther,* devoted himself largely to oratorios and other choral works. Totally blind for the last years of his life, he nevertheless continued to compose and perform (he was a fine harpsichordist and organist) until shortly before his death. His other works include the oratorios *Athalia, Saul, Israel in Egypt, Semele, Theodora, Judas Maccabeus, Susanna, Joshua,* and *Jeptha;* the secular choral works *Alexander's Feast* and *Ode for St. Cecilia's Day;* the *Utrecht, Chandos,* and *Dettingen* Te Deums; a dozen organ concertos and a dozen concerti grossi; seventeen harpsichord suites; and numerous songs. In recent years there has been renewed interest in Handel's operas, a number of which have been successfully revived. Among them are *Agrippina, Rinaldo, Teseo* ("Theseus"), *Giulio Cesare* ("Julius Caesar"), *Orlando, Samson,* and *Serse* ("Xerxes").

hand horn See under FRENCH HORN.

Handy (han'dē), **William Christopher,** 1873–1958. An American composer, often called "the father of the blues" (which he used as the title of his autobiography). A bandmaster for minstrel shows, Handy organized his own band and toured throughout the southern United States for almost twenty years (1903–1921). He is sometimes credited as the first to transform gay ragtime music into the sad, nostalgic blues, a development in which he certainly played a role. He also was one of the first to write down jazz. Handy's two most famous songs, "Memphis Blues" and "St. Louis Blues," are still frequently played.

Hanson (han'sən), **Howard,** 1896–1981. An American composer whose most important contribution was the championing of other young American composers, sponsoring performances of their works and festivals of American music. From 1924 to 1964 Hanson was director of the Eastman School of Music in Rochester, New

York, where he influenced many young composers and musicians. His own works, which are largely in the nineteenth-century romantic tradition, include seven symphonies, the opera *Merry Mount,* symphonic poems, choral and chamber works, keyboard music, and numerous songs.

hardanger (här′dän̄g ər) **fiddle** A Norwegian folk instrument that resembles a violin in shape but has, under its four strings, four or five sympathetic strings. When the four melody strings are bowed, the sympathetic strings vibrate along with them, producing a droning sort of sound. The instrument is used principally to accompany folk dances, such as the HALLING. The violin virtuoso Ole Bull (1810–1880) often played solos on the hardanger and also composed music for it.

hardingfele (hôr′ rinḡ fā″ lə). The Norwegian term for HARDANGER FIDDLE.

hard rock See under ROCK.

Harfe (här′fə). The German word for HARP.

harmonic 1 Pertaining to harmony. **2** Another word for overtone (see under HARMONIC SERIES; SOUND). **3** Also, *flageolet tone.* In stringed instruments such as violins and harps, a soft, clear, high-pitched tone that results from lightly touching a string at a particular point instead of pressing it down hard. Unlike the overtones present in most musical sounds, which blend together and are not heard as individual notes, a harmonic produced in this way is the only pitch sounded, hence its very clear tone quality. The pitch produced depends on where the string is touched. Lightly touching a string at its center causes it to vibrate in two parts (along half its length); touching a string at one-third of its length causes it to vibrate in three parts (along one-third its length); etc. Thus, the string touched at its center produces the note an octave above its normal pitch (the first overtone in the HARMONIC SERIES); the string touched at one-third of its length pro-

duces the note an octave and a fifth above its normal pitch (the second overtone in the harmonic series); etc. Harmonics thus extend the normal range of stringed instruments upward. Harmonics are indicated in scores either by a small circle or diamond sign over the note to be produced, or by a diamond-shaped note marking the point to be touched. They can be played on either an open string (**natural harmonics**) or a stopped string (**artificial harmonics**). Both kinds are used in the violin group (violin, viola, cello, double bass). In harps the octave harmonic (obtained by touching a string at its midpoint) is generally the only one used. **4** In wind instruments, overtones produced by OVERBLOWING.

harmonica (här môn′i kə). **1** Also, *mouth organ.* A small portable instrument consisting of a flat metal box containing pairs of free reeds (flexible metal tongues that vibrate when a stream of air is forced past them). The player breathes into holes in one of the long sides of the box, which he or she moves back and forth in front of the mouth. Each hole conveys air to a pair of reeds, one of which sounds when the player exhales and the other when inhaling. The reeds of a pair are normally tuned to adjacent pitches, so that, for example, exhaling will produce the note E and inhaling will produce the note F. There may also be a slider stop that makes available a second set of reeds, tuned a half tone higher than the first set. The harmonica as described here was invented in Germany early in the nineteenth century. It was probably based on a mouth organ brought to Europe from Asia, where this type of instrument has been widely used for many centuries (see SHENG). The slider stop is a later addition.

Although the harmonica is often dismissed as a toy, it can be played with considerable artistry, and a skilled player can, through changes in tonguing and wind pressure, produce a wide variety of effects. Harmonicas are used in folk music and occasionally in popular music. The harmonica of blues, the so-called **blues harp**, is not a fully chromatic instrument but a diatonic one, that is, it produces only a single scale with a few notes above and below it. To play a piece in a different key, therefore, one must change instruments. The blues harp is used not only for blues but also for folk music and, sometimes, jazz. Blues singer and harmonica player Little Walter (Marion Walter Jacobs, 1930–1968) pioneered in the use of an electronically amplified harmonica.

Several serious composers have been attracted to the harmonica, among them Milhaud (*Suite* for harmonica and orchestra, 1942) and Vaughan Williams (*Romance* for harmonica and orchestra, 1952). Concertos for harmonica include those by Malcolm Arnold (1954), Tcherepnin (1956), and Villa-Lobos (1959). Outstanding harmonica virtuosos of modern times are Larry Adler (1914–) and Chinese-born Cham-Ber Huang (1925–). Both had works especially written for them, and Huang also invented and manufactured several new models of harmonica.

2 Short for GLASS HARMONICA.

harmonic analysis The study of the chords of a musical composition and the ways in which they are related to one another. In analyzing the harmony of a traditionally tonal composition or section (see HARMONY; CHORD), the triads in each key are assigned Roman numerals (I, II, and so on, to VII), which indicate the SCALE DEGREE of their root. When chords are inverted (see INVERSION, def. 1), they are identified by two numerals, the Roman one showing the scale degree of their root, and a small Arabic numeral, placed after and slightly

below the Roman numeral, to mark the inversion. The first inversion is marked 1, the second, 2, etc. Thus V_2 indicates the second inversion (2) of the dominant triad (V) in a particular key. If additional thirds have been added to the triad, making it a seventh chord or a ninth chord, a second Arabic figure is added after and slightly above the Roman numeral (I^7, I^9). Thus V_2^7, for example, means a dominant seventh chord in second inversion—in C major, the chord D–F–G–B; V indicates the dominant triad (G–B–D), 7 shows it has another third added, making it a seventh chord (G–B–D–F), and 2 marks the second inversion (D–F–G–B).

Another kind of shorthand used in harmonic analysis is based on the system used in FIGURED BASS. Here the Roman numeral still indicates the scale degree of the root of the chord, but the Arabic figures stand for the intervals between the lowest note of the chord (not necessarily the root) and the notes above it. Thus I_3^5 (or simply I) is the tonic triad—in the key of C major, C–E–G, the 3 standing for E, a third above C, and the 5 for G, a fifth above C. Similarly, I_3^6 stands for the first inversion of the tonic triad, E–G–C, with 3 standing for G, a third above E, and 6 for C, a sixth above E. The second inversion, G–C–E, would be indicated as I_4^6. See HARMONY; also INVERSION.

These methods of harmonic analysis become more difficult to apply to the harmonically complex music of the late nineteenth century and are not appropriate for the nondiatonic music of the twentieth century.

harmonic inversion The inversion of intervals, chords, or counterpoint. See INVERSION, defs. 1, 2.

harmonic minor scale A minor scale with the seventh degree (step) raised by one half tone (see MINOR, def. 1).

harmonic rhythm The pattern of changes in harmony in a composition or section. Just as certain beats of music are considered rhythmically

strong and others are rhythmically weak, certain chord changes are considered strong and others weak.

harmonics See HARMONIC, def. 3.

harmonic sequence See under SEQUENCE.

harmonic series The entire series of notes produced by a vibrating material, string, or air column. Although only a single tone can usually be distinguished (that produced by vibrations along the whole length of the string or air column), smaller portions of the total length are also vibrating, producing different, much softer notes called **overtones** or **partials** (see SOUND for a fuller explanation). If the fundamental (principal note) of a string or pipe is the second G below middle C, the first overtone, which is produced by the vibration of the two halves of the string or air column, is the G one octave higher (the G below middle C); the second overtone, which is produced by the string or air column vibrating in quarters, is two octaves higher than the fundamental (G above middle C), etc. The accompanying example shows the first eight tones of the harmonic series beginning on the second G below middle C.

The harmonic series is of particular importance in brass instruments, which, unless they are provided with valves or some other means of changing the length of the vibrating air column inside, can produce only the notes of the harmonic series. As a rule the fundamental, or PEDAL TONE, cannot be sounded and the lowest usable note is the first harmonic, an octave higher. Tightening the lips and blowing harder produces the next note, a fifth higher, and still further OVERBLOWING produces still higher pitches in the series. The very high trumpet parts of the baroque period (1600–1750) can call for notes corresponding to the twenty-first or even higher harmonics.

harmonie 1 (AR mo nē′). The French word for HARMONY. **2** A French word for wind instruments, especially brasses, or an ensemble made up of such instruments. Also, *musique d'harmonie*. **3 Harmonie** (här mōn′ye) The German word for harmony. **4** A German word for wind instruments or an ensemble made up of wind instruments. Also, *Harmoniemusik*.

harmonium (här mō′ nē əm). Also, *reed organ*. A keyboard instrument that works on the same principle as the harmonica; that is, air pressure causes a series of free reeds (flexible metal tongues) to vibrate and thus produce sound. The wind is supplied by a pair of pedal-operated bellows, and the player selects which of the tuned reeds are to sound by means of valves connected to the keyboard. The tones produced are similar in sound to those of a pipe organ. Invented in France in the 1840s, the harmonium became very popular in homes, as well as in churches that could not afford large organs. Various improvements were made in the instrument, largely through the addition of stops, in attempts to give it the full range of expression available on the pipe organ. In Europe the most elaborate type was the **Mustel organ**, which had an expression stop

whereby the player could control the volume with the knees. Another type, popular in nineteenth-century America, differed from the European harmoniums in that the reeds were caused to sound by suction rather than by compressed air. This type, known as the **American organ**, was actually imported into America from France. In the twentieth century, the harmonium was largely replaced by the more efficient electric and electronic organ.

harmony 1 The pattern of intervals and chords in a composition, both those that are actually sounded and those that are merely implied by the melody. **2** The study of chords and intervals, of the ways in which chords and intervals are related to one another, and the ways in which one interval or chord can be connected to another. Because harmony concerns notes sounded together (intervals and chords), which are written in up-and-down columns on the musical staff, it is sometimes called the "vertical" (up-and-down) aspect of music, as opposed to melody, written as notes following one another across the staff and termed the "horizontal" aspect of music. These terms are somewhat misleading, however, because harmony also involves horizontal movement from one chord to another.

The modern view of diatonic harmony dates from the early eighteenth century, when it was first set forth by the French composer Jean-Philippe Rameau. The building block of harmony is the chord. Each chord is regarded in terms of its position in a given key, particularly in relation to the tonal center (tonic) of that key (see KEY, def. 3). The basic interval on which chords are built is the third, the most important kind of chord being the triad, which is made up of two thirds (C–E–G, for example). All chords, in Rameau's view—that of so-called classical harmony, which dominated music from about 1600 to 1900—derive their harmonic function from triads in root position (with

the main note in the bass; see CHORD for a fuller explanation). All other chords are regarded as inversions of chords in root position. (Also see HARMONIC ANALYSIS; INVERSION, def. 1.)

One of the most important aspects of harmony is MODULATION (def. 1), the logical change from one key to another within the course of a composition. In most cases, such a change is made possible by the fact that a single chord has different harmonic functions in different keys. For example, G–B–D is the tonic triad (I) in the key of G major and the dominant triad (V) in the key of C major.

The rules of classical harmony are based on the premise of a tonal center, or tonic. Toward the end of the nineteenth century, as composers became increasingly free in their use of dissonance, in the combining of many keys in a single piece, and in the blending of major and minor, the older concept of tonality—and with it, classical harmony—began to be abandoned. As a result, most of the compositions of the twentieth century cannot be analyzed or judged in terms of the harmonic concepts that governed the music of the baroque, classic, and romantic periods.

harp A large stringed instrument, in a triangular frame, whose strings are plucked with the player's thumbs and fingers (all but the little finger of each hand). The curved, top part of this frame is called the neck, and the straight upright part is called the pillar. The lower part connecting the pillar and the neck contains the soundboard of the instrument. The modern harp is about sixty-eight inches high and is leaned back against the player's right shoulder; the right hand plays mainly the higher strings, usually made of nylon, and the left hand the lower ones, made of gut (the lowest ones are wound with wire to give them more weight). There are forty-six strings, which provide a total range of six and one-half octaves, almost as great as the piano's, from the C-flat three octaves below middle

C to the G-flat three and one-half octaves above middle C. The strings are tuned in the key of C-flat major, with seven strings for each octave; thus each group of seven strings can play the scale of C-flat major. To make available notes outside that scale, there is a set of seven pedals at the foot of the instrument, one for all the A strings, another for all the B strings, etc. By pushing the A pedal down one notch, all the A strings are shortened slightly, causing them to sound one half tone higher (that is, A natural instead of A-flat). By pushing the A pedal down another notch, they are shortened a little more, causing them to sound another half tone higher (that is, A-sharp). Because each pedal has two such notches, the instrument is known as a **double-action harp.** Although the pedals make available all the notes, not all can be played at the same time. A chord containing both C-sharp and C natural, for example, cannot be played, since the C pedal cannot be in two different positions at the same time.

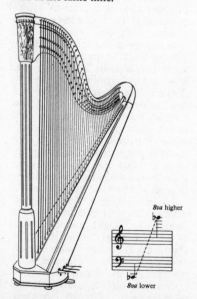

8va higher

8va lower

Harpists can obtain certain special effects. Probably the most familiar is

GLISSANDO, a rippling, almost liquid sound obtained by sliding a finger or fingernail rapidly over the strings. Also, by lightly touching the midpoint of a string, the note an octave higher is obtained (see HARMONIC, def. 3), and on the harp this has an especially lovely tone. Plucking a string close to the soundboard is another effect often called for.

Harps have existed since ancient times, although early references to them, in the Bible and elsewhere, do not always indicate a truly harplike instrument. True harps differ from zithers, psalteries, and other plucked stringed instruments in that they have a neck to which the strings are attached, and the strings are arranged so as to run perpendicular to the soundboard. The modern triangular harp first appeared in Europe about the twelfth century. Throughout the Middle Ages it was an important instrument, used for both solos and accompaniment. It had no pedals, and for the more complicated music of the Renaissance (1450–1600) the harp's single tuning proved inadequate, so as a solo instrument it was replaced by the lute. Various improvements were attempted, until at last the modern harp took shape in the early nineteenth century, the first double-action harp being built about 1810 by Sébastien Érard of Paris. Still built in small sizes for use in the home, the harp was also built in the concert size used today. By 1850 its place as a standard member of the orchestra was assured, mainly owing to Hector Berlioz, a master at exploiting the special tones of each instrument. Although its principal use today is still in the orchestra, there are numerous fine compositions for solo harp. The outstanding harp virtuoso and teacher of modern times was Carlos Salzedo (1885–1961). Among notable works for solo harp (or with important parts for solo harp) are: Handel's concertos in F and B-flat; Mozart's Concerto for flute and harp, K. 299; Saint-Saëns's *Concert Piece* for harp and orchestra, op. 154;

Glière's Concerto for harp and orchestra; Debussy's Sonata for flute, viola, and harp, and three symphonic sketches *La Mer;* Ravel's *Introduction and Allegro* for flute, clarinet, harp, and strings; Bax's Quintet for harp and strings; Hindemith's Harp Sonata; Villa-Lobos's Concerto for harp and orchestra; Salzedo's *Eight Dances* for harp; Ginastera's Harp Concerto; and Double Concertos for harp, oboe, and strings by Henze and by Lutoslawski. (See also IRISH HARP.)

harpe (ᴀrp). The French word for HARP.

harpsichord (härp' sə kôrd). An important keyboard instrument of the sixteenth to eighteenth centuries, resembling a grand piano in shape but with strings that are plucked instead of being struck by hammers. Although harpsichords varied somewhat during the period of their greatest popularity, some having one keyboard and others two, some with one

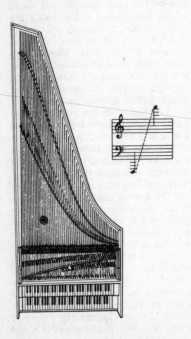

string for each key and others with as many as four or five, they all work basically in the same way. Each string is plucked by a plectrum of quill, hard leather, or plastic mounted in a wooden jack placed on the end of each key. On one side of the jack, at the top, is a small piece of felt that serves as a damper. When the key is pressed down, the jack rises up and the plectrum plucks the string. When the key is released, the jack falls back, but the plectrum, which is mounted so that it can pivot, passes the string without plucking it again. When the key is at rest, the damper touches the string, preventing it from sounding. Thus the harpsichord sounds only when the keys are actually pressed down; it does not continue to sound after the keys have been released. Also, the player cannot vary dynamics (loudness, softness) by varying the pressure of the fingers, as one can in the piano.

The accompanying illustrations show both a top view of a harpsichord, with the strings exposed, and an overall view of the instrument. The top view is of a fairly typical harpsichord of the mid-eighteenth century, with two keyboards, each with a range of five octaves, from the F below low C to the F above high C. Such harpsichords commonly had several stops, enabling the player to obtain different pitches and tone colors. The overall view shows a type of harpsichord built in the late eighteenth century. Unlike earlier instruments, it has two pedals, one a composition pedal serving to change the stops (so that the player does not have to take the hands from the keys to push and pull the stop-knobs), the other controlling a Venetian swell device that changed the volume (loudness) of sound produced, much as the swell pedal does in the organ. Harpsichords made today nearly always have pedals instead of hand-operated stops, except for those instruments built in exact imitation of older ones. With the twentieth-century revival of interest in early music, builders are returning to the

principles of the baroque instrument, which in the late eighteenth century had been displaced by the piano.

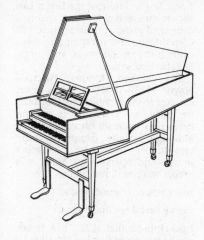

The harpsichord has a clear, resonant, metallic sound, ideal for providing the CONTINUO required in music of the baroque period (1600–1750), as well as for the contrapuntal keyboard compositions of such composers as Byrd, Bull, Gibbons, Frescobaldi, Chambonnières, Couperin, Purcell, Domenico Scarlatti, Rameau, Handel, and above all Bach. These and other composers provided an extensive literature for the harpsichord. Among twentieth-century composers who have been attracted to the harpsichord are Manuel de Falla (Concerto for harpsichord), Francis Poulenc (*Concert champêtre*), Frank Martin (*Petite Symphonie concertante*), Vittorio Rieti (Partita for solo harpsichord with flute, oboe, and string quartet), Elliott Carter (Double Concerto, Sonata a 4), and Henryk Górecki (Concerto for harpsichord and strings). See also SPINET, def. 1; VIRGINAL.

Harris (har'is), **Roy**, 1898–1979. An American composer whose music is noted for its skillful use of counterpoint. Harris employed traditional tonal material but avoided the use of key signatures; in effect, he wrote in a key without saying so. Sometimes his themes are based on American folk songs, although the tunes are usually no longer recognizable. Of Harris's symphonies (fourteen numbered), the most successful is Symphony no. 3 (1938). His works also include many chamber compositions, several ballets, choral music, and numerous pieces for piano.

hautbois (ō bwä'). The French word for OBOE.

Hawaiian guitar Also, *steel guitar*. A type of guitar that is held flat across the player's lap. Its metal strings are mounted higher above the fingerboard than those of the ordinary guitar and are stopped with a movable steel bar held in the player's left hand. There are no frets. The player strums the strings with the fingers of the right hand, which are protected by metal or plastic tips, and glides the stopping bar over the strings, producing various special effects (glissando, vibrato, etc.). The Hawaiian guitar developed in Hawaii from the classical guitar, which had been brought there by U.S. sailors. Today, the instrument is almost always used with electronic amplification, and mainly for country and Western music.

Haydn (hīd'ən), **Franz Joseph** (fränts yō'zef), 1732–1809. An Austrian composer remembered chiefly for his instrumental compositions—keyboard sonatas, string quartets, and more than a hundred symphonies—as well as some exceptionally fine choral music. Along with Mozart and Beethoven, Haydn is one of the main representatives of the CLASSIC style. Haydn began studying music as a young boy and supported himself through a number of musical posts, beginning at the age of eight as a choirboy in the famous choir of St. Stephen's Cathedral in Vienna. In 1761 he began working for the family of his most important patron, Prince Nicolaus Esterházy, at Eisenstadt, and

in the course of the next thirty years Haydn became Austria's most highly regarded composer. In 1791 he went to England at the invitation of the German-born English impresario, Johann Peter Salomon (1745–1815). During his year-and-a-half's stay there, and on a second trip in 1794, Haydn wrote his Symphonies nos. 93–104, which include many of his finest works in the form. Late in life, Haydn turned to choral music; between 1796 and 1802 he wrote two splendid oratorios (*The Creation, The Seasons*), six Masses, and the hymn that became Austria's national anthem (*Gott erhalte Franz den Kaiser,* "God Sustain the Emperor Franz").

Affectionately known as "Papa Haydn," the composer was essentially a gay, amiable person, qualities reflected in the humor, warmth, and lilting melodies of his music. Three composers exerted a major influence on him. During his youth, Haydn studied the keyboard works of Karl Philipp Emanuel Bach, with their emphasis both on elegance and refinement and on the expressive qualities of the keyboard instrument. In 1781 Haydn met Mozart, and the two men became close friends; each influenced the other, especially with regard to the form of the string quartet. Haydn wrote some sixty-eight works in this form, transforming it from what had been basically a piece for solo violin accompanied by second violin, viola, and cello, to a work in which all four instruments had equal importance. Finally, during his first trip to England, Haydn heard the music of Handel, and its influence is apparent both in his oratorios and in his late Masses.

Among those of Haydn's symphonies and quartets that are performed particularly often are: *Farewell Symphony* (no. 45), *Oxford Symphony* (no. 92), *Surprise Symphony* (no. 94), *Military Symphony* (no. 100), *Clock Symphony* (no. 101), *Drum Roll Symphony* (no. 103); *Sun Quartets* (op. 20), *Russian Quartets* (op. 33), *Razor Quartet* (op. 55, no. 2), *Quintenquartett* (op. 76,

no. 2), *Emperor Quartet* (op. 76, no. 3). In addition to those works already mentioned, Haydn wrote concertos for piano, violin, cello, horn, and trumpet; a good deal of church music (including a setting of the Seven Last Words later revised for string quartet); dozens of piano and string trios; 125 divertimentos for baryton; numerous other instrumental works; and songs. See also HOBOKEN.

His younger brother, **Michael Haydn** (1737–1806), served as music director to the Archbishop of Salzburg for forty-four years and is remembered principally for his sacred music, although he also composed thirty symphonies, concertos, chamber music, and operas. Carl Maria von Weber was one of his pupils.

head voice See under VOICE.

heavy metal See under ROCK.

heckelphone (hek'əl fōn"). A wood-wind instrument first built in 1904 by Wilhelm Heckel, a German instrument maker. Though it has roughly the same range as the baritone oboe, it has a much wider conical bore (cone-shaped inside). It also has quite a different tone, both more powerful and more flexible, somewhat like a cello's in quality. The heckelphone is built in a straight form and is about

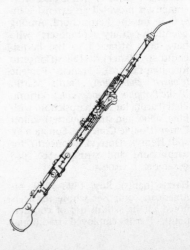

four feet long. It has a double reed mounted on a wide crook, and its bulb-shaped bell resembles that of the English horn. The instrument is pitched in C and has a range of three octaves, from the second A below middle C to the second G above middle C. Although not often called for in scores, the heckelphone has been used by Richard Strauss and by Delius, and Hindemith wrote a Trio for viola, piano, and heckelphone.

heftig (hef′tiкн) *German.* A direction to perform in a vehement, impetuous manner.

heiter (hī′tər) *German.* A direction to perform in a light, cheerful manner.

Heldentenor (hel′dən tā nôr″) *German:* "heroic tenor." A strong, dramatic but still agile tenor voice well suited for leading roles in opera, especially the operas of Richard Wagner.

helicon (hel′ə kon″, hel′ə kən). 1 A large bass tuba made in circular form, so as to encircle the player's body, and used mainly in bands. Such helicons are built in bass or double-bass size, pitched in E-flat or F (bass) and C or B-flat (double bass; the latter is often called BB-flat bass, pronounced "double B-flat bass"). Helicons have been used in Europe since about the middle of the nineteenth century. A closely related American instrument is the SOUSAPHONE. 2 Any brass instrument of bass range that is made in circular form, in order to be easier to carry in a marching band.

hell (hel) *German.* A direction to perform with clear, bright tone.

Helmholtz system See under PITCH NAMES.

hemidemisemiquaver (hem″ ē dem″ ē sem′ ē kwä″ vər). The British term for SIXTY-FOURTH NOTE.

hemiola (hem ē ō′ lə). The rhythmic relation of three to two. In Renaissance and baroque music, hemiola often occurs in the form of a sudden shift from 6/4 meter to 3/2 meter or vice versa, changing the basic beat from 1–2–3–4–5–6 to **1**–2–3–**4**–5–6 (bold type indicates the accented beats). In the baroque instrumental suite, hemiola is a basic feature of the courante movement. In the accompanying example, from the end of a motet by Bach, the closing measures in the alto part shift from the 3/4 meter of the piece into 3/2 meter (through the use of half notes), while the other three parts retain the 1–2–3 beat of the 3/4 meter. Later composers who often used hemiola are Chopin, Schumann, and Brahms.

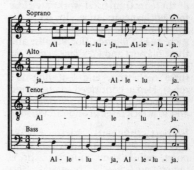

Henze (hen′tsə), **Hans Werner** (häns ver′nər), 1926– . A German-born composer who first became known for his operas. Using dissonant harmonies and, for a time early in his career, melodies based on a twelve-tone series, Henze concentrates on the inner reality of his characters, in the manner of earlier expressionist works (see EXPRESSIONISM). The formal structure of the operas tends to be strict, and occasionally there are direct allusions to older musical forms (for example, to a Bach chorale in *The Bassarids,* itself a treatment of Euripides' classical drama, *The Bacchae*). Henze's operas include *König Hirsch* ("Stag King"), *Boulevard Solitude, Die Elegie für junge Liebende* ("The Elegy for Young Lovers"), and *Der*

junge Lord ("The Young Lord"). In the 1950s Henze moved permanently to Italy. During the next decade he became a strong admirer of revolutionary socialist principles, which inspired the oratorio *Das Floss der Medusa* ("Medusa's Raft") of 1968, dedicated to Che Guevara, and his Sixth Symphony, written in Cuba, which quotes protest songs. He also composed numerous instrumental works, among them a Sonata for strings, Fantasia for string orchestra (originally a film score), Double Concerto for oboe, harp, and string orchestra, Second Violin Concerto, the symphonic poem *Tristan* for piano, tapes, and large orchestra, *Barcarola* for orchestra, and eight symphonies (1947–1993). At least some of these instrumental works are close to neoclassic in style. In both his small and large music theater pieces, such as *El Cimarrón* (for vocalist and three players) and *We Come to the River* (an opera calling for three stages, three orchestras, and featuring 111 roles), Henze continued to champion the underprivileged and oppressed and to attack fascism and militarism.

Herbert (hûr'bərt), **Victor**, 1859–1924. An Irish-born American composer, cellist, and conductor, who is remembered for his operettas. Herbert, educated in Germany, started his musical career as a cellist, and his earliest works are for this instrument. He began to write operettas in the 1890s. They were enormously successful, and the American public welcomed with enthusiasm Herbert's technically expert combination of delightful melodies and rhythms with simple harmonies. Among his forty or so operettas are *Babes in Toyland, Mlle. Modeste* (one of his greatest successes), *The Red Mill, Naughty Marietta, Sweethearts, Orange Blossoms,* and *The Dream Girl.* Of his serious music, his two cello concertos are occasionally still performed.

Hertz A unit of frequency equal to one cycle per second (see under

SOUND). Abbreviated **Hz**.

hervortretend (her fôr'trāt"ənt) *German.* A direction to perform in a prominent manner; in ensemble music, an indication that a particular voice or voice-part should stand out from the ensemble.

heterophony (het"ə rof'ə nē). The use of different versions of a single melody at the same time in different voice-parts. This device is very important in many kinds of non-Western music (China, Japan, especially Java), and has been used by Messiaen and other twentieth-century composers.

hexachord (hek'sə kord). **1** A scale of six tones, all separated by a whole tone except for the third and fourth, which are separated by a half tone. On the piano, it is represented by the white keys from C to A, or in solmization, by the syllables *do* (or *ut*), *re, mi, fa, sol, la,* regardless on which pitch the series begins. The hexachord was often used as a cantus firmus (a fixed melody to which other voice-parts are added), particularly in compositions of the sixteenth and seventeenth centuries. It was used for Masses (by Palestrina and others), madrigals, and, perhaps most notably, for keyboard and other instrumental pieces. An outstanding example of a keyboard work based on the hexachord is John Bull's *Fantasia on Ut, re, mi, fa, sol, la.* **2** In SERIAL MUSIC, a set of six different pitch classes. Usually the term refers to either the first or the second set of a twelve-tone series.

hichiriki See under GAGAKU.

hi fi See HIGH FIDELITY.

high fidelity Also, *hi fi.* The technique of recording music on records, tape, film and of playing it back on phonographs, tape recorders, etc. in a way that sounds as much as possible like the original performance. The term originated about 1930 and is heard less often today.

highlife A West African dance music that first appeared in the early 1900s

and became one of the most popular African styles of the century. Its name comes from the fact that it was associated with high living. The music is a blend of African, African-American, and European idoms, from such diverse sources as Yoruba songs and Western band music. It is usually in simple duple meter (any meter in which there are two beats per measure, such as 2/4) but is sometimes in 4/4 or, more rarely, in 6/8 meter. It is in strict tempo, the rhythm being provided by claves, castanets, drums, and maracas. The melodies, nearly always in the major mode, are catchy songs, with lyrics in various African languages as well as English, and subject matter covering a broad range.

hi-hat cymbals See under CYMBALS.

hillbilly music A somewhat disparaging name for the COUNTRY MUSIC of the southern Appalachian Mountains.

Hindemith (hin′də mit), **Paul** (poul), 1895–1963. A German composer who became one of the most influential musical figures of the first half of the twentieth century. Hindemith left Germany for Switzerland and then the United States, and became a U.S. citizen. In 1953 he went to Switzerland, where he remained until his death. In more than forty years as a composer, Hindemith developed various styles. His early works, such as *Suite 1922* for piano, reflect his rebellion against the nineteenth-century romantic tradition, expressed mainly in his use of dissonant harmonies. Gradually he began to adopt elements of the music of earlier periods, particularly the counterpoint of the baroque and the polyphony of the Renaissance. Active as a teacher and theorist, Hindemith was also an excellent violist, and he began to write for older instruments (such as the viola d'amore) and to perform in and direct presentations of early music. At the same time Hindemith formed new views concerning the composer's place in society, coming

to believe that music should be directed to the people who listen to it and perform it, not just to composers and professional musicians. He became a leading advocate of GEBRAUCHSMUSIK, and during the 1920s and 1930s he wrote many works for soloists and small ensembles to be performed by amateurs and students. Among these are sonatas; chamber works for virtually every orchestral instrument, including the heckelphone, trombone, and double bass; a children's opera *Wir bauen eine Stadt* ("We Are Building a City"); compositions for amateur musicians (*Music to Sing or Play*, op. 45); and numerous instructional pieces and exercises for violin, piano, and other instruments. Hindemith's compositions are noted for their use of counterpoint, which differs from conventional types in being highly dissonant. His major works include the operas *Cardillac, Mathis der Maler* ("Matthias the Painter") and *Hin und Zurück* ("There and Back"); the song cycle *Das Marienleben* ("The Life of Mary"); a symphony based on *Mathis der Maler;* the ballets *Nobilissima Visione* and *The Four Temperaments; Ludus Tonalis,* a set of twelve fugues for piano; the choral works *When Lilacs Last in the Dooryard Bloom'd* (based on Walt Whitman's poem) and *Apparebit Repentina Dies* ("Suddenly the Day Appears"); and numerous vocal works, solo sonatas, concertos, and chamber works, including a late Octet (1956). He also wrote an important two-volume book on composition, *Unterweisung im Tonsatz* (translated as "The Craft of Musical Composition").

hip-hop A generic name for African-American popular music originating in the 1970s, an offshoot of FUNK. It serves as the background to a vocal line in RAP, accompanied by the complex jagged rhythms of synthesizers and drum machines. Among the most popular hip-hop artists was Queen Latifah.

Hoboe (hō bō′ə). The German word for OBOE.

Hoboken (hō′ bō ken). A catalog of Franz Joseph Haydn's works compiled by the Dutch musicologist Anthony van Hoboken in two volumes, one for instrumental works (1957) and the other for vocal works (1971). In it all the movements of Haydn's works—both authentic and spurious (ascribed to, but not certainly by him)—are arranged according to genre and performance medium.

hocket (hok′ ət). In medieval music, the practice of dividing a melodic passage between different voice-parts, resulting in a kind of hiccup effect, a jagged rhythmic crossfire between the parts. The simplest form of hocket involves alternating notes and rests, usually in the two upper voices of a motet, with the notes of one voice filling in the rests of the other. Although it was usually employed only in certain passages, hocket technique occasionally was used throughout a piece, in which case the entire work is called a hocket. Modern composers occasionally make use of hocket; a notable example is Sofia Gubaidulina's *Quasi Hoquetus* ("Almost Hocket") for viola, bassoon, and piano (1984).

hoedown Originally, from about 1850 on, a general term for black American dances or imitations of them. Today, a broad general term for folk dances and square dances in duple meter (with two beats per measure, such as 2/4) performed by whites in America and Great Britain. The term is also used to describe music in which such folk-dance elements appear, for example, Copland's ballet, *Rodeo*.

hold See FERMATA.

Holst (hōlst), **Gustav Theodore**, 1874–1934. An English composer and teacher whose works reflect both his interest in occult Asian subjects (he learned Sanskrit in order to read the Hindu scriptures) and in early English music. His most important compositions are the orchestral suite *The Planets*, *St. Paul's Suite* for string orchestra, and *Choral Fantasia*.

Holzblasinstrument (hôlts″ bläs′ in strōō ment″). The German term for WOODWIND INSTRUMENT.

Homme armé, L' (lôm ar mä′) *French:* "The Armed Man." The title of a French song of the fifteenth century that was used as the cantus firmus in more than thirty Masses by composers between 1450 and 1600. Among the composers who wrote Masses based on *L'Homme armé* are Dufay, Ockeghem, Busnois, Obrecht, Josquin des Prez, and Palestrina. A more recent use is in the *Missa super l'homme armé* (1968) of Peter Maxwell Davies. (For the music of *L'Homme armé*, see the example at CANTUS FIRMUS.)

homophony (hə mof′ə nē). Music in which one voice-part, carrying the melody, is supported by chords in the other voice-parts, and the parts move together in the same rhythm. The opposite of homophony is POLYPHONY, in which the musical texture consists of a number of voice-parts moving independently. Much of the music of the classic and romantic periods (c. 1780–c.1900) is homophonic. In the Renaissance and baroque periods (1450–1750), however, polyphony was the more common musical texture, particularly in the form of COUNTERPOINT.

Honegger (ô ne ger′), **Arthur** (ar tyr′), 1892–1955. A Swiss composer who lived mostly in France and became a member of an influential group called Les Six (see SIX, LES). One of Honegger's first great successes was *Pacific 231* (1924), a tonal portrayal of a locomotive, which audiences hailed as a perfect picture of the modern machine age. Honegger, however, abandoned this type of realistic music soon afterward. A master of choral composition, he returned to the style of an earlier work, the oratorio *Le roi David* ("King David," 1921), producing such works as the dramatic oratorio *Jeanne d'Arc au bûcher* ("Joan of Arc at the Stake"). He also wrote five symphonies, numerous ballets, incidental music for plays, and several dozen

motion-picture scores. Honegger's music is noted for its regular, highly accented rhythms and effective use of counterpoint.

hootenanny (hōōt′ə nan″ ē) *pl.* **hootenannies.** A folk singers' jam session, that is, a performance by folk singers with, usually, some audience participation. The word appears to have been coined for such a performance held in 1941 in Seattle, Washington, but the practice of holding hootenannies originated in New York City in the 1940s with the beginning of a revival of folk song, especially songs of social protest. Hootenannies were organized to raise money for a folk music magazine (*People's Songs*) under the auspices of Oscar Brand, Pete Seeger, and others, and folk singers were hired by labor unions and political parties to entertain at their meetings, in colleges, and at private parties.

horizontal texture See under TEXTURE.

horn A name used loosely for almost any brass wind instrument—cornet, trumpet, trombone, etc.—and specifically for the orchestral horn (see FRENCH HORN). In addition, the word appears in the names of two woodwind instruments, the ENGLISH HORN (an alto oboe) and the BASSET HORN (an obsolete alto clarinet). All these instruments—in fact, all wind instruments—are probably descended from instruments used in ancient times, which were made from animal horns or tusks. Those made to sound by pressure of the player's lips are the ancestors of the French horn, trumpet, and other modern brass instruments. From animal horns and tusks, man progressed to imitating such devices in wood, ivory, or metal. The early instruments of this kind—the Roman lituus, Danish lur, Jewish shofar—were used mainly for signaling. Throughout the Middle Ages in Europe, horns were used in two principal ways, for hunts (**hunting horn**) and, with the rise of royal courts and powerful armies, for fanfares and mil-

itary signals (bugle calls). Horns of elephant tusk (ivory), imported from Africa and Asia, were used from about the eleventh century on; this type came to be called **oliphant**. By the later Middle Ages, horns were usually made in tightly coiled forms in order to make them easier to handle in spite of their great length. This coiled type may well have been the first horn capable of playing a melody, and it is from this instrument that the modern French horn developed. Until the development of valves, all horns were natural horns, that is, they could sound only one fundamental tone and its natural overtones (see HARMONIC SERIES). In the eighteenth century, crooks of different lengths might be inserted to change that tone (see CROOK, def. 2), a practice that died out when valves were invented (see VALVE). The accompanying illustration shows a natural horn of the first half of the eighteenth century.

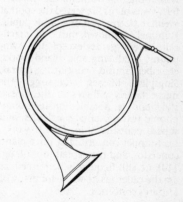

hornpipe 1 An old wind instrument consisting of one or two pipes sounded with a single reed (like the clarinet) and ending in either a single bell or two bells. Hornpipes were used by herdsmen, and although they have not been used in Scotland and Wales since the eighteenth century, very similar instruments are still used throughout the European Continent, from Spain to Russia. **2** A name for

various dances performed throughout the British Isles from the early sixteenth century until the end of the nineteenth century. One kind was a solo dance, another a round dance, and still another a complex country dance. The meter could be 3/2, 2/4, or 4/4. The solo dance in particular became associated with sailors. Purcell and Handel both included the hornpipe in some of their instrumental works. As a dance the hornpipe was usually accompanied by fiddles, bagpipes, or harp. Why its name is the same as the wind instrument's is not known.

Hummel (hŏom'əl), **Johann Nepomuk** (yō'hän ne'pō mŏok), 1778–1837. An Austrian pianist, composer, teacher, and conductor. A child prodigy as a pianist, he studied with Albrechtsberger, Haydn, and Clementi, as well as Mozart, with whom he formed a lasting friendship. He served for a number of years in Haydn's old post at Esterházy, and for the last eighteen years of his life served the court at Weimar. Czerny was one of his pupils. Hummel composed music in practically every genre except the symphony, producing solo piano works, chamber music, concertos, operas, Singspiele, Masses, and songs. His music largely adheres to the CLASSIC style and is notable for its homophonic texture, ornate melodies, and superb craftsmanship. Of his works, his trumpet concerto, last three piano concertos, and two septets (op. 74, op. 114) are still frequently performed, as are the cadenzas he wrote for many of Mozart's concertos.

Humoreske (hŏo"môr' es' kə). The German word for HUMORESQUE.

humoresque (ʏ mô resk') *French.* A title used by several nineteenth-century composers for a lively instrumental composition. Among them are Schumann's *Humoreske* (op. 20), Dvořák's *Humoresque* (op. 101), and Grieg's *Humoresker* (op. 6), all for piano, and Humperdinck's *Humoreske* (1880) for orchestra.

Humperdinck (hŏom' pər dingk"), **Engelbert** (eng' əl bert"), 1854–1921. A German composer who achieved lasting fame with a single work, the opera *Hansel and Gretel*, based on a fairy tale. Although Humperdinck wrote some other compositions of quality, among them the opera *Die Königskinder* ("The King's Children") and the song cycle *Kinderlieder* ("Children's Songs"), they are rarely performed.

hunting horn See under HORN.

Hupfauf (hŏopf'ouf) *German.* Another word for NACHTANZ.

hurdy-gurdy (hûr' dē gûr' dē). **1** Another name for the BARREL ORGAN. **2** A very old stringed instrument that is sounded by the strings' being rubbed by a rosined wooden wheel. Different pitches are produced by stopping the strings with a series of rods connected to keys. The rosined wheel, which acts as the bow, is turned by a crank. Originally (in the tenth century) the hurdy-gurdy was about six feet long and was rested across the laps of two players, one turning the wheel and the other depressing the keys. Later it

was built in smaller sizes and played by a single performer. Very popular throughout the Middle Ages, the hurdy-gurdy was known by a number of names (*organistrum* and *symphonia* in medieval Latin; *simphonie* and *vielle à roue* in France; *lyra* in Germany), and it remained fashionable in France until the early eighteenth century; Joseph Bodin de Boismortier (1689–1755) wrote numerous pieces for it. Haydn also wrote several pieces for it, commissioned by the King of Naples. Later it became a street musician's instrument, and it has survived in parts of Europe as a folk instru-

ment. The hurdy-gurdy usually has either one melody string, or a pair tuned in unison, and three or four bass strings that sound continuously as a drone or bourdon.

hurtig (hōōr′tiкн) *German.* A direction to perform in fast tempo, hurrying on to the end.

hybrid stop See under ORGAN.

hydraulis See HYDRAULOS.

hydraulos (hī drô′ ləs). Also, *hydraulis, hydraulus* (hī drô′lis). A keyboard instrument of the ancient Greeks and Romans. It was long known only through written descriptions, but in 1885 a small clay model and in 1931 portions of an actual hydraulos were discovered. The hydraulos was a type of pipe organ, but it differed from all other types in having its wind pressure regulated by the displacement of water. Air for the pipes was pumped into a water-filled chamber, pushing some of the water out. When the pipes were sounded, using air from the chamber, the water flowed back in and kept the pressure of the air steady. As a result the pitch of the pipes did not wobble at each stroke of the air pumps or if the rate of pumping changed.

hydraulus See HYDRAULOS.

hymn Any religious song that expresses praise or love of God, particularly those songs sung in the various Christian churches. One of the great early writers of hymns was St. Ephraim of Syria, who lived during the fourth century. The earliest Latin hymns were probably written in imitation of Greek and Syrian examples. The most important early writer of Latin hymns was St. Ambrose (c. 340–397), and many of the hymns written for the Roman Catholic Church during the next few centuries were modeled on his. However, because the church was long ambivalent about permitting hymns (as opposed to psalms), they play a relatively small part in the Roman Catholic liturgy. Until about 1400 most hymns had only a single voice-part, in the tradition of Gregorian chant. With the growth of polyphony during the late Middle Ages, polyphonic (many-voiced) settings of hymns became more and more common. From Ambrose's time, hymn texts consisted of several short stanzas of identical poetic structure with the same melody repeated for each stanza, that is, strophic form. Also, the same melody could readily be used for other hymns with stanzas of the same structure, so the use of a single melody for two or more different hymns became common in the Middle Ages and persists to the present day. Conversely, the same text might be sung to any of several melodies; this practice, too, is still common. Hymn texts usually consisted of four-line stanzas, and therefore most hymn melodies consist of four phrases, often different phrases. Thus, the musical form ABCD is also known as **hymn form**.

In the sixteenth century, the leaders of the Protestant Reformation in Germany stressed that religious services should be conducted in the language of the people instead of in Latin. Although some German hymns had existed for centuries before, the Reformation spurred an enormous production of new hymns in the German language. Some were based on earlier hymns, some on nonreligious songs, and some were original compositions. One particularly important type was the Lutheran CHORALE, which generally was harmonized with simple chords for congregational singing. In England a similar development took place when the Anglican Church separated from Rome. Most of the early English hymns, which were in regular meter and sometimes rhymed, were translations of the psalms, which were published in books called psalters. The newer Protestant denominations took over some of the Anglican hymns but also contributed hymns of their own, in which they sometimes replaced the strict meters of the

psalters with freer rhythms and melodies. Important in this development were Isaac Watts (1674–1748) and Charles Wesley (1757–1834), many of whose hymns are still sung today in English-speaking Protestant churches.

Collections of hymns are published in books called *hymnals*, which sometimes also include other music for religious services.

Hypoaeolian (hī″ pō ā ō′ lē ən) **mode** The plagal mode beginning on E. See under CHURCH MODES.

hyperinstruments See under ELECTRONIC INSTRUMENTS.

Hypodorian (hī″ pō dôr′ ē ən) **mode** The plagal mode beginning on A. See under CHURCH MODES.

Hypoionian (hī″ pō ī ō′nē ən) **mode** The plagal mode beginning on G. See under CHURCH MODES.

Hypolydian (hī″ pō lid′ ē ən) **mode** The plagal mode beginning on C. See under CHURCH MODES.

Hypomixolydian (hī″ pō mik″ sə lid′ ē ən) **mode** The plagal mode beginning on D. See under CHURCH MODES.

Hypophrygian (hī″ pō frij′ ē ən) **mode** The plagal mode beginning on B. See under CHURCH MODES.

Hz. Abbreviation for HERTZ.

idée fixe (ē dā″fēks′) *French:* "fixed idea." A term used by Berlioz for a short musical idea that reappears from time to time in slightly different versions throughout a composition. Berlioz first used this device in his *Symphonie fantastique.* In each of the symphony's five movements there appears a basic theme, which represents the woman loved by the story's hero. As the woman's character changes in the story, the music changes accordingly. In the first movement the theme is sweetly melodic; by the last movement, which represents the hero dreaming that his beloved has joined in a witches' orgy, the theme, as shown in the example here, has become a wild parody of itself. See also LEITMOTIF.

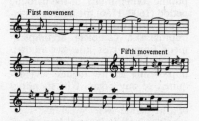

First movement

Fifth movement

idiophone (id′ē ə fōn″). Any musical INSTRUMENT made from a solid resonating material that produces a sound when struck (as the triangle, gong, xylophone, etc.), or shaken (as a rattle), or plucked (as a Jew's-harp), or rubbed (as the glass harmonica).

imitation In music with more than one voice-part, the repetition by one voice-part of a melody (or portion of a melody) that has been stated by another voice-part. The repetition may be exactly the same as the original, or it may differ somewhat. Imitation is basic to several musical forms, of which the most important are the canon and the fugue. Composers had discovered the usefulness of imitation by the thirteenth century, or almost as soon as they began to write music with two or more voice-parts of equal importance. By the sixteenth century imitation had become a basic device of composition in such forms as the motet and the ricercar. These two forms were the principal forerunners of the fugue of the baroque period (1600–1750). In the music of the classic period (1785–1820), imitation became less important to overall structure, though it still played a role in the development section of sonata form. For specific techniques of imitation, see AUGMENTATION; INVERSION, def. 3; RETROGRADE.

imitative counterpoint See under FUGUE.

imperfect cadence See under CADENCE.

imperfect consonance The intervals of a major or minor THIRD, a major or minor SIXTH, or their compounds (tenth, thirteenth, etc.) See also PERFECT CONSONANCE.

impressionism The name of a movement of nineteenth-century French painting, led by the painters Monet, Manet, Renoir, and others, which is also used for a style of music created principally by Debussy. Influenced both by the impressionist painters and by such symbolist poets of his time as Verlaine, Louÿs, and Mallarmé, Debussy emphasized the expression of mood and atmosphere through pure tone color instead of traditional melody or harmony. The general effect of impressionist music is vagueness of form, although the harmonies may actually follow a form as strict as sonata form. Debussy himself rejected the term "impressionist," but ironically he is the only composer to whom the term can be strictly applied. Nevertheless, his style had great influence on other composers, especially Ravel, and, somewhat less so, on Dukas and Roussel (France); Frederick Delius and Cyril Scott (England); de Falla (Spain); Respighi (Italy); and Charles Loeffler and Charles Griffes (United States). Perhaps the most important contribution of impressionism was its use of new harmonies and scales, which opened up new tonal possibilities for future composers.

impromptu (AN prônp tY′) *French:* "improvised." A term used as a title by nineteenth-century composers for a short keyboard composition that sounds as though it might have been improvised. Among the composers of impromptus are Schubert, Chopin, and Fauré.

improvisation The invention of music—a whole composition, a variation on a theme, or ornamentation of a repeated section—at the same time that it is being performed. In earlier periods the ability to improvise was considered essential for most musicians. Today it is an important element of jazz, and it also plays a role in aleatory music, in which the performer must decide which of a number of methods or notes to use, and in live electronic music.

The very nature of improvisation—being performed on the spot, without being written down—makes it impossible to know exactly how music was improvised long ago. The style of music produced in this way can only be guessed at from examples of similar music that were written down and from written instructions given to musicians. Improvisation most likely was a common practice throughout the Middle Ages, Gregorian chant melodies probably being composed in the course of performance simply by using the tonal material of the various church modes. In the later Middle Ages, as one or more voice-parts were added to the single voice-part of the plainsong, the new part frequently was a melody moving at a certain interval (distance) from the original melody (see CANTUS FIRMUS; DISCANTUS; FAUXBOURDON; ORGANUM). During the Renaissance (1450–1600), when instrumental music gained new importance, the improvisation of melody (rather than harmony) became an important practice. One of the more common practices was the improvisation of variations on a continuously repeated bass figure (OSTINATO), especially on such well-known bass patterns as the FOLIA, PASSAMEZZO, and ROMANESCA.

As counterpoint became more highly developed, the performer was called on to improvise lengthy polyphonic compositions. In the baroque period (1600–1750) the keyboard performer was expected to be able to improvise a complete accompaniment from a bass line (see FIGURED BASS). By the late seventeenth century, improvising entire fugues was required of any organist of standing; among the most famous improvisers of this period were Sweelinck, Frescobaldi, Buxtehude, and, later, Bach and Handel. Until about 1800, cadenzas in solo piano and violin concertos were left entirely to the performer (see CADENZA). The same had been true in solo vocal music (especially in opera), and in much instrumental music, a practice that gave virtuoso

performers a chance to show off their skill. After about 1800 composers tended to be more specific, writing out all the notes of the music. Nevertheless, improvisation continued to be practiced by some outstanding nineteenth-century pianists and organists, among them Beethoven and later Liszt (both on the piano), and Franck and Bruckner (organ). By the twentieth century improvisation of this kind was rare except among organists, where the tradition was kept alive by such great masters as Marcel Dupré.

Jazz is based largely on improvisation, not only by soloists but by an entire ensemble. Early jazz performers based their improvisations on a common tradition of rhythm, harmony, and instrumental styles, much as the baroque organist must have relied on certain standard practices and ideas in working out improvisations. Since the 1940s, however, jazz performers have broadened their musical heritage, including elements from contemporary serious music, such as chromatic harmonies, serial techniques, etc. At the same time, serious composers began to admit improvisational styles and techniques to their music in attempts to make the musical form appear to grow out of a live performance. Among those who have worked along these lines are Gunther Schuller, Lukas Foss, Morton Subotnick, Pauline Oliveros, and Frederic Rzewski. A somewhat extreme example is Pauline Oliveros's *Sonic Meditation I* (1974), in which any number of persons sit in a circle, observe their own breathing, and gradually utter any sounds they choose. Improvisation also is used in rock and new age music.

Another kind of music in which improvisation has long played an important role is folk music, whose very development depends on changes gradually made by performers over a period of many years. Also, improvisation is common in many kinds of non-Western music, although often within very strict guidelines (as, for example, in the Indian RAGA).

incalzando (ēn"käl tsän'dô) *Italian*. A direction to perform with increasing warmth and speed.

incidental music Music written for performance with a play or other theater piece, including works to be played before the play begins (overtures, preludes), pieces to be played between the acts (interludes, entr'-actes), and sometimes pieces played during the course of the action (dances, background music for actors' speeches, marches, etc.). Although most such music is instrumental, songs performed during the course of a play are also considered incidental music.

Incidental music is so called because the music usually is not basic to the play, that is, the play could be performed without it and would still make sense. In many cases the music, too, can stand alone, and today a considerable amount of music originally written for plays is performed by itself, the plays being long forgotten, or rarely performed, or performed without music. The English composer Thomas Arne (1710–1778) wrote incidental music for many plays, including John Milton's masque *Comus*, but is mainly remembered for the song "Rule Britannia," part of his music for the masque *Alfred* (1740). Often the music is put together into suites. Examples of this kind include Bizet's music for *L'Arlésienne* ("The Woman of Arles"), von Suppé's music for *Dichter und Bauer* ("Poet and Peasant"), Beethoven's music for *Egmont* and *Die Ruinen von Athen* ("The Ruins of Athens"), Tchaikovsky's music for *Hamlet*, Grieg's for *Peer Gynt*, Balakirev's for *King Lear*, Schumann's for *Manfred*, Khatchaturian's for *Masquerade*, Vaughan Williams's for *The Wasps*, and, perhaps most famous of all, Mendelssohn's for *A Midsummer Night's Dream*. Occasionally incidental music is so elaborate that it becomes a major work (not just a suite) in its own right. This happened to portions of Richard Strauss's music for Molière's *Le Bourgeois Gentilhomme*, which Strauss later made into

a full-fledged opera, *Ariadne auf Naxos*. See also FILM MUSIC.

inciso (ēn chē'zô) *Italian*. A direction to perform in a sharply marked, accented manner.

indeciso (ēn"de chē'zô) *Italian*. A direction to perform in a hesitant, tentative manner.

indeterminacy See under ALEATORY MUSIC.

Indy, d' (daN dē'), **Vincent** (vaN säN), 1851–1931. A French composer and teacher, whose music shows the combined influence of Wagner, Liszt, and Franck. D'Indy was also interested in medieval music, particularly Gregorian chant, and in 1894 he helped found the Schola Cantorum of Paris, a private conservatory of music that originally was to teach plainsong and the Palestrina style, but soon broadened its aims and became one of the world's outstanding music schools. D'Indy taught composition there, and he wrote an important manual, *Le Cours de composition musicale* ("A Course in Musical Composition"), which is still used today. D'Indy composed all kinds of music—operas, symphonic music, chamber works, choral music, songs, and piano and organ music—but he was at his best in long orchestral works, notably *Symphonie sur un chant montagnard français* ("Symphony on a French Mountain Air") and *Istar Variations* for orchestra.

innig (in'iKH) *German*. A direction to perform in a sincere, intense manner, with depth of feeling.

in nomine (in nom' ə nā") *Latin*. Also, *innomine*. A title used by numerous English composers of the sixteenth and seventeenth centuries for instrumental compositions based on a particular cantus firmus (a fixed melody to which other voice-parts are added). The melody, which is derived from Gregorian chant, appears in a Mass by John Taverner (c. 1490–1545), set to the words "in nomine" ("in the name [of the Lord]"), and it is from this association that the name of the works is derived. In nomines were composed for keyboard instruments, for lute, and, most often, for ensembles of viols or recorders, by such composers as Christopher Tye, Thomas Tallis, William Byrd, Thomas Weelkes, and Orlando Gibbons. Among the last to use the melody was Henry Purcell.

inquieto (ēn" kwē e' tô) *Italian*. A direction to perform in a restless, agitated manner.

instrument Any object used to produce musical sounds. Although the human voice is sometimes regarded as a musical instrument, it is usually treated separately (see VOICE, def. 2). Instruments are customarily divided into categories according to the way in which they produce sounds. In European and American music there are five main categories of instrument: a STRINGED INSTRUMENTS, which may be bowed (violin, viola, cello, viola da gamba, etc.) or plucked (banjo, guitar, lute, zither, harp, etc.); b WIND INSTRUMENTS, which include the WOODWIND INSTRUMENTS, either without reed (fife, flute, piccolo, recorder, etc.) or with a reed (clarinet, oboe, bassoon, saxophone, harmonica, etc.), and the BRASS INSTRUMENTS, sounded by the vibration of the player's lips (French horn, trumpet, trombone, tuba, etc.); c PERCUSSION INSTRUMENTS, which are struck and may have a definite pitch (chimes, glockenspiel, timpani, xylophone, etc.) or indefinite pitch (drum, castanets, cymbals, tambourine, triangle, etc.); d KEYBOARD INSTRUMENTS, which combine some of the sound-producing features of the first three groups (the piano and clavichord have strings that are struck, the harpsichord has strings that are plucked, the organ has pipes sounded with and without reeds, and the celesta has metal bars that are struck); and e ELECTRONIC INSTRUMENTS, which are either conventional instruments whose sound is changed electronically (electric guitar, electronic harpsichord, etc.) or instruments in which

the sound itself is produced electronically (electric or electronic organ, sound synthesizer, etc.).

A more fundamental system of classifying musical instruments, which is more general and makes it easier to include non-Western instruments, has five similar categories: **a** **idiophones**, objects consisting primarily of an elastic material that can produce sound when struck (triangle, gong, xylophone, etc.), shaken (rattle), plucked (Jew's-harp), or rubbed (glass harmonica); **b** **membranophones**, objects in which a stretched membrane (a thin piece of hide or parchment) produces sound (drums); **c** **aerophones**, objects in which sound is produced by a vibrating column of air or a moving stream of air, either with or without a reed (woodwinds, brass instruments, and free-reed instruments like the harmonium and accordion); **d** **chordophones**, instruments in which stretched strings produce a sound when bowed (violin), plucked (guitar, harp, harpsichord, etc.), or struck (dulcimer, clavichord, and piano); and **e** **electrophones**, objects that produce sound by electric or electronic means.

Musical instruments appear to have been used since prehistoric times by all peoples, and they include some highly ingenious devices. Stones of different size and shape have been used as xylophones, zithers have been made with a hollow in the ground serving as a resonator, and such objects as animal bones, horns, and shells have been used for scrapers, beaters, and trumpets. The ancient Greeks had not only wind instruments (aulos) and stringed instruments (kithara) but also an organ (hydraulos). The Middle Ages saw the further development of stringed instruments, both plucked (harp, lyre, and psaltery) and bowed (hurdy-gurdy, crwth, and vielle), wind instruments (trumpet, horn, shawm, recorder, and flute), as well as the development of keyboard instruments, especially the organ, and the importation of numerous instru-

ments from Asia (drums, lute, and castanets). During the Renaissance (1450–1600), with increased interest in ensemble music, instruments began to be built in families; thus there were numerous sizes of viol, recorder, crumhorn, etc. Information about the instruments in use was finally put in writing, and much of present-day knowledge of them comes from the treatises of Sebastian Virdung (published 1511), Martin Agricola (1528), and, most important of all, Michael Praetorius (1618). The baroque period (1600–1750) saw a renewed emphasis on stringed instruments—viol, lute, guitar, and the violin, which had been developed about 1540. The preclassic and classic periods (1750–1820) saw the development of the modern orchestra as well as the vast improvement of wind instruments through the addition of crooks, keys, and eventually valves, and the birth of the piano. During the first half of the twentieth century the new category of electronic instruments came into being. There also was a revival of old techniques of instrument building for the performance of older music (especially for keyboard instruments, such as the organ, harpsichord, and clavichord), as well as increasing use of non-European instruments, which, with a few exceptions (castanets, tambourine, bass drum, etc.) had been used very sparingly in European and American music before 1900.

instrumental duet See under DUET.

instrumental music Music for one or more instruments, as opposed to music for voices or for voices and instruments. (A composition for both voices and instruments, such as an opera or oratorio, is usually classified as vocal music.)

instrumentation The assignment of specific instruments for playing the various parts of a musical composition. Today this process is virtually part of composition, composers keeping in mind the different qualities of each instrument as they write. In ear-

lier periods instrumentation was more haphazard and open to much variation. During the Renaissance (1450–1600), for example, music originally written for voices was often performed on lutes and viols. Even as late as the early nineteenth century, Beethoven transcribed his own Violin Concerto in D, op. 61 (1806), for piano. (See also ARRANGEMENT, def. 1; INTABULATION; ORCHESTRATION.)

intabulation An arrangement of a vocal composition such as a Mass, motet, or secular piece for an instrument, usually lute, vihuela, organ, or harpsichord. This practice, common from the fourteenth to sixteenth centuries, involved combining the music for each voice-part, written separately, into a single score notated in the TABLATURE used for the lute, vihuela, or a keyboard instruments. Often the composition was changed considerably in the process, with parts being left out, added, transposed, and numerous ornaments being inserted.

intavolatura (ēn" tä vô" lä tōō' rä) *Italian.* 1 The word for TABULATURE. 2 The word for INTABULATION. 3 In sixteenth- and seventeenth-century Italian keyboard music, an indication that the music is notated on two staffs (like modern piano music) rather than with a separate staff for each voice-part.

interlude 1 A piece of music, usually relatively short, that is inserted in another composition. Examples are the improvised pieces inserted by organists between the verses of a hymn, and the brief instrumental sections sometimes inserted between the lines of a chorale. 2 Also, *entr'acte, intermezzo.* A piece of INCIDENTAL MUSIC performed between the acts of a play. 3 In operas and oratorios, an instrumental section between two vocal sections, used during a scene change or to describe or comment on some part of the action.

intermedio (ēn tar med' ē ô) *Italian.* See under INTERMEZZO.

intermezzo (ēn" ter met' tsô) *pl.* **intermezzi** (ēn" ter met' tsē) *Italian.* 1 From the early nineteenth century on, a title used for various short instrumental works, including piano pieces by Brahms and Schumann and orchestral interludes in operas and oratorios, and occasionally for a movement or section of larger works that replaces the scherzo. 2 See INTERLUDE, def. 2. 3 A short dramatic entertainment with music, formerly inserted between the acts of a play or opera. The practice of inserting such a musical playlet began in the late fifteenth century (when it was sometimes called an **intermedio**) and continued through the first half of the eighteenth century, especially in France and Italy. The sixteenth-century intermezzi that were inserted into the revivals of Greek and Roman plays are among the forerunners of opera. By the eighteenth century, the intermezzo was nearly always comic, whereas the play or opera into which it was inserted was serious. Another practice arose, especially in Italian opera, of presenting a series of intermezzi between the acts, which, taken together, made up a little comic opera. The most famous intermezzo of this type is Pergolesi's *La Serva padrona* ("The Maid as Mistress"), which originally was a comic intermezzo for the serious opera *Il Prigioniero superbo* but was so well received that eventually it was performed by itself. This type of intermezzo is the ancestor of the Italian OPERA BUFFA.

interpretation The act of performing, or the particular performance of a piece of music by a singer, instrumentalist, or conductor. Ideally the performer expresses what the composer intended as closely as possible. Where the composer's aims are indicated fairly precisely by notation, expression marks, etc., interpretation is largely a matter of following directions. Even in such cases, however, many details of phrasing, tempo, dynamics, tone color, articulation, etc., must be decided by the per-

former. Before about 1800 composers were far less explicit in recording their intention than they were in subsequent times, so that the modern performer must become familiar with the musical traditions and practices of each period in order to render its music as it was intended.

interrupted cadence Another term for deceptive cadence (see under CADENCE).

interval 1 A pair of notes sounded at the same time. **2** The distance between the pitches of two musical tones. The smallest interval in conventional Western music is the **half tone**, for example, the distance from C to C-sharp. Any interval smaller than a half tone is called a MICROTONE. Two half tones make up a **whole tone**. All other intervals are similarly made up of half tones (or half tones and whole tones) and they can be described in terms of the number of half tones (or half tones and whole tones) they contain.

When two tones of an interval are sounded one after the other, the interval is called **melodic**. Thus, a melody is simply a series of melodic intervals. When the two tones of an interval are sounded together, at the same time, the interval is called **harmonic**. Two or more harmonic intervals make up a chord. The pattern of intervals and chords in a musical composition constitutes its harmony.

Classical melody and harmony, which dominated Western music from c. 1600 to c. 1900, are based on two modes of a diatonic scale, the major and the minor, each of which is defined by a particular arrangement of half tones and whole tones. Intervals therefore are described not only as groups of half or whole tones, but also in terms of degrees of the diatonic scale they encompass. In the scale of C major, the first note, C, sounded with another note of the same pitch, is called **unison** (or *prime*); the intervals between C and all the other notes of the C-major scale are named for the number of

notes they "straddle"—C–D is a **second;** C–E is a **third** (it encompasses three notes, C, D, and E); C–F is a **fourth;** C–G is a **fifth;** C–A is a **sixth;** C–B is a **seventh;** and C–C' is an **octave** (the prefix *oct-* means "eight"). Intervals larger than an octave are called **compound intervals** because they can be regarded as a combination of two simple intervals. Thus the interval C–D' is a **ninth,** but it can also be considered an octave (C–C') plus a second (C'–D'); similarly, C–E' is a **tenth** but can be considered an octave plus a third; etc.

The names used for the intervals—second, third, fourth, etc.—are used no matter what pitch the interval begins with. Thus C–G, D–A, E–G, F–C, etc., all are fifths. However, intervals can be described still more precisely. Because of the different arrangements of half tones and whole tones in the major and minor scales, the third, sixth, and seventh all are one half tone smaller in a minor scale than they are in a major scale; in addition, there are two varieties of second, the larger consisting of two half tones and the smaller consisting of one half tone. The intervals therefore are described as **major second** (C–D) or **minor second** (C–D♭); **major third** (C–E) or **minor third** (C–E♭); **major sixth** (C–A) or **minor sixth** (C–A♭); and **major seventh** (C–B) or **minor seventh** (C–B♭). The unison, fourth, fifth, and octave remain the same size no matter what the key (they are not affected by the different arrangement of half tones and whole tones in major and minor), and therefore they are called **perfect intervals** (perfect unison, perfect fourth, perfect fifth, perfect octave). However, any perfect interval can be made larger or smaller by one half tone. Enlarged it is called an **augmented interval;** made smaller it is called a **diminished interval.** If a major interval is enlarged by one half tone, it, too, is called augmented (augmented second, augmented third, etc.); similarly, if a minor interval is made smaller by one half tone,

it is called diminished (diminished third, diminished sixth, etc.).

In all these instances the interval consists of a base note and a note above it. If the second note of an interval is lower (in pitch) than the first note, the interval is called *lower;* thus the lower fifth of C is F (F being a fifth down from C).

The accompanying example shows the different kinds of interval. The number in parentheses, below the name of the interval, shows the number of half tones it contains. The intervals joined by a bracket are enharmonic intervals, that is, even though they involve the same notes on keyboard instruments, they can be regarded as different intervals in different keys, and they actually sound different on instruments in which the pitch is directly controlled by the performer, such as the violin (see under ENHARMONIC).

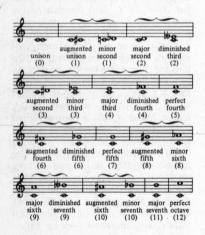

| unison (0) | augmented unison (1) | minor second (1) | major second (2) | diminished third (2) |

| augmented second (3) | minor third (3) | major third (4) | diminished fourth (4) | perfect fourth (5) |

| augmented fourth (6) | diminished fifth (6) | perfect fifth (7) | augmented fifth (8) | minor sixth (8) |

| major sixth (9) | diminished seventh (9) | augmented sixth (10) | minor seventh (10) | major seventh (11) | perfect octave (12) |

In the theory of harmony, certain intervals are regarded as **consonant** (pleasant-sounding, restful) and others as **dissonant** (harsh, restless, calling for resolution). In ancient Greek music, only the unison, fourth, fifth, and octave were regarded as perfectly consonant. The reason for this was worked out by Pythagoras, a mathematician of the sixth century B.C.

who devised a scale based on the vibrating string of a one-stringed instrument, the monochord (see PYTHAGOREAN TUNING). When the string vibrated along only three-fourths of its length, it sounded a tone a fourth above that sounded by the string vibrating along its full length. Similarly, if two-thirds of the string vibrated, it sounded the tone a fifth above that of the entire string, and if one-half of the string vibrated, it sounded a tone exactly one octave higher than that of the entire open string. These divisions of the string all yield simple mathematical ratios (the fourth 4:3, the fifth 3:2, the octave 2:1), whereas other intervals yielded much more complicated ratios (the third, for example, formed as a result of four fifths C–G–D–A–E, being 81:64). Pythagoras therefore concluded that the only truly consonant intervals were the unison, fourth, fifth, and octave. (Had he extended his theory to include division of his string into five parts, he would have discovered that another ratio could be found for the third, 5:4. This interval is smaller than Pythagoras's 81:64 and far more consonant.)

Today, it is known that the pitch of a tone is determined by its frequency (how fast the sound-producing agent, such as a string, vibrates; see SOUND), and an interval is regarded as a ratio of the frequencies of its two tones. Since the actual frequencies, measured in cycles per second, are cumbersome numbers, the unit of measure commonly used for intervals is the **cent.** An octave contains 1,200 cents. In the system of EQUAL TEMPERAMENT (used to tune pianos and other keyboard instruments), each half tone is exactly equal to 100 cents. In other systems of temperament, however, such as that of Pythagoras or that of JUST INTONATION, the half tones of the chromatic scale are not equal, and the distance between C and C-sharp, for example, differs from that between C-sharp and D. A major third, which is made up of four half tones, measures 400 cents in equal

temperament, 408 cents in the Pythagorean system of tuning, and 386 cents in just intonation.

intonation 1 A performer's accuracy with respect to pitch. Good intonation means playing or singing notes exactly on pitch; poor intonation means that the notes produced are above (sharp) or below (flat) their proper pitches. **2** In Gregorian chant, the opening notes of a PSALM TONE. **3** See JUST INTONATION.

intrada (ēn trä' dä) *Italian:* "entrance." **1** In the sixteenth and seventeenth centuries, an instrumental piece or section used to announce an entrance, open a festivity, or begin a suite. **2** A name occasionally used by Mozart, Beethoven, and others for a short overture.

introduction A short opening section of a longer composition, especially a slow section preceding the first (fast) movement of a concerto, symphony, or string quartet.

Introit (in'trō it, in'troit). In the Roman Catholic rites, the first musical section of the Proper of the Mass (see MASS).

invention A title used by several composers of the baroque period (1600–1750) for instrumental pieces of various kinds. The most famous are fifteen keyboard pieces by Bach, which he entitled *Invenziones* and which today are usually called his *Two-Part Inventions* since they are written in two-part counterpoint. (Another collection of them bears the name *Praeambulum*.) A similar group of fifteen pieces, which Bach called *Sinfonie* (it is not known why, since sinfonia meant a quite different form in Bach's day, and in another collection called *Fantasia*), is known as his *Three-Part Inventions;* they resemble the first group in style but have three voice-parts.

inversion 1 The procedure or result of shifting a note of an interval or chord so that what was originally the bass (the lowest note) becomes an

upper note. An interval (a group of two notes sounded at the same time) is inverted by moving its lower note up one octave, or its higher note down one octave. (See the accompanying example *A,* in which D–A, which is a fifth, has been turned, by either of the two possible inversions, into a fourth.) Similarly, a second would be changed into a seventh, a third into a sixth, a fourth into a fifth. (Note that the sum of the two intervals is always nine, and that the intervals together form an octave.) Although the perfect intervals (fourth, fifth, octave) remain perfect despite inversion, an inverted major interval becomes a minor interval (and vice versa), whereas an augmented interval becomes a diminished interval (and vice versa). (See INTERVAL, def. 2, for an explanation of these terms.)

A chord is inverted when its root (lowest note) is moved up an octave. If only the root is moved, the chord is said to be in first inversion. The triad C–E–G, for example, would become E–G–C. A triad in first inversion is sometimes called a **six-three chord** or a **sixth chord**, because its upper notes are a sixth and a third above the bass. If the note just above the root is also moved up an octave, the chord is said to be in second inversion. The chord C–E–G, for example, would then become G–C–E. A triad in second inversion is sometimes called a **six-four chord**, because its upper notes are a sixth and a fourth above the bass. (See also CHORD.) A triad, which consists of three notes, has only two possible inversions. A seventh chord, consisting of four notes, has three inversions. The first inversion of C–E–G–B♭, for example, is E–G–B♭–C, which is sometimes called a **six-five chord** because its uppermost notes are a sixth and a fifth above the bass. The second inversion,

G–B♭–C–E, is sometimes called a **four-three chord**; and the third inversion, B♭–C–E–G, is sometimes called a **four-two chord**. The theory of inversion, according to which chords are analyzed with regard to their root positions and inversions, is an important element in the study of HARMONY (see also HARMONIC ANALYSIS). **2** Counterpoint is inverted by moving an upper voice-part down so that the treble becomes the bass or by moving the bass upward so that it becomes the treble. (Counterpoint in which this is possible is called **invertible counterpoint**.) Usually a part is moved up or down one octave. Occasionally, however, a different interval, such as a fifth, a tenth, or a twelfth, is used. (See also under COUNTERPOINT.) **3** Also, *melodic inversion, contrary motion.* A melody or a motif is inverted by changing the direction of each of its intervals: when the melody goes up a third, the inversion goes down a third; when the melody goes down a minor second (half tone); the inversion goes up a minor second; etc. The accompanying example *B* shows a brief subject from Bach's *Two-Part Invention* no. 1 and example *C* shows its inversion. In this example the

inversion—C B A G♯ B A C—is not the exact mirror image of the theme—C D E F D E C—with regard to the number of half tones in each melodic interval (the exact mirror image is shown in example *D*). Instead, Bach's melodic inversion is tonal, following the scale degrees of the key (A minor) rather than the exact interval sizes. Except in music that avoids traditional tonality (such as atonal music or serial music), melodic inversion is nearly always effected in this way. (For another example of melodic inversion, see under SERIAL MUSIC.) The inversion of a melody occurring in a second voice-part before the melody itself has been completed in the first voice-part is called canon by inversion or canon by contrary motion (see also under CANON). Melodic inversion is also frequently used in fugues and gigues, and in the development section of movements in sonata form.

inverted mordent See example under ORNAMENTS.

inverted pedal See under PEDAL POINT.

inverted turn See under ORNAMENTS.

invertible counterpoint See COUNTERPOINT; INVERSION, def. 2.

Ionian (ī ō′nē ən) **mode** The authentic mode beginning on C. See under CHURCH MODES.

IRCAM Acronym for Institut de Recherche et de Coordination Acoustique Musique; see under BOULEZ, PIERRE.

Irish harp A harp that differs from the modern concert harp in several important ways: it is smaller, only about three feet high; its pillar is curved outward instead of straight; it has brass strings, from thirty to fifty in number, which are plucked with the fingernails instead of the fingertips; and it lacks the pedals that make all keys available on the concert instrument. The Irish harp provides the traditional accompaniment for Irish folk songs. It originated in the late Middle Ages and has changed relatively little since that time. In the early nineteenth century it was provided with seven levers to raise the pitch of the strings by one half tone; these were later replaced by hooks, operated by hand.

irresoluto (ēr re″ sô lōō′ tô) *Italian.* A direction to perform in a hesitant, undecided manner.

isorhythm (ī"sə riŧhm'). See under MOTET.

istampita (ē"stäm pē'tä). The Italian word for ESTAMPIE.

istesso (ē stes' sô) **tempo** Italian: "the same tempo." Also, *l'istesso tempo* (lē stes'sô tem'pô), *lo stesso tempo* (lô stes'sô tem'pô), *medesimo tempo* (me de' sē mô tem'pô). A direction to retain the same beat even though the time signature changes. Thus, if the time signature changes from 3/4 to 4/4, the overall tempo should nevertheless remain the same, with four quarter notes being given the same time as three had received.

Italian overture See under OVERTURE.

Italian sixth An augmented sixth chord containing only the augmented sixth and the third above the bass (see SIXTH CHORD).

Ives (īvz), **Charles**, 1874–1954. An American composer, now recognized as one of the most original and advanced composers of his time. A prosperous insurance broker, Ives never depended on music for his livelihood. He began composing in his teens, first studying music with his father (a bandmaster) and then more formally at Yale University. Most of his many works were not performed until after he had stopped composing, about 1930, when he retired from business. Ives won the 1947 Pulitzer Prize in music for the third of his four numbered symphonies, which he had written in 1904, and the fourth was not performed in full until 1965. His genius lay in combining a true expression of American tradition with daring experiments. On the one hand he quoted American hymns, popular songs, dance tunes, and marches, employing many of the conventional tonal forms of nineteenth-century music. On the other, he used such devices as conflicting rhythms and keys at the same time (polyrhythm and polytonality), dissonant harmonies, tone clusters, microtones, and optional voice-parts. Of his many works, the best known include his four symphonies, *Concord Sonata* for piano, *Three Places in New England* for orchestra, *The Unanswered Question* for a chamber ensemble of strings and winds, and *A Symphony: Holidays*. He also wrote four violin sonatas, piano works, string quartets, numerous songs, and choral music.

jam session An informal performance by a group of jazz or rock musicians or folk singers. In jazz it traditionally involves improvising. (See also HOOTENANNY.)

Janáček (yä′ nä chek), **Leoš** (lī′ ôsh), 1854–1928. A Moravian composer and teacher whose music, particularly works he wrote after about 1900, ranks with the finest produced in his country. Janáček spent the greater part of his life in the city of Brno, where he taught organ and composition. Like the Russian composer Mussorgsky, to whom he is often compared, Janáček became very interested in folk music. From his studies of folk song he derived a complex theory of harmony, which he applied in his own works. At the same time he adopted the characteristic intervals and scales of Slavic folk music, as well as the device of insistent melodic repetition, which he used with dramatic effect in his own work, especially in his operas. Among the best of Janáček's compositions are the operas *Jenůfa, Kata Kabanová, The Cunning Little Vixen,* and *From the House of the Dead;* the *Glagolitic Mass* (also called *Slavonic Mass*); Concertino for piano and chamber orchestra; Sinfonietta for orchestra; and numerous chamber works and folk song arrangements.

Janequin (zhAn kaN′), **Clément** (klā mäN′), c. 1480–c. 1560. Also, *Jan-* *nequin.* A French composer who is remembered as one of the first composers of PROGRAM MUSIC. His most notable works are several long chansons (polyphonic songs) that, quite independently of their texts, are full of programmatic effects. In *Chant des oiseaux* ("Birdsong") the singers imitate bird calls and songs, in *La Guerre* ("The War") the singers imitate fanfares, rallying cries, drumbeats, and other battle sounds, and so on. Janequin also wrote church music, especially psalm settings, as well as more conventional chansons.

Janissary (jan′ i ser″ ē) **music** A type of late eighteenth-century band music that used some of the percussion instruments employed by the military band of the Janissary, the life guards of the Sultan of Turkey. Among these instruments were the triangle, cymbals, bass drum, and Turkish crescent. Their sound, considered very exotic, became quite fashionable in Europe about 1780 and was imitated by serious composers. Notable examples are found in Mozart's opera, *Die Entführung aus dem Serail* ("The Abduction from the Seraglio"), which has a Turkish setting, and the so-called "Turkish" Rondo (*Rondo alla turca*) of his Piano Sonata in A, K.331; in Haydn's Symphony no. 100 (*Military Symphony*); and in Beethoven's incidental music

for *Die Ruinen von Athen* ("The Ruins of Athens").

Jannequin See JANEQUIN, CLÉMENT.

Jaques-Dalcroze (zhäk' dAl krōz'), **Émile** (ā mēl'), 1865–1950. A French-Swiss composer and teacher, remembered principally for his novel method of teaching music, called EURHYTHMICS. Although Jaques-Dalcroze wrote many songs and instrumental pieces, and much choral music, his works are seldom performed outside Switzerland.

jazz An important style of American popular music that originated about 1900 among black musicians in the South, moved north to Chicago and then to the rest of the world. Jazz developed from several earlier kinds of American music, mainly blues (which in turn derived from black work songs and spirituals), the ragtime of the late nineteenth-century minstrel shows (which was originally the white man's imitation of black music), the music of the brass marching band, and, finally, the music of the string bands that accompanied dancing and other festivities in rural areas of the South. The ragtime pianist, accompanied by banjos and later by other instruments as well, gave jazz one of its most distinctive features, a syncopated rhythm, with the accents falling on unexpected beats, and beats themselves divided unevenly. This gives the music a very complicated rhythm, which is virtually impossible to notate accurately. The blues, usually a vocal piece accompanied by guitar, contributed two more features, the use of "blue notes," the half-flatted (not quite natural and not quite flat) third, fifth, and seventh degrees of the scale, and the practice of improvisation, with the singer making up new verses in the course of performance. This last feature makes the history of jazz unique in that it is recorded not in scores but on phonograph records and tapes; moreover, since recording was

rare before about 1923, the earliest materials of jazz have been lost.

The merger of ragtime and blues into the new instrumental music called jazz occurred sometime between 1900 and 1910 in New Orleans, Louisiana, among black musicians who were employed as entertainers in an unsavory neighborhood called Storyville, and who also played for weddings, funerals, and other important occasions elsewhere in town. The most important jazz musicians associated with this period were Ferdinand "Jelly Roll" Morton (1890–1941) and Joseph "King" Oliver (1885–1938). Most of the early jazz musicians were not formally trained; they played by ear, and few knew how to read music. Their skill lay in making music together, each influencing the others during the course of a performance.

The basic New Orleans (or Dixieland) jazz ensemble consisted of wind instruments and a rhythm section. A cornet or trumpet, along with a clarinet and trombone, carried the melody. The trumpet or cornet was the leader, with the clarinet and trombone providing high and low harmony, respectively. The rhythm section was made up of a guitar, a double bass, and drums. Some of the early bands included a banjo and piano, and occasionally also a tuba. At first used principally for rhythm, the piano in time supplied both melody (with the right hand) and rhythm (left hand). The string bass frequently played a **walking bass**, a steady series of plucked eighth notes consisting of the ascending (or descending) notes of a chord, with each note sounded twice in succession. On the piano a walking bass is sounded by the left hand playing octave intervals. A slightly different left-hand pattern is the **stride bass**, which, played in rapid tempo with virtuoso technique in the right hand, constitutes the style called **stride piano**. (The left hand here plays a tonic octave or tenth, then a two- or three-note chord above it, followed

by the fifth of that chord below the octave, steadily repeated over and over.)

Near the end of World War I (1918) the illegal entertainments of Storyville were closed down, and many jazz musicians left New Orleans to seek work elsewhere. "King" Oliver with his famous Creole Jazz Band moved to Chicago, which became the new center for jazz. It was with this band that trumpeter Louis Armstrong launched his career. Another fine group was that of Fletcher Henderson (1898–1952), formed in New York City in 1919 (Armstrong later joined it). Henderson's band initiated the changeover to a new style of jazz and a new kind of ensemble, the **big band.** The jazz band's main role was to supply music for dancing, a pastime that became immensely popular in the 1920s, and bands were formed in all the large cities. In the course of the 1920s the band had begun to expand somewhat, adding a second cornet, a tenor saxophone, and later a couple of alto saxophones. These groups, numbering no more than nine players, could still follow the basic improvisational style of early jazz. After the band leader gave the tempo, the group together would play the basic song once. Then each instrument took its turn playing a solo, in which the soloist ornamented or otherwise changed the melody in whatever way he chose. The solo was ordinarily backed up by the rhythm section. The solos continued until the leader called a halt, and the piece ended with a final chorus played by the full ensemble, often repeating some of the variations that had been devised by the soloists. Henderson's band sometimes included as many as twenty-five musicians. Such a large size greatly limited the possibilities for improvising, and so the big bands came to rely on arrangements—music that had been written out beforehand and rehearsed.

For a time the small band, represented by Louis Armstrong, Eddie Condon, Bix Beiderbecke, and others, existed side by side with the increasingly popular big band. The small bands played what was called "hot" jazz. The big band, represented by the first important white jazz musician, Paul Whiteman, and later by Edward "Duke" Ellington, developed a smooth, four-beat, highly danceable style of music that came to be called **swing** in the 1930s. Swing, with its chugging rhythm of four beats to the bar, was the form of jazz that became, for a time, *the* popular music of the day. In the wake of its popularity came the revival of older forms, mainly vocal blues (represented by Huddie "Leadbelly" Ledbetter and others), boogie-woogie piano blues, and a version of the old New Orleans style by white musicians, who called it "Dixieland." Among the famous swing musicians were Benny Goodman (sometimes called "the king of swing"), Artie Shaw, Tommy and Jimmy Dorsey, Fletcher Henderson, William "Count" Basie, Earl "Fatha" Hines, Glenn Miller, Woody Herman, Harry James, Gene Krupa, and Lionel Hampton. Popular as their music was, it was far different from the original New Orleans jazz. The typical swing band had at least five brasses, four reeds, and four percussion, and so could not perform without written arrangements. While brasses and reeds alternated, the soloist (trumpet, clarinet, saxophone, or piano) starred. Even in this era offshoots of the main style developed. One was **Kansas City jazz,** represented by Count Basie's band and known for its use of blues motifs, repetitive riffs, and a more relaxed rhythm.

The bands were occasionally joined by a vocalist, of whom the earliest outstanding one was Billie Holiday (1915–1959). She was the first to make the transition from blues to jazz, and her life was dramatized in a motion picture, *Lady Sings the Blues* (1972). Later great jazz vocalists were Ella Fitzgerald (1918–) and Sarah Vaughan (1924–1990).

In the heyday of swing, the main opportunity for the spontaneous

improvisation of early jazz was in small jam sessions held by and for jazz musicians. By the end of World War II (1945) several small ensembles had formed again and began to develop new jazz styles. Most of the men involved were trained musicians (their experience in big bands, which depended on written out arrangements, had forced them to learn to read scores); they were more sophisticated in approach and taste; and the music they made was not primarily for dancing but for listening. The leaders of this movement were Charlie "Bird" Parker, Dizzy Gillespie, Art Tatum, Stan Getz, and Miles Davis. Their complex melodies and dissonant harmonies, but lighter in tone and with less intense improvisation, were called cool jazz (as opposed to the "hot" Dixieland style of the 1920s), and the new style came to be called bop. The 1950s brought the development of still another style, so-called progressive jazz, represented by Thelonious Monk, Dave Brubeck, Gil Evans, John Lewis and his Modern Jazz Quartet, Theodore "Sonny" Rollins, Gerry Mulligan, Charlie Mingus, Ornette Coleman, John Coltrane, and others. Theirs was a music that was far too complex for dancing. It was rhythmically very complicated; for example, two main rhythm instruments, drums and double bass, might play two separate rhythms against a third, still different rhythm played by the solo melody instruments. This extremely abstract form, with its heavily dissonant improvisations without any easily perceptible structure—no conventional bar lines or standard chord changes—and new ways of blowing and fingering instruments, also came to be called avant-garde or free jazz, especially as played by Coltrane and Coleman.

Almost from its beginnings jazz interested and influenced composers of other kinds of music. Among them, showing direct or indirect influence, are Igor Stravinsky, Darius Milhaud, Paul Hindemith, Ernst Krenek, Kurt Weill, Aaron Copland, John Alden Carpenter, Meyer Kupferman, Leonard Bernstein, occasionally Milton Babbitt and Stefan Wolpe, and, perhaps most of all, George Gershwin. In the 1950s and 1960s the influence of contemporary serious music on jazz musicians was also seen. The merging of elements of serial music, chromaticism, and jazz is sometimes called third stream, a term coined by Gunther Schuller. Another development of the 1960s was the use of jazz in religious services of the Roman Catholic and various Protestant churches, a leader in this movement being "Duke" Ellington. By the late 1960s America's popular music was no longer jazz but rock. In order to survive, many black jazz musicians formed cooperatives. One was the Art Ensemble of Chicago, founded in the mid-1960s and still active two decades later. That same period—from the late 1960s to the late 1970s—saw the development of rock-jazz fusion (also called jazz-rock or electric jazz) by Miles Davis, Jimi Hendrix, and others, who combined the electronic amplification and driving energy of rock with the complex harmonies and improvisatory freedom of jazz. Another fusion was the funk jazz of the late 1970s, inspired by African music and the black jazz musicians' interest in their ancient origins. Still another offshoot was Latin jazz, which combined the rhythms and instrumental colors of Latin American music with the jazz tradition.

By the 1980s jazz musicians had developed a totally eclectic style known as new jazz, which drew on the entire sweep of jazz history: African roots, swing, bop, free jazz, free-form improvisation, along with folk music from all over the world and the complex structures of contemporary classical music. Many of these jazz composers had a thorough training in classical music. The groups ranged in size from small (trio, quartet, quintet) to medium-size (octet) to big band (twelve or more players). They performed in night-

clubs and concert halls and at jazz festivals. By the 1990s, jazz history and performance were gradually being accepted as an academic discipline, with leading jazz musicians employed on college and conservatory faculties, and there was no doubt that jazz would remain a permanent part of America's musical heritage.

jazz band See BAND, def. 7.

jeté (zhœ tā') *French:* "thrown." Also, *ricochet* (rik"ô shā'). A direction to throw the bow against the string in such a way that it will bounce several times on the down-bow.

Jewish chant The traditional music of Jewish religious services. Three principal kinds of music are used. The first, and oldest, is the chanting of the prose books of the Old Testament, which is an essential part of the service. The style used is called **cantillation**, and it is performed by a soloist, usually a tenor, called the cantor. Cantillation consists of a series of melodic formulas, highly ornamented and in free rhythm; each book of the Bible is assigned its own mode, not unlike the modes used in the medieval Christian church (see CHURCH MODES). The texts are marked with special signs that indicate the formula to be used. A second type of music is used for the prayers. Each prayer or category of prayers has special melodies or motifs associated with it, but the cantor is free to embellish or improvise on them as he pleases. The third type of music is a standard group of chants, with fixed melodies. This last category, which is only a few hundred years old and thus is the most recent in origin, occasionally includes melodies and themes taken from non-Jewish sources, among them opera, Protestant church music, and Gregorian chant.

Jew's-harp A small musical instrument, only a few inches long, consisting of a wooden or metal frame, shaped somewhat like a horseshoe, with a narrow, flexible metal tongue attached at one end. The player holds the narrow end of the frame loosely between the teeth and plucks the metal tongue with one finger, making it vibrate. Although only one fundamental pitch is produced by the vibrating tongue, the player can, by changing the position of cheeks and lips, produce different harmonics (overtones) of the fundamental pitch, as in a bugle. Although the Jew's-harp is a very ancient instrument that came to Europe from Asia, it has no historical connection with the Jews. It is still used as a folk instrument in some places, such as Austria, but it has been largely replaced by the harmonica.

jig A lively dance popular in England and Ireland during the sixteenth century, and later adopted on the European continent (see GIGUE.)

jingling Johnnie Another name for the TURKISH CRESCENT.

jodel (yōd'əl). The German spelling of YODEL.

jongleur (zhôn glœr') *French:* "juggler." In the Middle Ages, a traveling minstrel-entertainer who sang, danced, juggled, performed tricks (sometimes with trained bears or other animals), etc. Some jongleurs worked together with troubadours and trouvères.

Josquin des Prez (zhôs kaɴ' dā prā'), c. 1445–1521. A Flemish composer, considered the single greatest member of the FLEMISH SCHOOL, even during his own lifetime. After beginning his musical career as a choirboy, Josquin went to Italy, where he worked for many years, first in Milan and then in Rome and Ferrara. Later he served as court composer to King Louis XII of France, and he spent his last years at

Condé and Brussels. His contemporaries regarded Josquin as the greatest composer of their time, and he had enormous influence on other musicians, many of whom studied with him. His compositions—mainly Masses, motets, and secular chansons (nonreligious songs with several voice-parts)—not only show the principal features of the new Renaissance style, but are outstanding for their great emotional expressiveness, ranging from lighthearted playfulness to somber mourning and penitence.

jota (ĸнô′tä) *Spanish.* A lively dance in triple meter (any meter in which there are three basic beats in a measure, such as 3/4 or 3/8), which originated in the province of Aragon, in northeast Spain. The jota is performed by couples to the accompaniment of castanets. Several composers have been attracted to the form, among them Liszt, who used a jota in his *Rhapsodie espagnole* ("Spanish Rhapsody") no. 16, and Glinka, who wrote an orchestral overture entitled *Jota aragonesa.*

jug band See BAND, def. 10.

just intonation A system of tuning in which the distances between pitches are based on the natural harmonic series. The main disadvantage of this system is that it works for only one key at a time, since the precise pitch of most notes would vary depending on what key one started in. For example, A in the key of C major would be slightly lower in pitch than A in the key of D major. In practice, therefore, it is impossible to modulate from one key to another on an instrument tuned to just intonation. Twentieth-century composers who have experimented with just intonation include LaMonte Young and Harry Partch. See also TEMPERAMENT.

K

K. 1 Also, *K.V.* An abbreviation for *Köchel-Verzeichnis* ("Köchel Catalog"), a catalog of all Mozart's compositions that assigns a number to each one, compiled in 1862 by Ludwig von Köchel, an Austrian musicologist. Since Mozart wrote more than six hundred works in his short lifetime and did not assign opus numbers to them, Köchel's attempt to list them in the order in which they were composed is most helpful for understanding the ways in which Mozart's music developed. Furthermore, his catalog serves to identify the numerous sonatas in A, quartets in B-flat, horn concertos in E-flat, etc. The Köchel catalog has been revised several times as scholars have uncovered new information about the dates of Mozart's compositions, identified additional ones, and eliminated works discovered to have been written by other composers. **2** Abbreviation for Kirkpatrick, that is, the catalog of Domenico Scarlatti's keyboard works that was compiled by harpsichordist Ralph Kirkpatrick.

kanon See QĀNŪN.

Kansas City jazz See under JAZZ.

kantele (kän' te le) *Finnish.* The national folk instrument of Finland, used to accompany folk songs, especially the narrative songs that make up the long epic called *Kalevala.* The kantele is a wing-shaped PSALTERY, with two long sides that come close together at the bottom and a diagonal upper side. Originally it had five strings of horsehair, which were plucked with the fingers. Today it may have as many as twenty-five strings, which are usually made of metal and are plucked with a plectrum. The player holds the instrument flat on the lap and strums the strings with the right hand, while the left hand holds down the strings that are not to sound.

Kantor (kän'tor). The German term for CANTOR, def. 2.

kanûn See QĀNŪN.

Kapellmeister (kä pel' mī" stər) *German.* In the seventeenth and eighteenth centuries, the musical director of a court or private orchestra or choir.

Kappelle (kä pel'le) *German:* "chapel." A term used in the seventeenth and eighteenth centuries for a small private orchestra maintained by a nobleman or by royalty.

Kastagnetten (käs" tä nyet' ən). The German word for CASTANETS.

kazoo (kə zōō'). A simple wind instrument that consists of a tube with a slitlike side hole covered with a thin material, such as parchment or hide. The player hums or sings into

the hole, cut in the side of the pipe, causing the covering to vibrate and produce a buzzing sound. The kazoo is a kind of MIRLITON, a group of instruments that do not produce their own sounds but rather modify an already existing sound—in the case of the kazoo, that of the human voice. Mirlitons of the kazoo type were used in Europe from the sixteenth to nineteenth centuries and were sometimes used in early jazz bands, but today are regarded chiefly as toys. A similar instrument can be made with an ordinary comb covered with tissue paper, which when hummed into produces much the same sound as the kazoo.

Kent bugle Also, *Kent horn.* Another name for KEY BUGLE.

Kent horn See KEY BUGLE.

Kern (kûrn), **Jerome,** 1885–1945. An American composer who became famous for his musical comedies and popular songs. He composed dozens of works for the stage and later also composed scores for motion pictures. His best-known musical comedies include *Sally, Music in the Air, Roberta* (which contains the song "Smoke Gets in Your Eyes"), and, most popular of all, *Show Boat* (which contains the song "Ol' Man River").

kettledrums See TIMPANI.

key 1 In KEYBOARD INSTRUMENTS, such as the piano, harpsichord, organ, and accordion, one of the series of levers whereby the player's fingers make the instrument sound. **2** In modern WOODWIND INSTRUMENTS, such as the clarinet, oboe, flute, etc., one of a series of levers whereby the player's fingers open and close holes in the body of the instrument, thereby causing it to sound different notes. The use of keys enables the player to use finger holes that would otherwise be awkward or impossible to reach. A **closed key** is one that is normally kept closed by a spring and is opened by the player's finger; an **open key** is one that is normally kept open by a

spring and is closed by the player's finger. **3** A group of tones related to a common center, called the **tonic** or **keynote,** which make up the tonal material (notes, intervals, chords) of a composition. The tones of a key put in order of rising pitch (from low to high) make up a SCALE. However, although a key uses the notes of a particular scale, it is not identical to a scale. For one thing, even though a composition is written in a particular key, it may contain notes that do not belong to the scale of that key. Furthermore, a key involves not only a series of individual notes, but also relationships between those notes and the chords that are made up of them. Thus the term "key" is often used interchangeably with "tonality," that is, the use of a tonal center (or tonic, or keynote) to which chords are related in one way or another and to which the composition usually returns for a sense of rest and finality. Tonality applies mainly to music written between 1600 and 1900. Before 1600, music was organized in terms of different tonal material—church modes, tetrachords, etc.—and after 1900 many composers began to avoid the use of a particular key, preferring to write atonal music (see ATONALITY).

Since the tones of a key make up a scale, it follows that there are as many keys as there are scales; thus in European and American music, there are twelve major and twelve minor keys. The relationships between the notes and the chords built on them are the same in any major scale, so that a composition in one major key can be transposed (moved) to any other major key; the only difference is one of pitch. The same is true of the minor keys. The key of a composition is indicated at the beginning by the KEY SIGNATURE, which shows the sharps or flats, if any, used to form the key. The key signature does not, however, show whether the key is major or minor.

Although more than one key may be used in a composition, chiefly for the sake of contrast, a work usually

begins and ends in the same key. Often different keys are used for the different movements of a sonata or symphony, and within certain forms, such as sonata form, a change of key may be an essential part of the design. If the change of key affects a long section, it is usually indicated by a new key signature. If the change is temporary, it ordinarily is not indicated specifically, although the relatively large number of accidentals (sharps, flats, natural signs) in the score may imply that a change of key is taking place.

Change of key within a section or short piece is usually made gradually rather than abruptly, in a process called MODULATION (def. 1). Such changes are easier to effect between two closely related keys than between two less closely related keys (called **remote keys**). The most closely related keys are:

a Parallel keys, that is, major and minor keys having the same tonic (keynote), such as A major and A minor, B-flat major and B-flat minor, etc. These also are called **tonic major** and **tonic minor,** A major being the tonic major of A minor, and A minor the tonic minor of A major.

b Relative keys, that is, major and minor keys that have the same key signature (same number of sharps or flats), such as C major and A minor (both of which have no sharps or flats), G major and E minor (both having one sharp), etc. These are referred to as **relative major** and **relative minor,** C major being the relative major of A minor, and A minor the relative minor of C major.

c Related keys, that is, major and minor keys that differ from one another by only one sharp or flat in the key signature, such as C major (no sharps or flats) and G major (one sharp), E minor (one sharp), F major (one flat), and D minor (one flat).

Because two keys related to one another in the ways described share a high proportion of the same chords (which may, however, have a different harmonic function), it is fairly easy to modulate by means of a shared chord (called **pivot chord**) from one key to another. Thus a piece in the key of C major might modulate to G major via the chord G–B–D, which is both the dominant triad in C major and the tonic triad in G major.

keyboard A series of levers arranged in a row, whereby the player makes a keyboard instrument (piano, organ, harpsichord, clavichord, etc.) sound. The piano keyboard has eighty-eight keys and a range of seven and one-quarter octaves, with seven white keys and five black keys in each octave (see the accompanying illustration). The reason for the two kinds of key is that the earliest keyboards were diatonic (corresponding to the white keys), the chromatic keys (black keys) being added only later.

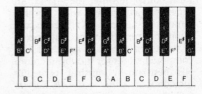

The earliest keyboards were built for organs. Organ keyboards are of two kinds, **manuals,** played with the hands, and **pedal keyboards** (or *pedalboards*), played with the feet. From a fairly early time organs were provided with two manuals, to permit rapid changes in loudness or tone color, and later they were sometimes given as many as six or seven. (Today even large organs rarely have more than four manuals.) In the fourteenth century keyboards began to be used for stringed instruments—the harpsichord and later the clavichord. The harpsichord, too, was often given two manuals, but the piano, dating from the eighteenth century, has only been provided with more than one for special purposes. One type had a second keyboard that played an octave higher than the regular one; another had a second keyboard playing strings tuned

a quarter tone (half of a half tone) higher than the other.

keyboard instruments Musical instruments that are sounded by means of a keyboard, mainly the organ, piano, clavichord, and harpsichord (including such varieties of harpsichord as the spinet and virginal). Although some other instruments, such as the accordion and celesta, have a similar keyboard, they are not generally considered part of the group.

keyboard music Music written for a keyboard instrument. The term is used most often for music written before about 1770, which could be played on any of the current keyboard instruments (organ, harpsichord, or clavichord) and was not necessarily intended for any one instrument in particular.

key bugle Also, *keyed bugle*. A brass instrument invented in the early nineteenth century (patented in 1810 in Dublin, Ireland) that was the first brass instrument on which a full chromatic scale could be played. Before its invention, brass instruments were confined to a single fundamental pitch and its harmonics, which could be varied only with the addition of cumbersome crooks (see FRENCH HORN). The key bugle had five keys covering holes in the body of the instrument, which made available all the notes from middle C to high C (two octaves). Later, it was given a sixth key, and still later, in France, several more were added. The key bugle was invented by Joseph Halliday, an Irish bandmaster, and later it became known as the **Kent bugle** or *Kent horn* in honor of the Duke of Kent, commander-in-chief of the British armies. Until about 1850, when it was replaced by the valved cornet, the key bugle was the chief solo brass instrument of treble range.

keyed harmonica See under GLASS HARMONICA.

keynote Another name for TONIC.

key signature The sharps or flats placed at the beginning of a musical staff, immediately after the clef sign, to indicate what KEY (def. 3) the music is in. The line or space of the staff on which the sharp or flat appears indicates the note affected, no matter what octave it is in. The key signature does not indicate whether the key is major or minor; thus the same signature is used for a major key, such as G major, and its relative minor, E minor, each of which have one sharp (F-sharp). The absence of a key signature indicates either that the composition is in the key of C major or A minor, or that the music is not written in any key (see ATONALITY).

The key signature is repeated at the beginning of each staff of the score. Temporary modulations into another key usually are not marked by a new key signature but are indicated by accidentals (sharp, flat, or natural signs) preceding the notes affected. However, a long passage in a different key is usually indicated with a new

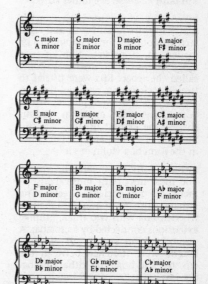

key signature, separated from the old by a double bar line. As shown in the accompanying example, there are fifteen possible key signatures. On keyboard instruments like the piano, which do not distinguish between enharmonic notes, six pairs of the possible keys are identical in sound. They are: B major and C-flat major; F-sharp major and G-flat major; C-sharp major and D-flat major; G-sharp minor and A-flat minor; D-sharp minor and E-flat minor; A-sharp minor and B-flat minor.

Khatchaturian (kä" c͟hä dōͦo͞r'ē ən), **Aram** (ä räm'), 1903–1978. An Armenian composer, teacher, and conductor who became known all over the world for a piece from his ballet *Gayane,* the "Saber Dance." Among his many other works, the best known are his two symphonies, piano concerto, violin concerto, and cello concerto. His music is traditional in form and reflects his interest in folklore, especially that of Armenia.

kin (kin) *Japanese.* See under KOTO.

kit A tiny violin used by dancing masters in the seventeenth and eighteenth centuries. Small enough to be carried in a pocket, the kit was descended from a medieval fiddle called the rebec. Kits were fifteen to twenty inches long, and had three or four strings that were played with a bow. They were made in various shapes, the earliest usually being in the form of a rebec, and the later ones in the form of a violin or viol.

kithara (ki̱th' ər ə). British, *cithara.* The most important musical instrument of the ancient Greeks. The kithara consisted of a square, shallow wooden box with two thick, armlike extensions connected by a crossbar. A number of gut strings, all of equal length, were stretched between the crossbar and box. The kithara probably was quite heavy and bulky, since the player held it upright, partly supporting it with the body; often it was further supported by leather bands

passed either around the shoulder or over the wrist. The earliest kitharas, dating from the eighth century B.C., had five strings, a number that was eventually increased to eleven. The kithara was used both to accompany the epic songs of the bards and as a solo instrument, the performer plucking the strings with a plectrum.

klagend (klä'gənt) *German.* A direction to perform in a mournful, plaintive manner.

Klangfarbenmelodie (kläng͡' fär" bən me lō͞ dē'ə) *German:* "tone-color melody." A term invented by Arnold Schoenberg to describe the device of creating a melody from different tone colors instead of different pitches. He illustrated this device in a number of works, such as the fifth of his *Five Orchestral Pieces,* op. 16, in which a single melody is taken up by different instruments throughout the entire piece. Klangfarbenmelodie particularly intrigued Schoenberg's pupil, Anton Webern, who used tone color as a structural element, and later, from the 1960s on, appealed also to Lutoslawski, Penderecki, Xenakis, Kagel, Ligeti, and Crumb, among others.

klar (klär) *German.* A direction to perform in a clear, bright manner.

Klarinette (klä"rē net'ə). The German word for CLARINET.

Klavier (klä vēr'). 1 The German word for piano (see PIANO, def. 2). 2 See CLAVIER.

kleine Flöte (klī'nə flœ'tə). The German term for PICCOLO.

kleine Trommel (klī'nə trô'məl). The German term for SNARE DRUM.

klezmer (klez'mər) *pl.* **klezmorim** (klez mə rēm') *Yiddish*: "vessel of music." An East European itinerant Jewish folk musician and, by extension, a kind of dance music played by bands of such musicians. Brought to America by Jewish immigrants in the 1880s, it combines the rhythms and improvisational style of folk music with instruments and techniques borrowed from both classical and popular music, including jazz and rock. At first used only for special festive occasions, such as weddings, it is now also performed in concert form.

Knarre (knä'rə). The German word for RATTLE.

Köchel-Verzeichnis (kœ'ᴋʜəl fer tsī͞ᴋʜ'nis) *German*. See K.

Kodály (kō dä' yē), **Zoltán** (zôl tän'), 1882–1967. A Hungarian composer, who combined in his music the Hungarian folk tradition with elements of conventional nineteenth-century romanticism. A close friend and colleague of Béla Bartók's, Kodály succeeded Bartók as the leader of his country's musical life. Compared to Bartók's works, Kodály's compositions are much more traditional in melody, harmony, and rhythm. He was at his best in vocal compositions—in fact, he emphasized singing as the most important kind of music education, believing that all children should take part in choral singing, and intended many of his own vocal works for students and amateurs. Kodály also wrote a great deal of chamber music, including two fine string quartets, a Sonata for unaccompanied cello, and a Serenade for two violins and viola. Outstanding among his choral works is *Psalmus Hungaricus*, a setting of Psalm 55 for chorus and orchestra. Also well known are his folk opera *Háry János*

and an orchestral suite derived from it; two suites of folk dances (*Marosszék Dances* and *Dances of Galanta*); and *Variations on a Hungarian Folksong (Peacock Variations)* for orchestra.

Kontrabass (kôn'trä bäs") *German*. 1 The word for DOUBLE BASS. 2 The word for CONTRABASS (def. 2).

Kontrafagott (kôn'trä fä gôt"). The German word for double bassoon (see under BASSOON).

Konzertstück (kon tsârt' s̱htyᴋ") *German*. A work for one or more solo instruments and orchestra, usually shorter than a concerto and sometimes in one movement. An example is Weber's *Konzertstück* in F minor for piano and orchestra.

Kornett (kôr net'). The German word for CORNET.

koto (kô'tô) *Japanese*. A Japanese zither that consists of a rectangular wooden board, about six feet long, over which are stretched from seven to thirteen silk strings. The player sets the instrument on the floor and plucks the strings with the fingers, occasionally assisted by three plectra of ivory, bamboo, or bone that are attached to fingers of the right hand like artificial fingernails. There are two main varieties of koto. One, called *sō*, has thirteen strings, each tuned separately with its own movable bridge (a modern version of this type has seventeen strings). The other, called *kin*, is virtually the same as the Chinese CHYN and like it has seven strings. The koto was one of the non-Western instruments that attracted Henry *Cowell*.

kräftig (kref'tiᴋʜ) *German*. Also, *mit Kraft* (mit kräft'). A direction to perform in a forceful, vigorous manner.

Kraft, mit See KRÄFTIG.

krakowiak (krä kō' vē äk") *Polish*. Also, *cracovienne*. A lively Polish dance, in 2/4 meter, with syncopated beats. Named for the city of Cracow, it was popular in the early nineteenth cen-

tury. Chopin used the form in a Rondo for piano and orchestra, op. 14.

Kreisler (krīs'lər), **Fritz** (frits), 1875–1962. An Austrian-American violinist and composer, acknowledged as one of the great violinists of all time. Kreisler composed numerous pieces for his instrument, among them *Caprice Viennois, Tambourin Chinois, Schön Rosmarin,* and *Liebesfreud.* He also wrote a number of other works in the style of such earlier composers as Vivaldi and Couperin and often played these works as encores, claiming that they were actually by the masters whose style he had imitated.

Krummhorn (krōōm' horn). The German term for CRUMHORN.

Kunstlied (kōōnst'lēd). The German term for art song (see LIED, def. 1).

K.V. See K.

Kyrie (kē'rē e") *Greek.* In the Roman Catholic rite, the first sung section of the Ordinary of the Mass (see MASS). The full text is *Kyrie eleison, Christe eleison, Kyrie eleison* ("Lord have mercy, Christ have mercy, Lord have mercy"), repeated three times. The Kyrie is the only portion of the Mass in which a Greek text is used, the rest being in Latin. See also LEISE, def. 2.

L

l. Also, *L.* An abbreviation for either *left* or *linke,* meaning "left" and referring to the left hand.

la (lä). In the system of naming the notes of the scale (see SOLMIZATION), the sixth note of the scale (the others being *do, re, mi, fa, sol,* and *ti*).

lacrimoso (lä" krē mô′ sô) *Italian.* Also, *lagrimoso* (lä"grē mô′sô). A direction to perform in a sad, mournful manner.

lagrimoso See LACRIMOSO.

lai (le) *French.* A form of music and poetry of the thirteenth century, developed mainly in northern France by minstrel-musicians called trouvères. Its southern (Provençal) counterpart, developed by the troubadours, was called **descort**. The lai is a poem made up of several stanzas, varying in length, rhyme scheme, and rhythm, each of which is set to a melody that is repeated several times. Sometimes the melody is repeated twice in a section, and sometimes three or four times. The lai form still interested Machaut, the leading French composer of the fourteenth century, who wrote at least eighteen such works. Machaut's lais tend to be more regular than earlier ones, consisting of two-section stanzas in which the same melody is used for each section. The German counterpart of the lai was the **Leich,** used in the fourteenth century by the minnesingers. It, too, tends to be quite regular in structure, generally consisting of a number of two-section stanzas with the same melody repeated for each section.

lament 1 A musical composition that mourns someone's death. The practice of writing laments dates from the eighth century or even earlier. Beginning about the fourteenth century, it became customary for the pupils of notable composers to write laments when their masters died. This practice was especially common in France, where the form was called **déploration;** examples include a lament by Johannes Ockeghem for Antoine Binchois, by Josquin des Prez for Ockeghem, and by Nicolas Gombert for Josquin. Heinrich Isaac wrote a famous one for his patron, Lorenzo de' Medici, who died in 1492. A notable English lament is John Blow's setting of an ode by the poet John Dryden, mourning the death of Henry Purcell. The lament also played an important role in early opera, the most notable examples being *Lamento d'Arianna* ("Ariadne's Lament," the only surviving portion of Monteverdi's opera *Arianna*), and Dido's lament, "When I Am Laid in Earth," from Purcell's *Dido and Aeneas.* During this same period (seventeenth century) French lute and keyboard composers wrote instrumental forms

of lament called **tombeau.** A more recent example is Maurice Ravel's piano suite *Tombeau de Couperin* ("Tomb of Couperin," 1917) written in honor of François Couperin, the seventeenth-century composer. **2** In Scottish and Irish folk music, a composition for voice or, often, for bagpipes, used for mournful occasions. Each Scottish clan has a traditional lament of its own that is performed when a clan member dies.

Lamentations In the Roman Catholic rite, a portion of the Book of Jeremiah that is sung on certain occasions to a simple chant, so simple that it is almost a monotone. From the fifteenth century on, numerous composers wrote polyphonic versions for this text. Among the most famous are those of Ockeghem, Palestrina, Lasso, Tallis, and Byrd. Stravinsky wrote a modern setting of the text entitled *Threni* (1958), for six soloists, chorus, and orchestra. In the Anglican services the Lamentations are sung at Matins on the last three days of Holy Week.

lamentoso (lä"men tô'sô) *Italian.* A direction to perform in a mournful manner.

lancio, con (kôn län'c̲h̲ô) *Italian.* A direction to perform in a lively, spirited manner.

Landini (län dē' nē), **Francesco** (frän c̲h̲es' kô), 1325–1397. An Italian composer, the leading musician of his time. Blind from early childhood, Landini lived most of his life in Florence, the city of his birth. He played the lute and probably several other instruments as well, but he became best known as a virtuoso organist. About 150 of his works survive, most of them in the BALLATA form. (See also ARS NOVA.)

Landini cadence A cadence often used by Francesco Landini, although he did not invent it. The Landini cadence contains the submediant (sixth scale degree) inserted within the normal progression from the leading tone (seventh scale degree) to the tonic (first scale degree). For example, in the key of C major, the progression from B to C, which has a sense of finality, is interrupted by A, the cadence becoming B–A–C, as shown in the accompanying example. It is the presence of the sixth scale degree that gives this cadence its alternative name, *Landini sixth.*

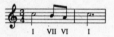

I VII VI I

Landini sixth Another term for LANDINI CADENCE.

Ländler (len'dlər) *German:* "from the country." A dance in slow tempo and 3/4 meter, similar to a slow waltz, that was popular in Austria in the early nineteenth century, and probably originated in rural areas. Mozart, Beethoven, and Schubert all wrote dances of this type.

langsam (läng'zäm) *German:* "slow." A tempo marking appearing in some German scores and approximately equivalent to ADAGIO.

largamente (lär" gä men' te) *Italian.* A direction to perform broadly, in a stately, dignified manner, but with no change in tempo.

largando (lär gän' dô) *Italian.* Another spelling of ALLARGANDO.

larghetto (lär get'tô) *Italian.* **1** A slow tempo, slightly faster than largo but slower than andante, ranging from about 60 to 66 quarter notes per minute. **2** A composition or section in this tempo.

largo (lär'gô) *Italian.* **1** A very slow tempo, with about 40 to 60 quarter notes per minute. The slowest of the conventional tempos, it is usually combined with a broad, dignified manner of performance. **2** A composition or section in largo tempo. Among the most familiar compositions having this title is a work by Handel, which was originally an aria in the opera *Serse,* or "Xerxes," where it was marked "larghetto."

laser recording See DIGITAL RECORDING.

Lasso (läs'sô), **Orlando di** (ôr län'dô dē), 1532–1594. Also, *Orlandus Lassus* (ôr lan' dəs las' səs), *Roland de Lassus* (rô län' də lʌ sy'). A Netherlands composer, the last of the great masters of the FLEMISH SCHOOL, and, together with Palestrina, one of the two greatest masters of Renaissance polyphony. A choirboy in his youth, Lasso was allegedly kidnapped three times because of his beautiful voice. At the age of twelve he went to Italy, where he remained for ten years. Thereafter he traveled to Belgium and Germany, spending most of the rest of his life in Munich, where he held various posts. He was a master of every style and genre of his time—both secular and sacred Latin compositions (more than fifty Masses, more than five hundred motets, a hundred Magnificats), Italian madrigals (150), French chansons (100) and German lieder (90). In the last two forms he often was humorous and sometimes bawdy. His music is especially notable for being highly expressive of the text. Technically, it combines the imitative counterpoint perfected by the Flemish school with strong rhythms and dramatic changes of mood.

Lassus, Orlandus (Roland de) See LASSO, ORLANDO DI.

Latin music A general term for the folk music, dance forms, and songs of Spain and Latin America, many of which have influenced both popular and serious music in North America and Europe. Among them are the Spanish BOLERO and FLAMENCO, Brazilian BOSSA NOVA, CHÔRO, and SAMBA, Colombian BAMBUCO and CUMBIA, Cuban HABANERA and RUMBA, Argentine TANGO, Dominican MERENGUE, Caribbean CALYPSO, REGGAE, and SALSA, and such instruments as the GÜIRO, CASTANETS, CLAVES, MARACA, BONGO DRUMS, MARIMBA, and steel drums (see STEEL BAND). Also see MARIACHI.

lauda (lou'dä, *pl.* **laude** (lou'de) *Italian:* "praise." A type of Italian hymn that probably originated in the thirteenth century. Its text was Italian rather than Latin, the language customarily used for religious music, and it was generally a song of praise. The earliest laude were simple songs with only one voice-part; they consisted of a number of stanzas alternating with a short refrain, which also preceded the first stanza. By the sixteenth century laude were often written with three or four voice-parts but usually were still in a simple style, with all of the parts sounding together in the same rhythm and each syllable of the text set to one note. Some composers, however, treated them much the same as the FROTTOLA (def. 1).

Lauds See under OFFICE.

laut (lout) *German.* A direction to perform loudly, same as FORTE.

Laute (lou'tə). The German word for LUTE.

lavolta The English name for *volta* (see VOLTA, def. 2).

leader 1 The British term for CONCERTMASTER. **2** In the United States, another term for conductor. **3** Also, *principal.* In orchestral sections other than the first violins, the chief player of each section (violas, cellos, etc.); in the case of wind instruments, the first oboe, first horn, etc. **4** Also, *section leader.* In choruses, the principal singer in each section (bass, tenor, etc.). **5** Also, *lead man.* In jazz bands, the highest or leading voice of a section, most often the first trumpet.

leading note See LEADING TONE.

leading tone Also, *leading note.* The seventh degree of the scale, that is, the seventh note in any major or minor scale, one half tone below the tonic (see SCALE DEGREES). In the key of C major the leading tone is B, in the key of D major it is C-sharp, in the key of A minor it is G-sharp, etc. Its name comes from the fact that it has a tendency to lead to the tonic note, which gives a sense of finality.

lebendig (lā ben' diᴋʜ) *German.* Also, *lebhaft* (lāb'häft). A direction to perform in a lively manner.

lebhaft See LEBENDIG.

ledger lines Also, *leger lines*. Short lines above or below the five-line staff, used for notes too high or too low in pitch to fit on the staff. Middle C, which lies exactly halfway between the highest note on the bass staff and the lowest note on the treble staff, is always shown with a ledger line.

legato (le gä′tô) *Italian*. A direction to perform smoothly, without any break between notes. It is sometimes indicated by a SLUR. The opposite of legato is STACCATO, calling for sharply detached notes.

légèrement (lā zher män′) *French*. A direction to perform lightly, delicately. Also, *léger* (lœ zhā′).

leger lines Another spelling for LEDGER LINES.

legg. Abbreviation for LEGGERO.

leggero (led je′ rô) *Italian*. Also, *leggiero* (led je′ rô). A direction to perform lightly, gracefully. Sometimes abbreviated *legg.*

leggiero See LEGGERO.

legno, col (kol le′nyô) *Italian:* "with wood." A direction to bounce the wooden stick of a violin bow against the strings instead of using the hair of the bow in the usual manner.

Lehár (lā′här), **Franz** (fränts) 1870–1948. A Hungarian composer who lived most of his life in Vienna and who is remembered chiefly for his highly successful operetta, *Die lustige Witwe* ("The Merry Widow"). Lehár's gay, frivolous music, with its charming melodies and lilting waltz rhythms, became very popular in the early twentieth century. The best known of his other operettas are

Zigeunerliebe ("Gypsy Love"), *Der Graf von Luxemburg* ("The Count of Luxembourg"), and *Das Land des Lächelns* ("The Land of Smiles").

Leich (līκн) *German*. See under LAI.

leicht (līκнt) *German*. A direction to perform lightly, delicately.

leidenschaftlich (lī′ dᵊn shäft′ liκн) *German*. A direction to perform in a passionate, expressive manner.

leise (lī′zə) *German*. 1 The German word for "soft," the same as PIANO (def. 1). 2 *Leise*, pl. *Leisen*. A traditional German folk hymn, the earliest example of which dates from about 1350. Some Leisen were monophonic (in one voice-part) and others polyphonic, for three or four voices. All, however, are characterized by the concluding refrain, "Kyrieleis" (also written *Kyrioleis, Kirleis,* or simply *Leis*), referring to the *Kyrie eleison* ("Lord have mercy") of the Mass.

leitmotif (līt′mō tēf″) *German:* "leading motif." Also, *leitmotiv*. A short musical theme (motif or figure) used to stand for a person, object, place, or idea, which reappears from time to time throughout a musical composition. Although musical themes have been used in this way earlier, both in opera (by Mozart, Grétry, Weber) and in instrumental music (by Berlioz, Schumann, Liszt), the term "leitmotif" is most closely associated with their extensive use by Wagner in his opera cycle, *Der Ring des Nibelungen* ("The Ring of the Nibelungs"). The device was later used by numerous composers (Richard Strauss, d'Indy, Debussy) in opera and in instrumental music, particularly in symphonic poems.

leitmotiv See LEITMOTIF.

lent See LENTEMENT.

lentamente See LENTO.

lentement (länt män′) *French*. Also, *lent* (län). A direction to perform in slow tempo.

lento (len′tô) *Italian*. Also, *lentamente*

(len"tä men'te). A direction to perform in slow tempo.

Leoncavallo (le ôn" kä väl' lô), **Ruggero** (rōōd je' rô), 1857–1919. An Italian composer remembered chiefly for a single opera, *I Pagliacci* ("The Clowns"). First performed in 1892, it was the only one of his numerous compositions to achieve great success. *I Pagliacci* is an example of late nineteenth-century verismo style, which aimed at presenting a realistic portrayal of life.

Leonin (le ô naɴ'), fl. c. 1163–1190. Also, Latin, *Leoninus* (lē on'i nəs). A French composer of the late twelfth century who worked at the Cathedral of Notre Dame, in Paris. Leonin and his successor, Perotin, were the two greatest composers of the Notre Dame school, Leonin being especially renowned for his organa, compositions with two voice-parts in free rhythm.

Leoninus See Leonin.

letter notation Any system of writing music in which letters (or numbers) stand for the different pitches. Today letters are used only to refer to pitches in speech or in writing about music, whereas notes and other symbols are used in the actual notation of music.

l.h. An abbreviation for "left hand" or the German, *linke Hand,* used in keyboard music as a direction to play a note or passage with the left hand.

L'Homme armé (lôm ᴀʀ mä'). See Homme armé, L'.

libretto (lē bret' tô) *Italian.* The text to which an opera or oratorio is set. Until the late nineteenth century, opera librettos were nearly always written by someone other than the composer, and often the librettist was considered as important as the composer.

Among the most famous librettists are Ottavio Rinuccini (1562–1621), who wrote the texts of some of the earliest operas, by Peri, Caccini, and Monteverdi; Pietro Metastasio (1698–1782), who wrote librettos for Alessandro Scarlatti, Handel, and Mozart; Lorenzo da Ponte (1749–1838), who wrote the librettos for Mozart's *Le Nozze di Figaro* ("The Marriage of Figaro"), *Così fan tutte* ("Women Are Like That"), and *Don Giovanni;* Arrigo Boito (1842–1918), librettist of Verdi's last two operas, *Otello* and *Falstaff;* and Gilbert, of Gilbert and Sullivan fame. Wagner was the first composer to insist on writing all of his own texts, a practice that has been followed (though less strictly) by such composers as Rimsky-Korsakov, Busoni, Delius, Holst, Hindemith, and Menotti. Later composers are divided, some writing their own librettos and others relying on librettists.

licenza, con alcuna (kôn äl kōō'nä lē chen'tsä) *Italian.* A direction indicating that the performer may have some freedom in interpreting a passage.

lied (lēt), *pl.* **lieder** (lē'dər) *German:* "song." 1 In English, the term for a type of romantic art song for solo voice with piano accompaniment written since the early nineteenth century by Schubert, Schumann, Loewe, Wolf, Brahms, and other German composers. (The German term for it is **Kunstlied.**) Lieder are often set to very fine poems, by poets such as Goethe or Heine. The accompaniment is often as important as the vocal part, particularly in those series of lieder called song cycles. The structure of the lied varies widely. Some consist of a number of stanzas with a refrain repeated after each stanza. Sometimes the music for the different stanzas is the same, and in other cases it varies from stanza to stanza. Other lieder are in three-part form, consisting of an opening section, a middle section, and a concluding section that is exactly or almost identical to the opening section. Many of the great lieder are, however, **through-composed;** that is, the music follows the poetry, changing throughout the piece, without any special scheme of repetition. A famous example of a through-composed lied is Schubert's "Der Erlkönig"

(The Erl-King). Although the nineteenth century was the outstanding period of lieder composition, later composers have produced some notable examples, among them Mahler, Richard Strauss, Reger, and, in more modern idioms, Schoenberg, Berg, Webern, and Hindemith. Songs very similar to German lieder were composed in other countries, most notably in France, by Chausson, Duparc, Fauré, and others. Such a song is generally called an ART SONG. (See also BALLADE, def. 3; SONG; SONG CYCLE.) 2 In the fifteenth and sixteenth centuries, a polyphonic (with several voice-parts) secular song, the German counterpart of the French CHANSON (def. 2). Three great collections survive from the second half of the fifteenth century (they also include monophonic pieces, a tradition continued with the Meistersinger): the Lochauer Liederbuch, Schedelsches Liederbuch, and Glogauer Liederbuch. The most important composers of the polyphonic lied were Heinrich Isaac (see chart accompanying RENAISSANCE), his contemporaries Paul Hofhaimer (1459–1537) and Heinrich Finck (1447–1527), and his pupil Ludwig Senfl (c. 1486–1542/3). 3 In modern German, any German song, whether folk song or art song.

Liederkreis (lē′dər krīs) *German*: "circle of song". 1 The German word for SONG CYCLE, used by Schumann as a title for two of his song cycles (op. 24 and op. 39, 1840). 2 A singing club, particularly for performing popular songs. Such organizations were very popular in nineteenth-century Germany.

lieto (lē e′tô) *Italian*. A direction to perform in a gay, joyful manner.

lievo (lē ā′vô) *Italian*. A direction to perform lightly, easily.

ligature 1 The clamp whereby the reed of a clarinet or a saxophone is held onto the mouthpiece. 2 Another word for SLUR. 3 In written music from the late twelfth century to about 1600, a form of writing several notes joined together. In Gregorian chant ligatures were simply a new variety of neume. In music with more than one voice-part, ligatures indicated not only pitch but rhythm (short and long notes). See also NOTATION.

Ligeti (le′ ge tē), **György** (dyŒr′ dyª), 1923– . A Hungarian composer who became known first for his serial music and electronic works, and later for nonelectronic pieces, all notable for their complex texture and also considerable humor. In 1956 Ligeti left Hungary and went to Vienna; he also worked for a time at the electronic studio in Cologne, Germany. His first major nonelectronic works following his departure were *Apparitions* (1958/9) and *Atmosphères* (1961), both for orchestra. *Atmosphères* and the Kyrie from his Requiem Mass (1969) became extremely well known because they appeared, without the composer's permission, in the sound track of Stanley Kubrick's film, *2001: A Space Odyssey*. A characteristic technique of Ligeti's is to lay down a complex tone cluster and then slowly move the individual parts around in steps and half-steps; this is clearly seen in *Lontano* (1967) for orchestra. Ligeti also acknowledged his link to MINIMALISM in his *Self-Portrait with Reich and Riley* (1976), for two pianos. His *Poème Symphonique* (1962) is composed for 100 metronomes ticking at different speeds and lasts until the slowest of them has run down. *Aventures* (1962) and *Nouvelles Aventures* (1962–1965) are "operas" sung to nonsense syllables. Some of his works, such as the set of *Etudes* for piano, show his love for ethnic music from many sources, ranging from the Caribbean to Eastern Europe. His other works include an opera, *Le grand Macabre* (1978), Horn Trio (1982), and Piano Concerto (1988).

light opera A term used rather loosely for an OPERETTA, MUSICAL COMEDY, or other stage entertainment falling somewhere between these two.

lining out (lī'nĭng out'). In the eighteenth and nineteenth centuries in England and America, the custom of having the minister or deacon read aloud each line of a psalm or hymn before it was sung by the congregation. This practice was necessary because people did not always know all the words of a hymn or psalm, and hymnbooks and psalters were scarce. The music, on the other hand, was familiar, since only a dozen or so melodies were used for most of the hymns and psalms.

linke Hand (lĭng'kə hänt) *German:* "left hand." A direction in keyboard music to play a note or passage with the left hand.

lip 1 Another word for EMBOUCHURE, def. 2. **2 to lip.** In playing wind instruments, to modify the pitch, especially raising it but also lowering it, by adjusting the embouchure. Also, *to lip up/down.*

lira (lē'rä) *Italian.* **1** A shortening of LIRA DA BRACCIO. **2** A shortening of LIRA DA GAMBA.

lira da braccio (lē'rä dä brät'chô) *Italian.* A forerunner of the violin that was developed in Italy late in the fifteenth century. The lira da braccio was about twenty-eight inches long and looked much like a large violin. However, it had seven strings, two of which ran to one side of the fingerboard and sounded a single pitch, without being stopped. The five melody strings were tuned G, g, d, a, d' (see the accompanying example). The head (top) of the instrument also differed from the violin's, being leaf- or heart-shaped, with the tuning pegs set into it vertically like those of a guitar. The instrument was held against the shoulder (*braccio* means "arm") and was bowed. See also VIELLE.

lira da gamba (lē'rä dä gäm'bä) *Italian.* A larger, lower-pitched version of the LIRA DA BRACCIO, used mainly in France and Italy c. 1550–c. 1650. The lira da gamba was about forty-three inches long, and was rested between the player's knees (*gamba* means "leg"). It had two drone strings (sounding only one pitch each) running to one side of the fingerboard, and anywhere from nine to fourteen melody strings. Its fingerboard was fretted (to mark the stopping positions) like that of the viola da gamba.

liscio (lē'shyô) *Italian.* A direction to perform smoothly, flowingly.

l'istesso tempo (lē stes'sô tem'pô) *Italian.* See ISTESSO TEMPO.

Liszt (list), **Franz** (fränts), 1811–1886. A Hungarian composer and pianist who was one of the great figures of nineteenth-century romantic music. Famous in his day as a masterful piano virtuoso and for the brilliant compositions he wrote for this instrument, Liszt today is also remembered as the inventor of the program symphony and symphonic poem. Liszt began to give piano concerts at the age of nine. In his twenties he had a love affair with a married countess, and one of their three children, Cosima, later married Richard Wagner. In 1848 Liszt settled in Weimar, Germany, as court music director, and he made Weimar a great cultural center (it was here that Wagner's opera *Lohengrin* was first produced and Berlioz's music was given its first performances in Germany). Liszt now began to devote himself to composition. His early piano music was technically dazzling, with its scale passages in octaves and tenths, chains of trills and arpeggios, and chromatic chord changes, but now he became more interested in the piano's expressive qualities. Breaking with the forms of the classical period, such as the sonata, he wrote pieces in free form, with such titles as "Rhapsody," "Fantasia," "Nocturne," "Elégie," and "Ballade." Usually in a single move-

ment, these pieces are held together by a system of short motifs that are repeated and varied and repeated again. In his use of this structural device, as well as in his experiments with chromatic harmonies and unconventional melodies, Liszt foreshadowed the innovations of Wagner and, some think, perhaps even the atonal melodies and polytonal harmonies of the twentieth century. In addition to original piano compositions, Liszt also wrote dozens of piano transcriptions of orchestral and vocal works, among them all of Beethoven's symphonies, Berlioz's *Symphonie fantastique*, and many songs by Chopin, Schubert, and Schumann.

It was in Weimar, too, that Liszt turned to a new orchestral form, the symphonic poem. Of his program music, the best-known works are the symphonic poems *Tasso, Les Préludes, Prometheus, Mazeppa*, and *Die Hunnenschlacht* ("The Battle of the Huns"), and the program symphonies *Faust Symphony* and *Dante Symphony*. After eleven years at Weimar, Liszt went to Rome, where he took religious orders (acquiring the title Abbé). He also produced a number of large choral works, including the oratorios *Die Legende der heiligen Elisabeth* ("The Legend of St. Elizabeth"), *Christus*, and the *Hungarian Coronation Mass*.

Liszt's piano compositions include his *Hungarian Rhapsodies* (probably his most famous works), three books of *Années de Pélérinage* ("Years of Pilgrimage"), three nocturnes called *Liebestraum*, two piano concertos, *Valse Impromptu, Valses Caprices*, twelve *Grandes Études de Paganini*, the *Mephisto Waltz* (originally for orchestra), and the terribly difficult *Études d'exécution transcendantes* ("Transcendental Etudes").

litany In the Roman Catholic rite, a solemn prayer to God, to the Virgin Mary, or to the saints, which is sung by the priest and answered by the congregation with *Kyrie eleison* ("Lord, have mercy") or a similar response. One such litany, the *Litaniae Lauretanae* ("Litanies of Loreto"), has been set to music by numerous composers, among them Lasso, Palestrina, Tallis, and Mozart. The Anglican Church uses a litany based on that of the Roman Catholic Church with an English text.

liturgical drama A dramatic presentation of a religious story, usually but not always based on the Bible and either wholly or partly sung, that was performed in conjunction with Roman Catholic services from the tenth to sixteenth centuries, and perhaps longer. The text was nearly always entirely in Latin, and the plays were performed by clerics in a church, usually with one or another Office (most often Matins, Lauds, or Vespers) or, occasionally, before a Mass. The earliest such dramas that survive, more or less complete with music, text, and performance directions, date from the tenth century. Most by far concern Christmas and Easter—that is, the birth, death, and resurrection of Jesus—but other Bible stories were also acted out, as were the miracles of the saints. Beginning as simple dialogues, liturgical drama evolved into fairly long plays performed with costumes and scenery. In the twelfth and thirteenth centuries the texts were increasingly revised into rhymed poems, and consequently both text and music strayed further and further from their original liturgical roots (Gregorian chant). However, the music, like chant, remained monophonic, that is, a series of solo songs. Among the most complex works, displaying a considerable variety of poetic forms and musical settings, is the Play of Daniel, which also was the first such drama to be revived by modern performers (in the mid-twentieth century). No new liturgical dramas appear to have been composed after the thirteenth century, when they were replaced by mystery and morality plays, written in the vernacular and performed outside the church, but the older liturgical dramas continued to be per-

formed until at least the sixteenth century.

lituus (lit'yōͦōəs), *pl.* **litui** (lit'yōͦō ī") *Latin.* **1** A trumpet used by the ancient Romans, who may have taken it over from the Etruscans. The lituus consisted of a long, slender tube of bronze with a cylindrical bore, ending in a turned-up bell. Pictures show that it was used as a military instrument, generally in pairs. **2** From the sixteenth to seventeenth centuries, the name was used for the crumhorn, which resembled it in shape, and also for the cornett. **3** In the eighteenth century, the name might be applied to any brass instrument, such as a tenor horn.

liuto (lē ōͦō'tô). The Italian word for LUTE.

live electronic music Music played and/or created on electronic equipment in live performance. John CAGE is generally considered the originator of such music, and his *Cartridge Music* (1960), in which several performers apply phonograph cartridges and contact microphones to various objects, the first such work. Live electronic music became important in the 1960s, when groups appeared using both conventional and electronic instruments, sometimes including synthesizers, with means of amplifying and otherwise altering and creating sounds. With the improvement and increased availability of various kinds of SYNTHESIZER the genre came into its own. An important element in live electronic music is improvisation. Although the composer usually specifies at least some elements of the composition, the performers respond to one another during performance, thereby introducing new, unforeseen elements. Also, they may employ electronic equipment that itself responds to the performance; for example, when certain pitches are sounded, a microcomputer may have been programmed to react to their order and timing by altering the synthesizer-generated harmonies, which in turn

may give new ideas to the improvising performers. Among the live electronic groups formed by serious musicians in the 1960s were AMM, in London, which included Cornelius Cardew; Musica Elettronica Viva, in Rome, with Frederic Rzewski and others; the Sonic Arts Union, formed by Robert Ashley, David Behrman, Alvin Lucier, and Gordon Mumma; and the German ensemble of Karlheinz Stockhausen. During the same period, rock groups like the Beatles, Grateful Dead and Pink Floyd also were using live electronic techniques. In succeeding decades the possibilities for modifying and projecting sound during performance were greatly expanded. Digital equipment became more sophisticated, and indeed the distinction between live electronic music and computer-generated sound diminished to the point where the former is no longer considered a separate genre. See also COMPUTER MUSIC.

loco (lô'kô) *Italian:* "place." A direction to resume playing at the normal pitch of the written notes, after a passage marked "ottava" or "8va" (indicating that the music should be played an octave higher or lower than written).

Locrian (lō'krē ən) **mode** See under CHURCH MODES.

Loesser (les'ûr), **Frank**, 1910–1969. An American composer, lyricist, and librettist who first became known for his lyrics for film songs in the 1930s and early 1940s. After World War II he increasingly wrote both music and words, producing the Broadway musical comedies *Where's Charley?* (1948), *Guys and Dolls* (1950; his greatest success), *The Most Happy Fella* (1956; his most ambitious score), and *How to Succeed in Business without Really Trying* (1961).

Loewe (lœ'və), **Karl** (kärl), 1796–1869. A German composer remembered mainly for his lieder and other art songs, some five hundred in all. Unlike the lieder of Schubert, his contemporary, Loewe's lieder are all

strophic in form, that is, made up of a series of stanzas for which the same melody is repeated. Among Loewe's most famous lieder, which he called *Balladen* ("ballads"), are "Edward" and "Der Erlkönig," the latter quite different from Schubert's setting of the same poem, composed about the same time. (See also BALLADE, def. 3.)

long appoggiatura See under APPOGGIATURA.

lontano (lôn tä'nô) *Italian.* A direction to perform softly, as though from a distance.

lo stesso tempo (lô stes'sô tem'pô) *Italian.* See ISTESSO TEMPO.

loud pedal Another term for DAMPER PEDAL. (See also under PIANO, def. 2.)

loure (loor) *French.* 1 A sixteenth- and seventeenth-century name for bagpipe, particularly the type used in the French province of Normandy. 2 A dance in 6/4 meter and slow to moderate tempo; an example is found in Bach's *French Suite* no. 5.

louré (loo rä') *French.* A direction to play a series of notes on the violin or other bowed stringed instruments slightly detached but without changing the direction of the bow. The effect, which may be indicated by a combination of a slur and dashes over or under the notes, sounds very much like PIQUÉ.

lullaby A cradle song used by mothers to lull a baby to sleep. Such songs are found among practically every people throughout the world. Lullabies generally have a steady, even rhythm, suitable for the rocking of a cradle, and are soft and gentle. Many lullabies are folk songs, passed on from generation to generation. Among well-known examples are the American "Hush, Little Baby," the German "Schlaf, Kindlein, Schlaf" (Sleep, Baby, Sleep), the English "Rock-a-bye Baby," the Welsh "All Through the Night," the Austrian "Schlafe, mein Prinzchen, Schlaf' Ein" (Go to sleep, little prince) ascribed to Mozart, and

Brahms's "Wiegenlied" (Lullaby). See also BERCEUSE. The term is also applied to instrumental works of a similar nature.

Lully (lv lē'), **Jean Baptiste** (zhäɴ bA tēst'), 1632–1687. An Italian-born composer who lived in France and is remembered principally for his ballets and as the founder of French opera. Born in Florence, Lully came to Paris at the age of fourteen and in 1653 was appointed court composer of instrumental music to King Louis XIV. He also became conductor of a chamber group, *Les petits violons* ("The little strings") formed from *Les Vingt-quatre Violons du Roi* ("The King's Twenty-four Violins"), which became famous for its beautiful and precise playing. Lully wrote music for the Royal Chapel, various marches and fanfares, and a number of ballets in which both he and the King danced. Together with the great dramatist Molière, Lully created a new form called **comédie-ballet**, which consisted of the acts of a play separated by ballet interludes on a related theme. Among their joint efforts were *Le Mariage forcé* ("The Forced Marriage") and *Le Bourgeois Gentilhomme* ("The Middle-Class Nobleman"). Lully then turned largely to writing opera, in 1672 receiving a patent (and therefore a monopoly) for setting up a Royal Academy of Music and an opera house. With his librettist, the poet Philippe Quinault (1635–1688), he created a new style of opera called **tragédie lyrique**. Unlike the traditional Italian opera of the time, which consisted primarily of arias to show off the singers' skills that were connected by short recitatives, the tragédie lyrique put great emphasis on the recitatives (which were carefully adapted to the rhythms and inflection of French speech), gave important parts to the chorus, and made considerable use of ballet. The subjects of Lully's operas, like those of French classical drama, were often drawn from Greek legend and history, as seen in the titles of such operas as

Alceste, Thesée ("Theseus"), *Psyche,* and *Acis et Galatée* ("Acis and Galatea"). Another of Lully's important innovations was the form of the overture used at the beginning of his operas. Examples of this so-called "French overture" (see under OVERTURE) were written by many other composers of the time, including Purcell, Bach, and Handel. In addition to his other achievements, Lully was one of the first important conductors in the history of music. In fact, his death was caused by an accident that occurred as he was conducting his Te Deum. While beating time with the sharp-ended long staff he used as a baton, Lully struck his foot and died of the resulting infection.

lunga (lōōn'gä) *Italian:* "long." Also, *lunga pausa* (lōōn'gä pou' sä). A direction written over or under a hold sign (see FERMATA), indicating that the pause should be longer than usual.

lunga pausa See LUNGA.

lur (lōōr). An ancient bronze trumpet of Denmark, northern Germany, Swe-

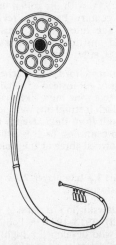

den, and Norway. About fifty examples thought to date from c. 1000 B.C. to 500 B.C. have been found by archaeologists. The lur had a twisted shape, and its bore was conical (cone-

shaped) along its entire length, ending in a flat disk. Lurs were always made in pairs turned in opposite directions, like a pair of animal tusks, which has led scholars to conclude that they may originally have been made from the tusks of a mammoth (a prehistoric elephant). Unlike other ancient brass instruments, such as the Roman lituus, the lur had a cup-shaped mouthpiece similar to that of the modern trombone.

lusingando (lōō"sēn gän'dô) *Italian.* A direction to perform in a persuasive, coaxing manner.

lustig (lōōs'tiKH) *German.* A direction to perform in a merry, cheerful manner.

lute A stringed instrument with a round body shaped like half a pear, a broad, flat neck, and a pegbox bent back at an angle from the top of the neck. At the height of its importance,

during the sixteenth century, the lute had six courses, one single and five double (that is, five pairs of strings tuned in unison), which were tuned either G' C F A d g or a tone higher.

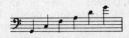

The lute was plucked with the bare fingers. Stopping positions were indicated by a number of frets (seven or more) of gut tied around the neck of the instrument. Lute music was written in TABLATURE, with letters or numbers indicating the frets of the courses to be played instead of showing the notes on a staff. After about 1600, when the lute began to be used less for solo music and song accompaniment and more for accompaniments in instrumental music, additional bass courses, each sounding a single low note, were sometimes added beside the fingerboard. The need for still stronger bass instruments led to the introduction, in the mid-seventeenth century, of larger lutes, such as the chitarrone and theorbo. Both had longer melody strings, usually single rather than in double courses, and extra bass strings carried on a second pegbox. The lute itself was also modified, being given a second pegbox to carry the extra bass strings but basically retaining most of its other features. In the second half of the seventeenth century numerous new tunings were used, the most popular being that of the school of French lutenists led by Denis Gaultier (c. 1600–1672).

The lute was brought to Europe from Asia in the late thirteenth century by the Arabs, whose name for it is al'ud. The early European lute was played with a plectrum and had four strings, which by the mid-fourteenth century were made into double courses. During the fifteenth century, a single course was added and lutenists began to pluck the strings with their fingers; by the end of the century a sixth double course had been added as well. The sixteenth century was the lute's golden age, in England, France, Germany, and Italy. (In Spain the VIHUELA, a kind of guitar whose tuning and music were virtually the same as the lute's, was preferred.) Dozens of lute books were published, containing dances and ricercars, fantasies and variations, as well as intabulations (arrangements for lute) of vocal music. Lute songs such as the AYRE were also popular, especially in England. Outstanding among the sixteenth-century **lutenists** (the word being used for both performers on and composers for the lute) were Francesco da Milano, Adrian Le Roy, Arnolt Schlick, Hans Judenkünig, Hans Newsidler, and John Dowland.

In the seventeenth century the lute began to be replaced: for solo and vocal accompaniments, the guitar became increasingly popular; for instrumental ensemble music, even the chitarrone and theorbo did not serve as well as the combination of harpsichord and cello. Only in France, with Gaultier, and in Germany, where Esajas Reusner (1636–1679) and a few others composed some lovely suites and sonatas for lute, did the instrument survive somewhat longer. By the end of the eighteenth century, the lute was virtually forgotten. However, one descendant of a small lute, the mandora, survived in the MANDOLIN, which became known throughout Europe during the late eighteenth century. As with the guitar, the twentieth century has seen revivals of both the lute and its music. (For related instruments, see BALALAIKA; PANDORA; PYIBA; TANBUR.)

lute-harpsichord A harpsichord with strings of gut instead of metal, which produce a tone more like that of the lute. Such instruments were occasionally built from the sixteenth to eighteenth centuries; Bach is believed to have owned three at the time of his death.

lutenist 1 A lute player. **2** A composer of music for lute.

Lutoslawski (lo͞o to släf'skē), **Witold** (vē'tolt), 1913–1994. A Polish composer who developed a highly original style despite years of censorship under Poland's Communist regime. His Symphony no. 1 was banned as "formalist," and he had to turn to state-run film, radio and theater work to support himself. Lutoslawski's

early compositions, like his Concerto for Orchestra (1954), show the influence of Polish folk music. Later he adopted newer techniques: a more chromatic idiom in *Five Songs* (1957), and aleatory elements in *Venetian Games* (1961). In his Cello Concerto (1970), players must choose vastly different tempos and note durations, even within the same voice-part. His works display a keen ear for instrumental timbres and a fine command of form. They include four symphonies, concertos, chamber music, choral works, and songs.

luttuoso (lo͞ot″ to͞o ô′sô) *Italian.* A direction to perform in a sad, mournful manner.

Lydian (lid′ ē ən) **mode** The authentic mode beginning on F. See under CHURCH MODES.

lyra (lī′rə) *Greek.* 1 A stringed instrument of ancient Greece, similar to the kithara but with a bowl-shaped body, usually made of tortoiseshell. The lyra was held against the player's body, supported by the left hand, and the strings were plucked with a plectrum held in the right hand. 2 Another name for REBEC. 3 Another name for HURDY-GURDY.

lyra viol A small bass viol used from about 1600 to 1680, mainly in England, where viol consorts (ensembles made up of viols in different sizes) were quite popular. Music for the lyra viol was characterized by many full chords. Its strings were tuned in many different ways, and its music, like that for the lute, was written in TABLATURE.

lyre (lī°r). A large group of stringed instruments that have a body with two armlike extensions connected near one end by a crossbar, and strings that extend perpendicularly (straight up and down) from the crossbar to a tailpiece in the body. Lyres have been known for thousands of years among many different peo-

ples. Some African lyres have a skin-covered body against which the vibrating strings make a buzzing sound; in others this effect is avoided by raising the strings by means of a footed bridge. Some lyres—for example, the ancient Greek LYRA (def. 1)—have bowl-shaped bodies; others, like the KITHARA, have boxlike shapes. Some lyres are plucked (nearly always with a plectrum rather than with the fingers), and others, such as the CRWTH, are played with a bow. The number of strings varies widely, and usually their tension (and hence their pitch) can be adjusted by means of tuning rings or cloth bindings.

Lyres were played throughout northern Europe until the eleventh or twelfth century, and they are still used as folk instruments in Baltic countries (Finland, Estonia), in Asia (mainly Siberia), and East Africa. The accompanying illustration shows an African lyre.

lyric 1 A word meaning "songlike"—that is, melodic—and used in the title of such works as Grieg's *Lyric Pieces,* short, expressive instrumental works. 2 A term used to describe a voice with a light, sweet, flexible quality. 3 Usually *lyrics.* The TEXT of a song.

lyrics See LYRIC, def. 3.

lyric soprano See SOPRANO, def. 1.

M

m. 1 An abbreviation for MINOR. **2** An abbreviation for MAIN or MANO ("hand").

M. 1 An abbreviation for MAJOR. **2** An abbreviation for MEDIANT.

ma (mä) *Italian:* "but." A word used in such musical terms as *ma non troppo* ("but not too much").

MacDowell (mək dou'əl), **Edward,** 1860–1908. An American composer remembered principally for his short piano compositions in romantic style. Often inspired by nature, MacDowell was at his best in such short pieces as the collections *Woodland Sketches* (among them, "To a Wild Rose" and "To a Water Lily") and *Sea Pieces.* MacDowell also wrote many songs and a number of longer works, including two piano concertos, several symphonic poems, and two suites. Although his musical style is that of nineteenth-century European romanticism, MacDowell often depicted in his music the natural beauty of America (for example, in *New England Idyls*) and occasionally even used American Indian melodies (as in his Suite no. 2). In 1907 a summer colony for artists, composers, and writers, the MacDowell Colony, was established in his honor at his former summer home in Peterborough, New Hampshire.

Machaut (mA s͟ho͞'), **Guillaume de** (gē yŏm' də), c. 1300–1377. A French composer and poet who was the most important French musician of the ARS NOVA. Machaut traveled widely for a time, finally settling in Rheims, where he remained for the last forty years of his life, serving as canon of the cathedral. Most of Machaut's music was secular (nonreligious). He wrote songs, using the important forms of his time—ballade, rondeau, and virelai—as well as the earlier lai. He also wrote motets, which are notable for their isorhythmic features (the use of the same rhythmic pattern for successive portions or repetitions of a melody). His most important composition is a Mass, the first polyphonic setting of the entire Ordinary of the Mass known to have been written as a unit by one composer. Previously, polyphonic Masses consisted of sections contributed by various composers, often written over a long period of time. Machaut's *Notre Dame* Mass, one of the finest compositions that survive from this period, consists of four movements based on chants of the Ordinary and set like motets, with highly independent part-writing over a supporting isorhythmic structure (see MOTET), and two movements in the older CONDUCTUS style, that is, with note against note and all the parts largely in the same rhythm.

madrigal 1 In Italy in the first half of the fourteenth century, a type of poem usually set to music with two

voice-parts, the upper part being more elaborately ornamented than the lower and both singing the same text. The poem consists of two or three stanzas of three lines each and a two-line closing section called the RITORNELLO (def. 1). In the typical madrigal the same music is repeated for each stanza while the ritornello has its own music, usually in a different rhythm. The chief composers of this kind of madrigal were Giovanni da Cascia (or da Firenze), Jacopo da Bologna, and Gherardello da Firenze. 2 In the sixteenth century, a musical form of great importance in Italy and England. The text of the sixteenth-century madrigal is in free form and is often very fine poetry. The music is intended to enhance both the beauty and the meaning of the words, and it usually changes with the words throughout, rather than being repeated for each stanza. There may be any number of voice-parts, from three to six or more, all of equal importance. The voice-parts may move together in chords (chordal style) or follow one another in counterpoint (contrapuntal style); occasionally the counterpoint is imitative, with the different parts taking up the melody in turn. If there is instrumental accompaniment, it simply doubles a vocal part, although some authorities believe instruments may occasionally have been substituted for one or more voices.

The fact that the voice-parts in the sixteenth-century madrigal are equal in importance is a development of the Flemish school of composers. Indeed, the first important composers of madrigals were Flemish masters who worked in Italy and used Italian texts: chief among them were Philippe Verdelot, Jacob Arcadelt, and Adrian Willaert. Willaert's pupil, Cipriano de Rore, developed in his madrigals two features already found in his master's work: faithfulness of the music to the mood (though not necessarily the subject or action) of the text, and increasing use of chromaticism (notes foreign to the key;

see CHROMATIC NOTE). These two characteristics were carried still further in the second half of the sixteenth century, when nearly all madrigals were written in imitative counterpoint. Although these features are less evident in the beautiful madrigals of Orlando di Lasso, they are present in some of the 1,100 madrigals written by Philippe de Monte and even more so in those of Andrea Gabrieli. The madrigalists working in Italy in the last quarter of the sixteenth century—Luca Marenzio, Carlo Gesualdo, Giaches de Wert, and Claudio Monteverdi—were more intent on dramatic expressiveness. They often made use of WORD PAINTING, that is, making the music represent a specific object, thought, or feeling. Another common device used was eye music, that is, making the appearance of the music itself fit the meaning of the words, with black notes standing for dark thoughts (or words related to darkness) and white notes for light. Although madrigals originally were performed with only one singer for each voice-part, it had become common to have several singers for each part, and, from about 1575 on, the madrigal was often treated chorally, with numerous singers for each part. Another development at this time was the MADRIGAL COMEDY, a series of madrigals grouped into acts and scenes.

With Monteverdi, whose life and work bridge the Renaissance and the baroque, the madrigal underwent further changes, which can be traced, almost step by step, in the eight books of madrigals that he published from 1587 to 1619. The madrigals in the first three books are polyphonic, although the third contains some using a style resembling recitative (speechlike song, which became important in the early baroque opera). The fourth book continues this trend and also turns more to chordal writing (the voice-parts sounding together, in chords, rather than in the separate lines of counterpoint). In the fifth book each piece is

provided with an accompanying basso continuo (see CONTINUO), which became a characteristic feature of the baroque. The sixth book, while still containing some pieces in Renaissance style, clearly belongs to the baroque, which wholly claims the seventh and eighth books. The madrigal is now a song for one, two, or three voices, with continuo; by about 1630 it had become, in this new guise, the most important vocal form of the baroque, the CANTATA.

While the Italian madrigal was changing so drastically, the contrapuntal, unaccompanied madrigal was still being written, mainly in England. Italian madrigals had already appeared in England for several decades, and about 1580 they suddenly became very popular. Their texts were translated into English and new music was written for them. In 1588 *Musica Transalpina*, a large anthology of Italian madrigals translated into English, was published, spurring still more interest in the form. During the next forty years, numerous publications of English madrigals appeared, including fine works by Thomas Morley (the first English composer to use the name "madrigal" for his songs), Thomas Weelkes (c. 1575–1623), John Wilbye (1574–1638), and Orlando Gibbons (1583–1625). The English madrigal developed somewhat differently from the Italian; retaining the imitative contrapuntal style, it often used word painting but seldom employed chromaticism. Although the madrigal reached other countries, such as Spain and Germany, where Heinrich Schütz produced an outstanding collection (1611), it never became as important there. In the twentieth century, Paul Hindemith, with his great interest in older forms, wrote a number of madrigals to texts by Joseph Weinheber.

madrigal comedy A series of twelve or more secular madrigals and other vocal pieces grouped into acts and scenes with a loose plot. The madrigal comedy is important as a forerunner of opera, the most famous example being *L'Amfiparnaso* by Orazio Vecchi, published in 1597.

madrigalist A composer of madrigals (see MADRIGAL, def. 2).

maestoso (mī stô'sô) *Italian.* A direction to perform in a stately, dignified manner.

maestro (mī'strô) *Italian:* "master." An honorary title or form of address for distinguished musicians, composers, conductors, or teachers.

maestro di cappella (mī'strô dē käp pel'lä) *Italian.* In the seventeenth and eighteenth centuries, the musical director of a court or private orchestra or choir.

Magnificat (mäg nif'i kät) *Latin.* A setting of the Virgin Mary's hymn of praise from the Gospel of St. Luke ("My soul doth magnify the Lord"). In the Roman Catholic rite the Magnificat is sung at Vespers to one of eight special chants, and in the Anglican rite it is sung at Evening Prayer. Both the Latin and English versions have been set polyphonically (with several voice-parts, as opposed to the original single part) by numerous composers, among the earliest settings being those of Dufay, Dunstable, and Binchois (fourteenth century). During the Renaissance (1450–1600) it was customary to write music for only the even-numbered verses, leaving the odd-numbered verses in the original plainsong. Such settings were written by Obrecht, Lasso, Palestrina, and others. J. S. Bach's fine setting of the Magnificat is similar in form to some of his larger cantatas. More recent settings are those of Hovhaness (1959), Penderecki (1974), and Pärt (1989).

Mahler (mä' lər), **Gustav** (gŌŌs' täf), 1860–1911. An Austrian composer and conductor remembered chiefly for his beautiful songs and his nine massive symphonies. From the age of twenty Mahler worked as a conductor, mainly of opera, and eventually he was given the most important

musical post in his country, director and conductor of the Vienna Opera. Mahler's most important vocal works are four song cycles, which have orchestral accompaniments instead of the usual piano accompaniment: *Lieder eines fahrenden Gesellen* ("Songs of a Wayfarer"), *Des Knaben Wunderhorn* ("Youth's Magic Horn"), *Kindertotenlieder* ("Songs of the Death of Children"), and his masterpiece, *Das Lied von der Erde* ("The Song of the Earth"). Mahler expanded the form of the symphony in a number of ways. He often used an enormous number of instruments, usually individually rather than all together, to obtain a great variety of tone colors. The Symphony no. 8 ("Symphony of a Thousand") calls for a huge array of soloists, choruses, and orchestral instruments. Mahler's symphonies also tend to be long; several consist of five or six movements, and some of the movements themselves—for example, the first movement of Symphony no. 3— are among the longest ever written. Some of the movements are essentially songs with orchestra, and others include solo voice and choral sections to emphasize the expression of feelings. Other characteristic features of Mahler's style are the use of counterpoint, the use of contrasting melodies (sometimes at the same time), frequent modulation (changes of key) within a movement or composition, and alternation (sometimes mixture) of major and minor keys. Although his music is strictly tonal, it constructs and shifts tonal material in ways that to some extent foreshadow the atonal music of the twentieth century.

main (maN), *pl.* **mains** (maN) *French:* "hand." A word used in directions for keyboard music such as *main droite* ("right hand"), *main gauche* ("left hand"), *à deux mains* ("for two hands"), *à quatre mains* ("for four hands"). Abbreviated *m.*

major 1 One of the two modes upon which the basic scales of European and American music from about 1600 to 1900 are based, the other being

called MINOR. The major mode can be described as a specific pattern of half tones and whole tones that covers the interval of an octave. If W stands for whole tone and H stands for half tone, a major scale has the pattern W W H W W W H, for example, C major: C D E F G A B C. (In contrast, a minor scale has the pattern W H W W H W W.) The major mode has the

same interval structure as the Ionian mode (see CHURCH MODES), and it has come to be associated with happy or serene music, in contrast to the minor mode, which is associated with sad or troubled music. (These qualities are often reversed in actual music, certain pieces in the major mode being quite sad and certain others in the minor mode being quite gay.) Abbreviated *M.* **2** A term applied to the keys based on major scales (see KEY, def. 3).

major interval An interval derived from the major scale. A major interval is one half tone larger than the corresponding minor interval (see INTERVAL, def. 2).

major triad A triad having a major third above the root (see CHORD).

malagueña (mä lä gwe'nyä) *Spanish.* A Spanish dance, in triple meter (any meter in which there are three basic beats in a measure, such as 3/4 or 3/8), which is named for the town of Málaga. The malagueña is often sung to verses based on other popular texts. The music usually begins and ends on the dominant (the fifth note in a scale) of the minor key in which it is set. A number of malagueñas, though not all, repeat a particular pattern of harmonies, consisting of the triads based on the first, seventh, sixth, and fifth scale degrees (in A minor, for example, the triads on A, G#, F, E).

male alto See ALTO, def. 2.

malinconico (mä" lēn kô' nē kô")
Italian. A direction to perform in a
plaintive, melancholy manner.

mancando (män kän'dô) *Italian.* A
direction to perform more and more
softly, as though the music were fad-
ing away.

mandolin A stringed instrument that
resembles and is closely related to the
lute. The mandolin has a pear-shaped
body, a fretted neck, and four double
courses (pairs of strings) made of
steel, which are plucked with a plec-
trum. Its tuning is the same as that of
the violin. First built in the early eigh-
teenth century, the mandolin is
descended from the **mandora**, a
small sixteenth-century lute. The ver-
sion of mandolin best known today
originated in Naples. (Other Italian
cities—Genoa, Florence, Milan—had
mandolins of slightly different shape
and stringing.) In the eighteenth and
early nineteenth centuries composers
occasionally wrote works for man-
dolin: Vivaldi wrote concertos for one
and two mandolins, Handel and
Mozart scored for mandolin occasion-
ally, and Beethoven wrote four short
works for mandolin and piano. Later
the mandolin was called for by Verdi
in *Otello,* Mahler in *Das Lied von der
Erde* ("The Song of the Earth"),
Schoenberg in *Serenade,* op. 24, and
Stravinsky in *Agon.* Today it is chiefly
a folk instrument, both in Italy (espe-
cially in the south), and in the United
States, where, along with guitars and
banjos, it is used for country music.

mandora See under MANDOLIN.

Mannheim (män'hīm") **school** A
group of composers who, toward the
middle of the eighteenth century,
played an important role in the devel-
opment of the modern orchestra and
orchestration, as well as contributing
to the form of the classical sym-
phony. Located in the German town
of Mannheim and associated at one
time or another with the orchestra of
a powerful German nobleman, Karl
Theodor, Elector of Palatinate, the
chief members of the group were
Johann Stamitz (1717–1757), Ignaz
Holzbauer (1711–1783), Franz Xaver
Richter (1709–1789), Christian Can-
nabich (1731–1798), and Stamitz's
sons Karl (1745–1801) and Anton
(1754–1809). Beginning about the
time that Bach and Handel were writ-
ing their last works in the baroque
tradition, Stamitz began to establish a
new style of orchestral music and per-
formance. Instead of the dense coun-
terpoint of the baroque masters, the
music became transparent and largely
homophonic (with chords sounded
together), with the violins generally
carrying the melody. The other sec-
tions (woodwind, brass) also were
given distinct roles, and all the sec-
tions were balanced with respect to
volume (more of the soft-sounding
strings were added to balance the
louder woodwinds and still more
powerful brasses and percussion). The
figured bass accompaniment of the
baroque period (see CONTINUO) was
replaced by written-out parts for all
the instruments. For proper tonal bal-
ance and convenience, the seating
arrangement of the players was set-
tled, with the strings on the left and
right, the winds in the center, and the
conductor out in front. New elements
of contrast (fast and slow, loud and
soft) were introduced, which were
carried over into the classical sym-
phony and sonata. (See also CLASSIC;
PRECLASSIC.)

mano (mä'nô), *pl.* **mani** (mä'nē) *Ital-
ian:* "hand." A word used in direc-
tions for keyboard music, such as

mano destra ("right hand"), *mano sinistra* ("left hand"), *a due mani* ("for two hands"), and *a quattro mani* ("for four hands"). Abbreviated *m*.

manual A KEYBOARD played by the hands.

manual coupler See under COUPLER.

maqam (mä′käm), *pl.* **maqamat** (mä′kä mät″) *Arabic.* A system of modes and melody types — that is, sets of notes and melodic shapes — associated with specific moods, seasons, colors, etc. It governs Islamic music much as RAGA does Indian music and the CHURCH MODES governed medieval Western music.

maraca (mä rä′kä) *Spanish.* A rattle made from a dry gourd filled with seeds, which is nearly always played in pairs. When the maracas are shaken, the seeds rattle against the inside of the gourd and also rub against it, making a kind of hissing sound. Maracas were originally invented by South American Indians, and various versions of them are used throughout Latin America. The kind used in modern orchestras and dance bands is based on the Cuban variety. Some of the gourds have a natural stem which serves as a handle, but many are made with a piece of wood inserted into the gourd.

marc. Abbreviation for MARCATO.

marcando See MARCATO.

marcato (mär kä′ tô) *Italian.* Also, *marcando* (mär kän′ dô), German *markiert* (mär kērt′), French *marqué* (mʌr kä′). A direction to perform with emphasis or with definite accents. Often it is indicated by short dashes or carets over (or under) the notes. Also abbreviated *marc*.

march A composition written in simple, strongly marked rhythm and regular phrases, suitable for accompanying a marching group. Marches are nearly always in duple meter (usually 2/4 or 4/4 but occasionally 6/8). The music is most often in ternary (three-part) form, consisting of an opening section A, a middle section B, called a trio (frequently in the key of the subdominant, that is, a fourth higher than the key of section A), and a final section that repeats the material of section A. In more elaborate marches the A section may alternate with several trios (B, B_1, B_2, etc.) in various different keys.

Some marches, especially funeral marches, are in slow tempo. Others are in so-called quick time (moderately fast, in 2/4 or 6/8 meter), and still others are in double-quick time (very rapid, 6/8 meter).

Compositions in the form of a march—although not necessarily intended to serve as such—date back at least as far as the sixteenth century. They are found in English virginal (harpsichord) music, in baroque instrumental suites, and in piano sonatas by Beethoven and Chopin. Marches used to accompany processions in operas are found from Lully and Handel through Verdi and Wagner. Particularly well-known marches are the wedding marches of Mendelssohn (from his incidental music for *A Midsummer Night's Dream*) and Wagner (from the opera *Lohengrin*); Schubert's *Marches militaires;* Tchaikovsky's *Marche slave;* Elgar's *Pomp and Circumstance* marches; Berlioz's "Rákóczi" March; the funeral marches from Handel's *Saul*, Wagner's *Götterdämmerung*, and Beethoven's *Eroica* (Symphony no. 3); the festive march from Act II of Wagner's *Tannhäuser;* and the triumphal march from Verdi's *Aida*. The most famous composer of marches intended primarily for performance by a marching group was John Philip Sousa.

marching band See BAND, def. 6;

marcia (mär′chä). The Italian word for MARCH.

marcia, alla (äl″lä mär′chä) *Italian.* A direction to perform a piece or section as if it were a march.

mariachi (mä″rē ä′chē) *Spanish.* A Mexican instrumental ensemble that is used for folk music. It includes four principal stringed instruments—violin, guitar, harp, and bass guitar—in numbers ranging from one instrument of each kind to a full-scale band of as many as twenty musicians, and may include two or more trumpets.

Marian antiphon See under ANTIPHON.

marimba (mä rēm′bä) *Spanish.* A percussion instrument of Central America, probably brought there by slaves from Africa. The marimba is still used in Africa, chiefly in Angola and Zaire, and it is the national instrument of Guatemala, where it is made in many sizes. Similar in appearance to the xylophone, the marimba consists of a series of wooden slabs, with a gourd placed underneath each one to make the tone more resonant. It is played by striking the slabs with sticks. About 1900 a version of the marimba began to be used in Western orches-

tras. The orchestral marimba (shown in the accompanying illustration) has metal tube resonators instead of gourds and is mounted on legs. It has a range of four octaves from low C to high C. Prominent parts for marimba are found in Elliott Carter's *Triple Duo,* Messiaen's *Chronochromie,* Davies's *Ave Maris Stella,* Tippett's Fourth Symphony, and Sessions's *When Lilacs Last* and his later symphonies. Solo works for the instrument include Milhaud's Concerto for marimba, vibraphone and orchestra (1949); Henze's *Five Scenes from the Snow Country* (1978); Richard Rodney Bennett's *After Syrinx II* (1984); and Emma Lou Diemer's Marimba Concerto (1991).

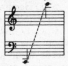

markiert *German.* See MARCATO.

marqué (мaʀ kā′) *French.* See MARCATO.

martelé (мaʀ tə lā′) *French.* In music for the violin and other bowed stringed instruments, a direction to

play with short strokes, releasing each stroke suddenly, usually using the point of the bow. This action produces a marked staccato. The effect is often indicated by black triangular signs placed over or under the notes.

martellato (mär″ tel lä′ tô) *Italian:* "hammered." 1 The Italian term for MARTELÉ. 2 In piano music, a direction to strike the keys heavily and stiffly, like a hammer.

Martinů (mär′ ti nōō″), **Bohuslav** (bô′hōō släf″), 1890–1959. A Bohemian composer whose music combines elements of his country's native folk tradition with international musical trends of his time. From 1923 to 1940 Martinů lived in Paris, where he studied with Albert Roussel, and then he spent eight years in the United States. His music is a blend of neoclassic and impressionist influences with Bohemian songs and dances. Of his dozen operas, *Comedy on a Bridge* is most often performed. Martinů's other works include two piano concertos; a Double Concerto for two string orchestras, piano, and timpani; ballets; several oratorios; six symphonies; and much chamber music.

Mascagni (mäs kä′ nyē), **Pietro** (pye′trô), 1863–1945. An Italian composer remembered principally for a one-act opera, *Cavalleria Rusticana* ("Rustic Chivalry"), which won first prize in a contest in 1889 and very quickly became part of the standard repertory of most opera companies. The opera is in verismo style, which aims at portraying life realistically; it is often performed on a double bill with Leoncavallo's *I Pagliacci,* which belongs to the same school.

masculine cadence See under CADENCE.

masculine ending See under CADENCE.

masque (mask). In sixteenth- and seventeenth-century England, an elaborate entertainment consisting of scenes about allegorical, mythological, or humorous subjects, and involving singing, dancing, poetry, and instrumental accompaniment. Chiefly an amusement for the nobility, these presentations often included ornate costumes and scenery. In the sixteenth century, music for masques was largely polyphonic, in the spirit of the madrigal; among the masque composers of this period are the poet Thomas Campion (1567–1620), Alfonso Ferrabasco II, and John Coperario (c.1580–1626). In the seventeenth century, the new monodic style characterized by melody with accompaniment was introduced by such composers as Nicholas Lanier (1588–1666), William Lawes (1602–1645), and Henry Lawes (1596–1662); the last-named wrote the music for a particularly famous masque, John Milton's *Comus,* in 1634. During the second half of the seventeenth century, the masque came to include more and more recitative, and soon it became almost indistinguishable from opera. Indeed, Blow's *Venus and Adonis* (c. 1685) is virtually a miniature opera. Among the last masque composers was Thomas Arne (1710–1778). He wrote new music for *Comus* in 1738, and the masque *Alfred* (1740), which includes "Rule Britannia," still a British national song.

Mass The central religious service of the Roman Catholic Church and one of the most important forms of sacred music. The Mass consists of two sections, the **Ordinary** and the **Proper.** The Ordinary is always the same, but the texts (and music) of the Proper vary from day to day, according to the church calendar. The Roman Catholic Church sets forth both the texts and the music for the Mass. The musical parts are in plainsong, or GREGORIAN CHANT. The portions assigned to the priest and other celebrants (those who help him celebrate the Mass) are recited in a special kind of monotone; the parts assigned to the choir are sung to special melodies. The texts are traditionally in Latin, although in the 1960s the Church began to allow the use of translations in the language of the country where the Mass was being performed. The music is notated in

neumes (see NEUME) on a four-line staff, a system that, like most of the music and words of the Mass, dates from the Middle Ages.

The most important musical sections of the Mass are those of the Ordinary. They are (in order of the service): (1) the Kyrie (*Kyrie eleison,* "Lord have mercy"; this is the only text in Greek rather than Latin); (2) the Gloria (*Gloria in excelsis Deo,* "Glory to God on high"); (3) the Credo ("I believe"); (4) the Sanctus (*Sanctus,* "Holy," with *Benedictus qui venit,* "Blessed is he who comes"); (5) the Agnus Dei ("Lamb of God"). The name Mass, in Latin *missa,* comes from a brief final section of the Ordinary, the *Ite, missa est,* which dismisses the congregation at the end of the service. (On some occasions it is replaced by an alternate dismissal, *Benedicamus Domino,* "Let us bless the Lord.") The musical sections of the Proper include the Introit, Gradual, Alleluia, Tract, Offertory, and Communion. The music and words of these sections are older than those of the Ordinary, but it is mainly the Ordinary that has attracted composers since about the thirteenth century. The only notable exception is the Requiem Mass.

Although there are many different melodies for each of the sections of the Proper and the Ordinary, in practice only about twenty are used for each. These are organized into sets or cycles, so that a single mode is used throughout a Mass (see CHURCH MODES for an explanation). As early as the eleventh century, composers began to use one or another of the prescribed melodies, which are all monophonic (have only one voice-part), as the basis for a polyphonic (many-voiced) composition. At first they wrote music for only one or another section. Not until about 1325 did a complete polyphonic Mass appear, the Mass of Tournai, which was made up of sections that were probably written by various composers over a span of almost fifty years. About 1360 the entire Ordinary was set to music by a single composer for the first time, when Guillaume de Machaut wrote his famous *Notre Dame* Mass, in four voice-parts. The Renaissance (1450–1600) was the great age of Mass composition, and as the settings became more elaborate, composers departed further and further from the original plainsong. During the fifteenth and sixteenth centuries they generally used a cantus firmus (fixed melody on which the other voice-parts are based) to unify the composition. Sometimes the cantus firmus came from the original Gregorian chant or a fragment of it, but more and more often the cantus firmus was a secular (nonreligious) tune, usually a popular song. Among the most famous melodies employed in this way was the one entitled *L'Homme armé* ("The Armed Man"), which was used by Dufay, Ockeghem, Obrecht, and many others. Subsequently motets and polyphonic songs were rewritten into Masses (see PARODY MASS).

Another development was the **organ Mass,** in which the choir, singing in plainsong, alternated with the organ, which repeated the chant in an elaborate polyphonic version. Sometimes instruments were introduced to reinforce parts of the music. In the mid-sixteenth century, however, the Church reacted. The complex interweaving of voices, the use of instruments, and the secular melodies were obscuring the words of its most solemn rite. The Council of Trent, which ended in 1563, at one point considered abolishing all polyphonic church music and permitting only the traditional plainsong. Although in the end the council did not go quite so far, it did outlaw some music, mainly tropes and sequences, and forbade the use of a secular cantus firmus. The rules were not too strictly enforced, however, and the greatest Mass composer of the late sixteenth century, Palestrina, wrote a *L'Homme armé* Mass as late as 1582.

In the seventeenth century, the Mass ceased to attract composers to so great an extent. In Italy the lucid

contrapuntal style of the sixteenth century continued to be used for a time, but by the end of the seventeenth century huge choirs were being used, with an enormous number of voice-parts. In Germany, much of which had become Protestant, Masses were still written, often for combinations of voices and instruments, and more and more in the styles of the baroque CANTATA. The greatest example of this type is Bach's Mass in B minor, which, however, was never performed complete in a church during Bach's lifetime. From about 1750 on, the Mass was treated more and more as a secular composition, notable examples for soloists, chorus, and orchestra being composed by Haydn, Mozart, Beethoven, Cherubini, Schubert, Liszt, Bruckner, Franck, Gounod, and Verdi. Among the twentieth-century composers of Masses are Villa-Lobos, Poulenc, Stravinsky, and Vaughan Williams. See also REQUIEM MASS.

Massenet (mAsᵊ nā′), **Jules** (zhyl), 1842–1912. A French composer who, although he wrote many kinds of music, is remembered chiefly for his operas. Notable for their graceful melodies and technically sound construction, they include *Werther, Thaïs, Le Jongleur de Notre Dame* ("The Juggler of Notre Dame") and his finest work, *Manon*.

mässig (mās′ᵢKH) *German:* "moderate." **1** A tempo indication corresponding to the Italian MODERATO. **2** Used with another tempo indication, the term means "moderately" or "somewhat," as in *mässig bewegt* ("moderately lively") or *mässig langsam* ("moderately slow").

Matins See under OFFICE.

Maxwell Davies, Peter See DAVIES.

mazurka (mə zŏŏr′ kə) *Polish.* A Polish dance, in 3/4 meter, with a strong accent on the second or third beat of the measure (which is normally weak), as shown in the accompanying example. The mazurka spread

throughout western Europe in the mid-eighteenth century, becoming immensely popular. It was danced by four, eight, or twelve couples. In the nineteenth century the rhythms of the mazurka attracted composers simply as an instrumental form. The most famous mazurkas are the fifty-two written by Chopin for piano; others were written by Tchaikovsky, Glinka, and Mussorgsky.

mbira See under SANSA.

m.d. An abbreviation for *main droite* (French) or *mano destra* (Italian), meaning "right hand" and used in keyboard music as a direction to play a note or passage with the right hand.

mean-tone temperament A system of tuning keyboard instruments that was widely used from about 1550 until about 1750, when it was gradually replaced by equal temperament. In contrast with equal temperament, in which all intervals except the octave are slightly mistuned but all major and minor keys are usable, mean-tone temperament provided some perfectly tuned intervals but permitted playing in only a restricted range of keys. (See also TEMPERAMENT.)

measure **1** Also, *bar.* A group of musical beats (units used to measure musical time) that are separated from one another by bar lines. In traditional Western music from about 1600 to 1900, such groups, of equal duration and with regularly recurring accents, appear over and over throughout a composition. The number of beats in a measure and their duration make up the meter of a composition. **2** In British terminology, another term for METER. **3** In fifteenth- and sixteenth-century England, a stately dance form in duple meter.

mechanical instruments Musical instruments that can produce music entirely without the aid of a performer. Most such instruments are

operated by a clockwork mechanism, as in the barrel organ or music box. Sometimes, as in the player piano, a roll of paper is perforated with holes corresponding to the notes to be played. This, in turn, makes the hammers strike appropriate keys.

medesimo tempo (me de' sē mô" tem'pô) *Italian.* See ISTESSO TEMPO.

mediant (mē'dē ənt). The third degree of a diatonic scale, that is, the third note in any major or minor scale (see SCALE DEGREES). In the key of C major the mediant is E, in the key of D major it is F-sharp, in the key of A minor it is C, etc. The mediant is so called because it is halfway between the first degree, or tonic (C in the key of C), and the fifth degree, or dominant. In analyzing the harmony of a composition, the Roman numeral III or the letter M is used to designate a triad built on the mediant.

medieval A term applied to music of the period from c. 450 to c. 1450. The principal kinds of music developed in Europe during this span of a thousand years were vocal, consisting of church music and secular (nonreligious) songs of various kinds. Until about the ninth century, all music was monophonic (written in one voice-part). The development of ORGANUM represents the earliest known attempts at polyphony (music in several voice-parts), but monophonic music continued to be written throughout the entire period. The chief kinds of monophonic music were, on the one hand, the chants of the various churches—Gregorian chant, Byzantine chant, etc.—and, on the other hand, the songs, at first in Latin and later in local languages, of minstrels and other entertainers— jongleurs, troubadours, trouvères, minnesingers, and later the Meistersinger. The early development of polyphony took place almost entirely in church music. Organum was cultivated by the school of St. Martial (tenth to twelfth centuries), which also made the traditional chant more

elaborate through the addition of tropes and sequences. During the twelfth and thirteenth centuries the center of musical activity shifted to Paris, where the Notre Dame school continued the development of organum as well as creating the polyphonic conductus, clausula, and motet (see ARS ANTIQUA). In the fourteenth century, with the ARS NOVA, polyphony appeared in secular music as well. The French wrote ballades, rondeaux, and virelais; the Italians preferred the madrigal, caccia, and ballata. Similar developments took place in England, but the close connections maintained with Continental culture, especially that of France, make it difficult to distinguish twelfth- and thirteenth-century English compositions. Most of what survives is sacred polyphony, the famous canon "Sumer is icumen in" being a rare exception. By the early fourteenth century English music did seem to sound different. The so-called **English descant** of this time was characterized by the use of similar rhythms in all the voices, often giving a chordal effect, the use of consonant harmonies that avoid dissonances on strong beats, and the employment of full triads. The leading English composers were Leonel Power and John DUNSTABLE.

Although vocal music predominated, there was some medieval instrumental music, presumably throughout the entire period. By the tenth century there were numerous instruments— stringed instruments, both plucked (harps, psalteries, lutes, and guitars) and bowed (viols and the rebec), percussion instruments (cymbals, bells, and drums), woodwinds (flageolets, flutes, panpipes, and shawms), brass instruments (horns and trumpets), as well as bagpipes and organs. Probably the earliest instrumental music was dance music; originally this music was also monophonic, but by the late twelfth century polyphonic dances were being composed. Theory and notation developed enormously during the course of the Middle Ages. The

NOTABLE MEDIEVAL MUSICIANS

Musician	Origin/Active in	Noted for
Adam de la Halle (c. 1245–c. 1287)	Northern France	Last of the trouvères; monophonic chansons; motets; oldest surviving polyphonic secular songs (rondeaux).
Bartolino de Padova (fl. c. 1370–1405)	Padua/northern Italy	Ballate and madrigals, mostly two-part, a few three-part.
Bernart de Ventadorn (c. 1140–1195)	France/Limousin, Toulouse, Dordogne, England (court of Eleanor of Aquitaine)	One of the greatest troubadours.
Johannes Ciconia (c. 1335–1411)	Liège/Avignon, Italy (especially Padua), Liège	Mass movements, motets (some isorhythmic), Italian ballate and madrigals, French virelais, treatise (De proportionibus musicae).
Franco of Cologne (fl. 1250–1280)	Cologne, Germany?	Formalized mensural notation in treatise Ars Cantus Mensurabilis (c. 1260).
Frauenlob (Heinrich of Meissen) (c. 1255–1318)	Germany/north and east, especially Mainz	Renowned minnesinger.
Giovanni da Cascia (da Firenze) (fl. c. 1340)	Italy/Padua, Verona, also Milan?	Two-part madrigals, three-part caccie.
Guido d'Arezzo (c. 997–c. 1050)*	Italy/Arezzo	Developed 4-line staff, solmization syllables; his Micrologus was first comprehensive treatise on musical practice.
Jacopo da Bologna (fl. c. 1350)	Italy/Florence, Verona, Milan	Two- and three-part madrigals, caccie, sacred songs.
Jacques de Liège (c. 1260–c. 1330)	Liège	Wrote influential 7-volume treatise, Speculum musicae; favored ars antiqua over ars nova.
Jehan de Lescurel [d. 1304] (Jehannot de l'Escurel)	France/Paris	Mostly monophonic ballades, rondeaux, virelais.
Francesco Landini (1325–1397)*	Italy/Florence, Venice	Ballate; also madrigals, caccie; renowned organist.
Leonin (fl. c. 1163–1190)*	France/Paris	First great Notre Dame school composer; two-part organa.
Guillaume de Machaut (c. 1300–1377)*	Northern France/Paris, Reims	Lais, motets, ballades, rondeaux, virelais; oldest surviving complete Mass by one composer.
Matteo da Perugia (died 1418)	Italy/Milan, Pavia, Bologna	Rondeaux, virelais, ballades, Mass movements.

Musician	Origin/Active in	Noted for
Johannes de Muris (Jehan de Murs) (c. 1295–1350)	France/Normandy, Paris	Wrote very influential treatise on mensural notation and musical proportions (*Ars nove musice*, c. 1320).
Neidhart von Reuenthal (c. 1185–after 1236)	Germany/Bavaria, Austria	Minnesinger; summer and winter songs, latter in Bar form.
Niccolò da Perugia (fl. 1360–1375)	Italy/Florence	Two-part ballate and madrigals, three-part caccie.
Notker Balbulus (c. 840–912)	Switzerland/St. Gall	Sequences.
Walter Odington (fl. 1298–1316)	England	Treatise (*Summa de Speculatione musicae*).
Oswald von Wolkenstein (c. 1377–1445)	Austria/South Tyrol	One of last minnesingers; monophonic and polyphonic songs.
Paolo Tenorista (Paolo da Firenze) (died c. 1419)	Italy/Florence, Rome	Two-part madrigals, two- and three-part ballate; treatise on counterpoint.
Perotin (fl. c. 1200)*	France/Paris	Successor of Leonin; three- and four-part organa and clausulae.
Pierre de la Croix (Petrus de Cruce) (fl. c. 1290)	France/Paris	Motets; introduced freer rhythms.
Leonel Power (c. 1370–c. 1445)	England/Canterbury	Paired Mass movements, cantus firmus Masses, motets.
Thibaut IV, Count of Champagne and King of Navarre (1201–1253)	France/Champagne, Navarre	Outstanding trouvère; chansons in all forms.
Philippe de Vitry (1291–1361)*	France/Champagne, Paris, Avignon	Helped establish mensural notation in treatise *Ars nova*; introduced isorhythmic motets.
Walther von der Vogelheide (c. 1170–1228)	Germany/Austria, Tyrol	Leading minnesinger; political and moralistic songs as well as love songs.
William IX, Count of Poitiers, Duke of Aquitaine (1071–1127)	Southern France	First known troubadour.
Wolfram von Eschenbach (fl. 1160–c. 1220)	Germany/Bavaria	Famous minnesinger.

*See separate article on this composer for more information.

church modes were set in order and expanded, and various systems of notation were devised, culminating with that of Guido d'Arezzo, which is essentially the system used today.

The medieval period was followed by the RENAISSANCE. See also BURGUNDIAN SCHOOL.

medley A group of familiar tunes played one after another, loosely linked together. Medleys generally are associated with popular music, as in a medley of "show tunes" assembled from various musical comedies. The overtures of numerous nineteenth-century operas are actually medleys, consisting of a group of arias and other pieces from the opera that is to follow, but arranged for instruments. Nearly all of the Gilbert and Sullivan operettas open with such a medley overture, which was popular also with such French opera composers as Daniel François Esprit Auber (1782–1871) and François Adrien Boïeldieu (1755–1834). See also PASTICCIO.

mehr (mer) *German:* "more." A word used in such musical terms as *mehr betont* ("more accented"), or *mehr bewegt* ("more lively").

Meistersinger (mī'stər zĭng"ər) *German:* "master singer." A master of one of the German guilds of poets and musicians that flourished in most major German towns from about 1450 to 1600. The Meistersinger were mostly middle-class tradespeople, and they strove to continue the great tradition of the MINNESINGERS, the aristocratic musicians of the late Middle Ages. To this end the Meistersinger organized schools, set up a series of tests and contests, and divided their members into different classes according to ability, the highest rank being *Meister,* or "master." The Meistersinger wrote both the words and music of their songs, generally in the same BAR FORM that had been used by the minnesingers. The music was monophonic (had only one voice-part) and in fairly free rhythm that tended to follow the rhythm of the words. Melismas (passages of notes sung to a single syllable) were often used.

The Meistersinger and their most famous composer, Hans Sachs (1494–1576), have been immortalized in Wagner's opera, *Die Meistersinger von Nürnberg* ("The Meistersinger of Nuremberg"). The real Hans Sachs wrote more than six thousand songs, some of which are very lovely. Today most Meistersinger songs, however, seem stilted and unoriginal. Thus, the main contribution of the Meistersinger appears to have been in spurring musical activity outside the church, among ordinary middle-class people.

melisma (mə liz'mə). A group of several notes or even a lengthy musical passage sung to one syllable of text. Usually the music is expressive, and does not consist merely of elaborate ornaments, as in a coloratura passage. Melismas are particularly important in Gregorian chant, in which a whole group of chants is classified as melismatic owing to the extensive use of them. (See also CLAUSULA; SYLLABIC.)

mellophone (mel'ə fōn"). Also, especially British, *tenor cor.* A brass instrument that is used as a substitute for the French horn in marching bands, school bands, and occasionally dance bands. The mellophone, which has three valves, looks much like a French horn but is much easier to play. The mellophone may be pitched in E-flat or in F and has a range of about two and one-half octaves. (The accompanying example shows the range of the E-flat mellophone.)

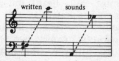

melodeon See under ACCORDION.

Melodica (mə lō'di kə). The trade name for a type of chromatic harmonica (see HARMONICA, def. 1) that

has a beaked mouthpiece like a recorder and a two-octave keyboard. The player blows into the mouthpiece while fingering the white keys with the right hand and the black keys with the left to produce the desired notes.

melodic inversion See INVERSION, def. 3.

melodic minor scale A minor scale having the sixth and seventh steps raised when ascending, but identical to those of the natural minor when descending. See also MINOR, def. 1.

melodic motion See MOTION, def. 1.

melodic sequence See under SEQUENCE.

mélodie (mā lô dē'). The French term for nineteenth- and twentieth-century ART SONG.

melodrama A musical form, generally used within an opera or other larger form, in which the protagonist of a drama tells the story (or part of it) during pauses of or over an orchestral accompaniment. Examples are found in Mozart's *The Abduction from the Seraglio*, Beethoven's *Fidelio* (in the dungeon scene), Weber's *Der Freischütz*, and elsewhere.

melody A group of musical tones sounded one after another, which generally have a characteristic rhythm and musical shape. The total melody makes sense to the ear; usually it can be remembered, at least in part. However, a melody is not precisely the same as a **tune**. A tune is a kind of melody that can readily be sung. In a composition for orchestra, for example, the tune is usually the melody that is most easily heard, but other melodies may be present as well.

A melody is a succession of pitches, and therefore it involves two principal factors: intervals (the distance between each pitch and the next) and duration (how long each pitch lasts, or is held). The former is often referred to as **melodic motion**, or *melodic movement,* since it describes the pattern of pitches—up, down, or continuing on the same pitch. (See also MOTION, def. 1.) The relative duration of the pitches produces a pattern of long-short, which is the basis of rhythm. Thus melody cannot be separated either from motion or from rhythm.

The way in which composers select musical tones in writing a melody has, over the centuries, been governed by different sets of rules (modes, scales, melody types). Among these are the Greek TETRACHORD, the medieval CHURCH MODES, the major and minor modes, and the various melody types found in non-Western music (see MELODY TYPE). The use of such rules has, in effect, trained the ears of listeners, so that, hearing one portion of a melody, they expect certain music to follow it. The medieval listener would expect to hear only the pitches of one of the church modes in a melody. Similarly, the listener of the eighteenth and nineteenth centuries might expect, after hearing a phrase ending on the fifth note of a scale, to hear a phrase ending on the first note of the scale. Another important factor influencing the composer's selection of tones is the range of the voice or instrument for which the melody is intended.

melody type A melodic formula, ranging in length from a short motif of a few notes to an entire melody, which is used as the basis for musical compositions. It differs from a mode, which simply sets forth a sequence of intervals (in Western music, half tones and whole tones), and from a scale (the notes of a mode in rising order of pitch), in that it is more specific: a melody type spells out actual sequences of tones, just as they are to appear in a piece, as well as particular beginnings and endings, ornaments, and other details. Melody types are found mostly in the music of ancient peoples—the Greeks, Hebrews, and others—and of Eastern peoples—the Arabs, Persians (Iranians), Indians, and others. For an example, see RAGA.

membranophone (mem brā' nə fōn"). Any musical INSTRUMENT in which sound is produced by the vibration of a stretched membrane, such as a thin piece of skin or parchment. Most membranophones are drums; however, this class of instruments also includes the mirlitons.

même (mem) *French:* "same." A word used in musical terms such as *à la même* ("at the same [tempo]").

Mendelssohn (men'dəl sōn"), **Felix** (fā'liks), 1809–1847. A German composer and conductor remembered mainly for his songlike melodies and his beautifully constructed compositions in a number of musical forms. Mendelssohn showed his great talent at an early age, giving his first piano recital at the age of nine and writing one of his most popular works, the overture to Shakespeare's *A Midsummer Night's Dream,* at seventeen. Among his other works, many of which are in the standard repertory today, are his last three symphonies (no. 3, the *Scotch;* no. 4, the *Italian;* and no. 5, the *Reformation*); the concert overtures *Die Hebriden* ("The Hebrides," or "Fingal's Cave") and *Meerestille und glückliche Fahrt* ("Calm Sea and Prosperous Voyage"); two piano concertos; a very fine Violin Concerto; the oratorios *St. Paul* and *Elijah;* eight books of *Lieder ohne Worte* ("Songs Without Words") and other works for piano (including the popular *Rondo capriccioso,* op. 14); dozens of songs; and numerous chamber works.

After some years of traveling, Mendelssohn at twenty-six became conductor of the famous Gewandhaus Orchestra in Leipzig, Germany, where a few years later he helped found a conservatory. Under his direction the orchestra became one of the best in Europe. Mendelssohn helped revive the music of Bach, which had been virtually forgotten since the master's death in 1750, conducting a performance of Bach's St. Matthew Passion in 1829.

Mendelssohn's sister, **Fanny Cäcilie Mendelssohn Hensel** (1805– 1847), received, with her brother, an excellent musical education at home and also became a composer. She published four books of songs, a collection of part songs, and *Lieder ohne Worte* ("Songs without Words") for piano, and is believed to have exercised considerable influence on her brother's compositions.

meno (me'nô) *Italian.* Less, as in **meno mosso** (me'nô môs'sô), less lively, a direction to perform somewhat more slowly.

Menotti (me nôt' tē), **Gian Carlo** (jän kär'lô), 1911– . An American composer known for his operas, which combine some of the traditions of the verismo movement with a dramatic approach that has been likened to Puccini's. Menotti wrote both the libretto and the music of his operas, conceiving plot and musical structure as a unified whole. His first opera was a one-act comedy, *Amelia Goes to the Ball.* Later works include *The Medium, The Consul, The Saint of Bleecker Street,* and *La Loca.* His most famous work is *Amahl and the Night Visitors,* a short Christmas opera written for television in 1951 and broadcast annually for many years thereafter, as well as being frequently performed by both amateur and professional groups. Menotti founded an annual festival of the arts, The Festival of Two Worlds, in Spoleto, Italy, in 1958, and its American offshoot, at Charleston, South Carolina, in 1976.

mensural notation A system of musical NOTATION used from about 1250 to about 1600, when it was gradually replaced by the simpler system used today. No bar lines were used in mensural notation. There were eight note values, named (in order of longest to shortest): *maxima, longa, brevis, semibrevis, minima, semiminima, fusa, semifusa.* Each note had either twice or three times the value of the next shorter note (for example, a brevis could be equal to either two or three

semibreves), the relationship to be applied being shown in the time signature (mensuration sign) of the composition. Other values were indicated by black or white notes, and by dots, and notes were linked by ligatures. In some cases, particularly in works by Burgundian and Flemish composers, one or more changes of time signature (mensural sign) occur during the course of a piece, and in these instances each new mensural sign indicates not only the meter of the new section but a tempo relationship as well. In a duple meter piece, for example, changes to sections with a triple meter indicate that each beat in the triple section must be faster, since the triple measure must equal the duple sections in duration. The system of mensural notation was established by Franco of Cologne, a thirteenth-century theorist, and was used to write down *Las Cantigas de Santa Maria,* a compilation of more than 400 songs (see under CANTIGA).

menuet (mœ nwā'). The French word for MINUET.

Menuett (men"o͞o et'). The German word for MINUET.

merengue (me ren' gā) *Spanish.* A fast dance in 2/4 meter, originating in the Dominican Republic in the nineteenth century and first coming to the United States in the 1950s. In the Dominican Republic, the music is still performed with accordion, scraper (güiro), drum, saxophone, and voice; the dance is performed with one leg held stiff. A Haitian version is called **meringue** (mœ raNg').

messa (mes'sä). The Italian word for MASS.

messa di voce (mes'sä dē vô'c̲he) *Italian.* A direction for a singer to gradually increase and then gradually decrease the volume on a single long-held note. This effect, which requires excellent breath control, was frequently used by bel canto singers of the eighteenth century.

messe 1 (mes). The French word for MASS. **2** *Messe* (mes'ə). The German word for MASS.

messe des morts (mes dā môr'). The French term for REQUIEM MASS.

Messiaen (mes yaN'), **Olivier** (ô lē vyā'), 1908–1992. A French composer who became known both as an influential teacher of numerous younger composers (including Boulez, Xenakis, and Stockhausen) and for his own innovative compositions. An excellent organist, Messiaen wrote organ pieces as well as works for piano, chamber groups, chorus, and orchestra. His works combine a number of interests and influences, among them a love for nature—in particular, his use of bird calls and other elements of birdsong, as in *Oiseaux exotiques* ("Exotic Birds") for orchestra and *Catalogue des Oiseaux* ("Catalog of Birds") for piano; his interest in elements of Hinduism, as in *Turangalîla,* a complex symphony in ten parts; and his mystical religious feeling and interest in medieval music, including Gregorian chant, evident in *Vingt Regards sur L'Enfant Jésus* for piano and *La Transfiguration de Notre Seigneur Jésus-Christ* for large chorus and orchestra. Messiaen's concern with different kinds of tone is apparent in his *Trois petites Liturgies de la Présence divine* ("Three Short Liturgies of the Divine Presence"), which is scored for soprano choir, celesta, vibraphone, maracas, Chinese cymbals, gongs, piano, ondes Martenot, and strings. *Des Canyons aux étoiles,* inspired by Utah's Bryce Canyon, similarly uses evocative and innovative instrumental combinations. Perhaps the most distinctive characteristic of Messiaen's music is his treatment of rhythm, which reflects an interest both in Oriental and medieval rhythms and in serial techniques (see SERIAL MUSIC), which sometimes he applies to rhythms as well as to pitches. His six-hour-long opera, *Saint-François d'Assise* (1983), includes all of his musical "trademarks." Although in his last years he concentrated increasingly on large structures, his best-known and most fre-

quently performed work is *Quatuor pour la fin du temps* ("Quartet for the End of Time"), written while in a Nazi prison camp for the instruments available there: violin, clarinet, cello, and piano.

mesto (mes'tô) *Italian*. Also, *mestoso* (me stô'sô). A direction to perform in a sad, melancholy manner.

mestoso See MESTO.

meter Also, British, *measure*. The arrangement of beats (units used to measure musical time) into measures, groups of equal size (time values) and with regularly recurring accents. From about 1600 to 1950, most European and American music has been organized into measures of equal duration, which are separated from one another by bar lines. The meter of a piece is indicated by the time signature, which tells how many beats there are in a measure and the value of the note that receives a beat. For example, the time signature 3/4 shows that there are three beats per measure (3), one for each quarter note (4). It should be noted that meter simply organizes musical time into measures. It is not identical with RHYTHM, which involves both meter and the patterns of time values within measures. In European and American music there are two principal kinds of meter, duple and triple. DUPLE METER has two basic beats to the measure, which may be subdivided into two, three, or more parts. TRIPLE METER has three basic beats to the measure, which may be subdivided into two, three, or more parts. In duple meters the accent tends to fall on every other beat, beginning with the first beat (the 1–2–3–4 of a march, for example; see ACCENT). In triple meters the accent tends to fall on the first of every three beats (the 1–2–3, 1–2–3 of a waltz). (See also COMPOUND METER; QUADRUPLE METER; QUINTUPLE METER; SIMPLE METER.)

metrical psalter See under PSALM.

metric modulation A shift from one meter to another, accomplished gradually by anticipating it with a change in rhythm, much as a pivot chord (see under MODULATION, def. 1) introduces a change of key. The change in meter is usually indicated by a new time signature and tempo indication, such as ♪ = 110 (110 eighth notes per minute; see METRONOME for explanation).

metronome (me'trǝ nōm"). A mechanical, electric, or electronic device for sounding or showing a steady beat at various speeds. There are a number of such devices. The oldest in common use was that first marketed in 1816 by Johannes Nepomuk Maelzel (1772–1838). Maelzel's metronome (the idea for which he may have stolen from a Dutch inventor) has a swinging bar driven by clockwork. A sharp "tick" is produced at each end of the swing, and the rate of these ticks is adjusted by moving a small weight up or down a graduated scale on the bar. The rate can be varied from as slow as 40 ticks per minute to as fast as 210 ticks per minute. The metronome is used by setting the weight at the desired rate. A piece or section marked, for example, ♩ = 125 should be played at the rate of 125 quarter notes per minute, which will be sounded out by setting the metronome at 125. Similarly, the indication "125 M.M." calls for a setting of 125 ticks per minute, M.M. standing for "Maelzel metronome." Today many musicians prefer an electronic metronome, in which the pulse is indicated by clicking sounds or a blinking light.

Meyerbeer (mī' ər ber"), **Giacomo** (jä' kô mô), 1791–1864. A German composer who is remembered chiefly for several grand operas produced in Paris relatively late in his life. The most famous of them are *Robert le Diable* ("Robert the Devil"), *Les Huguenots, Le Prophète,* and *L'Africaine.* All have librettos by the renowned French dramatist Eugène Scribe (1791–1861).

mezza voce (med'dzä vô'c̲h̲e) *Italian:* "half voice." A direction to sing at less than normal volume, that is, moderately softly.

mezzo (med'dzô) *Italian:* "half." **1** A shortening of MEZZO-SOPRANO. **2** Means "moderately" when combined with another word, such as MEZZO PIANO.

mezzo forte (med'dzô fôr'te) *Italian.* A direction to sing or play moderately loudly. It is usually abbreviated *mf.*

mezzo legato (med'dzô le gä'tô) *Italian.* A direction to perform smoothly but more lightly than full legato.

mezzo piano (med'dzô pyä'nô) *Italian.* A direction to sing or play moderately softly. It is usually abbreviated *mp.*

mezzo-soprano (med'dzô sô prä'nô) *Italian.* Also, *mezzo* (med'dzô). A woman's voice with a range and tone quality midway between those of an alto and a soprano. The usual mezzo-soprano range is from the A below middle C to the second F or G above middle C.

mezzo staccato (med'dzô stä kä'tô) *Italian.* Another term for PORTATO.

mf The abbreviation for MEZZO FORTE.

m.g. The abbreviation for *main gauche* ("left hand"), used in keyboard music as a direction to play a note or passage with the left hand.

mi (mē). In the system of naming the notes of the scale (see SOLMIZATION),

the third note of the scale (the others being *do, re, fa, sol, la,* and *ti*).

microtone (mī'krə tōn"). Any interval smaller than one half tone, which in traditional European and American music is the smallest interval used. Microtones are basic to many of the scales and modes of non-Western music, especially Asian music, and occur in Western popular and folk music—for example, the blue note of BLUES. Since about 1890 a number of serious composers have shown interest in intervals of various small sizes—quarter tones (half of a half tone), sixth tones (one-third of a half tone), sixteenth tones, etc. Notable among the composers who have experimented with microtones are Julián Carrillo of Mexico, Alois Hába of Czechoslovakia, Krzystof Penderecki of Poland, Hungarian-born György Ligeti, and Charles Ives, Harry Partch, and Easley Blackwood of the United States. Several systems of notating microtones have been devised, and some special instruments have been developed to perform microtonal music, notably several types of quarter-tone piano (see under QUARTER TONE). Among the more recent is the **zoomoozophone**, invented in 1977 by composer-performer Dean Drummond, a former pupil of Partch's. It is a mallet-played percussion instrument that consists of 129 suspended aluminum tubes tuned so as to produce 31 notes to the octave (instead of the conventional chromatic 12). The system of tuning used is JUST INTONATION (based on the harmonic series).

Middle Ages See MEDIEVAL.

middle C The pitch C that is located near the center of the piano keyboard and is written one line below the treble staff and one line above the bass staff.

MIDI Acronym for Musical Instrument Digital Interface. See under ELECTRONIC MUSIC.

Milán (mē län'), **Luis** (lo͞o ēs'), c. 1500–c. 1561. A Spanish composer and musician, remembered mainly for his collection *Libro de música vihuela de mano intitulado El Maestro* ("Book of Vihuela Music, entitled The Master"), published in 1536. In addition to VIHUELA pieces—pavanes, tientos, and fantasies—this collection contains a number of fine solo songs with vihuela accompaniment.

Milanese chant Another name for AMBROSIAN CHANT.

Milhaud (mē yō'), **Darius** (dA ryvs'), 1892–1974. A French composer who, after Ravel's death in 1937, was regarded as his country's outstanding living composer. Milhaud received a rigorous classical training at the Paris Conservatory under such composers as Charles-Marie Widor, Paul Dukas, and Vincent d'Indy. Later he became one of the group called Les Six (see SIX, LES). During World War II Milhaud lived and taught in the United States, and although he returned to Paris after the war he continued to visit America often. Milhaud's output is huge, including string quartets, symphonies, concertos, operas, and many short pieces, often arranged in suites. An outstanding feature of Milhaud's music is polytonality, that is, the use of different keys at the same time, which is sometimes employed for comic effect. It is also notable for its charming melodies and lively rhythms, the latter occasionally reflecting the influence of a two-year stay in Brazil when Milhaud was a young man. Outstanding among Milhaud's 450 or so works are *Les Choéphores*, which includes a rhythmic speaking chorus along with percussion; *Le Boeuf sur le toit* ("The Bull on the Roof"), based on popular tunes, mostly South American; the ballet *L'Homme et son désir* ("Man and His Desire"); *La Création du monde* ("The Creation of the World"), a ballet that portrays the world's creation through black folk legends and was one of the first serious compositions to use jazz; *Christophe Colomb* ("Christopher Columbus"), a huge symbolic opera in twenty-seven scenes; and a suite for two pianos, *Scaramouche,* whose last movement is in the form of a Brazilian samba.

militare, alla (äl' lä mē" lē tä' re) *Italian.* A direction to perform in a martial, military manner.

minim (min'əm). The British term for HALF NOTE.

minimalism Also, *minimalist music.* A style of music developed mainly in the United States in the early 1960s by La Monte Young and others, which is characterized by a steady pulsing beat, simple tonal structures, and a great deal of repetition with barely perceptible variations. So called because it pares music down to its most basic elements, constructing forms and conveying emotions with limited means, minimalist music frequently employs synthesizers and other electronic instruments. Often a minimalist work uses only a few carefully selected frequencies (pitches). The frequencies may consist of as little as two sine tones that drift very slightly and so vary only a little in volume, as in Young's *Drift Studies* (1964). (A **sine tone** is a sound with no harmonics, or overtones.) Another early minimalist composition, *In C* (1964) by Terry Riley, is a kind of improvisation for an ensemble of any number of players on any instrument capable of producing the required notes (approximately one and one-half octaves from middle C upward). The pulsed background is generated for each player by the others, all of whom individually decide how and when to choose from fifty-three short melodic motifs supplied in the score. In later works Riley focused on improvisation by an individual performer (himself) who augments his work by means of repetition, tape loops, tape delay systems, and multitracking

devices. Basically the music consists of a regular rhythmic pulse against which a limited number of short musical figures are played over and over, without thematic development of any kind. The minimalist approach, in part a reaction against the extreme openness of ALEATORY MUSIC, in which any event might become part of a composition, has its roots in non-Western musical tradition, particularly the Indian RAGA. As with Indian music, the listener must pay close attention in order to discern the very gradual changes that take place. The process of change itself engaged the attention of composer Steve REICH, who applied it to musical time. His *Piano Phase* for two pianos and *Violin Phase* for four violins, both composed in 1967, each use identical instruments that play the same melodic pattern over and over but gradually drift one or more beats out of phase with one another. In later works Reich applied this concept, called *phasing* or *phase music*, in such devices as gradually substituting beats for rests within a constantly repeating rhythmic cycle, or gradually altering timbre (tone color) while keeping rhythm and pitch constant. The best-known minimalist composer is Philip GLASS. Others who have worked in this style include John ADAMS, Louis Andriessen, Morton Feldman, Tom Johnson, Ivan Tcherepnin, and Michael Nyman.

In the 1990s several European composers, notably Arvo Pärt of Estonia, Giya Kancheli of Georgia, John Tavener of Great Britain, and Henryk Górecki of Poland, were called *mystical minimalists* for at least some of their works, which seemed to rebel against complexity and had liturgical elements. Using material from folk music, chants, and hymns, they created pure, soaring sound, building to grandeur through simple repetition. For example, in Górecki's Symphony no. 3, composed in 1976 but becoming well known only in the 1990s, a soprano sings chants over an endless string lament.

minnesinger (min' i sĩ͡ng" ər). A member of a group of poet-musicians, mostly of noble birth, that flourished in Germany from the twelfth to fourteenth centuries. Their songs, for which they wrote both words and music, are mostly about chivalric love (*Minne*), although some texts deal with political, moral, or satirical subjects, and have survived because of their lovely melodies as well as their historical importance. Many of them are in BAR FORM. The minnesingers combined the tradition of the French and Provençal minstrels (trouvères, troubadours) with native German and Austrian song. In a period when sacred music began to develop into complicated polyphony with several independent voice-parts, the minnesingers continued the tradition of monophonic (having a single voice-part) secular song. The early minnesingers preferred the Bar form for their songs; the later ones turned to the *Leich* (see under LAI). The most important early minnesingers were Walther von der Vogelweide and Neidthardt von Reuenthal. Also flourishing about 1200 were Tannhäuser and Wolfram von Eschenbach, who in 1207 took part in a contest that became the subject of Wagner's opera *Tannhäuser* (1845). They were followed by Heinrich von Meissen (also called Frauenlob). The late minnesingers include Hermann, Münch (Monk) of Salzburg and Oswald von Wolkenstein; both these men wrote some polyphonic songs as well as monophonic ones. (See the chart accompanying MEDIEVAL music for further detail.) The minnesinger tradition was carried on to some extent by the MEISTERSINGER.

minor 1 One of the two modes on which the basic scales of European and American music from about 1600 to 1900 are based, the other being called MAJOR. The minor mode can be described as a specific pattern of half tones and whole tones that covers the interval of an octave. If W stands for whole tone and H for half tone, a

minor scale has the pattern W H W W H W W, for example, A minor: A B C D E F G A. (In contrast a major scale has the pattern W W H W W W H.) In practice, this form of minor scale, called the **natural minor scale** or *pure minor scale,* is never used. Instead, two other forms are employed. One is the **harmonic minor scale,** in which the seventh note of the scale is raised by one half tone, producing an augmented second between the sixth and seventh steps (in A minor, A B C D E F G# A). The other is the **melodic minor scale,** in which both the sixth and seventh steps are raised when ascending (in A minor, A B C D E F# G# A), and both left the same as in the natural minor scale when descending (in A minor, A G♮ F♮ E D C B A). In all these scales, the total sum of half and whole tones is the same (12 half tones). Also see MAJOR, def. 1.

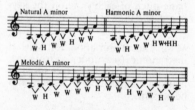

2 A term applied to keys based on the minor scale (see KEY, def. 3).

minor interval An interval derived from the minor scale. A minor interval is one half tone smaller than the corresponding major interval (see INTERVAL, def. 2).

minor second Another term for HALF TONE. (See also under INTERVAL, def. 2.)

minor triad A triad having a minor third above the root (see CHORD).

minstrel 1 A general name for various professional musical entertainers of the Middle Ages, among them the bards, troubadours, trouvères, minnesingers, and Meistersinger. These musicians performed songs, often their own compositions, and provided their own accompaniment (if any) on lute,

vielle, or some other instrument. **2** In the nineteenth century, a name used in the United States for a member of a troupe of entertainers, usually whites made up as blacks, that presented songs, dances, jokes, and comic skits.

minuet (min" yo͞o et'). A French dance, in moderate tempo and 3/4 meter, that was an important musical form for about two hundred years. The minuet, which probably originated as a country dance, was danced at the court of King Louis XIV from about 1650 on. The court composers, among them Lully, used it in their ballets and operas, and the German baroque composers frequently used it in their instrumental suites. In the classical period, the minuet, generally together with a contrasting TRIO—in the pattern, minuet–trio–minuet—became the standard third movement in the symphonies of Haydn and Mozart, who also used it in their sonatas and quartets. Their minuets tended to be somewhat faster and gayer than the graceful, somewhat stately dance of the baroque. Beethoven carried this trend even further, turning the minuet movement into a rapid, humorous scherzo (see SCHERZO, def. 1).

minuetto (mē"no͞o et'tô). The Italian word for MINUET.

mirliton (mer'li ton"). An instrument in which sounds are modified rather than being produced by the instrument itself. Mirlitons contain a thin membrane that vibrates and produces a buzzing noise when the sound of a voice or another instrument is directed against it. Typical examples are the kazoo, or the comb covered with tissue paper. Mirlitons were used in Europe from the sixteenth to the nineteenth centuries, but are generally regarded as toys today.

missa (mēs'sä). The Latin word for MASS.

missa brevis (mēs'sä brā'vis) *Latin:* "short Mass." **1** A setting of the Mass that is not too elaborate and hence takes a relatively short time to perform. **2** A musical setting of only the

Kyrie and Gloria sections of the Mass, which was customary in the early Lutheran church.

missa pro defunctis (mēs'sä prô de fōōnk'tis). The Latin term for REQUIEM MASS.

missa solemnis (mēs'sä sô lem'nis) *Latin:* "solemn Mass." A term for High Mass, that is, the entire Mass, performed with music except for the traditional spoken sections. See also MASS. Beethoven's Mass in D, op. 123, is entitled *Missa Solemnis*.

misterioso (mē" ster yô' sô) *Italian.* A direction to perform in a stealthy, mysterious manner.

misura, alla (äl'lä mē sōō'rä) *Italian.* Also, *misurata* (mē sōō rä'tä). A direction to perform in strict time.

misura, senza (sen'dsä mē sōō' rä). A direction to play with metric freedom, without strict regard to note values or regular accent.

misurata See under MISURA, ALLA.

mit (mit) *German:* "with." For musical terms beginning with *mit,* such as *mit Empfindung,* see under the next word (EMPFINDUNG).

mix See under EDITING.

mixed canon See under CANON.

mixed chorus A chorus that includes both men's and women's voices.

mixed media Also, *multi-media.* A term loosely used for a musical performance that combines acoustic and/or live electronic sound with taped material, special lighting effects, film, dance, gesture, or other means of artistic expression. Among the first to promote such performances was composer John Cage in the 1960s, when they were sometimes called "happenings." His *Musicircus* (1967), for example, involved numerous composers and performers, two jazz bands, light shows, refreshment stands, balloons, and the audience. Iannis Xenakis created works of tape sound and laser light, and a work

by composer Pierre Henry, light artist Nicolas Schöffer, and choreographer Alwin Nikolais, *Kyldex I* (1973), combines electronic music, light show, and abstract dance. Even more complex was *The Cave* (1993), by composer Steve Reich and video artist Beryl Korot, which combined computer technology synchronizing live musicians, digitally sampled speech, and multichannel video. The genre of PERFORMANCE ART usually involves mixed media. See also ELECTRONIC MUSIC.

mixed voices Men's and women's voices (as opposed to men's voices or women's voices alone, termed EQUAL VOICES).

Mixolydian (mik" sə lid' ē ən) mode The authentic mode beginning on G. See under CHURCH MODES.

mixture stop An organ stop that consists of several rows of pipes tuned to various harmonics (overtones) of the basic pitch of each note on the keyboard, and used to add richness to the tone. See also under ORGAN.

M.M. The abbreviation for Maelzel metronome (see under METRONOME), used to designate the exact speed at which a composition or section is to be performed.

mobile form A type of ALEATORY composition in which sections of the music are performed in any order the performer(s) select. The technique attracted a number of composers in the 1950s and 1960s, notably Boulez, Stockhausen, and Berio.

mode A pattern of pitches within the octave that makes up the basic melodic material of a composition. A sequence of these tones in ascending order of pitch (from lowest pitch to highest) is called a SCALE. In European and American music a mode is simply a sequence of half tones and whole tones; in music where intervals smaller than the half tone are commonly used, a mode involves such microtones as well. Related to modes but generally more specific are melody types (see MELODY TYPE).

From the seventeenth through the nineteenth centuries, two modes have dominated Western music, the MAJOR and the MINOR, which are distinguished principally by the number of half tones between the first and third notes of their scales. Prior to that, the eight CHURCH MODES governed melodic material. In practice, the terms **mode** and **modal** often still refer to these medieval modes, as well as to non-Western modes and melody types, all of which differ from one another in the arrangement of half tones and whole tones in their scales. See also RHYTHMIC MODES.

moderato (mô"de rä′tô) *Italian.* A direction to perform at a moderate tempo, neither fast nor slow, ranging from about 108 to 120 quarter notes per minute.

modern music See TWENTIETH-CENTURY MUSIC.

modulation 1 Changing from one key to another within a composition or a section of a composition. If the change is temporary, the key signature does not change, the notes foreign to the key being indicated by accidentals (sharps, flats, natural signs). If the change is for a relatively long period of time, a new key signature usually is given. The key signature is more likely to be changed when the change is to a remote or distantly related key than when it is to a closely related key (see under KEY, def. 3). Naturally, modulation is possible only in music that is written in one key or another. Therefore the processes of making key changes smoothly are found mainly in music of the seventeenth to nineteenth centuries, which involves tonality and follows the rules of classical HARMONY. There are many ways of effecting modulation. Most, however, involve the use of one or more chords that belong to both keys but have a different harmonic function in each, a so-called **pivot chord.** For example, G–B–D is the tonic triad in the key of G major and the dominant triad in the key of C major. Thus, this chord may be used to shift the tonal center from G to C or vice versa. Modulation is basic to the structure of such musical forms as the FUGUE and SONATA FORM. Also see METRIC MODULATION. **2** The process of altering some aspect of a sound signal by electronic means, usually in a repeating, continuous fashion. **Amplitude modulation** alters the amplitude (loudness) of a signal, which is accomplished by controlling a voltage-controlled OSCILLATOR with a second oscillator. **Frequency modulation** involves using the output of one oscillator to control the frequency (pitch) of a second, voltage-controlled oscillator. **Ring modulation** combines two signals (sounds) to produce an output containing only the sum and difference of their frequencies. **Pulse modulation** alters the pulse, the rhythmic regularity, of a sound, changing the length of individual pulses. **Phase modulation** superimposes a signal (sound) upon itself after a short but continually changing time delay, so that, in effect, sounds gradually move out of synchronization with one another.

moll (môl). The German word for MINOR; thus C-moll means C minor.

molto (môl′tô) *Italian:* "much, very." A word used in such musical terms as *allegro molto* ("very fast").

monochord (mon′ə kord). An ancient instrument that consists of a single gut or metal string that is stretched over a wooden soundbox. A small movable bridge, consisting of a block of wood placed between the string and the upper surface of the sound-box, was used to divide the string in two at various points (at one-half its length, one-fourth, etc.). The monochord was invented by the Greeks more than 2,500 years ago and was used by them to define and demonstrate various musical intervals and the relationships among them. It was used for the same purpose in the Middle Ages, when it sometimes was

employed in the performance of music as well. In the later Middle Ages, monochords were made with several strings and eventually the instrument was provided with a key action, thus transforming it into the clavichord.

monodic (mə nod' ik). **1** Concerning MONODY. **2** Concerning MONOPHONY; however, the term MONOPHONIC is preferable in this sense.

monodrama · A dramatic musical work involving one performer, in effect a spoken narrative with musical accompaniment. Examples include Schoenberg's one-act opera *Erwartung* (1909) and Peter Lieberson's *King Gesar* (1993).

monody (mon'ə dē). **1** Music consisting of a single voice-part with a chordal accompaniment provided by a lute or some other instrument (see CONTINUO). The term is used particularly for a style of music developed in Italy about 1600 both for separate songs and for songs within operas. These works are highly expressive and dramatic, clearly reflecting every nuance of the texts to which they are set. As exemplified in Caccini's collection *Le nuove musiche* ("The New Music"), first published in 1601, monody was developed as a reaction against the complex polyphony of the sixteenth-century madrigal. However, it had its roots in other sixteenth-century music, specifically, in the songs with lute or vihuela accompaniment written by Arnolt Schlick (c. 1460–1517), Luis Milán (c. 1500–1561), and others. **2** Occasionally, the term is used for music with one voice-part (either for one performer or for an ensemble performing in unison); to avoid confusion, however, such music is better called MONOPHONY.

monophonic (mon"ə fon' ik). **1** Concerning MONOPHONY. **2** Recorded for reproduction over only one speaker (as opposed to STEREOPHONIC).

monophony (mə nof'ə nē). Music consisting of a single voice-part, for either one performer or an ensemble performing in unison without accompaniment of any kind. Monophonic vocal music has existed since ancient times. Byzantine, Jewish, and Gregorian chant all are monophonic. The songs of the medieval minstrels (troubadours, trouvères, minnesingers, Meistersinger), and various medieval hymns (the Italian *laude,* German *Geisslerlieder,* Spanish *cantigas*) are also largely monophonic. In some instances, however, it is not actually known whether medieval songs are strictly monophonic or whether they had an improvised chordal self-accompaniment like that supplied by the modern folk singer on a guitar or banjo.

monotone (mon' ə tōn"). **1** The practice of singing a series of words on a single pitch. This type of performance is used in certain parts of numerous religious services. Portions of a text are recited on a single pitch, usually with inflections (a small number of rising or descending pitches) at certain points, as at the beginning and end of phrases. See also PSALM TONE. **2** A person who either cannot distinguish different pitches or who cannot accurately reproduce a melody, singing it on one or only a few pitches.

Monteverdi (môn"te ver'dē), **Claudio** (klou'dyô), 1567–1643. An Italian composer who is remembered for his fine madrigals, for helping to establish the new monodic style that replaced Renaissance polyphony, and for being the first important composer of operas. Monteverdi began his musical career as a choirboy. By the age of twenty-five he had already published a collection of three-part songs and the first three of his eight books of madrigals. Although he was a master of the Renaissance style of polyphony, Monteverdi turned increasingly to monody, in which one voice-part supported by a chordal accompaniment was used to give intense dramatic expression to the words. The change can be seen in Monteverdi's madrigal writing (see

MADRIGAL, def. 2), and in his first great opera, *L'Orfeo* ("Orpheus"), composed in 1607, in which the music genuinely contributes to the drama. His next opera, *L'Arianna* ("Ariadne"), composed the following year, has been lost except for a single aria, the famous "Ariadne's Lament," which is a poignant expression of the heroine's grief. In 1612 Monteverdi was named music director at St. Mark's Cathedral in Venice, where he remained until his death. During this thirty-year period Monteverdi wrote a great deal of church music—Masses, motets, Magnificats, and other works —largely in the new baroque style, that is, consisting of a series of arias, recitatives, and choruses, nearly always with a basso continuo accompaniment (see CONTINUO). At the same time, he continued to write secular songs and stage works. Of the latter, the most important works that survived (many have been lost) are *Il Combattimento di Tancredi e Clorinda* ("The Battle of Tancred and Clorinda"), a long dramatic scene between the two main characters, with a narrator explaining the background and action; and two operas, *Il ritorno d'Ulisse in patria* ("Ulysses' Return to His Homeland") and *L'incoronazione di Poppea* ("The Coronation of Poppea"). Monteverdi's music is notable for expressive and melodious qualities, for the skillful use of instruments with voices, and for the employment of such new instrumental techniques as pizzicato and tremolo.

Moog (mōg). A kind of SYNTHESIZER.

Moore (mo͞or, môr), **Douglas**, 1893–1969. An American composer who, after a long career of composing and teaching, became famous with the production of his opera, *The Ballad of Baby Doe* (1956). Moore's music reflects his interest in American history and legend, American speech, and American literature. Of his other works, the best known are the operas *Giants in the Earth, Carrie Nation*, and *The Devil and Daniel Webster*.

Moravian music Music composed between about 1750 and 1900 by members (often clergy) of the Moravian Church in America. Between 1741 and 1766 the Moravians, a Protestant sect, established communities in Pennsylvania (Bethlehem) and North Carolina (Salem), and music played an important part in their frequent services, especially in the Lovefeast and the *Singstunde* ("Singing Hour"). At the former, a cantata made up of congregational hymns, choral anthems, sacred solo songs and other pieces was sung and played by soloists, one or two choirs, and the congregation, accompanied by an orchestra and organ. The Singstunde consisted entirely of hymns sung by the congregation accompanied by organ. Each community had a *Collegium Musicum*, or instrumental ensemble, which played both European symphonic and chamber music and new compositions by their members. In addition, there was a trombone choir, which played mostly four-part chorales at funerals and on festive occasions. The principal musical forms were anthems for chorus and a small instrumental ensemble, songs for solo voice and keyboard, and hymns. Outstanding Moravian composers were Christian Gregor (1723–1801), who wrote several hundred anthems, songs, and duets and compiled the German Moravian hymnal and chorale book; Johannes Herbst (1735–1812), composer of 180 anthems and 200 sacred songs, who assembled a huge manuscript library of choral music by both Moravian and non-Moravian composers; Johann Friedrich Peter (1746–1813), who produced both vocal music and string quintets (among the earliest surviving American chamber music); and John Antes (1740–1811), instrument builder as well as composer.

morbido (môr′bē dô) *Italian*. A direction to perform in a gentle, delicate manner.

morceau (môr sō′) *French*: "piece." A word used in such terms and titles as

morceau de piano ("piano composition"), *morceau d'ensemble* ("work for a group of singers or instruments"), or Satie's mocking title, *Trois Morceaux en forme de poire* ("Three Pieces in the Form of a Pear").

mordent (môr'dᵊnt). See example under ORNAMENTS.

morendo (mô ren'dô) *Italian.* A direction to perform more and more softly, as though the music were dying away.

Morley (môr'lē), **Thomas,** 1557–1602. An English composer who wrote madrigals, solo songs with lute accompaniment, instrumental music for viols and for virginals, church music, and the first important English treatise on musical composition. A pupil of William Byrd, Morley served as organist at St. Paul's Cathedral in London. Morley wrote some of the songs for Shakespeare's plays, and he introduced the Italian balletto to England (see under FA-LA). His *Plaine and Easie Introduction to Practicall Musicke,* which appeared in 1597, was intended as a textbook and today is one of the best sources of information about English music in the Renaissance period.

mormorando (môr" mô rän' dô) *Italian.* Also, *mormoroso* (môr"mô rô' sô). A direction to perform with a gentle, quiet, murmuring tone.

mormoroso See MORMORANDO.

Morton (môr't°n), **Ferdinand** ("Jelly Roll"), 1890–1941. An American jazz pianist and composer who claimed he had invented jazz in New Orleans in 1902. Although this claim is undoubtedly false, jazz having developed gradually and from a number of sources, Morton did help develop jazz styles. His most famous composition is "Jelly Roll Blues," which he first played in the early 1900s.

mosso (môs'sô) *Italian.* A direction to perform in fairly rapid, agitated tempo. The word is also used in such phrases as *meno mosso* ("less quickly"), *più mosso* ("faster"), *poco mosso* ("somewhat quickly").

motet (mō tet'). A kind of vocal composition that developed during the Middle Ages and remained important until about 1750, although its form varied considerably within this period. The motet originated in the thirteenth century, when composers began to add a text to the upper part of a CLAUSULA, which until then had been sung to only a few syllables. (The name "motet" comes from the French *mot,* meaning "word.") Like the clausula, the motet was sung by a group of singers without instrumental accompaniment, and it was also in strict rhythm in place of the free rhythm of Gregorian chant. The early motet's rhythm was based on set patterns, the so-called RHYTHMIC MODES. The earliest motets, dating from about 1220, had only two voice-parts. The lower, the tenor, sang the cantus firmus (fixed melody), usually taken from Gregorian chant and always with a Latin text. The upper part, called the **duplum,** had a text in either Latin or French that was not necessarily related to that of the tenor. Soon a third part, called **triplum,** was added above the duplum; it had either the same text as the duplum or, more often, a text of its own, thus making a total of three texts sung at the same time. In general, the motets with Latin texts dealt with sacred subjects and were intended for church use. Those with texts in French usually dealt with worldly subjects (love, war, etc.) and were used outside the church. Some motets used both Latin and French simultaneously in different voice-parts. Late in the thirteenth century MENSURAL NOTATION, which permitted more accurate writing down of rhythms, came into common use.

By the fourteenth century most motets had three voice-parts, consisting of a tenor that may have been played by an instrument rather than sung, above which were a duplum and triplum with different texts. When a fourth voice-part was added it was not a **quadruplum,** with its own text, but lay in the same general

range as the tenor, had no text, and was called a **contratenor**. During the fourteenth century composers began to apply the principle of **isorhythm** to the motet, that is, they used the same rhythmic pattern in different portions of a melody. Sometimes they varied this procedure by repeating the pattern with shorter note values. At first this device was applied only to the tenor, but later it was used for the upper parts as well. Another technique used increasingly was HOCKET, to clarify the structure and to create accents and climaxes. In addition, complicated kinds of variation began to be used for the melody, which, for example, might be turned upside down or even backward. Chief among the composers of these quite elaborate motets were Machaut, and, in the fifteenth century, Dunstable and Dufay. Although Dunstable and Dufay wrote complex isorhythmic motets, they also wrote some motets in what came to be the new style of the Renaissance, which used the same text in all the voice-parts. The Flemish masters of the Renaissance (1450–1600) all treated the motet in this way. The texts were always sacred and always in Latin, and imitation among the voice-parts became increasingly important. The use of a tenor cantus firmus taken from Gregorian chant persisted until the early sixteenth century, but thereafter it was replaced by original music. The number of voice-parts was increased to four or five, and later to six, eight, or even more. The pieces became longer, occasionally being divided into sections. Chief among the Flemish composers of motets are Josquin des Prez, Nicolas Gombert, and Orlando di Lasso. In addition, there were the Italian composers Andrea and Giovanni Gabrieli and Palestrina, and the English composers Thomas Tallis and William Byrd. By the mid-sixteenth century the motet had become the sacred counterpart of the secular madrigal, with its various voice-parts woven into a complex fabric of counterpoint (see MADRIGAL,

def. 2). In England, however, after the break between the English (Anglican) church and Rome, the motet was replaced by the ANTHEM.

With the reaction against Renaissance polyphony that marked the beginning of the baroque period (1600), the unaccompanied polyphonic motet gave way to yet another change in style. During the next 150 years, motets began to include solo voices, instrumental accompaniment, and even arias and recitatives of the type used in seventeenth- and eighteenth-century opera. In Italy particularly, motets for solo voices became popular, while in Germany the trend was more toward choral writing. Among the finest motets of this period are those by Schütz (in his *Psalmen Davids* and *Symphoniae sacrae*), which are composed in a wide variety of styles, and six splendid examples by Bach, some accompanied and others *a cappella* (unaccompanied), for one chorus or for two. Although the motet never regained its early importance after 1750, it has continued to attract some composers to the present day. Notable later motets were written by Mozart (especially lovely is his *Ave verum corpus*, K. 618), Mendelssohn (op. 23, op. 39, op. 69), Schumann (op. 93), Brahms (op. 29, op. 74, op. 110), as well as Gounod, Saint-Saëns, Franck, and d'Indy, and, in the twentieth century, Krenek and Vaughan Williams.

motif (mō tēf'). Also, *motive*. Another term for FIGURE.

motion 1 Also, *melodic motion*. The pattern created by the successive notes that make up a melody. This pattern may, for example, consist of a series of rising pitches (**ascending motion**) or falling pitches (**descending motion**). Such a rise or fall may precisely follow the successive pitches of the scale (**conjunct motion**) or it may involve leaps of larger intervals (**disjunct motion**). In the accompanying example, *A*, a portion of the Christmas carol "Joy to the World," shows descending conjunct motion,

and *B,* from "Londonderry Air," shows disjunct motion. **2** In music with more than one voice-part, the relationship between the melodies of any two parts. If they move away from one another in pitch (one up, the other down), they are said to be in **contrary motion.** If they move in the same direction, always remaining the same distance (interval) apart from one another, they are said to be in **parallel motion.** If one part moves up or down and the other remains on the same pitch, they are said to be in **oblique motion.** In the accompanying example, *C* shows contrary motion in a harmonization of "The First Noel," *D* shows parallel motion in a harmonization of "Deck the Halls," and *E* shows oblique motion in Mozart's motet, *Ave verum corpus,* K. 618.

motive (mō′tiv). Also, *motif.* Another term for FIGURE.

moto, con (kôn″ mô′tô) *Italian:* "with motion." A direction to play more rapidly. Used with another tempo mark, it means "slightly faster than," as in *andante con moto,* "slightly faster than andante."

moto perpetuo (mô′tô per pe′tōō ô) *Italian:* "perpetual motion." Also, Latin, *perpetuum mobile* (per pet′ōō

əm mō′bi le). A title sometimes used for pieces, usually technical studies, that feature a rapid, seemingly endless pattern of notes.

Moussorgsky See MUSSORGSKY.

mouth bow See under MUSICAL BOW.

mouth organ See HARMONICA, def. 1.

mouthpiece The portion of a wind instrument into which the player blows. The shape of the mouthpiece and the presence or absence of a reed determine the kind of tone that the instrument produces.

movable do (dō). See under DO.

movement A major section in a long composition, such as a Mass, suite, sonata, symphony, concerto, or string quartet. Usually such a section can stand alone but is related in some way to the rest of the work. It nearly always has its own key signature and tempo indication—in fact, the practice of dividing a work into different movements comes from the use of contrasting tempos and moods in sixteenth-century music—and in performance there is frequently (but not always) a brief pause between the movements of a composition. In instrumental music movements are referred to by their order (first, second movement, etc.), or their form (scherzo, minuet, etc.), or, occasionally, special titles. In vocal music they are named for their text (Gloria, Sanctus, etc.)

The earliest instrumental form cast in movements was the seventeenth-century suite, which consisted of a series of dances, often alternating fast and slow, but usually in the same key. The number of movements varied a great deal, from four or so in the early suites to as many as twelve or more in later ones. The sonatas, symphonies, concertos, and quartets of the eighteenth and nineteenth centuries had three, four, or occasionally five movements. In the latter half of the nineteenth century there was an increasing tendency to link the different movements of a composition more

closely together. In some instances this trend led to long compositions without any clear-cut divisions into movements, which are described as being "in one movement" (examples include Barber's Symphony no. 1 and Sibelius's Symphony no. 7).

movimento (mô"vē men'tô) *Italian:* "speed." A word used in such directions as *lo stesso movimento* ("at the same tempo"), *doppio movimento* ("twice as fast").

Mozart (mō'tsärt), **Wolfgang Amadeus** (vôlf' gäṅg ä" mä dā' ōōs), 1756–1791. An Austrian composer who, during his short lifetime, produced more than six hundred compositions—sonatas, symphonies, concertos, quartets, instrumental pieces, operas, Masses and other sacred works—many of which rank among the finest of their kind. Along with Haydn and Beethoven, Mozart is one of the principal composers in the CLASSIC style. His works are particularly noted for their lovely melodies, their lively rhythms, their outstanding dramatic qualities (particularly in the operas), and their display of beautiful form and technique. Although Mozart was influenced by many composers, among them Handel, Haydn, and Gluck, and was apparently able to mimic any style he chose, the best of his music is unmistakably his own.

A child prodigy, Mozart first studied music with his father, **Leopold Mozart** (1719–1787), a renowned violinist, composer, and theorist. By the age of six young Mozart was composing and giving concerts on the harpsichord and violin. After a three-year concert tour with his father and sister, Anna (called Nannerl), which took them to most of the major cities of Europe, Mozart returned to his native Salzburg in 1766. By then he had already written the first three of some forty-five symphonies. A few years later his father took him to Italy, where he received many honors. Back in Salzburg in 1771, Mozart entered the employ of the Archbishop, a job he held for the next

decade. During this period he traveled to Paris, Mannheim, and Munich, trying to find a better post, but without success. In 1781 he went to Vienna, where he remained for the rest of his life. Although he continued to be respected as a performer, Mozart was not taken too seriously as a composer. He never received adequate patronage and had to rely on teaching and subscription concerts to support himself and his family. Constant financial worries did not deter him from composing at an astounding rate. During his years in Vienna he wrote the greatest of his operas, *Le Nozze di Figaro* ("The Marriage of Figaro"), produced in 1786; *Don Giovanni*, in 1787; *Così fan tutte* ("Women Are Like That"), in 1790; and *Die Zauberflöte* ("The Magic Flute"), in 1791. A minor court appointment in Vienna led him to write dozens of dances, marches, divertimentos, and other short instrumental pieces. During this period he also wrote six string quartets dedicated to his good friend, Haydn; oddly enough, each of the two composers believed that he had learned the art of quartet writing from the other. During the last months of his life, already ill, he began the composition of a lovely Requiem Mass, which he began to regard as his own requiem, and he died before completing it (it was finished by his pupil, Franz Xaver Süssmayr, 1766–1803).

Mozart's hundreds of compositions, often undated, were arranged in chronological order in the thematic catalog compiled in 1862 by Ludwig Köchel, and Mozart's works are still identified by their Köchel numbers, abbreviated **K.** or **K.V.** Besides those already mentioned, Mozart's outstanding works include the symphonies no. 31 (*Paris*), no. 35 (*Haffner*), no. 36 (*Linz*), no. 38 (*Prague*), no. 40, and no. 41 (*Jupiter*); ten of his twenty-seven piano concertos (see the chart accompanying CONCERTO); five violin concertos; four horn concertos; concertos for clarinet, for bassoon, and for flute; sonatas for piano and for violin and

piano; numerous quartets and quintets for strings; a Horn Quintet; a Clarinet Quintet; a Quintet for piano and winds; numerous serenades and divertimentos, including the famous *Eine kleine Nachtmusik* ("A Little Night Music"); three of his eighteen Masses; the operas *Bastien et Bastienne, Idomeneo, Die Entführung aus dem Serail* ("The Abduction from the Seraglio"), and *La Clemenza di Tito* ("Titus's Clemency"); and many concert arias and solo songs.

mp An abbreviation for MEZZO PIANO.

mridanga (mri duṅg' gə) *Sanskrit.* A barrel-shaped Indian drum that has two heads, one much larger than the other. The heads are fastened to hoops and are tightened by leather thongs laced from one end of the drum to the other. This tightening is used to tune the heads; however, additional tuning is accomplished with the aid of a paste made from metal filings and cooked rice, which is applied to the heads. The instrument is played with the fingertips. The mridanga is widely used in southern India, and occasionally also in the north.

m.s. An abbreviation for *mano sinistra* ("left hand"), used in keyboard music as a direction to play a note or passage with the left hand.

multi-media Also, *multimedia*. See MIXED MEDIA.

multiphonics The technique of producing chords on a wind instrument, using a single fingering. The effect is often created by humming a pitch while blowing a different pitch, thereby creating a two-note chord. Pioneered by the Italian composer Bruno Bartolozzi, multiphonics has appealed to a number of modern composers, who usually indicate the fingerings in their scores. It also is used by jazz virtuosos, such as saxophonist John Coltrane.

munter (mo͝on'tər) *German.* A direction to perform in a gay, lively manner.

musette (mY zet') *French.* 1 A type of French bagpipe in which the wind is supplied by a bellows. The musette was very popular during the seventeenth and eighteenth centuries, and often was beautifully made, with ivory pipes and a bag of silk or velvet decorated with lace and embroidery. 2 A dancelike piece with long-held bass notes resembling the drones of a bagpipe. Examples appear in several eighteenth-century instrumental suites.

musica ficta (myo͞o' zi kə fik' tə, mo͞o' zi kə fik' tə) *Latin:* "false music." In medieval and Renaissance music, accidentals (sharps and flats) that were added to the written notes during a performance, according to the traditional practice of the time (which was known to the performers). This practice varied a good deal at different times and in different places, and was not always accurately described in the theoretical treatises that survive. Consequently modern editors have had to rely on instrumental tablatures (for lute and guitar) of the period, which did show all the accidentals, and similar guidelines in trying to determine the proper notation. The term "musica ficta" was first used by early medieval theorists for any notes that lay outside the gamut of medieval chant. Although notation had improved considerably by the Renaissance, the practice of adding accidentals during performance continued until the end of the sixteenth century.

musical Short for MUSICAL COMEDY.

musical bow A primitive musical instrument, consisting of a flexible stick and a string. The string is either attached to both ends of the stick, as in a hunting bow, or it is attached to one end of the stick and held taut in some other way (weighted down with stones, for example). The player taps the string with a stick, strokes it, or plucks it. The sound produced may be reinforced by placing a gourd under the bow, or by placing the bow over a hollow pit in the ground, or by hold-

ing the bow close to the player's mouth (**mouth bow**). In each case a resonance chamber (gourd, pit, mouth) reinforces the sound of the string. In the case of the mouth bow, different harmonics can be emphasized by changing the position of the mouth, moving the lips, tongue, etc., as when playing the Jew's harp.

Musical bows appear to have been among the earliest musical instruments devised by man. A painting on the wall of a cave in southern France, thought to date from 15,000 B.C., shows a bow being used in this fashion. Musical bows have been found among the Indians of both North and South America, in Central and South Africa, and in the Pacific islands.

musical comedy Also, *musical*. A form of popular stage entertainment that combines spoken dialogue with songs, choruses, and dances. The plot is nearly always less important than the musical numbers. Today musical comedy is essentially commercial— that is, its main object is to make money. Composers therefore tend to use styles of current popular music in order to please as large an audience as possible. Even so, the genre has spawned some music of high quality, and in the best such works, like Rodgers and Hammerstein's *Oklahoma* (1943) and Lerner and Loewe's *My Fair Lady* (1956), the story, characters and songs are interrelated and mutually supportive.

The musical comedy originated in the light operas or operettas popular in Europe during the late nineteenth century and introduced in America by Rudolf Friml and Sigmund Romberg, both of whom were born in Europe. Outstanding musical comedies have been composed by Kurt Weill, Cole Porter, Jerome Kern, George Gershwin, Irving Berlin, Richard Rodgers, Leonard Bernstein, Jerry Herman, Burton Lane, Frank Loesser, Frederick Loewe, and Stephen Sondheim. A few European composers have succeeded in this genre, notably Britain's Andrew Lloyd Webber (*Jesus Christ Superstar, Cats, The Phantom of the Opera*) and France's Alain Boublil and Claude-Michel Schoenberg (*Les Misérables*).

musical glasses See under GLASS HARMONICA.

music box A mechanical musical instrument that consists of tuned metal prongs plucked by pins on a rotating barrel. The barrel is made to turn by means of a clockwork. Most music boxes play only a single tune over and over until the clockwork runs down; however, larger, more complex music boxes can play several tunes one after another, have interchangeable barrels to permit playing different groups of selections, and may have drum and cymbal effects as well.

music drama 1 A term used for the later operas of Richard Wagner, who came to believe that the music and story of an opera are of equal importance and should develop together continuously rather than being broken up into arias, duets, choruses, etc. The term is applied to the operas Wagner wrote after *Lohengrin*, which was completed in 1848, the earlier works being closer to the traditional operatic form. **2** Any opera in which the same principles are applied, especially some of the operas of Richard Strauss, such as *Salome* and *Elektra*. See also MUSIC THEATER.

music hall A form of popular British stage entertainment, originating in the early nineteenth century as an outgrowth of saloon theaters added by tavernkeepers to attract customers. Not permitted by law to present dramatic plays, saloon theaters featured singers and comedians and often invited audience participation. By about 1900 the entertainment was quite separate from drinking establishments and was performed in theaters. It featured not only musicians but, sometimes, acrobats, ventriloquists, animal acts, and the like. The main musical forms of music hall

were chorus songs in which a soloist sang verses and led the audience in catchy choruses (a famous one was *Ta-Ra-Ra-Boom-De-Ay*), and character songs, where the singer tells a story in the first person and puts on the character of the protagonist (for example, losing his girl in *The Flying Trapeze* and *After the Ball*). The American counterpart, VAUDEVILLE (def. 3), lost its popularity much earlier than Britain's music hall, which survived well into the age of television.

musicology The scholarly study of music. The term includes almost every field of music except actual performance and composition, and some authorities include these two areas as well. Among the fields generally included are theory (the elements of music: harmony, counterpoint, rhythm, and notation), the history of music and musical instruments, music education (the ways in which music is and should be taught), and ethnomusicology (the music of different peoples and its relationship to their cultures), as well as aesthetics (what makes music beautiful), psychology (what the listener hears, and how and why one hears what one does). Most musicologists devote their careers to research in a particular area, such as the music of a certain period, or a particular musical form, or the music of a particular people. They usually combine teaching and writing with their research. Musicology is taught in graduate school, following a four-year college course that may or may not specialize in music.

music theater A form of staged musical production that combines elements of OPERA with other theatrical traditions. The term is generally used for works by composers from about 1960 on that involve singing, acting, and instrumental performance but do not tell a story that progresses from beginning to end as in conventional drama. Rather, they lean on such traditions as Japanese NOH drama, where stylized gesture and delivery convey as much meaning as the actual text.

Also, such works usually call for much smaller forces than a full-scale opera. Frequently the composers quote other music (their own or by other composers) to convey a particular idea; a number of them acknowledge their debt to Arnold Schoenberg's *Pierrot lunaire* (1912) by using the same instrumentation (flute, piccolo, clarinet, bass clarinet, violin, viola, cello, and piano). Notable examples include Henze's *Der Langwierige Weg in die Wohnung der Natascha Ungeheuer* ("The Wearisome Journey into the Apartment of Natascha Ungeheuer," 1971) for baritone and several instrumental ensembles, including a Pierrot group, a brass quintet, pop group, and solo percussionist and Hammond organist; Bussotti's *La passion selon Sade* ("Passion according to Sade," 1965–1966) for mezzo-soprano and instrumental ensemble; and numerous works by Davies, especially *Eight Songs for a Mad King* (1969), *Miss Donnithorne's Maggot* (1974), and *Missa super L'Homme armé* (1968, rev. 1971), all for soloist and small instrumental ensemble. Other composers closely associated with music theater include Harrison Birtwistle, György Ligeti, Luciano Berio, Henri Pousseur, Meredith Monk, Philip Glass, and Nicola LeFanu.

music therapy The use of music to treat physical and mental disorders. The methods vary, ranging from dancing, singing, and playing instruments to clapping or other kinds of percussion activity or simply listening. It is not understood exactly why such treatment is beneficial, but it has been known to help revive patients in coma, treat severely retarded children, and ameliorate such conditions as cerebral palsy.

musique concrète (MY zēk' kÔN kret') *French*. A kind of music based on real ("concrete") sounds—street noises, human voices, sirens, thunder, etc.— that are recorded, usually altered in some way (changed in loudness, played backward, etc.), and put together on a magnetic tape or other recording medium. In a sense, the

method is similar to that in the visual arts of making a collage. Musique concrète differs from other kinds of music in that it cannot be "performed" other than by simply playing the recording. Since the composer (maker of the recording) and the performer are one and the same, no musical score is needed. Strictly speaking, musique concrète differs from ELECTRONIC MUSIC in that it employs already existing sounds as its raw material, instead of relying on sounds created in the laboratory. In practice, however, taped natural sounds have usually been employed together with electronically produced sounds, voices, or musical instruments. Composers of musique concrète include Pierre Schaeffer (who first coined the term c. 1948), Pierre Henry, Varèse, Boulez, Messiaen, Marius Constant, Luc Ferrari, and François Bayle. Many feel that the main contribution of musique concrète has lain in admitting all kinds of sound to the realm of music, instead of restricting the composer to vocal and instrumental sounds of definite pitch. The sound track of some motion pictures is a version of musique concrète.

Mussorgsky (mōō sôr'skē), **Modest** (mo dest'), 1839–1881. Also, *Moussorgsky*. A Russian composer who is remembered as one of the Five (see FIVE, THE), a group of composers who wanted to found a truly Russian music, and as the creator of what many consider the masterpiece of Russian nationalist music, the opera *Boris Godunov.* Mussorgsky started his career as a professional army officer, but he resigned in 1859 to devote himself to music. Ten years later he wrote *Boris,* the only large-scale work he ever completed. In this opera, which is based on a tragedy by the great Russian poet Pushkin, Mussorgsky's gift for creating melodies that follow the natural inflections of the Russian language greatly enhances the powerful drama, which, unlike earlier Russian operas, does not follow the conventions of Italian opera. Mussorgsky's

other works include some outstanding songs (among them the beautiful song cycle *Songs and Dances of Death*), a set of piano pieces called *Pictures at an Exhibition* (later transcribed for orchestra by Ravel), the symphonic poem *A Night on Bald Mountain,* and several unfinished operas, among them *The Fair at Sorotchinsk,* completed by César Cui, and *Khovanshchina,* completed and orchestrated by Rimsky-Korsakov.

Mustel organ See under HARMONIUM.

muta (mōō'tä) *Italian:* "change." **1** A direction to wind-instrument players to change instruments, as from oboe to English horn, from flute to piccolo, or from B-flat clarinet to A clarinet. **2** A direction to timpanists to change the tuning of one or more of their drums, as in *muta la in si,* which instructs the timpanist to change the tuning of the drum originally tuned to A (*la* in Italian) to B (*si* in Italian). **3** A direction to brass-instrument players to change crooks so as to convert, for example, from French horn in F to french horn in E.

mutation stop An organ stop whose pipes are tuned to a harmonic of the basic pitch of each note on the keyboard. A **quint** stop, for example, produces the note an octave and a fifth above the note ordinarily produced by each key (when the key for middle C is played, it will sound instead the second G above middle C). Similarly, a **tierce** stop produces the note two octaves and a third above the note ordinarily produced by each key. These pitches are those of the second and fourth overtones of the notes ordinarily produced. Mutation stops are used only to modify the tone of some other stop tuned to the basic notes. See also HARMONIC SERIES; MIXTURE STOP; ORGAN.

mute Any device that muffles the sound of a musical instrument, making it softer and, usually, also changing the tone quality (and sometimes the pitch). Mutes are used in stringed instruments, brass instruments, and drums.

Instruments of the violin family (violin, viola, cello, and double bass) are muted by means of a pronged device, which is clamped over the bridge to produce a muffled, thin sound.

The first brass instruments for which mutes were devised were the trumpets, in which a pear-shaped block of wood was placed inside the bell. This kind of mute also raised the pitch of the instrument, so a crook had to be used to lower it again. Later, trumpet mutes, in the shape of cups or hollow cones, were used for horns, trombones, and tubas. Today, however, the French horn is often muted by hand (players put their hand inside the bell both to alter the tone and to correct the pitch of the instrument), a procedure also known as STOPPING. French-horn mutes of cardboard or metal that do not affect the pitch are also used occasionally.

Orchestral trombone mutes usually consist of cone-shaped pieces of cardboard and do not alter the pitch; tuba mutes come in various shapes. In addition, jazz musicians use many different kinds of mute in brass instruments to obtain a wide variety of special effects.

In earlier times several orchestral woodwind instruments (oboes, clarinets) were muted sometimes, but they rarely are today. An exception is the bassoon, which occasionally is muted with a piece of cloth or cloth-covered tube placed inside the bell.

Drums are muted by placing a cloth over the drumhead, a practice sometimes called muffling.

mystical minimalism See under MINIMALISM.

mystic chord See under SCRIABIN, ALEXANDER.

N

nachdrücklich (näкн' drʏk" liкн) *German.* A direction to perform with emphasis, in a strongly marked manner.

nachlassend (näкн'läs"ənt) *German.* A direction to perform more and more slowly.

Nachschlag (näкн'sнläk") *German:* "afterbeat." 1 A term applied to the pair of notes often added to end a TRILL. 2 One or more ornamental notes added after another note, which take their time value from that note. See also ORNAMENTS.

Nachtanz (näкн'tänts") *German:* "after-dance." Also, *Hupfauf* (hoopf' ouf), *Proportz* (prô pôrts'), *Proporz* (prô pôrts'). A name used for a variety of fast dances, each of which was used immediately following a slower dance. The slow dance was nearly always in duple meter (any meter in which there are two basic beats per measure, such as 2/2 or 2/4), and the Nachtanz was in triple meter (in which there are three basic beats per measure, such as 3/8 and 3/4). Pairing a slow dance with a rapid one was a common practice during the sixteenth and seventeenth centuries. Particularly popular combinations were the pavane (slow) and galliard (fast), passamezzo (slow) and saltarello (fast), and later, the allemande (slow) and courante (fast).

national anthem Any song adopted by a country as its own official song. Among the oldest national anthems is Great Britain's "God Save the King," which dates from 1744. Although the United States's "The Star-Spangled Banner" was written in 1814, it did not officially become the national anthem until Congress passed a law to that effect in 1931. The present national anthem of Germany is sung to a melody composed by Haydn, which was used until 1918 for the national anthem of Austria. Another famous anthem is France's Revolutionary song, "La Marseillaise," composed in 1792. Canada's national anthem is "O Canada," composed in 1879 by Calixa Lavallée.

nationalism A widespread movement of the nineteenth century that emphasized national musical characteristics, especially as found in a country's folk songs, dances, and legends. The movement originally was associated with the political nationalism of nineteenth-century Europe, particularly in such countries as Russia, Bohemia (now part of the Czech Republic), Norway, Finland, Hungary, Rumania, Spain, and England. The earliest important expression of such nationalism in music is a Russian opera, Glinka's *A Life for the Czar,* completed in 1836. A few decades later the group of composers known as the Five (see FIVE, THE) gave fresh

impetus to the Russian nationalist movement, and one of them, Mussorgsky, wrote what many consider its masterpiece, the opera *Boris Godunov*. Opera was a particularly popular form for nationalist expression, since it could combine both folklore or history in its plot and folk materials in its music; for example, Smetana's *The Bartered Bride* combines a plot based on an episode from Bohemian peasant life with folk dances and other elements of folk music. Grieg (in Norway), Dvořák (in Bohemia), and Sibelius (in Finland), on the other hand, composed mostly songs and instrumental works that employed the musical idioms of their native lands, and Albéniz, Granados, and de Falla similarly used Spanish dance rhythms in their works. Other composers associated with nationalism include Moravia's Janáček, Hungary's Bartók and Kodály, Rumania's Enesco, Poland's Szymanowski, Great Britain's Elgar and Vaughan Williams, Brazil's Villa-Lobos, Mexico's Chávez, the United States' Grofé, Ives, and Copland, and, to a lesser extent, Denmark's Niels Gade.

Although other nineteenth-century composers also used national material—Liszt in his *Hungarian Rhapsodies* and Chopin in his polonaises, for example—they did so less with the aim of creating a "national" music than simply for the purpose of creating music itself. The nationalist composers are distinguished from these others by their intention to create "national" music and their emphasis on "national" materials.

natural 1 A note that is neither raised by a sharp nor lowered by a flat. All the white keys of the piano represent natural notes. **2** The sign ♮, which serves to cancel any sharp or flat present in the key signature or appearing earlier in the same measure. **3** A term applied to a horn or trumpet having no slide, keys, or valves to alter its pitch. Such instruments can sound only the notes of a single harmonic series.

natural minor scale A scale in which the third, sixth, and seventh degrees are each one half tone lower than the corresponding degrees in the major scale. (See also MINOR, def. 1.)

natural tone Another term for OPEN TONE.

Neapolitan sixth See under SIXTH CHORD.

neck In such stringed instruments as violins, guitars, lutes, and banjos, the narrow portion between the instrument's head (top) and its body, to which the fingerboard is attached.

neighboring tone Also, *auxiliary tone, embellishment, returning tone*. A dissonant note one scale step above or below any of the notes of a chord that is preceded and followed by the note of the chord. For example, if the chord is G–C–E and the E moves to F or D and then returns, F and D are neighboring tones. Since F is higher than E, it would be termed the upper neighboring tone; since D is lower than E it would be termed the lower neighboring tone.

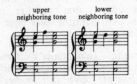

neoclassicism A name given to a twentieth-century revival of older musical forms and styles, particularly those of the baroque and classic periods (1600–1800). Partly in reaction against the highly personal, dramatic, emotional character of late nineteenth-century romanticism, certain composers turned to earlier music for its detachment, its clarity, its lack of nonmusical considerations (a "program" or "story"), and relatively strict closed forms. They replaced the huge nineteenth-century orchestra with the chamber orchestras of earlier periods. They turned away from the great masses of sound, the dramatic cli-

maxes, to a calm, measured, balanced counterpoint, in which each voice-part could be clearly heard. The precise manner in which this was accomplished varied from composer to composer. Few neoclassicists—perhaps none at all—copied old styles and forms literally. Rather, they took elements, such as the form of the fugue, and transformed them according to their own concepts of rhythm, tonality, etc.

The term "neoclassicism" was coined by Ferruccio Busoni (1866–1924), an Italian-German pianist and composer who was actually more modern in his ideas than in his compositions. By the time of Busoni's death neoclassicism interested many composers, and it remained a highly influential movement through the 1930s and 1940s. Many young composers learned its rudiments from Nadia Boulanger, who taught, among others, Aaron Copland, Roy Harris, and Elliott Carter. Most notable among composers of neoclassical works were Stravinsky, in such compositions as his Piano Concerto, *Oedipus Rex,* and *Symphony of Psalms,* and Hindemith, in the first version of his song cycle *Das Marienleben* ("The Life of Mary") and his many chamber works of the 1920s. Others were Albert Roussel in France, Alfredo Casella and Gian Francesco Malipiero in Italy, Max Reger in Germany, Walter Piston and Vittorio Rieti in America, and Sergey Prokofiev in Russia. Hindemith's work in particular illustrates the transformation of classical elements into a modern style. In many of his compositions he used the counterpoint of the baroque, but his harmonies are those of the twentieth century, and he used a complete range of chromaticism.

Few of the neoclassical composers confined themselves to neoclassical styles. For most, it was but one of a number of influences and styles present in their music, and in some instances, notably that of Stravinsky, it appeared for a limited time, being replaced (from about 1950 on) by newer developments.

neoromanticism Also, *new romanticism.* A term loosely applied to a style of composition dating from the late 1960s that is reminiscent of nineteenth-century romanticism in emphasizing emotional expressiveness rather than strictly rational formalism, in exploiting the sonorous possibilities of a full orchestra, in an interest in such large traditional forms as the symphony, and in using tonal melodies and consonant harmonies which both had been largely avoided in serial and postserial music (see SERIAL MUSIC). Among neoromantic composers were Nicholas Maw of Britain and two Americans, David Del Tredici, best known for his lush, lyrical *Alice in Wonderland* series (1968–1984), and George ROCHBERG, who in the mid-1960s abandoned the atonal serial idiom of earlier works and by the 1970s was producing tonal, melodic compositions such as his String Quartets nos. 4, 5, and 6.

Netherlands school A name used by some authorities for the composers of the BURGUNDIAN SCHOOL and the FLEMISH SCHOOL.

nettamente See NETTO.

netto (net'tô) *Italian.* Also, *nettamente* (net"tä men'te). A direction to perform in a neat, clear, distinct manner.

neume (noōm, nyoōm). A term for the signs that were used to write down the plainsong of Gregorian chant from the eighth to fourteenth centuries. These signs, written over the words of the various chants, indicated the direction of the melodies (up or down in pitch) and sometimes also the manner of performance. Some neumes stood for single pitches; others signified groups of two, three, or more pitches. During the six centuries when they were used, the shape and meaning of neumes changed considerably. The earliest neumatic manuscripts, dating from the ninth and tenth centuries, show neumes that look like little

curves and hooks and dashes, similar to the accent marks of Greek poetry, from which neumes are thought to derive (such marks were used not to show emphasis of syllables in the poetry but raising and lowering of the voice in reciting). During this early period, the neumes appear to have shown only whether a melody went up or down, and not the actual musical intervals. By the eleventh century, the neumes had changed somewhat in shape and, more important, it is thought that they indicated at least some intervals more specifically. They also seem to have indicated manner of performance. In the manuscripts of one monastery in southern Italy, the neumes appeared to indicate pitch by their placement, some being higher or lower than others. Eventually they were written on different lines, a practice that later gave rise to the musical staff. By the thirteenth century the neumes had become square, the shape in which they still appear today in the books containing the chants of the Roman Catholic Church.

What little is known about neumatic notation comes from manuscripts made and kept in various monasteries in Italy, France, Germany, Switzerland, and England. Different practices were in use in different places and periods. For example, square neumes were not adopted in Germany until about 1500, even though they had long been in use elsewhere. An area involving guess work is that of rhythm; it is not known in what way the neumes indicated time values (how long tones should be held), or if they did so at all. The accompanying illustration shows a portion of a chant written down in the twelfth century at the monastery of St. Gall, Switzerland.

new age music A style of popular instrumental music that blends elements of rock, jazz, and minimalist music into soft, gentle sounds. Using solo piano or guitar, small ensembles, synthesizers, or combined acoustic and electronic instruments, it is usually improvisational with little structure, slow tempos, simple harmonies, and much repetition.

New England school A term used for two groups of composers, the tunebook compilers of the late eighteenth and early nineteenth centuries (BILLINGS and others), and those working in Boston in the late nineteenth century, including John Knowles Paine, Horatio Parker, George Chadwick, and Amy BEACH.

new romanticism See NEOROMANTICISM.

new wave See under ROCK.

nicht (niкнt) *German:* "not." A word used in musical directions such as *nicht zu langsam* ("not too slow"), *nicht markiert* ("not accented"), *nicht schleppend* ("not dragging").

Nielsen (nēl'sən), **Carl,** 1865–1931. A Danish composer whose music is typical of nineteenth-century romanticism, although he made wider use of conflicting keys and chromatic harmonies. His works include six symphonies, the cantata *Hymnus amoris,* two operas, a clarinet concerto, numerous hymns and songs, and a large number of chamber compositions, including a fine Wind Quintet.

niente, a (ä nē en'te) *Italian:* "to nothing." A direction to perform more and more softly, as though the music were fading away.

ninth The interval of an octave plus a second (see INTERVAL, def. 2).

ninth chord See under CHORD.

noch einmal (nôK̲H'īn mäl") *German:* "once again." A direction to repeat once.

nocturne (nôk tʏrn') *French.* A piano composition that is fairly slow in tempo and has a songlike melody played by the right hand and a steady, soft accompaniment played by the left. First used by the Irish pianist-composer, John Field (1782–1837), the name and style were made famous by Chopin, who wrote nineteen nocturnes. Fauré wrote thirteen of them, also for piano, but later composers used the term more loosely; for example, Debussy's *Nocturnes* (1899) is a set of three pieces for women's chorus and orchestra.

noël (nō el') *French.* 1 A Christmas carol, especially one of French origin. Collections of such melodies have been published since the sixteenth century. 2 In the seventeenth century, an organ composition based on the tune of a Christmas carol and played during the holiday season.

noh (nō) *Japanese.* A very ancient type of Japanese play with music. Noh dramas are generally performed in costume and masks, with scenery. They feature reciting, solo and choral singing, and instrumental accompaniment. The subject and manner of performance of noh plays are guided by strict rules laid down centuries ago. Even the particular scale system to be used is prescribed, as are numerous rhythmic patterns maintained by the drums. Only one melody instrument is used, a kind of flute.

noise A random combination of many possible pitches (or frequencies; see under SOUND). In contrast to the regular vibrations of air that produce musical pitches, noise is produced by irregular vibrations. **White noise**, often used in early electronic compositions, resembles the hiss one hears when an FM radio is tuned between stations, and contains an even distribution of all frequencies. **Colored noise** is weighted, that is, some frequencies are emphasized and others reduced.

non (nôn) *Italian:* "not." A word used in musical terms such as *allegro ma non troppo* ("fast but not too fast").

nondiatonic Describing music that is not constructed on the basis of major or minor scales. Also see ATONALITY.

None See under OFFICE.

nonet (nō net'). 1 An ensemble of nine instruments or nine voices. In the late 1940s trumpeter Miles Davis formed a jazz nonet made up French horn, trumpet, trombone, tuba, alto and baritone saxophone, piano, bass, and drum. 2 A composition for nine instruments or nine voices. Since each singer or instrument has a separate part, the nonet is a form of chamber music; occasionally, however, one of the voice-parts will double another, perhaps in a different octave. — **instrumental nonet** A nonet for instruments. Examples include Schubert's *Eine kleine Trauermusik* ("A Short Funeral March") for nine wind instruments, Webern's *Concerto for Nine Instruments*, op. 24, Martinů's Grand Nonet, op. 31, and Copland's Nonet for strings.

nonharmonic tone In classical harmony, any note that is foreign to the harmony at the point where it appears. Such notes are used mainly to add interest to the melody, harmony, or both. Nonharmonic tones are classified according to the way in which they are related to the surrounding chords. However, scholars do not entirely agree in their termi-

nology; what one authority calls an "accented passing tone" may be called "cambiata" by another and "appoggiatura" by a third. (See also ANTICIPATION; APPOGGIATURA; CAMBIATA; NEIGHBORING TONE; SUSPENSION.)

nontonal A newer word for atonal; see ATONALITY.

noodling A slang term used by jazz musicians and others for the random playing of fast passages, scales, arpeggios, etc., usually for warming up.

North German school See under PRE-CLASSIC.

nota cambiata (nô'tä käm byä'tä) *Italian.* Another term for CAMBIATA.

notation Any system used for writing down music, showing the pitches to be sounded, how long each should be held in relation to the others, and sometimes also other aspects of musical tones. So long as music was an art that was passed down by rote from teacher to pupil, there was no need for notation. Similarly, in some modern music (electronic music, musique concrète), there is no need for symbols to stand for sounds; the sounds themselves, recorded on tape or disk, are sufficient. During the 1,500 or more years between these periods, from the time musicians began to perform music other than what they learned by ear until the mid-twentieth century, when composition and performance became a single process (at least for some composers), various systems of writing were devised. Beginning in the Renaissance with the development of complex polyphonic music where numerous voice-parts move independently of one another, the performers had to be able to read their parts. Thus, although performers of simple popular music could still rely on their ear, performers of complex art music had to be able to read music. This difference, too, endured until the mid-twentieth century, when many popular and jazz musicians could not read music and had no need to do so but

classical musicians found musical literacy essential. After 1950, electronic music and electronic instruments, especially the synthesizer, again blurred this distinction.

The system of notation followed in the musical examples in this dictionary dates from about the seventeenth century, although some elements of it, such as the five-line staff, are older. The most important features of this system are the black and white notes, with their various time values (indicating duration) and their placement on the staff (indicating pitch).

Present-day notation grew gradually out of the lines, hooks, and curves used in the Middle Ages (see NEUME). These came to be placed on a line and then on a STAFF to indicate pitch (ninth to tenth centuries). In the thirteenth century different shapes and forms, to indicate how long each note was to be held, were developed. Another system used during the Middle Ages, which has survived more for teaching purposes than for use in performance, is that of assigning letters or numbers to various pitches (see LETTER NOTATION). In addition there are systems of writing music for various stringed and keyboard instruments in which the player is shown how to finger the instrument to obtain the desired pitches (see TABLATURE). Also see GRAPHIC NOTATION; MENSURAL NOTATION; NOTES AND RESTS.

notes and rests The symbols used to write music on a staff, indicating the relative TIME values of each pitch (how long it is held compared to the others). The time value is indicated by a note's being black or white, and the presence or absence of a stem and flags. A whole note lasts twice as long as a half note, four times as long as a quarter note, and so on down to a sixty-fourth note, which is the smallest value in common use. A dot after a note adds half again as much time to its duration (see DOT, def. 4).

The British names for notes differ from the American names and appear

in parentheses in the accompanying illustration. Also, the British use the word "note" for both the written symbol and the sound it stands for, whereas Americans generally use the word "tone" for the sound and "note" for the sign.

note value Also, *time value, value.* The duration of a note. (See under TIME.)

Notre Dame (nô' trᵊ dAm") **school** Term for a group of composers of polyphonic church music, some of whom worked at the Cathedral of Notre Dame in Paris, during the thirteenth century. The two greatest masters of the Notre Dame school were Leonin and Perotin. See also ARS ANTIQUA.

notturno (nôt tōōr' nô) *Italian.* **1** The Italian word for NOCTURNE. **2** The title of various eighteenth-century compositions, usually for a small instrumental ensemble, to be played for an evening entertainment. Haydn and Mozart both wrote a number of such pieces, which are essentially similar to the serenade (see SERENADE, def. 2).

novachord (nô'vᵊ kôrd"). See under ELECTRONIC INSTRUMENTS.

number opera An opera that consists of separate pieces or "numbers"— duets, arias, choruses, ballets—connected by either spoken dialogue, recitatives, or both. The great majority of operas written between 1600 and 1850 are number operas, although a few composers tried to create works that were more unified both musically and dramatically. Among them were Gluck, who tried to make his music express the spirit of the story, and Mozart, who provided musical transitions between the separate numbers. Wagner was the first to discard the system completely, replacing it with continuous music and uninterrupted action.

nun's fiddle See under TROMBA MARINA.

nuovo, di (dē nwô'vô) *Italian:* "again." A direction to repeat.

nut 1 The British term for FROG. **2** In violins, guitars, and other stringed instruments, a thin strip of wood on the upper end of the neck, which serves to keep the strings raised from the fingerboard.

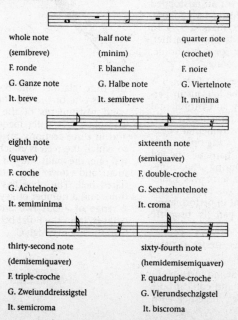

whole note half note quarter note
(semibreve) (minim) (crochet)
F. ronde F. blanche F. noire
G. Ganze note G. Halbe note G. Viertelnote
It. breve It. semibreve It. minima

eighth note sixteenth note
(quaver) (semiquaver)
F. croche F. double-croche
G. Achtelnote G. Sechzehntelnote
It. semiminima It. croma

thirty-second note sixty-fourth note
(demisemiquaver) (hemidemisemiquaver)
F. triple-croche F. quadruple-croche
G. Zweiunddreissigstel G. Vierundsechzigstel
It. semicroma It. biscroma

O

o **1** In scores, a sign placed over or under a note, directing the player to perform either an open note or a harmonic (overtone). **2** In music for stringed instruments (violins, cellos, etc.), a sign directing the performer to play the note on an open (unstopped) string, or to obtain the note by playing a harmonic; the pitch of the note so marked determines which direction is meant. **3** In music for brass instruments (French horn, trombone, etc.), a sign calling for an unstopped note (not muted), particularly following a stopped note, marked +. **4** In music for woodwinds (oboe, clarinet, etc.), a sign calling for a harmonic, produced by overblowing.

obbligato (ôb″ blē gä′ tô) *Italian.* **1** A part that may not be left out in performance, especially an instrumental part in the accompaniment of a vocal work. Arias with instrumental obbligatos are common in the operas and oratorios of the baroque period (1600–1750). **2** During the nineteenth century, the term was sometimes used to refer to an optional part that could be left out in performance, although such a part is properly termed AD LIBITUM.

oblique motion See under MOTION, def. 2.

oboe (ō′bō). A woodwind instrument with a double reed and conical bore (cone-shaped inside). Together with

the flute, clarinet, and bassoon, the oboe is one of the four basic woodwind instruments of the orchestra. The oboe is usually made of wood and in three sections: an upper one, to which the reed is attached; a central one, the main body of the instrument; and a lower one, with a slightly flared bell. The oboe has six finger holes and a number of keys, yielding a range of about two and one-half octaves, from the B-flat below middle C to the F above high C.

Instruments of the oboe family are very old. The ancient Greek aulos is one example. The modern form of oboe, an offspring of the shawm, was invented in the 1650s at the court of King Louis XIV of France. Its French name is **hautbois**, and the English name probably came from misspelling and mispronouncing the French (hoboy, oboe). The instrument won immediate popularity, and by 1700 it was used in virtually all orchestras (usually in pairs) as the principal soprano woodwind, as well as in military bands. In fact, a famous French band of this period was called *Les douzes grandes Hautbois du Roi* ("The Twelve Great Oboes of the King"); it consisted of ten oboes and two bassoons. During the nineteenth century the oboe, like the flute, clarinet, and other woodwinds, was improved, mainly through changes in keys and fingering. The fingering system in general use today is that adopted by the Paris Conservatory. Because its tube is so narrow compared to the flute's or clarinet's, the oboe requires very little wind pressure in order to sound; as a result, oboists must develop considerable control in order to blow gently enough. Also, perhaps more than with any other reed instrument, fashioning the reed is a vital and very exacting task, and most oboists make their own.

Nearly every composition for orchestra written since 1700 includes a part for oboe, as do most wind ensembles. A few of the many important compositions for solo oboe (or with major parts for solo oboe) are: Alessandro Marcello's Concerto in C minor; Bach's Double Concerto in C for violin and oboe; Handel's two concertos for oboe and strings; Telemann's Concerto in F minor; Cimarosa's Concerto for oboe and strings; Mozart's Concerto in C, K. 314, and his Quartet in F major for oboe and strings, K. 370; Schumann's *Drei Romanzen* ("Three Romances"), op. 94; Piston's Suite for oboe and piano; Milhaud's *Pastorale* for oboe, clarinet and bassoon, and *La Chem-*

inée du roi René for flute, oboe, clarinet, horn, and bassoon; Hindemith's Oboe Sonata; Vaughan Williams's Concerto for oboe and strings; Richard Strauss's Concerto for oboe; Britten's *Fantasy Quartet* for oboe and strings, and *Six Metamorphoses* for oboe; Poulenc's Oboe Sonata; Carter's Oboe Concerto; and Harbison's Oboe Concerto.

—**alto oboe** An obsolete oboe of the eighteenth century, pitched a fifth below the ordinary oboe (in F instead of C), which is the ancestor of the ENGLISH HORN. (See also OBOE D'AMORE.) —**baritone oboe** A large oboe usually built with an upturned globe-shaped bell, but occasionally also in straight form, that is pitched an octave below the normal oboe. The HECKELPHONE is a related instrument but has a different tone color.

oboe da caccia (ō'bō dä kät' c̲h̲ä). An alto oboe of the eighteenth century, forerunner of the ENGLISH HORN. It is occasionally called for in the cantatas of J.S. Bach.

oboe d'amore (ō'bō dä môr'e). An alto oboe pitched in A, a minor third below the normal oboe and having a bulb-shaped bell like that of the English horn. The oboe d'amore was popular in the eighteenth century and has been revived to some extent since 1900.

Obrecht (ō'brek̲h̲t), **Jacob** (yä'kôp), c. 1450–1505. A composer who was one of the leading masters of the FLEMISH SCHOOL. Obrecht worked in a number of important musical centers of the day, among them Utrecht in the Netherlands, Cambrai in Burgundy (now part of France), and Bruges in Belgium. Although he composed secular (nonreligious) songs to texts in Dutch, French, and Italian, he is remembered most for his religious music, especially his motets and his Masses. In his songs, Obrecht turned away from the rigid poetic forms that dominated fourteenth-century music (the ballade, rondeau, and virelai), preferring freer treatment. Many of

Obrecht's songs are in four voice-parts instead of the usual three, and considerable importance is given to the lower parts instead of exclusive emphasis on a melody in the top part. Some of his motets are for five and six voices. More than two dozen of his Masses survive, more than from any other composer of his time, and in these his finest music is found. A number of them are based on the melodies of a cantus firmus from well-known songs, among them the famous L'HOMME ARMÉ and the German hymn, *Maria zart* ("Tender Mary"). Others are based on polyphonic pieces, and in these Obrecht shows remarkable skill in making use of the material from each of the voice-parts of the earlier work. Obrecht also is one of the earliest known composers to write purely instrumental pieces.

ocarina (ok"ə rē'nə). Also, *sweet potato*. A wind instrument consisting of a globe-shaped body made of pottery and a whistle-like mouthpiece. The player blows into the mouthpiece and obtains different pitches by covering some of the eight finger holes and two thumb holes in the body of the instrument. Invented in Italy about 1860, the ocarina resembles much older primitive instruments that were used in ancient Egypt, China, and elsewhere. Various versions of it have been built, in sizes ranging from soprano (small) to bass (large). The ocarina has a range of about one and one-half octaves.

Ockeghem (ok' ə gem"), **Johannes** (yō hä' nəs), c. 1420–1495. Also, *Okeghem*. A Flemish composer who became the first great master of the FLEMISH SCHOOL. Born in Flanders (now part of northern France), he was employed for more than forty years at the French royal court, first in Paris and later in Tours. Ockeghem seems to have composed relatively little, even allowing for the fact that much of his music has been lost. He wrote a number of secular (nonreligious) songs, mainly in the conventional poetic forms of the fourteenth century (ballade, rondeau, virelai). In his motets and even more in his Masses, Ockeghem anticipated the more complex polyphony of the Renaissance. Although in some Masses he still used a cantus firmus (a fixed melody on which the other voice-parts are based), he occasionally varied it; moreover, he sometimes used several voice-parts from a secular song instead of taking only the melody for the cantus firmus. In addition to this use of parody (see PARODY, def. 2), which became an important compositional technique, he often increased the number of voice-parts from three to four or five. At least half of his surviving complete Masses are free; that is, no preexisting chant or melody has been identified, so they are presumably wholly original. Ockeghem's Requiem Mass is the oldest surviving polyphonic example of the form.

octave (ok'təv). **1** All eight tones of any major or minor scale (see *A* in the accompanying example). **2** The interval made up of the first and eighth tones (in rising order of pitch) in a major or minor scale (for example, C–C' in the scale of C major, *B* in the example). Tones an octave apart from one another sound so similar that the octave has become the basis of many scale systems, a scale beginning anew with each pitch an octave higher. Scientifically, the similarity in sound of two notes an octave apart is explained by the fact that the frequency of the higher note is exactly twice the frequency of the lower one (see SOUND for an explanation of frequency).

octave coupler See under COUPLER.

octave course See under COURSE.

octave key In wind instruments (clarinets, oboes, English horns), a key that makes available the note an octave above the note ordinarily sounded by a particular key. See also SPEAKER KEY.

octet (ok tet'). **1** An ensemble of eight instruments or eight voices. **2** A composition for eight instruments or eight voices. Since each singer or instrument has a separate part, the octet is a form of chamber music. Were there only four voice-parts, with two instruments or singers per part, the composition would be called a **double quartet;** an example is Mendelssohn's Octet in E-flat, op. 20, for double string quartet. —**instrumental octet** An octet for instruments. Notable examples are Beethoven's Octet in E-flat, op. 103, for two oboes, two clarinets, two French horns, and two bassoons; Schubert's Octet in F, op. 166, for two violins, viola, cello, double bass, clarinet, bassoon, and horn; Stravinsky's Octet for winds; Shostakovitch's *Two Pieces* for strings; and Varèse's *Octandre* for flute, oboe, clarinet, bassoon, horn, trumpet, trombone, and double bass.

ode A musical setting of a nonreligious poem, especially one written in honor of a particular person or special occasion. Notable examples include both Purcell's and Handel's *Ode for St. Cecilia's Day* and the various birthday and New Year's odes composed for the English court during the seventeenth and eighteenth centuries. These compositions are more in the form of a cantata, using a chorus, soloists, and orchestra. Later examples include Beethoven's setting of Schiller's "Ode to Joy" (incorporated in the last movement of his Symphony no. 9), Brahms's setting of verses by Schiller, *Nänie,* op. 82, and Schoenberg's setting of a text of Byron's, *Ode to Napoleon,* op. 41, for piano, string orchestra, and a reciting voice (Sprechstimme).

oeuvre (Œ'vrᵊ). The French word for OPUS.

off 1 In organ music, a direction to push in or disengage a stop or coupler. **2** A term referring to incorrect intonation, as in "off pitch" or "off key," meaning out of tune.

Offenbach (ô" fen bᴀk'), **Jacques** (zhäk), 1819–1880. A French composer who is remembered for a few of the hundred or so operettas he wrote, as well as for a single opera, *Les Contes d'Hoffmann* ("The Tales of Hoffmann"), considered his best work. A theatrical conductor, manager, and producer, Offenbach had intimate knowledge of the theater. In the 1850s he began producing his own enormously popular operettas, which represent the type known as OPÉRA BOUFFE. Among the best known, noted for their gay melodies and sprightly humor, are *Orphée aux enfers* ("Orpheus in the Underworld"), *La Belle Hélène* ("Beautiful Helen"), *La Périchole,* and *La Vie parisienne* ("Life in Paris"). Offenbach never saw the production of his masterpiece, *Les Contes d'Hoffmann* (1881), which he did not quite complete before he died.

Offertory 1 The fourth musical section of the Proper of the Roman Catholic Mass (see MASS). Originally the Offertory consisted of a psalm with an antiphon, but today only the antiphon remains. **2** In various Protestant churches the music performed during the collection of offerings from the congregation. Usually an anthem by the choir or a soloist or a piece of organ music, it may or may not have been composed specifically for this purpose.

Office In the Roman Catholic Church, a religious service held at a particular hour of the day. There are eight such services in all, with special music for each, consisting of psalms, antiphons, responsories, hymns, and canticles. They are Matins, Lauds, Prime, Terce, Sext, None, Vespers, and Compline. Vespers is the only Office for which music other than Gregorian chant is permitted, and as a result elaborate settings of the appropriate psalms and of the CANTICLE of Vespers, the Magnificat, have been written for the Vespers service. Particularly notable are Vespers settings for voices and orchestra by Monteverdi and by Mozart.

ohne (ô'nə) *German:* "without." A term used in such musical directions as *ohne Pedal* ("without pedal").

Okeghem See OCKEGHEM, JOHANNES.

Oktavflöte (ôk täf' flœ" tə). A German word for PICCOLO.

oliphant (ol'ə fənt). A HORN made from the tusk of an elephant.

ondeggiando (ôn" de djän' dô) *Italian:* "rocking." Also, French, *ondulé* (ôN dY lā'). A term used in violin music to direct the player to rock the bow back and forth. This movement gives the effect of slightly varying intensity on a single pitch.

ondes Martenot (ôNd' mʌr tə nō'). Also, *ondes musicales.* See under ELECTRONIC INSTRUMENTS.

ondulé See ONDEGGIANDO.

ongarese, all' (äl ôn" gä rā' ze) *Italian.* A direction to perform in Hungarian style, meaning particularly the style of Hungarian gypsy music.

op. Also, *Op.* An abbreviation for OPUS.

open form A structured composition with some ALEATORY elements.

open key See KEY, def. 2.

open note Another term for OPEN TONE.

open pipe An organ pipe that is open at the top.

open string A string that is plucked or bowed without being stopped (held down against a fingerboard). A note to be played on an open string is marked with a small circle above or below it.

open tone 1 Also, *open note.* Any note produced on a stringed instrument (violin, cello, etc.) or on a horn without STOPPING. 2 Also, *natural tone.* Any tone produced on a wind or brass instrument without the aid of finger holes, keys, valves, or stopping.

Oper (ō'pər) *pl.* **Opern** (ō'pərn). 1 The German word for OPERA. 2 The German word for OPERA HOUSE.

opera (op'ər ə, op'rə). A play in which the characters sing rather than speak their parts, usually accompanied by instruments. Like ordinary plays, operas are presented on a stage, with costumes, scenery, and lighting, and the singers act out the story in addition to singing. The instruments, usually a full orchestra, are placed in front of the stage in a low area called the pit. The text of an opera, which is called a LIBRETTO, generally consists of one or more sections called acts, which in turn may contain one or more scenes. In addition to the story, which is largely sung by the cast, an opera may include ballets and other dances, as well as purely instrumental sections. It frequently begins with an instrumental overture or prelude that is ordinarily performed before the curtain rises on the first act; further, some operas have a separate overture for each of the acts. In addition, instrumental pieces, called interludes, may be played at various points in the course of the opera. The vocal numbers range from solo songs (recitatives or arias) to vocal duets, trios, quartets, quintets, sextets, etc., up to pieces for a full chorus.

Though the first known combination of music and drama took place in ancient Greece, opera as a musical form was born in the 1590s in Florence, Italy. At that time a group of noblemen—the so-called CAMERATA—attempted to revive classical drama by setting Greek plays to music. Since they were interested mainly in the plays, they tended to stress the text more than the music. Their purpose could not be served by the complex polyphonic music of the late Renaissance, in which the interweaving of different voice-parts had become so complex that the words could scarcely be understood. What suited them perfectly, however, was a new musical style, the recitative, a kind of musical reciting in which a solo performer follows the natural accents and rhythm of the words. The earliest of the Florentine operas that survives is *Euridice,* with a text by Ottavio Rinuccini and music by Jacopo Peri; it was performed in 1600 at the wedding festivities of Maria de' Medici and King Henry IV of France. (Peri's opera *Dafne* is still older, but most of

its music has been lost. Giulio Caccini wrote an opera called *Euridice* to the same libretto by Rinuccini, which was published in 1600 but was not performed until 1602.) *Euridice* is basically a poem that is sung in recitative with a basso continuo accompaniment (see CONTINUO) supplied by a few instruments, and with an occasional chorus (usually at the end of a scene). The recitative follows the rhythm and inflection of the words —the so-called STILE RAPPRESENTATIVO— and the bass part, in simple chords, serves to keep the singer on key. The chief drawback of constructing a whole opera in this manner is dullness. The first composer to vary the form and make it more interesting was Claudio Monteverdi, whose first opera, *L'Orfeo*, was performed in 1607. Monteverdi not only enriched the harmony and made the recitative more expressive but added elaborate arias (solo songs), more choruses, and instrumental passages performed by a much larger ensemble. Another important early opera was Marco da Gagliano's *Dafne*, performed in 1608.

The new form spread rapidly, first to Rome and then to Venice, where in 1637 the first public opera house was opened. The goal of pleasing a paying audience had profound effects on the form. Operas became longer and productions more lavish; the plots became more involved, more characters were introduced, and comic portions were inserted to liven the performance. A new singing style, BEL CANTO, came into being, and audiences flocked to hear the popular virtuoso singers of the moment. As a result, the aria became all-important, and recitative, choruses, instrumental parts, and the drama itself were neglected. Operas in this style are now called **number operas**, the "numbers," chiefly arias and duets, being loosely connected by recitatives, choruses, and instrumental interludes. By 1700 this type of opera was immensely popular throughout Italy and had been introduced in most of the major countries of Europe, where it was accepted in varying degrees. Although the Florentine composers had emphasized text over music, their successors had reversed this emphasis. To them, sweetly singing melody was the paramount object, and in general it remained so in Italian opera for the next two hundred years, in the hands of such composers as Bellini, Donizetti, Rossini, Verdi, and Puccini.

In France, which already had a tradition of classical drama (the lofty plays of Corneille and Racine) as well as a form of theater combining music and action (the ballet), it required simply a fusion of the two to create opera. It was Jean-Baptiste Lully who accomplished just that, taking elements from both to create a new form called **tragédie lyrique** ("lyrical tragedy"). This form, with its great emphasis on drama and inclusion of instrumental and chorus numbers, dominated French opera until the Italian influence made itself strongly felt during the nineteenth century.

England, which also had its own stage form, the MASQUE, was slower to accept opera, although its greatest seventeenth-century composer, Henry Purcell, produced one example of lasting quality, *Dido and Aeneas*. In the eighteenth century, however, the English public turned to Italian opera with gusto. Italian composers who came to England were imitated more or less faithfully by native English composers. Italian composers also brought their own works to Germany and held posts in various important German cities. Their style was copied with few changes by such German composers as Johann Adolph Hasse (1699–1783) and Reinhard Keiser (1674–1739). Also, both Handel and Bach's son, Johann Christian, who had studied in Italy, wrote many operas in the Italian style for English audiences.

By the mid-eighteenth century, Italian opera had fallen into a rigid, totally predictable pattern, at least in the **opera seria** ("serious opera"). Such operas, based on stories from legend or ancient history and arranged into three acts, consisted of recitatives

alternating with arias. Each scene had a recitative to relate an event in the plot, followed by an aria that commented on the event. There were almost no choruses, and the orchestra played a very minor role. The arias often were written with specific singers in mind and were designed to show off their particular talents. There were various fixed types of aria, and even the order in which the different types occurred and to which singer they were assigned was subject to strict rules. This model, established by Alessandro Scarlatti (1660–1725) and Alessandro Stradella (1642–1682), was generally followed by Handel, Niccolò Jommelli (1714–1774), Niccolò Piccinni (1728–1800), and at times by Mozart (in *Idomeneo* and *La Clemenza di Tito*). A few composers, however, had begun to rebel. The most important of them was Gluck, whose early works followed the established form but who later tried to change it, in the belief that the music should express the characters' feelings and ideas of the plot instead of serving merely to show off beautiful voices. Gluck's greatest success was in France, where his "reform" operas eminently suited the tradition begun by Lully and continued by Rameau.

Separate from all these developments there existed another kind of opera, the **opera buffa** ("comic opera"). As far back as the 1620s, elements of humor and wit had been introduced into opera. Beginning with brief comic interludes, they grew into longer entertainments performed between the acts of a serious opera (see INTERMEZZO, def. 3), eventually developing into a full-scale work, the opera buffa. Unlike the standard three-act opera seria, the typical opera buffa was nearly always in two acts (since it probably grew from two intermezzos inserted between the three acts of the opera seria). The most famous is Pergolesi's *La Serva padrona*, written in 1733, an intermezzo so successful that it survived while the opera seria into which it was inserted is remembered only as a historical curiosity. The performance of *La Serva padrona* in Paris in 1752 provoked a famous quarrel between the supporters of traditional French opera, represented by Rameau's works, and those of Italian opera buffa.

Toward the end of the eighteenth century composers began to combine elements from both opera buffa and opera seria. The results, sometimes called **opera semiseria** ("half-serious opera"), include some of the best of Mozart's operas, *Le Nozze di Figaro*, *Don Giovanni*, and *Così fan tutte*. In other countries, too, comic opera developed side by side with serious opera. France had its **opéra-comique**, which in the eighteenth century meant a humorous play (satire or farce) combining spoken dialogue with songs. However, under the influence of the Italian opera buffa, the popular songs became arias and the subjects began to become more romantic. England had the BALLAD OPERA, Spain the TONADILLA and later the nineteenth-century ZARZUELA, and Germany the SINGSPIEL, with Mozart again providing an outstanding example, *Die Entführung aus dem Serail* ("The Abduction from the Seraglio").

During the nineteenth century, the opera buffa in Italy continued almost unchanged in the hands of Donizetti and Rossini. Serious opera continued the tradition of the eighteenth-century opera seria, with its melodramatic subjects, sumptuous melodies, and stunning arias. Outstanding examples are Bellini's *Norma*, Donizetti's *Lucia di Lammermoor*, and Verdi's *Rigoletto, Il Trovatore*, and *La Traviata*. Elsewhere, however, comic operas tended to be either more serious in style and subject, less easily distinguished from serious opera, or, on the other hand, closer to a light, popular entertainment (operetta). In France the opéra-comique had become quite similar to serious opera, distinguished from it mainly in that it included spoken dialogue; composers of such works included Boïeldieu, Auber, and Adam. The **opéra bouffe**, on the other hand, was gen-

uinely comic, usually poking fun at something or someone, and its music was in popular styles; this type was virtually the same as the OPERETTA, and its most representative composer was Offenbach. Serious opera, called **grand opéra**, continued the tradition of the eighteenth-century Italian opera seria, with its arias and recitatives; notable examples are Halévy's *La Juive* and Meyerbeer's *Les Huguenots*. These operas were on a grand scale, with lavish scenes involving huge choruses of soldiers, courtiers, or supernumeraries. England's most notable contribution came late in the nineteenth century, with the outstanding comic operettas of Gilbert and Sullivan. In Russia and Bohemia (now the Czech Republic) opera became the vehicle of the new nationalist movement in the hands of such composers as Glinka, Mussorgsky, Borodin, Rimsky-Korsakov, Smetana, and later, Janáček. (See also NATIONALISM.) In Germany, on the other hand, opera during the first half of the nineteenth century spoke for the new romantic movement, of which some features had already appeared in Mozart's *Die Zauberflöte* ("The Magic Flute"), written in 1791. The romantic opera took for its plot subjects from legend or folklore. Although nature and natural beauty were emphasized, as they were in romantic literature, magic, gods, and other supernatural forces usually played a role in the plot. Outstanding examples of German romantic opera are Weber's *Der Freischütz* ("The Free-Shooter") and Wagner's early operas, especially *Der Fliegende Holländer* ("The Flying Dutchman") and *Tannhäuser*. Soon afterward, however, Wagner developed the single most important new kind of opera, the MUSIC DRAMA, which had a lasting impact not only on opera but many other musical forms. A follower of Wagner, at least in his operas, was Richard Strauss (*Salome, Elektra, Der Rosenkavalier*). At the same time, a reaction against Wagner's influence appeared in the "realistic" operas of

Mascagni, Leoncavallo, and Puccini (see VERISMO), and in such impressionist works as Debussy's *Pélleas et Mélisande* (see IMPRESSIONISM).

Although the repertory of most large opera houses in the late twentieth century was still largely made up of eighteenth- and nineteenth-century operas, twentieth-century composers did not neglect opera. Operas have been written in virtually every style. There are neoclassic operas (Stravinsky's *The Rake's Progress*), serial operas (Berg's *Lulu*), expressionist operas (Berg's *Wozzeck*), ballad operas (Weill's *The Threepenny Opera*), folk operas (Moore's *The Ballad of Baby Doe;* Gershwin's *Porgy and Bess*), jazz operas (Křenek's *Jonny spielt auf*), opera-oratorios (Hindemith's *Mathis der Maler;* Stravinsky's *Oedipus Rex*), electronic operas (Blomdahl's *Aniara*), operas combining traditional instruments and electronic sound (Eaton's *The Cry of Clytaemnestra*), aleatory operas (Pousseur's *Votre Faust*), quarter-tone operas (Hába's *Die Mutter*), operas in the nineteenth-century tradition (Britten's *Peter Grimes;* Menotti's *The Medium;* Barber's *Vanessa;* Walton's *Troilus and Cressida*), rock operas (Webber and Rice's *Jesus Christ Superstar*), video (television) operas (Ashley's *Perfect Lives*), minimalist operas (Adams' *Nixon in China*), and blues operas (Ito's *Ghosts: Live from Galilee*).

In the course of the twentieth century the distinction between opera and related forms, such as OPERETTA, MUSICAL COMEDY, and MUSIC THEATER, has become less and less clear. In the 1990s mixed-media productions and performance art further blurred the differences, especially in such works as Steve Reich's *The Cave* (1993).

The accompanying chart lists important operas with their composers, librettists, and date of first performance.

opéra (ô pā ʀä'). 1 The French word for OPERA. 2 The French word for OPERA HOUSE.

opéra-ballet (ô pā ʀä' bä lä') *French*. An opera in which there are many

SOME IMPORTANT OPERAS

Title	Composer	Libretto by	Sections	Date
Abduction from the Seraglio, The (see ENTFÜHRUNG AUS DEM SERAIL, DIE)				
Adriana Lecouvreur	Francesco Cilèa	Arturo Colautti	4 acts	1902
Africaine, L'	Giacomo Meyerbeer	Eugène Scribe	5 acts	1865
Agrippina	George Frideric Handel	Vincenzio Grimani	3 acts	1709
Aida	Giuseppe Verdi	Antonia Ghislanzoni and composer	4 acts	1871
Albert Herring	Benjamin Britten	Eric Crozier	3 acts	1947
Alceste	Christoph Willibald Gluck	Ranieri di Calzabigi	3 acts	c.1767; rev. 1776
Amahl and the Night Visitors	Gian Carlo Menotti	composer	1 act	1951
Amore dei tre Re, L' ("The Love of Three Kings")	Italo Montemezzi	Sem Benelli	3 acts	1913
Andrea Chénier	Umberto Giordano	Luigi Illica	4 acts	1896
Anthony and Cleopatra	Samuel Barber	Franco Zeffirelli	3 acts	1966
Arabella	Richard Strauss	Hugo von Hofmannsthal	3 acts	1933
Ariadne auf Naxos	Richard Strauss	Hugo von Hofmannsthal	1 act and prologue	1912; rev. 1916
Assassinio nella cattedrale ("Murder in the Cathedral")	Ildebrando Pizzetti	Alberto Castelli	2 acts and intermezzo	1958
Aufstieg und Fall der Stadt Mahagonny ("Rise and Fall of the City of Mahagonny")	Kurt Weill	Bertolt Brecht	3 acts	1930
Ballad of Baby Doe, The	Douglas Moore	J. Latouche	2 acts	1956
Ballo in maschera, Un ("A Masked Ball")	Giuseppe Verdi	Antonio Somma	3 acts	1859
Barbier von Bagdad, Der ("The Barber from Baghdad")	Peter Cornelius	composer	2 acts	1858
Barbiere di Siviglia, Il ("The Barber of Seville")	Gioacchino Rossini	Cesare Sterbini	2 acts	1816
Bartered Bride, The (Prodana Nevesta)	Bedřich Smetana	Karel Sabina	3 acts	1866
Bassarids, The	Hans Werner Henze	W. H. Auden and Chester Kallmann	1 act	1966

Title	Composer	Librettist	Acts	Year
Billy Budd	Benjamin Britten	E. M. Forster and Eric Crozier	4 acts	1951
Bluebeard's Castle	Béla Bartók	Béla Balázs	1 act	1918
Bohème, La	Giacomo Puccini	Giuseppe Giacosa and Luigi Illica	4 acts	1896
Boris Godunov	Modest Mussorgsky	composer	3 acts	1874
Butterfly, Madama (see MADAMA BUTTERFLY)				
Cardillac	Paul Hindemith	Ferdinand Lion	3 acts	1926; rev. 1952
Carmen	Georges Bizet	Henri Meilhac and Ludovic Halévy	4 acts	1875
Cavalleria rusticana ("Rustic Chivalry")	Pietro Mascagni	Guido Menasci and Giovanni Targioni-Tozzetti	1 act	1890
Cenerentola, La ("Cinderella")	Gioacchino Rossini	Jacopo Ferretti	2 acts	1817
Christophe Colomb ("Christopher Columbus")	Darius Milhaud	Paul Claudel	2 parts	1930
Clemenza di Tito, La ("The Mercy of Titus")	Wolfgang Amadeus Mozart	Pietro Metastasio and Caterino Mazzolà	2 acts	1791
Combattimento di Tancredi e Clorinda, Il ("The Battle of Tancred and Clorinda")	Claudio Monteverdi	unknown	1 act	1624
Consul, The	Gian Carlo Menotti	composer	3 acts	1950
Contes d'Hoffmann, Les ("The Tales of Hoffmann")	Jacques Offenbach	Jules Barbier and Michel Carré	3 acts	1881
Coq d'or, Le (see GOLDEN COCKEREL)				
Così fan tutte ("Women Are Like That")	Wolfgang Amadeus Mozart	Lorenzo da Ponte	2 acts	1790
Cunning Little Vixen, The	Leoš Janáček	composer	3 acts	1924
Dame blanche, La ("The White Lady")	François-Adrien Boïeldieu	Eugène Scribe	3 acts	1825
Damnation de Faust, La ("The Damnation of Faust")	Hector Berlioz	composer and Almire Gandonnière	5 acts	1846
Death in Venice	Benjamin Britten	Myfanwy Piper	2 acts	1973
Devil and Daniel Webster, The	Douglas Moore	Stephen Vincent Benét	1 act	1939
Dialogues des Carmélites, Les ("Dialogues of the Carmelites")	Francis Poulenc	Georges Bernanos	3 acts	1957
Dido and Aeneas	Henry Purcell	Nahum Tate	3 acts	1689
Don Carlos	Giuseppe Verdi	François-Joseph Méry and Camille du Locle	4 acts	1867; rev. 1884
Don Giovanni ("Don Juan")	Wolfgang Amadeus Mozart	Lorenzo da Ponte	2 acts	1787
Don Pasquale	Gaetano Donizetti	composer and G. Ruffini	3 acts	1843
Don Rodrigo	Alberto Ginastera	A. Casona	3 acts	1964
Duenna, The	Sergey Prokofiev	Mira Mendelssohn	4 acts	1946

SOME IMPORTANT OPERAS *(continued)*

Title	Composer	Libretto by	Sections	Date
Elegy for Young Lovers	Hans Werner Henze	W. H. Auden and Chester Kallmann	3 acts	1961
Elektra	Richard Strauss	Hugo von Hofmannsthal	1 act	1909
Elisir d'Amore, L' ("The Elixir of Love")	Gaetano Donizetti	Felice Romani	2 acts	1832
Enfant et les sortilèges, L' ("The Child and the Magic Spells")	Maurice Ravel	Colette	1 act	1925
Entführung aus dem Serail, Die ("The Abduction from the Seraglio")	Wolfgang Amadeus Mozart	Gottlieb Stephanie the Younger	3 acts	1782
Erwartung ("Expectation")	Arnold Schoenberg	Marie Pappenheim	1 act	1924
Esther	Hugo Weisgall	Charles Kondek	3 acts	1993
Eugen Onegin (Yevgeny Onyegin)	Piotr Ilyitch Tchaikovsky	composer and Konstantin Shilovsky	3 acts	1879
Euridice	Jacopo Peri	Ottavino Rinuccini	—	1600
Euridice	Giulio Caccini	Ottavino Rinuccini	—	1602
Falstaff	Giuseppe Verdi	Arrigo Boito	3 acts	1893
Fanciulla del West, La ("The Girl of the Golden West")	Giacomo Puccini	Guelfo Civinini and Carlo Zangarini	3 acts	1910
Faust	Charles Gounod	Jules Barbier and Michel Carré	5 acts	1859
Fidelio	Ludwig van Beethoven	Josef von Sonnleithner; rev. by Stephan von Breuning, G. F. Treitschke	2 acts	1805; rev. 1814
Fille du régiment, La ("The Daughter of the Regiment")	Gaetano Donizetti	Jean-François-Alfred Bayard and Jules-Henri Vernoy de Saint-Georges	2 acts	1840
Fliegende Holländer, Der ("The Flying Dutchman")	Richard Wagner	composer	3 acts	1843
Forza del destino, La ("The Force of Destiny")	Giuseppe Verdi	Francesco Maria Piave	4 acts	1862

Four Saints in Three Acts	Virgil Thomson	Gertrude Stein; arr. by composer and Maurice Grosser	4 acts	1934
Francesca da Rimini	Riccardo Zandonai	Tito Ricordi	4 acts	1914
Frau ohne Schatten, Die ("The Woman Without a Shadow")	Richard Strauss	Hugo von Hofmannsthal	3 acts	1919
Freischütz, Der ("The Free-Shooter")	Carl Maria von Weber	Friedrich Kind	3 acts	1821
From the House of the Dead (see HOUSE OF THE DEAD, FROM THE)				
Ghosts of Versailles, The	John Corigliano	William Hoffman	2 acts	1991
Gianni Schicchi (see TRITTICO, IL)				
Gioconda, La ("The Happy Woman")	Amilcare Ponchielli	Arrigo Boito	4 acts	1876
Giulio Cesare in Egitto ("Julius Caesar in Egypt")	George Frideric Handel	Niccolò Francesco Haym	3 acts	1724
Glückliche Hand, Die ("The Fortunate Hand")	Arnold Schoenberg	composer	1 act	1924
Golden Cockerel, The (Le Coq d' or)	Nikolay Rimsky-Korsakov	Vladimir Bielsky	3 acts	1909
Good Soldier Schweik, The	Robert Kurka	L. Allan	2 acts	1959
Götterdämmerung, Die (see RING DES NIBELUNGEN, DER)				
Grand Macabre, Le ("Old Death")	György Ligeti	Michael Meschke	2 acts	1978
Gran Sole Carico d'Amore, Al ("In the Great Sun Charged with Love")	Luigi Nono	composer	2 acts	1975
Guillaume Tell ("William Tell")	Gioacchino Rossini	Étienne de Jouy and Hippolyte Bis	4 acts	1829
Hänsel und Gretel	Engelbert Humperdinck	Adelheid Wette	3 scenes	1893
Harmonie der Welt, Die ("The Harmony of the World")	Paul Hindemith	composer	5 acts	1957
Help! Help! The Globolinks	Gian Carlo Menotti	composer	1 act	1969
Heure espagnole, L' ("The Spanish Hour")	Maurice Ravel	Maurice Legrand	1 act	1911
House of the Dead, From the	Leoš Janáček	composer	3 acts	1930
Huguenots, Les	Giacomo Meyerbeer	Eugène Scribe and Émile Deschamps	5 acts	1836

Title	Composer	Libretto by	Sections	Date
Ice Break, The	Michael Tippett	composer	3 acts	1977
Incoronazione di Poppea, L' ("The Coronation of Poppea")	Claudio Monteverdi	Giovanni Francesco Busenello	3 acts	1642
Intermezzo	Richard Strauss	composer	2 acts	1924
Intolleranza 1960 ("Intolerance, 1960"); rev. Intolleranza 1970	Luigi Nono	composer	2 acts; rev. 1 act	1961; rev. 1970
Italiana in Algeri, L' ("The Italian Woman of Algiers")	Gioacchino Rossini	Angelo Anelli	2 acts	1813
Jenůfa	Leoš Janáček	composer	3 acts	1904
Jonny spielt auf ("Jonny Performs")	Ernst Křenek	composer	2 parts	1927
Juive, La ("The Jewess")	Jacques Halévy	Eugène Scribe	5 acts	1835
Junge Lord, Der ("The Young Lord")	Hans Werner Henze	I. Bachmann	2 acts	1965
Juniper Tree, The	Philip Glass and Robert Moran	Arthur Yorinks	6 scenes	1985
Kluge, Die ("The Clever Girl")	Carl Orff	composer	1 act	1943
Knot Garden, The	Michael Tippett	composer	3 acts	1970
König Hirsch, Der ("The Stag King")	Hans Werner Henze	H. von Cramer	3 acts	1956
Königskinder, Die ("The King's Children")	Engelbert Humperdinck	Ernst Rosmer	3 acts	1910
Lady Macbeth of Mtsensk	Dmitri Shostakovitch	composer and Y. Preis	4 acts	1934
Lakmé	Léo Delibes	Edmond Gondinet and Philippe Gille	3 acts	1883
Life for the Czar, A	Mikhail Glinka	Georgy Rosen	5 acts	1836
Lohengrin	Richard Wagner	composer	3 acts	1850
Louise	Gustave Charpentier	composer	4 acts	1900
Love of Three Oranges, The	Sergey Prokofiev	composer	4 acts	1921
Lucia di Lammermoor	Gaetano Donizetti	Salvatore Cammarano	3 acts	1835
Lulu	Alban Berg	composer	3 acts (incomplete)	1937
Macbeth	Giuseppe Verdi	Francesco Maria Piave	4 acts	1847; rev. 1865
Madama Butterfly	Giacomo Puccini	Giuseppe Giacosa and Luigi Illica	3 acts	1904
Magic Flute, The (see ZAUBERFLÖTE, DIE)				
Mamelles de Tirésias, Les ("The Breasts of Tiresias")	Francis Poulenc	Guillaume Apollinaire	2 acts and prologue	1947

SOME IMPORTANT OPERAS (continued)

Title	Composer	Libretto by	Sections	Date
Pelléas et Mélisande	Claude Debussy	Maurice Maeterlinck	5 acts	1902
Peter Grimes	Benjamin Britten	Montagu Slater	3 acts	1945
Pique Dame (see QUEEN OF SPADES, THE)				
Porgy and Bess	George Gershwin	DuBose Heyward and Ira Gershwin	3 acts	1935
Prigioniero, Il ("The Prisoner")	Luigi Dallapiccola	composer	prologue and 1 act	1949
Prince Igor	Alexander Borodin	composer	4 acts	1890
Prodana Nevesta (see BARTERED BRIDE, THE)				
Puritani di Scozia, I ("The Puritans of Scotland")	Vincenzo Bellini	Carlo Pepoli	3 acts	1835
Queen of Spades, The (Pique Dame)	Piotr Ilyitch Tchaikovsky	composer and Modest Tchaikovsky	3 acts	1890
Rake's Progress, The	Igor Stravinsky	W. H. Auden and Chester Kallman	3 acts	1951
Rape of Lucretia, The	Benjamin Britten	Ronald Duncan	2 acts	1946
Rheingold, Das (see RING DES NIBELUNGEN, DER)				
Rienzi	Richard Wagner	composer	5 acts	1842
Rigoletto	Giuseppe Verdi	Francesco Maria Piave	3 acts	1851
Ring des Nibelungen, Der	Richard Wagner	composer	4 operas	1876
("The Ring of the Nibelungs")				
Das Rheingold ("The Gold of the Rhine")			1 act, 4 scenes	1869
Die Walküre ("The Valkyries")			3 acts	1870
Siegfried			3 acts	1876
Götterdämmerung, Die ("The Twilight of the Gods")			prologue and 3 acts	1876
Roméo et Juliette	Charles Gounod	Jules Barbier and Michel Carré	5 acts	1867
Rosenkavalier, Der	Richard Strauss	Hugo von Hofmannsthal	3 acts	1911

Title	Composer	Librettist	Acts	Year
("The Knight of the Rose")				
Russlan and Ludmilla	Mikhail Glinka	V. F. Shirkov and V. A. Bakhturin	5 acts	1842
Saint François d'Assise	Olivier Messiaen	composer	8 scenes	1983
Salome	Richard Strauss	Hedwig Lachmann	1 act	1905
Samson et Dalila	Camille Saint-Saëns	Ferdinand Lemaire	3 acts	1877
Segreto di Susanna, Il	Ermanno Wolf-Ferrari	Enrico Golisciani	1 act	1909
("The Secret of Susanna")				
Semiramide	Gioacchino Rossini	Gaetano Rossi	2 acts	1823
Serse (see XERXES)				
Serva padrona, La ("The Maid as Mistress")	Giovanni Battista Pergolesi	Gennaro Antonio Federico	2 acts	1733
Siegfried (see RING DES NIBELUNGEN, DER)				
Simon Boccanegra	Giuseppe Verdi	Francesco Maria Piave; rev. Arrigo Boito	3 acts and prologue	1857
Soldaten, Die ("The Soldiers")	Bernd Alois Zimmermann	composer	4 acts	1965
Sonnambula, La ("The Sleepwalker")	Vincenzo Bellini	Felice Romani	2 acts	1831
Suor Angelica (see TRITTICO, IL)				
Susannah	Carlisle Floyd	composer	2 acts	1955
Tabarro, Il (see TRITTICO, IL)				
Tales of Hoffmann, The (see CONTES D'HOFFMANN, LES)				
Taming of the Shrew, The	Vittorio Giannini	composer and Dorothea Fee	2 acts	1953
Tannhäuser	Richard Wagner	composer	3 acts	1845
Taverner	Peter Maxwell Davies	composer	2 acts	1972
Telephone, The	Gian Carlo Menotti	composer	1 act	1947
Tender Land, The	Aaron Copland	Horace Everett	3 acts	1954
Teseo ("Theseus")	George Frideric Handel	N. Haym	4 acts	1713
Thaïs	Jules Massenet	Louis Gallet	3 acts	1894
Tosca	Giacomo Puccini	Guiseppe Giacosa and Luigi Illica	3 acts	1900
Traviata, La ("The Erring One")	Giuseppe Verdi	Francesco Maria Piave	3 acts	1853
Trial of Lucullus, The	Roger Sessions	composer	1 act	1947

SOME IMPORTANT OPERAS *(continued)*

Title	Composer	Libretto by	Sections	Date
Tristan und Isolde	Richard Wagner	composer	3 acts	1865
Trittico, Il ("The Trilogy")	Giacomo Puccini		3 operas	1918
Suor Angelica ("Sister Angelica")		Gioacchino Forzano	1 act	
Gianni Schicchi		Gioacchino Forzano	1 act	
Il Tabarro ("The Cloak")		Giuseppe Adami	1 act	
Trovatore, Il ("The Troubadour")	Giuseppe Verdi	Salvatore Cammarano	4 acts	1853
Troyens, Les ("The Trojans")	Hector Berlioz	composer	5 acts	1863
Turandot	Giacomo Puccini (completed by F. Alfano)	Giuseppe Adami and Renato Simoni	3 acts	1926
Turn of the Screw, The	Benjamin Britten	Myfanwy Piper	2 acts	1954
Vanessa	Samuel Barber	Gian Carlo Menotti	4 acts	1958
Volo di notte ("Night Flight")	Luigi Dallapiccola	composer	1 act	1940
Walküre, Die (see RING DES NIBELUNGEN, DER)				
War and Peace	Sergey Prokofiev	composer	5 acts	1957
Werther	Jules Massenet	Édouard Blau, Paul Milliet, and Georges Hartmann	4 acts	1892
Where the Wild Things Are	Oliver Knussen	Maurice Sendak	3 acts	1983
William Tell (see GUILLAUME TELL)				
Wozzeck	Alban Berg	composer	3 acts	1925
Xerxes (*Serse*)	George Frideric Handel	unknown	3 acts	1738
Yevgeny Onyegin (see EUGEN ONEGIN)				
Zar und Zimmermann ("Tsar and Carpenter")	Gustav Albert Lortzing	composer	3 acts	1837
Zauberflöte, Die ("The Magic Flute")	Wolfgang Amadeus Mozart	Emanuel Schikaneder	2 acts	1791

ballets. The term is used particularly for the operas of Lully and Rameau.

opéra bouffe (ô pä ɪ̇ʌ" bo͞of') *French.* A nineteenth-century type of comic opera that is very similar to an operetta, with spoken dialogue between musical numbers. The best-known composer of such works is Offenbach. See also OPÉRA-COMIQUE.

opera buffa (ô' pe rä bo͞of' fä) *Italian.* A type of comic opera that developed from the comic intermezzo of the eighteenth century (see INTERMEZZO, def. 3). The so-called "father of opera buffa" was Baldassare Galuppi (1706–1785), nicknamed *Il Buranello*; he wrote more than one hundred of them. Well-known composers of such works in the nineteenth century include Rossini and Donizetti.

opéra-comique (ô pä ɪ̇ʌ" kô mēk') *French.* 1 In the eighteenth century, a humorous play combining spoken dialogue with songs. An outstanding composer of such works was André Grétry (1741–1813). 2 In the nineteenth century, an opera, usually on a serious or sentimental subject, that includes some spoken dialogue, as opposed to *grand opéra*, which is sung throughout, and *opéra bouffe*, which is humorous or satirical. The best-known example of this type of opéra-comique is Bizet's *Carmen*, which was originally staged with spoken dialogue. France's leading composer in this style was François Boïeldieu (1775–1834), whose best-known work was *La dame blanche* ("The White Lady"; 1825).

opera house A theater devoted chiefly to the performance of operas.

opera-oratorio A work combining features of both opera and oratorio. Although an opera-oratorio is intended to be staged, there tends to be little action, the story being told through the words and music more than through the acting out of events. Examples include Hindemith's *Mathis der Maler* ("Matthias the Painter"), Stravinsky's *Oedipus*

Rex, and Penderecki's *Paradise Lost* (1978).

opera seria (ô' pe rä ser' ē ä) *Italian.* An opera on a serious subject, especially the type of opera dealing with a heroic or mythological subject and composed of a series of conventionalized arias loosely connected by recitatives. Many seventeenth- and eighteenth-century operas fall into this category, including those of Johann Adolf Hasse (1699–1783; sixty operas) and most of the works of Handel and Alessandro Scarlatti. Notable later examples are Mozart's *Idomeneo* and *La Clemenza di Tito* ("Titus's Clemency"). Also see under OPERA.

operetta An opera that is less serious in both subject and treatment than a serious opera. The subject is usually sentimental or humorous (occasionally satirical), or a combination of the two, and the music is popular in nature. Usually some spoken dialogue is included, as well as singing and dancing. The operetta came into being during the mid-nineteenth century. In France, Jacques Offenbach wrote several parodies on Greek myths in a similar form called *opéra bouffe*. Austria's first great composer of operettas was Franz von Suppé (1819–1895), who wrote about thirty works of this kind. Even more famous was his contemporary, Johann Strauss the Younger, who incorporated his lilting waltzes and marches into some sixteen operettas. Strauss's successor was Franz Lehár, who in 1905 achieved a tremendous popular success with his *Die lustige Witwe* ("The Merry Widow"); almost as popular were the operettas of Imre Kálmán (1882–1953). England's outstanding composer of operetta was Sir Arthur Sullivan, whose collaboration with librettist William Schwenck Gilbert produced a host of delightful satires. In the United States the first great composer of operettas was Victor Herbert. Early in the twentieth century the Viennese type of operetta, with its sentimental plots and lilting mel-

SOME FAMOUS OPERETTAS

Title	Composer	First performance
Babes in Toyland	Victor Herbert	Chicago, 1903
Belle Hélène, La ("Beautiful Helen [of Troy]")	Jacques Offenbach	Paris, 1864
Bettelstudent, Der ("The Beggar Student")	Karl Millöcker	Vienna, 1882
Blossom Time	Sigmund Romberg	New York, 1921
Cloches de Corneville, Les ("The Chimes of Normandy")	Jean-Robert Planquette	Paris, 1877
Csardasfürstin, Die ("The Csardas Countess")	Imre Kálmán	Vienna, 1915
Desert Song, The	Sigmund Romberg	New York, 1926
Firefly, The	Rudolf Friml	Syracuse (New York), 1912
Fledermaus, Die ("The Bat")	Johann Strauss the Younger	Bad Ischl (Austria), 1874
Gondoliers, The	Arthur Sullivan	London, 1889
High Jinks	Rudolf Friml	Syracuse (New York), 1913
Iolanthe	Arthur Sullivan	London and New York, 1882
Leichte Cavallerie ("Light Cavalry")	Franz von Suppé	Vienna, 1866
Lustige Witwe, Die ("The Merry Widow")	Franz Lehár	Vienna, 1905
Mikado, The	Arthur Sullivan	London, 1885
Naughty Marietta	Victor Herbert	Syracuse (New York), 1910
New Moon, The	Sigmund Romberg	New York, 1928
Orphée aux enfers ("Orpheus in the Underworld")	Jacques Offenbach	Paris, 1858 (rev. 1874)
Patience	Arthur Sullivan	London, 1881
Pinafore, H.M.S.	Arthur Sullivan	London, 1878
Pirates of Penzance, The	Arthur Sullivan	Paignton (England), 1879
Red Mill, The	Victor Herbert	Buffalo (New York), 1906
Rose Marie	Rudolf Friml	New York, 1924
Ruddigore	Arthur Sullivan	London, 1887
Student Prince, The	Sigmund Romberg	New York, 1924
Sweethearts	Victor Herbert	New York, 1913
Tapfere Soldat, Der ("The Chocolate Soldier")	Oscar Straus	Vienna, 1908
Trial by Jury	Arthur Sullivan	London, 1875
Vagabond King	Rudolf Friml	New York, 1925
Vie parisienne, La ("Life in Paris")	Jacques Offenbach	Paris, 1866
Yeomen of the Guard, The	Arthur Sullivan	London, 1888
Zigeunerbaron, Der ("The Gypsy Baron")	Johann Strauss the Younger	Vienna, 1885

odies, was brought to America by Rudolf Friml (1879–1972) and Sigmund Romberg (1887–1951). During the 1920s, however, the form changed into what is now known as MUSICAL COMEDY. The accompanying chart lists a few of the more famous operettas.

ophicleide (of'ə klīd"). A brass instrument of baritone range, the most important of several instruments developed in France in the nineteenth century from the key bugle. The ophicleide is pitched in C or B-flat. It has eleven keys and a range of about three octaves. Originally made as a replacement for the serpent, it was immensely popular in both orchestras and bands until the 1880s, when it was replaced by the tuba.

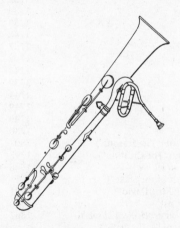

opp. 1 Also, *Opp.* An abbreviation for opuses (see OPUS). 2 An abbreviation for oppure (see under OSSIA).

oppure (ô pōōr'e). See under OSSIA.

opus (ō'pəs), *pl.* **opuses** *or* **opera** (ō' pər ə) *Latin:* "work." A term used for a musical work or musical composition and generally used to indicate, by number, the order of a composer's works, beginning with the first (opus 1) and continuing to the last, or to distinguish compositions that have the same title. In practice, however, opus numbers frequently refer not to

the order of writing but to the order of publication. Also, some composers assign opus numbers only to those compositions they consider important, leaving the less important (in their view) unnumbered. A single opus may include one or several compositions; in the latter case the pieces are usually related in some way, such as being published at the same time, or being written as a series. For example, Beethoven's opus 18 consists of six string quartets; they are referred to as Quartet op. 18, no. 1; op. 18, no. 2; etc. The word "opus" is often abbreviated *op.* (or *Op.*) and the plural form, *opp.*

opus posthumous A work published after the composer's death. Abbreviated *op. posth.*

oratorio (ôr" ə tôr' ē ō). A musical setting of a long text for soloists, chorus, and orchestra. The text is often based on the Bible, although a few secular (nonreligious) oratorios have been written. An oratorio is performed without scenery, costumes, or action. The story is told through the music, which consists of recitatives (solo, speechlike sections), arias (solo, songs), duets, quartets, and other small vocal ensembles, and choruses. The orchestra's main role is to accompany the singers, but it also has sections of its own, such as overtures and interludes. The sections and kind of music in an oratorio resemble those of an opera, but there is no acting out of the story. In many oratorios a narrator is used to explain and connect the events of the story; this is particularly true in the kind of oratorio called a PASSION, which tells about the events leading up to Jesus's death. In other respects the oratorio is essentially the same as a CANTATA, but it is longer, more elaborate, and usually has a plot, a feature generally lacking in a cantata.

The term "oratorio" comes from *oratory,* a chapel in a church. In the late sixteenth century St. Filippo Neri, an important Italian religious leader, used the oratory of his church for spe-

SOME NOTABLE ORATORIOS

Composer	Title	Date
Thomas Augustine Arne	*Judith*	1761
Karl Philipp Emanuel Bach	*Die Auferstehung und Himmelfahrt Jesu*	1787
	("The Resurrection and Ascension of Jesus")	
	Die Israeliten in der Wüste	1775
	("The Israelites in the Wilderness")	
Ludwig van Beethoven	*Christus am Ölberg*, op. 85	1800
	("Christ on the Mount of Olives")	
Hector Berlioz	*L'Enfance du Christ*	1854
	("The Childhood of Christ")	
Johannes Brahms	*Ein deutsches Requiem*, op. 45	1869
	("A German Requiem")	
Giacomo Carissimi	*Jephte*	before 1650
Antonin Dvořák	*St. Ludmila*, op. 71	1886
Edward Elgar	*The Dream of Gerontius*	1900
César Franck	*Les Béatitudes* ("The Beatitudes")	1879
Charles Gounod	*La Rédemption* ("The Redemption")	1882
George Frideric Handel	*Esther*	1732
	Israel in Egypt	1739
	Jephtha	1752
	Joshua	1748
	Judas Maccabaeus	1747
	Messiah	1742
	Samson	1743
	Saul	1739
	Semele	1744
	Solomon	1749
	Susanna	1749
	Theodora	1750
Franz Joseph Haydn	*Die Jahreszeiten* ("The Seasons")	1801
	Die Schöpfung ("The Creation")	1797
Arthur Honegger	*Jeanne d'Arc au bûcher*	1938
	("Joan of Arc at the Stake")	
	Le roi David ("King David")	1921
Franz Liszt	*Christus* ("Christ")	1866
	Die Legende von der Heiligen Elisabeth	1862
	("The Story of St. Elizabeth")	
Frank Martin	*Le Mystère de la Nativité*	1959
	("The Mystery of the Nativity")	
Felix Mendelssohn	*Elijah*	1846
	St. Paul	1836
Horatio William Parker	*Hora Novissima*, op. 30	1893
Charles Hubert Hastings Parry	*Job*	1892
	Judith	1888
	King Saul	1894
Camille Saint-Saëns	*Le Déluge* ("The Flood")	1876
	Oratorio de Noël ("Christmas Oratorio")	1863
Robert Schumann	*Das Paradies und die Peri*	1843
	("Paradise and the Peri")	
Heinrich Schütz	*Die sieben Worte Christi am Kreuz*	1645
	("The Seven Last Words of Christ on the Cross")	

SOME NOTABLE ORATORIOS *(continued)*

Composer	Title	Date
Ludwig Spohr	*Die letzten Dinge* ("The Last Judgment")	1826
John Stainer	*The Crucifixion*	1887
Igor Stravinsky	*Oedipus Rex*	1927
Arthur Sullivan	*The Light of the World*	1873
Michael Tippett	*A Child of Our Time*	1943
	The Mask of Time	1984
William Walton	*Belshazzar's Feast*	1931

cial services consisting of sermons and hymns. The hymns were of the type called LAUDA, which were sung in Italian rather than Latin, and occasionally were performed by different groups of singers. From this practice developed the oratorio. There is some disagreement as to which composition was the first real oratorio. Some authorities say it was Emilio del Cavalieri's *Rappresentazione di anima e di corpo* ("Portrayal of the Soul and the Body"), composed in 1600. Others state Cavalieri's work is too similar to the style of the early operas being written at the same time and hold the first oratorio to be Giovanni Francesco Anerio's *Teatro armonico spirituale* ("Theater of Spiritual Harmony"), composed in 1619. Nevertheless, it is generally agreed that the first great composer of oratorios was Giacomo Carissimi (1605–1674). His oratorios had Latin texts and were also similar to operas of the period—indeed, Carissimi's chief followers, Alessandro Scarlatti and Alessandro Stradella, both were more noted for their operas—but they made much greater use of the chorus and usually included a part for a narrator. Outstanding among early oratorios are those of the German composer Heinrich Schütz and of Carissimi's French pupil, Marc-Antoine Charpentier (1643–1704). Schütz and many of his successors, most notably Bach, also composed Passion settings. (Bach's *Christmas Oratorio*, however, is actually a series of six cantatas in which the narrative and dramatic elements

are present to only a limited extent.) The outstanding composer of English oratorios—and many consider him the greatest oratorio composer of all—was Handel, whose most famous work is *Messiah*. It was Handel's music that inspired Haydn at the end of his life to compose *The Creation* and *The Seasons,* the latter being one of the first important secular oratorios. Mendelssohn's *Elijah* and *St. Paul* also take their inspiration from Handel. The nineteenth century produced few other oratorios of lasting quality except for Berlioz's *L'Enfance du Christ* and Brahms's *Ein deutsches Requiem* (which is not a setting of the Requiem Mass). Since 1900, however, notable oratorios have been composed by Elgar, Walton, Honegger, Stravinsky, Tippett, and others. The accompanying chart lists a number of important oratorios.

orchestra Also, *symphony orchestra.* A large group of players performing on stringed, brass, woodwind, and percussion instruments, whose number and type date largely from the second half of the nineteenth century. They are led by a conductor who stands in front of them (in earlier periods one of the players—a harpsichordist, pianist, or violinist—conducted from his or her place at the instrument). The players perform seated, except for a few, such as the percussionists and double-bass players, who either stand or lean against high stools. The precise number of instruments and their arrangement on a stage or in a pit (a

low section in front of the stage) varies, depending on both the score and the conductor's wishes. Usually instruments of the same family (string, brass, etc.) are grouped together. A frequently used arrangement is that of a semicircle, with the bowed strings in front (the first violins and violas on one side of the conductor, the second violins and cellos on the other side), and the winds and percussion in the center and rear (see the accompanying illustration for one conventional arrangement). Twentieth-century composers have sometimes made radical seating changes, such as mingling players with the audience, or dividing the full orchestra into separate ensembles.

Throughout its history, the orchestra has employed more bowed strings than wind or percussion instruments because their tone is soft compared to the others and would otherwise be drowned out completely. The violins are divided into two groups, first violins and second violins. All the first violins play the same part (the same notes) as do all the second violins unless the score specifically tells them not to (see DIVISI). (The instruments on which the first and second violin parts are played are, of course, identical.) Similarly the violas, cellos, and double basses all play parts written for all the instruments of each group. With the woodwinds and brasses, however, the score usually has a separate part for each instrument; a score that calls for three horns, for example, generally has a separate part for each of them (called first horn, second horn, third horn). The same is true for plucked strings (harps) and percussion. In some cases the instruments known by one name, such as oboes, are identical. In other cases, however, they are not; for example, the clarinets may consist of some B-flat and some E-flat clarinets, and the tubas may be bass or tenor. Occasionally the separate parts for instruments coincide, that is, first and second horn may play the same notes at the

same time (for a time). This device, called **doubling**, is used to reinforce a part. Also, a player may play more than one instrument. One of the flutists plays piccolo when it is called for, one of the oboists plays English horn, etc.

The modern symphony orchestra has about forty to one hundred players (fewer than forty makes it a CHAMBER ORCHESTRA). Although an orchestra usually lists its players beginning with the first violins and other string players, the most important of whom is the leading first violin (see CONCERTMASTER), orchestral scores list the instruments in order of their range within each choir (group), from the highest pitches to the lowest. A conventional symphony orchestra listed in this manner might consist of the following (a total of ninety-eight to one hundred twelve players):

I. Woodwinds (16)
 1 piccolo
 3 flutes
 3 oboes
 1 English horn
 3 clarinets
 1 bass clarinet
 3 bassoons
 1 contrabassoon

II. Brasses (13 to 18)
 6 to 8 French horns
 3 to 5 trumpets
 3 to 4 trombones
 1 tuba

III. Percussion (5 to 9)
 2 to 4 timpani
 3 to 5 other percussion (bass drum, tenor drum, snare drum, tambourine, triangle, cymbals; also tuned percussion, such as glockenspiel, xylophone, celesta, chimes)

IV. Unbowed stringed instruments (2 to 3)
 1 to 2 harps
 1 piano

V. Bowed strings (62 to 66)

16 to 18 first violins
16 second violins
12 violas
10 cellos
8 to 10 double basses

In addition to these more or less basic instruments, many others are occasionally used, among them the saxophone group, instruments from earlier times (harpsichord, oboe d'amore, recorder, basset horn, etc.), specialized brasses (Wagner tuba, cornet, euphonium, etc.), an enormous variety of percussion instruments (sleighbells, gong, wood block, marimba, claves, maracas, bongo drums, cow bell, and many others), and electronic instruments (electric organ, electric guitar, synthesizer, etc.).

The orchestra differs from a chamber group (quartet, octet, or the like) in that there may be more than a single player for each part and there are always several for each violin, viola, and cello part. However, the exact size and instrumental makeup of the orchestra have changed considerably during the course of its history. The first true orchestra seems to have been the group of some three dozen musicians assembled for Monteverdi's *L'Orfeo* in 1609. (The score lists thirty-six, but presumably the trumpets were supported by timpani, as was customary, even though no percussion instruments are named.) Throughout the baroque (1600–1750) the orchestra remained small, with about twenty to thirty-five players. The choice of instruments varied considerably, especially since composers still did not always specify particular ones. The viols of the Renaissance were gradually replaced by violins, which became the single most important group, but wind instruments— flutes, oboes, horns, and, later, bassoons and trumpets—also played an increasingly important role. The basso continuo (see CONTINUO) needed in so much baroque music was at first performed on various instruments (bass viol, harp, lute, harpsichord, organ), but by the eighteenth century it was generally played by one or more cellos, together with harpsichord or organ.

In the middle of the eighteenth century in Mannheim, Germany, the orchestra became a more standard group (see MANNHEIM SCHOOL); in particular, the violins were given the role of providing contrasts in volume (loud-soft). The woodwinds and brasses gradually became still more prominent, although the strings remained the most important section. By this time composers generally spec-

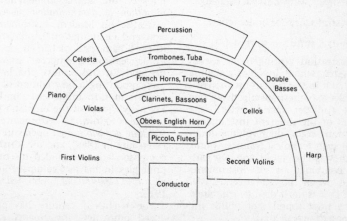

Percussion

Celesta

Trombones, Tuba

French Horns, Trumpets

Double Basses

Piano

Clarinets, Bassoons

Violas

Oboes, English Horn

Cellos

Piccolo, Flutes

First Violins

Second Violins

Harp

Conductor

ified particular instruments for the parts in their scores. The mid-eighteenth-century Mannheim orchestra consisted of thirty strings, four flutes, two oboes, two bassoons, and four horns; trumpets and timpani were available when needed. In the second half of the eighteenth century the CLASSIC composers expanded the wind section, adding a pair of clarinets (or more), a third oboe, and two more bassoons, and eventually gave each of these instruments a separate part (formerly they had often doubled one another, or even doubled a string or continuo part).

During the remainder of the nineteenth century the orchestra continued to grow, both in size and in variety of instruments. Winds and percussion instruments were added in great numbers, and the string section grew in proportion. First Wagner and Bruckner, and later Mahler and Richard Strauss, expanded the orchestral resources to huge proportions, creating great masses of sound. Debussy was among the first to react against this trend, returning to a careful selection of instruments for their individual tone color. Since about 1910 the size of the orchestra in general has shrunk, and composers have tended to pay careful attention to ORCHESTRATION. See also BAND; CHAMBER ORCHESTRA; GAMELAN; STRING ORCHESTRA.

orchestral score See under SCORE.

orchestral suite See SUITE, def. 1.

orchestration Writing music for an orchestra, which involves assigning parts of it to the various instruments. In order to orchestrate effectively, one must consider many factors: the ranges of the different instruments, their tone color, their volume (loudness), such technical features as how fast they can be played, and how various combinations of instruments sound when played together. All these factors must then be combined into a total sound that fulfills the composer's overall aims.

The complicated art of putting together instrumental parts in a specific way dates largely from the baroque period (1600–1750). Earlier composers often did not indicate which instruments were to play their music, and even in some baroque works instruments could be used interchangeably—for example, flutes or oboes could play violin parts, and vice versa. By the middle of the eighteenth century particular instruments were always specified in scores, although it was not uncommon for a single work to appear in arrangements for several different combinations of instruments.

The nineteenth century saw two important developments that revolutionized orchestration. First came the vast technical improvement of instruments, particularly the woodwinds (which received key mechanisms) and the brasses (which were given valves). At the same time came the romantic movement, with its emphasis on dramatically expressive music. In program music particularly, where the music was to tell a story, such expressiveness was vital. It was a French composer, Hector Berlioz, who made some of the greatest contributions to orchestration, both in his own compositions, in which he exploited the particular qualities of the various instruments, and in his book on the subject, *Traité d'instrumentation et d'orchestration moderne* ("Treatise on Modern Instrumentation and Orchestration"), published in 1844. Berlioz's book had enormous influence on such composers as Wagner and Richard Strauss, the latter even producing a new edition of it. Wagner in turn influenced Rimsky-Korsakov's ideas of the orchestra (in particular, following a performance of the *Ring des Nibelungen* operas in St. Petersburg in 1889), and the Russian composer later expounded his own principles in his two-volume *Principles of Orchestration*, published in 1913.

The twentieth century has produced both new instruments and unorthodox ways of using traditional

ones. In addition to ELECTRONIC INSTRU-MENTS, composers have introduced such folk instruments as the cimbalom into the orchestra and have even made serious use of such sound effects as sirens, typewriters, and pistol shots.

Most serious composers today orchestrate their own music, sometimes devoting at least as much or a great deal more time to this aspect of composition than any other. A few composers delegate orchestration to someone else, a practice that has long been the case in jazz, Broadway musical comedies, and other popular music, where this work is generally done by arrangers (see also ARRANGE-MENT, def. 2).

Ordinary 1 The portion of the Roman Catholic Mass that always remains the same, no matter what feast or holiday is being celebrated (see MASS). 2 The fixed (unchanging) portions of other Roman Catholic services, such as Vespers.

ordre (ôr' dr⁹) *French.* A name used by François Couperin and others for a suite of dances for harpsichord, all in the same key (see SUITE, def. 1).

Orff (ôrf), **Carl** (kärl) 1895–1982. A German composer whose music emphasizes rhythm more than melody or harmony. Orff's most famous work is the dramatic cantata *Carmina burana,* which is set to a text taken from some thirteenth-century songs in Latin, German, and French. The work is scored for solo singers, chorus and orchestra, and, like much of Orff's music, its score calls for heavy use of percussion instruments to punctuate the all-important rhythms. Of Orff's other works, the best known are two comic operas, *Der Mond* ("The Moon") and *Die Kluge* ("The Clever Girl"), both based on fairy tales. Shortly after World War I Orff became interested in music education, and in the early 1930s he wrote *Schulwerk* ("School Music"), a series of musical exercises whereby very young children can learn music

step by step, using recorders, xylophones, glockenspiels, and other percussion instruments. Orff later revised these pieces considerably, and they have come to be used in many different countries.

organ Also, *pipe organ.* A keyboard instrument in which keyboards and pedals are used to force air into a series of pipes, causing them to sound. The organ differs from the other important keyboard instruments—clavichord, harpsichord, piano—in that pipes rather than strings produce the sound. (For the reed organ, see HARMONIUM; for electric or electronic organs, such as the Hammond organ, see under ELEC-TRONIC INSTRUMENTS; see also BARREL ORGAN.)

The organ is the most complicated of all the musical instruments, yet the basic principles whereby it operates were discovered more than two thousand years ago. The basic parts of an organ are its keyboards, consisting of one or more **manuals** (played by the hands) and a **pedalboard,** or set of pedals, for the feet; sets of wooden and metal **pipes,** each set being called a **rank** or *register,* of different length (which determines a pipe's pitch) and shape (which determines its tone quality); **wind chests,** usually one for the pipes of each manual, connected to the keys by means of valves called **pallets** and given a steady supply of air by means of bellows or electric fans; and **stops,** one for each rank of pipes, each of which is connected by levers to a **slider,** a thin strip of wood or plastic bored with a hole for each pipe in the rank. Each key or pedal controls a single pitch, which may, however, be produced by a number of pipes, each with a different tone color. Each stop controls a rank of pipes, which all have the same tone color but each of which sounds a different pitch. In order to sound a note, the organist must both press a key or pedal (select a pitch) and draw a stop (select a tone color). Drawing a stop, which simply involves pulling out

one of a series of knobs attached to the manual, causes a slider to move so that the holes are directly in front of the pipes of that rank, permitting air to pass into any of them. Pressing a key causes its pallet to open, allowing air to pass from the wind chest into the pipes of the pitch controlled by that key.

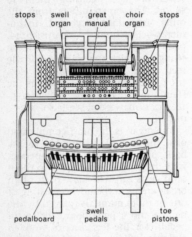

All organs work on these general principles. However, they may differ in their action, that is, how the keys and stops operate. **Tracker action** works in a purely mechanical fashion, by means of levers and other moving parts. (A *tracker* is a flexible piece of wood connecting a key with a valve.) **Electropneumatic action** employs electric current to move the sliders and pallets, so that the organ pipes need not be near the organ case or *console*, which houses the **keydesk** (the various keyboards). Since they are connected to the keydesk by electrical wiring, they can be fairly far removed, as, for example, at the far end of a large church. Occasionally an organ incorporates both mechanical and electrical action. In the concert hall organ at the Sydney Opera House in Australia, one of the world's largest organs, the mechanical action is duplicated by an electric action under microprocessor (computer) con-

trol. The organ therefore can be operated by a magnetic tape on which an original performance has been recorded digitally.

Aside from using one or the other kind of action, organs are essentially the same except for size—that is, the number of manuals, stops, and pipes. A small organ may have only a single manual and no pedal. On the other hand, huge organs have been built with up to seven manuals, a pedalboard, and 150 or more stops. To play most organ music, two manuals are required, each with five or six stops, plus a pedalboard with two to five stops. Three and four manuals are quite common.

Since each of the keyboards is more or less a complete organ—that is, it could be played without necessarily making use of the other keyboards—they often are called *organs* or *divisions*. They are named (except for the pedal) in order of their importance in British and American organs: PEDAL ORGAN, GREAT ORGAN, SWELL ORGAN, POSITIVE (or CHOIR) ORGAN, SOLO ORGAN, and ECHO ORGAN. An organ with but two manuals will practically always have a great organ and a swell organ, the swell manual being placed above the great manual. If a third is added, it is usually the positive (or choir) organ, whose manual is placed below that of the great organ. The solo manual is usually placed above that of the swell, and the echo manual above the solo manual. The positive (choir) organ originally was a separate instrument that in time became part of the main case.

Except for the pedal organ, whose range is lower than that of the other divisions and whose pipes are nearly always connected to the pedalboard, assignment of pipes and stops to the different keyboards is fairly flexible. Usually the great organ has the loudest stops and the swell organ the softest. In other respects the assignment of pipes to the different divisions, although it depends in part on tradition, varies widely, and very few organs are exactly alike. A device called a **coupler** makes available the

stops of one division on the keyboard of another. By drawing a certain coupler the organist can, for example, use on the pedals all the stops of the swell. Further, an **octave coupler** will bring into play the note an octave higher than the one played (plus the one ordinarily produced), and a **sub-octave coupler** will similarly provide the note an octave lower.

Organ **pipes** are open at the top and tapered at the bottom, where the air is blown in. The upper end of the pipe is surrounded by an adjustable sleeve (in an open pipe) or is closed by an adjustable stopper (in a closed pipe); either device makes it possible to change the length of the air column slightly for tuning. Organ pipes range from half an inch to thirty-two feet in length. The shorter a pipe, the higher its pitch. An open pipe (open at one end) that is two feet long will sound middle C; for an octave lower, it must be four feet long; for an octave higher, it must be only one foot long. In shape the basic organ pipe, called a **flue pipe**, resembles a whistle. If its SCALING (diameter) is fairly large in relation to its length (if it is fairly "fat"), the pipe's tone is muffled and dull; if its scaling is small (if the pipe is slender), the tone is much brighter. An open flue pipe that is overblown (has air forced into it under more pressure than usual; see OVERBLOWING) sounds an octave higher than its ordinary pitch; a stopped flue pipe (closed at one end) sounds an octave plus a fifth (a twelfth) higher when it is overblown. In the fifteenth century another kind of pipe, the **reed pipe,** was introduced. Unlike the flue pipe, in which air passes across a slit-shaped opening and causes the air column inside to vibrate, the reed pipe has a **beating reed,** a small piece of brass attached at one end that is made to vibrate by air and in turn passes its vibrations on to the air inside the pipe. Reed pipes are normally cone-shaped; when they are cylindrical (in straight tube shape) they sound an octave lower.

Flue and reed pipes are further

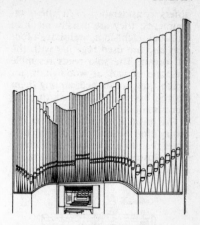

divided into categories, some of which are named for the tone color of the instrument they resemble (often only in a vague way), and all of which are based on minute differences in size, shape, and material of the pipes, which alter the proportion of the harmonics (overtones) and therefore the tone color. The main kinds of flue pipe are: **diapason,** made in all sizes (all pitches) and together producing the characteristic sound of the organ; there are further subdivisions in this family of pipes, among them open diapason (principal), flautino, and violin diapason; **flute,** a group of pipes, some stopped (stopped flute) and others open (chimney flute, spindle flute, block flute) which resemble the sound of a flute in that they sound few overtones; **string,** a group of pipes whose tone resembles that of various stringed instruments and whose members have such names as cello, viola, and gamba (for viola da gamba, the old bass viol). Flue stops that combine elements of several categories are called **hybrid stops.** Among them are gemshorn, combining string and flute, and spitzflute, combining principal and flute.

There are two main kinds of reed pipe, **chorus** and **solo.** The chorus reeds are named for trumpets and other brasses (trombone, trumpet, posaune, clarion) but their tone color

differs considerably from these instruments; they are usually made in four-foot, eight-foot, and sixteen-foot sizes and are used together with the full organ. The solo reeds resemble the tone of various woodwinds, for which they are named; among them are the bassoon, English horn, clarinet, and oboe.

The organ has an immense range, about nine octaves in all, which is larger than that of any other nonelectronic instrument. The written range is shown in the accompanying exam-

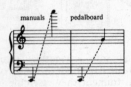

ple, but this range is greatly exceeded through the use of two-foot and sixteen-foot stops (see below). To have the organ's range, a piano would need a keyboard nearly half again as large. The organ manual actually contains only five octaves. However, the organ has not only pipes of normal pitch, which sound the note played on the keyboard, but additional pipes whose pitch is one and two octaves higher or lower. The normal pitch, called **unison**, is indicated by the sign 8′ (or 8-foot), the pitch one octave lower is indicated by 16′, and the pitches one, two, and three octaves higher are indicated by, respectively, 4′, 2′, and 1′. On the pedalboard the normal pitch is 16′ (an octave below the manual's), and the pitch one octave lower is 32′. These pipes are brought into play by the various stops and couplers.

The stops, too, are described in terms of size, as 4′, 8′, and so on. An 8′ stop sounds the pitch exactly as written, a 4′ stop sounds an octave higher, a 16′ stop an octave lower, and so on. The stops are named for the kinds of pipe they control, that is, principal stop, chorus stop, and so on. Thus an "8′ principal stop" con-

trols all the flue pipes of the type known as principal and sounding the same pitches as written. A 4′ principal would control the same kinds of pipe but an octave higher in pitch. These stops are known as **foundation stops**.

In addition, there are two special kinds of stop, mutation stops and mixture stops. A MUTATION STOP makes available not the unison pitch but one of its harmonics (overtones). The most important mutation stops are quint stops and tierce stops. Quint stops sound the twelfth, the third note in the harmonic series; for example, if middle C is played, the G in the octave above middle C (a twelfth higher than middle C) will sound. Tierce stops sound the seventeenth, the fifth note in the harmonic series; for example, if middle C is played, the third E above middle C will sound (two octaves and a third higher). Mutation stops are not played alone, but in combination with other notes, whose tone color they change by reinforcing a particular harmonic.

A MIXTURE STOP, also called *compound stop,* brings into play more than one pipe per note, that is, a chord. Usually combining anywhere from two to seven pipes per note, drawn from both unison and mutation ranks, the mixture stop is used together with a strong unison stop to vary, enrich, or reinforce the tone color. Among mixture stops are the *cymbal, fourniture, plein jeu,* and *Scharf.*

The stops selected for an organ by the builder are called its **specification;** the stops selected by the organist in playing are called the **registration.** Though some stops are naturally soft and others loud, their tone color influencing their volume, the organist also can control volume by means of a special pedal, the **swell pedal.** Located just above the pedalboard, the swell pedal controls a set of shutters in front of the pipes of one or more manuals, which are enclosed in a box; pressing it down gradually closes the shutters, thereby gradually reducing the loudness of the pipes.

(Originally the swell pedal controlled only the pipes of the swell organ, for which it is named. In modern organs it may control others as well.)

The technique of playing an organ is quite different from that for other keyboard instruments. The organist can play on one manual with the right hand and on another with the left; in fact, one may even manage to use three manuals at once, using four fingers on one manual and the thumb on another. At the same time, the feet work the pedals, which are laid out like an oversized keyboard. Organ music is ordinarily written on three staffs, two for the manuals and one for the pedals. Just as numbers are used to indicate fingering for keyboard instruments, special signs are used for the pedals, directing the player to use either heel or toe. Written over the notes, a sign means right foot; under the notes, it means left foot. The signs v or ʌ indicate toe, and ∪ or ∩ indicate heel. Complicated as it may seem, the organ has long been used for improvisation, both in earlier periods (especially the eighteenth century) and today.

The earliest known organ was the HYDRAULOS, built by the ancient Greeks about 250 B.C. It used water power to provide wind for the pipes. Between 350 and 400 years later, the water power was replaced by bellows, which were pumped by one or more assistants (in some medieval organs, as many as ten men were required for pumping). The first center of organ building was Byzantium (Constantinople), where elaborate instruments were constructed. By the eighth century organs were being built in Europe, where they were associated exclusively with the Church (the ancient Romans, on the other hand, had used organ music for entertainment at gladiatorial contests). These early organs were fairly primitive and loud, being more punched than played. The pipes varied only in length (and hence in pitch) and not width or shape, thus giving little variety of tone color. By the thirteenth century, however, the pipes were varied in numerous details. They were also increased in number, so that some organs now had three manuals plus a pedalboard, and numerous bellows. However, these organs still had no stops. Instead, the builder arranged pipes into "mixtures" (groups with different tone color), which became available by pressing a particular key. Of course, the organist could not personally select the mixture; it was prearranged by the builder. Along with these large, loud, cumbersome instruments, which could be used only in fairly large halls and churches, small organs were built. These were the **positives**, which stood on a table or on the floor, were much softer in volume, and had a more refined key action. It was in these that stops were first developed. Eventually they became part of the big organ (see POSITIVE ORGAN). In addition, two types of portable organ were built, the PORTATIVE and the REGAL.

The fifteenth century saw the development of three features that gave organs their basic modern characteristics: stops, reed pipes, and a coupling mechanism. The resulting rich palette of tone color soon attracted many composers, and the first really fine organ music, produced mainly by German masters (Paumann, Isaac, Hofhaimer, and especially Arnolt Schlick), dates from the second half of the fifteenth century. In England, Italy, and Spain, however, the organ of the Renaissance (1450–1600) remained much simpler, with only one manual, either no pedal or a very primitive one, and few stops. Though some fine music was written for this instrument as well— by John Redford (c. 1485–1547), Thomas Tallis, John Bull, Marco Antonio Cavazzoni (c. 1490-c. 1570), and Antonio de Cabezón—it proved inadequate for performing the masterpieces of organ music produced during the baroque period (1600–1750).

The baroque organ, as developed in northern Europe (Germany, Netherlands, France) between 1650 and

1750, and the music written for it by such masters as Sweelinck, Scheidt, Schein, Buxtehude, Pachelbel, Froberger, and above all Bach, represent one of the great high points in music history. (See also BACH; BAROQUE.) This extraordinarily rich period appears to have come to an abrupt end after Bach's death in 1750, at least with regard to organ music. For a century or so thereafter little organ music of note was composed, and few fine organs were built. The romantic movement of the nineteenth century, however, gave new impetus to the instrument, although its ideals, quite different from those of the baroque, gave rise to a quite different school of organ building. Whereas the baroque organ had a wide range of carefully balanced solo and chorus stops and little possibility for changes in volume, the romantic organ was designed to give a range of expression as wide as that of a full symphony orchestra. The number of stops grew and grew, and special pedals were added to achieve such effects as crescendo and decrescendo (gradual increase and decrease of volume), sforzando (sharp accent), and vibrato (a steady wavering of volume). Though the romantic organ was poorly suited for the performance of baroque music, its wide range of expressiveness made it highly suitable for the organ compositions of romantic composers, among them Liszt and Franck, and later Reger, Elgar, and Charles-Marie Widor (1844–1937). About 1900 electropneumatic action was invented, enabling the building of tremendous instruments with many more pipes (since the pipes now did not have to be housed near the keydesk). A slightly later development was the THEATER ORGAN.

Just about the time that the romantic organ reached the greatest extremes of size and tonal variety, a reaction set in. The early decades of the twentieth century saw a revival of interest in baroque music, and also in the ideals of the baroque organ. Spurred by the efforts of Albert Schweitzer (1875–1965), this "reform" movement began in Holland, Scandinavia, and Germany, and gradually spread to France, America, and Britain. Some builders turned wholly to the baroque organ, rejecting electropneumatic action in favor of tracker action and in effect building instruments as much as possible like those of the eighteenth century. Others combined features of the baroque organ with elements of the nineteenth-century organ in an attempt to build instruments suitable for performing the music of many periods.

Numerous twentieth-century composers have written for organ. Among them are Schoenberg (*Variations on a Recitative* for organ, op. 40), Hindemith (*Kammermusik no. 7,* op. 46, no. 2, for organ and chamber orchestra; Concerto for organ and orchestra), Francis Poulenc (Organ Concerto), the French virtuoso organists Marcel Dupré (several symphonies and concertos for organ), Jean Langlais, and Maurice Duruflé (preludes, suites), the Belgian Flor Peeters (1903–1986), the Austrian Johann Nepomuk David (many works in older forms such as partita, ricercar, toccata, fugue), Olivier Messiaen (*Les Corps glorieux,* a suite for organ), Mauricio Kagel (*Fantasy* and *Improvisation ajoutée,* or "Added Improvisation," both combining taped real-life noises with a live organ), and György Ligeti (*Volumina*).

organ, electric See under ELECTRONIC INSTRUMENTS.

organ, reed 1 See HARMONIUM. **2** For reed pipes (stops) of the organ, see under ORGAN.

organa (ôr' gǝ nǝ) *Latin.* The plural of ORGANUM.

organ chorale Another term for the CHORALE PRELUDE.

organetto (ôr gä net' tô) *Italian.* Another name for the medieval PORTATIVE organ.

organ hymn A hymn in which alternating verses are played by the organ and sung by the choir. Most often the

organ played the odd-numbered verses and the choir sang the even-numbered ones. This practice, used mainly from 1400 to 1600 for plainsong hymns, eventually gave way to more elaborate organ treatments, culminating in the organ chorale or CHORALE PRELUDE.

organistrum (ôr gə nis' trəm) *Latin.* See HURDY-GURDY, def. 2.

organ Mass A musical setting of the Ordinary of the Roman Catholic Mass in which the singers alternate with the organ. The earliest such settings date from the fifteenth century. Later ones were composed in the sixteenth century by Girolamo Cavazzoni, and in the seventeenth century by Frescobaldi, Claudio Merulo, Andrea Gabrieli, and several French composers, among them Couperin. In most organ Masses the singers' part is plainsong (with one voice-part), followed by an organ part that elaborates on the plainsong polyphonically (with numerous voice-parts).

organ point See PEDAL POINT.

organ stops See under ORGAN.

organum (ôr' gə nəm) *pl.* **organa** (ôr' gə nə) *Latin.* A general name for the oldest form of polyphony (music with more than one voice-part). The earliest surviving organum dates from the ninth century, when a lower part was added to a plainsong melody that duplicated the melody, note for note, but either a fourth or a fifth lower. Thus, if the melody sounded the notes A G F, for example, the second part would sound either the D E B♭ immediately below, or the E D C. The first is called organum at the fifth and the second organum at the fourth. Both are examples of **parallel** or **strict** organum, since the two parts move exactly parallel to one another (both go down by the same intervals). Occasionally, the original and/or the new part would be doubled, that is, the notes an octave higher or lower would also be sounded (D–D', E–E', B♭–B♭', so that a total of three or four notes would sound at one time). Dur-

ing the eleventh century a new feature appeared. Occasionally the new part would move not parallel to the original part, but in the opposite direction, that is, down in pitch when the original moved up, or up when it moved down, in contrary motion. As a result, the two parts sometimes crossed, and the original no longer was always the higher part. Out of this grew another practice, that of adding a second part above the original instead of below it. However, the only intervals still used in adding parts were the perfect intervals, the fourth, fifth, and octave (see INTERVAL, def. 2). By the middle of the twelfth century, the two parts were no longer note against note. Instead, the added part might have many notes for each note of the original, which must have been sung quite slowly. As a result, the original part, with its fixed melody (*cantus firmus*) in long-held notes, came to be called the **tenor** (from the Latin *tenere,* meaning "to hold") and the added part was called *organum.* The older style, with both parts having an equal number of notes, was called DISCANTUS (def. 2). The school of St. Martial and the first great composer of the succeeding school of Notre Dame, Leonin, used both the old and the new styles of organum, often in the same composition. Leonin usually alternated the two. His works are still in two voice-parts, called *organum duplum* (the second part being called *duplum*). His successor, Perotin, often used three voice-parts (*organum triplum*), and, in at least two cases, four parts (*organum quadruplum*). When, still later, texts were added to the melismatic upper parts, it created a very important form of vocal polyphony, the MOTET. Our knowledge of organum comes largely from the *Magnus liber organi de graduali et antifonario* ("Great Book of Organum for Graduals and Antiphons") of c. 1170, the principal collection of two-voice polyphony from this period. Thought to have been written by Leonin and revised by Perotin, it survives in three slightly different versions.

Orgel (ôr'gəl). The German word for ORGAN.

orgue (ôrg). The French word for ORGAN.

orgue de barbarie (ôrg dᵊ bᴀʀ bᴀ rē'). The French term for BARREL ORGAN.

orgue expressif (ôrg ex pre sēf'). The French term for HARMONIUM.

ornaments Also, *embellishments;* British, *graces.* A general term for extra notes or groups of notes with which composers and/or performers adorn a melody. Depending on their nature, they may enliven the melody or the rhythm, or enrich the harmony. The use of ornaments has varied widely from period to period. Sometimes the exact notes to be used are written out, but in earlier periods

Mordent Inverted mordent Double mordent

written played written played written played

Trill or or

written

played (19th century) played (17th-18th centuries)

Turn Inverted turn

written played written played

Nachschlag (17th-18th centuries)

written played

Nachschlag (19th century)

written played

Acciaccatura

written played written played

Grace note Long appoggiatura

written played written played

they were frequently left up to the performer. In the sixteenth century signs began to be used as abbreviations for ornaments, especially in keyboard and lute music, but there was still a great deal of confusion as to just what each sign meant. Gradually the signs became more standardized, although they still varied somewhat in different countries. Many of the signs that came into general use throughout Europe were based on those used by French keyboard composers of the seventeenth century, who called them **agréments.**

Although since about 1900 most composers have tended to write out ornaments note for note, using almost no abbreviations except for the trill, knowledge of the conventional signs is needed to perform music of the seventeenth, eighteenth, and nineteenth centuries. The most important ornaments are the mordent, inverted mordent, double mordent, trill, turn, inverted turn, Nachschlag, acciaccatura, grace note, appoggiatura; all of these are illustrated in the accompanying example.

oscillator (o' si lā tər). An electronic circuit that produces an alternating-current voltage signal at some specific frequency. In synthesizers and electronic sound systems, it is the oscillator that is responsible for producing all sounds of a definite pitch. Unlike any musical instrument, it can produce a **sine tone,** that is, a tone totally lacking in harmonics (overtones). In early synthesizers the oscillator was set to a desired frequency, the sound was recorded, turned off, and then the oscillator was reset for the next pitch. This tedious process was eliminated in the early 1960s with the invention of a system of voltage control whereby an electrical voltage itself was used to set an oscillator frequency. The device controlling the **voltage-controlled oscillator,** or *vco,* might be a keyboard, a strip of conductive resistance ribbon, a joystick, a sequencer, or another oscillator; when the last-named is

used, the technique is called **frequency modulation.**

ossia (ô sē' ä) *Italian:* "or else." A term indicating another way of performing a passage, usually a somewhat easier way. Also, *oppure, ovvero.*

ostinato (ôs"tē nä' tô) *Italian.* Also, British, *ground, ground bass.* A shortening of *basso ostinato,* a bass part that is repeated over and over throughout a composition or section while the upper part (or parts) change. The ostinato serves to unify a composition, since it remains constant while the melody, harmony (chords), or counterpoint change. The practice of using an ostinato was very popular from the sixteenth to the early eighteenth centuries, especially in instrumental music, much of which was based on dance music. However, outstanding examples in vocal music were written by Monteverdi (in *Lament of Ariadne,* 1608) and Purcell (in Dido's Lament, from *Dido and Aeneas*). In the seventeenth century it was common to improvise above an ostinato. Among the important musical forms based on a basso ostinato are the chaconne, passacaglia, romanesca, folia, ruggiero, and passamezzo. (See also DIVISION, def. 1.)

ôtez (ō tā') *French:* "take off." A word used in such musical terms as *ôtez les sourdines* ("take off the mutes"), or *ôtez les boutons* ("take off the stops"). Also, *ôter.*

ottava (ô tä' vä) *Italian:* "octave." Also written *8va, all' ottava* (äl"ô tä'vä). Indication to raise or lower notes by an octave, cancelled by LOCO. **1** Also, *ottava alta* (ô tä' vä äl'tä), *ottava sopra* (ô tä'vä sôp'rä). Placed over one note or a group of notes, an indication that the notes should sound one octave higher than written. **2** Also, *ottava bassa* (ô tä'vä bäs'sä), *ottava sotto* (ô tä'vä sôt'tô). Placed under a note or a group of notes, an indication that the notes should sound one octave lower than written. **3** Placed under the treble clef, an indication that all the notes

on the treble staff should sound one octave higher than written. **4** Placed under the bass clef, an indication that all the notes on the bass staff should sound one octave lower than written. **5** coll'ottava (kôl ô tä'vä). A direction to play, in addition to the notes written, the notes an octave below (or, sometimes, above).

ottava alta See OTTAVA, def. 1.

ottava bassa See OTTAVA, def. 2.

ottava sopra See OTTAVA, def. 1.

ottava sotto See OTTAVA, def. 2.

ottavino (ô tä vē' nô). The Italian word for PICCOLO.

ottoni (ô tôn'ē). The Italian for brass instruments.

oud Another spelling for 'UD.

ouverture (ōō ver tyr'). The French word for OVERTURE.

Ouvertüre (ōō" ver tyr' ə). The German word for OVERTURE.

overblowing Forcing more air pressure into a pipe, causing it to sound not the ordinary pitch but one of its harmonics (overtones). Most often the tone sounded is exactly one octave higher than the pitch produced ordinarily, that is, the first harmonic of the HARMONIC SERIES; this is true of open pipes, such as oboes, English horns, bassoons, and flue pipes of organs. In some instruments overblowing produces the sound a twelfth (an octave plus a fifth) higher than the ordinary pitch, that is, the second harmonic in the harmonic series; this is true of clarinets and stopped organ pipes, which both are closed at one end.

Overblowing, which is an important technique in playing wind instruments, particularly woodwinds (oboes, clarinets, etc.), is accomplished both by the performer's blowing harder and by changing the position of the lips. This increased air pressure causes the column of air inside the instrument to vibrate not along its full length, which would produce the fundamental pitch,

but along a portion of its length. If that portion is exactly half of the total length, the first harmonic is produced; if it is one-third of the total length, the second harmonic (twelfth) is sounded. (See also SOUND; WOODWIND INSTRUMENTS.)

overdubbing See DUBBING.

overtone Another name for harmonic; see HARMONIC SERIES.

overture (ō' vər chər). A piece of orchestral music that serves as an introduction to a longer work, such as an opera, oratorio, ballet, or instrumental suite. The practice of writing overtures dates from about the middle of the seventeenth century, and the first composer to give such pieces a more or less standard form was Lully. The form he used, which came to be called **French overture**, consists of two sections, a slow, stately opening part, usually with dotted rhythm, and a fast section featuring imitation (repetition of the same melody in different voice-parts). Occasionally Lully added a coda (brief concluding section) in the slow style of the first section. Famous examples of the French overture are found in Purcell's opera *Dido and Aeneas* (1689) and Handel's oratorio *Messiah* (1742). The so-called "French overtures" of Bach and other German composers actually consist of an overture followed by a suite (group of related dance movements; see SUITE, def. 1).

Later in the seventeenth century another form of overture was established, principally by Alessandro Scarlatti. This form, which came to be called **Italian overture**, consisted of three sections, fast–slow–fast. Whereas the French overture was largely abandoned about 1750, the Italian overture, often called **sinfonia**, eventually developed into the classical SYMPHONY.

The overtures of the classical period (1785–1820; Haydn and Mozart) tended to be in one movement, often in SONATA FORM. They generally included some material from the opera or play they introduced, usually in the form of melodies. Later, during the romantic period, overtures generally helped set the mood for the plot of the play or opera. Another nineteenth-century development was the CONCERT OVERTURE, an independent piece. Wagner, when he turned from opera to music drama (c. 1850; see WAGNER, RICHARD), rejected the conventional overture in favor of a much shorter prelude, which led directly into the first scene of the opera.

ovvero (ō ver'ō). See under OSSIA.

p In scores, an abbreviation for *piano* ("soft"). It is sometimes (but not often) used in keyboard music as an abbreviation for PEDAL.

Paderewski (pä der ef′ skē), **Ignace Jan** (i gnä′ tse yän), 1860–1941. A Polish pianist, composer, and statesman who is remembered as one of the most successful concert artists of all time. After years of study, both at the Warsaw Conservatory and under the greatest piano teacher of the time, Theodor Leschetizky (1830–1915), Paderewski began his concert career in 1887, touring the world for more than forty years. An intense patriot, he gave much of the enormous sums he earned to the Polish government. After World War I Paderewski served for a year as Premier of the new Polish republic, and in 1940, after the Nazis had invaded Poland, he was given an important post in the Polish government-in-exile. Though Paderewski's compositions include a symphony and other longer works, he is remembered mainly for his piano music, which includes the much played Minuet in G (op. 14, one of his six *Humoresques*).

Paduana (pä″ dōō ä′ nä). A German name for PAVANE.

Paganini (pä gä nē′nē), **Niccolò** (nē′ kô lô), 1782–1840. An Italian violinist and composer who is considered the greatest violin virtuoso of all time.

Paganini began making concert tours in his early teens, and his technical feats astounded audiences throughout Europe. He could play a whole piece on a single string, but aside from such achievements, which some dismissed as parlor tricks, he had tremendous command over double stops, pizzicatos, harmonics—in short, all the techniques of violin playing—and he advanced the technique of violin playing more than any previous performer. His compositions, few of which he allowed to be published during his lifetime, include Twenty-four Caprices for violin solo, op. 1; string quartets (in some of which a guitar is used instead of cello or bass); several concertos; and many sets of variations. Paganini's colorful career—he was a gambler and liked high living—as well his remarkable technique aroused the interest of later romantic composers, among them Liszt, Chopin, Schumann, and Brahms. Some wrote piano versions of his violin works. One of the caprices, in A minor, was used by Brahms for his *Variations on a Theme of Paganini* for piano (other composers, among them Schumann and Rachmaninoff, also used this theme as a basis for variations), which today is heard more often than any of Paganini's own compositions.

Palestrina (pä les trē′nä), **Giovanni Pierluigi da** (jô vän′ nē pyer″ lōō ē′

jē dä), c. 1525–1594. An Italian composer who is remembered as one of the greatest composers of church music. Born in the town of Palestrina, near Rome, he took its name as his own (his family name was Pierluigi). His early training was as a choirboy, at home and later in Rome, where he continued to work in various churches —as organist, choirmaster, and composer—for most of his life. Palestrina was a master of counterpoint, of weaving together melodies into a balanced fabric of harmony and rhythm. His works, which include hundreds of Masses, motets, and madrigals, are noted for the skillful use of IMITATION and of dissonance. Most of them have from four to six voice-parts and are sung *a cappella* (without accompaniment). The most famous of his more than a hundred Masses is the *Missa Papae Marcelli* ("Marcellus Mass," dedicated to the Pope), in six voice-parts. Near the midpoint of Palestrina's career, a church council, the Council of Trent, became concerned with the fact that the words of the Mass were often obscured by the complicated polyphonic music composed for it, much of it based on secular (nonreligious) melodies (see under MASS). Some authorities believe that Palestrina influenced the council in its decision not to outlaw all polyphony, but most scholars today believe that he took little (if any) part in the controversy. In any event, his own works were not censured, and his style was officially considered a model for church music for many years. Even today the term **Palestrina style** is used for well-controlled, transparent counterpoint, with proper attention to the text so that it is understandable but does not interrupt the flow of the music, and with very careful handling of dissonance.

pallet See under ORGAN.

palmwine A kind of West African popular music for acoustic guitars, light percussion, and one or two voices, so called because it originated in palmwine bars.

pandora (pan dôr′ ə). Also, *bandora*. A large stringed instrument supposedly invented in London in 1562 and used for about a hundred years. It very much resembled a bass CITTERN except that its body was not rounded, like the cittern's, but scalloped, usually in three sections. It had six or seven pairs of metal strings, which were plucked with a plectrum, and its fingerboard had frets to mark the stopping positions.

pandoura (pan do̅o̅r′ ä). Also written *pandura*. A lute used by the ancient Greeks and Romans. It had a long neck, a pear-shaped body, and usually two strings, which were simply tied to the neck. Its descendants remained popular in the Near East and eastern Europe, usually acquiring a third string in the course of time. Related folk instruments, such as the BANDURRIA of Spain and the tanbur of the Near East, generally have metal strings that are tuned by means of pegs.

pandura See PANDOURA.

panpipes A simple wind instrument consisting of two or more pipes of different sizes, which are fastened together like the logs of a raft. The pipes are stopped (closed) at one end and have no finger holes. Thus each pipe can sound only one note and its harmonics (overtones), which are obtained by OVERBLOWING. There is no reed. The player simply blows across the open top end of the pipes. One of the oldest and most widespread instruments, panpipes are found among peoples all over the world.

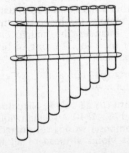

The ancient Greeks called them **syrinx**; they were used mainly by herdsmen, whose patron god was Pan (hence their English name). Though the Greek pipes were made of cane, other peoples have used stone, clay, metal, or wood. Panpipes were used in ancient China, as well as in South America and Europe.

pantonal See under ATONALITY.

parallel A term applied to intervals and chords, referring to the repetition of the same interval or chord, over and over, on successive degrees of the scale. This device is also termed *consecutive* intervals or chords. (In the accompanying example, *A* shows parallel intervals and *B* shows parallel chords.) Although parallel intervals

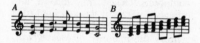

represent the earliest kind of polyphony (see ORGANUM), by the fifteenth century it was felt that the different voice-parts of a composition had to be more independent, and as a result parallel fifths (shown in the example here) and parallel octaves were avoided. This idea was incorporated into the rules of classical harmony and as such was maintained until about 1900. Certain parallel chords, however, were permitted—mainly the sixth chord and diminished seventh chord—but others, such as the triad and seventh chord, were avoided, since their use results in parallel fifths (the triad C–E–G, for example, includes the fifth C–G; see the example). (See CHORD for an explanation of these terms.) Of course there were occasional lapses from these rules, but on the whole they were accepted until about 1900, when Debussy and other composers deliberately began to use parallel chords. The use of parallel chords, which not only introduce dissonances but also deny the traditional idea that chords must function in particular ways, became typical of impressionist music (see IMPRESSIONISM). They have been used very effectively by various twentieth-century composers, notably Stravinsky. —**parallel key** See under KEY, def. 3. —**parallel motion** See under MOTION, def. 2. —**parallel organum** See under ORGANUM.

parameter (pə ram′ə tûr). A term borrowed from mathematics to describe any aspect of a musical sound that can be varied. In traditional music, consisting of sounds made by voices or musical instruments, these aspects include pitch, duration (how long a tone is held), volume (loudness), tone color (the mixture of specific harmonics, or overtones, which gives an instrument its characteristic sound), etc. Sounds that fill certain requirements are called for in the composer's score and are produced by the performer as well as possible (each instrument, for example, is limited in the matter of tone color). In serial music some or all of the parameters may be determined by serial procedures. In electronic music, in which the sounds are created by machinery, the composer can control virtually all the parameters of sound: pitch, duration, tone color, intensity, volume, attack (how fast a tone is produced), decay (the manner in which a tone fades away), and others. The mixture of harmonics can be altered in every imaginable way, and, in theory at least, an endless number of tonal combinations are possible. (See also ELECTRONIC MUSIC.)

paraphrase In music, the repetition of a musical idea (usually a melody or part of a melody) in different form. Often the original idea is so changed, or so much new material is added, that the original may be hard to recognize.

parlando (pär län′ dô) *Italian:* "speaking." **1** In vocal music, a direction to sing in a manner similar to speaking clearly, usually quite rapidly and with careful enunciation. A PATTER SONG is a good example of parlando. (See also RECITATIVE; SPRECHSTIMME.) **2** Also, *parlante* (pär län′te). In instrumental

music, a direction to play in a crisp manner, the opposite of legato (smooth).

parlante See PARLANDO, def. 2.

parlor music, parlor song See under SALON MUSIC.

parody 1 An exaggerated imitation of a composition or, more often, a style of composition, in order to make fun of it. The operattas of Gilbert and Sullivan often poke fun at musical conventions, particularly those of grand opera, either by setting a humorous text to traditionally serious music (for example, the Fairy Queen's lament about Captain Shaw in *Iolanthe*) or by exaggerating a musical device to the point where it is absurd (Mabel's opening aria, with a long cadenza on the *Ma-* of her name, in *Pirates of Penzance*). A famous example of musical parody is Mozart's *Ein Musikalischer Spass* ("A Musical Joke"), K. 522, which parodies a village band, wrong notes and all. Among the most successful recent composers of musical parodies is Peter Schickele (1935–), best known for his invention of the fictitious P.D.Q. Bach, through whom he pokes fun at the music of Johann Sebastian Bach and many other composers, as well as musical conventions. **2** In earlier music, before about 1650, borrowing two or more voice-parts from an existing polyphonic composition, such as a motet, for a new, usually more elaborate composition, such as a Mass. A not uncommon practice in sixteenth-century music was reworking a madrigal into a long piece for lute or harpsichord. Even more common, especially during this period, was taking portions (sometimes whole sections) from a madrigal or motet and using them in a Mass setting (see PARODY MASS).

parody Mass A Mass setting based on another piece of music. It differs from the cantus firmus Mass, in which only the CANTUS FIRMUS (fixed melody) in one voice-part (usually the tenor) is borrowed, in that its borrowed material comes from several or all the voice-parts of another work. The practice of writing parody Masses was quite common during the Renaissance (1450–1600). Composers used either their own music or someone else's, and they generally gave credit to at least the name of their source in the title of the Mass. For example, Ockeghem's *Missa Fors seulement* is based on his own chanson (secular polyphonic song) *Fors seulement l'attente;* Obrecht's *Missa Rosa playsant* is based on a chanson by either Caron or Dusart; Nicolas Gombert's *Missa Je suis désheritée* is based on a chanson by Pierre Cadéac; etc. The earliest examples of the parody technique, dating from the 14th century, use it only in a single section of a Mass. During the fifteenth century the Flemish composers (Ockeghem, Obrecht, and others; see FLEMISH SCHOOL) applied it more and more, and by the sixteenth century the majority of Masses written by the great masters of the form, Orlando di Lasso and Palestrina, were carefully constructed parody Masses.

part 1 In music for more than one instrument or voice, a term for the notes assigned to a particular instrument (or group of instruments) or voice (voices), such as the violin part, flute part, tenor part, bass part, etc. Depending on the composition, such a part may be solo (for one instrument or one voice) or ensemble (the entire cello section of an orchestra, or the alto section of a choir). **2** In all music other than monophony, which consists of only a single melodic line, a term used for each of the various melodic lines. Such music is sometimes called part music, although scholars prefer the more specific terms "homophony" and "polyphony." Since these parts may be played by a single instrument, this dictionary uses the terms "voice-part" for such a melodic line, in order to avoid confusion with def. 1 above. However, it does not distinguish which kind of part is meant in terms such as "three-part fugue," which means a fugue with three

voice-parts, in order to avoid the more cumbersome (but more accurate) term "three-voice-part fugue." Similarly, "four-part harmony" refers to a composition with four voice-parts. **3** In compositions that consist of several sections, such as a hymn with a number of verses (stanzas) alternating with a single refrain, a name given to the various sections. Thus one speaks of "three-part song form" (SEE BINARY FORM; TERNARY FORM; also PART SONG).

partbook In the fifteenth and sixteenth centuries, a book containing the music for only one voice-part of a polyphonic work (consisting of several voice-parts), either vocal or instrumental. In the seventeenth century, with improved printing techniques, the practice of publishing separate parts was replaced by use of a full score. (See also under SCORE.)

parte (pär' te) *Italian.* The Italian term for part (see PART, defs. 1, 2). —**colla parte** (kô'lä pär'te). A term meaning "with the part," indicating that the accompaniment (instruments or voices) are to follow the tempo set by the soloist.

partial Another name for overtone (see HARMONIC SERIES).

partita (pär tē'tä) *Italian.* **1** Originally, a variation, in the sense of theme (melody) and variations. The term was first used about 1600, mainly by Italian composers of keyboard music, such as Frescobaldi and others. **2** Later, another name for suite (see SUITE, def. 1). This meaning, which began to be used about 1700, mainly in works by German composers, is the one most current today, largely because the best-known partitas are suites by Bach (six partitas for harpsichord in his *Clavierübung*, Book 1; three partitas for solo violin).

part music Any music with more than one voice-part, either homophonic or polyphonic (see PART, def. 2; HOMOPHONY; POLYPHONY). However some writers use it only for poly-

phony, in which the voice-parts are of more or less equal importance. (See also PART SONG.)

part score See under SCORE.

part song 1 Any song with more than one voice-part. **2** A song in which one voice-part (nearly always the highest) carries the melody and the other parts provide an accompaniment in the form of chords. This type of song, which is better described as homophonic (see HOMOPHONY), is distinguished from a song in which all the voice-parts are more or less equal in importance, such as a madrigal (see POLYPHONY).

part writing See VOICE-LEADING.

passacaglia (pä" sä käl' yä) *Italian.* Also, French, *passacaille* (PAS A kī'y°), *passecaille* (PAS kī'). A dance form used in the suites of the seventeenth and eighteenth centuries (see SUITE, def. 1) that is almost impossible to distinguish from another dance form so used, the CHACONNE. Like the chaconne, the passacaglia is moderately slow and stately, and usually in triple meter (any meter in which there are three basic beats in a measure, such as 3/4 or 3/8). German composers always made the passacaglia a set of variations over a basso ostinato, a theme in the bass that is repeated over and over with little or no change. The most famous example of this type is Bach's Passacaglia in C minor for organ. French composers, notably François Couperin, did not always use the theme in the bass, nor did they repeat it without interruption. More commonly they alternated the theme with a series of short passages of equal length, so that the theme became a kind of fixed "refrain" for different "stanzas."

passacaille See PASSACAGLIA.

passage Any short section of a musical composition.

passage work A musical passage consisting of rapid figures (other than scales), whose performance requires

considerable technical skill. (See also RUN.)

passaggio (pä sä'djô) *Italian.* The portion of the singing voice where it changes from one REGISTER (def. 3) to another. The term is most often used for the transition from middle voice to head voice.

passamezzo (pä" sä me'tsô) *pl.* **passamezzi** (pä" sä me' tsē) *Italian.* A dance popular in Italy during the sixteenth century. In duple meter (any meter in which there are two basic beats per measure, such as 2/2 or 2/4), it is very similar to the PAVANE but is in faster tempo. Also like the pavane, it was often paired with a lively dance, such as the saltarello or galliard. Many passamezzi, like other dances of this period, are based on a particular harmonic pattern (pattern of chords related in a particular way, such as tonic–subdominant–dominant, or I–IV–V; see SCALE DEGREES for an explanation), which is repeated over and over in the bass. For the passamezzo, two harmonic patterns were so used. Frequently they appeared as a basis for variations (by William Byrd in compositions for virginal, for example), the same bass being used over and over to unify a melody and variations in the top parts. The two patterns, one called **passamezzo antico** (old passamezzo) and the other **passamezzo moderno** (modern passamezzo), are shown in the accompanying illustration. Note the

Passamezzo antico

Passamezzo moderno

shape of the notes: all but those in the next-to-last measure are *longae* (plural of *longa*), each of which is equivalent to four whole notes. The other two are *breves*, each of which is equal to two whole notes. These long-held notes in the bass made it easy for composers to construct a variety of

melodies in the upper parts, as well as to fill in the bass with shorter notes between the basic harmonies.

passecaille See PASSACAGLIA.

passepied (pas' pyā) *French.* A quick, gay French dance of the seventeenth century, in triple meter (any meter in which there are three basic beats per measure, such as 3/4 or 3/8). It is thought to have resembled a lively minuet. Popular at the French court, the passepied was included in the ballets and operas of the period, and later it became one of the dance forms used in eighteenth-century instrumental suites. Examples occur in Bach's Orchestral Suite no. 1 and his English Suite no. 5.

passing note See PASSING TONE.

passing tone Also, British, *passing note.* A note appearing between two chords that is dissonant with both of them and is one scale step removed from a note in each. Thus the passing tone fills the leap of a third between a note of the first chord and a note in the second chord, and the voice-part containing it must move stepwise either up or down. For example, if chord 1 is G–D–G'–B' and chord 2 is G–G'–B'–D', the note C' between the two chords, dissonant with the D held in the bass and creating the scale progression B-C-D in the top voice-part, is a passing tone. Passing tones are usually unaccented (fall on a weak beat) but they may be accented (fall on a strong beat).

Passion A musical setting of Bible texts telling the story of the Passion, that is, the events of the week leading up to Jesus's death on the cross. These texts are found in the first four books of the New Testament, called the Gospels, and often the title of the composition specifies which account

has been used (for example, Bach's Passion According to St. Matthew, or St. Matthew Passion). Most settings include the full story, beginning with Jesus's entry into Jerusalem on Palm Sunday and ending with his Resurrection (rising from death), and therefore they are fairly long compositions. Some, however, treat only a portion of the story.

In the Roman Catholic Church, the reading of the four Gospels takes place during Holy Week (the week between Palm Sunday and Easter Sunday, which celebrates Jesus's Resurrection). During the Middle Ages, this reading, which was actually a recitation in plainsong (Gregorian chant), began to be divided among three singers, one taking the part of Jesus, a second the part of the Evangelist (the narrator, that is, the author of the Gospel), and a third the part of the crowd of spectators. The part of Jesus was low-pitched and slow, the Evangelist's was of medium range and moderate tempo, and the crowd's was of high range and fairly rapid. During the Renaissance (1450–1600) polyphonic treatment (use of several voice-parts together, as opposed to the single voice-part of the plainsong) began to be used for the Passion, at first (fifteenth century) only to the sections sung by the crowd but later (sixteenth century) to the other sections as well. Often the original plainsong melody was used as a cantus firmus (fixed melody) over which other voice-parts were added. Among the notable settings of this period are those by Lasso, Byrd, and Victoria; Victoria's two Passions are still performed during Holy Week in the Sistine Chapel of the Vatican.

During the seventeenth century, when monody (accompanied melody) largely replaced polyphony (in which all voice-parts are equally important), two new forms, the aria and the recitative, began to be used in Passion music. Another new development was the addition of orchestral accompaniment. Until the Protestant Reformation (established first in Germany

during the 1520s), the Passion texts were always in Latin, and in countries that remained Catholic after the Reformation, such as Italy, they continued to be in Latin. In other countries, however, as the Bible was translated into the local language, the translated Gospel texts were set to music. Frequently other texts were added to them, mainly psalms and hymns. The German composers in particular contributed their own form, the Lutheran CHORALE, which they often included in Passion settings. The greatest seventeenth-century composer of Passion music was Schütz, whose settings were not wholly typical. In his three complete Passions (Matthew, Luke, John), dating from 1666, Schütz blended the old style (Renaissance polyphony) with the new (baroque monody). For the sections sung by the crowd he used *a cappella* polyphony (music in several voice-parts and without instrumental accompaniment), but for the Evangelist's part he created a wholly new effect, a monophonic recitative (chant with one voice-part), in spirit like the original plainsong but in practice consisting of new music. None of Schütz's Passions includes instrumental accompaniment (though he did use some in other works, such as an earlier oratorio about Jesus's Resurrection).

By 1700 the Gospel texts were sometimes completely replaced by contemporary poems, often not very good ones. At this stage the Passion differed little from an ORATORIO, and sometimes even from an opera, except that its text always concerned the story of Jesus's last days and, in Germany at least, the music included some chorales. Passions of this type were written by Handel, Telemann, and others. The greatest Passion music of the eighteenth century was composed by Bach, whose St. Matthew Passion and St. John Passion rank among the outstanding choral music of all time. The texts are those of the Gospel, along with new poetry for arias and choruses. Other eigh-

teenth-century composers of Passion music are Niccolò Jommelli and Giovanni Paisiello of Italy, and Telemann and Karl Philipp Emanuel Bach of Germany. There were also a number of oratorios dealing with the Passion story, of which the best known is Haydn's *Die sieben Worte des Erlösers am Kreuz* ("The Savior's Seven Last Words on the Cross"). The nineteenth century largely neglected Passion music. During the twentieth century, there has been a mild revival of interest in the form. Examples include a Passion (1933) by Hugo Distler and a St. Matthew Passion (1950) by Ernst Pepping. The Polish composer Krzysztof Penderecki also wrote a Passion According to St. Luke (1966), a large-scale work (for full orchestra, three soloists, narrator, and four choruses) that combines styles ranging from Gregorian chant and medieval polyphony to such modern devices as quarter tones and aleatory elements (in which the performers have a choice).

passionato (pä" sē ô nä' tô) *Italian.* Also, *con passione* (kôn pä sē ô'ne). A direction to perform in a fervent, highly expressive manner.

passione, con See PASSIONATO.

pasticcio (päs tē' tchô) *Italian.* A composition consisting of music by several composers. Composers may work together for the precise purpose of creating such a work, or it may be created by an arranger who takes material from already existing compositions. Famous examples of the first kind are the three-act opera *Muzio Scevola* (1721), for which Filippo Amadei (1683–?), Giovanni Bononcini (1670–1747), and Handel each wrote one act, and a piano work by Anton Diabelli (1781–1858), including a waltz on which fifty other composers, among them Beethoven, each wrote a variation. The second kind of pasticcio is associated mainly with the eighteenth century, when it was a common practice to create a composition by joining together arias

and other numbers from well-known operas. One of the best known is *Love in a Village* (1760) by the English composer Thomas Arne (1710–1780). (See also BALLAD OPERA; MEDLEY.)

pastoral A general term for any musical composition or section of a composition that suggests country life, especially the sounds associated with shepherds. See also PASTORALE.

pastorale (päs"tô rä' le) *Italian.* 1 A short dramatic entertainment of the sixteenth and seventeenth centuries whose plot concerns country life. Such plays, which are considered a forerunner of opera, were popular first in Italy and then in France. 2 A short instrumental composition or movement of a longer work in which the music to some extent imitates country sounds. Such music is usually in 6/8 or 12/8 meter and moderate tempo, not unlike a lullaby. Often there are long-held notes in the bass, suggestive of the drones of shepherds' bagpipes, and a lilting melody in the treble, suggesting the sound of a shepherd's pipe. Famous examples include Bach's Pastorale for organ, and the instrumental section marked *Pifa* (for *pifferari,* the Italian for "shepherds") in Handel's oratorio, *Messiah;* the latter is frequently referred to as *Sinfonia pastorale* ("Pastoral Symphony"). 3 A descriptive title for an instrumental work that more or less suggests aspects of country life. Among the best known are Beethoven's Symphony no. 6, to which he not only gave the title *Sinfonia pastorale* but added descriptive titles for each movement; Beethoven's Piano Sonata in D, op. 28, which the publisher entitled "Pastoral Sonata" for reasons that are not clear; and Vaughan Williams's Symphony no. 3, entitled *Pastoral Symphony.*

patching The process of combining various circuits or modules in a SYNTHESIZER to create a specific sound or "voice." Sometimes the sound so created is called a **patch.** The term comes from patch cords, the cables

used in early synthesizers to interconnect the various modules. Synthesizers often are used to imitate traditional acoustic instruments and naturally occurring sounds, and in many the interconnections between modules are hard-wired internally, so that preselected patches can be played simply by flipping switches and adjusting controls to obtain, for example, the rattling sound of snare drums.

patetico (pä tet' ē kô) *Italian*. A direction to express great feeling.

pathétique (pA tā tēk') *French*. A term directing the performer to express deep feeling. It also appears in the title of various compositions, of which the best known are Beethoven's Piano Sonata in C minor, op. 13, entitled *Grande sonate pathétique* (usually translated as "Pathétique Sonata"), and Tchaikovsky's Symphony no. 6 in B minor, op. 74, entitled *Symphonie pathétique*.

pathetisch (pä tā'tish) *German*. A direction to express great feeling.

patter song A humorous song, often used in comic opera, which is sung very fast, in parlando style (see PARLANDO, def. 1). Indeed, its humor depends as much on this style of performance as the actual words of the song. Examples are found in Mozart's *Don Giovanni* (Leporello's "Catalogue" aria), Rossini's *Il Barbiere di Siviglia* ("The Barber of Seville"; Figaro's "Largo al factotum" aria), and in nearly all of Gilbert and Sullivan's operettas ("I am the very model of a modern Major-General" in *Pirates of Penzance;* "The pluck of Lord Nelson" in *Patience;* "Oh a private buffoon is a light-hearted loon" in *The Yeomen of the Guard;* "When you're lying awake" in *Iolanthe;* etc.).

Pauke (pou'kə) *pl.* **Pauken** (pou'kən). The German term for kettledrum (see TIMPANI).

pausa (pou' zä). The Italian term for REST.

pause 1 A held note (see FERMATA). **2**

(pōz). The French term for REST. **3** *Pause* (pou' ze). The German term for REST.

pavan Another word for PAVANE.

pavana (pä vä' nä). An Italian and Spanish word for PAVANE.

pavane (pA vAn') *French*. Also, *pavenne;* Italian, Spanish, *pavana* (pä vä' nä); English, *pavan, pavin* (pa' vən); German *Paduana* (pä"doo ä' nä). A slow stately dance, usually in duple meter (any meter in which there are two basic beats per measure, such as 2/2, 2/4, or 4/4). A court dance, it originated in the sixteenth century, probably in Italy (the name is thought to come from Pava, another name for the city of Padua), and soon spread to other countries. It was usually followed by a lively dance in triple meter (in which there are three basic beats per measure, such as 3/4 or 3/8), most often the galliard or saltarello. The pavane remained popular until about 1575, when it was largely replaced by the PASSAMEZZO. By the early seventeenth century the pavane had become a purely instrumental form. As such it was used by the great English virginal composers (Byrd, Bull, Gibbons, Morley, and others; see also under VIRGINAL), as well as by German composers in instrumental suites (see SUITE, def. 1).

pavenne Another spelling for PAVANE.

pavillon (pA vē yôN') *French*. The bell of a brass instrument. —**pavillons en l'air** (pA vē yôN'zän ler'). A direction to a player of a brass instrument to perform with the bell held up, which increases the volume.

pavin (pa'vən). Another word for PAVANE.

Ped. An abbreviation for pedal; it is often printed in script (𝒫𝑒𝒹). See under PIANO, def. 2.

pedal 1 In the harp, a foot-operated lever that serves to change the tension, and therefore the pitch, of the strings. There are seven pedals, one for each note of the diatonic scale.

Each pedal can raise the pitch of a group of strings (all the C strings, for example) by either one half tone or one whole tone. (See also HARP.) **2** In some harpsichords, a foot-operated keyboard similar to that of the organ, enabling the bass part to be played with the feet. This type of instrument, also known as **pedal harpsichord**, was occasionally built in the sixteenth and seventeenth centuries, but no example of it has actually survived. Similar pedal mechanisms appear to have been used for clavichords as well. In the late eighteenth century harpsichords were sometimes provided with pedals to change the stops, and also to control a swell device for increasing and decreasing the volume (loudness). **3** Also, *pedal piano*. A piano equipped with a pedal mechanism like that of the pedal harpsichord (see def. 2 above). Such instruments were occasionally built during the nineteenth century, but their success was short-lived. Schumann and several other composers wrote a few pieces for pedal piano. **4** Also, *pedalboard*. In the organ, a set of levers that is in effect a keyboard played by the feet (see PEDAL ORGAN). In addition, special foot-operated levers may be added, such as the swell pedal, which controls shutters that regulate the volume of various organ pipes (see under ORGAN). **5** In the piano, two or three foot-operated levers that alter the volume and tone quality by controlling the dampers or hammers that touch the strings. (See under PIANO, def. 2.) **6** In timpani, a pedal serves to loosen or tighten the drumhead, thus changing the pitch. **7** A shortening of PEDAL POINT. **8** A foot-operated lever to sound a hi-hat cymbal.

pedalboard See under KEYBOARD; PEDAL, def. 4.

pedal clarinet Another name for the contrabass clarinet; see under CLARINET.

pedal coupler See under COUPLER.

pedal guitar A HAWAIIAN GUITAR fitted with pedals to change the pitch of a note before or while it is being sounded.

pedal harpsichord See PEDAL, def. 2.

pedal note The British term for PEDAL TONE.

pedal organ The division (sets of pipes) of an organ that is operated by the pedalboard, a foot-operated keyboard. Although the specific pipes assigned to the pedals vary widely from instrument to instrument, they nearly always include those of the lowest pitches. (see also ORGAN.)

pedal piano (See PEDAL, def. 3.

pedal point Also, *drone, drone bass, bourdon, pedal*. A note, usually in the bass, that is held while the upper parts move on to other notes, which sometimes are dissonant with the bass note. This device is one of the earliest forms of polyphony (music with more than one voice-part), since it represents a very simple way of adding another voice-part. In the study of harmony, pedal points are described in terms of their scale degree in the key of the composition; for example, in a piece in the key of C major, a pedal point on the note C is called a tonic pedal point, on the note G a dominant pedal point, on the note F a subdominant pedal point, and so on (see SCALE DEGREES for an explanation of these terms). Occasionally a pedal point is used in a middle or upper part instead of in the bass; in an upper part (for example, soprano) it is called an **inverted pedal**, and in a middle part (tenor, alto) it is called an **internal pedal**. (The example under PICARDY THIRD, showing the closing measures of a Bach fugue, has a tonic pedal point on C in these measures.)

pedal tone Also, British, *pedal note*. In wind instruments, particularly brass instruments, the lowest pitch available on the instrument, that is, the fundamental. This lowest tone, which is produced by the vibrations

of the pipe along its entire length, is sometimes quite difficult to produce. It is virtually impossible to obtain on a trumpet, and can only be achieved by a skilled player on the trombone and tuba. As a result, the practical range of brass instruments often does not begin with the fundamental (lowest tone) but with the first harmonic (overtone) in its HARMONIC SERIES, which is exactly one octave above the pedal tone.

peg In stringed instruments, a wooden pin used to adjust the tension, and therefore pitch, of a string. Also called **tuning pegs,** such pins are usually set into the neck (narrow upper portion) of the instrument, the part into which they are set being known as the **pegbox.**

pelóg See under GAMELAN.

Penderecki (pen də rets' kē), **Krzysztof** (krēs'tof), 1933– . A Polish composer who became known particularly for his large instrumental and sacred choral compositions. Until about 1974, Penderecki's music was strongly influenced by Bartók, Stravinsky, the serial composers (especially Schoenberg and Webern), his own experiments in a Warsaw electronic studio, and the microtones familiar to him as a violinist. He also became interested in exploring the narrow boundaries between musical tone and noise. At the same time Penderecki wanted his music to express his social and political ideas, specifically his opposition to warfare and oppression. In *Threnody to the Victims of Hiroshima* (1960) for string orchestra, for example, the performers play behind the instrument's bridge, on the bridge, produce a special kind of vibrato, play the highest and lowest obtainable pitches, and produce tone clusters. Other works from this period are *Anaklasis* (1960) for strings and percussion, *Stabat Mater* (1962) for a cappella choir, the *St. Luke Passion* (1966), *The Awakening of Jacob* (1974) for orchestra, and *Magnificat* (1974). After 1974 Penderecki's style changed. He largely abandoned complex tone clusters and microtonal material and turned to more lyrical themes and the heavy orchestration and doubling of instruments favored by nineteenth-century composers. This style is evident in his Violin Concerto (1977), the oratorio-like opera *Paradise Lost* (1978) to a libretto by Christopher Fry, Te Deum (1979) written for the first Polish Pope, John Paul II, Second Symphony (1980), Concerto no. 2 for cello and orchestra (1982), and Polish Requiem (1985). The Requiem indicates his continuing interest in political music as well as his deep religious feeling. Each section is dedicated to an event or individual in Poland during or after World War II. The *Adagio,* part of his five-movement Fourth Symphony, is firmly tonal but has Penderecki's typically inventive orchestration, here giving great prominence to violas and brasses.

penny whistle Also, *tin whistle.* A small, high-pitched FIPPLE FLUTE. It is made of metal, has six finger holes, and is fingered like a fife. Long used mostly as a folk instrument, it gained some prominence in the 1980s when virtuoso flutist James Galway occasionally performed on it in concerts.

pentatonic scale A scale made up of five tones, as opposed to the seven-tone diatonic scale and the twelve-tone chromatic scale. The most common type of pentatonic scale consists of the notes C D F G A; moved up one half tone, to C# D# F# G# A#, these are the black keys of the piano. This scale is found in the music of many Asian and African peoples, among them those of China and Japan, as well as in some European folk music, and has been used by Dvořák, Puccini, and other Western composers. It also appears in spirituals and, often, in rock. Another kind is C D E G A, which eliminates all minor seconds. Still another, the **sléndro** of Indonesia, is obtained by dividing an octave into five equal parts (see also GAMELAN). Since this requires a differ-

ent tuning system from that of Western (European and American) music, the tones cannot be produced on ordinary Western musical instruments. (See also TEMPERAMENT.)

percussion instruments A large group of instruments that are sounded by being struck, scratched, or shaken. There are two main kinds of percussion instrument, untuned and tuned. The former do not sound a particular pitch and are used purely for rhythm; the latter sound one or more definite pitches, and are used for both rhythm and harmony (and, in some non-Western music, melody). The first group includes most drums (snare drum, tenor drum, bass drum), as well as the triangle, castanets, cymbals, gong, tambourine, rattle, maracas, wood block, and güiro; the second group includes the timpani, glockenspiel, xylophone, celesta, chimes, bells, marimba, and vibraphone. In the twentieth century Western composers have given increased importance to the percussion section of the orchestra. Also, some composers have written concerto-like pieces for percussion—for example, Colgrass's *Déjà Vu* for percussion and orchestra (1978), Kraft's Percussion Concerto (1993), and Schwantner's Concerto for Percussion and Orchestra (1995). Further, percussion ensembles have been organized, and works written for them by Stockhausen, Birtwistle, Nishimura, and others. Among the few works for solo percussion are Stockhausen's *Zyklus* (1959) and several by Xenakis.

perdendosi (per" den dô' sē) *Italian.* A direction to perform more and more softly and more and more slowly, as though the music were dying away. Also, *perdendo.*

perfect cadence See under CADENCE.

perfect consonance The intervals of a major or minor FOURTH, a major or minor FIFTH, or their compounds (eleventh, twelfth, etc.), a concept used in analyzing Renaissance music. See also IMPERFECT CONSONANCE.

perfect interval See INTERVAL, def. 2.

perfect pitch See ABSOLUTE PITCH.

performance art A multi-media theatrical production in which the performance itself is more important than any narrative or specific message being conveyed, and in which the artist not only creates in most or all of the different media—poetry, dance, music, theater, film, graphic art, mime, etc.—included in the work but also is the performer. The style of presentation is usually fragmentary and allusive rather than narrative (no "story" as such is told), in effect, a series of images. Performance art was developed from about 1970 on. In part it represented a protest against the commercialization of art and against the separation of artist and work: a live performance is necessarily impermanent and ever-changing, and creator and performer are one. It also has its roots in the "happenings" of the 1960s, chaotic events originally invented by visual artists using words, music, sound, lighting, and action, which usually were performed only once for an audience of observer-participants. Unlike these, performance art clearly separates audience and artist. The first notable performance artists worked as solo performers. One of the most successful, Laurie Anderson (1947–), an accomplished sculptor and photographer as well as a classical violinist by training, created a work called *United States* (1978–83) in four hour-long sections that include songs, accompanying instruments, taped sound, lighting, and slide and film projections. Another notable performance artist, Meredith Monk (1943–), originally primarily a dancer and choreographer, also composed, directed, designed, and made films to present in mixed media performances. By the early 1980s the predominantly solo works of performance art were giving way to more complex collaborative efforts bordering on music theater or opera and involving numerous creators and performers. As with much

avant-garde music of this period, the distinctions between performance art, theater, opera, and other genres became more and more blurred. See also MIXED MEDIA; MUSIC THEATER.

performance practice The manner of performing a musical work as it would have been at the time of its composition. The term nearly always refers to music of the past. Over the centuries musical conventions, instruments, tempos, tuning, and numerous other details have changed drastically. Moreover, musical scores cannot define all the characteristics of a performance. Consequently attempts to produce a historically accurate performance must rely on whatever information is available, in other compositions of the period, contemporary writings, and the like. Similar problems arise with non-Western music, which in many cases relies entirely on an oral tradition. Presumably the availability of modern recording equipment will greatly simplify this task for future generations performing the music of our time. See also PERIOD INSTRUMENTS.

Pergolesi (per gô lā'zē), **Giovanni** (jô vän' ē), 1710–1736. An Italian composer who is remembered chiefly for a single work, *La Serva padrona* ("The Maid as Mistress"), which is considered the first important comic opera (see under OPERA). During his short life Pergolesi wrote a number of other operas, both serious and comic, as well as choral and instrumental music.

Peri (per' ē), **Jacopo** (ja' cô pô), 1561–1633. An Italian composer who is remembered for writing what was probably the first opera, *Dafne* (1597), which has been lost, followed by *Euridice* (1600). Peri was one of the group of Florentine noblemen and artists known as the CAMERATA. (See OPERA.)

period In music up to about 1900, a portion of a melody, made up of two or more phrases (that is, a group of eight, twelve, or sixteen measures) and ending with a cadence (see PHRASE). It has been defined as a "complete" musical thought, comparable to a sentence in prose. In twentieth-century music, some composers have applied the idea of such divisions not only to melody but to rhythm (groups of beats) and other elements of music.

period instruments A term applied to historic musical instruments or modern reproductions of them, used for performing the music of earlier periods (Renaissance, baroque, early classical, etc.). Until the mid-twentieth century, music from about 1700 on was routinely performed on modern instruments. Since then there has been increasing interest in more closely reproducing the original sound of such music, by using the instruments of the composer's time.

Perotin (pe rô taɴ'). Also, Latin, *Perotinus* (per ô' tin əs; per ō tī' nəs). A French composer of the late twelfth and early thirteenth centuries who was the second great master of the school of Notre Dame, in Paris, where he succeeded Leonin. He was noted particularly for his clausulae, in which he used three and even four voice-parts (see CLAUSULA). He also was among the first to follow the RHYTHMIC MODES in all the voice-parts. See also ARS ANTIQUA.

Perotinus See PEROTIN.

perpetuum mobile (per pet' ōō əm mō' bi le) *Latin:* "perpetual motion." Also, Italian, *moto perpetuo* (mô' tô per pe' tōō ô). A title for pieces performed in rapid tempo and featuring the same rhythmic patterns repeated over and over.

pesante (pe zän'te) *Italian.* A direction to perform in a weighty, impressive, firm manner.

petite flûte (pœ tēt' flyt). The French term for PICCOLO.

Petrushka (pe trōōsh' kə) **chord** See under BITONALITY.

peu (pœ) *French:* "little." A word used in such musical terms as *un peu* ("a little"), and *peu à peu* ("little by little").

pf 1 The abbreviation for *pianoforte* ("soft, followed by loud"). **2** An abbreviation for *pianoforte,* older name for the PIANO (def. 2).

phase modulation See under MODULATION, def. 2.

phasing. Also, *phase music.* See under MINIMALISM.

philharmonic A name often used for musical societies and for orchestras. It comes from the Greek words for "love" and "harmony," and today is applied in a very general sense, in such names as New York Philharmonic Society and Vienna Philharmonic Orchestra. "Old philharmonic pitch" and "new philharmonic pitch" are two standards of pitch that are no longer used, having been replaced by CONCERT PITCH.

phrase A division of a melody that has been compared to one line of a poem. It is larger than the smallest possible division, called a FIGURE or *motif,* but it is not a complete musical thought, which is called a PERIOD. In Western music of the seventeenth to nineteenth centuries a phrase most often consists of four measures, but this number is far from fixed.

Whereas a figure can serve to unify a composition simply by being repeated at various points, a phrase by itself cannot function in this way. Rather, it is a group of phrases, balancing one another, that makes up the melodic structure of a composition. In the accompanying example from a Mozart piano sonata, the section marked *A* is a figure, the section marked *B* is a phrase, and the entire excerpt represents a period. Note that the period here consists of two phrases equal in length and similar in rhythm. Also, the pattern of pitches is similar, going first up (measures 1 and 5), then down (measures 2 and 6), then up again (measures 3 and 7), and finally down again (4 and 8). Further, the first phrase ends with a feeling of incompleteness (incomplete cadence) and the second with a feeling of finality (complete cadence; see under CADENCE). See also PHRASING.

phrasing The art of performing music so that its phrases are executed correctly, that is, so that the notes of a phrase or part of a phrase sound as though they belong together. In practice, phrasing is accomplished by separating phrases (or sections of phrases) from one another by means of very short rests (not long enough to take away noticeably from the note values themselves). In singing and in playing wind instruments this is often accomplished by taking a new breath for each phrase or section of a phrase. On bowed stringed instruments a phrase is usually played with one bow stroke. Scores often are provided with large slurs (curved lines) to help the performer identify phrases. The example accompanying PHRASE also shows some of the other devices that assist in defining phrases, such as short slurs, staccato marks, and other accentuation showing how a note is to be attacked, and crescendo and decrescendo (growing louder and softer). Bringing out these details in order to shape phrases more effectively is called **articulation.** Phrasing is as important to musical performance as proper reading is to a play or poem. Without it, music becomes simply a succession of tones of different length and pitch, just as a play or poem would become merely a series of words.

Phrygian (frij'ē ən). **1** The authentic mode beginning on E. See under CHURCH MODES. **2** For Phrygian cadence, see under CADENCE.

piacere, a (ä pyä cher' e) *Italian.* A direction for performers to execute a

Andante grazioso

passage as they please, particularly as to tempo. See also AD LIBITUM.

piacevole (pyä che' vô le) *Italian.* A direction to perform in a smooth, graceful manner.

piangendo (pyän jen' dô) *Italian.* Also, *piangevole* (pyän je' vô le). A direction to perform in a mournful, plaintive manner.

piangevole See PIANGENDO.

pianissimo (pyä' nēs' sē mô") *Italian.* A direction to perform very softly (see PIANO, def. 1). It is generally abbreviated *pp,* and sometimes *ppp.*

piano 1 (pyä' nô). An Italian term used as a direction to perform softly. It is generally abbreviated *p.* **2** (pya' nō). A keyboard instrument in which the keys make hammers strike strings, causing them to sound. Its name is an abbreviation of its original name, *pianoforte,* Italian for "soft-loud," which refers to the fact that the player can produce softer or louder tones by varying the touch (finger pressure) on the keys. This feature is not present in either the harpsichord or the clavichord, two earlier keyboard instruments that the piano replaced in importance. Today the piano is by far the most popular acoustic keyboard instrument, and has long been the one instrument most used in homes, at least in Europe and America.

The piano has a range larger than any conventional instrument except the organ, either exactly seven octaves (from A to A) or seven octaves and a third (A to C). Each note is con-

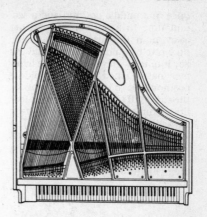

trolled by a single key, and there are eighty-eight keys in all. When the player presses a key, a felt-covered hammer is thrown against the string or strings for that particular pitch (there usually are three strings for each high note, two strings for each note of medium range, and one string for each bass note). At the same time, a felt-covered damper is lifted from those strings, allowing them to vibrate (and therefore sound) when the hammer strikes them. The hammer must quickly bounce away from the strings, however, so that it does not interfere with their vibration. When the key is released, the dampers fall back on the strings of that key, silencing them. The hammers are connected to the keyboard by a system of levers called the **action.** To make sure that the hammer does not bounce back onto a string after having struck it, a device called the **escapement** moves aside the lever nearest the hammer so that it falls back far enough not to bounce back; in addition, another device called the **check** catches the hammer as it falls. However, if the hammer must fall back far from the string, to avoid rebounding against it, it cannot bounce back quickly enough to allow for repeating the same note quickly. To solve this problem, modern pianos have a **double escapement,** which makes the hammer fall back twice,

once to a middle position and a second time to a position still farther away from the strings. If the same note is to be quickly repeated and the key is quickly pressed again, the hammer has reached only the middle position and so can rapidly return to the strings. If the note is not repeated, the hammer has time to fall back twice, to its final resting position. The sound of the strings is reinforced (made louder) by a **soundboard**, a large sheet of wood that strengthens their vibrations.

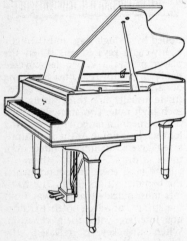

In addition to a keyboard, the piano has at least two pedals (some have three, and occasional early pianos had four). The pedal on the right, called **damper pedal** (also *sustaining pedal,* and, mistakenly, *loud pedal*), raises the dampers from all the strings, so that the strings whose keys are struck continue to vibrate after the keys have been released (though the pedal must be held down) and the other strings vibrate sympathetically. This both increases the volume of the sound and enriches the tone color, since many more overtones (harmonics) can be heard together. The pedal on the left, called **una corda** or *soft pedal,* moves the entire piano action of a grand piano slightly to the right, so that most of the hammers strike

one less string—only two instead of three for high notes, one instead of two for middle-range notes, but still one for bass notes. This both reduces the volume and changes the tone color, far fewer harmonics now being heard. The center pedal (in pianos that have one) is called the **solo sostenuto** (or just *sostenuto*) pedal; it keeps up the dampers from the notes that were played just before the pedal was depressed, allowing them to continue sounding while other notes are being played.

In piano music, the signs 𝕊𝕒 or ϒ. direct the player to use the damper pedal, and an asterisk (*) directs the release of the damper pedal. If the signs for the damper pedal appear without an asterisk following, one is to use the damper pedal repeatedly. In some piano scores brackets over or under groups of notes indicate where the pedal should be held down and released (see the example here).

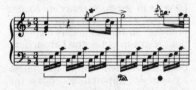

The basic mechanism of the piano was invented about 1709 in Florence, Italy, by a harpsichord builder, Bartolommeo Cristofori (1655–1731), who called his instrument a *gravicembalo col piano e forte* (harpsichord with soft and loud). He made about twenty instruments, gradually improving them, and his final design included an action with both escapement and check as well as an una corda device. Cristofori's piano, wing-shaped (like the harpsichord and the modern grand piano), was largely neglected until a German builder, Gottfried Silbermann, adopted it about 1745. Other German builders experimented with hammer-striking mechanisms, but their instruments, called **square pianos** because of their square shape (like the clavichord's), were inferior to Cristofori's. Later the square piano

was greatly improved, mainly in England. By about 1775 the piano came into its own, most of its problems having been solved by both German builders (with their so-called "Viennese" action; see also FORTEPIANO, def. 2) and English builders ("English" action). In 1821 a French builder, Sébastien Érard, invented the last basic refinement, a double escapement. Shortly thereafter, the heavy metal frame required by the action and strings was provided, and **cross-stringing**, a system whereby the long bass strings cross over the shorter middle-range and treble strings, was invented.

About 1770, after almost fifty years of neglect, the piano prompted great interest on the part of composers, and its repertory, considering its relatively short life (compared to the organ's, for example) is now enormous. The first piano compositions of note were written in the early 1770s by Clementi, Haydn, and, especially, Mozart. In études, sonatas, and concertos, these composers began to exploit the real resources of the instrument. Beethoven wrote some of the greatest piano music of all time, both sonatas and concertos, as well as the miscellaneous type of short piece (for example, his *Bagatellen*) that attracted so many nineteenth-century composers. The latter include pieces called *ballade* (Chopin), *fantasy* (Schumann), *impromptu* (Chopin), *moment musical* (Schubert), *intermezzo* (Brahms), *nocturne* (Chopin), *prelude* (Rachmaninoff), *étude* (Liszt), *rhapsody* (Liszt), *capriccio* or *caprice* (Mendelssohn), and others. During the last quarter of the nineteenth century, many of the nationalist composers wrote piano music of note, especially Grieg, Dvořák, Balakirev, MacDowell, Albéniz, and Granados. The two most important impressionist composers, Debussy and Ravel, produced some of their finest compositions for piano. Another outstanding piano composer of this period was Alexander Scriabin, who contributed some technically very difficult piano music. Practically all of the important composers of the first half of the twentieth century wrote significant piano music, beginning with Schoenberg's first atonal pieces (*Drei Klavierstücke*, op. 11) and continuing with Prokofiev (sonatas, concertos), Bartók (*Allegro barbaro;* six volumes of *Mikrokosmos*), Stravinsky (Sonata, 1924; Concerto, 1924), Webern (*Variations for Piano*, op. 27), and Hindemith (*Ludus tonalis,* 1942). Also known for their piano compositions are Fauré, Messiaen, Turina, de Falla, Poulenc, Crawford Seeger, Sessions, and Cage.

The piano is used mainly as a solo instrument and for accompaniment, especially for voice (songs) and for other solo instruments (flute, oboe, violin, or others). There are also duets for two players at one piano, and for two players at two pianos, and even a number of works for pianists with one hand (the most famous being Ravel's Concerto for the left hand alone, 1931); a more recent example is Ned Rorem's Piano Concerto no. 4, 1993). The piano has been used a good deal in chamber music (piano trio, piano quartet, piano quintet) but less so than the various stringed instruments. The piano is also used in orchestral compositions. Some twentieth-century composers have altered the tone of the piano in various ways, through special tunings, to obtain microtones (see MICROTONE; also QUARTER TONE), or by tampering with the strings to produce special effects (**prepared piano;** see under CAGE, JOHN). Like most other instruments, some pianos have been altered electronically (see under ELECTRONIC INSTRUMENTS and **electronic piano** below). In addition, the piano has played a very important role in ragtime, blues, and jazz, in the hands of outstanding performers such as Scott Joplin, Fats Waller, Duke Ellington, Earl Hines, Fletcher Henderson, John Lewis, Dave Brubeck, Thelonious Monk, Mary Lou Williams, and Marian McPartland.

The best-known piano concertos are listed under CONCERTO, def. 2. See also PIANO QUARTET; PIANO QUINTET; PIANO TRIO; under QUARTET; under QUINTET; PIANO DUET; SONATA, def. 1; PLAYER

MUSIC FOR TWO PIANOS

Composer	Work	Date
Béla Bartók	*Concerto for two pianos*	1940
	Sonata for two pianos and percussion	1937
Luciano Berio	*Two-Piano Concerto*	1973
Pierre Boulez	*Structures* I for two pianos	1952
	Structures II	1961
Johannes Brahms	*Sonata in F minor for two pianos, op. 34a*	1864
	Variations on a Theme by Haydn for two pianos, op. 56b	1873
Ferruccio Busoni	*Fantasia contrappuntistica for two pianos*	1922
Frédéric Chopin	*Rondo in C, op. 73*	1828
György Ligeti	*Self-Portrait with Reich and Riley*	1976
Bohuslav Martinů	*Concerto for two pianos*	1943
Darius Milhaud	*Concerto for two pianos*	1941
	Scaramouche (suite of three pieces)	1939
Wolfgang Amadeus Mozart	*Sonata for two pianos, K. 448*	1781
	Concerto no. 10 in E-flat for two pianos, K. 365	1779
Quincy Porter	*Concerto concertante for two pianos and orchestra*	1954
Francis Poulenc	*Sonata for two pianos*	1955
	Concerto for two pianos	1932
Mel Powell	*Concerto for two pianos*	1990
Sergey Prokofiev	*Concerto for two pianos and string orchestra, op. 133* (incomplete)	1952
Robert Schumann	*Andante and Variations in B-flat, op. 46*	1843
	Eight Polonaises for two pianos	1828
Dmitri Shostakovitch	*Concertino for two pianos*	1953
Igor Stravinsky	*Concerto for two pianos*	1935

PIANO. A few of the notable compositions for two pianos are listed in the chart above.

—**grand piano** A piano in which the strings are horizontal (parallel to the floor) and the soundboard lies flat, under the strings, which are raised from it by bridges. Grand pianos are made in various sizes, ranging from a **baby grand** about five feet long to the large **concert grand**, about nine feet long. —**upright piano** A piano in which the strings are vertical (perpendicular to the floor) and the soundboard is upright, behind the strings. The chief advantage of upright pianos is that they require less floor space than grand pianos. Their chief disadvantage is that they generally have shorter strings, less resonance, and poorer tone than grand pianos. Moreover, in the smallest models (spinets) the action is sometimes placed below the keys, resulting in a quite different touch. Various versions of upright have been built since the eighteenth century. Tall upright pianos, forty-eight to fifty inches high, have not been built since about 1920, although several builders began returning to them in the 1960s. Other sizes are the **studio upright**, forty-four to forty-six inches high, the **console**, forty to forty-two inches high, and the **spinet**, thirty-six to thirty-eight inches high (see SPINET, def. 2). As a rule, the higher an upright piano, the longer the strings and the better the tone. —**electronic piano** A piano in which the soundboard is replaced by a system of electrical connections wired to amplifiers, and the amplified sound is led to loudspeakers built into the bottom of the instrument. Extra pedals give very precise control of the volume (loudness), and adjustable knobs connected to the amplifiers

alter the mixture of tones. Also known as a **digital piano**, it produces sound through computer technology. With the flick of a switch it can reproduce the sound of either a grand piano or a harpsichord, or, in some models, the sound of any of 150 instruments. See also FORTEPIANO, def. 2; PLAYER PIANO.

piano arrangement A piece of music composed for one or more other instruments (or even voices) but arranged so that it can be played on the piano. Piano arrangements are usually made either for study purposes, or to make it possible to perform a large work, such as an opera, with limited resources (the piano takes the place of the orchestra). See also *piano score*, under SCORE.

piano concerto See CONCERTO, def. 2.

piano duet A piece for two pianists, usually playing on the same instrument. One plays the upper portion of the keyboard and the other the lower. In the score, the upper part may be marked *primo* (Italian for "first") and the lower *secondo* ("second"); in some scores the parts are on facing pages, the lower on the left and the upper on the right. Mozart, Schubert, and Brahms each have written outstanding piano duets. A piece for two pianos is generally so described (Concerto for two pianos, Sonata for two pianos, and so on), but occasionally the term "piano duet" is used in this sense, too. See also DUET.

pianoforte (pyä" nô fôr' te) *Italian.* 1 An older name for the piano (see PIANO, def. 2). 2 Usually written *pianoforte*. A direction to perform first softly and then loudly. Abbreviated *pf.* See also FORTE PIANO, def. 1.

Pianola See PLAYER PIANO.

piano quartet A composition for four instruments, one of which is a piano, and each of which plays a separate part (chamber music). The most common combination is that of violin, viola, cello, and piano, but occasion-ally one or more of the stringed instruments is replaced with a wind instrument (clarinet, oboe, flute, or other). See also under QUARTET.

piano quintet A composition for five instruments, one of which is a piano, and each of which plays a separate part (chamber music). The most common combination is that of piano and string quartet (first and second violins, viola, cello), but occasionally one violin is replaced by a double bass, as in Schubert's *Trout Quintet,* op. 114, or one or more of the stringed instruments is replaced with a wind instrument (clarinet, oboe, flute, horn, or other). See also under QUINTET.

piano reduction See under SCORE.

piano score See under SCORE.

piano sonata See SONATA, def. 1.

piano trio A composition for three instruments, one of which is a piano, and each of which plays a separate part (chamber music). The term is most often used for the most common combination, violin, cello, and piano. A particularly well-known example is Beethoven's *Archduke Trio* op. 97. Others are his *Ghost Trio,* op. 70, no. 1; thirty-one piano trios by Haydn; seven by Mozart; Schubert's trios in op. 99 and 100 (the latter, in E-flat, is particularly lovely); several piano trios each by Schumann, Mendelssohn, Dvořák, and Brahms (especially the Trio in C minor, op. 101); Tchaikovsky's Trio in A minor (1882); Ravel's Trio in A minor (1914); Copland's *Vitebsk* (1929); Schuller's Piano Trio (1984); and Bright Sheng's Piano Trio (1990). See also TRIO, def. 2.

piatti (pyä'tē). The Italian term for CYMBALS.

Picardy (pik' ər dē) **third** Also, French, *tierce de Picardie* (tyers' də pē kАr dē'). A major third appearing at the end of a composition that is otherwise in a minor key. This type of ending was often used from about

1550 to 1750; it appears in many of Bach's compositions (see the accompanying example from the Fugue in C minor, from Book 1 of *The Well-Tempered Clavier*). The origin for the name is not known, but it appeared in Jean-Jacques Rousseau's music dictionary, published in 1764.

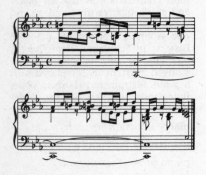

picchiettato (pē" kye tä' tô). The Italian term for PIQUÉ.

piccolo (pik'ə lō, pē'kô lô) *Italian:* "small." A small flute, sounding one octave higher than the ordinary flute. Its music is written an octave lower than it sounds, to avoid the use of ledger lines. The piccolo's range is from the C above middle C to two octaves above high C, making it the highest-pitched instrument of the orchestral woodwinds. It is built almost exactly the same as the flute,

except for its smaller size (it is about half as long), and most flutists in orchestras are expected to play it when necessary. However, many orchestral players prefer a piccolo made of wood (instead of silver), which has a less piercing, darker sound. A piccolo in D-flat is occasionally used in bands.

piccolo trumpet See under TRUMPET.

pick Another word for PLECTRUM.

pickup 1 A receiving or recording device, in particular a small microphone attached to a guitar or other musical instrument. 2 An informal word for UPBEAT.

p'ipa Another spelling for PYIBA.

pipe 1 A general name for any musical instrument whose sound is produced by means of air vibrating inside a tube (pipe). This category includes all of the wind instruments and the organ. For organ pipes, see under ORGAN. 2 A small end-blown flute, similar to a recorder, which was used together with a small drum to accompany dancing in medieval Provence (in southern France) and Spain, and later also in England. The pipe had three finger holes, two in front and one behind (for the thumb), and was held and played with one hand. With the other hand, the player beat a small snare drum, called a **tabor**, which was hung over the shoulder. Today the pipe and tabor are still used in Spain to accompany folk dancing.

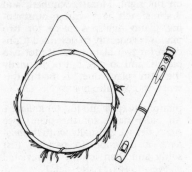

pipe organ See ORGAN.

piqué (pē kā') *French*. Also, Italian, *picchiettato* (pē"kye tä'tô). A direction to play short, detached notes but without changing the direction of the bow. The result is a combination of slur and staccato, very similar to LOURÉ.

Piston (pis'tən), **Walter,** 1894–1976. An American composer and teacher whose compositions and writings on music theory set forth his aim of presenting purely musical ideas in beautifully executed form. In this and in his general style of composition Piston is a neoclassicist (see NEOCLASSICISM). A master of counterpoint, he employed the traditional forms—string quartet, sonata, concerto, symphony—and produced basically tonal works (that is, written in definite keys; see KEY, def. 3), although he occasionally used dissonance and other modern elements, such as jazz rhythms. From 1926 until 1960 Piston taught at Harvard, where his pupils included Leonard Bernstein, Harold Shapero, and Daniel Pinkham. His books on harmonic analysis, harmony, counterpoint, and orchestration have become standard college texts. Piston's best-known compositions are his Concerto for orchestra, eight symphonies, and the suite *The Incredible Flutist* (based on a ballet of that name).

pitch The highness or lowness of a musical tone, usually considered in relation to other tones. The pitch of a tone depends on its frequency, that is, the number of vibrations per second of the string, air column, or other sound-producing agent. (See SOUND for further explanation.) In practice, the exact frequency (and therefore pitch) of only a single tone is needed in order to obtain the other tones. Since the middle of the nineteenth century there have been international agreements concerning a single standard pitch, so that instruments in different countries all can be tuned the same way. The present international standard, called CONCERT PITCH, is 440 cycles per second for the A above middle C (see also A). However, in practice there is considerable variation from this standard. During Bach's time (1685–1750) three different pitches were in common use—one for instrumental music (about one half tone lower than modern concert pitch), one for church music (both organ and choral), and a third for brass bands. Today performers of baroque music on period instruments generally use a compromise standard such as A = 415 cycles per second.

The term "pitch" is also used to describe various instruments; for example, a trumpet is said to be "pitched" in B-flat or C, meaning it is built so that its fundamental tone (produced by the vibration of the entire air column inside) is B-flat or C.

pitch bend A slight raising or lowering of a note's pitch (less than a half tone up or down). Long common in jazz, the technique has been called for by numerous twentieth-century composers, mainly for woodwinds and brasses but also for stringed instruments.

pitch class A set of all the pitches with the same name—for example, all A's—regardless of what octave they occur in. The term was introduced by Milton Babbitt to help in analyzing SERIAL MUSIC.

pitch names The syllables or letters of the alphabet that are used for the pitches contained in an octave. They are shown, along with the notes on the treble and bass staves, under *A* in the accompanying illustration. Various systems are used to indicate

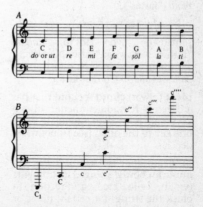

which octave a pitch belongs to. One of the most common of such systems, called the *Helmholtz system*, is shown under *B* in the illustration. See also SOLMIZATION.

Pitch names have been used by numerous composers to create *ciphers*. A particularly common one is BACH (the German names for the notes B-flat, A, C, B natural), used by J. S. Bach in the final fugue of *The Art of Fugue* and, in homage to him, by Schumann, Liszt, Schoenberg, and Webern, among others. Alban Berg in his *Lyric Suite* encoded his initials along with those of his secret lover, Fuchs-Hannah Robertin, which was only discovered years after their deaths.

pitch pipe A small pipe with a movable stopper enabling it to sound any of the pitches of an octave. Formerly used to set the pitch for a choral group or for the stringed instruments of the orchestra, it was largely replaced by the TUNING FORK. Pitch pipes are still used by many amateur groups, however.

più (pyōō) *Italian:* "more." **1** A term used in directions such as *più lento* ("slower"), *più marcato* ("more marked [accented]"), *più mosso* or *più moto* ("faster"). **2** Used with *il*, *più* means "most," as in *il più presto*, the fastest tempo ("as fast as possible"). **3** Used alone, *più* usually means *più moto* ("faster").

più tosto See PIUTTOSTO.

piuttosto (pyōō tôs′tô) *Italian:* "rather, somewhat." Also, *più tosto*. A word employed in such directions as *piuttosto allegro* ("rather fast").

pivot (pi′vət) **chord** A chord that has a different harmonic function in two keys and is used to modulate from one key to the other (see MODULATION, def. 1).

pizzicato (pēt″tsē kä′tô) *Italian.* In music for bowed stringed instruments (violin, cello, etc.), a direction to pluck the strings for certain notes or passages with the fingers or thumb. It is often abbreviated *pizz.* Monteverdi is thought to have been the first composer to call for pizzicato, in his opera *Il Combattimento di Tancredi e Clorinda* ("The Battle of Tancred and Clorinda"), composed in 1624. The great violin virtuoso Paganini was the first to use the technique of plucking the strings with the left hand, either at the same time as they are bowed with the right hand or in alternation with bowed strokes.

placido (plä′chē dô) *Italian.* A direction to perform in a smooth, tranquil manner.

plagal (plā′gəl) **cadence** See under CADENCE.

plagal modes See under CHURCH MODES.

plainchant See CHANT, def. 1.

plainsong See CHANT, def. 1.

player piano A mechanical piano in which the hammers are operated not by fingers depressing keys but by means of air pressure (wind). The wind is supplied by bellows, which are operated by pedals or electrically. The notes for a composition are marked on a roll of paper, which is pierced with a hole for each note; the hole's position regulates the pitch, and its size the time value of the note (how long it is held in relation to the other notes). Wind forced through the holes then causes the appropriate hammers to strike the keys. Player pianos of various kinds were invented in the nineteenth century. One of the best-known mechanisms of this kind was the *Pianola,* invented in 1897, and this trade name came to be used for any player piano. Immensely popular for a time, the player piano went out of fashion in the 1920s, when it was replaced by the radio and phonograph. The American Conlon Nancarrow is one of the few serious composers who continued to write for this instrument. Nancarrow wrote on piano rolls for specially prepared player pianos, perforating the rolls by hand. An electronic version of the player piano, like the Disklavier, uses

floppy disks instead of piano rolls. Another kind, called Contraption IPP 71512 and invented by a German composer named Trimpin, uses pre-arranged computer signals, which control not only pitches but dynamics, articulation, and tone quality.

plectrum (plek'trəm) *pl.* **plectra** (plek'trə) *Latin.* Also, *pick.* A general name for any device used to pluck the strings of a musical instrument. The term is most often used for a device held in or worn on the player's hand, such as the pieces of wood, ivory, metal, plastic, or quill used to pluck mandolins, lutes, guitars, banjos, and zithers. However, the term is also used for the jacks of the HARPSICHORD, which pluck the strings when the player depresses the keys.

poco (pô'cô) *Italian:* "little, somewhat, slightly." A word used in such musical terms as *un poco crescendo* ("becoming slightly louder"), *poco allegro* ("somewhat fast"), *poco più lento* ("a little more slowly"), *poco a poco* ("little by little [gradually]"), *poco meno* ("somewhat less [slowly]").

podium (pô'dē əm) *Latin.* A raised platform on which conductors stand, so that all the performers can see their directions.

poem, symphonic See SYMPHONIC POEM.

poi (poi) *Italian:* "then, afterward." A word used in musical directions such as *piano poi forte* ("soft followed by loud"), or *poi la coda* ("after this section play the coda"), used with a repeat sign to show that after a section (for example, a minuet) is repeated, the coda is to follow.

pointing See under ANGLICAN CHANT.

polacca (pô lä'kä) *Italian.* A Polish dance, usually the POLONAISE.

political music General term for music composed to convey specific political and/or social beliefs. Some music is written exclusively for this purpose, for example, the political campaign song. However, composers also produce major works with this purpose in mind, although it is not always the primary one; Verdi's opera *Un Ballo in Maschera,* for example, championed the Italian republican cause. Some political music echoes the official party line of a strict authoritarian regime; this was the case with much of the music written by Soviet composers under the Stalinist regime in the 1930s and 1940s. From the 1960s on, a number of prominent Western composers have expressed in their music ideologies ranging from Maoism (composers Cornelius Cardew, Frederic Rzewski, and Christian Wolff) to Cuban socialism (Hans Werner Henze in *El Cimarrón*) to general support of the oppressed and underprivileged (Luciano Berio in *Opera,* likening the sinking of the *Titanic* to the decline of materialist capitalism; Henri Pousseur in *Couleurs croisées,* quoting the civil rights song "We Shall Overcome"; Henze in his antiwar opera, *We Come to the River*). Their counterpart in folk and popular music is the **protest song,** upholding the poor and the persecuted (blacks, women, homosexuals, various minority groups) or taking a stand on other, sometimes quite controversial social and political issues.

polka (pôl'kə). A lively dance in 2/4 meter, which originated as a folk dance, probably in Bohemia (now part of the Czech Republic) in the early nineteenth century, and became an immensely popular ballroom dance. The Bohemian composers Smetana and Dvořák occasionally used polkas in their serious music. The characteristic rhythm of the polka is shown in the accompanying example.

$$\frac{2}{4} \; \text{♫ ♫ | ♩ ♩}_{\textit{etc.}}$$

polonaise (pô lô nez') *French.* A stately dance, in 3/4 meter and moderate tempo. It has a steadily repeated

rhythmic pattern (S stands for a short beat and L for a beat exactly twice as long): L S S L L L L / L S S L L L L (see *A* in the accompanying example). The polonaise also tends to use feminine cadences, that is, a cadence occurring on a weak beat instead of a strong one (most often, on the second of the three beats in the measure, instead of on the first); *B* in the accompanying example shows the last two measures of Chopin's *Polonaise militaire*, op. 40, no. 1.

Although its name means "Polish," the polonaise's origin is not known. Earlier pieces called "polonaise" have been found, but the first compositions with the characteristic rhythmic pattern and feminine cadences appeared in instrumental suites of the eighteenth century. Both J. S. Bach and his son Wilhelm Friedemann wrote numerous polonaises (examples occur in J. S. Bach's *Brandenburg*

Concerto no. 1 and in his Orchestral Suite no. 2). In the nineteenth century Beethoven, Liszt, Weber, Schubert, and others wrote polonaises, but the best-known polonaises of all are those of Chopin, which are more like marches than dances.

polychoral A term describing music written for two or more choruses, performing both in turn and together. This style of writing is associated particularly with sixteenth-century Venice and the Venetian composers Andrea and Giovanni Gabrieli (see GABRIELI), although it was known

throughout northern Italy and survived in various places (Rome, Germany) well into the eighteenth century. Often the choruses were placed in different parts of the church, and sometimes two organs were used (also placed separately). See also VENETIAN SCHOOL.

polymeter (pol' ē mē" tər). Also, *polyrhythm* (pol"ē rith'əm). The device of using two different meters at the same time, for example, 2/4 meter in the treble and 3/4 or 6/8 meter in the bass. Polymeter appears in ragtime piano music and jazz, as well as in the works of Paul Hindemith and other twentieth-century composers. It was also common in music of the late Middle Ages.

polyphonic (pol" ē fon' ik). 1 Pertaining to POLYPHONY. 2 Describing music with more than one voice-part, whether or not the parts are of equal importance.

polyphony (pə lif'ə nē). Music with more than one voice-part. There may be as few as two voice-parts or as many as forty or more. Each part may have its own melody, or a single melody may be taken up by the different parts in turn. It is polyphony that gives Western music a harmonic, or vertical, dimension, thereby distinguishing it from most kinds of Asian music and primitive folk music.

Although strictly speaking polyphony means any music with more than one voice-part, musicologists generally reserve the term for music in which the different parts are more or less independent. They thus distinguish polyphony not only from monophony (music with one voice-part) but also from homophony, in which one part carries the melody and is supported by other voice-parts that make up a chordal accompaniment. Consequently the term "polyphony" has practically the same meaning as COUNTERPOINT, and many authorities use the two interchangeably. Some scholars, however, prefer "polyphony" for medieval and early Renais-

sance music, and "counterpoint" for the music of the sixteenth, seventeenth, and eighteenth centuries. The twentieth century has seen a revival of interest in polyphonic composition (as opposed to the previous century's concentration on homophony).

The earliest instance of adding a second voice-part to a melody dates from the ninth century (see ORGANUM), and truly polyphonic music, in which the parts were more independent, began to be written during the eleventh century. The most important forms of vocal polyphony from the Middle Ages and Renaissance are the motet, round, chanson, Mass, and madrigal. The most important forms of instrumental polyphony are the canzona (see CANZONA, def. 4), ricercar, canon, and fugue.

polyrhythm **1** Another term for POLYMETER. **2** Another term for CROSS RHYTHM.

polytonality (pol"ē tō nal' i tē). The use of three or more keys at the same time, the use of two keys being described as BITONALITY. Although it occasionally occurs in earlier music, polytonality is primarily associated with twentieth-century composers, particularly Stravinsky, Bartók, and Milhaud. Milhaud, who wrote an article on the subject, sometimes constructed a counterpoint of polytonal chords (chords in contrasting keys).

Pommer (pom' ər). The German name for the large sizes of the SHAWM.

pomposo (pôm pô'zô) *Italian.* A direction to perform in a stately, dignified manner.

Ponchielli (pôn kye' lē), **Amilcare** (ä mēl cä' re), 1834–1886. An Italian composer who is remembered mainly for one of his many compositions, the opera *La Gioconda* (1876). The ballet "The Dance of the Hours," from Act III, is often performed alone.

ponticello (pôn" tē chē lō) *Italian.* The bridge of a violin or other stringed instrument. The direction *sul ponticello* tells the player to bow over the bridge of the instrument, producing a nasal, brittle tone.

popular music Also, *pop.* A large category of music, consisting basically of works designed to please the general public. Since public taste changes from period to period, not only in the course of history but in the course of the average person's lifetime, what is popular during one period (as, for example, the madrigal during the sixteenth century) or for one age group (rock for young people) is not necessarily popular today for all audiences. The most important kinds of popular music of the twentieth century include BLUES, COUNTRY MUSIC, JAZZ, MUSICAL COMEDY, OPERETTA, RAGTIME, RHYTHM AND BLUES, and ROCK.

The term "popular music" is also used in a very general way to distinguish it from "serious" or "classical" music. In this sense it appears in the name Boston Pops Orchestra, an ensemble that performs mainly popular music and so-called "light classics" as opposed to symphonies, concertos, and other longer, serious forms.

Sometimes "popular music," especially the abbreviated term "pop," is used more narrowly for commercially successful music that appeals to a large audience—the so-called "mainstream"—as opposed to a particular genre such as jazz, country music, or rock, often by virtue of its softer, blander, easy-to-listen-to sound.

One factor that distinguishes popular music is commercial success. Before the advent of radio, television, and phonographs, people had to go to concert halls and theaters to hear the music they liked. Although composers earned some money from the tickets bought and the sheet music sold for playing their music at home, the amounts were negligible compared to present-day proceeds from record sales and royalties for broadcasting their music. Serious composers, on the other hand, rarely consider money a primary goal, hoping rather to create a work of

art that will endure long beyond their own lifetime.

portamento (pôr" tä men' tô) *Italian*. Also, French, *port de voix* (pôr dᵃ vwA'). A slide from one note to another executed so rapidly that the intermediate pitches cannot be distinguished. In effect it is similar to a GLISSANDO, in which, however, the intermediate pitches consist of whole steps and half steps; in a portamento smaller intervals intervene. Thus a portamento cannot be executed on the piano or harp, where only half and whole tones are available. It can be executed on the violin and trombone, and by the voice, where it is actually easier to perform than a glissando. In vocal music a portamento is often indicated by a slur (curved line) between the first and second notes. The slide may be up or down in pitch, but in practice it is more often up.

portative (pôr' tə tiv). A portable organ used during the Middle Ages and Renaissance (twelfth to sixteenth centuries). It was slung around the neck, and the player fingered the keyboard with one hand while pumping a bellows with the other hand. The portative thus could be used only to play a melody. The fourteenth-century composer Landini was famous for playing the portative, which in Italy was called *organetto* ("little organ").

portato (pôr tä' tô) *Italian*. Also, *mezzo staccato* (med'dzō stä kä'tô). A direction to perform a group of notes in a style halfway between legato (smoothly) and staccato (detached). It is usually indicated by a slur and dots: ♫ ♫.

port de voix (pôr dᵃ vwä') *French*. 1 Today, same as a vocal PORTAMENTO. 2 In the seventeenth and eighteenth centuries, an APPOGGIATURA.

Porter, Cole, 1892–1964. An American songwriter who is remembered for his popular songs and musical comedies. Educated at Yale and Har-

vard universities as well as in Paris, Porter wrote more than twenty shows, six film scores, and dozens of famous songs, among them "Begin the Beguine," "Night and Day," "My Heart Belongs to Daddy," "I Get a Kick Out of You," "Just One of Those Things," "All through the Night," "I've Got You under My Skin," and "Don't Fence Me In." Among his most successful musical comedies are *Kiss Me, Kate*, *Can-Can*, and *Silk Stockings*.

Posaune (pō sou'nə). The German name for TROMBONE. Abbreviated *Ps.*

position 1 In stringed instruments, the place where a string is stopped (held down) by the left hand while the string is bowed by the right hand. The **first position** of the first finger is that closest to the pegs, producing a note one whole tone higher than that of the open (unstopped) string, the **second position** is the next one down the fingerboard, and so on. In the first position on the G string of a violin, the first finger plays A, in the second position it plays B, in the third position C, etc. On the cello the thumb is used for the higher positions. 2 In trombones, the placement of the slide. The **first position** is with the slide drawn all the way in, the **second position** is the first point to which it is extended, and so on to the **seventh position** (with the slide fully extended). 3 In harmony (the study of chords), the order of the notes in a chord, determined by the bottom note *only*. If the root is at the bottom, the chord is said to be in **root position**; if the second note is at the bottom, the chord is said to be in **first inversion**; etc. (see also CHORD.)

positive organ One of the manuals (keyboards played by the hands) of the ORGAN. It was developed from a small organ that stood on the floor or on a table, which could be used at home or in a small church (it is still occasionally built for such use). The organist fingered the keyboard while an assistant worked the bellows, either by hand or with pedals. Posi-

tive organs first appeared about the tenth century. In the thirteenth and fourteenth centuries, when large organs, powerful enough to fill huge churches, were being built, the small and much softer positive came to be used alongside the large organ. The positive organ was the first kind of organ to be provided with stops, giving it much greater flexibility of tone. At first it stood near the large organ, and the organist simply moved back and forth between the two instruments. Later it was given a permanent position on the gallery rail, behind the organist. In Germany this organ came to be called *Rückpositif* (*Rück-* means "back"), and in England, where a similar development took place, it was called *chair organ,* which during the late eighteenth or early nineteenth century was corrupted into CHOIR ORGAN. Eventually the positive was incorporated into the large organ, so that it could be played from the latter's keydesk. Today the positive organ is associated with certain stops; for example, whereas the great (large) organ is always based on an eight-foot or sixteen-foot principal stop, the positive organ is based on a four-foot principal (an octave higher than the eight-foot; see ORGAN for further explanation). Occasionally organs with both positive and choir manuals are built; in such instances one of them is an unenclosed division of the main case, played from the main keydesk, and the other is separate from it, with a case of its own.

post- A prefix, literally meaning "after," attached to a number of twentieth-century styles of music — for example, **post-minimalist, post-modernist, post-serial.** It is of limited usefulness mainly because it is employed with several quite different meanings. It can signify simply "after," that is, a work follows the period when serial music or minimalism was *the* new style; thus post-serial can mean a work composed after the 1935–1960 period, when serialism

dominated the avant-garde. Or it can signify, in a general way, that the work retains elements of a style but has somehow moved beyond it; for example, a so-called post-minimalist composition might feature minimalist techniques but used with more variety (in rhythm, harmony, expressiveness), or a post-serial composition might employ serial techniques, but less strictly. Or, occasionally, it means that the work represents an outright rebellion against the style; for example, post-modern is often used for works of the 1960s that deliberately rebelled against the markedly experimental styles of Cage and his colleagues.

post horn A simple brass instrument consisting of a metal tube, either straight or coiled, that originally was used for signaling by mail coaches. Since it had neither valves nor keys, it could sound only a single note and its overtones (see HARMONIC SERIES). In France during the nineteenth century valves were added to a circular (coiled) post horn, transforming it into the modern CORNET.

postlude (pōst′ lōōd). A closing piece of music, usually played by the organist at the end of a church service, while the congregation is leaving. See also PRELUDE, def. 1.

potpourri (pō″pōō rē′). The French term for MEDLEY.

Poulenc (pōō lank′), **Francis** (fräN sēs′), 1899–1963. A French composer who wrote numerous songs, piano works, chamber pieces, choral works, and several operas, the best of which show his remarkable gift for writing melody and lively sense of rhythm. Poulenc studied in Paris and became a friend of Erik Satie, who had great influence on him. He later became one of the influential group called Les Six (see SIX, LES). A great lover of poetry, Poulenc wrote some outstanding musical settings of modern French poems, by such writers as Guillaume Apollinaire, Jean Cocteau,

and Paul Éluard; among these are the song cycles *Le Bal masqué* ("The Masked Ball"), *Telle Jour telle nuit* ("Like Day, Like Night"), and *Le Travail du peintre* ("The Painter's Work"), and the cantata *La Figure humaine* ("The Human Face"). Other notable works are the opera *Les Mamelles de Tirésias* ("The Breasts of Tiresias"), which uses, in a satirical fashion, wrong notes, barroom songs, and parodies of sentimental songs; the opera *Les Dialogues des Carmélites* ("Dialogues of the Carmelite Nuns"); the ballet *Les Biches* (translated as "The Houseparty"); *Concert champêtre* for harpsichord and orchestra; *Babar the Elephant* (the children's story) for narrator and piano; and some large sacred choral works, among them a Mass in G for *a cappella* choir, a Stabat Mater, and a Gloria.

poussé See POUSSEZ.

poussez (poo sā'). Also, *poussé*. The French term for up-bow (see under BOWING).

pp Also, *ppp*. An abbreviation for PIANISSIMO.

Praetorius (prē tôr'ē əs), **Michael**, 1571–1621. A German composer and theorist who is remembered for his many vocal compositions and for a three-volume book, *Syntagma musicum* ("Musical Syntax"), which is one of the most important sources of information about both earlier music and the music of Praetorius's time. Some of Praetorius's works use several choruses, in the elaborate POLYCHORAL style of the Venetians. The others range from simple settings of Lutheran chorales (hymns) to complex contrapuntal works in which eight or nine voice-parts are set against one another. The first volume of Praetorius's book, which is written in Latin, tells about ancient music and church music, including a description of ancient instruments. The second volume, in German, describes the musical instruments of the author's own time, among them the organ, and includes drawings of the most important ones.

The last volume, also in German, gives an account of seventeenth-century secular music, notation, and details of performance.

precentor (prē sen' tər). The musical director of a cathedral, chapel, or monastery. See also CANTOR, def. 2.

precipitando (pre" chē pē tän' dô) *Italian*. Also, *precipitato* (pre" chē pē tä' tô), *precipitoso* (pre" chē pē tô' sô). A direction to perform in a hurried, impetuous manner.

precipitato See PRECIPITANDO.

precipitoso See PRECIPITANDO.

preclassic A term used for styles of music that fall somewhere between the baroque (1600–1750) and the classical (1785–1820), in time as well as style. It takes in the gallant or rococo style (light, graceful, highly ornamented) of late eighteenth-century keyboard music (see GALLANT STYLE). It encompasses the new instrumental style, with its fast-slow and loud-soft contrasts, its melodies carried by violins, and its individual treatment of wind instruments, as developed by STAMITZ and his followers at Mannheim, Germany (see MANNHEIM SCHOOL), by Georg Wagenseil (1715–1777) and Georg Monn (1717–1750) in Vienna, and by Giovanni Battista Sammartini (1701–1775) in Italy. Further, the term preclassic is sometimes used for a group of composers who worked in Berlin from about 1750 to 1790, also known as the Berlin school or North German school of composers. Most of them were employed by Frederick the Great of Prussia, who hired many musicians and composers for his court and was himself an accomplished musician and composer. Among them were Johann Joachim QUANTZ, Franz Benda (1709–1786), the opera composer Karl Heinrich Graun (1704–1759), the theorist Friedrich Wilhelm Marpurg (1718–1795), and Karl Philipp Emanuel BACH. In general, preclassic music is no longer wholly BAROQUE (with its imitative counterpoint, fugal style, and

continuo accompaniment), nor is it wholly classical (see CLASSIC).

prelude 1 An introductory piece of instrumental music, either to a church service (organ prelude, played while the congregation is entering the church), or, more often, to another piece of music, such as a fugue, suite, or opera. Among the most famous examples are the preludes Bach wrote for each of the forty-eight fugues in his *Well-Tempered Clavier,* which use a single theme and all the possible keys. Wagner began all of his late operas (the so-called music dramas) with preludes instead of overtures; unlike the conventional overture, his preludes lead directly into the first act, without pause. **2** In the nineteenth and twentieth centuries, a short independent piano composition, in one movement. Among well-known examples are twenty-four preludes by Chopin, which, like Bach's preludes (see above), use a single theme and all the possible keys. Other examples are twenty or so preludes by Rachmaninoff (the best known being the Prelude in C-sharp minor, from op. 3), twelve by Scriabin (op. 11), which are notable for their difficulty, two sets of twelve preludes by Debussy, twenty-four by Shostakovitch (op. 34), and *Nine Preludes* (1927–1928) by Crawford Seeger.

première (*French* prœ myer'; *English* pri mẽr', prē' mẽr). The first performance of a musical composition. See also DEBUT.

preparation The device of preparing the listener for a dissonant note, by using that note in an immediately preceding chord in which it is consonant. For example, in the chord C–E–B, B is a dissonant note. If this chord is preceded by the chord D–G–B, in which the B is consonant, the dissonance in the second chord is said to be *prepared,* or the chord (C–E–B) is called a **prepared chord.** For another kind of preparation, see SUSPENSION.

prepared chord See under PREPARATION.

prepared piano See under CAGE, JOHN.

pressando (pre sän' dô) *Italian.* Also, *pressante* (pre sän' te). A direction to perform with increasing speed.

pressante See PRESSANDO.

prestissimo (pres tē'sē mô) *Italian.* Also, *presto assai.* At the quickest possible tempo. See also PRESTO.

presto (pres'tô) *Italian.* **1** A very fast tempo, faster than allegro, ranging from about 168 to 200 quarter notes per minute. **2** A composition or section in this tempo.

presto assai (pres' tô ä sī') *Italian.* Also, *prestissimo.* A direction to perform at the quickest possible tempo.

prima (prē'mä) *Italian:* "the first." **—come prima** (kô' me prē' mä). A term meaning "as at first," indicating that a passage should be performed as before, particularly with regard to tempo. (See also *tempo primo,* under PRIMO.) **—prima volta** (prē'mä vôl'tä). A term meaning "the first time," indicating the first of two different endings for a section that is to be repeated. This direction is often given by a bracket and the figure 1 enclosing the notes of the first ending: ⌐— **—prima vista** (prē'mä vēs'ta). "At first sight," that is, sightreading. **—prima donna** (prē' mä dôn'ä). The leading female singer in an opera.

prime 1 The first scale degree, that is, the first note of any diatonic (major or minor) scale—C in the scale of C major, D in D major, E-flat in E-flat minor, etc. (See SCALE DEGREES.) **2** Another term for unison (see UNISON, def. 2), that is, the interval of two notes of the same pitch, the distance between the two being zero (see INTERVAL, def. 2). **3** *Prime.* See under OFFICE.

primo (prē'mô) *Italian:* "the first." **1** The first part, used for the upper part in a piano duet. **2** The first of two or more performers on the same kind

of instrument, such as *violino primo* ("first violin"), *flauto primo* ("first flute"), etc. **3** In orchestral scores, an indication that only the leader of a section (first oboe, first flute, first horn, etc.) is to play a passage. Often abbreviated *Imo* or *I°* or *I.* —**tempo primo** (tem'pô prē' mô). A direction to resume the tempo used at the start of a composition or section. (See also *come prima,* under PRIMA.) —**primo uomo** (prē'mô wô' mô). The leading male singer in an opera.

principal 1 In organs, the name for an important stop that controls certain of the open diapason pipes. In American and British organs, the term is used for a four-foot open diapason on the manuals and an eight-foot open diapason on the pedals, each sounding an octave higher than the pitch of the key or pedal depressed. In German and Italian organs the term is used for any open diapason, no matter what size. (See also ORGAN.) **2** Another term for LEADER, def. 3.

Prix de Rome (prē dᵃ rôm') *French:* "prize of Rome." A famous award, given by the French government to musicians, as well as to artists in other fields. The winner, who is judged on the basis of examinations, is given a course of study in Rome for several years. The first Prix de Rome in music was awarded in 1803. Among the composers who have won it are Halévy, Berlioz, Gounod, Bizet, Massenet, Debussy, and Ibert.

processional antiphon See under ANTIPHON.

program music Also, *descriptive music.* A general term for music that tells a story without using words. Some program music tells a story very specifically, as, for example, Prokofiev's musical fairy tale, *Peter and the Wolf,* in which different instruments "act out" the narrator's words. Other works are descriptive in a more general way, suggesting emotions (Liszt's *Les Préludes,* based on a poem by Lamartine), or describing nature

(Debussy's *La Mer,* depicting the sea; the last movement of Beethoven's Symphony no. 6, portraying a thunderstorm). Some compositions follow a fairly complicated plot, which is usually described in program notes by the composer; an outstanding example is Berlioz's *Symphonie fantastique,* about the strange dreams of a young musician who falls into a drugged sleep. The opposite of program music is called ABSOLUTE MUSIC. Some use the term "program music" only for instrumental music; others use it also for songs in which the music is highly appropriate to the meaning and mood of the words, as in the lieder of Schubert, Schumann, and Brahms. Actually, both "absolute" and "program" music are a matter of degree, and to what extent (if any) a Beethoven string quartet, for example, "tells a story" is really a matter of opinion. Certainly such music expresses feelings, and listeners would probably find it easy to agree as to whether the feelings expressed are sad or happy. On this basis, a Beethoven quartet might be said to be more "programmatic" than a quartet by Boccherini or a fugue by Bach. In general, however, the terms "program music" and "programmatic" are best confined to music that describes something specific—a particular feeling or mood, a scene, a story, an idea—which is recognizable both from the music itself and from the titles or other notes provided by the composer.

The earliest program music fitting this description dates from the fourteenth and fifteenth centuries. In the early sixteenth century the French composer Janequin wrote songs descriptive of nature (with imitations of birdcalls) and of battles (with fanfares and other sounds of battle). In the late seventeenth century the German composer Johann Kuhnau wrote a series of sonatas for harpsichord (entitled *Biblische Historien,* or "Biblical Stories") that describe, purely through the music, such events as David's fight with the giant Goliath. Although attempts along these lines

continued, it was not until the nineteenth century that program music became really significant. Many of the romantic composers wrote more program music than any other kind, particularly orchestral music in four important forms: the program symphony, symphonic poem, suite, and concert overture. Berlioz invented the PROGRAM SYMPHONY, a work in several movements with a written description (the "program") explaining the story the music is supposed to tell. To help the listener follow the story, Berlioz used repeated motifs (short themes), which he called *idées fixes* ("fixed ideas"). Liszt invented another form, the SYMPHONIC POEM, a long work in one movement. A shorter form that became popular was the one-movement CONCERT OVERTURE (a well-known example is Tchaikovsky's *1812 Overture*). Still another new form was the suite, no longer a series of dance movements but a series of "scenes"; examples include Saint-Saëns's *Le Carnaval des animaux* ("The Carnival of the Animals") and Rimsky-Korsakov's *Scheherazade* (see SUITE, def. 2). The nineteenth-century expansion of the orchestra, with its greatly improved instruments, made possible more realistic portrayal of sounds and special effects. These were exploited to the full by Richard Strauss, the last great composer of symphonic poems. After about 1915 program music became less important.

Besides those mentioned so far, other notable composers of program music are Mendelssohn, Borodin, Smetana, Franck, Sibelius, Dukas, Respighi, Elgar, and Delius.

program notes In printed programs for concerts and recitals, notes about the works to be presented, including information about their composers, the circumstances under which the particular compositions were written, and various details about the music itself. Well-prepared, accurate program notes can be of considerable value, pointing out what in particular the audience may listen for.

program symphony An orchestral composition in several movements, like a symphony, but following a specific program, like a symphonic poem. (See PROGRAM MUSIC; also SYMPHONIC POEM.) Usually the whole symphony and each movement are given titles that indicate what the music is supposed to portray. Occasionally the composer provides a detailed story of the program, as Berlioz did in what is generally considered the first program symphony, his *Symphonie fantastique* of 1830. (A few authorities regard Beethoven's Symphony no. 6, the *Pastoral Symphony*, as the earliest example.) Other well-known program symphonies are Berlioz's *Harold en Italie*, op. 16, and *Roméo et Juliette*, op. 17; Liszt's *Faust Symphony* and *Dante Symphony*, both of 1857; and Richard Strauss's *Symphonia domestica* ("Domestic Symphony," 1903) and *Alpensinfonie* ("Alpine Symphony," 1915).

progressive rock See under ROCK.

Prokofiev (prô kôf'ē ef), **Sergey** (ser gā'), 1891–1953. A Russian composer whose works include some very frequently performed music, notably his *Classical Symphony* and Piano Concerto no. 3, the orchestral fairy tale *Peter and the Wolf*, the suite from his film score *Lt. Kije*, and the cantata *Alexander Nevsky*. Prokofiev's works and style fall into three periods,—an early period in Russia (to 1918), a second period spent mostly in Paris (to 1933), and a final period back in Russia. The music of the first period, which includes the *Classical Symphony*, the first two piano concertos (of five), the first violin concerto (of two), and the orchestral *Scythian Suite*, is characterized by driving rhythms and highly dissonant harmonies, although still within a tonal framework (that is, in definite keys), moving in directions similar to Stravinsky's (see STRAVINSKY, IGOR). During the second period, in the United States and in Paris, Prokofiev first produced two fine operas, *The Love for Three Oranges* and *The Flaming Angel* (he based his Symphony no. 3

on the latter), as well as two ballets for Diaghilev's brilliant Ballets Russes. He also wrote three symphonies (nos. 2, 3, and 4) and three more piano concertos, but in general this period was less productive than his first. In 1936 Prokofiev returned permanently to Russia, where he wrote film scores, ballets (*Romeo and Juliet, Cinderella), Peter and the Wolf,* symphonies, chamber works, and a number of propaganda works. In accordance with Soviet rules that art must serve and be understood by the people, Prokofiev wrote in a greatly simplified style, using less dissonance than before, remaining essentially tonal, and often following the classical forms of sonata, symphony, and concerto. Nevertheless, he was publicly denounced in 1948 for being "too modern," although his high prestige in Russia survived until his death.

Proper The portion of the Roman Catholic Mass that varies according to the holidays and other special occasions marked on the church calendar. (See MASS.)

proportion In MENSURAL NOTATION, which was the system of indicating note values (how long notes must be held) used from about 1250 to 1600, a way of decreasing (or, less often, increasing) the time values of notes. For example, in a passage marked $\frac{4}{3}$, each note was to be held only three-fourths as long as it was held in the passage immediately preceding. Similarly, $\frac{2}{1}$ (often marked ¢) meant that each note should be held only half as long as before. These signs were later adopted for the present system of time signatures. (See also TIME SIGNATURE.)

Proportz (prô pôrts') *German.* Also, *Proporz.* Another name for NACHTANZ.

ps. 1 An abbreviation for PSALM. **2** An abbreviation for POSAUNE.

psalm (säm). A musical composition based on a text from the Book of Psalms, in the Old Testament of the Bible. The 150 psalms contained there were originally Hebrew songs.

The early Christian churches took over the poems, translated into Greek or Latin, and made them part of their liturgy (religious rites). The psalms became the most important texts used in Gregorian chant, which also adopted the chanting manner of performance used by the ancient Hebrews. There were eight melodic patterns used for reciting the psalms, called **psalm tones** (SEE PSALM TONE), one corresponding to each of the CHURCH MODES.

The psalms are the oldest music used in Christian services. At first they were simply sung or chanted from beginning to end by one or more singers. In time, two other methods of performance were developed. One, taken over from the Jewish services, involved a short response, such as the word "Amen," repeated after each verse of the psalm; the response was sung by the choir (originally, perhaps, by the congregation), and the psalm verses were sung by a soloist (in the Jewish services, the cantor). At the same time, the music began to become more elaborate; instead of one note for each word or syllable, there might be many notes for a single syllable (see MELISMA), making the entire performance of a psalm much longer. As a result, part of the psalm began to be left out, and perhaps also part of the response. In time, so little of the psalm remained—perhaps only a verse or a phrase—that it scarcely resembled the original. These **responsorial psalms,** so called because they involve a RESPONSE, are a basic part of the Roman Catholic liturgy.

The second new method of performance involved dividing the choir (or congregation) in half, so that the two sections might take turns in singing a psalm. Exactly how the psalm was divided between them is not known; probably one group sang one verse, the second group the next verse, the first group the next, etc. Soon a small section was added to the beginning and end of a psalm, to be sung by both groups together. This

method of performance resulted in the **antiphon**, from which several important parts of the Roman Catholic service are derived. (See also ANTIPHON, def. 1.)

By the late Middle Ages the psalms had become an integral part of Gregorian chant. With the development of polyphony (music with more than one voice-part), composers began to write new settings for the psalms. Some wrote in the increasingly elaborate counterpoint coming into fashion; others preferred a simple, homophonic style (melody in one voice-part accompanied by chords in the other voice-parts). Outstanding composers of the Renaissance (1450–1600) who used psalm texts in their motets are Josquin des Prez and Orlando di Lasso. Another new practice was using the Gregorian psalm melodies as the basis for instrumental works. Antonio de Cabezón and others wrote **versets** for organ, short pieces for the even-numbered verses of a psalm; the odd-numbered verses would be chanted in plainsong, alternating with the even-numbered ones played on the organ.

With the spread of Protestantism and its emphasis on church services in the language of the people (instead of in Latin), the psalms continued to be used for worship services, but in translation. A book containing the psalms in translation is called a **psalter.** If the translation was a rhymed, metrical poem (with regular meter), as it often was, the psalter was called a **metrical psalter.** Psalters were used from the sixteenth century on by English, French, and Dutch congregations. Music sung by the choir also made use of psalm texts. In Anglican churches the anthem, which replaced the Latin motet, often consisted of psalm texts translated into English.

During the seventeenth and eighteenth centuries psalm texts continued to be used, for motets, anthems, and cantatas. Among the outstanding psalm settings of this period are the *Psalmen Davids* ("Psalms of David,"

1619) of Heinrich Schütz, written for two, three, or four choruses, in the Venetian POLYCHORAL style.

During the nineteenth century Schubert, Mendelssohn, Liszt, Bruckner, and Brahms were among the composers who set psalms to music, usually for chorus but occasionally for solo voice. Notable psalm settings of the twentieth century are Reger's *Psalm no. 100,* Bloch's *Psalm 22,* Honegger's *Le roi David* ("King David"), Kodály's *Psalmus Hungaricus* (in Hungarian), Stravinsky's *Symphony of Psalms,* Britten's *Psalm no. 150,* Milhaud's *Psalm no. 129,* Schoenberg's *Mima' amakim* ("Out of the Depths," Psalm no. 130), Ives's *Sixty-seventh Psalm,* and Bernstein's *Chichester Psalms.*

psalm tone A name for any of the eight melodies used for singing (or intoning) the psalms in Gregorian chant. There is both a simple and a more elaborate psalm tone for each of the eight CHURCH MODES. Each psalm tone has a basic reciting note, called the **tenor,** on which most of the words are chanted. Originally it was always a fifth above the final in the authentic modes and a third above in the plagal modes, but after the eleventh century it shifted to one tone higher in modes III, IV, and VIII (see the illustration accompanying church modes). In addition, there are special groups of notes for the beginning (called *initium*), ending of the first half of the psalm (*mediatio*), and final ending of a psalm verse (*terminatio*). The resulting melody is an inflected monotone, that is, performed largely on a single note (monotone) but with a few pitches up or down (inflection) from that note at the beginning, middle, and end.

psalter (sôl'tər). See under PSALM.

psaltery (sôl'tə rē). A stringed instrument of the Middle Ages, consisting of a flat soundboard and strings, which were plucked with the fingers or with a plectrum. In this respect the psaltery differed from the medieval

dulcimer, whose strings were struck with hammers (see DULCIMER, def. 1). Psalteries were made in various shapes, either four-sided (trapezoidal, that is, with both short sides slanted inward, as in the accompanying illustration), or three-sided (half a trapezoid, resulting in a wing shape). The psaltery probably originated in the Near East about the tenth century; it was being played in Europe by the twelfth century. The strings were usually arranged in multiple courses, that is, with two, three, or more strings per note, so that their sound would be loud enough to be heard. In time, the psaltery was given a keyboard whereby the strings were plucked, and eventually it became a HARPSICHORD. For folk music, the dulcimer was generally preferred, and as a result relatively few forms of psaltery have survived. Among the most important that are still used today are the Arab qānūn, Austrian zither, the Russian gusli, and Finnish kantele.

Puccini (po͞o tche̱'nē), **Giacomo** (jä' cô mô), 1858–1924. An Italian composer who is remembered for his operas, some of which are among the most popular operas ever written. His *La Bohème, Tosca,* and *Madama Butterfly,* performed again and again all over the world, are noted for their lovely melodies, skillful orchestration, and highly dramatic plots. Puccini's first great success was the opera *Manon Lescaut* (1893). It was followed by *La Bohème* (1896), *Tosca* (1900), and *Madama Butterfly* (1904), and then *La Fanciulla del West* ("The Girl of the Golden West," 1910), and *Il Trittico* (a trilogy of one-act operas: *Il Tabarro,* or "The Cloak"; *Suor Angelica,* or "Sister Angelica"; and *Gianni Schicchi*). Puccini died before completing

Turandot, which was finished by Franco Alfano (1876–1954). Musically Puccini was less traditional than he is often given credit for being; his harmonies are both freer and richer. It is his dramatic structure, however, that is outstanding. Arias, duets, and choruses alternate with scenes of narrative or dialogue, with the orchestra carrying on the musical continuity and meaning. To some extent Puccini's operas belong to the school of VERISMO (attempting to portray life realistically), but they tend to be wider in subject than the verismo operas of Mascagni and Leoncavallo. His detractors, on the other hand, consider Puccini's works shallow and oversentimental.

pulse The regularly repeated accents or beats that underlie music, similar to the ticks of a clock. See BEAT; RHYTHM.

pulse modulation See under MODULATION, def. 2.

puncta (po͞onk' tä) See under ESTAMPIE.

punta (po͞on'tä) *Italian:* "point," "tip." A word used in the direction *a punta d'arco,* directing the player to use the point of the bow (for playing the cello, violin, etc.).

Purcell (pûr'səl), **Henry,** 1659–1695. An English composer who is remembered as the greatest English composer of the seventeenth century. During his short life he held several important posts at the English court and managed to write a large number of compositions in almost every form —opera, church and other choral music (especially odes), incidental music for plays, chamber music, keyboard works, and many songs of various kinds. Purcell's music is typically baroque in the treatment of counterpoint and harmony. However, he used the forms and styles of his time in a highly personal way. His vocal music in particular shows remarkable skill in setting to music the inflections and accents of the English language. Purcell wrote only one opera,

Dido and Aeneas, which is among the finest of the early operas. His other works include incidental music for *The Fairy Queen, Dioclesian,* and *King Arthur;* four *Odes for St. Cecilia's Day;* two sets of trio sonatas, including the famous *Golden Sonata* in F for two violins, viola da gamba (bass viol), and continuo (harpsichord); numerous fantasias for viols; and *Orpheus Britannicus,* a collection of songs published after his death.

pyiba (pē'pä) *Chinese.* Also spelled *pyipar, p'ipa.* A short-necked lute of China, dating back as far as the second century and still played today. It has a flat, pear-shaped body of wood and four silk strings, with frets showing the stopping positions. The player holds the instrument upright and plucks the strings with the fingers. The Japanese use a version of pyiba called BIWA.

pyipar See PYIBA.

Pythagorean (pi t̲h̲ag"ə rē'ən) **tuning** A system of tuning named for the Greek mathematician Pythagoras, who is believed to have invented it in the sixth century B.C. In the Pythagorean system, all the tones of the scale are derived from a single interval, the perfect fifth (2:3, because when two-thirds of a string vibrate, it produces the tone one fifth above that produced by the vibration of the entire string). According to this system, the interval of one whole tone is always 8:9 (if eight-ninths of a string vibrate, it produces the note one whole tone above that produced by the whole string's vibrations), and the interval of one half tone is always 243:256. The Pythagorean system worked better than the system of just intonation, but it did not work for enharmonic tones (such as D-sharp and E-flat, which sound the same on a modern keyboard instrument). Thus it was replaced, about 1500, by mean-tone tuning, which itself was later replaced by the system of equal temperament used today. See also INTERVAL, def. 2; TEMPERAMENT.

Q

qānūn (kä' nōōn) *Arabic.* Also, Greek, *kanûn* (kä nōōn'), *kanon* (kä nôn'). An Arab PSALTERY that dates from the tenth century or earlier and is still played today in Egypt, Syria, Iraq, and Turkey. It is the leading instrument of the traditional Egyptian orchestra, which consists also of a lute, violin, and flute. Versions of the qānūn are played in India and Indonesia.

The present-day qānūn consists of a shallow box, usually trapezoidal in shape (four sides, with the two shorter sides slanting outward), strung with seventeen to twenty-five triple courses (sets of three strings each, each set being tuned to the same pitch). The Egyptian qānūn has gut strings and is played with two plectra worn on the player's forefingers. The instrument is held flat on the player's lap; the right hand plucks the melody notes and the left hand repeats them in a lower octave. The Egyptian instrument also has movable bridges for slightly raising the pitch of the strings. During the Middle Ages the qānūn was held upright instead of flat and usually had metal strings.

quadrille (kwə dril'). A dance that became popular in the early nineteenth century in France, and later also in England and Germany. Danced by either two or four couples, it had five sections, the odd-numbered ones (1, 3, 5) in 6/8 meter and the others (2, 4) in 2/4 meter. The music was usually taken from popular songs, operatic arias, and other familiar music of the period.

quadrophonic See under STEREOPHONIC.

quadruple counterpoint See under COUNTERPOINT.

quadruple fugue See under FUGUE.

quadruple meter Any METER in which there are four beats per measure, such as 4/4 or 4/8. Quadruple meter is often considered a type of duple meter, since there are two accented beats in a measure (the first and third).

quadruplet A group of four notes of the same time value (all eighth notes, or all quarter notes, for example) that are to be performed in the time usually taken for three notes of that value. For example, in 3/4 meter, calling for three quarter notes per measure, a quadruplet might be a group of four quarter notes within a measure. The quadruplet is usually marked with the figure 4 and with a bracket or slur.

quality, tone See TONE, def. 4; TONE
COLOR.

Quantz (kvänts), **Johann Joachim**
(yō' hän yō ä' ҟнim), 1697–1773. A
German flutist and composer who is
remembered not only for his flute
compositions but for his book on
flute playing, which contains much
valuable information about the music
and instruments of his time. Quantz
learned how to play several instru-
ments during his boyhood. He
became an oboist, but then he took
up the flute. Later, he taught Frederick
the Great of Prussia how to play the
flute, and he was employed at his
court for a number of years. Quantz
wrote some five hundred works for
flute, among them about three hun-
dred concertos (for either one or two
flutes). His book, *Versuch einer An-
weisung die Flöte traversiere zu spielen*
("Essay on the Instruction of Flute-
playing"), was first published in 1752.

quarter note British, *crotchet*. A note,
♩, equal in time value to (lasting as
long as) one-fourth of a whole note.
Thus, four quarter notes equal one
whole note, two quarter notes equal
one half note, and one quarter note
equals two eighth notes.

quarter rest A rest, 𝄽, indicating a
silence lasting the same length of
time as a quarter note.

quarter tone An interval equal to
one-fourth of a whole tone or one-
half of a half tone (a half tone nor-
mally being the smallest interval in
traditional Western music; see INTER-
VAL, def. 2). Since an octave contains
twelve half tones, it contains twice as
many quarter tones, twenty-four in
all.

The most commonly used of the
microtones, the quarter tone was
used in ancient Greece, again in the
Middle Ages, and by various twenti-
eth-century composers. Since the
ordinary keyboard instrument cannot
be tuned to produce any interval
smaller than a half tone, special
instruments are needed for perform-
ing quarter-tone keyboard music.

Among them is the **quarter-tone
piano,** a grand piano made in the
1920s by several companies. The
piano has two keyboards, one above
the other, and two sets of strings,
tuned a quarter tone apart. Alois
Hába (1893–1972) is the most promi-
nent of the composers who wrote for
this instrument. (See also MICROTONE.)

quarter-tone piano See under QUAR-
TER TONE.

quartet 1 An ensemble made up of
four instruments or voices. **2** A com-
position for four instruments or four
voices. Since each voice or instru-
ment has a separate part, the quartet
is a form of chamber music. —**instru-
mental quartet** A quartet for instru-
ments. There are numerous combina-
tions, the most familiar of which is
the STRING QUARTET, consisting of four
stringed instruments (first and second
violin, viola, cello). Others are the
piano quartet (piano, violin, viola,
cello), a wind instrument with three
stringed instruments (**oboe quartet,**
flute quartet, and so on, depending
on the kind of wind instrument; the
strings are nearly always violin, viola,
and cello), **woodwind quartet** (most
often flute, oboe, clarinet, and bas-
soon), **brass quartet** (either two trum-
pets, horn, and trombone, or two
trumpets and two trombones, or some
other combination), and **wind quar-
tet** (mixing brasses and woodwinds,
such as flute, clarinet, horn, bassoon).
Piano quartets have been written
since the time of Mozart (by Mozart,
Beethoven, Schumann, Brahms,
Fauré, and Copland, among others).
Wind quartets also date from Mozart's
time, although they have attracted
relatively fewer composers. The most
popular and oldest form is the string
quartet. —**vocal quartet** A composi-
tion for four singers, each performing
a separate part. The vocal quartet was
probably the earliest kind of four-part
music, dating from c. 1400. The most
usual combination today is the quar-
tet for soprano, alto, tenor, and bass.
However, there are quartets for first
and second soprano with first and

second alto, and quartets for first and second tenor with baritone and bass. The latter combination describes the **barbershop quartet,** which is associated with a style of unaccompanied singing of popular songs in close harmony that was originally developed in nineteenth-century American barbershops. Today there is a society for the preservation of this style, which has chapters nationwide and runs an annual contest for the national championship. The female counterpart of the barbershop quartet is called **Sweet Adelines,** named for the song, "Sweet Adeline" (1903), an extremely popular number with barbershop quartets.

quasi (kwä′zē) *Italian:* "as if" or "nearly" or "almost." A word appearing in such musical terms as *allegro quasi presto* ("quick, almost very quick"), and *quasi niente* ("almost nothing," meaning so soft it can scarcely be heard).

quaver (kwā′vər). The British term for EIGHTH NOTE.

quint (kwint). See under MUTATION STOP.

quintet 1 An ensemble made up of five instruments or voices. 2 A composition for five instruments or five voices. Since each singer or instrument has a separate part, the quintet is a kind of chamber music. —**instrumental quintet** A quintet for instruments. The most familiar combination is the STRING QUINTET, usually with parts for first and second violin, first and second viola, and cello; occasionally a second cello is substituted for the second viola. Another combination is that of a keyboard or wind instrument (piano, oboe, clarinet, flute, horn, or other) with a string quartet (usually first and second violin, viola, cello; occasionally a double bass is substituted for one of the stringed instruments). Such a combination is called a **piano quintet, clarinet quintet,** and so on, depending on which instrument is used with the strings. Among the best-known ex-

amples is Schubert's *Trout Quintet,* op. 114 (for piano, violin, viola, cello, and double bass); more recent ones are Hindemith's Piano Quintet, op. 7, Schnittke's Quintet for piano and strings (1972–1976), and Diamond's Quintet for guitar and strings (1993). Still other combinations are the **wind quintet** (Milhaud's *La Cheminée du roi René* is for the most common combination, flute, oboe, clarinet, horn, and bassoon; other examples are Anton Reicha's two dozen Wind Quintets (opp. 88, 91, 99, 100), Nielsen's Wind Quintet of 1923, Schoenberg's Wind Quintet, op. 26, of 1927, Carter's Wind Quintet of 1948, and Birtwistle's *Five Distances for Five Instruments* (1993), or for piano and four wind instruments (Mozart's Quintet in E-flat, K. 452, for piano and winds; Carter's Quintet for piano and winds, 1991). A **brass quintet** normally consists of two trumpets, horn, trombone, and tuba. Examples include brass quintets by Victor Ewald (opp. 5, 6, 7, 9), Gunther Schuller (*Music* for brass quintet, 1961), and Malcolm Arnold (1963). In addition, Ingolf Dahl's sextet, *Music for Brass Instruments* (1944), is often performed in a quintet version. (See also STRING QUINTET.) —**vocal quintet** A composition for five singers. This form has been popular since the sixteenth century. The madrigal composers in particular favored it (Lasso, Byrd, and others; see MADRIGAL, def. 2). The most common combination today is first and second soprano, alto, tenor, and bass.

quintuple counterpoint See under COUNTERPOINT.

quintuple meter Any meter in which there are five beats per measure, such as 5/8. Such a meter usually breaks down into either duple plus triple (2/8 + 3/8) or triple plus duple (3/8 + 2/8), depending on where the secondary accent (if any) falls. (See also METER.)

quintuplet A group of five notes of the same time value (all eighth notes

or all quarter notes, for example) that are performed in the time usually taken for four notes of that time value. For example, in 3/4 meter, calling for three quarter notes (or six eighth notes) per measure, a quintuplet might be a group of five sixteenth notes instead of four (see the accompanying example, from a Chopin waltz). The quintuplet is normally marked with the figure 5 and a bracket or slur.

quodlibet (kwod′lə bet″) *Latin.* A composition in which two or more familiar melodies are contrapuntally combined. The practice of treating tunes in this way, usually just in fun, began with thirteenth-century composers of motets, who would use one melody in one voice-part and another in a different voice-part. The melodies so used often combined religious music (Gregorian chants, for example) with popular songs. The Spanish version of quodlibet, which first appeared in the Cancionero del Palacio (c. 1500), is called **ensalada** ("salad"). A particularly well-known example of quodlibet is found in the last variation of Bach's *Goldberg Variations,* in which two popular tunes are combined.

quotation, musical The deliberate inclusion of musical material from another composition, to convey an idea or a mood, evoke an ironic comparison, or make some other analogy. The technique is also called **quotation and collage** (*collage* is French for "necklace"), a term borrowed from the visual arts to describe the layering of tunes or other borrowed musical elements with new material. It has been used in titles, as by Roberto Gerhard for his Symphony no. 3, *Collages with Tape* (1960).

The process of quotation is far from new. J. S. Bach, for example, quoted a bawdy folk song in his Peasant Cantata for humorous effect, and many other composers have used the device both before and since. However, quotation has become particularly associated with certain composers from the 1960s on. George Crumb, in *Ancient Voices of Children,* evoked the mood and manner of Ravel's *Boléro* and Debussy's *Ibéria* without precisely quoting these earlier compositions; Druckman's *Windows* similarly evokes Ravel's *La Valse;* Rochberg in *Music for the Magic Theater* quoted Beethoven, Mozart, and Mahler, and in his String Quartet no. 3 used both older styles (Beethoven, Mahler, Bartók, Stravinsky) and direct quotation (Mahler's Ninth Symphony); Davies frequently quoted medieval and Renaissance music. Stockhausen not only quoted the music of other cultures but sometimes actually included it—in the form of tape recordings made in the field, of music from Africa, South America, Japan, Bali, Vietnam, and elsewhere—as raw material for his tape piece *Telemusik,* although he then modified these segments electronically to integrate them with the composition. Other modern composers known for their use of quotation are John Cage, Bernd Alois Zimmermann, Michael Tippett, Mauricio Kagel, Hans Werner Henze, Luciano Berio, Henri Pousseur, and Christopher Rouse (his Trombone Concerto, in memory of Leonard Bernstein, quotes Bernstein's Kaddish Symphony, and his Cello Concerto of 1994 quotes from works by three other recently deceased composers, William Schuman, Andrzej Panufnik, and Stephen Albert, as well as from Monteverdi).

R

R. An abbreviation for either *right* or *rechte,* meaning "right" and referring to the right hand.

rabab (rab'əb) *Arabic.* Also, *rebab, ribab, ribible, rubebe.* A name used in the Near East for a bowed stringed instrument that dates back at least as far as the tenth century. Developed from a lute, the rabab originally had a pear-shaped body, a belly covered with hide or parchment, one to three strings, and a short, stumpy neck. Arab peoples brought the rabab to many countries, eastward as far as Indonesia, and west to North Africa and Spain. Over the centuries the instrument was modified in many ways. Some rababs were boat-shaped, some rectangular, some trapezoidal (four-sided, with the two short sides slanted), and some round. In Europe the rabab eventually became the REBEC, a forerunner of the violin.

R and B An abbreviation for RHYTHM AND BLUES.

Rachmaninoff (räкн mä' nē nôf''), **Sergey** (ser gā'), 1873–1943. A Russian pianist and composer who wrote a number of works that have become part of the standard piano repertory. Rachmaninoff studied at the St. Petersburg and Moscow conservatories. At the age of twenty he wrote one of the most popular piano pieces ever written, the Prelude in C-sharp minor, op. 3, no. 2. In time Rachmaninoff became known as a virtuoso pianist and toured the world, giving concerts. In 1917 he left Russia, settling first in Switzerland and later in the United States. Most of his best-known compositions were written before his departure. Rachmaninoff's music continued the tradition of Tchaikovsky, whom he greatly admired. Like Tchaikovsky's, Rachmaninoff's works are very melodic and often melancholy in mood (he used mostly minor keys), but his writing for piano is technically as brilliant as that of Liszt. Although he wrote a great many works, he is remembered largely for one symphonic poem, *The Isle of the Dead,* his four piano concertos (especially no. 2), preludes and other short piano works, and *Rhapsody on a Theme of Paganini,* a set of twenty-four variations for piano and orchestra.

racket (rak'it). Also spelled *rackett.* A woodwind instrument of the sixteenth century. It consisted of a short thick cylinder (tube), made of wood or ivory, with a number of finger holes and with a reed inserted into the top. Inside the tube a series of very narrow up-and-down channels were bored, connected at top and bottom so as to form a very long, continuous tube. This construction made it possible to obtain very low tones (ordinarily produced by very long instruments) from an instrument that was only about twelve inches long.

The racket's soft, low, buzzing tone was highly suitable for bass parts in the ensemble music of the late sixteenth and seventeenth centuries. By 1700, however, it had died out, at least in its original form. A different version of it survived somewhat longer; it had a conical bore (cone-shaped inside), a bell like a bassoon's, and a double reed carried on a crook (also like a bassoon's). Built in the early eighteenth century, it was called a **racket bassoon** or, because of its shape, **sausage bassoon**.

racket bassoon See under RACKET.

raddolcendo (rä dôl chen'dô) *Italian.* Also, *raddolcente* (rä dôl chen'te), *raddolcito* (rä dôl chē'tô). A direction to perform more and more softly.

raddolcente See RADDOLCENDO.

raddolcito See RADDOLCENDO.

raga (rä'gə; räg) *Sanskrit.* A name for the MELODY TYPE basic to Indian music. There are several thousand ragas, each with its own particular combination of notes, although in practice only fifty or so ragas are in common use. Each raga also has its own special quality; since it originally celebrated a particular time or season or god or event, it is associated with a particular mood or atmosphere, as well as a particular time of day (morning raga, evening raga). Besides consisting of a number of pitches, which are selected from various combinations of SRUTI, a raga has strong and weak notes, as well as notes performed in a special way (with special intonation). The basic note of the raga, comparable to the tonic (keynote) of the Western diatonic scale (C in C major or C minor, D in D major, etc.), is sounded throughout the performance of a raga by a drone, that is, it is sounded constantly for the whole length of the piece. Generally some other note a specific distance away from the basic note is sounded along with it, perhaps a fourth or fifth away. The tones of a raga must be used throughout the performance. They are not written

down, traditional Indian music still being taught by word of mouth. The music thus consists of improvising (inventing a composition) based on a memorized raga, using the notes of the scale, observing strong and weak notes and phrases associated with that raga, and performing particular notes in the approved fashion. Further, raga performance also involves certain set rhythmic formulas, called **talas**, and a particular musical form. For example, a raga often begins with a slow opening section, called **alap**, in which the basic features of the raga are introduced. It is followed by several other sections, usually four, which are known by different names in North and South India. In general they elaborate on different aspects of the raga. The raga closes with either a repetition of the original material or still another variation on it. The rules are so strict that it would seem little was left to the performer's improvisation; on the contrary, it is the very ingenuity required to improvise without breaking any of the rules that is considered a measure of musical skill.

North and South Indian music differ somewhat. The former, called Hindustan music, has been influenced more by the music of its Arab neighbors. South Indian music, called Carnatic music, shows less foreign influences. Although both systems are based on the same underlying concepts, the names of ragas, details of performance practice, and even the instruments used differ somewhat. The performance of ragas involves three basic features: the melody, performed by the singer (all ragas are essentially vocal) and either a wind instrument (flute or oboe) or the SITAR (North India) or VINA (South India); the rhythm provided by drums, usually TABLAS (North) or MRIDANGA (South); and a drone, most often provided by the TAMBURA (sometimes called tanbura).

raga rock See under ROCK.

ragtime A type of American dance music that developed in the nine-

teenth century and was very popular around 1910. Although it grew out of band and vocal music, ragtime became mainly a style of piano playing. Its harmonies and melodies were conventional; what set it apart was its thumping rhythm, steady in the left-hand part and very syncopated in the right-hand part. Though most ragtime pieces are notated in 2/4 or 4/4 meter, in performance the syncopation (accents on unexpected beats and unevenly divided beats) is so marked that the music sounds polymetric (as if two meters were being used at the same time; see POLYMETER). The so-called "father of ragtime" was the black composer and pianist Scott Joplin (1868–1917), whose most popular composition was "Maple Leaf Rag" (1899). Other important ragtime artists were Eubie Blake (1883–1983) and Jelly Roll MORTON. One of the important forerunners of jazz, ragtime was replaced by jazz in popularity, though it continued to appeal to a great many people. It occasionally influenced serious composers, most notably Stravinsky, whose works include *Ragtime* for eleven instruments (1911) and *Piano Rag-Music* (1920). See also JAZZ; STRIDE PIANO.

rall. An abbreviation for RALLENTANDO.

rallentando (rä len tän' dô) *Italian.* A direction to perform more and more slowly. The same as RETARD and RITARDANDO. Often abbreviated *rall*.

Rameau (rA mō'), **Jean-Philippe** (zhän fē lēp'), 1683–1764. A French composer and theorist who is remembered both for his compositions, especially his ballets, operas, and keyboard music, and for his treatise on harmony, which is considered the basic work on classical harmony. Published in 1722, Rameau's *Traité de l'harmonie réduite à ses principes naturels* ("Treatise on Harmony Reduced to Its Natural Principles") discusses all the basic principles of classical harmony—a tonal center (see KEY, def. 3), roots and inversions of chords (see CHORD), and how chords, especially triads, are put together (see HARMONY, def. 2). Originally an organist, Rameau wrote harpsichord compositions in the so-called GALLANT STYLE, much like those of François Couperin. Later he began to write operas and ballets, carrying on the tradition of French opera founded by Lully. Outstanding among these are the opéra-ballet *Les Indes galantes* ("The Gallant Indies," 1735) and the opera *Castor et Pollux* (1737). In the early 1750s the supporters of Rameau's style of opera clashed with those who favored comic operas in Italian style (see COMIC OPERA). The production of Pergolesi's *La Serva padrona* touched off a famous quarrel called *la guerre des bouffons* ("the war of the buffoons"). Pergolesi's side was taken by a group of intellectuals known as the Encyclopédistes ("Encyclopedists"), among them Jean-Jacques Rousseau. Rameau undertook his own defense, writing numerous articles in which he upheld his treatment of harmonies and his use of instruments. Soon after Rameau's death, the controversy collapsed, and his music was regarded as a model for students and composers.

range Also, *compass, gamut.* The entire series of notes, from the lowest to the highest, that a voice or musical instrument is capable of performing. In this dictionary the ranges of the most important instruments are given in the article for each instrument, and the range of the various voices (soprano, tenor, and so on) in the article for each type of voice. (See also TESSITURA.)

rank In organs, a set of pipes controlled by a single stop. Most stops control just one rank of pipes, all of the same kind. A mixture stop, however, which sounds several notes at one time, controls several ranks of pipes, usually three or four. (see also ORGAN.)

ranz des vaches (rän dä väsh') *French.* A type of tune played on the alphorn by Swiss cowherds. There are numerous versions of such tunes, played in different parts of the Alps. Occasion-

ally composers have used such melodies in serious compositions, as, for example, Beethoven in his Symphony no. 6 (*Pastoral Symphony*) and Rossini in the overture to his opera *William Tell.*

rap A kind of improvised chatter, often in rhyme, over REGGAE, rock, or some other popular dance music. Rap originated in New York City in the late 1970s as an outgrowth of *toasting*, a rhythmic, improvised recitation practiced by disk jockeys (deejays) in Jamaica. At first the deejay simply made up rhymes over recorded dance music, played over transportable sound systems. Deejays then began to manipulate the records on the turntable by hand, while one or more vocalists improvised lyrics. Next they moved into the recording studio, where they went one step further, now manipulating the components of a recording through the use of reverb and echo, giving birth to DUB. Deejays now could, by boosting the bass, phasing parts of the vocal in and out, and adding extramusical noise, create endless versions of a single piece of material, and in effect the producer or mixer of rap replaced the live performer.

After moving to New York, rap was subjected to still newer techniques, such as *scratching* (repeated manipulation of a single passage or beat on a record), *punch phasing* (using a particular vocal, drum beat or horn phrase as a kind of punctuation), and *break beats* (isolating a particularly lively rhythmic track from a recording so as to encourage the dancers).

Until the late 1980s rap was mainly produced by black artists. When white producers began to take it over, they added yet another element, *digital sampling*, which allows, with the help of a computer, incorporating prerecorded material into a new composition.

Over the years, rap became increasingly controversial. Not only was the technique of sampling denounced as outright theft, but the lyrics of rap, especially the variety called *gangsta rap*, were condemned for their angry profanity, graphic sex, homophobia, and black separatism (intolerance of nonblacks). See also HIP-HOP; SCATTING.

rappresentativo, stile See STILE RAP-PRESENTATIVO.

rapsodie (rAp sô dē′). The French word for RHAPSODY.

rasch (rä<u>sh</u>) *German.* A direction to perform in quick tempo.

rattle 1 A large group of percussion instruments that produce a sound when numerous small objects, such as seeds or pebbles or pieces of bone, are made to strike against one another. The objects may be in a container (a gourd, tube, basket; see MARACA), or they may be strung together on a frame (see SISTRUM) or cord. Usually rattles are sounded by being shaken; sometimes they are rubbed or struck. **2** Also, *cog rattle.* An orchestral percussion instrument that consists of a wheel with cogs (notches) cut into it and attached to a flexible strip of wood or metal. When the wheel is turned, the strip strikes the cogs, producing a rattling sound. Actually this device is not a rattle but a **ratchet.** Instruments of this kind have been used since ancient times in many parts of the world and for many purposes, including religion and magic. In the orchestra they are used only occasionally; among the scores that call for a rattle is Richard Strauss's *Till Eulenspiegel.*

Rauschpfeife (rou<u>sh</u>′ pfī fe) *German.* A SHAWM of the Renaissance, used mainly during the sixteenth century and today used in the performance of Renaissance music. Unlike other shawms, it has a rear thumb hole in addition to seven finger holes, and its double reed, enclosed in a protective cap, is mounted directly on the body of the instrument, which ends in a slightly flared bell. It was made in sizes ranging from soprano to contrabass.

Ravel (rA vel′), **Maurice** (mō rēs′), 1875–1937. A French composer who

wrote relatively few compositions, about half of which are now part of the standard concert repertory. He is noted particularly for his piano works, chamber music, and stage works (theater and ballet). Ravel attended the Paris Conservatory, where he studied under Gabriel Fauré. His first important works were the piano pieces *Jeux d'eau* ("Fountains") and *Pavane pour une Infante défunte* ("Pavane for a Dead Infanta"), which have remained very popular. In the next decade he composed several more immensely successful works—the orchestral *Rapsodie espagnole* ("Spanish Rhapsody"), *Ma Mère L'Oye* ("Mother Goose"; originally a piano duet for children but later made into an orchestral suite), the one-act opera *L'Heure espagnole* ("The Spanish Hour"), and the ballet *Daphnis et Chloé* (later made into two orchestral suites). His other works include the quite difficult piano compositions *Miroirs* ("Mirrors") and *Gaspard de la nuit* ("Gaspard of the Night"); the dance *La Valse;* the ballet *Boléro;* Piano Concerto in G; Piano Concerto for the left hand alone; *Introduction and Allegro* for harp, string quartet, flute, and clarinet; *Tzigane,* a rhapsody for violin and piano (or orchestra); and several dozen songs and song cycles.

Ravel's music is often coupled with that of Debussy, the founder of impressionism. Like Debussy, Ravel was inspired by poetry, especially the modern French poets of his time, such as Stéphane Mallarmé, and sought to develop poetic and pictorial ideas in his music. Also like Debussy, Ravel was attracted by different scale systems (medieval, Oriental) and by lively dance rhythms (especially Spanish), and he, too, expanded the traditional ideas of harmony, freely using dissonance. But Ravel was much more organized and formal in his approach. He adhered to the conventional forms, such as sonata form, and he avoided the whole-tone scale, often used by Debussy. Although a master of orchestration, he wrote few independent orchestral works; most are adapted from theater or ballet music, or are transcriptions of piano music. After about 1913 Ravel turned more to smaller forms—trios, quartets, etc.—and began to revive or recreate classical forms. Examples include his lament on the death of Couperin (see LAMENT, def. 1), and his opera *L'Enfant et les sortilèges* ("The Child and the Magic Spells"), a series of arias and ensemble numbers in the style of the eighteenth-century NUMBER OPERA. In some of his late works, especially the piano concertos, jazz elements appear.

ravvivando (rä vē vän' dô) *Italian.* A direction to perform faster and faster.

re (rā). In the system of naming the notes of the scale (see SOLMIZATION), the second note of the scale (the others being *do, mi, fa, sol, la,* and *ti*).

real answer See under ANSWER.

real sequence See under SEQUENCE.

rebab Another spelling for RABAB.

rebec (rē'bek). A bowed stringed instrument used in Europe from about the eleventh to the eighteenth centuries, which is an ancestor of the modern violin. The rebec is believed to have come to Europe from Greece and was called LYRA (def. 2). Sometime in the thirteenth century its resemblance to the Arab RABAB was noted and it began to be called **rubebe**, and later rebec. The rebec was carved from a single piece of wood (instead of separate pieces for neck and body). Like the rabab, it had a pear-shaped body and short neck. Like the lyra, it had three strings, tuned a fifth apart. Unlike the two Eastern instruments, however, the rebec was held upright, against the player's shoulder, and the strings were bowed with the palm down, as with the modern violin. By the sixteenth century the violin had been developed, with its more distinct neck and fingerboard, four strings, soundpost, and other features. A small pocket-sized violin resembled the rebec more closely (see

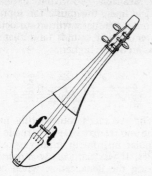

KIT). The rebec continued to be used, though less and less, and by the eighteenth century it was used only by street musicians. The accompanying illustration shows a three-stringed type of rebec used in the seventeenth century.

rebop see BOP.

recapitulation See under SONATA FORM.

rechte Hand (reĸн′ te hänt) *German:* "right hand." A direction in keyboard music to play a note or passage with the right hand. Abbreviated *R.H.*

recital A public performance by one or two performers (singer and accompanist, instrumental duet) as opposed to a concert, a performance by three or more performers (trio, quartet, band, orchestra). Occasionally the terms "recital" and "concert" are used interchangeably, especially for small groups, such as a trio. For popular music the term recital is rarely used.

recitation tone See TONE, def. 3; also PSALM TONE.

recitative (res″i tə tēv′). A style of singing that closely resembles speech, with relatively little change in pitch and the rhythm governed largely by the rhythm of the text. It was first used in the late sixteenth century, and it soon played an important part in operas, oratorios, cantatas, and other vocal music. In accord with the new monodic style (see MONODY, def.

1), most recitatives were accompanied by an instrument playing simple chords (see CONTINUO), usually a harpsichord or organ (with or without a cello or bass viol to strengthen the bass line). This kind of recitative was said to be in STILE RAPPRESENTATIVO. Early operas actually consisted of a series of recitatives with instrumental accompaniment. In the first half of the seventeenth century, with Monteverdi, operatic music became more expressive and dramatic, and arias, with more melody, were introduced. The recitative continued to tell the basic events of the plot, while the characters' thoughts and feelings were expressed in arias. The eighteenth-century opera was essentially an alternation of recitatives with arias and duets and other ensemble numbers (see under OPERA). The style of the recitatives now so closely resembled speech, the score often giving only approximate pitches and time values of the notes, that it came to be called **recitativo secco** (literally "dry recitative"). In church music, however, recitatives were often more dramatic and expressive, especially in Passions and cantatas, and often were accompanied by the orchestra; this style came to be called **recitativo stromentato** or *accompagnato* ("instrumental" or "accompanied recitative").

Recitative was not a new invention of the 1590s. The chants of various churches, especially those used for psalms (see under PSALM), represent a similar style of singing. The general style of recitative, particularly its free rhythms, has occasionally been used in instrumental works, by Bach, Haydn, Beethoven, and others. In the twentieth century, recitative began to play an increasingly important part in opera, quite apart from conscious attempts to revive the seventeenth-century style (as in Stravinsky's opera *The Rake's Progress*). Schoenberg called for a new vocal style, halfway between speech and song, which he called SPRECHSTIMME, used also by Berg in his opera *Lulu*. Later composers, such as Luciano Berio, continued to

combine speech and song, often in quite novel ways. (See also PARLANDO, def. 1.)

recitativo arioso (re" chē tä tē' vô ä rē ô'sô) *Italian.* See under ARIOSO, def. 2.

recitativo secco (re" chē tä tē'vô sek' ô) *Italian.* See under RECITATIVE.

recitativo stromentato (re" chē tä tē' vô strô" men tä' tô) *Italian.* See under RECITATIVE.

recorder The most important of the end-blown flutes, that is, a flute that is held straight and blown into at one end instead of sideways, like the orchestral flute. The recorder consists of a whistle mouthpiece (see FIPPLE FLUTE) and a body with a conical bore (cone-shaped inside), which becomes narrower at the lower end. It has seven to nine finger holes in front, some of which may be fitted with keys, and one thumb hole at the back. Used since the Middle Ages, recorders began to be built in a number of sizes during the sixteenth century. Today the soprano and tenor sizes are pitched in C and the alto and

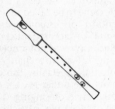

bass sizes in F, each with a range of two octaves. The soprano size (called *descant* in Great Britain; it is shown in the accompanying illustration) has one joint (between the head and body); the alto (called *treble* in Britain) and tenor sizes both have two joints, one between the head and body and a second between the body and bell. The bass size usually has three joints (an extra section is between the head and body). In addition, sopranino and contrabass sizes

are available. To avoid excessive ledger lines, the music for soprano recorder is usually written an octave lower than it sounds (and that for bass an octave higher).

The recorder's soft, slightly nasal tone and relative simplicity made it a popular instrument from very early times. It was particularly important during the Renaissance, when consorts of recorders were used for ensemble music (see CONSORT). It remained popular during the baroque (1600–1750), when a great many chamber works included a part for recorder. On the Continent the recorder was then known as a flute (in Italian, *flauto*), the orchestral flute being called *flauto traverso* (transverse flute; see under FLUTE) in order to distinguish the two instruments. After about 1750 the recorder was largely replaced by the flute, which has a greater dynamic range (from very soft to quite loud) and a slightly larger range (of pitches), and allows more variety of expression, all factors important in the music of the classical and romantic periods (1785–1900). Early in the twentieth century Arnold Dolmetsch, an Englishman interested in early music and early instruments, revived the recorder, and today it is again very popular. Relatively easy to play and quite inexpensive (it is available in plastic as well as wood), it is often recommended as a first instrument for young children (especially the soprano, whose closely spaced finger holes are in easy reach for small hands), as well as for amateur performances at home. Moreover, it is used for both solo and ensemble music of the Middle Ages, Renaissance, and baroque periods, and for the music of some twentieth-century composers (Bartók and others).

Two systems of fingering are in general use. Some German instru-

ments have the so-called **German fingering**, with a lowered fifth hole. More common is the **English** or **baroque fingering**. The main difference between the two is in fingering the F and F-sharp in the soprano and tenor instruments (B-flat and B in the alto and bass). Although the German fingering is easier to learn, the instruments designed for it are generally less useful in their higher registers.

reed A thin strip of metal, cane, plastic, or some other flexible material, whose vibrations are used to produce sound in various musical instruments. In woodwind instruments such as the clarinet, saxophone, and oboe, the player's breath makes the reed vibrate, and these vibrations in turn cause the column of air inside the body of the instrument to vibrate, producing sound. The pitch of the sound is controlled by the length of the pipe, which is varied by means of finger holes and keys. —**single reed** The type of reed used in the clarinet, saxophone, bagpipes, and organ (in the so-called reed pipes; see ORGAN). This reed is made to vibrate against a part of the pipe. The accompanying illustration shows the type of single reed used in the bagpipe drone.

—**double reed** The type of reed used in the oboe, English horn, and bassoon. It consists of a strip of cane so folded that the two ends vibrate against each other (see also DOUBLE REED). —**free reed** Also, *beating reed*. A tongue-shaped reed, nearly always made of metal, which is fastened at one end and free at the other. It is made to vibrate by means of air pressure, provided either by the player's breath or by bellows. A free reed itself produces a sound. Each such reed can produce only a single note, whose precise pitch depends on the reed's thickness and length. Among the instruments sounded by means of

free reeds are the accordion, harmonica, and harmonium.

reed organ Another name for HARMONIUM.

reed pipe See under ORGAN.

reel A lively dance for two or more couples. The music is in duple meter (any meter in which there are two basic beats per measure, such as 2/2 or 2/4), usually 2/4 or 4/4 meter, and consists of regular four- or eight-measure phrases that are repeated over and over. The reel originated in northern Europe, mainly in Great Britain and Scandinavia. The American version known as **Virginia reel** is modeled on the Irish and Scottish reel.

reform opera See under GLUCK, CHRISTOPH WILLIBALD.

refrain 1 Also, *chorus*. In a poem or song, certain lines that are repeated at regular intervals, both words and music remaining the same each time. The changing portions of the poem or song are called verses or stanzas, and they alternate with the unchanging refrain. (When the music for the verses remains the same as well, the form is called STROPHIC.)

The idea of a refrain stems from early church music, with its responses (first by the congregation and later by the choir) to solo chants (see ANTIPHON, def. 1; PSALM). Songs with refrains began to be written early in the Middle Ages. Particularly important were three French forms, the ballade, rondeau, and virelai. In these the text of the refrain was often taken from a well-known poem or song. Sometimes the refrains from several poems were used in a single song, so that actually each refrain was different. Such borrowed refrains were also to be used in one voice-part of a motet, usually in the highest part. 2 In instrumental music, a term occasionally used for a periodically recurring section. The most important musical form with a section repeated over and over is the RONDO.

regal (rē'gəl). A small portable organ of the late Middle Ages and Renaissance. It had only reed pipes, which are made to sound by the vibrations of a flexible strip of metal (see under REED). Early regals had only a single rank of pipes; later more were added. In the course of the fifteenth century, reed pipes began to be used in the larger church organs, which until then had had only flue pipes, and these reed pipes themselves were called regals. One version of regal was small enough to be folded in half like a book; for this reason it was called **bible regal**. See also ORGAN.

Reger (rā'gər), **Max** (mäks), 1873–1916. A German composer who composed an enormous number of works in almost every form except opera, particularly a great deal of organ and chamber music. Reger rejected the ROMANTICISM of the late nineteenth century, turning for inspiration to the works of Bach. He used numerous baroque forms—prelude and fugue, toccata, suite, sonata for unaccompanied violin—and he emphasized counterpoint and rapid movement, resulting in a texture like that of many baroque concertos. However, Reger's treatment of harmony, the piling up of chord after chord in rapid succession, is a feature that belongs more to his own time than to Bach's. Notable among Reger's orchestral works are *Sinfonietta*, op. 90; *Eine Lustspielouvertüre* ("A Comedy Overture"), op. 120; and *Variations and Fugue on a Theme by Mozart*, op. 132.

reggae (rā'gā, re'gā). A kind of popular dance music that developed in Jamaica in the late 1960s and spread first to Great Britain and then throughout America and Europe. An outgrowth of earlier Jamaican popular forms melded with elements of Latin music and American rhythm and blues, reggae is vocal music, either a solo or harmonized (by three, four, or more voices) song, usually strophic (in stanzas), supported by the driving melodies and rhythms of guitars, percussion (especially hi-hat

cymbals, snares, and bass drum), and sometimes electric organ, mouth organ, piano, and/or winds. The most important instrument by far is the electric bass. Like many popular genres, reggae is in 4/4 time. However, as in most other Jamaican music, the strongly felt beats are not 1 and 3 but 2 and 4. The bass drum plays a definite rhythm and also may play a distinct melody line; reggae bass lines are called **riddims** (a corruption of "rhythms"). They complement the chords, melody, and lyrics of the song but, because of their distinct pattern, can stand as a separate composition. The name "reggae" itself comes from a Jamaican street expression meaning "raggedy, everyday stuff," and initially the music served as an expression of protest for the island's urban poor. The texts of reggae most often are social commentary of a revolutionary or radical nature, sometimes satirical and bitter, yet often holding up ideals of love, loyalty, justice, and hope. Most of the early reggae performers embraced a religion known as Rasta, whose practitioners are called Rastafarians and whose God is called Jah. Their customs include wearing "dreadlocks" (obeying the biblical injunction never to cut one's hair), a vegetarian diet, and the use of marijuana to attain a higher state of consciousness.

The major outlet for reggae in Jamaica was the mobile sound system—basically a turntable, amplifier, and large speakers that could be placed on a truck—which first appeared in the island in the late 1940s and became a cultural force from the 1960s on. One or more sound systems are used in a dance hall, presided over by the **deejay**, or disk jockey, whose rapping introductions and interjected patter enhance the rhythm and encourage the dancers. This patter became part of reggae music (see also RAP). Indeed, the recordings and stage performances of reggae musicians were strongly influenced by the requirements of the sound systems, which still are used for dances in Jamaica. Sophisticated stu-

dio recording equipment, enabling the separate recording of rhythm tracks and the addition of a solo vocal, harmony vocal, instrumental solo, or rap over the same rhythm tracks, has resulted in highly complex recordings. The performer who first popularized reggae and whom many still consider its finest artist was Bob Marley (1945–1981).

register 1 In organs, another term for RANK (a set of organ pipes controlled by a single stop). See also REGISTRATION. 2 In harpsichords, a set of strings. 3 A term used for different parts of a singer's range, such as head register (high notes) and chest register (low notes). See under VOICE. 4 In instruments, a name for different parts of the range. Woodwinds in particular have a different tone color in their high and low registers; for a specific example, see under CLARINET.

registration In playing the organ, the art of selecting and combining various stops. The chief difference between the organ and other instruments is the wide variety of tone colors it can provide, owing to the many kinds of pipe. Playing the organ thus is not simply a matter of sounding the right pitches for the right length of time but picking the proper tone color for each of them. This is done by operating the stops, each of which brings into play a different kind of pipe, or, in the case of mixture and mutation stops, several kinds. Although modern composers usually indicate exactly which stops are to be used, relatively few organ scores dating from before about 1800 contain such directions. (See also ORGAN.)

Reich (rīsh), **Steve,** 1936– . An American composer who became one of the pioneers of LIVE ELECTRONIC MUSIC and minimalism. Influenced by his studies of African drumming (in Ghana) and of gamelan, in the 1970s he created works for his group of largely percussion instruments. Subsequently his style changed, but Reich's music continued to be

grounded in the minimalist hallmarks of tonality and, until the late 1980s, a steady pulse. He introduced the practice of phasing—repetition of the same part but gradually moving out of synchronization (see under MINIMALISM for a more detailed explanation). Notable among his compositions are *It's Gonna Rain* (1965), a single phrase shouted by a Pentecostal preacher and manipulated by a tape loop so the words go in and out of phase; *Piano Phase* (1967), in which two pianos go out of phase with each other; and *Tehillim* (1977), based on Hebrew psalms. In the 1980s Reich began to write for larger forces; his *The Desert Music* (1984) calls for 89 instrumentalists and 27 voices. *Different Trains* (1988) dispenses with the formerly unvarying pulse and draws on more personal material, the voices of childhood friends seeing him off on early train journeys and the memories of Holocaust survivors. In 1993, in collaboration with his wife, video artist Beryl Korot, Reich produced *The Cave*, a three-act video opera with spoken texts manipulated through computer sampling, which are the basis for the corresponding pitches, harmonies and rhythms of the computer-processed score, also assisted by 17 live musicians and with the whole projected on five huge video screens.

related key See KEY, def. 3c.

relative key See KEY, def. 3b.

remote key See KEY, def. 3.

Renaissance (*English,* ren' i säns"; *French,* rœ ne säns'). In the history of music, the period between about 1425 and 1600, including the work of the Burgundian and Flemish schools, as well as that of composers in Italy, England, and Spain. Some scholars leave out the Burgundian school, dating the Renaissance from about 1475 (marking the death of Guillaume Dufay and the early career of Josquin des Prez). This dictionary holds with a compromise date, 1450, on the ground that the Burgundians should be

IMPORTANT RENAISSANCE COMPOSERS

Composer	Origin/Active in	Noted for
Alexander Agricola (c. 1446–1506)	Flemish/Milan, Florence, Cambrai, Paris, Spain, Belgium	Many three-part rondeaux and virelais; also motets, Masses, instrumental music; renowned singer; associated with Ockeghem at French royal chapel.
Jacob Arcadelt (c. 1505–c. 1568)	Flemish?/Italy, Rome, Paris	Madrigals, chansons; also motets.
Hugh Aston (c. 1480–c. 1558)	England	Famous *Hornpipe* for virginals; also church music.
Adriano Banchieri (1568–1634)	Italy	Sacred and secular music; important treatise on how to play figured bass.
Gilles Binchois (c. 1400–1460)	Burgundy/Dijon	Chansons, especially rondeaux; also motets, Mass movements.
Antoine Brumel (c. 1460–c. 1520)	France/Chartres, Geneva, Paris, Ferrara	Many Masses; also motets, other sacred music.
John Bull* (c. 1562–1628)	England/London, Brussels, Antwerp	Organ and harpsichord music; virtuoso harpsichordist.
Antoine Busnois (deBusne) (died 1492)	Flemish/Dijon, Bruges	Pupil of Ockeghem; Masses, motets, chansons.
William Byrd* (1543–1623)	England/Lincoln/London	Sacred choral music, madrigals, keyboard music
Antonio de Cabezón* (1510–1566)/Spain		Keyboard music; virtuoso organist.
Jacobus Clemens non Papa (c. 1510–c. 1556)	Flemish/Flanders, Netherlands	Motets; also Masses, sacred and secular songs; Dutch *Souterliedekens* (hymns).
Loyset Compère (c. 1445–1518)	France/Milan, Paris, Cambrai, St. Quentin	Chansons, motets, substitution Masses (motets that replaced movements of the Mass).
Thomas Crecquillon (c.1500–1557)	Flemish	Chansons; also Masses, motets.
John Dowland* (1562–1626)	England/Paris, Oxford, Denmark, London	Organ and harpsichord music; lute songs;virtuoso lutenist.
Guillaume Dufay* (c. 1400–1474)	Burgundy/Cambrai, Italy	Masses, chansons
John Dunstable* (c. 1380–1453)	England/England, Burgundy	Masses, motets.
Giles Farnaby (c. 1565–1640)	England	Four-part canzonets, psalms, and other sacred pieces; more than 50 keyboard works in Fitzwilliam Virginal Book.

*See separate article on this composer for additional information.

IMPORTANT RENAISSANCE COMPOSERS (continued)

Composer	Origin/Active in	Noted for
Robert Fayrfax (1464–1521)	England	Masses, motets, songs.
Alfonso Ferrabosco I (1643–1588)	Italy/England	Motets, madrigals.
Alfonso Ferrabosco II (1578–1628)	England	Masques, sacred music, lute songs, instrumental fantasias.
Walter Frye (fl. c. 1450–1475)	England/Burgundy?	Masses, motets, chansons.
Andrea Gabrieli* (c. 1520–1586)	Italy/Venice	Sacred choral music, organ music, instrumental works.
Giovanni Gabrieli* (c. 1557–1612)	Italy/Venice	Motets, organ works, instrumental music; nephew of Andrea Gabrieli.
Don Carlo Gesualdo (c. 1560–1613)	Italy/Naples, Ferrara	Madrigals, motets in highly chromatic style.
Orlando Gibbons* (1583–1625)	England	Madrigals.
Nicolas Gombert (c. 1495–1556)	Flemish/Vienna, Madrid, Brussels, Tournai, Germany (at court of Emperor Charles V)	Many motets, chansons, parody Masses; numerous songs arranged for lute or guitar; pupil of Josquin.
Francisco Guerrero (1528–1599)	Spain/Jaén, Seville, Italy	Masses, motets, secular songs; pupil of Morales.
Hans Leo Hassler (1564–1612)	Germany/Augsburg, Nuremberg, Dresden, Venice	Sacred music in polychoral style, secular polyphonic songs, organ music; pupil of Andrea Gabrieli.
Heinrich Isaac (c. 1450–1517)	Flemish/Florence, Germany, Innsbruck, Vienna	Masses, motets, *Choralis Constantinus* (cycles of Mass Proper); songs in French, Dutch, Italian, and German, including famous "Innsbruck, ich muss dich lassen."
Clément Janequin* (c. 1480–c. 1560)	France/Paris, Bordeaux, Angers	Chansons.
Josquin des Prez* (c. 1445–1521)	Flemish/Milan, Rome, Cambrai, Paris, Ferrara, Condé	Masses, motets, chansons.
Pierre de La Rue (1455/60–1518)	Flemish/Brussels, Netherlands, Spain (Burgundian court of Hapsburgs)	Masses, motets, chansons.

IMPORTANT RENAISSANCE COMPOSERS (continued)

Composer	Origin/Active in	Noted for
Orlando di Lasso* (1532–1594)	Flemish/Italy, Antwerp, Munich	Masses, motets, madrigals, chansons.
Claude Le Jeune (c. 1528–c. 1600)	France	Polyphonic chansons, psalm settings in *musique mesurée à l'antique* (where poetic meter governs musical rhythm).
Luca Marenzio (1553–1599)	Italy/Rome, Florence, Poland	17 books of madrigals; also motets and other sacred vocal music.
Claudio Merulo (1533–1604)	Italy/Venice, Parma	Famous organist; madrigals, motets, organ works (especially toccatas).
Luis Milán* (c. 1500–c. 1561)	Spain/Valencia	Vihuela virtuoso; earliest collection of vihuela pieces and first with tempo indications.
Philippe de Monte (1521–1603)	Flemish/Belgium, Italy, Spain, England, Austria	Madrigals, Masses, motets; also chansons.
Cristóbal de Morales (c. 1500–1553)	Spain/Avila, Toledo, Málaga, Rome	Masses, motets, other church music.
Thomas Morley* (1557–1602)	England	Madrigals, instrumental works, sacred choral music.
Jean Mouton (c. 1459–1522)	France/Amiens, Grenoble, Brittany, Paris	About 100 secular and sacred motets; also Masses, chansons; colleague of Josquin, teacher of Willaert, court composer to Francis I.
Luis de Narváez (fl. 1530–1550)	Spain/Spain, Italy, northern Europe	Vihuela virtuoso; wrote first known variations (*diferencias*) for vihuela; also other vihuela music.
Jacob Obrecht* (c. 1450–1505)	Flemish/Cambrai, Bruges, Antwerp, Italy	Motets, Masses.
Johannes Ockeghem* (c. 1420–1495)	Flemish/Paris, Tours	Motets, Masses.
Diego Ortiz (born c. 1510)	Spain/Toledo, Naples	Viola da gamba virtuoso; treatise on variations and ornamentation; sacred music.
Giovanni Pierluigi da Palestrina* (c. 1525–1594)	Italy/Rome	Masses, motets.

*See separate article on this composer for additional information.

IMPORTANT RENAISSANCE COMPOSERS (continued)

Composer	Origin/Active in	Noted for
Jean Richafort (c. 1480–1548)	Flemish?/French court	Masses, motets, chansons; pupil of Josquin.
Cipriano de Rore (1516–1565)	Flemish/Flanders, Venice, Ferrara, Parma	Madrigals; also motets, Masses, other sacred music; pupil of Willaert.
Arnolt Schlick (c. 1460–after 1517)	Germany/Netherlands, Strasbourg	Organ music; also a treatise on organs and organ building.
Ludwig Senfl (c. 1486–1543)	Switzerland/Germany, Italy, Vienna	Pupil of Isaac; Latin Masses and motets, German motets; over 250 German secular songs (lieder, mostly four-part).
Claudin de Sermisy (c. 1490–1562)	France/Paris	175 chansons, mostly four-part; 110 sacred works, including Masses, motets, St. Matthew Passion.
Thomas Tallis* (c. 1505–1585)	England	Motets, anthems, other sacred music.
John Taverner (c. 1490–1545)	England	Masses, Magnificats, motets, other sacred music.
Christopher Tye (c. 1500–1572)	England	Masses, motets, anthems; In nomines for string consort.
Philippe Verdelot (died c. 1550)	France/Italy	Madrigals, motets.
Tomás Luis de Victoria* (c. 1548–1611)	Spain/Rome	Masses, motets, other sacred music.
Thomas Weelkes (c. 1575–1623)	England	Madrigals; also sacred music.
Giaches de Wert (1535–1596)	Flemish/Italy (Mantua, Novellara, Ferrara)	12 books of madrigals, other songs, sacred works.
John Wilbye (1574–1638)	England	Madrigals.
Adrian Willaert* (c. 1490–1562)	Flemish/Netherlands, Venice, France	Masses, motets, chansons, instrumental ricercars; pupil of Mouton.

included but that it was some years before their influence was felt. Also, it should be noted that in England the Renaissance lasted about twenty-five years longer than on the Continent (see MADRIGAL, def. 2).

The Renaissance followed the Middle Ages (see MEDIEVAL) and was itself followed by the BAROQUE period (1600–1750). Unlike the Renaissance in painting, sculpture, and architecture, the Renaissance in music began not in Italy but in northern France and the Netherlands (see BURGUNDIAN SCHOOL), although in its last decades Italy was the center of the most significant innovations. Nor was it associated with attempts to revive the classical art of ancient Greece and Rome. The most important advances of Renaissance music concerned the development of polyphony (music with several independent voice-parts). The Burgundians, of whom the most important were Gilles Binchois and Guillaume Dufay and who were influenced by John Dunstable and other English composers, wrote works in three and four voice-parts, and also extended the range of the voice-parts by adding a bass part. They used harmonies based on triads (see CHORD) instead of the fourths and fifths relied on in the Middle Ages (see ORGANUM). They used polyphony for secular (nonreligious) songs, which in the hands of the medieval minstrels had been largely monophonic (with one voice-part). Their Flemish successors carried these trends even further. They gave all the voice-parts equal importance (instead of having one part carry the main melody while lesser parts carried the supporting harmony). To this end they used imitative counterpoint, with the melody being taken up by the different parts in turn. (See FLEMISH SCHOOL.)

As in the Middle Ages, vocal music was more important than instrumental music. When instruments were used together with voices, they usually had no separate part, simply doubling (playing the same part as) one of the voices or, sometimes, substituting for a voice. On the other hand, purely instrumental music was also written, especially dance music, for ensembles and for individual instruments; frequently songs were transcribed for an instrument (usually the lute or virginal; see also INTABULATION). The main instruments of the period were the lute and vihuela, plucked stringed instruments; keyboard instruments, mainly the harpsichord, virginal, clavichord, and organ; bowed stringed instruments, such as the rebec and viols in various sizes; and winds, chiefly the recorder, shawm, crumhorn, cornett, and sackbut. Pieces were written for ensembles made up of a single instrument in different sizes, such as viols or recorders. Instrumental dances, such as the basse danse, galliard, pavane, passamezzo, and saltarello, were popular. For keyboard instruments the fantasia (fancy), toccata, and ricercar were often used. Another form for keyboard, and later instrumental ensemble, was the CANZONA (def. 4). The organ was employed mainly for church music, and brass instruments (trumpets, trombones) chiefly for military and ceremonial purposes (signaling, fanfares).

Church music continued to be important during the Renaissance, as it had been in medieval times, the main forms still being the motet and Mass, and also the Passion. An innovation was the POLYCHORAL style developed by the Venetians, with several choirs singing in turn and together (see VENETIAN SCHOOL). The most important form of secular vocal music was the MADRIGAL (def. 2). Late in the sixteenth century solo songs with instrumental accompaniment, especially by lute, became popular, foreshadowing the development of monody (accompanied melody) that became so important about 1600 (see MONODY, def. 1). Another sixteenth-century development was the Lutheran CHORALE, which played an important role throughout the baroque. Finally, the Renaissance marks the beginning of modern music

theory with the writings of Johannes Tinctoris, Gioseffo Zarlino, Francino Gaforio, and others, as well as the first printing of polyphonic music set in movable type (by Ottaviano Petrucci in Venice, beginning with *Harmonice Musices Odhecaton* in 1501). The accompanying chart lists important composers of the Renaissance.

repeat 1 A section of a composition that is to be performed again, exactly the same as the first time (though occasionally with a different ending). Such repetitions are indicated by various signs.

a ‖ at the end of a composition or section indicates that the entire composition or section should be performed again, from the beginning to the sign.

b ‖ within a composition, later followed by ‖, indicates that a section is to be performed again, beginning at the first sign and ending at the second.

c The term **da capo** ("from the beginning"), or the abbreviation **D.C.**, shows that the first portion of a composition is to be performed again

after a middle section has been performed; for example, in a minuet and trio, the minuet is repeated after the trio has been performed.

d The term **dal segno** ("from the sign"), referring to the sign ‰, indicates that a section is to be repeated, beginning at the sign.

2 Certain abbreviations indicating the repetition of notes, groups of notes, or measures are used for convenience in musical notation. These are illustrated below.

reprise (rœ prēz′) *French.* **1** The repetition of a section of a composition after a later section has been performed (see REPEAT, def. 1c). **2** Another name for the recapitulation in SONATA FORM. **3** In SONATA FORM, the repetition of the exposition before the development.

Requiem (rek′ wē əm) **Mass** In the Roman Catholic rites, the Mass for the Dead, named for the opening words of the Latin text, *Requiem aeternam* ("Give them eternal rest"). Part of it belongs to the Proper of the Mass, that is, for a special occasion,

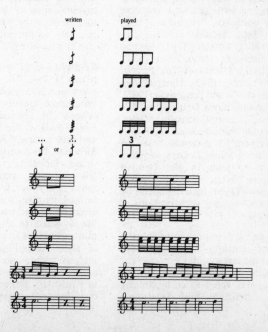

and part of it belongs to the Ordinary, the unchanging part of the Mass (see MASS). The Requiem Mass consists of the following sections: (1) the Introit (*Requiem aeternam,* "Give them eternal rest"); (2) the Kyrie (*Kyrie eleison,* "Lord, have mercy upon us"); (3) the sequence *Dies irae* ("Day of wrath"); (4) the Offertory (*Domine Jesu Christe,* "Lord Jesus Christ"); (5) the Sanctus (*Sanctus, sanctus, sanctus,* "Holy, holy, holy"), with a subsection, the Benedictus (*Benedictus qui venit,* "Blessed is he who comes"); (6) the Agnus Dei ("O Lamb of God"); and the Communion (*Lux aeterna,* "Eternal light"). Occasionally a closing responsory is added (*Libera me,* "Deliver me"). The two joyful sections of the normal Mass, the Gloria and the Credo, both are omitted.

Composers began to write polyphonic settings (with several voice-parts, as opposed to the plainsong Gregorian chant) of the Requiem Mass in the fifteenth century, the earliest surviving example being a Requiem by Ockeghem. Until the seventeenth century the sequence "Dies irae" was always left in the original plainsong. Outstanding settings of the Requiem include those of Palestrina (1554), Lasso (1589), Victoria (1603), Jommelli (1756), Mozart (1791), Berlioz (1838), Bruckner (1849), Verdi (1873), Fauré (1887), Dvořák (1890), Pizzetti (1922), Duruflé (1947), Ligeti (1969), Schnittke (1975) and Penderecki (1985). A few compositions bearing the title "Requiem" are not actually Masses. Brahms's *Ein deutsches Requiem* ("A German Requiem") is a cantata based on biblical texts, while Delius's Requiem (1916) is to texts by the German philosopher Nietzsche, and Britten's *A War Requiem* (1961) includes poems by Wilfrid Owen along with portions of the liturgy.

rescue opera An opera in which the hero (or heroine) is rescued from death at the last minute. Very popular at the time of the French Revolution, rescue operas were written by, among others, Cherubini and Beethoven (*Fidelio*).

resolution In classical harmony, the movement of a dissonant interval or chord to either a less dissonant one or a consonant one. Dissonance implies tension, and consonance the release of tension, or rest. For example, suppose chord C–E–B♭, in which the minor seventh (C–B♭) is dissonant, is followed by E–G–C, a consonance; the B♭ from the first chord is said to resolve into the C of the second chord, or the first chord itself is said to resolve into the second chord, and the succession of the two chords is called a resolution.

resonator 1 The part of a musical instrument that is made to vibrate, and hence produce sound, for example, the strings of the violin, the air column inside a clarinet, the skin of a drumhead, etc. **2** An object or material that reinforces the vibrations of sound, such as the piano's soundboard and the violin's belly, which both strengthen the vibrations of the instrument's strings by vibrating along with them. **3** Specifically, a hollow body attached below a vibrating material, such as the gourd attached to a SITAR or the tubes placed under the bars of the orchestral MARIMBA. (See also SYMPATHETIC STRINGS; SOUND.)

Respighi (res pē' gē), **Ottorino** (ô tô rē'nô), 1879–1936. An Italian composer who is famous largely for three symphonic poems, *Le Fontane di Roma* ("The Fountains of Rome"), *I Pini di Roma* ("The Pines of Rome"), and *Feste romane* ("Roman Festivals"). Although he composed many other works, including numerous operas (all failures), cantatas, chamber music, and songs, they are rarely performed. Respighi studied with several eminent musicians, among them Rimsky-Korsakov and Max Bruch. His music combines an enormous number of styles, including elements from impressionism, medieval plainsong, and late romanticism (Richard Strauss, in particular), subjected to Respighi's own masterful orchestration.

respond See RESPONSE.

response Also, *respond, responsory.* In the Roman Catholic and various Protestant church services, an answer by the congregation or choir to a chant, prayer, lesson, or other statement made by the priest or a soloist. In the Roman Catholic rites, the psalms were often performed in this way, a style called responsorial psalmody (see PSALM). In the Middle Ages, composers frequently gave the solo portions of such chants a polyphonic setting (with several voice-parts), sung by several soloists, while the responses sung by the choir remained in plainsong (with one voice-part, with the choir singing in unison). This practice persisted in some of the motets based on responses that were written during the Renaissance, such as those by the English composer Thomas Tallis. In the Anglican rites, responses continued to be used for portions of the service. In other Protestant churches, however, the response came to mean simply a short musical piece (usually no more than ten or twelve measures long) sung by the choir after the minister's prayer or after the benediction (closing blessing). Also see CALL AND RESPONSE.

responsory See RESPONSE.

rest A silence or pause in the music, in any or all of the voice-parts. Such pauses are indicated by signs that tell how long they are to last, corresponding to the time value of the various notes (quarter rest, eighth rest, and so on). For a table of these signs, see NOTES AND RESTS.

resultant tone See under TARTINI, GIUSEPPE.

retard A direction to perform more and more slowly; the same as RALLENTANDO and RITARDANDO.

retardation A suspension in which the dissonant note resolves upward. See SUSPENSION.

retrograde (re′trə grād). A term describing a melody or theme that is reversed, so that the last note becomes the first, the next to the last the second, and so on all the way through. Essentially a device of imitation, retrograde was very popular from the fourteenth to seventeenth centuries and was revived in the twentieth century by neoclassic and serial composers. It is found particularly in canons and fugues, the two principal forms of imitative counterpoint (see also under CANON; IMITATION). —**retrograde inversion** A melody or theme that is both reversed (from last note to first) and turned upside down (going up in pitch where it went down, and vice versa). This device, too, has been revived by twentieth-century serial composers (for an illustration, see the example accompanying SERIAL MUSIC).

returning tone Another term for NEIGHBORING TONE.

reverberation Also, *reverb.* A kind of continuing echo effect produced electronically, by elongating the duration of sound or by delaying sound through tape echo. In essence such effects are created by controlling the time lapse between the original sound and its reflection back from a natural or electronic barrier. Reverberation is used in recording rock and other popular music, as well as in electronic keyboards such as the Casio and in synthesizers.

rf Also, *rfz.* An abbreviation for RINFORZANDO.

rfz Also, *rf.* An abbreviation for RINFORZANDO.

r.h. Also, *R.H.* An abbreviation for "right hand" or the German, *rechte Hand,* used in keyboard music as a direction to play a note or passage with the right hand.

rhapsody A title used by nineteenth- and twentieth-century composers for a relatively short composition, free in form and expressing a particular mood. It is virtually the same as a fantasy (see FANTASIA, def. 5). There are

rhapsodies based on a "national" idea—that is, suggesting a particular people or country through the melodic and rhythmic idioms of its music—such as Liszt's *Hungarian Rhapsodies* for piano, each of which ends with a movement imitating a csárdás (a Hungarian dance). Similar examples are Emmanuel Chabrier's orchestral rhapsody *España*, Georges Enesco's *Rumanian Rhapsodies* and Ravel's *Rapsodie espagnole*. In other compositions the title seems to refer more to the very free form of the music; among these are Brahms's rhapsodies for piano and Gershwin's *Rhapsody in Blue* for piano and orchestra. Other rhapsodies are based on a tune from folk music or by another composer (Rachmaninoff's *Rhapsody on a Theme of Paganini*, for example). Still others appear to be so named purely for their poetic quality (Brahms's *Alto Rhapsody*, for alto solo, men's chorus, and orchestra, based on part of a poem by Goethe).

rhumba See RUMBA.

rhythm The movement of musical tones with respect to time, that is, how fast they move (tempo) and the patterns of long and short notes as well as of accents. The concept of rhythm thus takes in METER (the patterns of time values), BEAT (accents), and TEMPO (rate of speed). Some authorities hold that rhythm involves all musical movement, including melodic movement (the movement of a melody up or down in pitch). Others include also harmonic rhythm, that is, the pattern of harmonies (chords). Most, however, define rhythm purely as a matter of notes in time, no matter what their pitch, and consider music to be made up of three basic elements: melody, rhythm, and harmony. Nevertheless, in practice these elements cannot really be separated, since each influences the other.

Since the sixteenth century or so, the rhythm of most Western (European and American) music has been based on patterns of accents and time

values (meters). For three centuries prior to that, musical time was organized by means of MENSURAL NOTATION, and before that it was governed by the RHYTHMIC MODES. All these systems are more or less based on the idea of regularly repeated beats. Most Asian music, on the other hand, is not organized by means of regularly recurring accents, nor are the lengths of the tones necessarily measured (time values). Such a system is called **free rhythm**, and some examples of it can be found in Western music as well—in Gregorian chant, in operatic recitative, and in general wherever music imitates the rhythms of ordinary speech rather than those of metrical poetry. (See also ACCENT; TIME SIGNATURE.)

rhythm and blues A style of black American popular music that combines elements of blues and jazz. Developed in the United States in the 1940s, it began mainly as dance music. Loud and blaring in performance, with heavily punctuated, driving rhythms, it is generally performed with electronically amplified instruments (among them guitars) and a loud tenor saxophone. Rhythm and blues is said to reflect the haste and clangor of city life as it must have seemed to many blacks who came from rural areas to find work in factories during World War II. It flourished until about 1960. In the hands of white performers, rhythm and blues became rock. Black performers, on the other hand, turned rhythm and blues into SOUL MUSIC. Abbreviated *R and B*. (See also BLUES, def. 1; ROCK; FUNK.)

rhythmic modes A system of organizing musical time, based on the meters of classical Greek and Latin poetry, that was used from the middle of the twelfth to the middle of the thirteenth centuries. There were six rhythmic modes, consisting of patterns of two time values, the brevis (double whole note) and the longa (twice or three times as long as a brevis). The six modes were: I. longa–bre-

vis; II. brevis–longa; III. longa–brevis–brevis; IV. brevis—brevis–longa; V. longa–longa; VI. brevis–brevis. Reducing the time values to modern ones, with a longa equal to a half note and a brevis to a quarter note, they would be:

I. ♩ ♩

II. ♩ ♩

III. ♩. ♩ ♩

IV. ♩ ♩ ♩.

V. ♩. ♩.

VI. ♩ ♩ ♩

Music during this period was written in neumes rather than notes (see NEUME), and the modes were indicated by ligatures, short lines linking the neumes. The opening ligature of a composition showed what rhythmic mode was to be used throughout; this rhythmic pattern then was used more or less consistently in all the voice-parts of the composition. A longa was held three times as long as a brevis except when it was immediately preceded or followed by a brevis (as in modes I, II, III, and IV). About the middle of the thirteenth century the rhythmic modes were replaced by another system, called MENSURAL NOTATION, which eventually developed into the present-day system of indicating time and rhythm in the seventeenth century.

Rhythmicon See under COWELL, HENRY.

ribab Another name for RABAB.

ribible Another name for RABAB.

ribs The side walls of stringed instruments that have a boxlike body, such as the guitar and violin.

ricercar (rē"cher kär') *Italian.* 1 An instrumental composition of the sixteenth and seventeenth centuries in imitative counterpoint, that is, with several voice-parts taking up the melody in turn. Such ricercars, written either for organ or for an instrumental ensemble, were the instrumental counterpart of the vocal MOTET. Among the composers who wrote organ ricercars were Andrea Gabrieli, Frescobaldi, Froberger, Pachelbel, and Bach, who included a famous ricercar in his *Musikalisches Opfer* ("Musical Offering," 1747). Ricercars for instrumental ensemble were written by Willaert, Domenico Gabrielli, and others. The ricercar also was called *fantasia* (see FANTASIA, def. 2; TIENTO). 2 A sixteenth-century Italian composition for lute, similar to a short prelude and usually not in imitative style. 3 A sixteenth- or seventeenth-century composition for viols and other stringed instruments, and also for voice, similar to an exercise for study purposes.

ricochet (ri kô shā') *French.* Another term for JETÉ.

ride cymbal See under CYMBAL.

Riegger (rē'gər), **Wallingford**, 1885–1961. An American composer who is remembered for his experiments with serial techniques. Slow to win recognition, Riegger supported himself for years by making arrangements, copying music, and similar jobs. Not until 1948, when the third of his four symphonies won the New York Music Critics Award, did Riegger become nationally known. Riegger used the twelve-tone technique (see SERIAL MUSIC) in a highly personal way. In his *Dichotomy,* for chamber orchestra, he used two opposing twelve-tone rows. His *Music for Younger Orchestra* can be performed by anywhere from two to twenty or more players. Other of his works, notable for their driving rhythms, are *New Dance* for orchestra (also in a version for two pianos), *Dance Rhythms,* and Concerto for piano and woodwinds.

riff In jazz and other popular music, a brief melodic figure that is repeated or imitated over a changing chord pattern. It is similar to the OSTINATO of baroque music.

rigadoon See RIGAUDON.

rigaudon (rē gō dôɴ') *French.* Also, English, *rigadoon* (rig" ə do͞on'). A

lively dance in duple meter (any meter in which there are two basic beats per measure, such as 2/2 or 2/4). Originating in Provence (part of southern France), it was used in French operatic ballets of the seventeenth century (by Lully and others), and occasionally was used as a movement in eighteenth-century instrumental suites (by Bach and others).

rigore, con (kôn rē gô' re) *Italian.* Also, *rigore di tempo* (rē gô're dē tem'pô). A direction to perform strictly, especially with regard to time.

rilasciando (rē lä\underline{s}h yän'dô) *Italian.* A direction to perform more slowly.

Rimsky-Korsakov (rēm'skē kôr sä kôf'), **Nikolay** (nē' kô lī), 1844–1908. A Russian composer who was one of the Five, the group of composers who wanted to found a truly Russian style of music (see FIVE, THE). Beginning his career in the navy, Rimsky-Korsakov studied music with Balakirev. He continued in the navy for some years, but in 1871 he became professor at the St. Petersburg Conservatory, where he remained for most of his life. Among his pupils was Igor Stravinsky. Although his major interest lay in founding a national style of music, Rimsky-Korsakov became a skillful craftsman, particularly with regard to orchestration, on which he wrote a two-volume treatise. The best-known of his works—the symphonic poems *Sadko* and *Scheherazade,* the *Russian Easter Overture,* and *Capriccio espagnol* ("Spanish Caprice")—all show his skill in effective use of instruments. Among his other works are fourteen operas, of which the most notable is the last, *The Golden Cockerel* (1909). He also orchestrated Borodin's opera *Prince Igor* and revised and reorganized many of Mussorgsky's works, including *Boris Godunov.*

rinf. An abbreviation for RINFORZANDO.

rinforzando (rēn fôr tsän' dô) *Italian.* 1 A direction meaning the same as SFORZANDO. Often abbreviated *rf, rfz,* or *rinf.* 2 In earlier music and occa-

sionally today, a direction for a sudden increase in volume (loudness) for a particular note or passage.

ring modulation See under MODULATION, def. 2.

ripieno (rē pye'nô) *Italian:* "full." 1 In the baroque concerto grosso, the full orchestra, as opposed to the soloists (called CONCERTINO, def. 2). 2 In organs, a PRINCIPAL (def. 1) stop. —**registro di ripieno** (re jis' trô dē rē pye'nô). The Italian term for MUTATION STOP. —**violino da ripieno** (vē ô lē'nô dä rē pye'nô). The Italian term for second violin. —**senza ripieni** (sen' dzä rē pye' nē). A direction calling for the leader of each orchestral section (first oboe, first horn, etc.) only, the others of the section remaining silent.

ripresa (rē prä'zä) *Italian.* 1 In the fourteenth-century BALLATA, the refrain. 2 In the sixteenth and seventeenth centuries, a short instrumental passage that appears before, after, or between repetitions of the principal music of a song or dance. This later was called a RITORNELLO. 3 In general, any REPEAT.

risoluto (rē sô lōō'tô) *Italian.* A direction to perform in a firm, vigorous manner.

rit. An abbreviation for RITARDANDO (*not* for ritenuto).

ritardando (rē tär dän'do) *Italian:* "retarding." Also, *tardando.* A direction to slow down gradually. The same as RETARD and RALLENTANDO. Often abbreviated *rit.*

riten. An abbreviation for RITENUTO.

ritenuto (rē te nōō'tô) *Italian.* A direction to hold back, meaning to perform somewhat more slowly, but immediately, not gradually. Sometimes abbreviated *riten.*

ritmico (rēt'mē kô) *Italian.* A direction to perform in exact time.

ritmo (rēt'mô) *Italian:* "rhythm." Used in the terms *ritmo di tre (due, quattro) battute* ("in a rhythm of three [two, or four] measures"), meaning

that a certain number of measures (three, two, or four) are to be played quite fast, grouped together as a single metrical phrase.

ritornello (rē tôr nel'ô) *Italian:* "return." **1** In the fourteenth-century madrigal, a closing section at the end of each verse; it differed from a refrain in that it contained new material each time it appeared (see CACCIA; MADRIGAL, def. 1). **2** In seventeenth-century vocal music (opera, oratorio, cantata), a short instrumental part that was used at the beginning as well as at the end of an aria. **3** In the baroque concerto grosso (seventeenth and eighteenth centuries), a section that was repeated throughout by the full orchestra (as opposed to the soloists), as well as at the end of the work.

Rochberg (rok'bûrg), **George**, 1918– . An American composer whose style was influenced in turn by neoclassic models, serialism, and, from the late 1960s on, tonal works of the nineteenth century. Rochberg's compositions of the 1940s, like *Night Music,* reflect the influence of Stravinsky and Hindemith. In the 1950s he wrote serial music, at first in Schoenberg's twelve-tone idiom and later in the expanded serial style of Webern. Some of his music of the 1960s represents quotation and collage; his quartet *Contra mortem et tempus*, for flute, clarinet, violin and piano, quotes from Ives, Boulez, Varèse, and Berio. Still later works reflect the influence of Mahler and Beethoven. Rochberg's output includes five symphonies, seven string quartets and numerous other chamber works, piano pieces, and songs.

rock A type of American music that became popular in America, England, and elsewhere, and in the 1960s replaced jazz as *the* popular American music. Its main distinguishing feature is a driving rhythm based on eighth notes of equal duration, the eight-to-the-bar of boogie woogie. The meter frequently is a solid 4/4, with accents on the second and fourth beats of the measure instead of the traditional first and third. The melodies often are built from the older modes instead of confining themselves to major and minor; the Dorian, Mixolydian, and others occasionally appear (see CHURCH MODES). Harmonies range from the common triad of classical harmony to formerly forbidden parallel fourths and fifths, as well as every kind of dissonant harmonic progression. Entire songs may be built up from as few as one or two chords. Unlike earlier American popular music, rock does not necessarily consist of four-, eight- or sixteen-bar phrases, rather using such divisions as seven or nine bars, or sixteen bars divided into ten and six (instead of eight and eight), or the twelve-bar phrase of blues. Also unlike earlier popular styles, the lyrics of rock are not only love ballads but deal also with sex, rebellion (both violent and nonviolent) against the "establishment" (the law, police, middle-class complacency, wars), civil rights, social concerns, drug use, and life styles. Unusual performance styles are basic to rock. Vocal techniques such as portamento, falsetto, and speech are mingled in unexpected combinations. Electronic instruments, especially the electric guitar and electric bass, are important. The former is usually played with the amplifier set for high distortion, in contrast to the clean tone favored by jazz guitarists. The bass player, unlike the walking bass of jazz, usually plays either the fundamental of the chord, repeated over and over, or a short motif, similarly repeated again and again until the harmony changes. Special recording-studio effects such as fuzz tone, reverberation, wah-wah, and feedback are freely used, and many can be used in live performance as well. A wire from the guitar or bass passes through a "black box" en route to the amplifier, and the player can produce the desired effect by means of a foot-operated switch. In addition, electronic instruments, especially synthesizers (including guitar and

drum synthesizers), were embraced by many rock musicians. Another development was the **rock video**, originally a short video version of a rock song produced by a record company to promote a recording but soon becoming a separate audiovisual form. In 1982 MTV, an American cable television station, began offering twenty-four-hour rock-video programming.

Beginning in the mid-1950s as an outgrowth of black RHYTHM AND BLUES and white COUNTRY MUSIC, along with some elements of gospel and folk song, rock was first considered music by and for African-Americans. The name "rock and roll" (or "rock 'n roll") was popularized in the early 1950s by Alan Freed, a disk jockey in Cleveland, Ohio, who played such music on the air. Its popularity grew, spurred by a white singer of country music, Elvis Presley, whose recording of the song "Heartbreak Hotel" broke all sales records in the late 1950s. His style, sometimes called **rockabilly**, has been described as a mix of country music and rhythm and blues; his accompaniment used electric guitar, rhythm guitar, and string bass. The new style was adopted by other singers and vocal groups, including such British groups as the Beatles and Rolling Stones. Increasingly, rock performers wrote their own songs, which they sang almost exclusively. Although rock is predominantly vocal music, there are some purely instrumental rock pieces and some of it is dance music. In the 1960s people danced the *twist* to it, and in the 1970s a form called **disco** (for *discothèque*, a dance hall where records were played), characterized by metronomic drumming, very simple chords, and heavy amplification, was very popular. Rock musicians such as Jimi Hendrix developed special effects on the electric guitar, notably feedback and distortion.

In the mid-1960s "rock 'n roll" was shortened to "rock," and a number of offshoots developed. One was **folk rock**, which combined the balladlike quality of folk song with the rhythmic instrumental and vocal styles of rock. Folk rock, whose main representative was Bob Dylan and (Paul) Simon and (Art) Garfunkel, often had quite poetic lyrics dealing with protest (against war, racism, injustice) as well as more personal problems (love, youth, alienation). Other types to develop were **raga rock**, which used foreign instruments, such as the Indian sitar, Greek buzuki, and Arab 'ud, as well as some idioms of Asian music (such as the five-tone scale); **psychedelic rock** or **acid rock** ("acid" referred to mind-expanding drugs such as LSD), which employed electronic sounds and instruments to create a highly emotional style, intended to depict the experience of drug users (performers include the long-surviving group, the Grateful Dead); **soft rock**, which returned to sixteen-bar forms with accents on the strong beats (first and third), revived the acoustic guitar, piano, and country instruments like the accordion, banjo, and mandolin, and was generally softer and gentler; **hard rock**, which worked within the twelve-bar blues form but emphasized strong, hammering rhythms, prominent lead guitars, and a loud, jarring, raucous sound; **heavy metal**, also with a hard driving sound, but musically much simpler, with four- and eight-bar phrases, rudimentary harmonies consisting of often-repeated simple chords and short melodic progressions, and performed with exaggerated vocal mannerisms, sudden changes in volume, and violent stage antics; **thrash**, **death metal**, and **speed metal**, more extreme and still angrier versions of heavy metal; **blues rock**, solid, intensely rhythmic, electrically amplified blues, with vocal styles heavily influenced by soul music; **country rock**, a combination of rock rhythms with largely southern rural white folk music, with elements of gospel music; **punk rock**, later called **new wave** or **hard core rock**, uncomplicated, rough, percussive rock with lyrics expressing strong antiestablishment protest, often

deliberately offensive; **art rock** or **progressive rock**, a combination of classical music and rock, which began in Great Britain with "translations" of traditional music into rock by clever recording-studio tricks and then became, in New York, a kind of reductionism, reducing rock to its basic elements (an outstanding art-rock figure was Frank Zappa and his band, the Mothers of Invention); and **jazz rock** or **fusion**, a combination of jazz and rock. By the 1980s many of the features of these forms had been combined and recombined, so that it was not always possible to distinguish between one or another kind of rock. Thus **alternative rock**, a development of the mid-1980s, blended the progressive social causes of folk rock and punk rock with experimental musical touches. See also BLUES; COUNTRY MUSIC; GOSPEL MUSIC; RHYTHM AND BLUES; SOUL.

rococo (*English* rə kō'kō; *French* rô kô kō'). A term borrowed from painting and other visual arts to describe a light, highly ornamented style used by certain eighteenth-century composers, especially in keyboard music. It is virtually the same as the GALLANT STYLE. See also PRECLASSIC.

Rodgers (rä'jərz), **Richard**, 1902–1979. An American composer who became known for his musical comedies, outstanding particularly for their melodies. Beginning with his first great success, *The Girl Friend* (1926), Rodgers went on to write such shows as *A Connecticut Yankee* (1927), *The Boys from Syracuse* (1938), *On Your Toes* (1936), and *Pal Joey* (1940), all with lyrics by Lorenz Hart (1895–1943). After Hart's death Rodgers found a new collaborator in Oscar Hammerstein II (1895–1960), with whom he wrote two of the most successful musical comedies ever written, *Oklahoma* (1943) and *South Pacific* (1949). Their other works include *Carousel* (1945), *The King And I* (1951), *The Flower Drum Song* (1958), and *The Sound of Music* (1959). Rodgers also wrote *No Strings* (1962), *Do I Hear a Waltz?* (1965), and *Two by Two* (1970).

roll A series of very rapid, even drumbeats that give the effect of a single sustained sound. On the snare drum a roll is played by alternating double beats with each hand; on the bass drum it is played by alternating the heads of the double-headed beater. On the tenor drum a single-stroke roll is produced by a rapid succession of single beats. See also under TIMPANI.

romance (*English* rō mans', rô' mans; *French* rō mäns'). Also, German, *Romanze* (rō män' dze). 1 A lyrical (songlike) piece for instruments, voice, or both. Examples include Fauré's Romance for violin and orchestra, op. 28; Beethoven's two *Romanzen*, for violin and orchestra, op. 40 and op. 50; Schumann's *Drei Romanzen* ("Three Romances") for oboe and piano, op. 94, and *Romanzen* for chorus, op. 67 and op. 75. 2 A slow, lyrical movement within a longer work. Examples include the second movements of Mozart's Piano Concerto in D minor, K. 466, and Schumann's Symphony no. 4.

romanesca (rô mä nes' kä) *Italian.* A pattern of bass harmonies that was used again and again by composers of songs and dances during the sixteenth and seventeenth centuries. (See the accompanying example for the exact pattern; the rectangular

notes are double whole notes, each having the value of two whole notes.) Like the passamezzo, folia, and similar bass patterns, the romanesca was used as a bass for continuous variations in pieces for lute, guitar, vihuela, violin, or a keyboard instrument (see also OSTINATO). In songs, the singer often improvised a melody in the top part. The romanesca was particularly popular in Italy and Spain. Among those who used it are the Spanish composers Luis de Narváez,

PRINCIPAL ROMANTIC COMPOSERS*

Composer	Country	Noted for
Hector Berlioz (1830–1869)	France	Program music, operas, choral music.
Johannes Brahms (1833–1897)	Germany	Symphonies and other instrumental music, songs, choral music.
Anton Bruckner (1824–1896)	Austria	Symphonies, choral music.
Frédéric Chopin (1810–1849)	Poland	Short piano works.
Antonin Dvořák (1841–1904)	Bohemia	Instrumental music, choral works, songs.
Edward Elgar (1857–1934)	England	Instrumental works, oratorios.
Gabriel Fauré (1845–1924)	France	Songs, choral works, piano pieces, chamber music.
César Franck (1822–1890)	Belgium	Instrumental works, organ music.
Charles François Gounod (1818–1893)	France	Operas, sacred choral music.
Edvard Grieg (1843–1907)	Norway	Songs, piano music, instrumental works.
Franz Liszt (1811–1886)	Hungary	Piano works, program music.
Edward MacDowell (1861–1908)	United States	Piano works.
Gustav Mahler (1860–1911)	Austria	Symphonies, song cycles.
Felix Mendelssohn (1809–1847)	Germany	Symphonies and other instrumental music, songs, choral music.
Modest Mussorgsky (1839–1881)	Russia	Operas, songs, instrumental works.
Giacomo Puccini (1858–1924)	Italy	Operas.
Sergey Rachmaninoff (1873–1943)	Russia	Piano works.
Nikolay Rimsky-Korsakov (1844–1908)	Russia	Instrumental music, operas.
Gioacchino Rossini (1792–1868)	Italy	Operas, sacred choral music.
Camille Saint-Saëns (1835–1921)	France	Operas, instrumental works.

*See also the individual entry for each composer.

PRINCIPAL ROMANTIC COMPOSERS* *(continued)*

Composer	Country	Noted for
Franz Schubert (1797–1828)	Austria	Songs, symphonies, chamber and piano works.
Robert Schumann (1810–1856)	Germany	Piano works, symphonies, chamber music, songs.
Jean Sibelius (1865–1957)	Finland	Symphonies, symphonic poems.
Bedrich Smetana (1824–1884)	Bohemia	Operas, instrumental works.
Richard Strauss (1864–1949)	Germany	Symphonic poems and other instrumental works, operas.
Piotr Ilyitch Tchaikovsky (1840–1893)	Russia	Orchestral music, operas, ballets.
Giuseppe Verdi (1813–1901)	Italy	Operas.
Richard Wagner (1813–1883)	Germany	Operas.
Carl Maria von Weber (1786–1826)	Germany	Operas, instrumental works.

*See also the individual entry for each composer.

Antonio de Cabezón, and Antonio de Valderrábano, and the Italian composers Frescobaldi, Caccini, and Monteverdi.

romanticism A nineteenth-century movement in the arts that influenced music from about 1820 until about 1910, and has continued to influence some composers to the present day. Romanticism was preceded by classicism (see CLASSIC) and was followed by a large variety of styles, some in reaction against romanticism (impressionism, neoclassicism), others largely independent of it (aleatory music, electronic music, serial music), and still others partly an outgrowth of it (expressionism). The chief characteristic of romanticism in music, as in the other arts, is emphasis on feeling, both very personal emotions and larger ones, such as love for one's country (see NATIONALISM). The romantic era in music, beginning with the late works of Beethoven and Schubert, and ending with such composers as Richard Strauss and Jean Sibelius, was an extraordinarily rich period. It saw the creation of important new forms—the symphonic poem, the short expressive piano piece, the music drama, the lied—and the development of instruments, mainly in terms of technical improvements, as well as the enormous growth of the ORCHESTRA. Harmony was expanded from the predominating diatonicism of the classical period (see DIATONIC) to the chromaticism of Wagner and Richard Strauss, paving the way for twentieth-century atonality. New materials were used by serious composers—folk songs, elements of Oriental music, subjects from the Middle Ages as well as the down-to-earth present (VERISMO). In a broad sense, all these features resulted from attempts to make music more closely express human feelings. The most important

romantic composers are listed in the accompanying chart. Among composers who showed the strong influence of romanticism long after it was no longer a major force in the arts are Hanson, Kodály, Walton, Barber, and Menotti. See also NEOROMANTICISM.

Romanze (rō män'dze) *pl.* **Romanzen** (rō män' dzən). The German word for ROMANCE.

Rome, Prix de See PRIX DE ROME.

rondeau (rôn dō') *French.* **1** A form of French poetry of the thirteenth and fourteenth centuries that was often set to music, at first monophonic (with one voice-part) and later polyphonic (with several voice-parts). The poem consists of a refrain, part of which alternates with a stanza (see also REFRAIN, def. 1). Only the refrain was set, to two sections of music, which then were also used for the stanza. Later, in the fifteenth century, the poem was lengthened considerably so that the refrain might have as many as six lines, but the basic musical structure remained the same. The rondeau was one of the fixed forms used by fourteenth-century composers such as Machaut. It continued to be popular in the fifteenth century with Dufay, Binchois, Ockeghem, and numerous other composers. **2** In the seventeenth century, an instrumental piece that contained a refrain repeated at regular intervals. It was used by such French keyboard composers as François Couperin, and in ensemble music by Lully. An important outgrowth of this form is the RONDO. Neither it nor the seventeenth-century form appears to have any connection with the medieval and Renaissance rondeau (def. 1).

rondo (rôn'dô) *Italian.* A form of instrumental music that developed from the seventeenth-century rondeau (see RONDEAU, def. 2) and was frequently used by Haydn, Mozart, and Beethoven as the last movement of sonatas, symphonies, and concertos. Like the rondeau, the rondo has a kind of refrain, a section that is repeated at regular intervals throughout the movement. Usually the refrain, or rondo theme, alternates with contrasting sections. Bach's son Karl Philipp Emanuel wrote several independent pieces in rondo form. One of the most familiar rondos is the last movement of Mozart's Piano Sonata in A, K. 331, marked "alla turca" (in Turkish style). The rondo is usually in lively tempo and forms a cheerful (sometimes humorous) conclusion to a composition.

root In classical harmony, the fundamental note of a chord, which is said to be in *root position* if that note is the lowest note of the chord. See CHORD; HARMONY.

rose See under SOUND HOLE.

Rossini (rô sē'nē), **Gioacchino** (jô ä kē'nô), 1792–1868. An Italian composer who is remembered mainly for his operas, of which the most famous is *Il Barbiere di Siviglia* ("The Barber of Seville"). Producing his first opera at the age of eighteen, Rossini wrote a total of forty operas during the next fifteen years, among them, *L'Italiana in Algeri* ("The Italian Woman in Algiers"), *La Cenerentola* ("Cinderella"), *Mosè in Egitto* ("Moses in Egypt"), *Semiramide,* and his last opera, *Guillaume Tell* ("William Tell"). After 1829, during the remaining thirty-nine years of his life, Rossini wrote some songs, cantatas, piano works, chamber music, a Stabat Mater and *Petite Messe solennelle* ("Short Solemn Mass"), but no more operas.

round A vocal composition with three or more parts that enter one after another, repeating the same

1 Chairs to mend, Old chairs to mend,

2 Mack - er - el, Fresh mack - er - el,

3 Old rags, an - y old rags.

music and words. The parts can continue an indefinite number of times, over and over. Rounds are among the most popular of children's songs; familiar examples include "Row, Row, Row Your Boat," "Three Blind Mice," and "Frère Jacques." The accompanying example shows a three-part round, "Chairs to Mend." The round is a form of CANON. See also CATCH.

rounded binary form See under BINARY FORM.

Roussel (rōō sel'), **Albert** (Al bâr'), 1869–1937. A French composer who was his country's leading neoclassic composer (see NEOCLASSICISM). Roussel studied with Vincent d'Indy, and his earliest music reflects the influence of his teacher and of the impressionists (see IMPRESSIONISM). In the 1920s Roussel developed his own neoclassic style, using the forms of the baroque period and exercising his mastery of counterpoint. This style is evident in such works as his Suite in F, Concerto for orchestra, the last three of his four symphonies, Sinfonietta for string orchestra, Cello Concertino, and most of his chamber music. Among Roussel's best-known works are his early ballet, *Le Festin de l'araignée* ("The Spider's Feast," 1913), and a later ballet, *Bacchus et Ariane* (1931).

row a shortening of tone row; see under SERIAL MUSIC.

rubato (rōō bä'tô) *Italian:* "robbed." A direction to perform in somewhat free tempo or rhythm. Most often rubato involves slightly changing the duration of notes, playing some a little faster and others a little slower. In effect some time is taken away from certain notes and given to others, slightly changing the rhythm but not the overall duration. It may also involve accenting notes that are not normally accented. Used mainly to make music more expressive, rubato was employed as early as the seventeenth century, especially in keyboard music. It was used even more in the eighteenth century, at the keyboard by Bach's son Karl Philipp

Emanuel, and on the violin by Mozart's father, Leopold. Presumably rubato was applied only to the melody, the accompaniment (in piano music, the left-hand part) remaining in strict tempo. This technique seems to have been used by Chopin in his nocturnes and other short piano pieces. In Chopin's mazurkas, however, it is thought that "rubato" calls for accents on normally weak beats, since the mazurka rhythm does not allow for changes in time values. Today the term is generally interpreted as a slight slowing down of certain notes or phrases, without a compensatory speeding up of other notes and phrases.

rubebe Another name for RABAB. See also under REBEC.

Rubinstein (rōō" bin shtīn') **Anton** (än tôn'), 1829–1894. A Russian composer and pianist who is remembered chiefly as a virtuoso performer. Of his numerous compositions, which include operas, symphonies, and concertos, very few are still played, except for one very popular piano piece, Melody in F, op. 3, no. 1 (1853).

Rückpositif (rγk' pô zē tēf"). The German name for POSITIVE ORGAN.

ruggiero (rōō jē er' ô) *Italian.* A pattern of bass harmonies that was used for many songs and dances of the sixteenth and seventeenth centuries. (See the accompanying example for the exact pattern.) Like the passa-

mezzo, romanesca, and similar bass patterns, the ruggiero was used as an OSTINATO, that is, a bass repeated over and over. It was particularly popular in Italy. In songs, the singer frequently improvised (invented) a melody in the top part; in instrumental music, especially music for keyboard or lute, the ruggiero was used as the basis for continuous variations.

Ruggles (rug′ əlz), **Carl,** 1876–1971. An American composer and painter who between about 1920 and 1947 produced a small number of highly individualistic compositions that resemble the work of no other composer. They are characterized by a dense, dissonant, contrapuntal texture, the use of similar tone colors (for example, all brasses or all strings), and subtly irregular rhythm. Ruggles constantly reworked his compositions, so that his total output numbers only a dozen or so works. Notable among them are *Men and Angels* (1922), a symphonic suite for five trumpets and one bass trumpet revised in 1938 as *Angels* for four violins and three cellos or four trumpets and three trombones; the suite *Men and Mountains; Portals* for string orchestra (1926); *The Sun-Treader* (1933), and *Organum* (1945) for orchestra; *Polyphonic Compositions* (1940) for three pianos; and *Evocation* (1937–1945), four chants for piano.

Rührtrommel (rʏr′ trôm əl). The German name for TENOR DRUM.

rumba (ro͞om′ bä) *Spanish.* Also spelled **rhumba.** A lively Cuban dance that became very popular in the United States in the 1930s. It is notable for its syncopated rhythm, with accents falling on unexpected beats.

run A musical passage that consists of a scale, or virtually a scale, and is performed quite rapidly. (See also PASSAGE WORK.)

Russian bassoon See under SERPENT.

ryúteki See under GAGAKU.

S

S. 1 In choral music, an abbreviation for SOPRANO. **2** In sixteenth-century compositions, an abbreviation for *superius,* the highest part. **3** An abbreviation for SEGNO. **4** An abbreviation for SINISTRA.

Sachs (säks), **Hans** (häns), 1494–1576. A German poet and composer who is remembered as the most famous of the MEISTERSINGER. He wrote hundreds of poems and melodies.

sackbut The ancestor of the modern TROMBONE, invented in the fifteenth century and built in numerous sizes. It had a somewhat narrower bore and smaller bell than the trombone, giving it a softer sound and more agility. It also had a wide dynamic range and blended well with voices.

Saint-Saëns (saN säN′), **Camille** (kA mē′y³), 1835–1921. A French composer who is remembered for just a few of his hundreds of compositions. Of his dozen or so operas, only *Samson et Dalila* (1877) is part of the current repertory of most opera houses. Also well known are his instrumental suite, *Le Carnaval des animaux* ("The Carnival of the Animals"), which he wrote in 1886 but did not allow to be published until after his death; the symphonic poem *Danse macabre* ("Dance of Death"); and his Cello Concerto no. 1. Trained as a pianist and organist, Saint-Saëns became very influential in the French musical world. He performed, taught (his most famous pupil was Gabriel Fauré), founded a national music society to encourage French composers, conducted, and wrote a number of books (most of them on music, but also two books of poems). His compositions are in the romantic tradition of Liszt and other nineteenth-century composers. Saint-Saëns was particularly skilled at orchestration, and his use of instruments often reveals a delightful sense of humor. His works include, besides those mentioned, three symphonies, concertos (piano, violin, cello), chamber music, choral works, and songs.

salon music Music composed for or performed in a salon, a gathering of artists and intellectuals in a private home, often held on a regular basis. The practice of holding salons was popular among the upper classes in nineteenth-century Europe. The music on such occasions consisted mostly of works for solo piano, voice and piano, and occasionally small chamber ensembles. Today the term "salon music" is often used disparagingly for works of slight quality, oversentimental songs, and the like. The American equivalent, *parlor music* (and *parlor songs*), performed in middle-class homes, carries both this implication and that of amateurism.

salsa (säl′sä) *Spanish:* "sauce." A lively Latin dance music, originating in

Puerto Rico and Cuba and popular in the United States since the late 1960s. Originally a name that Cuban musicians used much as Americans used "swing," it came to refer to a fusion of SON vocals, jazz improvisation and voicings, Cuban rhythms, rock chord sequences, and, often, electronic instruments such as synthesizers. The lyrics, generally improvised, combine bittersweet romance and sharp social and political comment.

saltando (säl tän' dô) *Italian*. Also, *saltato* (säl tä'tô). Same as SAUTILLÉ.

saltarello (säl" tä rel' ô) *Italian*. A lively dance that originated in Italy during the Renaissance or earlier (fourteenth century). During the sixteenth century the saltarello came to be used as the second of a pair of dances, the first being a slow, stately dance, at first usually a pavane and later a passamezzo. The saltarello was very similar to another dance used in such pairs, the GALLIARD, but it probably was performed somewhat less vigorously. Although examples of the early saltarello are in various meters, the sixteenth-century dance is nearly always in triple meter (any meter in which there are three basic beats per measure, such as 3/4 or 3/8).

samba (säm'bä) *Spanish, Portuguese*. A Latin American dance in lively tempo and 2/4 meter with a highly syncopated rhythm (accents on unexpected beats). It became popular as a ballroom dance in the United States in the 1940s. Although usually danced by couples, in Brazil the samba is sometimes performed as a round dance (with the dancers forming a circle).

samisen Another spelling for SHAMISEN.

sampling The process of using a computer that digitizes and stores sounds, such as those of an instrument, to manipulate the sounds electronically. It enables such techniques as incorporating prerecorded material in a new composition. Also, *digital sampling*.

Sanctus (saṅgk'tŏŏs) *Latin:* "holy." The fourth section of the Ordinary of the Roman Catholic Mass (see MASS). It is also part of the Anglican Communion service (see SERVICE).

sanft (zänft) *German*. A direction to perform softly and smoothly.

sansa (sän'sä). Also, *ambira, kalimba, mbira, thumb piano*. A tuned African percussion instrument consisting of a series of long, thin metal tongues held to a soundboard by a lateral bar so that they can freely vibrate. The length of the vibrating portion can be quickly adjusted so as to change the tuning. The sansa is played by depressing the free ends of the tongues with the thumbs and forefingers. In some places the tongues are made of bamboo or cane instead of metal.

santouri (sän tŏŏr'ē) *Greek*. A kind of DULCIMER.

saraband (sar' ə band"). Also, French, *sarabande* (SA"ra bänd'). A slow, stately dance in triple meter (any meter in which there are three basic beats per measure, such as 3/4 or 3/8), which became one of the standard movements of the baroque instrumental suite. The origin of the saraband is not known, but it is thought to have come from Spain (or perhaps Mexico), beginning as a very lively dance. By 1600 it had reached Europe, and by 1650 it had become fairly slow and sedate. The seventeenth-century saraband often had a slight accent or longer-held note on the second beat of each measure (see the accompanying example), and its phrases had feminine endings (that is, they ended on a weak beat instead of a strong one).

$$\tfrac{3}{4} \; \text{♩ ♩. ♪|♩ ♩ |}$$

sarangi (sä ruṅ gē') *Hindi*. A bowed stringed instrument of India. Like the Arab RABAB, it is carved from a single block of wood. The neck is very wide. There are three melody strings of gut,

whose sound is reinforced by a dozen or so metal strings that vibrate sympathetically (SYMPATHETIC STRINGS) when the gut strings are bowed. The player holds the instrument upright, stopping (holding down) the strings with the fingernails. There are no frets to indicate stopping positions. The sarangi is used mainly to accompany the classical dances of northern India.

Sarasate (sä" rä sä' te), **Pablo de** (pä'blō de), 1844–1908. A Spanish violinist and composer who is remembered mainly for his virtuoso playing. Numerous composers wrote violin compositions especially for him, among them Édouard Lalo (*Symphonie espagnole*) and Max Bruch (*Schottische Fantasie*, or "Scottish Fantasy"; also his Violin Concerto no. 2). Most of Sarasate's own compositions are of slight quality, but one of them, *Zigeunerweisen* ("Gypsy Melody"), has remained popular.

sarod (sə rōd') *Hindi.* A short-necked lute of India. Like European lutes, it has a pear-shaped body, and there are four gut melody strings, which pass over a metal fingerboard, and which may be either plucked or bowed. In addition, there may be a dozen or so sympathetic strings, of metal, which vibrate when the melody strings are played. The sarod has a soft, twangy tone, not unlike the banjo's. It is used to accompany the classical dances of northern India.

saron (sə'ron) *Javanese.* A family of important melody instruments in the GAMELAN. Each saron consists of seven thick, slightly curved metal bars mounted over a single trough resonator. Struck with hard mallets, of wood or horn, it possesses considerable dynamic range, from almost inaudibly soft to very loud.

sarrusophone (sə rus' ô fōn). A group of brass instruments with a conical bore (cone-shaped inside) and a double reed, which were invented in the 1850s by a French bandmaster named Sarrus. Designed to replace the oboe and bassoon in large military bands, they were made in eight or nine sizes, ranging from sopranino to double bass. Although the double-bass sarrusophone is occasionally called for in orchestral scores to replace the double bassoon, sarrusophones are largely confined to European bands.

sassofono (sä sô'fô nô). The Italian word for SAXOPHONE.

S A T B In choral music, an abbreviation for soprano, alto, tenor, and bass.

Satie (SA tē'), **Erik** (e rēk'), 1866–1925. A French composer who is remembered less for his compositions than for his enormous influence on other composers. Among those he influenced were Maurice Ravel, the group of composers called Les Six (see SIX, LES), and another group of composers who called themselves L'École d'Arcueil ("School of Arcueil") after the Paris suburb where Satie lived. Satie preached that music's greatest virtue was simplicity. All materials could be used by the serious composer, even music-hall songs. In fact, any sound could be the material of music, a concept that later became important in musique concrète and electronic music. Also influential was Satie's concept of **musique d'ameublement** ("furnishings" or "background music"), not to be heard in the traditional concert setting but surrounding the listener from all sides. This concept was later expanded by such composers as Stockhausen, and was carried to its extreme by composers of the SONIC ENVIRONMENT.

Essentially Satie was a rebel. He rebelled against the German style of Wagner, as well as against the French impressionists (Debussy); often his attacks took the form of satire. Particularly famous are the titles of some of his piano works, such as *Trois Morceaux en forme de poire* ("Three Pieces in the Form of a Pear"), Satie's reply to Debussy's criticism that his music lacked form. His most unusual work—and some think his best—is the ballet *Parade* (to which Cocteau

contributed the staging and Picasso the scenery), whose score calls for a typewriter, steam whistle, and other unorthodox sounds. It also includes classical elements (a fuguelike passage), a ragtime section, a march using whole-tone and pentatonic (five-tone) scales, and a waltz. Other notable works of Satie's are *Socrate,* for four sopranos and chamber orchestra, and two of three pieces called *Gymnopédie,* originally for piano but arranged by Debussy for orchestra.

Satz (zäts) *German.* **1** A section of a composition, usually a movement of a large work, such as a symphony or concerto; *erster Satz* ("first movement"), *zweiter Satz* ("second movement"), etc. **2** A musical setting; *Tonsatz* means "musical composition." **3** A musical theme or subject; *Hauptsatz* means "principal theme," *Nebensatz* means "secondary theme." **4** The style of composition, as in *freier Satz* ("free style") and *strenger Satz* ("strict style").

sausage bassoon See under RACKET.

sautillé (sō tē yā') *French.* Also, Italian, *saltando.* A direction to use the bow (of a violin, cello, etc.) with a short, rapid stroke, causing it to bounce lightly off the string. A sautillé stroke is played between the middle and upper third of the bow.

saw, musical Also, *singing saw.* An ordinary saw (the hand tool) that is played with a violin bow, originally a folk instrument but today more of a novelty entertainment. The player holds the saw between the knees or against a table edge and bows the blade, bending it slightly with one hand so as to alter the tension (and therefore the pitch). In Crumb's *Ancient Voices of Children,* it is used to produce keening sounds.

saxhorn A brass instrument devised in the 1840s by Adolphe Sax, a Belgian instrument maker. It resembles a bugle, having a conical bore (cone-shaped inside) and a medium-sized bell. However, its mouthpiece is fun-nel-shaped (the bugle's is more like a cup), and it has a series of valves, which make available notes other than the fundamental (basic tone) and its harmonics (overtones). Although earlier valved instruments already existed, notably the cornet and flugelhorn, Sax's instrument had a better valve mechanism. Also, the saxhorn was made in numerous sizes (originally seven, later even more), ranging from soprano to bass, keyed in B-flat or E-flat. Further, Sax, who during this period lived in Paris, had considerable influence in official circles, and as a result his instrument was officially adopted for French army bands.

Saxhorns are still used in bands today, especially in marching bands. However, they often differ from Sax's original models, tending to resemble the flugelhorn. In fact, there is considerable confusion concerning the names for these closely related instruments. German makers tend to use the name "flugelhorn" (in German, *Flügelhorn*) for many different sizes of saxhorn. This dictionary follows the common American practice of confining the name "flugelhorn" to the soprano instrument pitched in C or B-flat (see FLUGELHORN). Other variants are: *tenor horn* for the tenor saxhorn (Sax's *saxhorn baryton*); *euphonium* for the baritone saxhorn (Sax's *saxhorn basse*); *bass tuba* for the bass saxhorn (Sax's *saxhorn contrebasse*); and *BB-flat bass* for the contrabass (double-bass) saxhorn (Sax's *saxhorn bourdon*).

saxophone (sak'sə fōn) A wind instrument invented c. 1840 by Adolphe Sax, a Belgian instrument maker, which combines features of the oboe and clarinet. Like the clarinet, the saxophone has a beaklike mouthpiece to which a single reed is attached. Like the oboe, it has a conical bore (cone-shaped inside), a flared bell, and a similar arrangement of keys. Sax originally built the instrument in fourteen sizes, one group of seven, keyed in E-flat and B-flat, for military bands, and another group of seven, keyed in F

and C, for orchestras. All but the two smallest in each group were built with the tube bent back, forming a curved bell, and were fitted with a crook to make the mouthpiece easier to reach. Today only the instruments in E-flat and B-flat are commonly built, the most popular sizes being the *E-flat alto*, the *B-flat tenor* (shown in the illustration), and the *E-flat bari-*

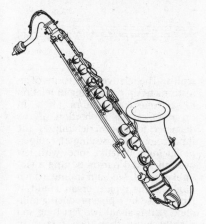

tone. Each has a range of about two and one-half octaves. The saxophones are TRANSPOSING INSTRUMENTS, their music being written in a different key from their actual sound (see the accompanying example).

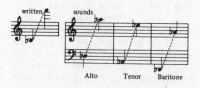

Alto Tenor Baritone

The saxophone has been used principally in bands and jazz ensembles, although some composers, especially in France, have occasionally used it in orchestral scores. Outstanding compositions for saxophone (or with important saxophone parts), most of them for the E-flat alto saxophone, are: Debussy, *Rapsodie* for saxophone and piano (also arranged for saxophone and orchestra); Webern, Quar-

tet for saxophone, clarinet, violin, and piano, op 22; Ibert, *Concertino da camera* for saxophone and orchestra (1935); Glazunov, Concerto for saxophone (1936); Elliott Carter, Suite for quartet of alto saxophones (1939); Paul Creston, Sonata for saxophone and piano, op. 19 (1939), and Concerto for saxophone (1944); and Villa-Lobos, *Fantasia* for saxophone and orchestra (1948).

The saxophone was added to the jazz band sometime around 1920 (see JAZZ) and soon became one of its most important instruments. A big band, with ten to twenty players, would include anywhere from three to six saxophones (though occasionally one of the saxophonists might switch to clarinet). Their main role at first was to provide a soft, steady background of chords for the melody, played by trumpet, trombone, or clarinet. Later, with the emergence of outstanding saxophonists, the instrument was also used as a melody instrument. Most jazz artists have preferred the tenor saxophone, among them such virtuosos as John Coltrane, Lester Young, Coleman Hawkins, Bud Freeman, and Stan Getz, but one of the finest of all jazz saxophonists, Charlie "Bird" Parker, played alto saxophone, as did Ornette Coleman, and Sidney Bechet was a virtuoso on the difficult soprano saxophone. Often abbreviated *sax.*

saxotromba See SAXTROMBA.

saxtromba Also, *saxotromba.* A valved brass instrument with a bore (inside tube) halfway between that of the saxhorn and trombone. Invented by Adolphe Sax, a Belgian instrument maker, it was made in seven sizes, ranging from soprano to double bass, but it never gained wide acceptance. It is rarely used today.

scale A selection of tones within one octave (for example, from C to C′), arranged in rising order of pitches. In Western (European and American) music these notes are a selection from the twelve half tones that make up an

octave. In non-Western music—Arab, African, Asian—intervals smaller than half tones may be used. The arrangement of the tones selected in terms of intervals (how far in pitch each tone is from the next) is called a MODE. —**chromatic scale** A scale made up of all twelve half tones of an octave. See CHROMATIC SCALE. —**diatonic scale** A scale consisting of eight tones selected from an octave, which can be divided into two groups of four tones called **tetrachords**. Diatonic scales date from the times of the ancient Greeks and possibly even earlier. Western music from about 1600 to 1900 has been largely based on two modes (patterns of half and whole tones) of the diatonic scale, the MAJOR and the MINOR. These modes are such that a scale can begin on any pitch and still carry out the proper pattern of half and whole tones; thus there are twelve major and twelve minor scales. —**whole-tone scale** A scale that contains only intervals of whole tones (no half tones). In Western music such a scale can begin on only two pitches, C and D-flat (see WHOLE-TONE SCALE). —**pentatonic scale** A scale made up of only five tones (see PENTATONIC SCALE). —**hexachord** A medieval scale made up of six tones (see HEXACHORD, def. 1).

scale degrees A method of describing tones in terms of their position in a diatonic scale (any major or minor scale; see under SCALE). It is used mainly to analyze the harmony (chords) of a composition. Each tone is assigned both a name and a number, the latter usually indicated by a Roman numeral. Beginning with the first note in a scale, they are: I, TONIC; II, SUPERTONIC (meaning "above the tonic"); III, MEDIANT ("halfway" between tonic and dominant); IV, SUBDOMINANT ("below the dominant"); V, DOMINANT; VI, SUBMEDIANT; VII, LEADING TONE or subtonic. The tonic is referred to as the "first degree," the supertonic as the "second degree," etc. In the accompanying example, the scale degrees are marked for the

scales of C major and A minor. Note that the scale degree of a tone remains the same for a particular key, no matter what octave the tone is in. Thus all C's are regarded as the tonic in the key of C, all B's as the leading tone, and so on. In classical harmony the most important scale degrees are the tonic, dominant, and subdominant. See also CADENCE.

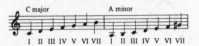

scaling The relative dimensions of an instrument's pipe or string in relation to its tone color and/or pitch. In organ pipes the proportion of the diameter to length determines the tone color, wide scaling (fat pipes) producing a flutelike tone (with few overtones) and narrow scaling a violinlike sound. Medium scaling, which produces the typical organ sound, is represented by a pipe producing middle C that is about two feet long and slightly more than two inches in diameter. In stringed instruments not only the length of a string determines its pitch but also its thickness and density.

Scarlatti (skär lät' ē). The family name of two important Italian composers of the baroque period, father and son. —**Alessandro Scarlatti**, 1660–1725. Remembered chiefly for establishing the style of the so-called OPERA SERIA, which prevailed in all Europe throughout the eighteenth century. The outstanding Italian composer of his day, Scarlatti wrote more than a hundred operas (many of which are lost), as well as six hundred cantatas for solo voice with continuo, chamber music, and church music (including several hundred Masses). He helped bring to prominence the *da capo* aria (see under ARIA), and in his later works he developed the style of the Italian overture, a forerunner of the symphony (see under OVERTURE). Born in Palermo, Scarlatti may

have studied with Giacomo Carissimi. His own most famous pupil was his son, Domenico. Scarlatti spent much of his life in Naples, and the type of opera he wrote is often called "Neapolitan." Among his operas are *Il Tigrane* (1715) and his only comic work (all the rest are serious), *Il Trionfo dell'onore* ("The Triumph of Honor," 1718). —**Domenico Scarlatti**, 1685–1757. Remembered chiefly for his harpsichord compositions. Studying first with his father, Scarlatti at sixteen became organist of the royal chapel at Naples. His earliest compositions include operas and oratorios. Shortly before his father's death he went to Portugal as music teacher to a young princess; in 1729 she married the heir to the Spanish throne, and Scarlatti accompanied her to Spain, where he remained for the rest of his life, teaching and composing. During this period he wrote mainly harpsichord music—in all, some six hundred "sonatas" and "fugues." Most of the pieces are in binary (two-part) form, and many of them introduce new devices of keyboard technique, such as frequent crossing of the hands, rapidly repeated notes, quick arpeggios (broken chords), and wide leaps (skips of more than an octave between notes). Some regard Scarlatti as the founder of modern keyboard technique.

Scarlatti's most notable pupil in Spain was Padre Antonio Soler (1729–1783), who was an organist and, like his master, wrote many fine keyboard sonatas.

scatting Also, *scat-singing.* In jazz, a style of singing in which nonsense syllables, yodels, tremolos, and other vocal devices replace the lyrics (words) of a song. The singer Ella Fitzgerald became renowned for her scatting. See also RAP.

scena (shā'nä) *Italian:* "stage." 1 A scene in an opera, usually consisting of several elements, such as one or more recitatives, arias, and/or choruses. 2 A concert piece for solo voice with accompaniment, similar to an operatic aria but presented without scenery or costume. 3 In instrumental music, a term used to describe the dramatic nature of a piece or section; for example, Ludwig Spohr described his Violin Concerto no. 8 as being *in modo d'una scena cantante,* that is, "in the style of a vocal scena." —**sulla scena** (sōō'lä shā'nä). The Italian term for "on stage."

schalkhaft (shälk'häft) *German.* A direction to perform in a playful manner.

Schalmei (shäl'mī). The German name for the small sizes of SHAWM.

Schellen (shel'ən). The German term for bells (see BELL, def. 1; also CHIMES, def. 1).

Schellentrommel (shel'ən trôm"əl). The German term for TAMBOURINE.

Schenker analysis (shen'kər) A system of studying musical structure invented by the Austrian theorist Heinrich Schenker (1868–1935). Schenker believed that all music consists of three layers: a foreground, the surface detail of the music; a middle ground, the elaboration of the underlying harmonies; and a background, the basic harmonic progressions of the work. Although Schenker applied this system to tonal music (he disapproved of atonality), later theorists have transferred his ideas to atonal works as well, and at least one composer, Milton Babbitt, consciously tried to use the three-level structural model in composing his works.

scherzando (sker tsän' dô) *Italian.* A direction to perform in a playful, lively manner, in the manner of a scherzo (see SCHERZO, def. 1).

scherzo (sker'tsô) *Italian:* "joke." 1 From the late eighteenth century on, a movement of a sonata, symphony, quartet, etc., that is in rapid tempo, usually in 3/4 meter, and involves elements of surprise in the music. The scherzo movement usually replaces a minuet and, like it, is generally followed by a trio (see TRIO, def. 1). Dur-

ing the classical period (1785–1820), composers such as Haydn occasionally replaced the minuet of the third movement with a scherzo. At first the scherzo was so much like the minuet that practically the only difference lay in the name. By Beethoven's time, however, it had become faster, more vigorous, and no longer dancelike. Other composers who have used a scherzo in symphonies are Schubert, Bruckner, and Sibelius. **2** From the early seventeenth century until about 1750, a vocal or instrumental piece, or section of a piece, in a light vein. **3** A title used by some nineteenth-century composers, notably Chopin and Brahms, for an independent piece that may be serious and dramatic rather than playful or light.

Schlag (s͟hläk). The German word for BEAT.

Schlaginstrumente (s͟hläk' in stro͞o men" te). The German term for PERCUSSION INSTRUMENTS.

schleppend (s͟hlep'ənt) *German.* A direction to perform in a heavy, dragging fashion. The term also appears in the direction *nicht schleppend,* warning the performer to maintain a brisk tempo.

schmetternd (s͟hmet'ernt) *German.* A direction to horn players to produce a harsh, brassy tone by increasing their wind pressure. (See also FRENCH HORN.)

Schmieder (s͟hmē'dər). See under BACH.

schnell (s͟hnel) *German.* A direction to perform in fast tempo.

schneller (s͟hnel' ər) *German.* **1** A direction to perform faster (see SCHNELL). **2** *Schneller.* The inverted mordent (see under ORNAMENTS).

Schoenberg (s͟hœn'berk), **Arnold** (är'nôlt), 1874–1951. An Austrian composer who originated the twelve-tone technique to replace traditional tonality (see under SERIAL MUSIC), thereby becoming one of the most influential figures in twentieth-century music. Schoenberg's first impor-

tant work was the string sextet *Verklärte Nacht* ("Transfigured Night"), op. 4 (1899), still in the tradition of late romanticism (Wagner) and one of his most frequently performed compositions, especially in the version for string orchestra he made in 1917. His next important work was a huge cantata, *Gurrelieder,* which is scored for an orchestra of some 140 players, five soloists, three men's choruses, and one mixed chorus—about four hundred performers in all. During the first decade of the 1900s Schoenberg's growing reputation attracted more and more students, among them Alban Berg, Anton Webern, and Egon Wellesz, who became his most important followers. In 1908 Schoenberg finished the last work of his that bears a key signature, his String Quartet no. 2 (op. 10). It was another fifteen years, however, before he formulated the twelve-tone system. The most important of his atonal works (see ATONALITY), written between about 1909 and 1913, are *Drei Klavierstücke* ("Three Piano Pieces"), op. 11, in which he completely did away with the sense of a home key (tonality) and eliminated any difference between consonance and dissonance; *Fünf Orchesterstücke* ("Five Orchestral Pieces"), op. 16, in which subtle changes in tone color are exploited (see KLANGFARBENMELODIE); the two musical dramas *Erwartung* ("Expectation") and *Die glückliche Hand* ("The Lucky Hand"), the former projecting the psychological state of a single character; and *Pierrot lunaire* ("Pierrot by Moonlight"), a cycle of twenty-one songs (in rondeau form) accompanied by five instrumentalists and performed in SPRECHSTIMME, a musical recitation, half-sung, half-spoken, which Schoenberg had already used in *Gurrelieder. Pierrot lunaire* in particular aroused much controversy among audiences and critics, but its style and instrumentation were to appeal to numerous later composers (see under MUSIC THEATER). In 1925 Schoenberg received a teaching post in Berlin, but in 1933, with the Nazis

in power, he was, being a Jew, dismissed. He went to Paris and then to the United States, where he remained, teaching and composing (mostly in California), for the rest of his life.

Shortly before he went to Berlin, Schoenberg completed the formulation of the twelve-tone system (which he preferred to call a "technique" or "process"). It first appeared in his *Fünf Klavierstücke* ("Five Piano Pieces"), op. 23, and Serenade for seven instruments and bass voice, op. 24 (both completed in 1923), and later in the Suite for piano, op. 25 (the first work in which he used a twelve-note series in all the movements), and Wind Quintet, op. 26, as well as *Variations for Orchestra*, op. 31. After his move to America Schoenberg began to use the twelve-tone technique somewhat less strictly and occasionally admitted some tonal elements. The notable works of this final period include the Suite in G major for string orchestra of 1934, intended for use by students; *Kol Nidre*, op. 39, a setting of a Jewish prayer; a Piano Concerto; a Violin Concerto; and *A Survivor of Warsaw*, a cantata dedicated to Jews who died in concentration camps during World War II. He never completed his only full-scale opera, *Moses und Aron* ("Moses and Aaron"), but the two acts he did finish have been performed as is (for a third there is only the libretto, no music). See also BERG, ALBAN; WEBERN, ANTON.

school A term loosely used to describe a group of musicians who worked in the same place, or during the same period, or in the same style of composition (or performance). The school of Notre Dame, for example, refers to a group of musicians who worked in Paris during the thirteenth century, developing a style of polyphonic church music (music with several voice-parts). Similarly, the Mannheim school was a group of musicians who played in, conducted, and composed music for the orchestra of a German prince in Mannheim,

Germany, about the middle of the eighteenth century, and who developed a particular style of orchestral music and performance. Neither of these movements was associated with a particular educational institution.

schottische (s̲h̲ôt′ i s̲h̲e) *German:* "Scottish." Also, British, *German polka.* A dance popular in nineteenth-century Europe. It was performed as a round dance (with the dancers forming a circle). Its music is similar to the polka, but considerably slower in tempo.

Schubert (s̲h̲o͞o′ bərt), **Franz** (fränts), 1797–1828. An Austrian composer who is remembered for his songs, symphonies, chamber music, and piano works, which show a remarkable gift for creating lovely melodies. He wrote some of the finest examples of the LIED (def. 1) ever written, among them "Gretchen am Spinnrade" (Gretchen at the Spinning Wheel), "Der Erlkönig" (The Erl-King), and the songs in the two song cycles, *Die schöne Müllerin* ("The Fair Maid of the Mill") and *Die Winterreise* ("The Winter Journey"). Schubert studied music from an early age and became a teacher, but at twenty he decided to devote himself entirely to music. Although money was a constant problem throughout his short life, he managed to compose more than six hundred songs, eight symphonies (one unfinished, and portions of two more), a great deal of chamber music, and many works for piano, among them numerous piano duets. In style his music bridges the classic and romantic periods. Although his sonatas, quartets, and symphonies are constructed in the classical style of Mozart and Beethoven, his harmonies show more chromaticism (freer use of dissonance), and he often shifted from major to minor and back again. Schubert's songs are most notable for their lovely melodies, yet he did not neglect the piano accompaniment, which he treated more and more elaborately. He selected poems of great beauty, often by outstanding poets such as Heinrich Heine, and made both melody and

accompaniment fit the words. Schubert wrote works in every form—operas, Masses, and overtures, as well as the forms already cited. Except for his incidental music to the play *Rosamunde,* these works are performed more rarely than many of them deserve. Some of his best-known compositions are the *Unfinished Symphony* (the next to last; 1822) and Symphony in C major (comp. 1825–1826); String Quartet in A minor (1824) and the String Quartet in D minor (1826–28, known as *Der Tod und das Mädchen,* or "Death and the Maiden"); the Piano Quintet in A, op. 114 (known as the *Trout Quintet*); Octet in F (1824); and for piano, the *Wanderer-Fantasie, Impromptus, Moments musicals, Valses sentimentales, Valses nobles,* and *Deutsche Tänze* ("German Dances"). Schubert's last songs, published after his death, were grouped together under the title *Schwanengesang* ("Swan Song").

Schuller (s<u>h</u>ōōl' ər), **Gunther,** 1925– . An American composer and conductor who in his music combines a variety of elements—jazz, serial techniques (see SERIAL MUSIC), classical forms, and microtones. Beginning his career as a French horn player, Schuller wrote a number of works for that instrument as well as for other wind instruments, among them a Suite for woodwind quintet, a Quintet for four horns and bassoon, and *Five Pieces for Five Horns.* His other works include the ballet *Modern Jazz: Variants,* the opera *The Visitation,* a symphony, Piano Trio, *Duologue* for violin and piano, *On Light Wings* for piano quartet, and a *Chamber Symphony.* He also wrote an outstanding history of jazz (it was he who coined "third stream" for a fusion of jazz and classical music). From 1967 to 1977 Schuller was director of the New England Conservatory of Music, and he also directed the Berkshire Music Center for a decade (1974–1984). Thereafter he continued to combine teaching and conducting with composition.

Schuman (s<u>h</u>ōō'mən), **William How-**ard, 1910–1992. An American composer who became known for his melodic, highly rhythmic symphonies, concertos, and choral works. Involved with jazz and popular music during his youth, Schuman turned to serious music in his twenties, studying for a time with Roy Harris. His first great success was his Symphony no. 3 (1941), which continued to be performed fairly often. From 1945 to 1961 he was director of the Juilliard School of Music, and he was the founding president of New York's Lincoln Center (1962–1969). Schuman's music is tonal (see TONALITY), although he omits key signatures, and it incorporates both folk and jazz elements. Notable among his other works are Symphony no. 7 (he wrote ten in all), the secular cantata *A Free Song,* the ballet *Undertow,* the orchestral works *American Festival Overture* and *New England Triptych,* and four string quartets.

Schumann (s<u>h</u>ōō' män), **Robert** (rō' bert), 1810–1856. A German composer who is remembered chiefly for his songs and piano music, in which he proved to be one of the great masters of ROMANTICISM. His music combines songlike melody with complex rhythms and, from time to time, strongly dramatic elements. Schumann himself felt his personality to be divided between a gentle, poetic nature and a strong, impulsive one. For much of his life he lived in fear of a mental breakdown, and he finally died in a mental institution, at the age of forty-six.

Schumann first wanted to be a concert pianist. He studied piano with Friedrich Wieck in Leipzig, and later married his daughter, Clara, who became one of the great performers of her husband's music as well as a composer in her own right (see below). In an attempt to strengthen his hands, Schumann permanently disabled one finger and ended his concert career. He then turned to composition, writing exclusively for the piano (until 1840). His works were performed by

his wife, and also by Liszt. Schumann also wrote articles on music, and he became a founder of a very influential journal, *Neue Zeitschrift für Musik* ("New Music Journal"). In his writings Schumann became a harsh opponent of program music and of dramatic music as conceived by Liszt, and later, by Wagner. He was a champion of Chopin and of Brahms. His wife encouraged Schumann to try his hand at songs, and in 1840 alone he wrote some 120 of them, including the song cycles *Frauenliebe und Leben* ("Woman's Love and Life") and *Dichterliebe* ("Poet's Love"), which contain some of his finest work. Soon after, he turned to larger forms, and eventually he completed four symphonies, string quartets and other chamber music, his popular Piano Concerto in A minor, and some dramatic and choral works (the last seldom performed today). Schumann's lieder show a fine understanding of poetry, and his handling of the piano accompaniment is even more elaborate than Schubert's. His piano music, much of it short pieces, is typically romantic in its complex rhythms and meters, and abrupt changes of harmony. Outstanding among his many piano works are the *Études symphoniques* ("Symphonic Studies"), *Davidsbundlertänze*, *Carnaval*, *Abegg* Variations (on the name Abegg, using the theme A B♭, E G G), *Papillons* ("Butterflies"), *Kinderscenen* ("Childhood Scenes"), *Kreisleriana*, *Albumblätter* ("Album Leaves"), *Blumenstücke* ("Flower Pieces"), and *Humoreske*. Of his other works, the overture and incidental music for Goethe's play *Manfred* still are often performed. —**Clara** (klä'rä) **Wieck** (vēk) **Schumann** (1819–1896), who married Schumann in 1840, had made her debut as a pianist at the age of nine and four years later begun to tour Europe regularly. Except for the years during which she bore their seven children, she continued to tour regularly for more than fifty years. She also taught piano, and she directed several music schools. Much of her time and energy were devoted to promoting her husband's music; she saw to it that his works were published and performed, and she played much of his piano and chamber music herself. She also played much of the music of Brahms, her lifelong friend. Her own compositions include a piano concerto, chamber works, including Piano Trio in G minor, numerous shorter piano works, and songs.

Schuplattler (s͟hoo͞' plät lər) *German.* A folk dance of southern Germany and Austria, in which the dancers slap their knees and the soles of their feet. The music, gay and lively, is similar to a fast waltz.

Schütz (s͟hyts), **Heinrich** (hīn' riк͟н), 1585–1672. A composer who is remembered as the greatest German composer of his time. He is noted especially for his church music, in which he combined Renaissance polyphony (music with several independent voice-parts of equal importance) with elements of the new monodic style of the baroque (accompanied melody; see MADRIGAL, def. 2; also MONODY, def. 1). Schütz studied in Italy with Giovanni Gabrieli, master of the Venetian polychoral style (using two choirs in alternation and together), which he employed in some of his own works. He also adapted features of Monteverdi's operas, mainly the recitatives and arias with continuo accompaniment. He himself wrote the first German opera, *Dafne*, which, however, has been lost. Schütz worked first at Kassel, where he was court organist, and later at Dresden, where he was music director for the Elector of Saxony. He often visited Italy, where he studied all of the current Italian styles, but at the same time he criticized German composers who copied the Italians without having a thorough background in contrapuntal writing. All of Schütz's surviving music is vocal, much of it accompanied by various instrumental groups. His finest works were written for the Lutheran church. They include his *Psalmen Davids* ("Psalms of David"; 1619), *Cantiones*

sacrae ("Sacred Songs"; 1625), *Symphoniae sacrae* ("Sacred Symphonies," for voices and instruments; 1629–1650), *Kleine geistliche Konzerte* ("Short Sacred Concerts"; 1636–1639), *Christmas Oratorio,* and three Passions (see also ORATORIO; PASSION).

schwach (shväкн) *German.* A direction to perform softly.

schwindend (shvin'dənt) *German.* A direction to perform more and more softly, as though the music were dying away.

sciolto (shôl' tô) *Italian.* Also, *scioltamente* (shôl"tä men'te). A direction to perform lightly and nimbly.

scoop In singing, the undesirable practice of sliding from one pitch to another pitch, usually a higher one, instead of attacking each note cleanly. It differs from a deliberate PORTAMENTO.

scordatura (skôr"dä toŏr'ä) *Italian.* A change in the ordinary tuning of a stringed instrument, such as a violin, in order to play a particular passage or composition. It involves tuning one or more strings up or down in pitch by one half tone, one whole tone, or even more. In the seventeenth century scordatura was frequently used for lute compositions, the exact tuning required being indicated at the beginning of each work. Later it was used for violins and cellos. The music was written as though the tuning were normal; thus, if the strings were tuned one whole note higher than usual, the instrument would sound G for a written F, F for a written E, and so on. Paganini often tuned all four of his violin strings as much as a third (two whole notes) higher in order to brighten the tone. In Mozart's *Sinfonia concertante* in E-flat, K. 364, for violin, viola, and orchestra, the solo viola is tuned one half tone higher than normal (its part is written in D) so that it can be heard above the orchestra's viola section. Tuning down is usually done to increase the range (downward). Since the late nineteenth century, scordatura has been used mainly for special effects, as in Saint-Saëns's *Danse macabre* ("Dance of Death"), where the solo violin's E-string is tuned E-flat to obtain an eerie effect.

score The written notes to be performed by all the instruments or voices (or both) in a particular composition. Today they are arranged on a series of staves placed one under another, vertically aligning all the notes to be sounded together at one time. The term "score" alone is loosely used to mean any written music, and one speaks of a piece being "scored for" the particular voices and instruments involved. —**full score** Also, *orchestral score.* A score that shows all the parts, for voices and instruments, sometimes requiring thirty or more staves. Pairs of instruments, such as first and second oboes, share a staff. Ordinarily a full score is used only by the conductor. The general order of an orchestral score is woodwind parts at the top, then brass instruments, then percussion, then keyboard instruments, and last stringed instruments. A harp part is placed between keyboard and stringed instruments, and parts for voices are placed between keyboard and strings, as is a solo instrument in a concerto (the solo violin in a concerto for violin and orchestra). Within each group the order is usually from highest to lowest pitch. The order of a typical score is:

Woodwinds:		
		Piccolo
		Flutes
	treble clef	Oboes
		English horn
		Clarinets
		Bass clarinet
	bass clef	Bassoons
		Double bassoon

Brasses:		
		French horns (first and second)
	treble clef	French horns (third and fourth)
		Trumpets (two to a staff)

tenor clef { Trombones
 (first and second)

bass clef { Trombone (third;
 sometimes com-
 bined with tuba)
 Tuba

Percussion:

bass clef { Timpani
 Other percussion
 (a series of one-line
 staves)
 Celesta (two staves)

Keyboard: Piano (two staves)
 Organ (three staves)

Voices: Soprano, alto, tenor,
 bass (two staves)

Strings: Harp (two staves)

treble clef { Violins (first)
 Violins (second)

alto clef { Violas
 Cellos

bass clef Double basses

Although full scores were used until about 1200, from the thirteenth to sixteenth centuries polyphonic church music (music with more than one voice-part) was written in **choir-books**, with each part written out separately, either on the same page or on facing pages. These books were quite large, and a number of singers used the same book. In the sixteenth century separate **partbooks** were published for secular vocal compositions, each containing a single part (soprano, tenor, and so on) for a composition. These were quite small and probably used by just one singer. About 1600 the modern method of writing scores came into use, along with the use of bar lines to separate measures. The order of instruments used in present-day scores dates from the Mannheim school of the mid-eighteenth century.

Reading an orchestral score requires considerable skill. It involves, among other things, reading the various clefs and mentally translating the score for transposing instruments, whose actual sound is in a different key from the written notes. —**part score** A score showing only the music for one instrument (or family of instruments,

such as all the French horns). —**vocal score** A score showing all the parts for voices, with the orchestral parts reduced to a single part for piano (on two staves).—**piano score** Also, *piano reduction, short score.* A score showing all the parts reduced to a part for piano (on two staves).

scorrevole (skô re′ vô le) *Italian.* A direction to perform in a smooth, flowing manner.

Scotch snap The name for a rhythmic pattern of two beats, short-long, which is found in Scottish folk music and elsewhere as well:

scratching See under RAP.

Scriabin (skryä′bin), **Alexander** (ä″le ksän′dər), 1872–1915. A Russian composer who is remembered for piano music and orchestral works in which his novel harmonies foreshadowed the revolutionary atonality of Schoenberg (see ATONALITY). Although Scriabin's works created a sensation when they were first played, for a time they were seldom performed. Scriabin was a virtuoso pianist, and his earlier works, particularly short piano pieces (mazurkas, impromptus, études), are in the tradition of Chopin. Gradually he became more experimental, especially in longer works, among them his three symphonies, piano concerto, and two long orchestral compositions, *Poem of Ecstasy* and *Prometheus—The Poem of Fire.* In the last, he based the harmony on a single chord, C-F♯-B♭-E-A-D, which is characteristic of his later work in that it proceeded by fourths instead of by the conventional thirds (triadic harmony). This chord is sometimes called the **mystic chord.** Scriabin also explored the association of music with color; the score of *Prometheus* calls for a color organ to project onto a screen colors in keeping with the mood of the music. In his emphasis on dissonance and lack of reference

to a single tonal center, Scriabin was proceeding along lines later followed by many twentieth-century composers.

S C T B In vocal music, an abbreviation for soprano, contralto, tenor, and bass. See also S A T B.

sec (sek) *French:* "dry." A direction that a note or passage is to be performed crisply, the notes being attacked and released without delay.

secco (sek'ô) *Italian:* "dry." The Italian term for SEC. —**recitativo secco** See under RECITATIVE.

second 1 A term used for another instrument or voice of the same kind, usually performing a part at a somewhat lower pitch than the first, for example, second horn, second oboe, second violin, second soprano, etc. **2** Also, *major second.* The interval made up of the first and second tones (in rising order of pitches) in any major or minor scale, for example, C–D in the scale of C major (*do* and *re* in solmization syllables). Also see WHOLE TONE. —**augmented second** The interval one half tone larger than a major second, such as C♭–D or C–D♭. —**minor second** The interval one half tone smaller than a major second, such as C–D♭ or C♭–D♮. Also see HALF TONE.

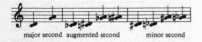

major second augmented second minor second

secondary dominant See under DOMINANT.

seconda volta (se kôn'dä vôl'tä) *Italian:* "second time." A term meaning "second ending" (see under PRIMA).

secondo (se kôn' dô) *Italian.* **1** In piano duets (for two players at one piano), the lower of the two parts, the upper being called *primo.* **2** A second instrument, such as *flauto secondo,* second flute; see SECOND, def. 1.

section 1 A clearly defined portion of

a composition, usually shorter than a MOVEMENT but longer than a PERIOD. **2** In an orchestra or band, the instruments of one kind, such as flute section, horn section, cello section, etc. **3** Also, *choir.* In an orchestra or band, the instruments of the same family, such as woodwind section, brass section, etc.

Seeger, Ruth Crawford See CRAWFORD SEEGER, RUTH.

segno (sen'yô) *Italian:* "sign." The sign ℅, used in compositions to indicate a section that is to be repeated from a particular point marked by that sign. The term *dal segno,* abbreviated *D.S.,* means "repeat from the sign," usually up to the point marked *fine* ("end"), whereas *al segno* means "up to the sign." (See also under CAPO.)

segue (se'gwe) *Italian.* **1** A direction that the performer continue with the next section, without pause or interruption. **2** A direction to continue a particular pattern of performance, such as broken chords (with the notes played in succession rather than together) or doubling in octaves.

seguidilla (se" gē t̪h̪ē' lyä) *Spanish.* A lively Spanish dance in 3/8 or 3/4 meter. Accompanied by guitars and castanets, it is similar to the bolero, but faster. In Act I of Bizet's opera *Carmen,* Carmen sings about a seguidilla, and the music of her song resembles that of the actual dance.

sehr (zer) *German:* "very." A word used in such musical directions as *sehr schnell* ("very fast"), or *sehr langsam* ("very slow").

semibreve (sem'ē brēv"). The British term for WHOLE NOTE, derived from the Latin *semibrevis* (see under BREVIS).

semiclassic A very general term for music that is midway between "popular" and "classical" or "serious" music. Some use it for the lighter works of serious composers (such as Saint-Saëns's *Le Carnaval des animaux,* "The Carnival of the Animals"). Oth-

ers use it for the serious works of popular composers (for example, Gershwin's *Rhapsody in Blue*). Still others use it for works by lesser composers that have become especially popular (such as Khatchaturian's "Sabre Dance"). In fact, the meaning of "semiclassic" is so broad and subjective that the term is, for practical purposes, useless.

semiquaver (sem'ē kwā"vər). The British term for SIXTEENTH NOTE.

semitone Another term for HALF TONE.

semplice (sem' plē c̲h̲e) *Italian.* A direction to perform in a simple, straightforward manner.

sempre (sem'pre) *Italian:* "always." A word used in such musical terms as *sempre forte* ("always loud"), or *sempre più mosso* ("always faster"; that is, gradually becoming faster).

sentito (sen tē' tô) *Italian.* A direction to perform expressively, with feeling.

senza (sen'dzä) *Italian:* "without." A word used in such musical terms as *senza rallentando* (abbreviated *senza rall.;* "without slowing down"); *senza battuta* or *senza misura* ("without 'measure'"; that is, not in strict time); *senza sordini* ("without mutes"; in music for horns or violins; see also SORDINO).

septet (sep tet'). **1** An ensemble of seven voices or instruments. **2** A composition for seven instruments or seven voices. Since each instrument or singer has a separate part, the septet is a form of chamber music. —**instrumental septet** A septet for instruments. Most such pieces include parts for both stringed and wind instruments. Among the best-known examples are Beethoven's Septet in E-flat, op. 20, for violin, viola, horn, clarinet, cello, bassoon, and double bass; Saint-Saëns's Septet, op. 65, for piano, trumpet, and strings; Ravel's *Introduction and Allegro* for flute, clarinet, harp, and string quartet (first and second violin, viola, cello); Schoenberg's Septet, op. 29, for clar-

inets, bass clarinet, violin, viola, cello, and piano; and Stravinsky's Septet (1954) for clarinet, bass clarinet, horn, violin, viola, cello, and piano. —**vocal septet** A septet for singers. Some sixteenth-century madrigals are vocal septets. Examples in opera are found at the end of Act II of Mozart's *Le Nozze di Figaro* ("The Marriage of Figaro") and at the end of Act I of his *Don Giovanni.*

septimole See SEPTUPLET.

septuplet (sep tup' lət). Also, *septimole.* A group of seven notes of the same time value (all quarter notes or all eighth notes, for example) that are performed in the time usually taken for a different number of notes. For example, in 6/8 meter, a septuplet might take the place of six eighth notes (making up a whole measure), or in 3/4 meter it might replace three quarter notes. A septuplet is marked with a bracket or slur and the figure 7.

sequence In the Roman Catholic rites, a particular form of chant that is used in the Proper of the Mass, that is, for special occasions during the church year. The sequence originated in the ninth century. Scholars disagree about its precise beginnings, but it is generally considered a form of TROPE. During the eleventh century it became more standardized and eventually became a poem consisting of a series of rhymed pairs of lines, with the same melody used for both lines of a pair. As early as the tenth century, sequences were given polyphonic settings (music with several

voice-parts), a practice that became very popular during the Renaissance; Dufay, Dunstable, and Josquin des Prez were among the composers who wrote particularly noteworthy settings. In the sixteenth century, however, the Council of Trent (which met 1545–1563) decided that sequences represented a corruption of the liturgy and abolished all but four of them. In 1727 the Church readmitted one more sequence in the liturgy, the famous STABAT MATER. The other four still in use are the DIES IRAE, in the Requiem Mass; *Lauda Sion Salvatorem,* sung on the feast of Corpus Christi; *Veni Sancte Spiritus,* sung on Pentecost Sunday; and *Victimae paschali laudes,* sung on Easter. —**melodic sequence** Repeating the same melodic pattern at a different pitch. In a **real sequence** the intervals remain exactly the same as in the original; in a **tonal sequence** the intervals are changed slightly, usually in order to remain in the same key. —**harmonic sequence** A repetition of harmonies (chords) rather than of a melody. (See the accompanying example, from the rondo of Mozart's Piano Sonata in A, K. 331, where the intervals are repeated in all the voice-parts.)

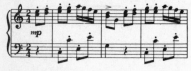

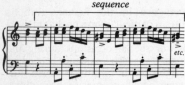

sequence

sequencer See under SYNTHESIZER.

serenade 1 A love song sung during the evening below the beloved's window. A famous example is found in Act II of Mozart's opera *Don Giovanni,* where the Don sings to Elvira's maid, accompanying himself on the mandolin. **2** An instrumental composition for a small ensemble, such as a chamber orchestra, group of wind instruments, or even smaller group, originally intended as an evening entertainment. Such compositions were especially popular during the second half of the eighteenth century. They ordinarily consist of several movements, among them marches, minuets or other dances (as in the suite), and slow and fast movements like those of the sonata. Among the best-known serenades are two by Mozart, *Eine kleine Nachtmusik* (literally, "A Little Night Music"), K. 525, and the *Haffner Serenade,* K. 250. In form these serenades are hard to distinguish from pieces called *divertimento, cassation,* or *notturno.* Other serenades have been written by Beethoven (he wrote two as trios but later revised them for different instruments), Brahms, and, in the twentieth century, by Schoenberg (op. 24, for seven instruments, plus a bass voice in one of the seven movements).

serenata (ser" e nä' tä) *Italian* **1** A serenade (see SERENADE, defs. 1, 2). **2** In the eighteenth century, a short work that combined features of an opera with those of a secular (nonreligious) cantata. The best-known example is Handel's masque, *Acis and Galatea;* it could be performed either in concert form, as a cantata, or with costumes and scenery, as a short opera.

seria, opera See OPERA SERIA.

serial (sēr'ē əl) **music** Also, *serialism.* Any musical composition that is based on a particular succession (series) of pitches (notes), rhythms, dynamics, or other elements, which are repeated over and over throughout the work. The first important system of serial music was formulated by Arnold Schoenberg about 1920. Having rejected the traditional ideas of tonality—of organizing a work around one or more keys—Schoenberg felt the need for some kind of organizing principle for musical compositions. The system he formulated is known as the **twelve-tone technique** or *twelve-tone system* because it uses all twelve notes

of the chromatic scale. In a twelve-tone composition the twelve notes of the chromatic scale appear in a particular order selected by the composer. This order of notes, called the **series** or *tone row*, appears again and again throughout the work, in both melody and chords. No one note can be used again until all eleven of the others have appeared. However, certain modifications of the series are permitted. A tone may appear in any octave; for example, if the original series contains middle C, any other C may be substituted the next time a C is to appear. The series may be moved to some other part of the scale, provided all the intervals (distances between pitches) remain intact. For example, if the first three notes of a series are C C♯ D, they may be moved to G G♯ A, so long as all the other nine notes of the series also are moved up one fifth. Further, the entire series may be **inverted** (turned upside down, so that a half tone up in pitch becomes a half tone down, and so on). It may appear in **retrograde** (backward, beginning with the last note of the series and ending with the first), or in **retrograde inversion** (backward and upside down). These opportunities for change—forty-eight in all—make possible a considerable amount of variety. The accompanying example *A* shows the original series of Schoenberg's *Variations for Orchestra,* op. 31

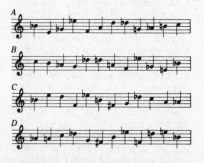

(1928), followed by the series in retrograde, *B,* in inversion, *C,* and in retrograde inversion, *D.* Schoenberg at

first used the series as a melody, usually placed in several voice-parts (counterpoint). About 1928 he began to use the tones of the series in chords, grouping them into three four-note chords, four three-note chords, or similar combinations. In Schoenberg's last period, he no longer used the twelve-tone principle as rigidly as before, at least not in all of his works (see also SCHOENBERG, ARNOLD).

Other composers wrote twelve-tone music—Josef Hauer (who formulated his own system, published in 1923), Ernst Křenek, Luigi Dallapiccola, Wolfgang Fortner, Milton Babbitt, Nikos Skalkottas, Stefan Wolpe, Meyer Kupferman, and others—but Schoenberg's two most important disciples were Alban Berg and Anton Webern. Berg used the twelve-tone system more freely than Schoenberg, often combining it with elements of tonality. Webern, on the other hand, paved the way for applying the idea of a series to elements other than pitch—to rhythm, tone color, and dynamics. (This is sometimes called **total serial music** or **total serialism**.) It was only after Webern's premature death in 1945 that his influence was felt among young musicians, particularly Pierre Boulez, and also Karlheinz Stockhausen, Luciano Berio, Henri Pousseur, Bruno Maderna, Luigi Nono, and Igor Stravinsky (the last beginning in the late 1950s). In the early 1960s several Polish composers—Witold Lutoslawski, Krzysztof Penderecki, Grazyna Bacewicz—and the Hungarian György Ligeti produced works in which the themes were not melodies but timbres, densities, or contrasting motion. Others who have written serial music or have used serial techniques in combination with other methods include Jean Barraqué, Hans Werner Henze, René Leibowitz, Elizabeth Lutyens, Humphrey Searle, Peter Maxwell Davies, Karl-Birger Blomdahl, Olivier Messiaen, Gunther Schuller, Frank Martin, Wallingford Riegger, Aaron Copland, Ross Lee Finney, Charles Wuorinen,

and Roger Sessions. (See also the chart with TWENTIETH-CENTURY MUSIC.)

series See under SERIAL MUSIC.

serious music Also, *classical music.* A term used to distinguish popular music and folk music from music by composers with formal training who strive to create works of artistic significance rather than for primarily commercial success. Unfortunately, this term implies that popular and folk music are unimportant or not serious, an arbitrary judgment at best.

serpent (sûr′pənt). A wind instrument invented in the late sixteenth century and played for more than two hundred years. Named for its snake-like shape, it consisted of a leather-covered wooden tube with a conical bore (cone-shaped inside), about eight feet long and bent into an S-shape to make it more manageable. It had a cup-shaped mouthpiece mounted on a long brass crook, six finger holes, and a range of about one and one-half octaves. Generally similar to the CORNETT, it is often called the bass member of the cornett family. The serpent is thought to have

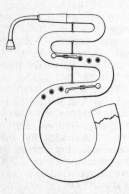

been invented about 1590 in France, where it was used principally for church music. Later its use spread to England, Germany, and other countries. Toward the end of the eighteenth century bandmasters realized the serpent's usefulness in wind ensembles, especially in military bands, and about this time it was provided with keys to help players with fingering. The serpent in the accompanying illustration has four keys.

Another version of serpent, known as the **bass horn** or **Russian bassoon,** is basically a serpent in the shape of a bassoon; it was popular in the first half of the nineteenth century, mainly in military bands.

service In Anglican churches (Church of England, Episcopal Church of the United States, etc.), the musical part of the worship service, aside from hymns and anthems. Most of the individual items of the service, whose texts are found in the Book of Common Prayer, still bear Latin names, since they were originally derived from the Roman Catholic rites, but are sung in English. Each service has its own particular items. The most important kinds of service are Morning Prayer, Evening Prayer, and Communion, the last corresponding to the Roman Catholic Mass. The Morning Service (that is, the service music for Morning Prayer) consists of the *Venite exultemus* ("Come, let us rejoice"), *Te Deum,* and *Benedictus* (or *Jubilate*); the Evening Service consists of the *Magnificat* (or *Cantate domino*) and *Nunc dimittis* (or *Deus misereatur*); the Communion Service consists of the *Decalogue* (or *Responses*), *Kyrie, Creed, Sanctus, Benedictus qui venit, Agnus Dei,* and *Gloria in excelsis* (compare the parts of the Roman Catholic Mass; see under MASS). A **full service** consists of musical settings of all these parts, usually in the same key. Such a service is referred to by both the composer's name and the key of the music, for example, Purcell's Service in B-flat.

Service music has been written since the sixteenth century, when the Anglican Church declared itself independent of Rome. Among the notable early composers of service music are Christopher Tye (c. 1500–c. 1572) and Thomas Tallis (c. 1505–1585). The early composers distinguished between

a **short service**, a relatively simple setting, and a **great service**, set either in elaborate counterpoint or antiphonally (with two choirs singing in turn and together). Other notable composers of service music are Byrd, Thomas Tomkins (1572–1656), and Gibbons. With only a few exceptions, little service music of quality was produced during the seventeenth and eighteenth centuries. Even composers such as Purcell and William Boyce wrote better anthems than services. The nineteenth century saw little improvement, though Samuel Sebastian Wesley (1810–1876), John Stainer (1840–1901), and Charles Villiers Stanford (1852–1924) made some contributions of note. In the twentieth century, Ralph Vaughan Williams and Benjamin Britten both wrote some fine service items but no full services.

Sessions (sesh'əns), **Roger**, 1896–1985. An American composer who became known as one of the outstanding American composers of his time, even though much of his music is quite difficult and therefore performed relatively rarely. Among Sessions's teachers was Ernest Bloch, who had great influence on his development. Sessions himself became an influential teacher, and he also devoted himself to promoting the performance of contemporary American music, through festivals and similar activities. Sessions's own works are largely atonal (see ATONALITY) and make considerable use of counterpoint. Occasionally he used serial techniques (as in his Violin Sonata and Symphony no. 3), but generally he drew on a large variety of forms and styles, including the large classical forms (sonata, symphony). Sessions's works of the 1920s are generally neoclassic, with their emphasis on counterpoint. In the 1930s and 1940s he used more and more chromatic harmonies, and in his later works (from the 1950s on) more and more serial elements appeared. Besides eight symphonies, Sessions's compositions include a Violin Concerto (composed 1935, first per-

formed 1960), the one-act opera *The Trial of Lucullus* (1947), a Sonata for solo violin (1953), Piano Concerto (1956), *The Idyll of Theocritus* (1954) for soprano and orchestra, the opera *Montezuma* (composed 1941–1962), the cantata *When Lilacs Last in the Dooryard Bloom'd* (composed 1970, performed 1977), Concerto for Violin, Cello, and Orchestra (1971), Concerto for Orchestra (1981), three piano sonatas, and many smaller works. His books include an important text, *Harmonic Practice*.

set A group of musical elements, most often pitch classes, particularly the twelve-note set of pitches in a serial composition (see SERIAL MUSIC). The term was borrowed from mathematical set theory by Milton Babbitt and occasionally is applied to durations, dynamic levels, and other elements subjected to serial techniques.

Webern liked using a *derived set*, that is, a twelve-note set derived from a smaller set by means of inversion, retrogression, and transposition. In his Concerto op. 24, for example, he used a group of three notes, B♮ B♭ D♭, along with its retrograde inversion (E♭ G♮ F♮), its retrograde (G♮ E♮ F♮), and its inversion (C♮ C♯ A♮) to create a new twelve-note set.

Serial composers sometimes invoke *combinatoriality*, the relationships between different arrangements of a set, so as to create a new series. For example, if the above-described set of Webern's Concerto were divided into two six-note series (hexachords) and inverted, one might combine the original set's first hexachord with the inversion's second hexachord to create a new set.

seventh Also, *major seventh*. The interval made up of the first and seventh tones (in rising order of pitches) in any major or minor scale, for example, C–B in the scale of C major (*do* and *ti* in solmization syllables). **—minor seventh** The interval one half tone smaller than a major seventh, such as C–B♭, or C♯–B♮. **—diminished seventh** The interval one half

tone smaller than a minor seventh (and one whole tone smaller than a major seventh), such as C–B♭♭ or C♯–B♭.

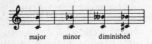

major minor diminished

seventh chord See under CHORD.

Sext See under OFFICE.

sextet (seks tet'). **1** An ensemble of six voices or six instruments. **2** A composition for six instruments or six voices. Since each instrument or singer has a separate part, the sextet is a form of chamber music. —**instrumental sextet** A sextet for instruments. It may have parts for only stringed instruments or for both strings and winds. A **string sextet** commonly means two violins, two violas, and two cellos. Notable sextets include Beethoven's Sextet in E-flat, op. 81b, for two horns and string quartet (first and second violins, viola, cello), and his Sextet in E-flat, op. 71, for winds (two clarinets, two horns, two bassoons); Brahms's two string sextets, op. 18 and op. 36; Schoenberg's *Verklärte Nacht* ("Transfigured Night"; 1899), later revised for string orchestra; Janáček's Wind Sextet entitled *Mládí* ("Youth"; 1924); Roy Harris's String Sextet (1932); Poulenc's Sextet for piano, flute, oboe, clarinet, bassoon, and horn (1932; revised 1940); Copland's Sextet for clarinet, piano, and string quartet (1939); Piston's String Sextet (1964); and Judith Weir's Sextet for piano and winds. —**vocal sextet** A sextet for singers. Examples are found in some sixteenth-century madrigals and thereafter largely in opera. A particularly famous sextet is found in Act II of Donizetti's *Lucia di Lammermoor*.

sextolet See SEXTUPLET.

sextuplet (seks tup' lit). Also, *sextolet*. A group of six notes of the same time value (all quarter notes or all eighth notes, for example) that are performed in the time usually taken for

four notes. For example, in 2/4 meter, calling for two quarter notes (or four eighth notes, eight sixteenth notes) per measure, a sextuplet might consist of six eighth notes in the place of four eighth notes (as in the accompanying example, from Beethoven's Piano Sonata, op. 14, no. 2). The sextuplet is usually marked with a bracket or slur and the figure 6. However, sometimes it is written as a group of two triplets, in which case it is played with a slight accent on the first and fourth notes (see *B* in the accompanying example).

sf An abbreviation for SFORZANDO.

sforzando (sfôr tsän' dô) *Italian:* "forcing." Also, *sforzato* (sfôr tsä'tô). An indication for a sharp, strong accent on a note or chord. Abbreviated *sf* or *sfz*.

sforzato See SFORZANDO.

sfp An abbreviation for SFORZANDO (sharp accent) followed by PIANO (soft), in other words, a sharp accent on a note or chord, immediately followed by a soft note or chord.

sfz An abbreviation for SFORZANDO.

shake 1 A name formerly used for a TRILL. **2** In playing brass instruments, the rapid alternation of several notes, usually notes of the HARMONIC SERIES. It is performed by shaking the instrument's mouthpiece against the lips in a sideways motion. The shake is often used by jazz musicians.

shakuhachi (sha koo ha'chē) *Japanese*. A Japanese flute, end-blown (from one end, like the recorder, instead of across a side hole, like the orchestral flute) and with four finger holes and a thumb hole. It is made in numerous sizes, depending on the tuning desired. The shakuhachi is made of fairly thick bamboo, with a

conical bore (cone-shaped inside) that is largest at the top. A skilled shakuhachi player can obtain a wide variety of tone colors on the instrument.

shamisen (s̲ham' i sen) *Japanese.* Also, *samisen.* A long-necked lute that is one of the most important instruments of Japan. It has a square wooden body covered with hide (usually catskin) on the top and bottom. There are three strings, which are plucked with a large, axlike plectrum of ivory. The shamisen is about three feet long (including body and neck). Unlike European lutes, it has no frets to mark the stopping positions. Also, the plectrum is used with considerable force, hitting the strings rather than merely plucking them. Made in various sizes, the shamisen is used principally to accompany singers, the size and exact tuning being adjusted to fit the particular singer's range. Sometimes two or more shamisens provide accompaniment. For use in chamber groups (as with a singer, a koto, and a flute), the shamisen is provided with a heavy bridge and strings of special weight and is plucked with a thinner plectrum in order to give it a very soft sound. The twentieth-century composer Hirohisa Akigishi wrote a Concerto for shamisen and (Western) orchestra.

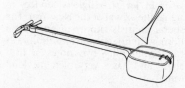

shanty (s̲han'tē). Also spelled *chantey, chanty.* A kind of work song that was sung by sailors in England and America to help them keep time in jobs that required teamwork, such as pulling heavy ropes. There are numerous collections of shanties, some of which date as far back as the sixteenth century; many of them have become familiar folk songs. Among them are "Yeo, Heave Ho!" used to hoist anchor (which involved winding a heavy cable around a barrel), "The Rio Grande," "Haul Away, Joe," "Blow the Man Down," and "The Drunken Sailor."

shape-note notation Also, *buckwheat notation, patent-note notation.* A system of notation based on SOLMIZATION, which uses syllables instead of letters for pitch names and is employed principally for teaching purposes and to facilitate sight-singing. The most popular system so used was a simplification of the octave into four syllables, fa–sol–la–fa–sol–la–mi–fa, which traveled from England to North America in the eighteenth century and became known as **fasola.** For notation purposes, different notehead shapes (triangular, diamond, square, round) were associated with the four syllables used, thereby eliminating the need for a staff. Rhythm was indicated by the presence or absence of a note stem. Shape-note notation was used principally for psalms and fuging tunes. In the mid-nineteenth century the system was expanded to a seven-note series. It is still used in some areas of the United States. See also TUNEBOOK.

sharp 1 An accidental that raises the pitch of a note by one half tone, indicated by the sign #. **2** A term to describe tones, sung or played, that are slightly higher than the correct pitch, and instruments tuned slightly higher than normal pitch.

shawm (s̲hôm). A wind instrument played with a double reed that is thought to be about two thousand years old. It is the forerunner of the modern oboe. Varieties of shawm are still found in various countries of the Near East and Africa. Like the oboe, the shawm has a conical bore (cone-shaped inside), flaring into a bell. The reed is mounted on a small metal tube fitted into the top of the instrument. African and Near Eastern shawms also have a disc below the reed, which supports the player's lips;

European shawms have a small piece of wood that partly covers the reed and supports the lips. There are seven finger holes, placed in the upper part of the instrument. The shawm has a bright, loud sound, owing to the reed and the way it is mounted, which permit a great deal of vibration.

The shawm came to Europe about the twelfth century, probably from the Arab countries of the Near East. It was used mainly outdoors, in bands, and was made in a variety of sizes, ranging from soprano to bass (the accompanying illustration shows a tenor shawm). In Germany small ones were called **Schalmei** and large ones **Pommer** (in France, **bombarde**). In the seventeenth century the shawm was largely replaced by the OBOE, but it survived as a folk instrument in Spain.

sheng (s̲h̲eng) *Chinese.* A mouth organ of China that dates back three thousand years or more and is still used today. It consists of a wooden wind chest in the shape of a bowl, into which are inserted a series of seventeen bamboo pipes of different lengths, arranged in a circle. Each pipe has a brass reed, which is fixed over a small slit near the lower end of the pipe. Above the reed is a small vent (air hole) and, still higher in the pipe, a finger hole, which must be covered if the pipe is to sound. The player blows into the mouthpiece, which is inserted in the side of the bowl, and at the same time covers the finger holes of those pipes that are to sound. The player's breath causes the appropriate reeds to vibrate, which in turn makes the air inside their pipes vibrate, so that they sound. The sounds produced are either single reedy tones or dense clusters.

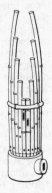

The Japanese use a virtually identical instrument called **sho** (s̲h̲ō).

shift In playing stringed instruments or the trombone, a change of position. See POSITION, defs. 1, 2.

sho (s̲h̲ō). See under SHENG.

shofar (s̲h̲ô fär′, s̲h̲ō′ fər) *Hebrew.* One of the oldest instruments that is still in use. A wind instrument made from a ram's horn, the shofar has been used for more than three thousand years in Jewish religious services to signal the arrival of the New Year. The shofar consists simply of an animal horn, with no separate mouthpiece. It can sound only two notes, a fifth apart, and has a very piercing, loud tone.

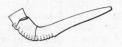

short appoggiatura See under APPOGGIATURA.

short score See under SCORE.

short service See under SERVICE.

Shostakovitch (s̲ho stä kô′ vich̲),
Dmitri (di mē′ trē), 1906–1975. A
Russian composer who became the
leading Soviet composer of his time.
Shostakovitch studied at the St.
Petersburg Conservatory and for his
graduation, at the age of nineteen,
wrote his Symphony no. 1, which
became one of his most popular
works. In his early works (up to the
early 1930s), Shostakovitch combined
songlike melodies with vigorous disso-
nances, precise orchestration, and,
often, witty satire. These features
appear in his opera *The Nose* (based on
a short story by Nikolay Gogol), the
ballet *The Golden Age,* his first four
symphonies, and the opera *Lady Mac-
beth of Mtsensk.* Several times during
his career Shostakovitch was harshly
criticized by the Soviet government
for his decadent, "too modern" music.
In each case he accepted the criticism
and revised the work; in the case of
Lady Macbeth, the opera was with-
drawn and did not reappear for nearly
thirty years (revised as *Katerina
Ismailova*). From the mid-1930s on
Shostakovitch wrote in a style that
won Soviet approval. It is evident
most clearly in a number of very long
symphonies, which are tonal in con-
ception, with a good deal of repetition
of rhythms and harmonies and large-
scale dramatic contrasts. Shosta-
kovitch wrote fifteen symphonies in
all. Some are associated with specific
historic events (no. 13 commemorates
Babi Yar, site of a Nazi massacre of
Jews) and others are intensely per-
sonal (no. 14 is a song cycle on
death). His other works include con-
certos for piano (some for two
pianos), ballets, patriotic cantatas,
songs, incidental music for plays and
motion pictures, and fifteen string
quartets and other chamber music.

shout A spiritual that expresses reli-
gious jubilation rather than sorrow.
In RHYTHM AND BLUES the term came to
mean a vigorous style of singing, in
marked contrast to the wailing, sigh-
ing style of some blues.

shuffle 1 A dance of black Americans.

2 A rhythm pattern similar to that of
BOOGIE-WOOGIE but syncopated, that
is, with eight eighth notes to the bar
and the first, third, fifth and seventh
dotted:

si Same as *ti;* see under SOLMIZATION.

Sibelius (si bā′lē əs), **Jean** (z̲hän),
1865–1957. A Finnish composer who
was his country's leading nationalist
composer (see NATIONALISM). Of his
works, the best known are the long
ones, principally his seven sym-
phonies and his symphonic poems.
He also wrote a great many piano
works and songs. Sibelius's music is
largely traditional in the treatment of
melody and harmony. Although he
used folk elements, he never actually
quoted folk songs. Among his most
popular works are his Symphony no.
2, the symphonic poems *The Swan of
Tuonela, En Saga, Karelia,* and *Finlan-
dia,* the string quartet entitled *Voces
intimae* ("Intimate Voices"), and a
Violin Concerto. All these were writ-
ten before 1927; for the last thirty
years of his life Sibelius produced
almost no music.

siciliana (sē c̲hēl yä′ nä) *Italian.* Also,
siciliano (sē c̲hēl yä′nô); French, *sicili-
enne* (sē sēl yen′). A moderately slow
dance of the island of Sicily, in 6/8 or
12/8 meter, which came to be used as
the slow movement in sonatas and
suites of the seventeenth and eigh-
teenth centuries. With its lilting
melody and slightly uneven rhythms,
it is very similar to the pastorale (see
PASTORALE, def. 2). It was also used in
vocal music, mainly in cantatas and
operas.

siciliano See SICILIANA.

sicilienne See SICILIANA.

side drum British name for SNARE
DRUM.

sightreading The ability to perform a
piece of music at first sight, without

studying or practicing it beforehand. Sightreading requires an instant understanding of pitches and rhythms as well as the ability to produce them more or less correctly, that is, shaping the musical phrases. There is less emphasis on playing or singing every single note with complete accuracy, and more on understanding the overall idea of a piece. Skill in sightreading is important for professional musicians, as well as making amateur music-making more pleasurable. See also SOLFÈGE, def. 1.

sight-singing Performing vocal music without prior rehearsal; see SIGHTREADING.

signature A name for the signs placed at the beginning of a musical composition to indicate the key and meter. See KEY SIGNATURE; TIME SIGNATURE.

sim. An abbreviation for SIMILE.

simile (sē' mē le) *Italian:* "same." Also, *simili* (sē' mē lē). A direction to continue performing in the same manner as before, for example, to continue playing broken chords (with the notes played in succession instead of together). It is sometimes indicated by the sign ✗. Abbreviated *sim.*

simili See SIMILE.

simphonie (saN fô nē') *French.* A name for the HURDY-GURDY, def. 2.

simple meter Any meter in which the number of beats in a measure is a multiple of two, such as 2/2, 2/4, 4/4, 4/8, etc., that is, a meter in which there are 2, 4, 8, or 16 beats per measure. See also COMPOUND METER.

sin'al (sēn'äl) *Italian:* "up to." A term used in the musical directions *sin'al fine* ("up to the end"), and *sin'al segno* ("up to the sign"), both indicating the point to which a section of a piece is to be repeated.

sine (sīn) **tone** See under OSCILLATOR.

sinfonia (sēn fô nē' ä) *Italian.* 1 Today, the Italian term for SYMPHONY. 2 During the baroque period (1600–1750), an OVERTURE. 3 A title

used by J.S. Bach and others for various kinds of independent instrumental piece. Bach used it for a group of keyboard pieces with three voice-parts (see under INVENTION). Other composers used it for pieces that might just as well have been called "canzona," "sonata," or even "trio sonata." (See also SINFONIA CONCERTANTE; SINFONIETTA, def. 1.)

sinfonia concertante (sēn fô nē' ä kôn" cher tän' te) *Italian.* In the eighteenth century, a work in which one or more solo instruments have an important part and serve as a contrast to the full orchestra, much as in the CONCERTO GROSSO. Examples include Johann Christian Bach's *Sinfonia concertante* in A major for violin, cello, and orchestra (one of a series of twelve published in Paris in 1771), Mozart's *Sinfonia concertante* in E-flat, K. 364, for violin, viola, and orchestra, and more than two dozen such pieces by Karl Stamitz.

sinfonietta (sēn fôn yet'ä) *Italian:* "little symphony." 1 A short symphony, usually played by a chamber (small) orchestra. 2 A chamber (small) orchestra.

singing The art of producing musical sounds with the voice (see VOICE, def. 2).

singing saw See SAW, MUSICAL.

singing school In eighteenth-century America, a more or less informal class in music conducted by teachers who traveled from town to town. Pupils were taught mainly how to read music and how to sing. Singing schools were especially popular along the east coast of the United States. Many of the schoolmasters, who often pursued some other trade to earn an adequate living, wrote music expressly for their teaching. Among their compositions are numerous fuge tunes (see FUGING TUNE). The most famous of the composers who wrote for singing schools and occasionally taught were William Billings (see BILLINGS, WILLIAM) and Daniel Read

(1757–1836), a surveyor and comb maker whose publications include *The American Singing Book, or A New and Easy Guide to the Art of Psalmody, Devised for the Use of Singing Schools in America.* Another important teacher was Andrew Law (1749–1821)..

single reed See under REED.

single tonguing See under TONGUING.

Singspiel (ziṅg′ shpēl) *pl.* **Singspiele** (ziṅg′ shpē′lə) *German.* A type of comic opera popular in Germany in the eighteenth century. Consisting of both sung and spoken dialogue, the Singspiel began as an imitation of the English BALLAD OPERA; indeed, the first examples (dating from about 1750) were translations of ballad operas set to new music by German composers. The Singspiel became popular in Leipzig, Berlin, and other cities, and in 1778 a special company for such performances was established in Vienna. It was for this group that Mozart wrote his *Die Entführung aus dem Serail* ("The Abduction from the Seraglio") in 1782, one of the finest Singspiele. Other outstanding examples are Mozart's early *Bastien et Bastienne* (1768); *Der Jahrmarkt* ("The Fair") by Georg Benda (1722–1795); *Der krumme Teufel* ("The Crooked Devil") by Haydn, which has unfortunately been lost; *Die Bergknappen* ("The Miners") by Ignaz Umlauf (1746–1796); *Doktor und Apotheker* ("Physician and Pharmacist") by Karl Ditters von Dittersdorf (1739–1799), a friend of Mozart's and Haydn's; and *Die Zwillingsbrüder* ("The Twin Brothers") by Schubert, one of the last Singspiele written. Later in the nineteenth century the Singspiel became indistinguishable from the musical comedy or operetta. (See also under OPERA.)

sinistra (sē nēs′ trä) *Italian:* "left." A direction to play a note or passage with the left hand.

sistrum (sis′trəm) *pl.* **sistra** (sis′trə) *Latin.* A kind of rattle used since ancient times among different peoples all over the world—in ancient Mesopotamia, Egypt, and Greece, as well as in Mexico, Brazil, and parts of Africa. It consists of a U-shaped frame, usually of metal, to which are attached objects that rattle when the frame is shaken. In one kind of sistrum, two loose crossbars rattle against the frame; in another kind, rings strung on a crossbar rattle against one another and against the frame.

sitar (si där′) *Hindi.* A long-necked lute that is one of the most important instruments of India, especially in the north. The sitar has a pear-shaped body, consisting of either hollowed-out wood or a gourd, and a wooden soundboard (over the hollow part). There may be an upper gourd as well, which today is mainly decorative but also serves to keep the instrument off the ground when it is laid down. The neck is quite long and has sixteen to twenty movable metal frets, which indicate the stopping positions for the melody strings. There are four to seven metal strings, usually five

melody strings and two drones (which are not stopped, but sound only a single pitch each), below which there may be eleven to thirteen sympathetic strings, each tuned to a different pitch, which vibrate in sympathy with the melody and drone strings. The tuning of the sitar is adjusted to fit the particular RAGA being performed. The player plucks the main strings with a plectrum worn on the forefinger and occasionally strums the sympathetic strings as well. (For a similar instrument played mainly in southern India, see VINA.)

site composition See SONIC ENVIRONMENT.

Six, Les (lā sēs) *French:* "the six." A group of six French composers who, about 1916, formed a loose bond under the leadership of Erik SATIE. They were Louis Durey (1888–1979), Arthur HONEGGER, Darius MILHAUD, Germaine Tailleferre (1892–1983), Georges AURIC, and Francis POULENC. Toward the end of World War I they joined forces in opposing the impressionist style of Debussy (see IMPRESSIONISM), supporting instead a return to classical clarity and simplicity (NEOCLASSICISM). Despite agreeing on basic ideas and producing a number of works collectively, they soon went on to pursue their own individual styles of composition.

six-five chord The first inversion of a seventh chord (see INVERSION, def. 1).

six-four chord The second inversion of a triad (see INVERSION, def. 1).

sixteenth note British, *semiquaver.* A note, ♪, equal in time value (lasting as long as) one-sixteenth of a whole note. Thus, sixteen sixteenth notes equal one whole note, eight sixteenth notes equal one half note, four sixteenth notes equal one quarter note, and two sixteenth notes equal one eighth note. When sixteenth notes are written in succession, their flags are joined together by double cross-bars, called *double beams:* ♪♪=♫.

sixteenth rest A rest, ♪, indicating a silence lasting the same length of time as a sixteenth note.

sixth Also, *major sixth.* The interval made up of the first and sixth tones (in rising order of pitches) in any major or minor scale, for example, C–A in the scale of C major (*do* and *la* in solmization syllables). **—augmented sixth** The interval one half tone larger than a major sixth, such as C♭–A or C–A#. **—minor sixth** The interval one half tone smaller than a major sixth, such as C#–A or C–A♭.

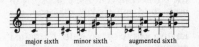

major sixth minor sixth augmented sixth

sixth chord Also, *six-three chord.* The first inversion of the triad (see INVERSION, def. 1). Sixth chords can occur on any degree (note) of the scale. **—Neapolitan sixth** The first inversion of the triad on the flatted supertonic, so called because it was frequently used during the eighteenth century by a group of composers working in Naples, Italy (as well as by others). In the key of C major the flatted supertonic is D-flat; the triad on D-flat is D♭–F–A♭; the first inversion of that triad (the Neapolitan sixth) is F-A♭–D♭. **—augmented sixth** A sixth chord that contains, in addition to a third, an augmented sixth (a sixth one half tone larger than a major sixth; see under SIXTH). The augmented sixth was frequently used throughout the nineteenth century. There are three principal varieties, distinguished from one another by the notes of the chord. They are known as **Italian sixth, German sixth,** and **French sixth** (all three are shown in the accompanying example, in the key of C major); the reason for the names is not known. **—added sixth** A triad with a sixth added to it (see ADDED SIXTH). **—Landini sixth** See under LANDINI CADENCE.

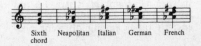

Sixth Neapolitan Italian German French
chord

six-three chord Another name for SIXTH CHORD.

sixty-fourth note British, *hemidemisemiquaver.* A note, ♪, equal in time value (lasting as long as) one sixtyfourth of a whole note. Sixty-four sixty-fourth notes equal one whole note, thirty-two sixty-fourth notes equal one half note, sixteen sixtyfourth notes equal one quarter note, eight sixty-fourth notes equal one eighth note, four sixty-fourth notes equal one sixteenth note, and two sixty-fourth notes equal one thirtysecond note. When sixty-fourth notes are written in succession, their flags are joined together by quadruple crossbars, called **quadruple beams:**

♪♪ = ♬

sixty-fourth rest A rest, ⅞ , indicating a silence lasting the same length of time as a sixty-fourth note.

slancio, con (kôn slän' chô) *Italian:* "with dash." A direction to perform in a strong, impetuous manner.

sléndro A kind of PENTATONIC SCALE. See also GAMELAN.

slentando (slen tän'dô) *Italian.* A direction to perform more and more slowly.

slide 1 In stopping the strings of a violin, a gliding movement whereby the hand moves quickly and smoothly from one position (note) to another. (See also GLISSANDO.) **2** In the TROMBONE, a movable section of tubing that changes the length of the vibrating air column inside. In the eighteenth and nineteenth centuries some trumpets had a similar device (slide trumpets). **3** A kind of ornament (see APPOGGIATURA, DOUBLE, def. 3).

slide trumpet See under TRUMPET.

slur A curved line over or under a series of notes of *different* pitches, indicating they are to be performed as a group. (A curved line over or under two notes of the *same* pitch is not a slur but a TIE.) A slur over just a few notes shows that they are to be performed legato (smoothly, without breaks between them). In music for violin or another bowed instrument, this often means they should be performed in one bow stroke; in music for voice or wind instruments, they generally should be performed in one breath. Over a larger group of notes the slur may indicate phrasing. Sometimes a slur is accompanied by staccato signs (a dot with each note), indicating a kind of half-legato performance (see PORTATO).

Smetana (sme'tä nä), **Bedřich** (bed' zhrikh), 1824–1884. A Bohemian composer who is remembered for his operas, symphonic poems, and other instrumental and vocal works in which he used the traditional subjects and musical idioms of his country. His best-known work is the opera *The Bartered Bride.* Although a fine pianist, Smetana could not earn a living from concerts, and his earliest compositions were largely ignored. To support himself, he took a conducting post in Sweden, where he remained for five years. In 1861 he returned to his homeland and helped found a national opera company in the capital city of Prague. For this group he eventually wrote nine operas (the last never completed). In 1874 he suddenly became deaf and was forced to resign as conductor of the Prague Opera. He continued to compose, however, producing the best of his symphonic poems, a series of six works entitled *Má Vlast* ("My Country"), as well as his first string quartet, entitled *From My Life* (it had a program, in the manner of program music). Other chamber works, piano pieces, and several more operas followed, despite Smetana's failing health. Eventually he was confined to a mental institution, where he died a few months later.

smorz. An abbreviation for SMORZANDO.

smorzando (smôr tsän' dô) *Italian.* A direction to perform more and more slowly, as though the music were fading away. Abbreviated *smorz.*

snare drum Also, British, *side drum*. A small cylindrical drum, consisting of a metal shell covered at both ends with a plastic or leather skin, which is used in orchestras, concert bands, marching bands, and jazz groups. Snare drums vary considerably in size, ranging from twelve to eighteen inches in diameter (across the head) and from three to twenty inches in depth (the height of the metal cylinder). The top, which is the side that is struck, is called the batter head. The bottom, across which are stretched the **snares** (a series of strings made of gut, nylon, or steel wire), is called the snare head. When the batter head is struck, the snares vibrate against the snare head, producing a rattling sound. The tone can be altered by loosening the snares, which gives the drum a low, dull sound, or by placing a cloth over the batter head, producing a muffled sound. The snare drum is played with two sticks, usually made of wood. It may also be played with felt-tipped sticks or with wire brushes, which are rhythmically slid across the head. Special effects obtained with the drumsticks are the ROLL, DRAG, and FLAM.

The snare drum dates from the Middle Ages; a small medieval variety is the tabor, always played with a pipe (see PIPE, def. 2, for an illustration of the tabor). The modern snare drum (shown in the illustration here) is usually held at an angle when played.

so See under KOTO.

soave (swä've) *Italian.* A direction to perform in a smooth, gentle manner.

soft pedal Another name for the una corda pedal of the piano (see under PIANO, def. 2).

sol (sōl). In the system of naming the notes of the scale (see SOLMIZATION), the fifth note of the scale (the others being *do, re, mi, fa, la,* and *ti*).

Soler (sō lâr'), **Padre Antonio** See under SCARLATTI.

solfège (sôl fezh') *French.* **1** Also, Italian, *solfeggio* (sôl fej' ē ô). A kind of musical training, involving both ear training and sight-singing (the ability to sing a musical passage at sight). The student learns to recognize clefs, intervals, rhythm, signatures—in short, all elements of musical notation—and to translate them into actual sounds. Often SOLMIZATION syllables (do, re, mi, etc.) are used. **2** A short exercise sung to SOLMIZATION syllables (do, re, mi, fa, etc.) Sometimes the term is also used for exercises sung to a vowel (a, o, u), which are more commonly called **vocalises**. (See also VOCALIZATION.)

solfeggio The Italian term for SOLFÈGE.

soli (sô' lē) *Italian.* The plural of SOLO.

solmization (sol" mi zā' shən). A system of naming the degrees (notes) of the scale by syllables instead of letters. The syllables commonly used today are *do* (or *doh*), *re, mi, fa, sol, la, ti* (or *si*). They come from syllables devised by GUIDO D'AREZZO, who used them as a teaching aid. There are two principal systems of solmization. One system, called **fixed do**, assigns the syllables to specific notes; thus *do* always means C, *re* always means D, etc. In the other system, called **movable do**, *do* indicates the first scale degree of any key, *re* the second scale degree, etc.; thus, *do* would mean C in the keys of C major or C minor but G in the keys of G major or G minor, A-flat in the key of A-flat, etc. Still another system of solmization was introduced in Germany in 1959. Called *jale*, it gives a separate name to each rising or falling half tone of the chromatic scale. See also SHAPE-NOTE NOTATION; TONIC SOL-FA.

solo *pl.* **solos, soli 1** A musical work for one voice or one instrument, with

or without accompaniment. **2** An important passage for one voice or one instrument, occurring within a composition for vocal or instrumental ensemble (cantata, opera, symphony). **3** In a solo concerto, the soloist's part, as opposed to that of the orchestra (see CONCERTO, def. 2). **4** In orchestral scores, a direction to make a particular part (not necessarily the main part) stand out so that it can be clearly heard.

solo concerto See CONCERTO, def. 2.

soloist A performer who performs a single part, which is not duplicated by other instruments or voices. The term "soloistic" is used to describe an orchestral part that emphasizes the individual qualities of the instrument for which it is intended rather than its contribution to the total effect.

solo organ A manual keyboard of the organ that is provided with stops for solo use (alone, rather than together with other stops). It generally is provided only in quite large organs, with four or more manuals. The solo organ's pipes are enclosed, so that their volume can be varied by means of a pedal. (See also ORGAN.)

solo sonata See under SONATA.

solo sostenuto See under PIANO, def. 2.

son (sôn) *Spanish.* A Cuban song form originating in the island's Oriente province in the late nineteenth century, which relies heavily on characteristic West African improvised call-and-response lyrics and cyclical backing riffs. Early son sounds much like blues set to a *clave* rhythm, that is, a two-bar pattern with a three-two or two-three beat. After spreading to Havana, son generally was performed by two singers, accompanied by two guitars, claves, maracas, bongos, and either a thumb piano (see SANSA) or string bass. In the late 1920s a cornet or trumpet was added. This form spread to the United States, where it influenced not only popular music but composers like George Gershwin.

sonata (sô nä′ tä) *Italian.* **1** From the second half of the eighteenth century on, an important form of instrumental music for either a keyboard instrument (piano, organ, etc.) or for another instrument (violin, cello, oboe, flute, etc.), either unaccompanied or with piano accompaniment. The sonata consists of three sections, or movements, in contrasting tempo: fast–slow–fast. The first movement, usually marked "Allegro," is in so-called SONATA FORM, which prescribes a particular treatment of its themes. The second movement is slow (marked "Andante," "Adagio," "Lento," "Largo," etc.) and usually songlike in its melodies. The third movement ("Allegro" or "Presto") is frequently in the form of a RONDO. The first and third movements are in the same key, whereas the second is in a different key. There have been many departures from this general scheme. Some sonatas include an additional dancelike movement (minuet or scherzo) before the final fast movement. Sometimes the third movement is in the form of theme and variations (a melody with numerous variations on it). However, there always are several movements—usually three or four, rarely two or five—in contrasting tempo and style. Very similar to the sonata in this respect, and coming into existence about the same time (after 1750), are the symphony, concerto, and chamber music for anywhere from three to eight players (trio, quartet, quintet, etc.). The sonata is sometimes called chamber music for two players, the second player providing the piano accompaniment.

The form just described, sometimes called the **classic sonata**, developed gradually from the end of the baroque period (1750) through the classic period (1785–1820). Exactly how it evolved is not known. The use of three movements, fast–slow–fast, appears to be derived from the Italian overture style of Alessandro Scarlatti (see under OVERTURE), which was adopted by Bach for several of his concerti grossi and for six organ

sonatas, as well as by his son Karl Philipp Emanuel for his piano sonatas. The insertion of a minuet before the last movement originated with Stamitz of the Mannheim school and was adopted by Haydn and Mozart in their quartets and symphonies but not in their sonatas. The development of sonata form, used for the first (and sometimes also the last) movement of the classic sonata, is even more difficult to trace. Haydn wrote mainly piano sonatas (about sixty in all), although he produced some sonatas for stringed instruments. Mozart and Beethoven are considered the greatest sonata composers of the classic period, and perhaps of all time. Mozart wrote more than forty violin sonatas and numerous piano sonatas, including a number of duets (two players at one piano) as well as some for two pianos. The sonatas of Haydn and Mozart are usually in three movements. Beethoven, who generally used four movements but replaced the minuet with a scherzo (see SCHERZO, def. 1), wrote thirty-two piano sonatas, among them some of the finest works ever written for the piano. A number of them bear names as well as opus numbers; the best known of these are the *Pathétique Sonata* (op. 13), *Moonlight Sonata* (op. 27, no. 2), *Pastoral Sonata* (op. 28), *Waldstein Sonata* (op. 53), *Appassionata Sonata* (op. 57), *Farewell Sonata* (op. 81a), and *Hammerklavier Sonata* (op. 106). His violin and cello sonatas (among the best known are the *Kreutzer Sonata,* op. 47, and *Spring Sonata,* op. 24, both for violin) are also outstanding. Schubert wrote ten or so piano sonatas, still using the classic form but a more songlike style throughout. Mendelssohn wrote a Violin Sonata, two cello sonatas, and six organ sonatas, and César Franck wrote a particularly lovely Violin Sonata. Liszt and Chopin, the outstanding piano composers of their day, devoted themselves more to shorter forms, although each did write a few sonatas. Liszt in particular treated the

form quite loosely; his Sonata in B minor (1854) has only a single movement, although it is as long as a three- or four-movement work and employs contrasts of tempo and style. Some of the late romantic composers, notably Brahms, returned to the classic sonata form; his sonatas, for violin, piano, or clarinet, are among the best written between 1850 and 1900. Also notable from this period is Gabriel Fauré's first Violin Sonata. The late nineteenth-century organ composers (Reger, Widor) wrote sonatas for organ, and the two leading impressionists, Debussy and Ravel, both wrote piano sonatas.

Although the sonata was avoided for a time as too traditional a form, it was revived by the twentieth-century neoclassicists (see NEOCLASSICISM). Chief among the composers of sonatas in the first half of the century were Stravinsky, Prokofiev, Bartók, and Hindemith. Hindemith in particular revived interest in sonatas for instruments other than violin, cello, or piano; in addition to these, and a sonata for double bass, he wrote sonatas for flute, English horn, oboe, clarinet, bassoon, horn, trumpet, and trombone. Samuel Barber's Piano Sonata in E-flat minor is frequently performed. Berg, Ives (*Concord Sonata*), Carter, Sessions, Boulez, and Górecki wrote piano sonatas in various modern idioms, ranging from atonal (Berg's, though nominally in B minor) to serial (Sessions). Ives also wrote four violin sonatas, and there are cello sonatas by Shostakovitch, Fauré, Kodály, and Penderecki. 2 From the Renaissance (1450–1600) on, a term loosely used to distinguish an instrumental piece from a vocal composition, the latter being called *cantata* (from *cantare,* "to sing"). Until about 1600 such sonatas were virtually identical with canzonas (see CANZONA, def. 4), and the only feature they had in common with the classic sonata was the use of contrasting sections. —**solo sonata** Early in the seventeenth century, a name used occasionally for a piece written for one or more solo

instruments accompanied by a basso continuo (see CONTINUO). The name is misleading, since these sonatas had two voice-parts, the top line and the bass, and were usually performed by three instruments (the bass part was most often played by cello and harpsichord). —**trio sonata** An outgrowth of the seventeenth-century solo sonata that became one of the most important instrumental forms of the baroque (1600–1750). It had three voice-parts performed by four instruments (cello and harpsichord both played the bass; see TRIO SONATA). — **unaccompanied sonata** During the baroque, a composition for a single instrument. The most notable examples are Bach's unaccompanied sonatas for violin and cello. Although similar works were written for keyboard instruments, they were rarely called sonata before 1700, the only notable exceptions being keyboard sonatas by Johann Kuhnau published in the 1690s. —**sonata da camera** (sô nä' tä dä käm' er ä) *Italian:* "chamber sonata." A term originally identifying the place of performance ("chamber" or "court") of a piece, but in the course of the seventeenth century coming to mean a TRIO SONATA in the form of a kind of suite consisting of an introduction and three to four dances. The number of movements varied, and their order was not fixed. Such works were written by Corelli, Torelli, Veracini, and others. —**sonata da chiesa** (sô nä' tä dä kyä' zä) *Italian:* "church sonata." A term originally identifying the place of performance of a piece ("church") but in the course of the seventeenth century coming to mean a TRIO SONATA in four movements, the first and third slow, the second and fourth fast.

sonata-allegro form See under SONATA FORM.

sonata da camera See under SONATA.

sonata da chiesa See under SONATA.

sonata form A name for the structure commonly used, since about 1750, for the first movement of sonatas, symphonies, overtures, and chamber works (trios, quartets, quintets, and so on). For this reason it is also known as **first-movement form** and **sonata-allegro form** (the first movement of a sonata is nearly always marked "Allegro"). However, the same structure has been used for the final movement of sonatas, and occasionally even for the slow (second) movement. In any case, it should not be confused with the overall form of the classic sonata, which consists (usually) of three or four movements; see SONATA, def. 1.

A movement or section in sonata form consists of three subsections, called **exposition, development,** and **recapitulation.** In addition, there may be an introduction preceding the exposition, and a coda (end) following the recapitulation. The exposition presents two different, contrasting themes, linked by a series of modulations (key changes) called the **bridge** or *transition.* The music moves from theme 1, in the tonic (main key of the composition), to theme 2, in the dominant (or, if the main key is a minor key, in the relative key); following theme 2 there may be a brief closing theme. For the first century or so of the classic sonata's existence (1760–1860), the exposition was generally repeated (performed twice in succession). The development consists of an expansion of any or all of the themes presented in the exposition. Whereas the exposition presents the themes in a fairly direct way, the development often pulls them to pieces, using fragments of melody in various combinations, rapid changes in harmony, contrapuntal treatment, and any other device the composer chooses. Somehow, however, there must be a return to the tonic key, required for the recapitulation. The recapitulation, in the tonic key, repeats the themes of the exposition in a slightly modified way but in the same order, first theme 1 and then theme 2. Theme 2, however, which will end the recapitulation, must now appear in the tonic key; therefore the

bridge material (making the key change from tonic to dominant in the exposition) is eliminated or greatly shortened. At the end of the recapitulation there may be a coda, ranging from a concluding phrase of a few measures to what may virtually amount to another development section.

Over the years composers have used this general framework with varying degrees of freedom, and there have been exceptions to just about every rule of the form. Nevertheless, sonata form has proved flexible enough to survive individual modifications, and twentieth-century composers such as Stravinsky, Hindemith, Bloch, and Bartók, while making their own contributions, still managed to use sonata form so that it remained recognizable as such.

Sonata form grew out of the rounded binary form used for the dance movements of the baroque suite (see BINARY FORM). The principal difference between the two is the development section, which grew from a simple modulation back to the tonic key into an area of vast possibilities limited only by the composer's imagination.

sonata-rondo form A form that expands a RONDO by using elements of SONATA FORM, adding episodes and following a conventional pattern of key changes. It was employed by the classical composers in the rondo finale of sonatas and symphonies, for example, by Beethoven in the finale of his Symphony no. 8.

sonata cyclique (sô nAt′ sē klēk′) *French.* See under FRANCK, CÉSAR.

sonatina (sô nä tē′nä) *Italian:* "little sonata." A short SONATA (def.1), with fewer and/or shorter movements than the ordinary sonata, and usually (but not always) technically easier to perform. The keyboard sonatinas of Clementi and Kuhlau are easy enough to be used by students. From the late nineteenth century on, however, some very difficult sonatinas have been written by composers who considered the classical sonata too traditional a form for their purposes and preferred the shorter sonatina; among these are sonatinas by Ravel, Busoni, and Milhaud.

Sondheim (sond′hīm), **Stephen**, 1930– . An American composer and lyricist known primarily for his musical comedies. His first great Broadway success was *A Funny Thing Happened on the Way to the Forum* (1962). It was followed by such works as *Company* (1970), *Follies* (1971), *A Little Night Music* (1973), *Pacific Overtures* (1976), *Sweeney Todd* (1979), *Sunday in the Park with George* (1984), *Into the Woods* (1987), *Assassins* (1991), and *Passion* (1994). Sondheim's works are especially notable for his ability to let the rhythm of the words shape the musical phrasing. His own lyrics abound with unexpected puns and rhymes. Schooled in classical and contemporary music by Milton Babbitt, among others, he used dissonance more freely than most Broadway composers. He also used motifs to tie together themes and characters. Further, he treated more serious subjects than the typical musical, for example, the problems of modern marriage (*Company*), injustice and revenge (*Sweeney Todd*), Western imperialism (*Pacific Overtures*), the nature of art (*Sunday in the Park with George,* concerned with the French painter Georges Seurat), which led some authorities to consider his works more "music theater" than "musical comedy." Sondheim also wrote the lyrics for several musical comedies, most notably Leonard Bernstein's *West Side Story* and Richard Rodgers's *Do I Hear a Waltz?*

song 1 In common usage, any piece of vocal music. **2** A term used by scholars for a short musical composition for solo voice, with or without instrumental accompaniment. (Vocal music for more than one singer is termed either *choral music,* with several singers for each voice-part, or *chamber music,* with one singer per

voice-part; the latter is named, according to the number of parts involved, duet, trio, quartet, etc.) The text of a song is nearly always a poem. Songs can be divided into two categories, folk songs (see FOLK MUSIC) and art songs (see ART SONG). Important types of art song are the ARIA, RECITATIVE, and LIED (def. 1).

Songs have very likely been sung since the dawn of civilization. One of the few fragments of music surviving from ancient Greece is a drinking song thought to have been composed by Seikilos. The oldest Western (European) songs known come from the tenth century and have Latin texts. During the later Middle Ages (1000–1400) minstrels in various European countries—troubadours, trouvères, bards, minnesingers, Meistersinger—kept alive the art of secular (nonreligious) song. There also were religious songs, such as the Italian LAUDA and Spanish CANTIGA. In the fourteenth century, composers turned to songs with a written accompaniment (although the minstrels probably also accompanied themselves, the music they played was not written down). During the course of the Renaissance (1400–1600) vocal music with several voice-parts (vocal chamber music, as defined above) became increasingly important. However, in some cases all but one voice-part may well have been performed by instruments; such music thus can be described as a song with instrumental accompaniment. In addition, true solo songs continued to be written, among them the English AYRE and the French AIR DE COUR, as well as other songs with lute (or vihuela) accompaniment. The baroque period (1600–1750) saw the rise of recitative and aria. Simpler types of song continued to be written mainly in France (the CHANSON) and Germany, but the next great period of song composition did not come until the nineteenth century, with the type of art song known as LIED (def. 1). The nineteenth-century nationalist composers often found songs a highly suitable vehicle for the expression of folk and national traditions; particularly notable in this area were Grieg, Mussorgsky, and Borodin. Since the late nineteenth century, French and British composers in particular have written outstanding solo songs, among them Debussy, Fauré, Poulenc, and Milhaud in France, and Vaughan Williams and Britten in Great Britain. Some twentieth-century composers have treated the song in highly original ways. Among them are Ives, Berg, Webern (his first twelve-tone works were songs; op. 17, 1924), Schoenberg (his *Pierrot lunaire* calls for a kind of musical declamation called *Sprechstimme*), Hindemith (the song cycle, *Das Marienleben;* also madrigals), and Luciano Berio (*Circles,* for voice and instruments; *Thema* [*Omaggio a Joyce*], combining live and taped sounds).

song cycle A group of poems, by either a single poet or several poets, that are set to music. The texts of the poems are usually closely related. The songs are solo art songs and are meant to be performed together, but in practice singers frequently select single songs for a performance. The text generally has an overall theme (idea), in some cases fairly specific (as in Schubert's *Die schöne Müllerin,* dealing with aspects of country life centered about a mill), and in others very general (Schumann's *Dichterliebe,* a set of love poems). Although sets of songs were composed as early as the sixteenth century, the songs then being mostly madrigals (see MADRIGAL, def. 2), the song cycle is associated largely with the nineteenth century. One of the earliest was Beethoven's *An die ferne Geliebte* (1816), and among the finest are those of Schubert and Schumann, the great masters of the LIED. During the twentieth century composers continued to write art songs, and occasionally song cycles. The accompanying chart lists some notable song cycles. See also ART SONG.

song form Another name for TERNARY FORM, which is actually employed more in instrumental music than in songs.

NOTABLE SONG CYCLES

Title	Composer	Date	Poet
Ancient Voices of Children	George Crumb	1974	Federico García Lorca
An die ferne Geliebte ("To the Distant Beloved")	Ludwig van Beethoven	1816	Alois Jeitteles
Bonne Chanson, La ("The Good Song")	Gabriel Fauré	1892–93	Paul Verlaine
Canto a Sevilla ("Song of Seville")	J. Turina	1927	M. San Roman
Chansons de Bilitis ("Songs of Bilitis")	Claude Debussy	1897	Pierre Louÿs
Dichterliebe ("Poet's Love")	Robert Schumann	1840	Heinrich Heine
Elegiac Songs	John Harbison	1974	Emily Dickinson
Frauenliebe und Leben ("Woman's Love and Life")	Robert Schumann	1840	Adelbert von Chamisso
Hermit Songs	Samuel Barber	1953	Irish poets (8th–13th centuries)
Holy Sonnets of John Donne	Benjamin Britten	1945	John Donne
Honey and Rue	André Previn	1993	Toni Morrison
Kindertotenlieder ("Songs on the Death of Children")	Gustav Mahler	1902	Friedrich Rückert
Lieder eines fahrendes Gesellen ("Songs of a Wayfarer")	Gustav Mahler	1884	composer
Liederkreis, op. 24 ("Song Cycle")	Robert Schumann	1840	Heinrich Heine
Liederkreis, op. 39 ("Song Cycle")	Robert Schumann	1840	Josef von Eichendorff
Lied von der Erde, Das ("The Song of the Earth")	Gustav Mahler	1911	Hans Bethge
Marienleben, Das ("Life of Mary")	Paul Hindemith	1922–23; rev. 1948	Rainer Maria Rilke
Nantucket Songs, The	Ned Rorem	1978–79	Numerous poets
On Wenlock Edge	Ralph Vaughan Williams	1909	A. E. Housman
Pierrot lunaire ("Pierrot by Moonlight")	Arnold Schoenberg	1912	Albert Giraud
Romanzen aus L. Tieck's Magelone ("Magelone Romances")	Johannes Brahms	1861–68	Ludwig Tieck
Schöne Müllerin, Die ("The Fair Maid of the Mill")	Franz Schubert	1823	Wilhelm Müller
Shéhérazade	Maurice Ravel	1903	Tristan Klingsor
Songs and Dances of Death	Modest Mussorgsky	1875–77	Prince Golenishchev-Kutusov
Vier ernste Gesänge ("Four Serious Songs")	Johannes Brahms	1896	the Bible
Winterreise ("Winter Journey")	Franz Schubert	1827	Wilhelm Müller

408

sonic (so'nik) **environment** Also, *ambient music, environmental music, site composition, sound installation sculpture.* A form of ELECTRONIC MUSIC that is installed in a particular location and performed continuously. It tends to be characterized by a great deal of repetition and very gradual changes, producing a hypnotic effect. Generally the composer sets up a patch—a combination of circuits or modules (see PATCHING)—and a synthesizer then simply plays itself. Some sonic environments imitate natural sounds, such as the wind's howling or the surf's pounding, whereas others are purely abstract. Occasionally melodic elements are present, in the form of wind chimes or a similar means. One sonic environment, *Times Square,* was created in a New York City subway ventilation chamber under Broadway in the late 1970s by the composer Max Neuhaus and stayed in place, still sounding, for over a decade. Like most sonic environments, it is not meant to be attentively listened to for a particular length of time but rather is heard as a kind of acoustic background. Neuhaus's work is, in effect, a selective amplification of sounds from the environment—the noise of the subway, the traffic above it, and so on. It therefore is constantly changing, and Neuhaus did not believe it could or should be recorded. Another kind of sonic environment involves sound that is modified by the audience or environmental conditions. Sensors detect such changing factors as body heat or wind speed, which then can alter the electronic sounds in preprogrammed ways. The composer Liz Phillips installed one such sonic environment at a music festival, where the response of passersby actively affected the composition. In contrast to such works, which involve constant change, another kind of sonic environment can be created from sounds that are taped or piped in live to a concert hall or other space from a distant location. For example, Maryanne Amacher produced tapes

of pier noises and ship's horns from the Hudson River. Similarly, the English composer Brian Eno's *Music for Airports* can be purchased as a recording and played back anywhere, although this composition, which he called *ambient music,* was actually installed for a time in several airports. Among the first to experiment with sonic environments was the minimalist composer LaMonte Young, who set up an environment of constant periodic sound wave forms and played it in his home almost continuously, for several weeks or months at a time, for more than three years. Subsequently he set up similar works for shorter periods at universities, art galleries, and music festivals, creating what he called "dream houses." This music consisted of continuous live electronic sound generated by sine-wave oscillators and augmented by additional frequencies performed at prescribed time intervals by Young's performing ensemble. (See also MINIMALISM.)

sons bouchés (sôn boo shā') *French.* In music for the horn or other brasses, stopped notes (see STOPPING, def. 2).

sons étouffés (sôn"zā too fā') *French.* In music for the harp, stopped notes (see STOPPING, def. 1).

sopra (sôp'rä) *Italian:* "above." A word used in keyboard music to direct the player to place one hand over the other (cross hands) for a particular passage. The term *mano sinistra sopra* (or *m.s. sopra*) means cross the left hand over the right; *mano dextra sopra (m.d. sopra)* means cross right hand over left. —**come sopra** (kô'me sôp'rä). A term meaning "as above," a direction to perform a note or passage as before.

sopranino (sô" prä nē' nô) *Italian:* "little soprano." A term used for an instrument that is smaller (and thus higher-pitched) than the soprano size, such as the sopranino recorder.

soprano (sô prä'nô) *Italian.* 1 The highest range of female voice. Its

range is roughly from middle C to high C, although a trained voice can exceed this by a number of notes.

Operatic sopranos are sometimes classified according to their tone quality: **dramatic soprano**, a powerful, expressive voice; **lyric soprano**, a light, sweet voice; **coloratura soprano**, very agile and with a high range, suitable for COLORATURA parts. (See also SPINTO.) In four-part choral music the soprano is the highest part. **2** A male voice having the same range as the female soprano. It occurs in young boys whose voices have not yet changed, the so-called **boy soprano**. It occasionally can be duplicated by a grown man singing FALSETTO. **3** Among instruments that are built in various sizes, an instrument that has about the same range as the soprano voice, such as the soprano saxophone. (See also SOPRANINO.)

sordino (sôr dē′nô) *pl.* **sordini** (sôr dē′nē) *Italian:* "mute" or "damper." A word used in the directions *con sordino (sordini),* directing the player of a stringed or wind instrument to use the mute (mutes), and *senza sordino (sordini),* directing one to stop using the mute (mutes); see also MUTE. Occasionally the terms refer to the una corda (soft) pedal of the piano (see under PIANO, def. 2). Abbreviated *sord.*

sospirando (sôs pē rän′dô) *Italian.* A direction to perform in a sighing, plaintive manner.

sostenuto (sôs te nōō′ tô) *Italian:* "sustained." A direction to hold (sustain) each note for its full time value. In practice this usually requires a slightly slower tempo as well.

sostenuto pedal The center pedal of the piano, which prolongs the sound of the notes that were played just before this pedal was depressed. See PIANO, def. 2.

sotto (sô′tô) *Italian:* "under." A word used in keyboard music to direct the

player to place one hand under the other (cross hands) for certain passages: *mano sinistra sotto (m.s. sotto)* means cross the left hand under the right; *mano destra sotto (m.d. sotto)* means cross the right hand under the left hand.

sotto voce (sô′tô vô′che) *Italian.* A direction to perform softly, in an undertone.

soukous (sōō′kōōs) Originally, a Congolese dance popular in the late 1960s. With a rumba-like beat, it features three-chord vamps and arpeggiated guitar lines, accompanying vocalists who sing in French, Lingala, and/or English. Today it is used as a generic name for any modern Zairean dance music.

soul A type of vocal music popular in the United States in the 1960s. Derived from RHYTHM AND BLUES and GOSPEL MUSIC, it is sung in a wailing style but with marked rhythm, sometimes accented by "stomping." The lyrics, in down-to-earth language and slang, deal with various problems—love, death, city life—but more the problems of the individual, especially of the black and the poor, than social problems. Well-known soul singers include Ray Charles and Aretha Franklin. See also ROCK.

sound A tone produced by the regular vibrations of an elastic material. The vibrations, or back-and-forth movements, set up vibrations in the air (sound waves), which in turn make the human eardrum (a thin, elastic membrane inside the ear) vibrate and cause the tone to be heard. In musical instruments, sound is produced in one of four principal ways: (1) a tightly stretched string or wire is set in motion by a bow (violin), by plucking (guitar, harp, harpsichord), or by hammers (dulcimer, piano); (2) a column of air inside a tube or pipe is set in motion, either by one or more reeds activated by air pressure (organ, oboe, clarinet) or by the lips (brass instruments); (3) a

tightly stretched membrane or skin is set in motion by a beater (drum) or by the vocal chords (voice); (4) a solid body is set in motion by striking, rubbing, or other contact (xylophone, triangle, bell). In some instruments, electric impulses create vibrations that correspond to those of musical tones (see ELECTRONIC INSTRUMENTS).

The difference between musical tones and noise depends on the nature of the vibration. A musical tone has a regular number of vibrations per second, called its **frequency.** Frequency is measured in cycles per second, or **Hertz,** each cycle representing one complete back-and-forth movement (NOISE has no regular number of vibrations per second). However, with the introduction of electronic music, the definition of what constitutes musical sounds has been greatly expanded.

Conventional musical tones differ from one another in five ways: pitch, intensity, duration, quality, and resonance. (For electronic music the essential characteristics of a sound are ATTACK, or beginning, its ENVELOPE, or continuation, and DECAY, or ending.) The **pitch** of a tone (how high or low it is) depends on its frequency, that is, the number of vibrations per second. The higher the frequency (the faster the vibrations), the higher is the tone's pitch. The frequencies produced by an instrument (its so-called **range**) depend on the size, weight, and tension of the vibrating substance and, in the case of a vibrating air column, the size, material, and shape of the body (pipe) enclosing it. Generally, a short, taut string or a short, narrow air column will produce a higher pitch than a longer, looser string or a longer, wider air column. The piccolo is shorter than the flute and has a higher range (produces higher pitches). But the clarinet is the same length as the flute and produces much lower tones. The reason is that the clarinet is stopped at one end, that is, the pipe is closed at one end (by the nature of the mouthpiece),

whereas the flute is open at both ends.

Since pitch depends on frequency, it follows that an **interval** (the difference in pitch between two tones) is determined by the difference between their frequencies. More than 2,500 years ago the Greek mathematician Pythagoras discovered some of the laws that govern the relationships of intervals. For example, the relationship of two tones exactly one octave apart is 2:1. The tone A above middle C, which is used to tune the instruments of the orchestra, has a frequency of 440 cycles per second (by international agreement); the A ex-/actly an octave above this tone has a frequency of 880 cycles per second. Similar mathematical relationships exist between other intervals, and it is on the basis of these that instruments are tuned (see TEMPERAMENT; also CONCERT PITCH; INTERVAL, def. 2).

The **intensity,** or loudness, of a musical tone depends on the energy of the vibrations, that is, how hard the tone-producing substance vibrates (or if one thinks of a vibration as a back-and-forth movement, how far backward and forward it moves from a rest position). Physicists call this distance the **amplitude.** The intensity of a sound gradually lessens from the first moment it is produced. A stretched rubber band makes the loudest sound when it is first plucked, for it then vibrates with the most energy. The tone then gradually becomes softer (the vibrations gradually become weaker) until it stops sounding (the vibrations stop completely).

The **duration** of a tone means simply how long it sounds. Some tones sound for only a fraction of a second, and others for as long as three or four minutes.

The same note played on different instruments has a different tone quality. Even though its pitch, intensity, and duration may be the same, it sounds different. The tone quality of instruments, generally called **tone color** or *timbre,* can be so distinctive

that a listener can instantly tell what instrument is being played. The differences in tone color are caused by the fact that most sounds are made up not of a single frequency but of many different frequencies. A violin string (or enclosed air column) vibrates not only along its whole length, but at the same time along halves, thirds, fourths, and many smaller divisions of its length. Each of these shorter lengths produces a tone of different pitch (and the shorter the length, the higher the pitch). The tone produced by the full-length string is called the **fundamental**, and it is the loudest of the pitches heard. The tones sounded at the same time by the shorter portions of the string are called **harmonics** or *overtones,* and each of them is related mathematically to the fundamental in a specific way (actually, the divisions of the string into two, three, four or more parts correspond to the intervals created by the fundamental and each of the harmonics). Noise, on the other hand, is a mixture of frequencies *not* related to one another in this way. Another name for the harmonics is *partials*. The fundamental is also known as the *first partial* or the *harmonic of lowest frequency,* and the overtones are known as *upper partials*. (This terminology is confusing, since the second partial is called the *first overtone* or *first harmonic,* the third partial is the *second overtone* or *second harmonic,* and so on). The fundamental and all the harmonics together are known as the HARMONIC SERIES.

The harmonics have much less intensity (amplitude) than the fundamental and therefore are heard much less distinctly. Nevertheless, it is they that account for the difference in tone quality among the various instruments. Each instrument produces a different combination of harmonics with different combinations of intensities among the harmonics. Thus, although the cello and French horn produce the same harmonics, they vary in relative loudness (intensity), and as a result

the tone of the two instruments is very different.

The **resonance**, or fullness, of a musical tone depends on the presence of another material that is made to vibrate with the original vibrations and reinforce them. In the violin the vibrating strings cause the belly to vibrate, reinforcing their tone. In wind instruments like the oboe, the vibrating air column causes itself to vibrate. Resonance is an important consideration for instrument makers; a fine violin, for example, must resonate with all of the fundamental tones and their harmonics, providing beautiful and consistent tone quality. (See also RESONATOR; SOUNDBOARD; SYMPATHETIC STRINGS.) Resonance and tone color are further affected by the place in which an instrument is heard. The same instrument may sound quite different in a small room, a large room, and a concert hall, and even in rooms of the same size (see ACOUSTICS).

soundboard 1 In stringed instruments, such as the piano, harpsichord, and zither, a thin board over which the strings are strung. When the strings are played, the soundboard vibrates sympathetically with them, reinforcing their sound. Soundboards are made of thin strips of wood or some other material, which are glued together and varnished. In worn or neglected instruments the soundboard may begin to crack or bend, causing defects in the tone. **2** The BELLY of the violin.

sound hole In stringed instruments such as the violin and guitar, small openings cut into part of the body of the instrument. Sound holes enable the belly, back, or another part of the body to vibrate freely when the strings are played, thus reinforcing their sound. Violins, violas, cellos, and double basses usually have a pair of sound holes in the belly, cut in the shape of an F (and therefore known as **F-holes**). Older bowed instruments, such as the viols, generally had **C-holes** (in the shape of a C), whereas guitars and lutes have a single large,

round hole in the middle of the table (top part), covered wth a decoration called a **rose.**

soundpost In violins, viols, and other stringed instruments with a boxlike (four-sided) body, a small wooden dowel placed between the belly (top) and the back. When the strings are played and the belly vibrates in sympathy with them, the soundpost transmits the belly's vibrations to the back, further reinforcing the sound. (For a cross section of the violin that shows the soundpost, see under BRIDGE, def. 1.)

sound sculpture See SONIC ENVIRONMENT.

sourdine (soo̅r dēn') *pl.* **sourdines,** *French:* "mute." A word used in the directions *avec les sourdines,* directing the player of a stringed or wind instrument to use mutes, and *sans les sourdines,* directing him or her to stop using them. (See also MUTE.)

Sousa (soo̅'zä), **John Philip,** 1854–1932. An American bandmaster and composer who is remembered for his stirring marches, as well as for his world-famous bands. First trained as a violinist, Sousa became leader of the United States Marine Band in 1880, a post he held for twelve years. He left to found his own band, which toured the world. Sousa's marches and his arrangements for band were so outstanding that he is sometimes called "the March King." His most famous march is "Stars and Stripes Forever." He also wrote "El Capitán," "The Washington Post," "Semper Fidelis," and "Hands Across the Sea." His other compositions, which include numerous comic operas and a symphonic poem, are rarely performed.

sousaphone (soo̅' zə fōn"). A large helicon—that is, a large bass tuba in circular form, held so that it encircles the player's body (see HELICON, def. 1)—that was built and named for the band of John Philip Sousa, and in 1908 was officially adopted by all United States military bands. Origi-

nally, it had a very large bell, about two feet in diameter, that was pointed upward. Today, however, the bell, still very large, is made to point forward. Two sizes are made, a bass pitched in E-flat and a double bass (contrabass) pitched in B-flat.

spasshaft (s̲h̲päs'häft) *German.* A direction to perform in a lively, playful manner.

spatial music The disposition of performers and/or loudspeakers in different parts of an auditorium or hall in order to obtain particular effects. While this idea is far from new—physically dividing choirs and instruments was a favorite technique of the sixteenth-century Venetian school—it became of particular interest in the twentieth century. Among the composers frequently associated with spatial effects are Henry Brant, Elliott Carter, and Karlheinz Stockhausen.

speaker key In wind instruments with reeds, especially the clarinet and oboe, a key that opens a hole in the body of the instrument in such a way that it becomes easy to obtain harmonics by overblowing. Most oboes have two such keys, one used to produce the note an octave above the note sounded ordinarily (that is, the first harmonic instead of the note itself) and the other to produce a tone one twelfth higher (the second har-

monic, an octave plus a fifth); the former is also called **octave key**. Clarinets usually have only one speaker key, used to produce the twelfth. (See also OVERBLOWING.)

speech song See SPRECHSTIMME; also PARLANDO, def. 1; RECITATIVE.

speed metal See under ROCK.

spianato (spyä nä'tô) *Italian.* A direction to perform in a smooth, even manner.

spiccato (spē kä' tô) *Italian.* A direction to players of violins and other bowed stringed instruments to play a light STACCATO, executed at a point between the frog and midpoint of the bow, with slow to moderate speed.

spinet (spi'nət). **1** A small harpsichord, usually with a single keyboard and a single set of strings, which are set so that they are diagonal to the keyboard. Spinets were used from the sixteenth through eighteenth centuries. In England the spinet was known as a "virginal" until about 1660, as were other kinds of small harpsichord. After that time, a distinction was made, the name "spinet" being confined to a small harpsichord with one keyboard, transverse (diagonal) strings, and any shape except an

oblong (rectangular) one. In fact, spinets were made in a large variety of shapes, some five-sided, others six-

sided, and still others triangular; in Germany the name "spinet" was also used for the oblong instrument.

The spinet works like a harpsichord, that is, striking the keys makes small, hooklike devices called jacks pluck the strings. However, like the virginal and unlike the harpsichord, the spinet has only one string per key. Also, whereas the virginal's strings run parallel to the keyboard, the spinet's run at an angle, which permits the use of longer bass strings; this makes for a fuller (less hollow) tone than the virginal's. Most spinets had a range of about four and one-half octaves, from low C to high F. (See also HARPSICHORD; VIRGINAL.)

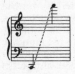

2 A small upright piano. The smallest size of piano made today, its strings are perpendicular to the keyboard, as in other upright pianos. However, its strings are shorter and most of the key mechanism is beneath the keys instead of above them, permitting a smaller case. The shorter strings and less direct key action combine to give the spinet a thinner tone than that of larger uprights.

spinto (spēn'tô) *Italian:* "pushed." Also, *lirico spinto* (lē'rē cô spēn'tô). A term describing a tenor or soprano voice that is essentially lyrical but has a fuller, more powerful quality as well. Some authorities describe it as midway between a lyric and dramatic soprano (see also SOPRANO, def. 1).

spirito, con See SPIRITOSO.

spiritoso (spē rē tô'sô) *Italian.* Also, *con spirito* (kôn spē'rē tô). A direction to perform in a lively, spirited manner.

spiritual A type of religious song developed by African-Americans. It

usually consists of a simple melody, often based on a pentatonic (five-tone) scale. Its rhythms, on the other hand, tend to be complex and nearly always feature syncopation (accents on unexpected beats). Originally it was sung in unison, often in CALL AND RESPONSE form. Exactly how spirituals originated is not known, since they are basically a form of folk music. The gospel hymns of traveling white evangelists (preachers) had some influence; in fact, some spirituals most likely originated as gospel hymns. The African musical traditions brought to America by slaves also played an important part, especially in the rhythms. African music often features several rhythms at the same time, and much of it is based on five-tone scales.

Spirituals, at first known only in the southern United States, became famous throughout the country in the 1870s when groups of students from black colleges made concert tours in order to raise funds. Their programs consisted mainly of spirituals and, as a result, the secular (nonreligious) songs of their people—work songs, blues, and other kinds—were long neglected. The most successful touring group were the Jubilee Singers of a school that later became Fisk University, in Nashville, Tennessee.

Spirituals have played an important role in American music. They are still widely performed by soloists and by choral groups, and they influenced such white composers as Stephen Foster, George Gershwin, and Virgil Thomson, and black composers as diverse as William Grant Still and Julia Perry. Their influence appears in many kinds of popular music as well—blues, jazz, rhythm and blues, soul music. Among the best-known spirituals are "Steal Away," "Now Let Me Fly," "Nobody Know the Trouble I Seen," "Joshua Fit the Battle of Jericho," "Swing Low, Sweet Chariot," "Oh, Won't You Sit Down," "Deep River," "Sometimes I Feel Like a Motherless Child," and "Go Down, Moses." Some of the finest arrangements of spirituals

were made by Harry Burleigh (1866–1949), Florence Price (1888–1953), and Margaret Bonds (1913–1972).

Sprechgesang See under SPRECHSTIMME.

Sprechstimme (s̲hpreᴋH' s̲htim" ə) *German*: "speaking voice." A kind of musical recitation in which the pitches (notes) are approximated rather than definitely sung. In effect, the voice produces a note but does not hold it, instead sliding on to the next. Usually the pitches are indicated in some special way, such as notes with a cross through the stem. Rhythm, dynamics, and phrasing are also indicated in the score. The first composer to exploit Sprechstimme was Schoenberg, first in a part of his *Gurrelieder* and then in all of the song cycle *Pierrot lunaire*. It was also used by Schoenberg's disciple, Alban Berg, in the opera *Wozzeck*. Although there are other, similar kinds of speechlike singing, none is exactly like Sprechstimme. The accompanied RECITATIVE of operas is freer than Sprechstimme, the exact rhythm and phrasing rarely being specified in the score. In Sprechstimme, the voice glides along, but according to patterns specified by the composer. Sometimes the gliding results in a kind of wail. A variety of Sprechstimme was used by Engelbert Humperdinck in the first version of his opera, *Die Königskinder* ("The King's Children," 1897), but in his revision of 1910 the composer replaced it with ordinary song. Another kind of speechlike song is PARLANDO (def. 1), which also is freer than Sprechstimme.

In German, *Sprechgesang* (s̲hpreᴋH' ge zänk") refers to the manner of performance, and *Sprechstimme* to the voice performing it.

square piano A piano with a square shape, like that of a clavichord. It was built in the eighteenth century, first in Germany, and later, in an improved version, in England. (See also under PIANO, def. 2.)

sruti (sro͞o' dē) *Sanskrit*. In Indian music, the smallest interval (difference between two pitches) that can

be detected by the ear. In contrast to Western (European and American) music, where the octave is divided into twelve half tones, in India the octave is divided into twenty-two or more sruti. A number of sruti combined make up a musical tone, and certain such tones are selected to make up a RAGA, or MELODY TYPE. —s'ruti An Indian wind instrument that, like the Western oboe, has a conical bore (cone-shaped inside) and double reed. It is used exclusively to provide a steady drone accompaniment (see DRONE, def. 3).

S S A Abbreviation for soprano–soprano–alto, used in choral music for women's voices.

sta, come (kô'me stä) *Italian*: "as it stands." A direction to play a passage exactly as written.

Stabat Mater (stä'bät mä'ter) *Latin.* A Latin poem, written sometime during the thirteenth century, that has often been set to music. It was set in the form known as sequence, with pairs of lines and the same music for each line of a pair (see SEQUENCE). In the sixteenth century the Stabat Mater was outlawed by the Council of Trent, along with most other polyphonic settings (with more than one voice-part, as opposed to the one-part Gregorian chant), but in 1727 it was readmitted to the official liturgy, and today it is included in the Proper of the Mass for the Feast of the Seven Sorrows of the Blessed Virgin Mary.

The Stabat Mater, which tells about Mary's vigil by the cross on which Jesus died, has been set to music for hundreds of years. Among the more notable settings are those of Josquin des Prez (fifteenth century), Palestrina (sixteenth century), Pergolesi and Haydn (eighteenth century), Schubert, Rossini, and Verdi (nineteenth century), Poulenc (1951), and Penderecki (1962).

stacc. An abbreviation for STACCATO.

staccato (stä kä' tô) *Italian.* A direction to perform a note quickly, lightly, and separated from the notes before and after it. Staccato performance in practice reduces the time value of a note by one-half or more; thus a quarter note, performed staccato, lasts only as long as an eighth note, the rest of its value being replaced by silence. In playing a bowed stringed instrument, such as the violin, slightly different kinds of detached notes can be produced by varying the bowing technique; among them are MARTELÉ; PIQUÉ; SPICCATO; SAUTILLÉ.

Staccato normally is indicated by a dot over or under the note to be so performed; sometimes the abbreviation *stacc.* is used. A series of dots combined with a slur indicates a kind of half-staccato called PORTATO. A short dash usually indicates a more pronounced staccato, slightly accented. Composers of the eighteenth century indicated staccato with a wedge (pointed downward) or a dot. Some also used a straight vertical sign, but its meaning is not clearly understood.

staff *pl.* **staves** Also, *stave.* A set of horizontal lines used to indicate the pitch of notes. Both the lines and the spaces between them indicate specific pitches. Since the thirteenth century most music has been written on a five-line staff, although Gregorian chant is still written on the four-line staff devised by Guido d'Arezzo in the eleventh century. A CLEF at the beginning indicates the pitch of one of the lines, from which the pitches of the others are inferred. Ledger lines are used for pitches higher or lower than the top and bottom lines of the staff, along with octave symbols to indicate a higher or lower octave (see OTTAVA, defs. 1, 2). Music for instruments in which the player's hands each play different pitches, such as pianos, harps, and celestas, is usually written on two staves joined by a brace. (See the musical example accompanying STRETTO.) Organ music is commonly written on three staves, the bottom one for the pedal and the top two for

the manuals (only two are used if there is no pedal). The music for percussion instruments of indefinite pitch, such as cymbals or drums, is usually written on a single line (one-line staff), showing only the duration (time value) of the notes.

Although lines were used to represent pitch as far back as the ninth century, Guido was the first to use a staff of the present-day type; his had three lines, and later he added a fourth. During the Renaissance (1450–1600), keyboard music was sometimes written on staves of six or more lines, whereas lute and vihuela music was written on what looks like a staff but is actually a TABLATURE, which represents not the pitches but the instrument's strings. In the eighteenth century the modern system of writing all the music of an orchestral work on a series of staves was devised (see *full score,* under SCORE). In the twentieth century, as composers began to experiment with new methods of composition (electronic music, aleatory music, musique concrète), numerous new methods of notation were devised, many of which dispensed with staves (see also GRAPHIC NOTATION).

Stamitz (s̲htä′mits), **Johann Wenzel Anton** (yō′hän ven′tsəl än′tōn), 1717–1757. A Bohemian-born German composer and violinist who, as musical director of the Mannheim orchestra, helped establish the modern symphony orchestra. Further, his compositions, among them more than seventy symphonies, established some of the basic features of the classical symphony. Stamitz was also an influential teacher. His pupils included his sons, Karl and Johann Anton (owing to the similar names, the latter is often confused with his father), Johann Christian Bach (Bach's youngest son), Luigi Boccherini, and Karl Ditters von Dittersdorf. Among Stamitz's innovations was using marked dynamic contrasts (of loud and soft), contrasting themes within a movement (see SONATA FORM),

the elimination of the baroque continuo accompaniment indicated by figured bass (see CONTINUO; FIGURED BASS), and increasing use of wind instruments (he wrote the first symphony with parts for clarinet). See also MANNHEIM SCHOOL.

Ständchen (s̲htent′ᴋʜən). The German term for serenade (see SERENADE, def. 1).

stanza See VERSE, def. 1.

stark (s̲htärk) *German:* "strong" or "strongly." A direction to perform loudly, forcefully. It is also used together with other terms, as in *stark betont* ("strongly emphasized"), and *stark bewegt* ("very [strongly] lively").

stärker (s̲hter′kər) *German:* "stronger" or "more strongly." A direction to perform louder, more forcefully.

stave Another word for STAFF.

steel band An instrumental ensemble made up of steel drums, which are fashioned from oil drums. The bottom lids are dented and otherwise bent so as to produce different pitches, the pitch sounded depending on the exact point where the drum is struck. For rhythm the bands use maracas, scrapers, and the like. Originating in the islands of the Caribbean, especially Trinidad, steel bands provide the rhythmic accompaniment for calypso and other popular music. Steel drums are used occasionally in American jazz and dance bands.

steel drum See under STEEL BAND.

steel guitar 1 Another name for the electric guitar, which normally has metal strings in place of the classic guitar's gut strings. (See under ELECTRONIC INSTRUMENTS.) **2** Another name for HAWAIIAN GUITAR.

Steg, am (äm s̲htäk) *German.* In music for violins and other bowed instruments, a direction to bow over the bridge of the instrument, producing a nasal, brittle tone.

stem The short vertical line that is part of the written half note, quarter

note, eighth note, etc. Only the whole note lacks a stem. Stems may point either up or down; ordinarily notes on the upper half of the staff have downward stems, and those on the lower half have upward stems, a practice whose only purpose is to save space between staves. However, when music for two instruments or voices is written on one staff (for example, the parts for first horn and second horn, or for alto and soprano), the notes with upward stems are to be performed by the upper voice and those with downward stems by the lower; also, a note given two stems, one upward and the other downward, is to be performed by both instruments (or voices).

step The interval (distance) between two adjacent notes of a scale. In Western (European and American) music, scales are based on half steps and whole steps. The term "step" is used mainly for students, to help convey the idea of a scale as a ladder of tones. American scholars usually prefer the term *tone*, speaking of *half tones* and *whole tones*.

stereo See STEREOPHONIC.

stereophonic (ster"ē ə fon'ik). Also, *stereo*. A term describing a method that uses two or more microphones to record sound and an equal number of speakers to reproduce the sound so recorded. The recorded sound from the separate channels blends, recreating the breadth and depth of the original. This method was perfected in the 1950s and was widely adopted soon afterward. By the late 1960s, relatively few recordings of music were made in any other way. In fact, many old **monophonic** (one microphone, one speaker) recordings and tapes were being converted (through re-recording) to stereophonic, a practice of questionable value since what a recording might gain in sounding more "live" was offset by the distortion of the original performance. In the early 1970s **quadrophonic** recording, a sound system involving

four channels, was introduced. The music is played back through two stereo amplifiers into four speakers, ideally placed in the four corners of a room so that the listener is surrounded by sound. See also TAPE RECORDING.

stessa (ste'sä) *Italian:* "the same." Also, *stesso* (ste'sô). A direction that the performer is to continue as before. See also ISTESSO TEMPO.

stesso See STESSA.

stile rappresentativo (stē'le rä"pre zen tä tē' vô) *Italian:* "representational style." A term used to describe the kind of RECITATIVE found in early Italian opera (see under CACCINI, GIULIO), as well as in oratorios and cantatas from about 1590 to 1650. The term has also been used for instrumental music that resembles vocal recitative in having the free rhythm and irregular phrasing that are typical of spoken language.

Still, William Grant, 1895–1978. An American composer and conductor who wrote the first symphony by an African-American to be played by a major orchestra (*Afro-American Symphony*, 1930) and the first opera by an African-American to be produced by a major company (*Troubled Island*, 1934, by New York's City Center), which, however, used singers in blackface. Early in his career Still worked as an arranger for W. C. HANDY, and he also studied with George Chadwick and Edgar Varèse. Supporting himself with stints in the pit of theater orchestras and making arrangements for radio shows and popular bands (including those of Paul Whiteman and Artie Shaw), Still nevertheless managed to compose a considerable amount of serious music. His output includes five symphonies and numerous other orchestral compositions, ballets and other music for the stage, seven operas, choral works, and numerous works specifically for young people. All of his works are traditionally tonal and most reflect his African-American heritage, especially in the use of spirituals.

Stimme (s̲h̲tim'ə) *pl.* **Stimmen** (s̲h̲tim'ən). The German term for voice (see VOICE, defs. 1, 2).

Stimmung (s̲h̲tim'o͞onk) *German.* 1 Mood, used in such musical directions as *heitere Stimmung* ("happy mood") and *traurige Stimmung* ("sad mood"). 2 Tuning.

stochastic (sto̅kas'tik) **music** See under XENAKIS, IANNIS.

Stockhausen (s̲h̲tok'hou zən), **Karlheinz** (kärl' hīnts"), 1928– . A German composer who became one of the pioneers of electronic music. After World War II Stockhausen studied with the Swiss composer Frank Martin and later with Olivier Messiaen in Paris. After a period of experimentation with serial techniques, musique concrète, and aleatory music, he became involved with a radio studio at Cologne, Germany, that became a leading center for ELECTRONIC MUSIC. Up to the mid-1960s Stockhausen's works often made use of serial techniques applied not just to pitches but to all aspects of the material—duration (time values of sounds), degrees of density, the disposition of sounds in space, and even the extent to which the composer dictates performance (see SERIAL MUSIC). Among notable works from this period are *Zeitmasse* ("Measures of Time") for oboe, flute, English horn, clarinet, and bassoon, in which the tempo and rhythm for each instrument's part are governed by the instrument's capabilities; *Klavierstücke XI* ("Piano Pieces XI"), in which the pianist may choose how to play the nineteen fragments of which the piece consists; *Gruppen* ("Groups") for three orchestras placed in different parts of a hall, each with its own conductor; *Carré* ("Square") for four choruses and four instrumental groups; *Momente* ("Moments") for soprano, four choruses, keyboard, percussion, and brass instruments, which consists of many kinds of sound—banging, singing, speaking, babbling, whispering, and all kinds of instrumental sound—arranged into a series of "moments," each with a given duration, but which may be performed in any order; and *Mikrophonie 1,* his first electronic piece, for a single tam-tam (gong) that is played on by six performers in all kinds of ways, including the use of microphones to pick up the gong's vibrations. From the mid-1960s on Stockhausen toured widely with his own live electronic music ensemble and continued to explore the application of electronics to traditional instruments. The new sounds and procedures he called for often required new notation; for example, he sometimes used the plus, minus, and equal signs of arithmetic to instruct performers. Works from this period include *Stimmung* ("Tuning") for six vocalists, who tune to different overtones of a low B-flat and proceed to sing and chant given sounds for more than an hour; *Mantra,* for two pianos and tape, based entirely on a single melody, in which ring modulators alter the harmonics so as to create patterns of consonance and dissonance. In 1977 he began *Licht* ("Light"), a seven-evening musical theater piece dealing with mythic subjects, scheduled for completion in 2002. In it he combines the principal features of his work: a carefully planned formal scheme, using formulas for melodies rather than individual notes, new electronic sounds, and influences from non-Western cultures (such as Japanese drama and Indonesian gamelan).

Stollen See under BAR FORM.

stomp A blues composition with a heavily marked beat. This feature is also present in SOUL. See also BLUES.

stop 1 In organs, a knob or lever that controls the passage of air to a particular rank (set) of pipes, causing them to sound or remain silent. The rank of pipes so controlled is also called a stop. The organist selects the desired pipes by drawing the appropriate stops. An organ has as many stops as

it has ranks of pipes, as well as some stops that control several ranks at a time (mixture stops). See also ORGAN. 2 In harpsichords, a lever that moves to one side the slides holding certain jacks (hooklike devices that pluck the strings), so that only some of the strings are plucked when a key is depressed. The use of such stops alters the pitch, the tone color, or both. Harpsichords have far fewer stops than organs, usually anywhere from four to six. Sometimes the stops are controlled by pedals instead of knobs. See also HARPSICHORD.

stopped note See under STOPPING.

stopped string See under STRING; also STOPPING, def. 1.

stopping 1 In stringed instruments, such as the violin, guitar, and lute, altering the pitches of sounds produced by each string by holding down the string at certain points, thereby shortening its sounding length. A string so held down is said to be stopped; an unstopped string is called an **open string**. The technique of holding down two strings at the same time is called DOUBLE STOPPING (although this term also refers to playing on two open strings at the same time); holding down three strings is called TRIPLE STOPPING. Stopping is a basic technique for playing nearly all stringed instruments. **2** In playing wind instruments that are open at the lower end, such as the French horn, altering the tone quality, and sometimes also the pitch, by placing the hand or an object (see MUTE) inside the bell. The tones so produced are called stopped notes, and in scores they are indicated by the sign + over a note or passage. Stopped notes are also called, French, *sons bouchés* (sôn bōō shā'); German, *gestopft* (ge shtôpft'); Italian, *chiuso* (kyōō' zô). **3** In organs, closing a pipe that is normally open at one end, thereby producing a different pitch from the usual one. A flue pipe so closed, termed a stopped flue pipe, produces the tone one octave below

that produced by an open pipe. See also under ORGAN.

Strad A shortened form of STRADIVARI.

Stradivari (strä"dē vä'rē), **Antonio** (än tô' nyô), c. 1644–1737. An Italian violin maker who is remembered as the most famous violin maker of all time. He lived in Cremona and learned his trade from another great instrument maker, Niccolò Amati. The best of his instruments were made between 1700 and 1725, and today they are of priceless value. He made about 1,200 in all, and about half are believed to have survived. Stradivari is also known by the Latin form of his name, with which he marked his instruments, **Stradivarius** (strad"ē vâr'ē əs). Sometimes shortened to *Strad*.

Stradivarius See under STRADIVARI, ANTONIO.

strascicando See STRASCINANDO.

strascinando (strä shē nän'dô) *Italian:* "dragging." Also, *strascicando* (strä shē kän'dô), *strascinare* (strä shē nä're). A term used in the directions *strascinando l'arco*, telling the player to draw the bow across the strings so that the notes glide from one to another without a break, and *strascinando la voce*, directing the singer to perform very smoothly. In both cases the effect is similar to a very smooth legato, or even a PORTAMENTO.

strascinare See STRASCINANDO.

Strauss (shtrous), **Johann** (yō' hän). The name of two Austrian composers, father and son, who both are remembered mainly for their waltzes. —**Johann Strauss the Elder,** 1804–1849. A violinist, conductor, and composer. In addition to waltzes, he composed many polkas and marches. One of his most famous compositions is the "Radetzky" March, op. 228 (1848), named for an Austrian field marshal and considered a symbol of the Hapsburg royal family, which ruled Austria until 1918. —**Johann Strauss the Younger,** 1825–1899. A violinist and conductor who became

known as "the Waltz King." In addition to waltzes, among them "Wine, Women, and Song," "The Blue Danube," and "Tales from the Vienna Woods," he wrote polkas and other dances, as well as numerous operettas. The best of his operettas, *Die Fledermaus* ("The Bat") and *Der Zigeunerbaron* ("The Gypsy Baron"), are both often performed.

Strauss (s͟htrous), **Richard** (rik͟H´ ärt), 1864–1949. A German composer whose music is largely in the romantic tradition of Liszt and Wagner. Strauss's eight great symphonic poems—*Aus Italien* ("From Italy"), *Macbeth, Don Juan, Tod und Verklärung* ("Death and Transfiguration"), *Till Eulenspiegel, Also Sprach Zarathustra* ("Thus Spake Zarathustra"), *Don Quixote,* and *Ein Heldenleben* ("A Hero's Life")—as well as his two program symphonies were composed between 1887 and 1915, as were four of his most important operas (*Salome, Elektra, Der Rosenkavalier,* and *Ariadne auf Naxos*), and many of his lieder. Although until about 1909 his harmonies were often more dissonant and chromatic than Wagner's, Strauss never abandoned tonality (the presence of a central key) and, beginning with *Der Rosenkavalier* (1911), he returned to more conventional harmonies, and in *Ariadne auf Naxos* (1912) to classic forms and techniques. He was particularly skillful in using a large orchestra with great effectiveness.

Although Strauss continued to compose for the rest of his long life, producing several more important operas (*Arabella, Daphne, Capriccio, Die Frau ohne Schatten, Die Liebe der Danae*) and some outstanding songs (especially his *Vier letzte Lieder,* or "Four Last Songs," written at the age of eighty-four), he was unaffected by contemporary styles, adhering to the musical language of late nineteenth-century romanticism. Nevertheless, his best works remain in the standard repertory of orchestras and opera houses. During World War II Strauss remained in Germany and his apparent support of the Nazi regime harmed his reputation abroad. Among his other works are two fine horn concertos, the first written for his father, who was an outstanding French horn player.

Stravinsky (strä vēn´ skē), **Igor** (ē´gôr), 1882–1971. A Russian-born composer who, as the outstanding representative of NEOCLASSICISM, became one of the two most influential musicians of the first half of the twentieth century (the other was Arnold Schoenberg, founder of serial music). Stravinsky studied music from an early age. His most famous teacher was Rimsky-Korsakov, whose influence is reflected in Stravinsky's Symphony no. 1. His first important composition was *The Firebird,* a ballet commissioned by Sergey Diaghilev for his famous troupe in Paris, and it was based on Russian folklore. It was followed by the ballet *Petrushka,* which contained a daring innovation, the use of two keys at the same time (see BITONALITY). Two years later, in 1913, Stravinsky produced what was to be his most revolutionary and shocking piece, the ballet *The Rite of Spring,* in which he used not only numerous keys (polytonality) but irregular, constantly changing meters, and which caused a near-riot at the first performance. Indeed, it was in his novel approach to rhythm that Stravinsky proved to be most distinctive and exerted the greatest influence on other composers.

Stravinsky spent the years of World War I in Switzerland, composing vocal pieces to Russian texts and experimenting with various idioms and forms. From this period date *Les Noces* ("The Wedding") for chorus and solo quartet, to be accompanied by dances (for four pianos and percussion), which was not performed until 1923; and *L'Histoire du soldat* ("The Soldier's Tale"; 1918), combining narration, music, and dance, and including marches, a waltz, and ragtime. The Russian Revolution preventing his return to his homeland, Stravinsky moved back to Paris. He now.

turned to the past, to the forms and styles of earlier periods, to smaller ensembles and the *concertante* style of the baroque, with its masses of contrasting tone (see SINFONIA CONCERTANTE). The first clearly neoclassic work was *Symphonies of Wind Instruments* of 1920, dedicated to Debussy. Also in this vein are the ballet *Pulcinella,* supposedly based on music by the eighteenth-century Italian composer Pergolesi, a piano sonata (1922), Serenade in A for piano (1925), and Concerto for piano and wind ensemble (1924). Stravinsky's neoclassicism focused on the revival of classic forms; it did not return to tonality, or to classic harmony. His large-scale neoclassic works of the 1920s and 1930s also include the opera-oratorio *Oedipus Rex*, the *Symphony of Psalms*, the ballet *Apollon Musagète*, the choral work with dance *Perséphone*, the ballet *Orpheus*, a violin concerto, and the concerto for winds entitled *Dumbarton Oaks*.

In 1939 Stravinsky moved to America and eventually became a United States citizen. In the 1940s he continued to compose in a combination of styles and forms. Notable are his *Ebony Concerto* for jazz band, the Symphony in C, *Symphony in Three Movements,* Mass in G, and the opera *The Rake's Progress* (which combined elements of eighteenth-century Italian opera, the English masque, and the French opéra-comique). Late in life Stravinsky became attracted to serial techniques, which are evident in his *Canticum sacrum* ("Sacred Canticle") for tenor, baritone, chorus, and orchestra, to some extent in the ballet *Agon*, and in the choral work *Threni*. (See also SERIAL MUSIC.) All the works of his last period were twelve-tone. They include *Movements* for piano and orchestra; *Noah and the Flood* for soloists, chorus, and orchestra; *Elegy for J.F.K.* (dedicated to President John F. Kennedy) for baritone, two clarinets, and basset horn; and *Variations* for orchestra.

street funk See under FUNK.

street organ See under BARREL ORGAN.

strepitoso (stre" pē tô'sô) *Italian.* A direction to perform in a loud, boisterous manner.

stretta See under STRETTO.

stretto (stret'ô) *Italian:* "narrow" or "close." A means of varying a musical theme so that its parts come closer together. One kind of stretto simply involves performing the notes of a theme faster, so that they are closer together in time. This kind is often used in the closing section of a composition, the section itself being called a stretto (or **stretta**). In another kind of stretto, frequently found in fugues, the subject (theme) is repeated in a second voice-part before the first voice-part has finished stating it; thus part of the subject and its repetition are performed at the same time, producing an effect of greater intensity. In fugues, too, stretto is generally used in a closing section. The accompanying example, from a portion of Bach's first fugue from *The Well-Tempered Clavier,* Book 1, shows the subject being repeated in the bass (and in the dominant rather than the tonic) just one beat after it is begun in the treble part.

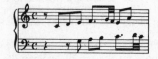

strict counterpoint See under COUNTERPOINT.

stride piano A style of piano playing associated with early jazz, featuring a stride (walking) bass and rapid right-hand figurations. James P. Johnson, Fats Waller and Art Tatum were among those noted for this style. (See JAZZ.)

string A thin cord of wire, gut, nylon, or some other material that is made

taut by being fastened at both ends and is caused to vibrate, and therefore sound, by being struck, stroked (bowed), or plucked. Some strings are caused to vibrate indirectly, by means of another vibrating material (see SYMPATHETIC STRINGS). The tone quality and pitch of the sound produced depend on the length and thickness of the string, as well as on its surroundings (the presence or absence of factors that will increase, decrease, or otherwise change the string's vibrations). If the string is allowed to vibrate along its entire length, it is termed an OPEN STRING. If it is allowed to vibrate along only a portion of its length, it is termed a **stopped string**. See also SOUND; STRINGED INSTRUMENTS.

string. An abbreviation for STRINGENDO.

string bass Another name for DOUBLE BASS.

stringed instruments A family of musical instruments in which the sound-producing agent is one or more taut strings (see STRING). The term most often refers to instruments whose strings are bowed (violin, viola, cello, double bass, viol) or plucked (harp, guitar, zither, lute). However, it may also be applied to the piano, harpsichord, and clavichord, all keyboard instruments whose sound is produced by strings that are struck (piano, clavichord) or plucked (harpsichord). In the bowed stringed instruments the individual strings are sometimes referred to by number; the string of highest pitch is called the first string, the next highest the second string, and so on.

The stringed instruments of the modern orchestra are the violin, viola, cello, and double bass. In practice the harp and piano, although commonly included in symphony orchestras, are not referred to as strings, and their music appears in different places in orchestral scores. There are two main differences between the orchestral strings and the other principal orchestral group,

the wind instruments (both woodwinds and brass). First, on the strings, unlike the winds, two or more notes can be played simultaneously. Second, the strings' tone is so soft that far more of them are needed to balance the sound of the winds. The strings are considered the backbone of the symphony orchestra, giving it its characteristic sound. Bands, on the other hand, rarely include any stringed instruments, usually consisting wholly of winds and percussion. In popular and folk music, the plucked strings—guitar, bass, mandolin, banjo—play a vital role. See also STRING ORCHESTRA.

stringendo (strēn jen'dô) *Italian.* A direction to perform faster. It is sometimes found toward the end of a movement or section, in anticipation of a climax or a change to a new, faster tempo. Often abbreviated *string.*

string orchestra An instrumental group made up entirely of stringed instruments. Today they are usually the bowed strings used in the symphony orchestra (violin, viola, cello, double bass). String ensembles have been used for at least four hundred years. In England, particularly, consorts of viols—small ensembles consisting entirely of viols in different sizes—were popular during the sixteenth and seventeenth centuries. Throughout the baroque and classic periods (1600–1820) a considerable amount of music was written for string orchestra, and the practice has continued, although to a lesser extent, to the present day. During the baroque period (to 1750) a keyboard instrument, most often a harpsichord, was generally included to perform the basso continuo (continuous bass part; see CONTINUO); today a piano or harp is added only rarely.

The term CHAMBER ORCHESTRA is sometimes used for string orchestra, despite the fact that such an ensemble does not play chamber music (it uses several instruments per voice-part, instead of the one per voice-part used in chamber music). The latter

term is further misleading because it is also used for small orchestras that include woodwinds and brasses as well as strings.

string quartet 1 A composition for four stringed instruments, in which each instrument plays its own part (see QUARTET). The traditional string quartet consists of parts for first violin, second violin, viola, and cello. It is the most popular form of chamber music, and the repertory includes thousands of compositions.

Although music for four stringed instruments was written during the sixteenth and seventeenth centuries, the history of the string quartet as such begins with works written by Haydn during the 1750s. These pieces are still largely in the style of a DIVERTIMENTO—light pieces with five movements, including two minuets. In the 1760s Haydn began to use four movements and to develop the style of the classical string quartet, which is in effect a classic sonata for four instruments (see SONATA, def. 1). He wrote more than eighty string quartets in all, some of which bear titles in addition to opus numbers. Among the best known of them (the titles here are in English translation) are the *Emperor* Quartet in C, *Razor* Quartet, six *Sun* Quartets, *Horseman* Quartet in C minor, *Hunt* Quartet in B-flat, *Lark* Quartet in D, and *Quintenquartett* (quint means "fifth"; the title is not generally translated) in D minor. Mozart wrote more than two dozen string quartets, some of which also bear titles (*Hunt* Quartet, three *Prussian* Quartets, *Dissonance* Quartet in C major, and six *Haydn* Quartets dedicated to Haydn). The most prolific quartet composer of the classical period was Boccherini, who wrote about a hundred of them; compared to those of Haydn and Mozart, however, most of them are mediocre in quality.

So far as quality is concerned, some of the sixteen string quartets composed by Beethoven stand alone in the history of the form. The late quartets in particular, written during the last two years of his life (1825–1827), carried the form far beyond both the classical sonata and earlier concepts of writing for four instruments. Outstanding among these is the quartet entitled *Grosse Fuge* ("Great Fugue"), op. 133, which originally was to be the final movement of an earlier quartet but grew, owing to its complexity, into a separate work. In it Beethoven dispensed with divisions into movements (it consists only of an overture and fugue), but it nevertheless falls naturally into contrasting sections—an overture, double fugue, slower section, galloping fast section, and coda.

During the remainder of the nineteenth century, the string quartet had an uneven history. Schubert wrote several fine ones, the most familiar of which is no. 14 in D minor, entitled *Der Tod und das Mädchen* ("Death and the Maiden"; 1826). Schumann, Mendelssohn, Cherubini, Franck, Smetana, Dvořák, Tchaikovsky, Borodin, and Chausson all wrote quartets, and Brahms's three string quartets are considered outstanding. Debussy and Ravel each wrote one.

The composers of the twentieth century turned to the string quartet with new enthusiasm. Perhaps most notable in the repertory of the first half of the century are the six quartets of Béla Bartók, written between 1910 and 1939. The three chief composers of serial music—Schoenberg, Berg, and Webern—all wrote string quartets. The leading neoclassicists all used the form—Stravinsky (1914; 1920) and Hindemith (seven quartets, between 1915 and 1945), as well as Reger, Piston, and Sessions. Other notable string quartets have been written by Glazunov (seven; 1882–1931), Charles Ives (1896; 1913), Kodály (1908; 1916), Nielsen (four; 1888–1906), Sibelius (*Voces intimae;* 1909), Elgar (op. 83; 1918), Fauré (1924), Janáček (1923; 1928), Crawford Seeger (1931), Milhaud (eighteen; 1912–1950), Shostakovitch (fifteen; 1938–1974), Carter (1951; 1959; 1973; 1986), Penderecki (1960), Tippett

(five; 1935–1990), Ligeti (1954; 1968), Lutoslawski (1965), Hiller (especially no. 6, 1972), Henze (five; 1947– 1977), Babbitt (six; 1950–1993), Rochberg (six; 1952–1978), and Gubaidulina (four; 1982–1993). **2** An ensemble consisting of four stringed instruments.

string quintet 1 A composition for five stringed instruments, in which each instrument plays its own part (see QUINTET). The most common combination consists of a string quartet (two violins, viola, cello) plus either a second viola or a second cello. A few quintets include a double bass with the string quartet instruments, or, very occasionally, a third violin.

The string quintet came into being about the same time as the STRING QUARTET, and it, too, is a classic sonata in form, but for five instruments (see SONATA, def. 1). However, the quintet has attracted fewer composers than the quartet. The only exception is Boccherini, who exceeded his total of 102 string quartets with some 125 string quintets. Unfortunately, many of them are slight in quality. More notable are the string quintets of Mozart, Beethoven, Schubert, Mendelssohn, and Brahms. Dvořák also wrote two string quintets, one with double bass. In the twentieth century, composers have largely preferred the quartet to the quintet, at least for strings, but Vaughan Williams produced one fine example, his *Fantasy Quintet* (1910), and Sessions another (1958). **2** An ensemble of five stringed instruments.

string sextet See under SEXTET.

string trio 1 A composition for three stringed instruments, in which each instrument plays its own part (see TRIO, def. 2). The traditional string trio consists of a violin, viola, and cello. Although this form has appealed to far fewer composers than the piano trio (see PIANO TRIO) and string quartet, there are some notable examples.

The string trio, like the string quar-tet, dates from the middle of the eighteenth century. Although there were earlier works for three stringed instruments, they did not follow the structure of four contrasting movements that is characteristic of the classic sonata and other chamber music (see SONATA, def. 1). Among the earliest examples are some twenty string trios by Haydn, for two violins and cello. (Some of Haydn's compositions for baryton are also, in effect, string trios; see HAYDN, FRANZ JOSEPH.) Boccherini wrote sixty or so string trios, mostly of mediocre quality. More important are a Divertimento by Mozart (K. 563) for violin, viola, and cello, and five string trios by Beethoven. For the next century or so the form was largely neglected, but in the twentieth century it was revived, notably by Dohnányi (Serenade in C, 1902), Hindemith (String Trio no. 1, 1924; no. 2, 1934), Webern (op. 20, 1927; a twelve-tone work), and Schoenberg (op. 45, 1946; one of the composer's last works). **2** An ensemble made up of three stringed instruments.

strisciando (strē̲s̲h yän' dô) *Italian*. A direction to glide smoothly from one note to the next. Some authorities consider it identical to a GLISSANDO, but others as a very smooth LEGATO.

stroboscope (strō̄'bə skōp"). An instrument used to measure the precise frequency of musical sounds (frequency determines pitch; see under SOUND). It can be used to determine whether an instrument or voice is sounding various pitches correctly. It can also measure the pitches of harmonics (overtones), and it can detect the tiny variations in pitch known as VIBRATO. It has proved particularly useful in studying the scales, tunings, and singing practices of Asian, African, and other non-Western music. The stroboscope, invented in the early 1940s, is manufactured under a variety of trade names, such as Stroboconn.

stromenti di legno (strô men'tē dē len'yô). The Italian term for WOOD-WIND INSTRUMENTS.

strophic (strof'ik, strō'fik). A term describing a piece of music, usually a song, that consists of a series of stanzas of equal length, with each stanza sung to the same music. The stanzas may or may not alternate with an unchanging refrain (in which words and music remain the same, but differ from the music of the stanzas; see REFRAIN, def. 1). Most hymns and many folk songs are in strophic form. The opposite of strophic is sometimes called **through-composed** (a literal translation of the German term *durchkomponiert*), applied to a song in which the music changes along with the words; most of the great nineteenth-century lieder (by Schubert, Schumann, Brahms, and others) are through-composed rather than strophic.

Stück (s̲h̲tʏk) *German.* A musical composition or piece; *Klavierstück* means "piano piece."

studio upright See under PIANO.

study Another word for ÉTUDE.

stürmisch (s̲h̲tʏr' mis̲h̲) *German.* A direction to perform in a stormy, vehement manner.

style In music, a term used for the composer's manner of treating the various elements that make up a composition—the overall form, melody, rhythm, harmony, instrumentation, etc.—as well as for the performer's manner of presenting a musical composition. The style of both composer and performer is influenced by many factors, personal and historical. A composer may be aiming to present a particular musical idea, which may seem more important than anything else. The way of doing so, however, is affected by one's age and experience, with whom one has studied, what music one admires, etc. The performer's style is influenced by talent and experience as well. Further, both composer and performer are influenced by history, by the music of the past and of their own time.

The study of musical style and how it has changed over the centuries is the chief object of **music history**. It may concentrate on a particular musical form (symphonic style, operatic style), a particular period (baroque style, Renaissance style, impressionist style), a method of composition (contrapuntal style), a kind of instrument (keyboard style), a nationality (French style, Italian style), or a particular composer (Beethoven's style, Schoenberg's style). The study of how a particular work is put together is called **style analysis.** Once a cumbersome and time-consuming task, style analysis today is greatly assisted by the use of computers.

style galant (stēl gʌ län'). The French term for GALLANT STYLE.

subbass tuba See under TUBA.

subcontrabass tuba See under TUBA.

subdominant (sub dom' ə nant). The fourth degree of the diatonic scale, that is, the fourth note in any major or minor scale (see SCALE DEGREES). In the key of C major the subdominant is F, in the key of D major it is G, in the key of A minor it is D, etc. Along with the tonic and dominant (first and fifth scale degrees), the subdominant is one of the three principal tones used in harmony. In analyzing the harmony of a composition, the Roman numeral IV is used to indicate the subdominant or a chord built on it. —**subdominant chord** A chord built on the subdominant. The most important subdominant chord is the subdominant triad, the major triad whose root is the subdominant (in the key of C major, F–A–C).

subito (sōō' bē tô) *Italian:* "at once" or "immediately." A word used in such directions as *forte subito* ("suddenly loud") and *subito piano* ("suddenly soft").

subject Also, *theme.* A melody, usually fairly short, that is used as the basis of a musical composition or section. A subject is longer than a FIGURE (or motif), which is the shortest possible musical idea, consisting of as few as two or three notes. The subject

usually first appears near the beginning of a piece or section, and is made to stand out from other melodic parts of the work, mainly in the way it is treated. It may be repeated a number of times, or portions of it may be developed in one way or another (see DEVELOPMENT). In a FUGUE, which normally has one subject, the subject is first stated in the main voice-part and then is repeated in the other voice-parts. In SONATA FORM, there are usually two subjects, often of contrasting nature, which are treated in a particular way. An important use of a subject is in the form known as THEME AND VARIATIONS, consisting of a subject (usually fairly long) that is varied in a number of ways. In SERIAL MUSIC the subject may be the tone row, or series.

submediant (sub mē′dē ənt). Also, *superdominant.* The sixth degree of the diatonic scale, that is, the sixth note in any major or minor scale (see SCALE DEGREES). In the key of C major the submediant is A, in the key of D major it is B, in the key of A minor it is F, etc. In analyzing the harmony of a composition, the Roman numeral VI is used to indicate the submediant or a chord built on it. —**submediant chord** A chord built on the submediant. The most important submediant chord is the submediant triad, the major triad whose root is the submediant (in the key of C major, A–C–E).

suboctave coupler See under COUPLER.

subtonic Another name for LEADING TONE.

suite (swēt). **1** During the baroque period (1600–1750), a form of instrumental music that consisted of a series of movements (sections), most of them based on dances and all in the same key. The movements, ranging from four to twelve or more, were stylized dances, that is, they were not actually performed by dancers.

The suite grew out of the custom of pairing together dances in the lute and keyboard music of the sixteenth century, such as the pavane and galliard, or the passamezzo and saltarello. In time more dance forms were linked in this way, and they were treated in a more unified fashion. Eventually a fairly standard order was established. This sequence, which was introduced in the mid-seventeenth century by Johann Jakob Froberger (1616–1667), alternated slow and fast dances and consisted of at least four movements: ALLEMANDE (slow), COURANTE (fast), SARABAND (slow), and GIGUE (fast). Sometimes an introduction, called a prelude, preceded the allemande. Between the saraband and gigue, it became customary to include other dances, which were optional (a matter of choice) and numbered from one to as many as four. Most of the optional movements were French dances, such as the minuet, pavane, galliard, bourrée, rigaudon, loure, anglaise, branle, passacaglia, passepied, gavotte, polonaise, saltarello (originally Italian), and air (also called *ayre* or *aria;* this was a song type rather than a dance type; see AIR, def. 3).

A basic feature of the suite is that the dance movements nearly always are in binary (two-part) form, that is each consists of two sections, each of which is performed twice. Sometimes a movement was followed by a variation on it, called a *double.*

In general the description above applies to the suites of Bach, which are called either suite or partita (his six French Suites, six English Suites, and six Partitas, all for harpsichord or clavichord) and to Handel's seventeen harpsichord suites. Most such suites were written for a single instrument, usually a keyboard instrument (harpsichord or clavichord) but occasionally lute or violin (Bach wrote three suites for solo violin). In addition, Bach wrote four suites of a different kind, which he called *overture* and which today are generally known as **orchestral suites.** These were modeled on an instrumental form often used by Lully and other French composers to open an opera or ballet; it

consisted of an introduction plus a series of dances, nearly always French in origin and in no particular order. Other German composers who wrote orchestral suites were Muffat and Telemann. Handel's *Royal Fireworks Music* is of a similar nature.

French composers also wrote suites for individual instruments, chiefly the harpsichord; these are usually called **ordres,** and the best were written by Couperin and Rameau. The order of movements in these is less fixed than in the German suite, and the movements themselves bear the name of either a dance (allemande, courante, gavotte) or a descriptive idea (see COUPERIN, FRANÇOIS). The most important English composer of suites, besides Handel, was Purcell. In Italy in the seventeenth century a similar type developed, called the *sonata da camera,* which, however, was a form of chamber music (each instrument played its own part; see under SONATA).

The end of the baroque period (1750) also marks the end of the instrumental suite. Elements of it survived during the classic period in the serenade, divertimento, and cassation, all instrumental compositions originally designed for light evening entertainment, as well as in the minuet movement of the classic sonata, symphony, and quartet. Nevertheless, these forms replaced the suite as such. In the first half of the twentieth century there were some attempts to revive the baroque form. Such compositions, usually consisting of a series of connected movements with a dancelike character, include Stravinsky's Suite for chamber orchestra (1921), Bartók's Suites for orchestra (op. 3, 1905; op. 4, 1907), Kodály's orchestral suite entitled *Dances of Galanta,* Schoenberg's Suite for string orchestra (1934), Debussy's *Suite bergamasque* for piano solo (1905), and Milhaud's *Suite provençale* for orchestra (1937) and *Suite française* for band (1945). In some of these works (by Bartók, Kodály, Debussy, and Milhaud) there is a conscious attempt to use the forms and idioms of folk dances, whereas others (by Stravinsky and Schoenberg) represent principally an interest in the form of the suite as such. **2** A type of instrumental composition that became very popular in the late nineteenth century. It consists of a series of movements, either of original music, or, quite often, of arrangements of music from folk dances, ballets, operas, or incidental music for plays or motion pictures. The arrangements may be made by the original composer or by someone else. Often such suites have a program (see PROGRAM MUSIC). Examples include the suite based on Bizet's incidental music to the play *L'Arlésienne,* Rimsky-Korsakov's *Scheherazade* and *Capriccio espagnol* (original music), Ferde Grofé's *Grand Canyon Suite,* Prokofiev's suite from the film score *Lieutenant Kije,* Ravel's suite *Ma mère l'oye* ("Mother Goose Suite"), Tchaikovsky's suite based on the ballet *The Nutcracker,* Stravinsky's suite from the ballet *Petrushka,* Grieg's two suites based on the music for the play *Peer Gynt,* de Falla's Suite for piano and orchestra, *Noches en los jardines d'espana* ("Nights in the Gardens of Spain"; original), and Copland's suite from the ballet *Appalachian Spring.*

suivez (swē vā') *French:* "follow." **1** The French term for *colla parte* (see under PARTE). **2** A direction to continue to the next section without pause, the French equivalent of SEGUE (def. 1).

sul (sool) *Italian:* "on" or "at." For musical terms beginning with *sul,* such as *sul ponticello,* see under the second word (PONTICELLO). Used with a letter or Roman numeral, *sul* tells the performer which string to play (*sul G* or *sul IV,* play on the G string; *sul A,* play on the A string, etc.).

Sullivan (sul' ə vən), **Arthur Seymour,** 1842–1900. An English composer who is remembered chiefly for writing the music for a series of very popular comic operettas (see GILBERT AND SULLIVAN). Despite their enormous

success, Sullivan considered them unimportant compared to his serious compositions, most of which have been virtually forgotten. Sullivan at the age of twenty-four was appointed professor at the Royal Academy of Music, a great honor for so young a man. His serious works include a symphony, the opera *Ivanhoe*, incidental music to Shakespeare's play *The Tempest*, ballets, and many choral works and hymns. However, besides the operas he wrote with Gilbert, the only works of his that achieved lasting fame are the hymn "Onward, Christian Soldiers" and the song "The Lost Chord."

superdominant Another word for SUBMEDIANT.

superius (sə pēr' ē əs) *Latin.* Also, *cantus* (kan'təs). In sixteenth-century vocal or instrumental music, the highest part. Abbreviated *s*.

supertitle Also, *surtitle*. In opera performances, the practice of supplying a translation of the text, projected on a screen above the stage. (In some houses individual monitors are placed around the hall for this purpose, on the backs of seats or elsewhere.) The use of supertitles, which dates from the 1970s, is strongly supported by those who believe that fully understanding the text is essential to audience appreciation of a production; it is equally strongly opposed by those who believe it distracts audience attention from the performance.

supertonic (sōō" pər ton' ik). The second degree of the diatonic scale, that is, the second note in any major or minor scale (see SCALE DEGREES). In the key of C major the supertonic is D, in the key of D major it is E, in the key of A minor it is B, etc. In analyzing the harmony of a composition, the Roman numeral II is used to indicate the supertonic or a chord built on it. **—supertonic chord** A chord built on the supertonic. The most important supertonic chord is the supertonic triad, the major triad whose root is

the supertonic (in the key of C major, D–F–A).

sur (sʏr). For French musical terms beginning with *sur*, such as *sur la touche*, see under the main word (TOUCHE).

surtitle Another name for SUPERTITLE.

suspension A note of a chord that is held while a second chord, with which it is dissonant, is sounded. A suspension always resolves stepwise (usually downward) to a note consonant in the new chord. (If the dissonant note resolves upward, it is termed a **retardation**.) For example, if Chord 1 is F–B–D and Chord 2 is G–E–D, the D having been held over from Chord 1, the D is a suspension. Chord 2 is followed by Chord 3, E–G–C, the D having resolved down to a C. A suspension always falls on a strong beat (or portion of a beat), whereas its preparation (its appearance in the first chord) and its resolution (in the third chord) fall on weak beats (or portions of weak beats).

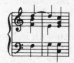

sustaining pedal A name sometimes used for the DAMPER PEDAL (see also under PIANO, def. 2).

Suzuki (sōō zōō' kē) **method** A method of teaching young children to play the violin. It is named for its inventor, Shinichi Suzuki (1898–) of Japan, who amazed audiences with his string orchestras made up entirely of young children. Suzuki's method begins pupils at the age of three with an intensive course in ear training. At first they learn to play by imitating music on records. After several years of learning in this way (by ear and memory), they learn to read music. In the early years, the child's parent is asked to be intimately involved in the method, often practicing along with the child. In the 1960s the Suzuki

method began to be used by a number of important music schools in Western (European and American) countries; it has become especially popular in the United States.

svegliato (svel yä' tô) *Italian.* Also, *svegliando* (svel yän' dô). A direction to perform in a lively, brisk manner.

sw. An abbreviation for SWELL ORGAN.

swan song A term used for a person's last work or achievement before death, so called because of an ancient belief that a swan sings just before dying. It was used as a title for Schubert's last songs by his publisher, who issued them under it (in German, *Schwanengesang*) after the composer's death. Gibbons's famous madrigal "The Silver Swan" has been described as representing, symbolically, the swan song of the madrigal form.

Sweelinck (svä'link), **Jan** (yän), 1562–1621. A Dutch composer and organist who is remembered mainly for his great influence on keyboard music. He may have studied in Venice under the theorist Zarlino, although some authorities think he never left Holland. In any case, Sweelinck was well acquainted with both Italian and English musical styles of his day, and he passed on to his pupils features of both. A church organist, Sweelinck was renowned as both performer and teacher. His own organ compositions are remarkable for their time. He developed the form of the fugue for organ, using intricate counterpoint and building up theme upon theme into a grand climax, a technique later perfected by Bach. Sweelinck was one of the first to use the pedal of the organ for one of the fugue's voice-parts (see under FUGUE). He is said to have taught nearly all the important North German organists of the next generation, of whom the best known is Samuel Scheidt. Sweelinck also wrote a great many choral works, few of which were published until after his death; on the whole, they represent less of an achievement than his organ compositions.

Sweet Adelines The female equivalent of the barbershop quartet; see under QUARTET.

sweet potato Another name for OCARINA.

swell See under SWELL ORGAN. For swell pedal, see under ORGAN.

swell organ The second most important manual keyboard of the organ (after the great organ), and the stops (groups of pipes) associated with it. Also known simply as **swell**, it is so called because its pipes are enclosed in a kind of box, and their loudness can be controlled by opening and closing shutters on one side of the box. The shutters are operated by a pedal; when they are opened, the volume increases ("swells"). Since the volume can be controlled, the swell organ usually includes the softer stops. Its keyboard is placed directly above that of the great organ. Today other divisions of the organ may also be enclosed and their volume adjusted by a similar mechanism. Abbreviated *sw.* See also ORGAN.

swell pedal See under ORGAN.

swing A style of JAZZ popular in the 1930s, so named by "Duke" Ellington.

syllabic (sə lab'ik). A term used for vocal music in which there is just one note for each syllable of the text. The opposite is melismatic, where many notes are sung to a single syllable (see MELISMA).

sympathetic strings In certain stringed instruments, a set of metal strings that are not touched with the fingers or bow but vibrate and therefore sound along with the strings that are bowed or plucked. They serve to strengthen the sound of the strings that are played, acting as resonators (see RESONATOR). Among the instruments that have sympathetic strings are the baryton and viola d'amore (see the illustration accompanying BARYTON). The pitches and harmonics (overtones) sounded by sympathetic strings are the same as those sounded on the played strings.

symphonia (sim fōn'yä) *Latin*. See under HURDY-GURDY.

symphonic band See BAND, def. 5.

symphonic poem Also, *tone poem*. The most important type of nineteenth-century PROGRAM MUSIC. A symphonic poem is generally in one fairly long movement, scored for orchestra. It bears a title that describes its subject or "program," which may be supplemented by program notes. The program may be a fairly complicated story, such as the fairy tale in Dukas's *L'Apprenti sorcier* ("The Sorcerer's Apprentice"), or a series of descriptive scenes from nature, as in Debussy's *Prélude à l'après-midi d'un faune* ("Prelude to the Afternoon of a Faun," based on Mallarmé's poem), or a play, such as Liszt's *Hamlet*, or a kind of mood picture of a nation, such as Sibelius's *Finlandia*. The music follows the story; often different themes are made to stand for a person or situation (see IDÉE FIXE; also LEITMOTIF). The wide range of possibilities appealed in particular to the romantic composers of the nineteenth century, and later also to the impressionists, especially Debussy.

The symphonic poem grew out of two other forms popular with romantic composers, the CONCERT OVERTURE and PROGRAM SYMPHONY. The first composer to write symphonic poems was Liszt, who invented the name (*sinfonische Dichtung* in German). His first symphonic poem was *Ce qu'on entend sur la montagne* ("What One Hears on a Mountaintop"; 1848), after a poem by Victor Hugo, and he went on to write eleven more symphonic poems. Notable symphonic poems were produced by Tchaikovsky, Saint-Saëns, Scriabin, Franck, and, later, by Richard Strauss, whom many consider the supreme master of the form (Strauss called his works *tone poem*, in German, *Tondichtung*). The symphonic poem also appealed to nationalist composers, who found in it an outlet for national legends and traditions; among those who used the form in this way are Smetana,

Dvořák, Sibelius, Borodin, Mussorgsky, and in the twentieth century, Respighi and Gershwin. The accompanying chart on page 432 lists some of the symphonic poems still frequently performed.

symphony A long composition for orchestra, usually divided into four major sections called movements (see MOVEMENT). The general order of movements resembles that of the classical sonata (see SONATA, def. 1), and indeed, many authorities define a symphony as "a sonata for orchestra." Like the sonata, the symphony developed during the mid-eighteenth century. Although the name "symphony," especially in its Italian form (*sinfonia*), had been used much earlier, the works to which it was applied were quite different. It was used for music for instruments and voices (by Schütz), for instrumental interludes in an opera, and for various kinds of introductory music for cantatas, suites, songs, and operas (see SINFONIA). The classical symphony grew out of several older forms, chief among them the Italian overture, an instrumental work in three movements, fast–slow–fast (see under OVERTURE). Various eighteenth-century composers, among them those of the Mannheim school (see MANNHEIM SCHOOL), inserted a minuet before the final movement, creating the four-movement form that became customary in the 1760s. In style the movements drew on features of the overture, concerto grosso, baroque suite, and operatic aria.

Although many composers contributed to this early development (among them Stamitz and Franz Xaver Richter of Mannheim, George Monn and Georg Wagenseil of Vienna, Giovanni Bastista Sammartini of Italy, and Johann Christian Bach of London), the first classical symphonies were written by Haydn. In all, Haydn wrote 104 symphonies, over a period of thirty-six years (1759–1795). His contemporary, Mozart, wrote 41 symphonies. In the case of both composers, it is their last dozen or so symphonies that estab-

NOTABLE SYMPHONIC POEMS

Composer	Title	Date
Alexander Borodin	*In the Steppes of Central Asia*	comp. 1880
Claude Debussy	*Prélude à l'après-midi d'un faune*	1894
	("Prelude to the Afternoon of a Faun")	
	La Mer ("The Sea")—three works	1903–1905
Paul Dukas	*L'Apprenti sorcier* ("The Sorcerer's Apprentice")	1897
Edward Elgar	*Falstaff*	1913
César Franck	*Le Chasseur maudit* ("The Accursed Huntsman")	1882
George Gershwin	*An American in Paris*	1928
Arthur Honegger	*Pacific 231*	1923
Franz Liszt	*Tasso*	1849; rev. 1854
	Les Préludes	1854
	Mazeppa	1851
	Orpheus	1854
	Prometheus	1850
	Hamlet	1858
	Hunnenschlacht, Die ("The Battle of the Huns")	1857
Modest Mussorgsky	*A Night on Bald Mountain*	1867; rev. 1886
		by Rimsky-Korsakov
Sergey Rachmaninoff	*The Isle of the Dead*	1909
Ottorino Respighi	*Fontane di Roma* ("Fountains of Rome")	1917
	Pini di Roma ("Pines of Rome")	1924
	Feste Romane ("Roman Festivals")	1929
Camille Saint-Saëns	*Le Rouet d'Omphale* ("Omphale's Spinning Wheel")	1871
Alexander Scriabin	*Poem of Ecstasy*	1908
Jean Sibelius	*En Saga*	1892
	The Swan of Tuonela	1893
	Lemminkäinen's Homecoming	1895
	Pohjola's Daughter	1906
	Finlandia	1899
Bedřich Smetana	*Ma Vlást* ("My Fatherland";	comp.
	cycle of six works)	1874–1879
Richard Strauss	*Aus Italien* ("From Italy")	1887
	Don Juan	1889
	Macbeth	1890
	Tod und Verklärung ("Death and Transfiguration")	1890
	Till Eulenspiegels lustige Streiche	1895
	("Till Eulenspiegel's Merry Pranks")	
	Also Sprach Zarathustra ("Thus Spake Zarathustra")	1896
	Don Quixote	1898
	Ein Heldenleben ("A Hero's Life")	1899
Piotr Ilyitch Tchaikovsky	*Romeo and Juliet*	1869
	Francesca da Rimini	1876
	Hamlet	1888

lished the form of the classical symphony. This type of symphony begins with an allegro (fast) movement in SONATA FORM, sometimes preceded by a

slow introduction. It is followed by a slow, song-like movement, then a minuet with trio, and finally a fast, often brilliant closing movement. It is scored for a relatively small orchestra, consisting of strings, one or two flutes, two oboes, two bassoons, and two horns; later, trumpets, timpani, and clarinets were added. Beethoven expanded both the form and the instrumentation of the symphony. In the first movement he lengthened both introduction and coda (ending) and greatly expanded the development section (see under SONATA FORM). He used a scherzo in place of the minuet, sometimes as the second movement instead of the third. To the orchestra he added piccolo, trombones, double bassoon, and numerous percussion instruments. He also enlarged the string section and doubled the number of horns. In his last symphony (no. 9) he included a choral section in the last movement.

The expansion of the symphony, both in length and in orchestration, continued throughout the nineteenth century. The movements became longer and more complex, occasionally one or two additional movements were included, and the orchestra became huge, with sometimes as many as 200 performers. Although many of the nineteenth-century composers concentrated more on shorter works and on program music (see PROGRAM SYMPHONY), the central tradition of the symphony was continued by such composers as Schubert, Mendelssohn, Schumann, Bruckner, Brahms, Tchaikovsky, and Mahler, as well as some of the nationalist composers, especially Borodin, Dvořák, and Sibelius.

The first half of the twentieth century saw a reaction against the huge forces of the romantic composers (see NEOCLASSICISM), and composers again turned to symphonies for chamber (small) orchestra, among them Milhaud, Schoenberg, Webern, and Hindemith. Until about 1950, when many composers became engrossed with newer kinds of music (electronic music, aleatory music, etc.), nearly every major composer wrote at least one symphony. Outstanding twentieth-century symphony composers include Vaughan Williams, Prokofiev, Shostakovitch, Hindemith, Stravinsky, Sessions, Honegger, Nielsen, Ives, Piston, Copland, Harris, and Davies. However, their symphonies sometimes differed radically from the classical form described above, especially those composed in the second half of the twentieth century.

The chart on the following pages lists most of the famous symphonies written between about 1765 and 1960. The total number of symphonies written by a composer, shown in parentheses after his name, is given only for composers no longer living. Symphonies are identified by number and key, as is conventional, and titles and nicknames are included wherever they were added by the composer or have come into common use.

symphony orchestra See ORCHESTRA.

Synclavier (sin' kla vēr). A kind of SYNTHESIZER.

syncopation An effect of uneven rhythm that results from changing the normal pattern of accents and beats. For example, in 3/4 meter (waltz time) the normal pattern accents the first of the three beats in each measure (*one*-two-three, *one*-two-three). This pattern can be changed in several ways. One way would be to accent the second beat instead of the first (one-*two*-three). Another would be to hold the first beat for the length of two beats instead of one, in effect skipping the second beat (*one* ... -three). Still another way would be to skip the first beat altogether, replacing it with a rest (silence-two-three). These three methods are the most common types of syncopation. However, there is another, more subtle way of altering the pattern; it consists of tiny hesitations, playing a note very slightly sooner or later than it would normally be played. This last kind of syn-

Composer*	Symphony	Date
Ludwig van Beethoven (9)	No. 1 in C major, op. 21	1800
	No. 2 in D major, op. 36	1803
	No. 3 in E-flat major, op. 55 (*Eroica*)	comp. 1804
	No. 4 in B-flat major, op. 60	1807
	No. 5 in C minor, op. 67	1808
	No. 6 in F major, op. 68 (*Pastoral*)	1808
	No. 7 in A major, op. 92	1813
	No. 8 in F major, op. 93	1814
	No. 9 in D major, op. 125 (*Choral*)	comp. 1817–1823
Alexander Borodin (3)	No. 2 in B minor	completed 1876
Johannes Brahms (4)	No. 1 in C minor, op. 68	comp. 1876
	No. 2 in D major, op. 73	comp. 1877
	No. 3 in F major, op. 90	comp. 1883
	No. 4 in E minor, op. 98	1885
Anton Bruckner (10)	No. 4 in E-flat major (*Romantic*)	comp. 1874; rev. several times
	No. 7 in E major	1884
	No. 9 in D minor	unfinished
Ernest Chausson (1)	Symphony in B-flat major, op. 20	completed 1890
Aaron Copland (3)	No. 3	1946
Antonín Dvořák (9)	No. 7 in D minor	comp. 1884–1885
	No. 8 in G major	comp. 1889
	No. 9 in E minor (*From the New World*)	1893
César Franck (1)	Symphony in D minor	1888
Howard Hanson (7)	No. 1 in E minor (*Nordic*)	1922
	No. 2 (*Romantic*)	1930
Roy Harris (14)	No. 3	1939
Franz Joseph Haydn (104)	No. 31 in D (*Horn Signal*)	1765?
	No. 45 in F-sharp minor (*Farewell*)	1772?
	No. 48 (*Maria Theresa*)	1769?
	No. 53 (*L'Impériale*)	comp. 1778–1779
	No. 69 in C major (*Laudon*)	1779
	No. 85 in B-flat major (*Queen of France*)	pub. 1788
	No. 88 in G major	1787
	No. 92 in G major (*Oxford*)	1791
	No. 94 in G major (*Surprise*)	1791
	No. 100 in G major (*Military*)	1794
	No. 101 in D major (*Clock*)	1794
	No. 103 in E-flat major (*Drum Roll*)	1794?
	No. 104 in D major (*London*)	1795
Paul Hindemith (5)	Symphony in E-flat	1941
	Mathis der Maler ("Matthias the Painter")	1934
	Die Harmonie der Welt ("The Harmony of the World")	1951
Arthur Honegger (5)	No. 2 for string orchestra	1943
	No. 3 (*Liturgical*)	1946
	No. 5 (*Di tre re*)	1951
Charles Ives (4)	No. 2	comp. 1897–1901; pub. 1951
	No. 3	comp. 1904; performed 1946
	No. 4	comp. 1915? performed 1965
Gustav Mahler (10; 1 unfinished)	No. 1 in D major (*The Titan*)	1889
	No. 2 in C major (*Resurrection*)	1895
	No. 4 in G major	1901
	No. 8 in E-flat major (*Symphony of a Thousand*)	1910
Felix Mendelssohn (5)	No. 3 in A minor (*Scotch*)	completed 1842
	No. 4 in A major (*Italian*)	1833
	No. 5 in D major (*Reformation*)	1832
Olivier Messiaen (1)	*Turangalîla* (in 10 movements)	1949

Composer*	Symphony	Date
Wolfgang Amadeus Mozart (about 45; 41 numbered)	No. 31 in D major, K. 297 (*Paris*)	1778
	No. 34 in C major, K. 338	1781
	No. 35 in D major, K. 385 (*Haffner*)	1782
	No. 36 in C major, K. 425 (*Linz*)	1783
	No. 38 in D major, K. 504 (*Prague*)	1787
	No. 39 in E-flat major, K. 543	comp. 1788
	No. 40 in G minor, K. 550	comp. 1788
	No. 41 in C major, K. 551 (*Jupiter*)	comp. 1788
Carl Nielsen (6)	No. 5	1922
Walter Piston (8)	No. 3	1948
Sergey Prokofiev (7)	No. 1 (*Classical Symphony*)	comp. 1916–1917
	No. 5 in B-flat major, op. 100	1945
	No. 7, op. 131	1952
Sergey Rachmaninoff (3)	No. 2 in E minor, op. 27	1909
Wallingford Riegger (4)	No. 3 (a twelve-tone work)	1948
Albert Roussel (4)	No. 3 in G minor, op. 42	1930
Camille Saint-Saëns (3)	No. 3 in C minor (*Organ*)	1886
Arnold Schoenberg (2)	Chamber Symphony, op. 9	1906; rev. for large orchestra
Franz Schubert (8 completed)	No. 2 in B-flat major	comp. 1815
	No. 3 in D major	comp. 1815
	No. 4 in C minor (*Tragic*)	comp. 1816; performed 1849
	No. 5 in B-flat major	1816; performed 1841
	No. 6 in C major	completed 1818; performed 1828
	No. 8 in B minor (*Unfinished*)	comp. 1822
	No. 9 in C major (*The Great;* published as no. 7)	completed 1828
Robert Schumann (4)	No. 1 in B-flat major, op. 38 (*Spring*)	1841
	No. 2 in C major, op. 61	1846
	No. 3 in E-flat major, op. 97 (*Rhenish*)	1851
	No. 4 in D minor, op. 120	comp. 1841; rev. 1851
Roger Sessions (8)	No. 1	1927
	No. 4	comp. 1958
Dmitri Shostakovitch (15)	No. 1 in F major, op. 10	1926
	No. 5 in D major, op. 47	1937
	No. 7, op. 60 (*Leningrad*)	1941
	No. 10 in E major, op. 93	1953
	No. 13 in B-flat, op. 113	1962
Jean Sibelius (7)	No. 1 in E minor, op. 39	1900
	No. 2 in D major, op. 43	1902
	No. 3 in C major, op. 52	completed 1907
Piotr Ilyitch Tchaikovsky (6)	No. 2 in C minor, op. 17 (*Little Russian,* or *Ukrainian*)	1873
	No. 3 in D major, op. 29 (*Polish*)	comp. 1875
	No. 4 in F minor, op. 36	1877
	No. 5 in E minor, op. 64	1888
	No. 6 in B minor, op. 74 (*Pathétique*)	1893
Ralph Vaughan Williams (9)	No. 1, *Sea Symphony*	1910
	No. 2, *London Symphony*	1920
	No. 7, *Sinfonia Antartica*	1953
Anton Webern (1)	Symphony, op. 21	1928

*Number in parentheses is total number composed.

copation is very common in jazz but is used much less in other kinds of music, probably because it is very hard to notate exactly (the hesitation could, conceivably, be indicated by a very short rest).

Syncopation has been used since the Middle Ages. It most often occurs in a single voice-part, since the effect is heightened when the other voice-parts continue the regular rhythmic patterns. However, since Beethoven's late works (from the mid-1820s on) it has occasionally been used throughout all the voice-parts of a work. Syncopation is basic to blues, ragtime, and jazz, and it has become increasingly important in the works of twentieth-century composers. Some authorities consider sudden changes of meter (from one measure to the next) a form of syncopation, but others disagree. Still others regard a dynamic accent (sudden loudness) on a weak beat as a form of syncopation (see ACCENT).

Synket (sin'kət). A kind of SYNTHE-SIZER.

synthesizer A machine that consists of a collection of circuits or modules for the purpose of creating ELECTRONIC MUSIC. Basically it consists of five types of component: signal (sound) generators, devices to modify signals, devices to control signals, mixers to combine signals, and internal communication to enable interaction of the components. It may also contain an amplifier and speaker, and the sounds created may be recorded on tape or some other medium and/or produced live.

In the earliest synthesizers, such as the RCA Mark I developed in the early 1950s, the composer selected the desired sounds by manipulating switches and then punching the code for the switches onto a paper tape. The tape was inserted into the machine, bringing into play oscillators, filters, and other sound generators and modifiers as brushes passed over the holes in the tape. These elements then were combined into sound and recorded on magnetic tape, which could be played back (and/or altered further). Its successor, the RCA Mark II, installed in the Columbia-Princeton studio in 1959, used a binary number system on punched cards. Both these machines were huge and unwieldy. Although some noteworthy works were composed on them, such as Milton Babbitt's *Philomel* (1963) for live voice and synthesized accompaniment and Charles Wuorinen's *Time's Encomium* (1968–69), the 1960s saw the invention of smaller and less costly synthesizers that could achieve far better results. One was the **Synket**, a compact device developed by John Eaton and Paul Ketoff; it had three two-octave keyboards and took up little more space than an upright piano. Another, the **Moog**, invented by Robert A. Moog and popularized by Walter Carlos through his Bach arrangements (*Switched on Bach,* 1968), controlled not only pitch but tone color, attack and decay of the tone, and numerous other characteristics. The **Buchla**, devised by Donald Buchla, used a keyboard without movable keys that worked much like the fingerboard of a violin; Morton Subotnick used it to compose *Silver Apples of the Moon* (1967). Similar to these synthesizers was the first **ARP**, named for inventor Al R. Pearlman, who developed it in the early 1970s; it became particularly associated with studios and performers devoted to popular music.

These synthesizers all embodied an important new principle called **voltage control,** which eliminated the tedious and less accurate process of manually setting and resetting the various components. Now, instead of turning a dial or flicking a switch for each change, an electric voltage could be used to act on oscillators and other components. In the next two decades further technological advances both improved the machinery and cut its cost. The newer machines could register any frequency or interval, including microtones, and repeat complex rhythms with inhuman speed and

accuracy. They also could imitate the sound of conventional instruments so well that it took a fine ear to distinguish between, for example, synthesized and real drums. Increasingly, synthesizers were used not only by serious composers but for popular music ranging from film scores to rock groups, and for live performance as well as composition. The synthesizers used primarily for live performance tended to be self-contained, or **integrated**, meaning that all the functions are built into the system. In contrast, **modular systems** are composed of interchangeable units, or modules, each of which provides a specific function or closely related set of functions (oscillators in one module, filters in another, etc.). These more complex and more versatile systems remained more expensive and were used mainly in electronic studios.

The next major advance was the introduction of computerized or digital synthesizers, including a digital sequencer that could play the entire synthesizer. A **sequencer** is a device that generates control information (in the form of adjustable voltages) to create a series or sequence of events. The digital sequencer, in effect a microcomputer memory, can control many voltage lines and steps of variable length, and can store hundreds of steps. No separate controls are required for each step (as in playing a keyboard); the computer simply stores the "numbers" and feeds them to a digital/analog converter. The "numbers" are control voltages, so the sequencer can control any aspect of sound that can be put under voltage control. Thus, with a good digital/analog converter, which changes "numbers" into audible sounds, a computer can become a highly versatile musical instrument. Moreover, when linked with both a sequencer and the technology called MIDI (see under ELECTRONIC MUSIC), several synthesizers can be marshaled by a single player.

Two synthesizers incorporating this technology were the Synclavier II

and the Fairlight CMI. The Synclavier, originally invented by Jon Appleton and two engineers, had a five-octave keyboard and a solid-state computer memory that functions just like a sixteen-track tape recorder. The microprocessor stored the user-designed sounds so that they could be recalled at the touch of a button. Software was available for creating additional voices (up to 128), allowing the computer to play on the keyboard in real time, and playing back, editing and printing out a score. The Synclavier thus provided the capacities of a full array of synthesizer modules and a sixteen-track digital recording studio within the reach of a single performer. The Fairlight CMI, made in Australia and available commercially since 1979, was entirely digital. Sounds were generated, stored, and processed by means of a computer. One of its special features was the ability to take in natural sounds through a microphone or tape recorder, analyze them into their harmonic components, and then recreate them, with altered pitch and rhythm if desired. Thus it could make musical scales from any natural sound, such as human speech or animal noises. The Fairlight also had a display screen (like a computer monitor) which could graphically show wave forms; further, the performer-composer could, with a light-pen, draw on the screen a wave form that the synthesizer then could convert into sounds and play. In addition to these quite sophisticated synthesizers, more and more smaller, preprogrammed synthesizers, with limited capability but at much lower cost, became available.

Although most synthesizers are controlled by a keyboard, their popularity among rock musicians prompted the invention of guitar and drum synthesizers. The former are controlled by means of an electric guitar, usually with a special pickup. The Avatar, for example, requires a special hexaphonic pickup on the guitar, that is, a separate output for

each string. There are two basic kinds of **drum synthesizer.** One is a rhythm generator that provides fixed rhythmic patterns using imitative drum voices; the other is a percussion-oriented synthesizer that allows drummers to create new voices. The former can play only preset patterns—for example, bossa nova, fox trot, Latin, rock, waltz—and the user can vary only the speed. A programmable synthesizer, in contrast, can produce any rhythm the user invents.

Among the primary uses of synthesizers, in addition to live performance, are the creation of new sounds and new compositions; use by composers to hear works in progress without having to hire an orchestra or other performing group; making a small ensemble sound larger or, in effect, mimicking the sound of a band or other large instrumental ensemble for a variety of purposes (radio broadcast, film soundtrack, etc.); and help in teaching the principles of music. See also ELECTRONIC MUSIC; ENVELOPE; MODULATION, def. 2; OSCILLATOR; PATCHING; SOUND.

syrinx See PANPIPES.

T

T 1 In choral music, an abbreviation for TENOR. **2** In seventeenth-century music, an abbreviation for TRILL. **3** Part of the abbreviation *t.c.,* for *tutte le corde* or *tre corde* (see under CORDA).

tablas (däb läs') *Hindi.* A pair of drums used to provide the rhythmic beat in Indian music. They are used mainly in central and northern India, the MRIDANGA being preferred in the south. One drum of the pair, the **tabla,** consists of a hollowed-out log with parchment stretched over the open end. The other, called **baya,** is made of metal, usually copper, and

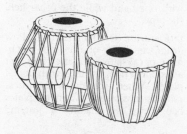

also has a parchment head. Both drums are tuned by means of braces. In addition, each drumhead is marked with a round black spot of tuning paste (made from rice and metal shavings), which affects both the pitch and the tone color. The tablas are always played as a pair, the tabla being struck with the right hand and the baya with the left. The tabla

is tuned to the tonic, dominant, or subdominant of the music being played, whereas the baya sounds various pitches, controlled by the pressure of the player's palm.

tablature (tab'lə chər, tab'lə choor). A system of writing music in which the performer is shown what strings or keys to play in order to produce the desired pitches. It differs from the present-day system of notation in that numbers or other signs are made to stand for each string of a lute, for example, instead of for each note to be played. Various kinds of tablature were widely used from the fifteenth to seventeenth centuries. The most important of them were those used for lute (and also vihuela), and those used for organ. In the systems devised for lute, or lute tablatures, of Italy, Spain, and France, lines stood for the instrument's strings and letters or numbers stood for the stopping positions (points where the string was to be stopped, or held down). Today a similar system is used for guitar and ukulele music; however, it is usually in the form of a diagram of the strings and frets, with dots indicating the position of the player's fingers for each note or chord. (See the illustration accompanying UKULELE for an example.) In Spanish organ tablatures, lines were used to represent the different voice-parts of a composition, and numbers stood for the notes

TABLE 440

of the scale, the octave being indicated by special signs. In German organ tablatures, letters were used to represent all or some of the different voice-parts.

table Another word for BELLY.

tabor (tā'bər). A small SNARE DRUM played together with a pipe to accompany dancing. (See also PIPE, def. 2.)

tacet (tach'it) *Latin:* "be silent." A word used in orchestral and vocal scores to direct a particular instrument or voice to remain silent during a particular passage or section, usually one of considerable length (such as a whole movement).

tala (däl) *Hindi.* See under RAGA.

talking drum Originally, a West African means of nonverbal communication, in which either a two-headed drum or two separate drums sounding different pitches, corresponding to the low- and high-pitched vowels of the local language, is used to transmit a message. In recent years, as African performers brought their music to Europe and America, such drums have sometimes been incorporated in ensembles with other instruments, where they generally supply a rhythmic lead.

Tallis (tal'əs), **Thomas,** c. 1505–1585. An English composer and organist who is remembered for his outstanding church music. One of the first to write sacred music to English texts (after the Anglican church broke away from the Roman), Tallis wrote anthems, as well as Latin Masses, Magnificats, motets, and madrigals. Together with William BYRD, he was given a monopoly by Queen Elizabeth I on printing and selling music, and in 1575 the two men together published a collection of their motets, *Cantiones sacres* ("Sacred Songs"). A master of counterpoint, Tallis also wrote keyboard and lute pieces, some of them secular (nonreligious), but it is mainly for his church music that he is considered one of the finest composers of his time.

talon, au (ō tA lôn') *French.* A direction to play with the frog end of the bow (the part nearest the hand).

tambour (tän bōor'). The French word for DRUM.

tambour de Basque (tän bōor' də bask'). The French term for TAMBOURINE.

tambourin (tän bōo raN') *French.* **1** An 18th-century dance form based on an older Provençal dance that features accompaniment with a drum (also called tambourin) and pipe. In keyboard pieces by Rameau, mostly in a lively 2/4 meter, the bass (left-hand) part imitates the steady drumbeat and the right hand plays rapid figures imitating the pipe. **2** Also, *tambourin de Provence.* A large double-headed drum, with a cylindrical body and single snare in the upper head, that was played to accompany dancing. It was played with a single stick and was generally used with a small flute called **galoubet. 3** Also, *tambourin de Béarn* (tän bōo raN' də bā arn'). A small zither with gut strings, which were struck with a stick. It sounded only two notes, a fifth apart, and it, too, accompanied dancing and was played together with a galoubet (see def. 2); the zither was hung around the player's neck and played with one hand while the other held the pipe.

tambourine (tam bə rēn'). A shallow drum, consisting of a head of parchment or calfskin that is stretched over a wooden hoop strung with metal plates. When the drum is struck, rubbed, or shaken, the metal plates bang together, making a jingling

sound. Instruments similar to tambourines have been used since ancient times. The medieval **timbrel** was one of the first that combined a single head with jingles. Used to accompany dancing, the tambourine was introduced into the orchestra in the eighteenth century in imitation of Turkish military music (see JANISSARY MUSIC), and in time it became a standard member of the percussion section of the orchestra.

tambura (dum bo͞or′ə) *Hindi*. Also spelled *tanboura, tanbura*. A long-necked lute used in India to accompany the singing of ragas (see RAGA). It has four or five metal strings, which are always played open (without being stopped), so that each sounds only a single note. The tambura thus serves as a drone (provides a single, continuous sound). The instrument's body is made of wood or of a round gourd. The player holds it upright and strums the strings with the forefinger of one hand. The tuning of the strings is changed to suit the particular raga being performed.

tamburo (täm bo͞or′ô). The Italian word for DRUM.

tampon (tam′pon). A drumstick with two heads. Held in the middle, it is used to produce a roll (usually on the bass drum) by means of a rapid shaking of the wrist, so that the two heads alternately strike the drumhead.

tam-tam (tam′tam, tum′tum). See under GONG.

tanbur (tän bo͞or′) *Persian*. A lute with a long neck, pear-shaped body, and metal strings, which is played in many countries of southeastern Europe and the Near East. The number of strings varies. Stopping positions are indicated by frets, and the strings are tuned by means of pegs inserted in the neck. It is very similar to the Greek BUZUKI.

tanbura Another name for TAMBURA.

tango (täng′gō) *Spanish*. A fairly slow dance in 2/4 meter, with a characteristic syncopated rhythm, that became popular about 1900 in the cities of Argentina. Danced by couples, it became known throughout Latin America and later in the United States and Europe. The music consists of two sections of equal length. Its rhythm resembles that of the HABANERA.

tanto (tän′tô) *Italian:* "so much." A term used in such directions as *adagio ma non tanto* ("slow but not too slow"), and *a tanto possibile* ("as much as possible").

Tanz (tänts). The German word for dance.

tape music A name sometimes used for ELECTRONIC MUSIC.

tape recording A means of recording sound that began to be developed in the late nineteenth century but was not perfected until the late 1930s. It uses recording tape made of an acetate base and evenly coated with a magnetic oxide. The tape is moved at a constant speed past magnetic heads: first, an **erase head**, which removes previous recordings; next, a **recording head**, which converts electric impulses from a microphone or other sound source into magnetic impulses that are recorded on the tape in sequence as it moves along; and finally, a **playback head**, which picks up the magnetic impulses and reconverts them into electrical impulses that can then be amplified and fed through a loudspeaker, reproducing the original sound. Tape

recording was the principal means of sound reproduction from the mid-1940s to the mid-1980s, when it gradually began to be replaced by DIGITAL RECORDING. For the use of tape recording by composers, see under MUSIQUE CONCRÈTE and ELECTRONIC MUSIC.

tarantella (tä rän tel' ä) *Italian.* Also, French, *tarentelle* (tA räN tel'). A fast dance in 6/8 meter, in which the music keeps moving from a major key to a minor key and back again. The dance becomes faster and faster, ending in very rapid tempo. Originating in southern Italy, the tarantella became popular with nineteenth-century composers, among them Chopin and Liszt, who wrote short, very fast pieces in this style.

tardamente See TARDO.

tardando (tär dän' dô) *Italian.* Another word for RITARDANDO.

tardo (tär' dô) *Italian.* Also, *tardamente* (tär dä men'te). A direction to play in slow tempo.

tarentelle See TARANTELLA.

Tartini (tär tē' nē), Giuseppe (jōō sep'pe), 1692–1770. An Italian violinist and composer who is considered one of the founders of modern violin technique. One of the first to compose string quartets, Tartini also wrote an important treatise on violin playing (published in 1750). Further, he discovered a strange phenomenon of sound, the **combination tone** (also called **differential tone, resultant tone,** or **Tartini's tone**), a third tone that is heard when two loud tones are sounded together (as in double stopping on the violin); the pitch of the third tone, which is quite low, is determined by the precise difference in frequency between the two loud tones (see SOUND for an explanation of frequency and pitch). Although Tartini wrote music for other instruments and some church music, the bulk of his works are for the violin, including more than 100 sonatas, some 150 concertos, and a set of 50 variations on a theme by Corelli, entitled *L'Arte dell'arco* ("The Art of the Bow"). One of Tartini's most famous works is his Sonata in G minor, *Il Trillo del diavolo* ("Devil's Trill Sonata"), a difficult piece named for a long passage of double trills in the last movement (said to have been inspired by a dream about the devil).

Tartini's tone See under TARTINI, GIUSEPPE.

tastiera, sulla (sōō' lä täs tyer' ä) *Italian.* Also, *sul tasto* (sōōl täs' tô). A direction to play over the fingerboard (of violins, violas, etc.), producing a FLAUTATO tone.

tasto (täs'tô) *Italian.* 1 The key of a keyboard instrument. 2 The fingerboard of a stringed instrument (see TASTIERA, SULLA). 3 The FRET of a fretted stringed instrument, such as the viol or lute.

tbn. An abbreviation for TROMBONE.

t.c. An abbreviation for *tre corde* or *tutte le corde;* see under CORDA.

Tchaikovsky (chī kôf' skē), **Piotr** (*Peter*) **Ilyitch** (pyô' tər il yēch'), 1840–1893. Also, *Tschaikowsky.* A Russian composer who became his country's outstanding representative of the European romantic tradition (see ROMANTICISM). Remembered especially for his orchestral music, which includes six symphonies, three piano concertos, a violin concerto, and numerous overtures, marches, and ballets, Tchaikovsky was the only important Russian composer of his day who did not embrace nationalism. Nevertheless, his music is thought to be very "Russian" in its melancholy moods (he nearly always wrote in a minor key), in its emphasis on personal feelings, and even in its occasional use of Russian melodies and rhythms (for example, the Russian church service for the dead in Symphony no. 6, the *Pathétique* symphony; the folk rhythms of the famous orchestral *Marche slave*). Beginning his career as a government clerk, Tchaikovsky turned to music at the age of twenty (although he had

studied a little before). He studied with Anton Rubinstein, among others, and in 1866 he became a professor at the Moscow Conservatory. Much of Tchaikovsky's music was very successful during his lifetime and has remained so to the present day, both in Russia and abroad, even though he has been criticized for lack of originality and for lack of form (especially in his long works). Outstanding among his many works are Symphonies nos. 4, 5, and 6; Piano Concerto no. 1, in B-flat minor; the Violin Concerto; the operas *Eugene Onegin* and *The Queen of Spades* (both still widely performed); the ballets *Swan Lake, Sleeping Beauty,* and *The Nutcracker,* which are perhaps his most popular works; the overture-fantasy *Romeo and Juliet* (begun early in his career but not completed to his satisfaction until 1879); the program symphony *Manfred; Capriccio italien* for orchestra; three string quartets; Piano Trio in A minor; *1812 Overture;* and numerous songs, including some for children, and piano pieces.

technique (tek nēk'). A general term for the physical skills involved in singing or in playing an instrument, such as hand and finger dexterity, breath control, etc. A musical composition designed to improve such skills is often called a **technical study,** exercise, or ÉTUDE.

tedesca (te des'kä) *Italian.* A shortening of *danza tedesca,* meaning "German dance." In the seventeenth century it was used for the allemande, and in the nineteenth century for the Ländler and others. —**alla tedesca** In the style of a German dance of the waltz type, that is, in 3/4 meter with slightly changing tempos.

Te Deum (tā dā'o͞om) *Latin.* An ancient hymn of praise and thanksgiving, beginning with the words *Te Deum laudamus* ("We praise thee, God"), which is used in the Roman Catholic, Anglican, and other church services. In the Roman Catholic Church it concludes the Office of

Matins. Independent compositions based on the Gregorian chant for this hymn, some for organ, have been written since the Middle Ages. From the seventeenth century on, settings for voices and orchestra were written to celebrate various secular (nonreligious) occasions having nothing to do with the church, such as Handel's *Utrecht* Te Deum, to celebrate the Peace of Utrecht concluded in 1713, and his *Dettingen* Te Deum, to celebrate a battle won in Dettingen in 1743. Other settings have been composed by Berlioz, Bruckner, Dvořák, Verdi, Sullivan (for Queen Victoria's Diamond Jubilee), Vaughan Williams (for the coronation of King George VI of Great Britain), Britten (two, 1935, 1945), Walton (for the coronation of Queen Elizabeth II), Persichetti (1964), Penderecki (in honor of Pope John Paul II), and Arvo Pärt.

Telemann (tā' le män), **Georg Philipp** (gā'ork fēl'ip), 1681–1767. A German composer and organist whose works bridge the late baroque style and early classicism (see PRECLASSIC). Largely self-taught, Telemann became the most prolific composer of his day, completing several thousand compositions in just about every form—operas, Passions, oratorios, cantatas, chamber music, organ pieces, songs, and orchestral works, including concertos and hundreds of French overtures (see under OVERTURE). His keyboard music in particular, with its simple harmonies and highly ornamented melodies, is typical of the GALLANT STYLE. Elements of Polish and Moravian folk music also appear occasionally. Born into an educated upper-class family, Telemann studied law at the University of Leipzig but soon turned to music fulltime and held a variety of posts, beginning as director of the Leipzig Opera. He also was at the court at Eisenach, where he met J. S. Bach; in 1714 he became the godfather of Karl Philipp Emanuel Bach. Telemann also was a good friend of Handel and corresponded with him all his life. In

1712 Telemann became music director in Frankfurt, but in 1721 he moved to Hamburg, where he served for the remainder of his long life. In addition to composing two cantatas for every Sunday, an annual Passion, and numerous oratorios and other large works for special occasions, Telemann, who by then was considered the best and most influential German composer of his time, organized public concerts and wrote a number of instructional books on ornamentation, realization of figured bass, and other aspects of performance practice. After his death he was succeeded by his godson.

Telharmonium See under ELECTRONIC INSTRUMENTS.

temperament The tuning of an instrument, that is, determining the exact pitches to be sounded. Since pitch depends on frequency (see under SOUND for an explanation), differences in tuning are created by differences in frequency. The most important systems of temperament that have been used in Western (European and American) music are the Pythagorean system, just intonation, the mean-tone system, and equal temperament, the last being the one in current use since about 1800. In the current system (EQUAL TEMPERAMENT), the octave is divided into twelve equal parts, so that the distance between each half tone and the next (C and C-sharp, C-sharp and D, D and D-sharp, etc.) is exactly the same in terms of frequency. For convenience, a unit of measure called the **cent** is used; an octave contains 1,200 cents, each half-tone interval containing 100 cents. The system of MEAN-TONE TEMPERAMENT, which preceded equal temperament and was used mainly for keyboard instruments, was a compromise between Pythagorean tuning and just intonation. For instance, its fifth (distance from C to G in the key of C, for example), contains 697 cents, as opposed to the fifth of 702 cents in Pythagorean tuning and the 700 cents of

equal temperament. The mean-tone system worked fairly well for the keyboard music of the fifteenth to seventeenth centuries, which used mostly keys with fewer than three sharps or flats, but in more complex keys (three accidentals or more) it resulted in music badly out of tune. The system of JUST INTONATION, based on the harmonic series, required new tuning for almost every change of key. The Pythagorean system (see PYTHAGOREAN TUNING), in which all the other intervals are derived from a single one, the perfect fifth, did not work for enharmonic tones (C-sharp and D-flat, for example; see ENHARMONIC). Although equal temperament is slightly inexact for all intervals except the octave, most of the "errors" are too small to be heard, and further, listeners have become so accustomed to the inaccuracies that they sound correct.

tempo (tem'pō) *pl.* **tempos, tempi** (tem'pōs, tem'pē). The rate of speed at which a piece of music is performed. Until about 1700, various conventions of tempo were followed, indicated by the notes themselves. Since then, composers generally have indicated tempo by the use of certain terms. This practice began in Italy, and as a result the conventional tempo indications are still in Italian. The most important of them are shown in the accompanying table.

Changing tempos, becoming faster, slower, or simply varying, are indicated by RITARDANDO, RALLENTANDO, ACCELERANDO, and RUBATO.

TEMPO INDICATION	M.M.*
lentissimo	40
larghissimo	
largo, lento	40–60
larghetto	60–66
adagio	66–76
andante	76–108
moderato, allegretto	108–120
allegro	120–168
presto	168–200
prestissimo	200–208

*M.M = number of quarter notes per minute

With the invention of the METRO-
NOME composers could be quite pre-
cise in indicating tempo, by telling
exactly how long a quarter note, for
example, is supposed to be held; thus
the sign ♩ = 60 M.M. means that a
quarter note should be held for
exactly 1/60 of a minute, or 1 second.
In practice, however, performers and
conductors still tend to regard tempo
as a matter of interpretation, and
they rarely follow metronomic signs
very precisely. —**a tempo** A direction
to return to the original tempo.
—**tempo giusto** See under GIUSTO.
—**tempo primo** A direction to return
to the original tempo (used at the
beginning of the piece or section).
Often abbreviated *tempo I°*. —**tempo
rubato** See RUBATO.

ten. An abbreviation for TENUTO.

teneramente (te" ner ä men' te) *Ital-
ian*. Also, *con tenerezza* (kôn te" ner
et'sä). A direction to perform deli-
cately and softly, with tenderness.

tenerezza, con See TENERAMENTE.

tenor (ten'ər). 1 The highest range of
male voice in modern choral music
(in earlier music the highest was the
boy soprano; see SOPRANO, def. 2). Its
range is from the second B below
middle C to the G above middle C,
although a trained voice can exceed
this range by a number of notes.

Music for tenor voice is often written
in the treble clef, an octave higher
than it sounds. In choral music for
four voice-parts, in which the tenor
sings the second lowest part (the low-
est is sung by the bass), the music
may be written in the bass clef. Oper-
atic tenors are sometimes classified
according to their tone quality: **lyric
tenor,** a light, sweet voice; **Helden-
tenor** (hel'den te nôr", German for

"heroic tenor"), a brilliant, expres-
sive, powerful but still agile voice.
2 In polyphonic music of the Middle
Ages, the lowest voice-part, which
carried the cantus firmus (fixed
melody) on which the other parts
were based. The word tenor comes
from the Latin *tenere*, "to hold," the
part being so called because the can-
tus firmus usually consisted of long-
held notes. (See also ORGANUM.) After
about 1450, a lower part (the bass)
was generally added, putting the
tenor in its present-day position.
3 The basic reciting note of a PSALM
TONE. 4 Among instruments that are
built in various sizes, an instrument
having about the same range as the
tenor voice, such as the tenor saxo-
phone or tenor trombone. In size it is
larger than the alto or soprano mem-
bers of the family but smaller than
the bass.

tenor clef See under CLEF.

tenor cor British term for MELLO-
PHONE.

tenor drum A drum midway in size
between the BASS DRUM and SNARE
DRUM, used mainly in military and
marching bands. It has no snares and
is usually played with a pair of soft-
headed sticks like those used for the
snare drum.

tenor horn 1 A name used in the
United States, Great Britain, and Ger-
many for various sizes and forms of a
brass instrument that is used mostly
in bands. It is a valved instrument
with a conical bore (cone-shaped

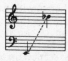

inside). One kind is pitched in E-flat;
this is called tenor horn in Great
Britain and *alto horn* in America and
France; another kind, pitched in B-
flat, is called tenor horn in France
and America but *baritone* in Germany

and Britain. Both kinds are sometimes made in circular shape, like the tuba, as well as in other shapes. The B-flat has a range from the E above low C to the B-flat above middle C. **2** A name sometimes used for the tenor size of SAXHORN.

tenor saxophone See SAXOPHONE.

tenor trombone See under TROMBONE.

tenor tuba See under TUBA.

tenor viol See under VIOL.

tenor violin An older name for the VIOLA.

tenth The interval of an octave plus a third (see also INTERVAL, def. 2).

tento (ten′tô). The Portuguese name for TIENTO.

tenuto (te nōō′tô) *Italian:* "held." A term directing the performer to hold a note or chord for its full value; it thus is the opposite of STACCATO, which takes away from its value. Often abbreviated *ten.*

Terce See under OFFICE.

ternary form A basic musical form, consisting of three sections, A B A, the third section being virtually identical to the first. If it is exactly identical, the third section often is not written out, the performer simply being directed to repeat the first section (usually marked *da capo*, or *D.C.*); this happens in the da capo aria (see under ARIA) and also in the minuet (or scherzo) with trio (see MINUET). Sometimes the third section is a shorter version of the first; in that case the performer may be asked to repeat the first section up to or from a certain point (*dal segno*, "from the sign"), which is marked by a sign (see SEGNO) or by an asterisk (*).

Ternary form, sometimes mistakenly called **song form**, is found in instrumental music more than in vocal music. Besides the forms mentioned (da capo aria, minuet or scherzo with trio), it is frequently found in the short piano pieces that were so popular with nineteenth-century composers—nocturnes, ballades, preludes, etc.

tessitura (te sē tōōr′ä) *Italian.* **1** The general range of a piece of vocal music, that is, the range in which most of the notes lie, excluding the few highest and lowest notes. **2** The range of notes readily produced by a particular singer (not necessarily including the very highest and lowest notes). See also RANGE.

testo (tes′ tô) *Italian:* "text." A term used for the part of the narrator in oratorios and Passions, who relates, in recitative (speechlike song), the events of the story.

tetrachord (tet′rə kôrd). **1** A series of four notes that form the intervals of whole tone, whole tone, half tone, with the top and bottom notes forming the interval of a perfect fourth (see INTERVAL, def. 2, for further explanation). The major scale consists of two such tetrachords, in C major, C D E F and G A B C. The ancient Greeks constructed a scale based on a tetrachord; theirs also consisted of whole tone, whole tone, half tone, but in descending order, from high to low pitch (for example, A G F E). **2** A four-note scale, or, in serial music, four pitch classes.

text Also, *lyrics.* In vocal music, the words. A text need not consist of whole words; it may consist of nonsense or other syllables (solmization, vocalization).

texture The relationships among the various notes in a musical composition, both as they sound together (vertical texture) and one after another (horizontal texture). **Vertical texture** refers to the chords formed by individual notes—in other words, the harmony. **Horizontal texture** refers to the melodies formed by the notes in succession, not only in the

main voice-part but in all the voice-parts. It may also refer to the progression of chords, one after another. Music in which several voice-parts have more or less equal importance is said to have a **contrapuntal** or **polyphonic texture**. Music consisting of a melody in one voice-part accompanied by chords in the other voice-parts is said to have a **homophonic** or **chordal texture**. Most music with more than one voice-part falls somewhere between these two extremes. (See also COUNTERPOINT; HOMOPHONY; POLYPHONY.)

The term "texture" is also used to describe the instrumentation of a composition. A piece using few instruments or instruments of light tone color (with few harmonics, such as the flute) is said to have a light texture, whereas a piece using many instruments or some with heavy tone color (many harmonics) is said to have a dense or heavy texture.

theater orchestra Also, *pit orchestra*. An ensemble that plays in the pit for musicals, ballets, and similar productions. It generally consists of no more than two dozen instrumentalists.

theater organ A kind of organ used to supply background music for silent motion pictures. It was widely used in the United States from about 1918 until the development of motion-picture soundtracks in the late 1920s. The theater organ was a pipe organ (see ORGAN), often very large, with many stops and special effects, including a variety of percussion (bass drum, cymbals, xylophone, etc.). Sometimes an entire grand piano was incorporated into the instrument.

theme Another word for SUBJECT.

theme and variations An important musical form, consisting of a subject and a series of variations on it (different versions of the subject). The variations may differ from the theme with regard to harmony, melody, rhythm, form, texture, key, mode, meter, or tempo—in short, in any aspect whatever—alone, or in combination. In analyzing a composition in this form, it is customary to designate the subject as A and the variations as A', A'', A''', etc., depending on the number of variations. A theme and variations may be part of a larger work, such as a movement of a sonata or symphony, or it may be an independent piece. The theme may be a melody, as in Beethoven's *Diabelli Variations*, op. 120, or it may simply be a pattern of bass harmonies a few measures long (as in the CHACONNE, FOLIA, PASSACAGLIA, ROMANESCA, etc.).

The form of theme and variations first become popular during the sixteenth century, with notable examples found in various English dances for keyboard instruments (especially for virginal) or for chamber ensembles (consorts of viols), as well as in Spanish music for organ and other instruments (especially diferencias; see DIFERENCIA) by Luis Narváez, Antonio de Cabezón, and others. During the baroque period (1600–1750) the tradition was continued in keyboard partitas (by Frescobaldi, Froberger, and others) and in numerous variations on Lutheran hymns (chorales) by German composers. In the classical period (1785–1820) Haydn, Mozart, and Beethoven often included a theme-and-variations movement in their sonatas, quartets, and symphonies, and Beethoven in particular wrote numerous independent pieces in this form. Except for Chopin, nearly all the great nineteenth-century keyboard composers—especially Schubert, Schumann, Liszt, Brahms—wrote sets of variations for piano, and the form continued to interest twentieth-century composers. The accompanying chart lists some of the best-known examples of theme and variations in independent compositions.

theorbo (thē ôr′bō). A bass lute that began to be made sometime between 1550 and 1600 and was played until about 1800. It was used almost exclusively to provide the bass accompaniment for songs and the basso continuo (see CONTINUO) in baroque

EXAMPLES OF THEME AND VARIATIONS

Composer	Composition	Date
Johann Sebastian Bach	*Goldberg Variations* (from *Clavierübung,* Part 4) pub. for harpsichord	1742
Ludwig van Beethoven	*Diabelli Variations,* op. 120, for piano	1823
	Eroica Variations in E-flat major, op. 35, for piano	1802
Johannes Brahms	*Variations on a Theme by Handel,* op. 24, for piano	1861
	Variations on a Theme by Paganini, op. 35, for piano	1863
	Variations on a Theme by Haydn, for comp. two pianos (op. 56a) or orchestra (op. 56b)	1873
Elliott Carter	*Variations for Orchestra*	1955
Ernst von Dohnányi	*Variations on a Nursery Song,* for piano and orchestra	1916
Edward Elgar	*On an Original Theme (Enigma Variations),* op. 36, for orchestra	1899
César Franck	*Variations symphoniques* ("Symphonic Variations") for piano and orchestra	1886
George Frideric Handel	"The Harmonious Blacksmith" (from *Suite des pièces*) for harpsichord	1720
Paul Hindemith	*The Four Temperaments,* for piano and strings	1944
Vincent d'Indy	*Istar Variations,* op. 42, for orchestra	1897
Zoltán Kodály	*Variations on a Hungarian Folksong (Peacock Variations)* for orchestra	1939
Franz Liszt	Variations on Bach's prelude, *Weinen, Klagen* ("Weep, Mourn"), for piano	1862
Witold Lutoslawski	*Variations symphoniques* ("Symphonic Variations") for orchestra	1939
Felix Mendelssohn	*Variations concertantes,* op. 17, for cello and piano	1829
	Variations sérieuses, op. 54, for piano	1841
	Variations in E-flat, op. 82	1841
	Variations in B-flat, op. 83	1841
Arnold Schoenberg	*Variations for Orchestra,* op. 31	1928
	Theme and Variations, op. 43, for band	1943
	Variations on a Recitative, op. 40, for organ	1941
Franz Schubert	*Introduction and Variations,* op. 160, for flute and piano	1824
	Variations in E minor on a French Air, op. 10, for piano	1818
	Variations in C minor on a Diabelli Waltz, for piano	1821
Robert Schumann	*Variations on A–B–E–G–G (Abegg Variations),* op. 1, for piano	1830
	Études symphoniques ("Symphonic Etudes"), op. 13, for piano	1834
Anton Webern	*Variations for piano,* op. 27	1936
	Variations for Orchestra, op. 30	1940
Charles Wuorinen	*Piano Variations*	1963
	Variations for bassoon, harp, and timpani	1972

instrumental music. Its strings were so long that its frets were too far apart to be fingered quickly, as the smaller lutes could be. In addition to stopped strings (whose pitch could be altered), it had a set of open strings (each sounding only one pitch) attached to a separate peg box. See also LUTE.

theory Today, all the technical aspects of musical composition, including the study of harmony, melody, counterpoint, rhythm, orchestration, notation, and so on. Until about 1800, theory meant mainly the philosophical and scientific aspects of music and musical sound, involving scales, intervals, modes, etc.—the tonal material of Western music (European and American). Western music theory begins with Pythagoras's studies of the monochord, about 400 B.C., and continues through the writings of modern composers concerning the very latest techniques of composition.

theremin (ther′ə min). See under ELECTRONIC INSTRUMENTS.

third Also, *major third*. The interval made up of the first and third tones (in rising order of pitches) in any major or minor scale, for example, C–E in the scale of C major (*do* and *mi* in solmization syllables). **—minor third** The interval one half tone smaller than a major third, such as C–E♭ or C#–E. **— diminished third** The interval one half tone smaller than a minor third (and one whole tone smaller than a major third), such as C–E♭♭ or C#–E♭. (See also PICARDY THIRD; CHORD.)

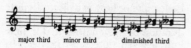

major third minor third diminished third

third stream See under JAZZ; also FUSION.

thirteenth The interval of an octave plus a sixth. See INTERVAL, def. 2.

thirteenth chord See under CHORD.

thirty-second note British, *demisemiquaver*. A note, ♪, equal in time value to (lasting as long as) one thirty-second of a whole note. Thirty-two thirty-second notes equal one whole note, sixteen thirty-second notes equal one half note, eight thirty-second notes equal one quarter note, four thirty-second notes equal one eighth note, and two thirty-second notes equal one sixteenth note. When thirty-second notes are written in succession, their flags are joined together by triple crossbars, called *triple beams:* ♪♪ = ♬.

thirty-second rest A rest, ♪, indicating a silence lasting the same length of time as a thirty-second note.

Thompson (tom′sən), **Randall**, 1899–1984. An American composer who became known particularly for his choral music, written largely in the nineteenth-century tonal tradition (see TONALITY). After studying at Harvard University and with the composer Ernest Bloch, Thompson held teaching positions at various schools until 1948, when he returned to Harvard. Of his instrumental works, the Symphony no. 2 is performed most often, but far better known are such choral works as *The Testament of Freedom, Alleluia* (his most popular work by far), *The Peaceable Kingdom,* and *Mass of the Holy Spirit,* which are particularly notable for rhythms and melodies that reflect the special qualities of American speech and song.

Thomson (tom′sən), **Virgil**, 1896–1989. An American composer and music critic whose outstanding compositions are operas and motion-picture scores. Residing in Paris in the 1920s, Thomson became acquainted with the leading artists there. Among them was the writer Gertrude Stein, to whose libretto he wrote one of his best works, the opera *Four Saints in Three Acts* (1934). Later he collaborated with her on another opera, *The Mother of Us All* (1947), about the life of Susan B. Anthony. Thomson's best

film scores are for two documentaries, *The Plough That Broke the Plains* (1936) and *Louisiana Story* (1949). From 1940 to 1954 Thomson was music critic of the New York *Herald Tribune,* for which he wrote some highly stimulating articles about current music. He then resigned to devote himself to composing and conducting. Although Thomson occasionally used twentieth-century styles, among them chromaticism (dissonance) and the twelve-tone technique (see SERIAL MUSIC), his music is more notable for its lively melodies, often based on American hymn and folk tunes, and his skill in setting words to music.

thoroughbass Also, *thorough bass.* Another term for basso continuo (see CONTINUO).

through-composed The literal English translation of the German term *durchkomponiert,* describing a song in which the music changes throughout instead of being repeated for a series of verses. For the opposite, see STROPHIC.

thumb piano See SANSA.

ti (tē). Also, *si* (sē). In the system of naming the notes of the scale (see SOLMIZATION), the seventh note of the scale (the others being *do, re, mi, fa, sol,* and *la*).

tie Also, *bind.* A curved line that connects two notes of the same pitch, indicating that the note is to be sounded only once and held for the time value of both notes. Thus a half note and a quarter note connected with a tie would be sounded once and held for the time value of both (lasting as long as three quarter notes). A tie is used to connect either two notes that are separated by a bar line, or to obtain a time value that cannot be obtained by using only one note, such as nine eighth notes (see the accompanying example). A tie should be distinguished from a SLUR, which connects two notes of different pitch, and from a PORTATO, indicated by a curved line with dots that connects

notes of either the same or different pitch. It should also be distinguished from the larger curved lines that mark phrases (see PHRASING).

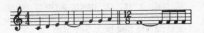

tiento (tyen'tô) *Spanish.* Also, Portuguese, *tento* (ten'tô). In the sixteenth and seventeenth centuries, a type of Spanish and Portuguese organ composition that is virtually identical to the Italian organ ricercar (see RICERCAR, def. 1; also FANTASIA, def. 2). Tientos were written by, among others, Antonio de Cabezón and Luis Venegas de Henestrosa.

tierce (tērs). See under MUTATION STOP.

tierce de Picardie See PICARDY THIRD.

timbales (tēm bä' läs) *Spanish.* 1 A pair of single-headed drums mounted on a stand and played with sticks. They usually are tuned a fourth apart and have a fairly high pitch. Also called **tom-toms,** they are used in Latin American music. 2 Spanish name for TIMPANI (the singular is *timbal*). 3 (taN bAl') French name for TIMPANI (the singular is *timbale*).

timbre (tim'bər; *French* taN'br°). The French term, also used in English, for TONE COLOR.

timbrel See under TAMBOURINE.

time 1 The METER of a composition, indicated by the TIME SIGNATURE. 2 The speed at which a composition is performed, usually called TEMPO. 3 The basic pulse or beat of a piece of music (see BEAT; RHYTHM). —**time value** The duration of a given note, that is, how long a given note must be held, in relation to the other notes of a piece. In conventional modern notation, time value is indicated by the shape of the note, that is, whether it is a whole note, half note, quarter note, and so on. A whole note is held twice as long as a half note, a half note twice as long as a quarter note, and so on. See NOTES AND RESTS. For another

system of indicating time value, see MENSURAL NOTATION. In twentieth-century music, duration is sometimes indicated by special kinds of notation.

time point A term coined by Milton Babbitt to indicate the starting point of a sound in relation to the meter of a work. For example, in a bar of music in 3/8 meter, there are 12 time points at intervals of a thirty-second note. If one refers to each sound by its time point, one can devise a SET of time points for a melody, which can then function as a series.

time signature A sign consisting of two numbers, one placed above the other, that indicate the METER of a musical composition or section. The upper number shows the number of beats per measure, and the lower shows the time value of the note to receive a beat. Thus, the time signature of $\frac{2}{4}$ indicates there are two (2) beats per measure, with each quarter note (4) receiving a beat. It also shows that there are two quarter notes per measure. Similarly, $\frac{6}{8}$ indicates that there are six (6) beats per measure, with each eighth note (8) receiving a beat. (In books discussing music, including this dictionary, $\frac{6}{8}$ is often written 6/8, $\frac{2}{4}$ appears as 2/4, etc.).

The modern system of time signatures comes from the medieval system of proportions (see PROPORTION), which indicated meter as a fraction of a fixed note value, the **semibrevis** (equal to the modern whole note). Two of the older signs have survived, the C used for $\frac{4}{4}$ meter, and the ¢ used for $\frac{2}{2}$ and $\frac{4}{4}$ meter. Besides these two, other time signatures that are found with reasonable frequency are: 2/4, 3/2, 3/4, 3/8, 3/16, 4/8, 5/2, 5/4, 5/8, 5/16, 6/4, 6/8, 7/16, 9/8, 9/16, 12/8.

The time signature ordinarily appears near the beginning of the staff, after the clef sign and the key signature (indicating sharps and flats, if any). Sometimes two time signatures appear together; this indicates either that two meters are being used at the same time (see POLYMETER) or that the

music is constantly changing back and forth between the two meters. Some twentieth-century composers have devised still other, more novel forms of time signature.

time-space notation A system of notation that indicates rhythm— that is, the duration of sounds—by horizontal lines related to a fixed scale. Introduced by Earle Brown in 1953, it is particularly useful for representing tape portions in music that combines live and recorded sound.

time value See under TIME.

timpani (tim' pə nē) *sing.* **timpano** (tim'pə nō) *Italian.* Also, *kettledrums.* An important orchestral percussion instrument and the only orchestral drums that are tuned to a definite pitch. At least two timpani have been included in every standard orchestra since about 1700, and often there are three or four timpani (played by one player). Each drum consists of a shell, which is a basin or "kettle" of copper or brass, with a head of calfskin or plastic stretched over the open top. The head can be tightened or loosened by means of screws, which are either turned by hand or operated by pedals. The exact pitch to which a drum is tuned depends on the diameter of the bowl (the smaller the diameter, the higher the pitch), as well as on the tautness of the head (the tauter it is, the higher the pitch) and the actual condition of the calfskin (its thickness, resiliency, and so on). A good drum will have a range of about one fifth (from C to G in the key of C, for example) and some have a range of an octave or more. Modern timpani can be tuned as low as the second C below middle C and as high as the second A above middle C. The symphony orchestra normally has three timpani, with a combined range from low E-flat to the G below middle

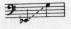

C. The lowest-pitched drum measures about thirty inches in diameter, the middle one about twenty-six to twenty-seven inches, and the highest about twenty-three to twenty-four inches.

The timpani are sounded by being struck with a pair of padded drumsticks, which the player selects for the desired effect. The drumsticks come in different sizes, and the heads are covered with various materials—cork, wood, sponge, felt, or others; the harder materials produce louder, sharper sounds than the soft ones. The player stands behind the drums, the larger one usually to the left and the smaller to the right. The best tone is obtained by hitting the drums about one-fourth of the way from the edge to the center. If the drum is struck elsewhere, as, for example, in the center, fewer harmonics are heard and the sound is that of a dull thump. The most common way of playing is to alternate right and left drumstrokes, but numerous special effects are possible. Among the most dramatic is the ROLL, a series of left–right–left–right beats on a single drum, producing a long-held note. Also, two drums can be struck at the same time producing two notes together, or each drum can be struck twice in succession (left–left–right–right). Timpani can be played very softly or very loudly, and crescendos and diminuendos can be obtained as well.

Owing to their wide range of expression, timpani have been popular in Western (European and Ameri-can) music since they were brought to Europe by the Turks in the fifteenth century. At first they were played in cavalry bands, the drums being mounted on horses. Usually they were played together with trumpets, a pair of timpani being used with anywhere from three to a dozen trumpets. During the seventeenth century they were improved somewhat and began to be included in the orchestra. Usually a pair of timpani was used, tuned a fifth apart, one to the tonic key of the composition and the second to the dominant (C and G in the key of C, D and A in the key of D, etc.). This practice persisted until the time of Beethoven (early nineteenth century), who greatly extended the timpani's role. His music called for rolls and other special effects, and frequently it required different tunings from the conventional one. Berlioz suggested replacing the heavy wooden drumsticks used since the fifteenth century with sponge- or leather-headed sticks, making possible a greater variety of effects. His Requiem Mass calls for sixteen timpani (played by ten timpanists). After about 1850 composers often called for fairly frequent changes of tuning, instead of a single tuning for a whole movement or piece. This led to the invention of pedal-tuned drums, as well as drums tuned by a single turn of a handle (in the older type, each screw had to be turned by hand). Composers have occasionally written for timpani alone, as, for example, Elliott Carter's Fantasy and Improvisation for 4 Timpani (1966).

Tinctoris (tink tôr′ əs), **Johannes** (yō hän′ əs), 1436–1511. A Belgian composer and theorist who wrote one of the earliest music dictionaries, *Terminorum musicae diffinitorium* ("Definitions of Musical Terms"), published in 1473, as well as some important essays on the music of his time. Tinctoris said that no music written before about 1430 was of real importance, and he pointed out that most of the major new developments of his

time were begun in England, whose most important composer was John DUNSTABLE.

Tin Pan Alley A term applied to the principal American music publishers, song promoters, songwriters, and record companies engaged in producing and promoting popular music. The name dates from the early twentieth century, when a single block in New York City (28th Street between Fifth Avenue and Broadway) housed most of the publishers, and the street echoed with the sound of rehearsal pianists, described by songwriter-journalist Monroe H. Rosenfeld as tin pans being struck simultaneously. In succeeding years the locus of Tin Pan Alley moved uptown, and by 1960 music publishing was no longer centered exclusively in New York, but the name is still used in a general way for POPULAR MUSIC.

tin whistle See PENNY WHISTLE.

Tippett (tip'ət), **Michael** 1905– . An English composer who wrote sonatas, quartets, concertos, and symphonies but became best known for his operas and large-scale choral works, all to his own texts. Although Tippett began composing at an early age, he discarded most of the works he produced before 1935. Of his early pieces, the Double Concerto for string orchestra (1939) is still performed. In 1938, inspired by a political incident, Tippett began to write a large oratorio to protest against the persecution of Jews. This work, *A Child of Our Time* (1943), uses black spirituals interspersed among the dramatic sections to comment on the story. His first opera, *The Midsummer Marriage* (1955), was concerned more with the inner lives of the characters than the events of the plot and was not well received. In his second opera, *King Priam* (1962), Tippett used voices in a declamatory rather than lyrical fashion and broke up the large orchestra into smaller sections, used a few at a time, making for clearer musical textures (since the whole orchestra rarely

plays at the same time). This technique also appears in his Concerto for Orchestra (1963), dedicated to Benjamin Britten. Tippett's third opera, *The Knot Garden* (1970), is, like his first, symbolic in subject, but the music is much more spare and is in part based on a twelve-tone theme (see SERIAL MUSIC). Here Tippett used QUOTATION in both music and text. Blues and other elements of popular music also are present, and the third act contains charades on themes from Shakespeare's *The Tempest.* It was followed by *The Ice Break* (1977) and Triple Concerto (1979) for violin, viola, cello and orchestra. In *The Mask of Time* (1984), for solo quartet, mixed chorus, and large orchestra, the text, composed of metaphors from many sources, is divided into ten scenes representing various stages of the creation of the cosmos, the appearance of human life, the development of society and technology and its potential for self-destruction. Quotations abound, from other composers and Tippett's own works. In addition to these large-scale vocal compositions, Tippett's output includes three piano sonatas, four string quartets, four symphonies, the oratorio *The Vision of St. Augustine,* the opera *New Year* (1989), *The Rose Lake* for large orchestra (composed 1993), and numerous madrigals, choral works, and solo songs.

tiré See TIREZ.

tirez (tē rā'). Also, *tiré.* The French term for down-bow (see under BOWING).

toasting See under RAP.

toccata (tô kä' tä) *Italian.* A keyboard composition for harpsichord, clavichord, or organ that contains a great deal of elaborate and rapid passage work—runs, arpeggios, and ornaments—which sometimes alternates with sections in imitative counterpoint (a melody being taken up in turn by the different voice-parts; see IMITATION). The toccata was developed by Italian keyboard composers of the

sixteenth century, mainly Andrea Gabrieli, and later by Giovanni Gabrieli, Claudio Merulo, and Girolamo Frescobaldi. It was taken up by numerous German keyboard composers of the baroque period (1600–1750), among them Froberger, Pachelbel, and Buxtehude, and eventually by Bach, who often paired an organ toccata with a fugue, the toccata replacing the prelude that normally preceded a fugue. In the nineteenth century the toccata became a piece to show off the performer's technical skill; such works were written by Schumann, Debussy, and others.

tombeau (tôn bō') *French.* A lament (see LAMENT, def. 1).

tom-tom 1 A general name for drum, used by various Indian tribes of North America. Contrary to popular belief, tom-toms were always played with drumsticks, never with the bare hands. **2** A type of high-pitched drum employed in dance bands, usually in sets. Supposedly imitating African drums, they can be tuned to definite pitches. Some tom-toms have two heads, and others only one. See also TIMBALES, def. 1.

tonada (tō nä' dä). The Spanish word for tune or SONG.

tonadilla (tô nä t̲h̲ē'yä, tô nä t̲h̲ēl'ya) *Spanish.* A type of short comic opera that was popular in Spain from about 1750 to 1850. Replacing the older and more complicated ZARZUELA, the tonadilla originated much as the Italian comic opera did, that is, as a humorous interlude inserted in a serious play or opera that eventually became an independent work.

tonal Describing music that is in a definite key; see KEY, def. 3; TONALITY. —**tonal answer** See under ANSWER; see also under SEQUENCE.

tonality (tō nal'i tē). The use of a central note, called the **tonic**, around which the other tonal material of a composition—the notes, intervals, and chords—is built and to which the

music returns for a sense of rest and finality. Tonality refers particularly to harmony, that is, to chords and their relationships. Nearly all music of the seventeenth to nineteenth centuries is based on tonality (and often is described as "tonal" or "diatonic"), but since about 1900 many composers have abandoned this concept. See ATONALITY; also KEY, def. 3.

tonante (tô nän'te) *Italian.* A direction to perform very loudly and vigorously, in a thundering fashion.

tone 1 Any sound of definite pitch; a note. In British terminology a definite pitch is called a note, not a tone. **2** In British usage, the interval of one whole tone (or major second; see INTERVAL, def. 2), as opposed to one half tone (minor second). In American terminology this is usually referred to as a whole tone. **3** Also, *recitation tone.* In Gregorian chant, a melodic formula used for reciting the psalms, gospels, and other parts of the religious service. It is usually based on a single tone (pitch), with some slight variations from it (a few notes up or down in pitch). A PSALM TONE is one kind of recitation tone. **4** The quality of sound. An instrument is said to have "good tone" if it has good intonation (is properly tuned) and pleasing tone color (a good blend of harmonics). Performers are said to produce good tone if they play or sing exactly on pitch and obtain a pleasing tone quality.

tone cluster See CLUSTER.

tone color Also, *timbre.* The blend of harmonics (overtones) that distinguishes a note played on a flute, for example, from the same note played on the violin. Tone color is determined by both the particular harmonics sounded and their relative loudness. Combining the different instruments, each with its characteristic tone color, is a major concern in writing music for an instrumental ensemble. See also under SOUND.

tone poem Another name for SYM-PHONIC POEM.

tone row Another name for the series of twelve tones used in twelve-tone music; see under SERIAL MUSIC.

Tonette (tō net'). A small plastic wind instrument that is used mainly in teaching music to young children. It consists of a pipe not quite eight inches long, stopped at one end and with a whistle-like mouthpiece (like the recorder's) at the other end. There are seven finger holes, plus a rear thumb hole. The small size and close position of the finger holes make the Tonette easy for a child to handle. A similar instrument is the FLUTOPHONE.

tonguing (tung'ing). In playing wind instruments, the technique of using the tongue to produce clear and separate tones, as well as staccato and other special effects. Tonguing, which is essential for proper PHRASING, involves a silent pronunciation of the letters T or K, which interrupts the flow of air. —**single tonguing** The silent pronunciation of the letter T over and over, enabling the clear articulation of different notes. This technique is used in all wind instruments. —**double tonguing** The silent pronunciation of *ta-ka* over and over, enabling the quick repetition of a single note. This technique is used mainly in wind instruments that have no reed, such as the recorder, flute, and most brass instruments. —**triple tonguing** The silent pronunciation of *ta-ta-ka* over and over, enabling very rapid playing. Triple tonguing is used mostly in playing brass instruments and the flute. —**flutter tonguing** The technique of silently rolling the letter R over and over while blowing, which results in a tremolo (a kind of trembling on a single note). It is used in playing the flute and some other instruments, and produces a rather odd effect. Notes to be so played are sometimes indicated by either a wavy line over them or by strokes through their stems.

tonic Also, *keynote, prime.* The first degree of the diatonic scale, that is, the first note in any major or minor scale (see SCALE DEGREES). In the keys of C major and C minor, the tonic is C, in the key of D major it is D, etc. The tonic is the most important note of the scale, dominating both melody and harmony (see TONALITY). In analyzing the harmony of a composition, the letter T or the Roman numeral I is used to indicate the tonic or a chord built on it. —**tonic chord** A chord built on the tonic. The most important tonic chord is the tonic triad, the triad whose root is the tonic (in the key of C major, C–E–G; see also CHORD).

tonic accent See under ACCENT.

tonic major See under KEY, def. 3.

tonic minor See under KEY, def. 3.

tonic sol-fa (ton' ik sōl fä'). A method of solmization developed in England and widely used there since about 1840. The syllables *doh, ray, me, fah, soh, lah,* and *te,* are used for the degrees of the scale, *doh* standing for the tonic (first note) in any key, *fah* for the subdominant (fourth note), and so on. (This differs from the French system of solmization, in which *ut,* which is substituted for *doh,* always stands for C, no matter what the key.) The vowel *e* is used for sharps (in the key of C, *de* means C-sharp) and the vowel *a* for flats (*da* is C-flat). In notating (writing music) only the initials of the syllables are used (*d, r,* etc.). See also SOLMIZATION.

top Another word for BELLY.

Torelli (tô rel' ē), **Giuseppe** (jōō sep'e), 1658–1709. An Italian composer and violinist who is remembered as one of the earliest composers of the concerto grosso and solo violin concerto and the most important member of the BOLOGNA SCHOOL. He studied and lived most of his life in Bologna, except for some years spent in Germany and Vienna. His concerti grossi were the first to be published (in 1709), although he was not the

first to use the form. In addition Torelli wrote six solo violin concertos, also published in 1709.

tosto (tôs'tô) *Italian.* A direction to perform quickly, in a hurried manner. See also PIUTTOSTO.

total serialism See under SERIAL MUSIC.

Totenmesse (tō'tən mes"ə). The German term for REQUIEM MASS.

touch 1 The technique of pressing down the keys in a keyboard instrument, such as the piano or harpsichord. In pianos, heavier touch produces louder tones; in harpsichords and clavichords, volume (loudness) does not change with the weight of touch, but tone quality does. **2** The looseness or tightness of the key mechanism in a keyboard instrument; a piano with a heavy touch requires strong finger pressure to be played.

touche, sur la (SYr lA tōōsh') *French.* A direction to play over the fingerboard (of violins, violas, etc.), producing a FLAUTATO tone.

Tourte (tо̄ort) **bow** See under BOW.

tpt. An abbreviation for TRUMPET.

tr. An abbreviation for TRILL. It often appears in script (*tr* ⌇⌇⌇⌇).

tracker action See under ORGAN.

Tract In the Roman Catholic rite, a part of the Proper of the Mass that is substituted for the Alleluia during certain festivals of the church calendar, such as Lent. The Tracts are among the oldest portions of Gregorian chant, believed to date back to the fourth or fifth century. Their music is in either the second or the eighth church mode (see CHURCH MODES), a restriction not found in most other chants, and their texts are from the Book of Psalms.

tragédie lyrique (trA zhā dē' lē rēk') *French.* See under LULLY, JEAN-BAPTISTE; OPERA.

tranquillo (trän kwē' lō) *Italian.* Also, French, *tranquille* (träN kē'y°). A direction to perform in a quiet, calm manner.

transcription 1 See ARRANGEMENT, def. 1. **2** Copying a work from a live or recorded performance to written notation. **3** A recording made especially for broadcasting.

transition See BRIDGE, def. 2; see also SONATA FORM.

transpose To write or perform a musical work in a key other than that in which it was originally written. Such a key change, or **transposition**, is nearly always made in order to accommodate the range of a singer or a different instrument from the one the composer originally intended. Trained performers often can transpose music at sight, a skill that is particularly useful for accompanists.

transposing instruments Instruments for which music is written at a different pitch or in a different octave from the sounds actually produced. By far the great majority of transposing instruments are wind instruments, which frequently are pitched in keys involving numerous accidentals (B-flat, E-flat, etc.), or which sound so high (piccolo) or so low (double bassoon) that their music requires many ledger lines (lines above and below the normal staff). To make it easier to read, therefore, the music for such instruments is written either in a simpler key, such as C (with no sharps or flats), or in an octave that can be notated on the staff with fewer ledger lines (substituting middle C for high C, for example). On the B-flat clarinet, for instance, the easiest key to play is the key of B-flat, but the music is written in a key much easier to read, the key of C major. Since C is one whole tone (a major second) higher than B-flat, each note of the music is written one whole tone higher than the note sounded. If the note sounded is F, the written note will be G. The music for clarinets pitched in A and E-flat also is written in the key of C major, one and one-half tones (a minor third) below and above C respectively.

The practice of transposing instruments—or rather, of transposing music for certain instruments—dates from the time when most wind instruments could sound only a fundamental note and its harmonics (overtones), and changing that fundamental to a different one involved changing the length of the instrument, either by adding or taking away from its tubing, or by substituting a longer or shorter instrument. The practice has persisted, despite attempts by some twentieth-century composers to do away with it. Today nearly all wind instruments not pitched in C are transposing instruments, except for the trombone (whose music, even for an instrument pitched in B-flat, is written as it sounds). The chief transposing instruments of the orchestra are the English horn, the various clarinets and bass clarinets, the French horn, and the trumpet. Such band instruments as cornets and saxophones are also transposing instruments. In addition, the music for piccolo and soprano recorder is written an octave lower than it sounds, and that for double bass and double bassoon is written an octave higher than it sounds.

transposing keyboard A keyboard that permits playing in different keys or tunings with the same fingering. Such keyboards were devised for harpsichords in the sixteenth century for various purposes, such as to obtain accidentals not available with a tuning in mean-tone TEMPERAMENT, or to accommodate a singer's range. etc. About 1800 a similar mechanism was devised for a transposing piano. Some modern harpsichords have a transposing keyboard that permits shifting from modern pitch to baroque pitch, which was considerably lower.

transposition See under TRANSPOSE.

transverse flute An older name for the orchestral flute, which is side-blown, to distinguish it from the recorder, which is end-blown. (See under FLUTE.)

traps A general term for the drums and other percussion instruments (including rattles, whistles, and other devices for special effects) used in dance bands and jazz ensembles.

trascinando (trä shē nän'dô) *Italian.* A direction to slow down gradually, or to perform at a dragging pace.

trattenuto (trä te nōō' tô) *Italian.* A direction to hold back in tempo, to slow down somewhat.

träumerisch (troi'mer ish) *German.* A direction to perform in a dreamy manner.

traurig (trou'riкн, trou'rik) *German.* A direction to perform in a sad, mournful manner.

Trautonium (trou tōn' yum). See under ELECTRONIC INSTRUMENTS.

tre, a (ä tre) *Italian:* "for three." **1** An indication that a part is to be played by three instruments in unison, for example, the first, second, and third horns (which normally play separate parts). **2** An indication that a composition or section is written for three voice-parts, as in *sonata a tre* ("trio sonata").

treble 1 A high-pitched voice, either an adult's (soprano, male alto) or a child's. **2** In choral or instrumental music with several voice-parts, the highest voice-part. **3** In instruments that are made in different sizes, such as the recorder, the highest-pitched instrument of the group.

treble clef See under CLEF.

tre corde See under CORDA.

treibend (trī'bent) *German.* A direction to hurry, to perform as though being driven forward.

tremolo (tre'mô lō) *Italian:* "trembling." **1** Rapid repetition of a single pitch or of two pitches alternately, producing a trembling effect. Produced on a single pitch, tremolo differs from vibrato in that the trembling is caused by rapid changes in volume (loud–soft) instead of slight changes in pitch (see VIBRATO,

def. 1). **2a** Also, *bowed tremolo*. In
bowed stringed instruments (violin,
cellos, etc.), a single note is rapidly
repeated by means of quick back-and-
forth strokes of the bow. It is often
indicated by a series of horizontal
lines through the stem of the note: ♪.
Performed by a group of violins, as in
the orchestra, such a tremolo has a
highly dramatic effect; one of the ear-
liest uses of violin tremolo was in
Monteverdi's opera, *Il Combattimento
di Tancredi e Clorinda* (1624), and it
has been used frequently ever since.
In scores it is indicated as shown
under *A* in the accompanying exam-
ple. If the tremolo is to be performed

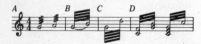

staccato, dots are added under the
notes; if portato is required, dots and
a slur are added (see STACCATO and POR-
TATO for definitions). **2b** Also, *fingered
tremolo*. In bowed stringed instru-
ments (violins, etc.), the rapid alter-
nation of two pitches, usually no
more than a third apart (C and E, D
and F, etc.). It is executed on a single
string that is stopped at two different
points; the effect is smoother and less
agitated than the bowed tremolo,
instead resembling a fluttering effect,
similar to a trill. In scores fingered
tremolo is indicated as shown under *B*
in the accompanying example. A com-
bination of bowed and fingered
tremolo is indicated in the same way
as fingered tremolo but without the
slur (*C* in the example). **3** In wind
instruments an effect like bowed
tremolo can be achieved by flutter
tonguing (see under TONGUING). A
tremolo like the fingered tremolo usu-
ally sounds the same as a trill. **4** On
the piano an effect similar to fingered
tremolo is produced by the rapid alter-
nation of two notes, or even two inter-
vals or chords. It is often indicated as
shown under *D* in the accompanying
example. **5** In organs a special stop
called the **tremulant** (or *tremolo*) pro-
duces an effect not of tremolo but of

vibrato (see VIBRATO, def. 5). **6** In
singing, tremolo is a slight wavering of
pitch on a single note, similar to the
vibrato of stringed instruments (see
VIBRATO, def. 2). As in vibrato, the
singer alternates between slightly flat
and slightly sharp intonation instead
of producing a single true pitch, but it
is an exaggerated vibrato, the result of
poor singing. A true tremolo—the
quick repetition of a single note—is
possible to produce but is seldom
called for today; in early music, how-
ever, it was used fairly often.

tremulant An organ stop that pro-
duces a vibrato. See VIBRATO, def. 5.

trepak (tre päk') *Russian*. A Russian
dance in 2/4 meter and lively tempo.
Originating among the Cossacks, the
trepak appears in a number of Russian
compositions, among them Mus-
sorgsky's song cycle, *Songs and Dances
of Death*, and Tchaikovsky's piano
work, *Invitation to the Trepak*, op. 72,
no. 18.

très (tre) *French*: "very." A word used
in such musical terms as *très lente-
ment*, very slowly.

triad (trī′ad). A chord made up of two
thirds; see under CHORD.

triangle A percussion instrument
that consists of a steel rod bent into
the shape of a triangle and suspended
(hung) from a string made of gut. It is
played with a metal beater, with
which it is struck either inside (on the
inner part of the triangle) or outside.
A tremolo (see TREMOLO, def. 1) can be
produced by holding the beater
inside the triangle and rapidly mov-
ing it back and forth. The most
important of the smaller orchestral
percussion instruments, the triangle
first appeared in Europe during the
late Middle Ages. Until the eigh-
teenth century, when it became part
of the orchestra, it usually included
several metal rings, which jingled
when it was struck. Mozart was the
first to use it in the orchestra, intro-
ducing it along with two other Turk-
ish instruments, the bass drum and

cymbals, in his opera *Die Entführung aus dem Serail* ("The Abduction from the Seraglio," 1782; see also JANISSARY MUSIC). The triangle has a notable solo part in Liszt's Piano Concerto no. 1 in E-flat, and it appears in hundreds of other orchestral works.

trill One of the most frequently used musical ornaments. It consists of the rapid alternation of a note with the note one half tone or one whole tone above it (such as C and C-sharp, or C and D); it frequently ends with another ornament known as a NACHSCHLAG (def. 1). The accompanying example shows one of the common abbreviations for the trill and its execution, together with the closing ornament. (See also the example accompanying ORNAMENTS.) In the

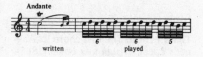

written played

seventeenth and eighteenth centuries the trill was usually begun on the upper note; since the early nineteenth century it generally has been begun on the lower note. The exact number of notes played depends both on the performer's skill and on the tempo of the passage. In the example here, the tempo is moderately slow (andante), making it possible to perform quite a few notes; in a fast

tempo (allegro or presto) groups of four notes might be substituted for the groups of six.

trio (trē'ō). 1 A section of a minuet, scherzo, or march that occurs between the first section and its repetition, the normal scheme being minuet–trio–minuet (or scherzo–trio–scherzo, or march–trio–march). The trio is so called because in the seventeenth century it was customary to write the music for minuets and other dances for three voice-parts. Although this custom was dropped in the sonatas and symphonies of the classical period (1785–1820), the name "trio" was retained, both for the minuet and for the scherzo that was sometimes used in place of a minuet (by Beethoven and others). 2 A composition for three instruments or three voices. Since each instrument or singer has a separate part, the trio is a type of chamber music. For instruments, the most familiar combination is the PIANO TRIO, consisting of piano, violin, and cello. Another combination is the STRING TRIO (usually violin, viola, and cello), which has proved far less popular than the piano trio. Other combinations usually involve one or more wind instruments. Examples include Beethoven's Trio in C, op. 87, for two oboes and English horn; Brahms's Horn Trio, op. 40 (1865) and Wuorinen's Horn Trio (1981) for horn, violin, and piano; Milhaud's *Pastorale* (1935), for oboe, clarinet, and bassoon; and Debussy's Sonata for flute, viola, and harp (1915). 3 An ensemble made up of three voices or instruments.

trio sonata The most important form of chamber music during the baroque period (1600–1750). Its name comes from the fact that it has three voice-parts (*trio*) and it is a piece of instrumental music (*sonata,* as opposed to vocal music, called *cantata*). Actually, the three parts are played by four instruments; the top two parts are often for two violins, and the bottom part is a basso continuo (see CONTINUO) played by a cello supported by

a keyboard instrument (harpsichord or organ). In the early baroque period the violin parts were often scored for viols or cornetts, the cello part for a bass viol, and the keyboard part for a theorbo (bass lute). In the late baroque, other combinations were used—for example, Telemann's Trio Sonata in E-flat is for oboe, bassoon, lute, and harpsichord.

The trio sonata developed early in the seventeenth century; at the beginning it was simply a canzona with three voice-parts (see CANZONA, def. 4). About 1700, two distinct forms of trio sonata developed, the *sonata da camera* and the *sonata da chiesa* (see under SONATA). The trio sonata remained popular throughout the baroque, outstanding examples being written by Buxtehude, Purcell, Corelli, Handel, Couperin, Vivaldi—in fact, all the major composers of the period. Bach wrote not only trio sonatas for two violins and continuo but also organ sonatas with three voice-parts (the pedal playing the continuo part) as well as numerous sonatas for two violins and harpsichord (distinguished by the fact that the harpsichord part was written out in full, rather than being the figured bass customarily used for the continuo; see FIGURED BASS). As late as 1766 Haydn wrote some sonatas for two violins and bass. Later, in the classical period (1785–1820), the trio sonata became the trio of chamber music (see TRIO, def. 2). Its ancestry is particularly evident in the piano trio, where the piano part might be said to replace the baroque continuo, and the violin and cello take over the two violin parts.

triple concerto See under CONCERTO.

triple counterpoint See under COUNTERPOINT.

triple course See under COURSE.

triple fugue See under FUGUE.

triple meter Any meter in which there are three basic beats per measure, such as 3/2, 3/4, and 3/8, which may be subdivided into two, three, or more parts. See also METER.

triple stopping In violins and other bowed stringed instruments, playing three notes at the same time, either by stopping (holding down) three strings with the fingers so that the bow passes across them in a single stroke, or by passing the bow across three open strings at the same time. In either case, a three-note chord is sounded.

triplet A group of three notes of the same time value (all eighth notes or all quarter notes, for example) that are to be performed in the time usually taken for two notes. For example, in 2/4 meter, calling for two quarter notes per measure, a triplet might be a group of three quarter notes within a measure. The triplet is usually marked with a bracket or slur (curved line) and the figure 3. In the accompanying example, from a Mozart piano sonata, six groups of three sixteenth notes are played in the time normally allotted to six pairs of sixteenth notes.

triple tonguing See under TONGUING.

Tristan chord The first chord in Wagner's opera, *Tristan und Isolde* (1865), F-B-D#-G#. This form of the seventh chord, made up of a minor third, diminished fifth, and minor seventh (see under CHORD), came to be regarded as signaling the extreme chromaticism that eventually led to the breakdown of traditional harmony.

triste (trēst) *French.* Also, Italian, *tristo* (trēs'tô). A direction to perform in a sad, mournful manner.

tristo See TRISTE.

tri-toms See under DRUM AND BUGLE CORPS.

tritone An interval of three whole tones, either an augmented fourth, such as C–F# or D–G#, or a diminished fifth, D–A♭ or E–B♭. (See INTERVAL, def. 2, for an explanation of these terms.) The tritone was long considered an interval to be avoided, both in building chords and in melodic progressions. Hence its medieval name, *diabolus in musica* (Latin for "devil in music," often translated as "devil's tritone"). However, twentieth-century composers generally use it as freely as any other interval.

tromba (trôm'bä). The Italian word for TRUMPET.

tromba marina (trom'bä mä rē' nä) *Italian:* "marine trumpet." An instrument with a single long gut string that was played with a bow and sounded only harmonics. Unlike most bowed instruments, the bowing took place above the fingering, for which the thumb was much used. One leg of the bridge (see BRIDGE, def. 1) was shorter than the other and so was free to vibrate against a metal plate fixed to the soundboard, producing a brassy sound. The tromba marina was used principally from about 1450 to 1775, and the reason for its name is not known. It also was called **nun's fiddle** because it was often used in convents. Other names were the German *Nonnentrompete, Nonnengeige, Marientrompete,* and *Trumscheit,* the French *trompette marine,* and the English *trumpet marine.*

trombone A brass instrument of medium-low pitch, a standard member of the orchestra and band. It has a cup-shaped mouthpiece and a cylindrical bore (tube-shaped inside) that widens gradually at the bottom into a flared bell. In addition, attached between the mouthpiece and the main tube of the instrument is a long, U-shaped length of tubing, called a **slide.** The slide, which can be pushed

toward and away from the player, plays the role of valves in other brass instruments—that is, it changes the length of the total tube, and therefore alters the pitch. Like other brass instruments, the trombone is made to sound by vibrations of the player's lips; see BRASS INSTRUMENTS for further explanation. With the slide pushed

all the way in, in first position, the player sounds the fundamental note of the instrument (in a tenor trombone, the B-flat above middle C; in a bass trombone, the F above middle C). In second position, with the slide pulled out a little, the instrument sounds exactly one half tone below the fundamental, in third position one whole tone below the fundamental, and so on to the seventh position, lowering the pitch by three whole tones. In this way, all the notes of the chromatic scale become available. However, since it takes time to move the slide from one position to another, it is difficult to play a series of notes very smoothly.

The trombone is descended from the SACKBUT, which was invented as an improvement on the natural trumpet in the fifteenth century. Numerous sizes of trombone were built, ranging from soprano and alto to contrabass (double bass). Today mainly the bass and tenor sizes are used, each with a range of about two octaves. The tenor trombone is usually pitched in B-flat and the bass in F; a symphony orchestra generally includes two tenors and

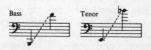

one bass. In addition to its normal range, the tenor has three low pedal tones, which, however, are difficult to obtain. This difficulty is largely solved by providing the trombone with an extra coil of tubing, which is brought into play by means of a thumb valve and which lowers the pitch from B-flat to F. It is this instrument, in effect a combination tenor-bass trombone, that is shown in the accompanying illustration. It is less cumbersome, easier to play, and has replaced the bass in many orchestras.

Music for tenor trombone is written in the bass clef, but for the top of its range the tenor clef is sometimes used in order to avoid ledger lines. Music for bass trombone is always written in the bass clef. Unlike most brass instruments, the trombone is not a transposing instrument, its music being written at the same pitch that it sounds.

In the early nineteenth century, a contrabass trombone came into use; bent into four parallel tubes and having a double slide, it was pitched an octave below the tenor trombone. It is seldom used today. In addition, at various times trombones with valves instead of slides have been built, but their tone is inferior to that of the slide trombone.

Nearly every composition for orchestra written since about 1800 includes parts for trombones, as do many earlier ones. It has been used less as a solo instrument. A few of the notable works for solo trombone (or with prominent parts for solo trombone) are: Poulenc, Trio for trombone, trumpet, and horn (1922); Martin, *Ballade for Trombone and Orchestra* (1940); Hindemith, Sonata for trombone (1942); Dubensky, Concerto for trombone and orchestra (1953); Milhaud, *Concertino d'hiver* for trombone and string orchestra (1953); and Zwilich, Trombone Concerto (1994). The trombone has also been important in jazz, with Jack Teagarden, J. J. Johnson, and other outstanding artists. Often abbreviated *tbn*.

Trommel (trôm'əl). The German word for DRUM.

Trompete (trôm pā' te). The German word for TRUMPET.

trompette (trôn pet'). The French word for TRUMPET.

trope (trōp). A general name for a section, consisting of words or music or both, that was added to a Gregorian chant. The practice of adding to the original chant in this way, called **troping**, was very common from the tenth to twelfth centuries. Numerous techniques were used. One was to give the melisma (a passage of music sung to a single syllable) of a chant an entirely new text. Another was to add a melisma to a chant. Still another was to add a new song (words and music) before, after, or in the middle of a chant. Practically all the sections of the Mass were treated in this way. One such trope was the SEQUENCE, originally an addition to the Alleluia, which eventually became an independent hymn. The music for the various tropes was collected in a book called a **troper**. From the twelfth century on, with the development of polyphony (music with several voice-parts), composers began to write polyphonic settings of the tropes as well as of the original plainsong chants. In the sixteenth century, when the Council of Trent decided to reform the Roman Catholic liturgy, it abolished all tropes, judging them, along with most sequences and elaborate polyphonic Mass settings, to be a corruption of the liturgy.

troper (trō'pər). See under TROPE.

troppo (trôp'ô) *Italian:* "too" or "too much." A word used in such musical terms as *allegro (ma) non troppo* ("fast but not too fast").

troubadour (trōō' ba dôr"). A kind of poet-musician who lived in Provence (now part of southern France) in the twelfth and thirteenth centuries. The troubadours were the first important group of European poets to use the

language of the people (*langue d'oc*, today called occitan in France and Provençal elsewhere) instead of Latin, the learned language of the time. The troubadours' music, of which about 275 melodies survive, was monophonic (consisted of a single voice-part, the melody). The texts are mostly love poems (*cansos*), consisting of several stanzas and a short ending stanza; however, in some the music changed throughout while in others one or more phrases were repeated. The melodies were written down without showing the rhythm (how long each note is to be held in relation to the others), so it is not known exactly how the songs were performed. Also, although there are pictures of troubadours either accompanying themselves on an instrument or performing together with a fiddler or other instrumentalist, the music does not indicate what part the instrument played; most likely it simply doubled (repeated) the singer's part, perhaps being given a short beginning or concluding section of its own.

Even though the troubadours wrote in the language of the common people, a number of them were noblemen, and most had noble patrons and performed at court. One of the earliest troubadours was also an influential ruler, Guilhem (William) IX, Count of Poitiers and Duke of Aquitaine (1071–1127). Perhaps the most famous troubadour of all was Bernart de Ventadorn (c. 1140–1195).

The influence of the troubadours spread to northern France, which by the mid-twelfth century had minstrels of its own, the trouvères. They also had a counterpart in Germany, the minnesingers. (See also TROUVÈRE.)

trouvère (trōō ver') *French.* One of a group of poet-musicians who lived in northern France in the twelfth and thirteenth centuries. Like the troubadours of Provence, the trouvères wrote in the language of the people instead of in Latin. Their language was French, at that time called *langue d'oïl* (the troubadours' was Provençal, called *langue d'oc*). Also like the troubadours, they wrote mostly love songs, and the music was monophonic (with one voice-part only). However, their songs featured more repetition, and they often had a refrain. They also used another form, the LAI.

The trouvères included both noblemen and commoners. Among the most notable were Blondel de Nesles (late twelfth century), a favorite of King Richard I (the Lionhearted) of England; Count Thibaut IV of Champagne (later King of Navarre; 1201–1253); Perrin d'Angecourt (thirteenth century); and Adam de la Halle (c. 1245–c. 1287). The trouvère songs have survived in far greater quantity than the troubadour songs, and their influence seems to have lasted longer and been more widespread, continuing until the early fourteenth century. (See also TROUBADOUR.)

trumpet A brass instrument of soprano range, a standard member of the orchestra and band. It has a cup-shaped mouthpiece and a cylindrical bore (tube-shaped inside) for most of its length but gradually widens at the bottom into a moderately flared bell. Like all brass instruments, the trumpet is made to sound by means of vibrations of the player's lips, which are tightly pursed and then buzzed against the mouthpiece.

The modern trumpet is bent back on itself, so that its overall shape is oval. It has three valves, each of which lengthens the tube slightly and thus lowers the pitch. Owing to these valves, which can be used alone or in combination, the trumpet can produce all the notes within its range. Without them, it could sound only one fundamental tone plus some of

its harmonics (overtones). The standard orchestral trumpet is pitched in B-flat and has a range of about two and one-half octaves, from E below middle C to B-flat below high C. (Jazz

trumpeters, however, are expected to extend this range by a fifth, to high G, and some can play up to a full octave higher.) Trumpets are TRANSPOSING INSTRUMENTS, their music being written in the key of C, one whole tone higher than it actually sounds. However, in recent years a nontransposing trumpet in C, with a more brilliant sound than the B-flat, has been favored by many players, especially in U.S. orchestras.

In the nineteenth century numerous other sizes of trumpet were in use, and although most of them have been discarded, a few are still used for special purposes. They include the **trumpet in** F, a perfect fourth lower than the B-flat trumpet, used for solo work in romantic music, and the **bass trumpet** in C or B-flat, an octave lower than the orchestral trumpet, used mainly for Wagner's opera cycle, *Der Ring des Nibelungen*. Modern players also use a D—E♭ trumpet (a slide makes both keys available), both in the orchestra and for the high-pitched music of the baroque and other periods. For the latter, many prefer to use a **piccolo trumpet** in B♭ or A, an octave higher than the orchestral trumpet and often equipped with a fourth valve, which makes available an extra fourth. There also is a piccolo trumpet keyed in C.

The tone of the trumpet is brilliant and penetrating. It can also be altered in various ways through the use of a MUTE, a block of wood, leather, or some other material pushed into the bell. Mutes can create echo effects, comic effects, and numerous special sounds; they are used a great deal by jazz trumpeters.

Trumpets are among the oldest brass instruments used in ancient China, Egypt, Rome, and elsewhere. Originally they consisted simply of a straight metal tube, flaring out at the end into a slightly wider open bell, and with or without some kind of mouthpiece at the top. Used for signaling, they could produce only one or two notes and presumably had a very harsh tone. This type of trumpet had no finger holes, slides, valves, or other means of altering its length (and therefore pitch), and thus is known as a **natural trumpet**. At first straight, the natural trumpet later (fourteenth century) was bent back on itself, and by the fifteenth century it was wound into a long, narrow oval shape. During the Renaissance (1450–1600) **slide trumpets**, which operate like trombones, were occasionally built, but they never became very popular. In Renaissance music the trumpet continued to be used for military and ceremonial purposes; there appeared to be no need for obtaining the notes between the fundamental and the harmonics (overtones), and trumpeters, usually members of a highly exclusive guild (trade society), learned how to play very elaborate fanfares using just the harmonics. During the sixteenth and seventeenth centuries trumpeters developed the **clarino** technique, whereby they obtained a very large number of harmonics, sometimes as many as sixteen notes (see HARMONIC SERIES). This made it possible to play simple tunes, and the trumpet began to be used in the orchestra. The great masters of the baroque (1600–1750) —Purcell, Bach, Handel, and others— often wrote high-pitched parts calling for clarino technique (see BACH TRUMPET). Baroque trumpets were usually pitched in D, but crooks (additional lengths of tubing) could be added to lower the pitch by as much as a fourth.

During the second half of the eighteenth century clarino technique

declined. For one thing, the upper harmonics were quite soft, and as the orchestra grew in size the clarino part was drowned out by the other instruments. Attempts to expand the use of the trumpet included the addition of keys (**key trumpet**), but this muffled the instrument's naturally bright, penetrating tone. Slides were tried again, with somewhat more success. Finally, about 1815, valves were invented by two German builders (working separately), and the trumpet became a true melody instrument. (See also VALVE.) Since about 1840, practically every major composition for orchestra has included a part for trumpet. A few works for solo trumpet (or with major parts for solo trumpet) are: Clarke's *Trumpet Voluntary* (long thought to have been written by Purcell); Handel's Concerto in D for two trumpets; Bach's *Brandenburg* Concerto no. 2; Telemann's Concertos (for one, two, three trumpets); Hummel's Concerto in E-flat; Haydn's Concerto in E-flat for trumpet; Honegger's Symphony no. 2 for strings and trumpets; Hindemith's Sonata for trumpet (1940); Hovhaness's Concerto for trumpet and strings (1945); Dlugoszewski's *Space Is a Diamond* for solo trumpet (1970); Henze's Sonatina for solo trumpet (1976); and Zwilich's *Concerto for Trumpet and Five Players* (1985). Further, the trumpet (along with the COR-NET) has been important in jazz since its early history; outstanding jazz trumpeters include Dizzy Gillespie, Miles Davis, Louis Armstrong, and Wynton Marsalis. Often abbreviated *tpt*.

Tschaikowsky See TCHAIKOVSKY.

tuba (tōō′bə). **1** The Latin word for trumpet. It appears in the text of the Requiem Mass in the *Dies irae* section, which begins, *Tuba mirum spargens sonum* ("The trumpet, spreading a marvelous sound"). **2** Also, *double-bass tuba, contrabass tuba, BB-flat bass*. A brass instrument of bass range, a standard member of the orchestra. It has a cup-shaped mouthpiece and a

very wide conical bore (cone-shaped inside), flaring out into a large bell. Basically, the tuba is a very large bugle with a very wide bore. Like all brass instruments, it is made to sound by vibrations of the player's lips against the mouthpiece. Three to five valves make available extra lengths of tubing, and hence different pitches.

Tubas are made in a large variety of sizes and shapes, and there is considerable confusion concerning the names of the various instruments. Some authorities regard only the instruments in straight shape, with the bell pointing upward, as true tubas, terming those made in circular shape (so as to encircle the player's body) helicon; see HELICON, def. 1. Further, some consider the euphonium a type of high-pitched tuba and others classify it as a saxhorn (see EUPHONIUM). In general, the band instruments are made in circular shape, so that they can be carried more easily, whereas the orchestral instruments are built in straight form. Another kind of tuba used in bands is the SOUSAPHONE. In the United States the principal orchestral tuba is keyed in B-flat, has three or four valves, and has a range of about two octaves, from low E to the B-flat below middle C (skilled players can reach the F above middle C; see the accompany-

ing example). In Europe the orchestral tuba is often pitched one whole tone higher, in C.

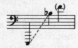

The tuba is among the most recently developed orchestral instruments; it was first built in the 1830s. The instrument has a heavy, dense, rich tone, and it soon became a standard member of the orchestra. Although it plays an important part in ensemble music, it is rarely used for solo works or for chamber music. One of the few works exploiting its solo possibilities is Vaughan Williams's Concerto for bass tuba and orchestra (1954). —**bass tuba** A tuba in E-flat, pitched a fourth higher than the BB-flat bass. Formerly called **bombardon**, it is still very popular in British brass bands. In Europe the bass tuba is often pitched in F (and the BB-flat bass in C, so it is still a fourth lower). —**tenor tuba** A tuba in B-flat, pitched an octave higher than the BB-flat bass, which has been largely replaced by the BARITONE HORN OR EUPHONIUM. —**sub-bass tuba** A tuba in E-flat, pitched an octave below the bass tuba. —**subcontrabass tuba** A tuba in B-flat, pitched an octave below the BB-flat bass. — **Wagner tuba** An instrument that combines features of the tuba and the French horn (see WAGNER TUBA).

tubular bells See CHIMES, def. 1.

tubular chimes See CHIMES, def. 1.

tune 1 See MELODY. **2** A term used to refer to correctness of pitch, as "in tune," meaning correct intonation (see INTONATION, def. 1; TUNING).

tunebook A collection of hymns and psalm tunes used in eighteenth- and nineteenth-century America mainly for teaching purposes (see SINGING SCHOOL). Among the important compilers of tunebooks, whose music often was in SHAPE-NOTE NOTATION, were Samuel Holyoke (*The Columbian Repository*), Daniel Read (*The American Singing Book*), Timothy Swan (*The New England Harmony; The Songster's Assistant*), Andrew Law (*The Select Harmony*), William BILLINGS, and Oliver Holden (*Union Harmony*). Some of these also contained a few original compositions. The first American tunebook with English fuging tunes and anthems, *Urania* (1761), was put together by James Lyon. One of the last and most influential was *The Southern Harmony* (1735), compiled by William Walker. Although still later tunebooks were published (*The Social Harp* came out in 1855), mainly containing folk songs, the practice then died out.

tuning Adjusting an instrument's strings (in the violin, piano, harpsichord, etc.) or pipes (in the organ) so that they will accurately produce the pitches required. In wind instruments intonation can be adjusted by altering the player's embouchure slightly or, in reed instruments, with the shaping of the reed. Tuning is based on one or another system of TEMPERAMENT. See also SCORDATURA.

tuning fork A steel instrument that sounds a single pitch with great accuracy and with few or no harmonics (overtones); it is used to tune instruments. Invented in 1711 by an English trumpeter named John Shore, it looks like a small, two-tined fork. Modern tuning forks usually produce the standard concert pitch, A above middle C (see A; SOUND). Today the tuning fork has been largely replaced by various electronic instruments, which can be tuned to varying pitch standards.

tuning peg See PEG.

turca, alla (ä"lä too͝r'kä) *Italian.* A direction to perform in Turkish style, referring to the style of music played by eighteenth-century Turkish military bands. See JANISSARY MUSIC.

Turkish crescent Also, *jingling Johnnie.* A percussion instrument consisting of a crescent mounted on a stick, over which is an ornament shaped

like a peaked Chinese hat. Both crescent and hat are hung with bells and jingles (small metal plates), which jangle when the stick is shaken. Used in Turkish military bands, the crescent became popular in the eighteenth century in music imitating that of the Turkish bands (see JANISSARY MUSIC).

turn See example under ORNAMENTS.

tutte le corde See under CORDA.

tutti (tōōt'tē) *Italian*: "all." **1** A term used in scores to indicate that all the performers are to play (or sing) a particular section. **2** In the CONCERTO GROSSO, a name for the full orchestra.

tweeter (twēt' ûr). In sound equipment, a speaker designed to handle high frequencies only. It is usually used together with a WOOFER and sometimes with a mid-range speaker.

twelfth The interval of an octave plus a fifth. (See INTERVAL, def. 2.) In most organs a special stop is provided to sound the twelfth (see MUTATION STOP). The twelfth is the third note of the

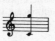

HARMONIC SERIES (the second overtone), and a closed pipe, such as a clarinet, tends to overblow at the twelfth (see OVERBLOWING).

twelve-tone technique Also, *dodecaphonic*. A method of composition in which the composer takes the twelve notes of the chromatic scale, in any order desired, and uses this series of tones over and over, so that they provide the underlying structure of the composition. See SERIAL MUSIC.

twentieth-century music A general name for musical styles developed since about 1900. Among the most important in the first half of the century were ALEATORY MUSIC, ATONALITY, ELECTRONIC MUSIC, EXPRESSIONISM, MUSIQUE CONCRÈTE, NEOCLASSICISM, and SERIAL MUSIC. Of these, atonal and expressionist styles dominated the first decades, and neoclassicism and serial music the period until about 1950. Since then, electronic music has become the dominant force in both serious and popular music, and the possibilities for new kinds of sound it introduced have influenced virtually every composer.

After 1950 some composers extended serial techniques to rhythm, dynamics, tone color, and other elements, but many others rebelled against the mathematical determinism of the tone row and turned to freer systems of construction. Some carried aleatory music to its ultimate, in compositions where performers, audience, and environmental events all contribute to the musical content of the musical work. Others rejected indeterminacy and returned to what they considered basic musical elements with MINIMALISM. Still others returned to tonality and other features of romanticism (NEOROMANTICISM). At the same time that electronics created new varieties of sound, composers explored new sounds from conventional instruments and the human voice, created, for example, by using novel fingerings and singing into woodwind instruments, bowing unusual parts of stringed instruments, and the like. Technical innovations enabled simultaneous composition and performance (see SYNTHESIZER; also COMPUTER MUSIC), and LIVE ELECTRONIC MUSIC became important in both serious and popular music. Composers experimented with continuous performance in the form of a SONIC ENVIRONMENT. There was increased work with MIXED MEDIA productions, combining elements of opera, spoken drama, lighting, staging, and dance with various kinds of sound, both acoustic and electronic, live and taped (see also MUSIC THEATER; PERFORMANCE ART). A number of composers used these forms to express political ideas, often of a radical nature (see POLITICAL MUSIC). At the same time, many composers continued to pursue styles developed in earlier periods,

and some directly used the music of the past in their own compositions (see QUOTATION).

In popular music, the most important styles of the first half of the century were RAGTIME, BLUES, and JAZZ, whereas the second half was dominated by the many kinds of ROCK music but also saw the increasing influence of Latin and Third World styles such as REGGAE and SALSA, and the continuing importance of Broadway musical comedy and of commercially successful COUNTRY MUSIC. There are separate entries about the most important twentieth-century composers, among them ADAMS, ANTHEIL, AURIC, BABBITT, BARBER, BARTÓK, BERG, BERIO, BERNSTEIN, BLOCH, BOLCOM, BOULANGER, BOULEZ, BRITTEN, CAGE, CARTER, CHÁVEZ, COPLAND, COWELL, CRAWFORD SEEGER, CRUMB, DALLAPICCOLA, DAVIES, DELIUS, DOHNÁNYI, DRUCKMAN, DUKAS, ENESCO, DE FALLA, FOSS, GERSHWIN, GLASS, GLIÈRE, GRAINGER, GRIFFES, GUTHRIE, HANDY, HANSON, HARRIS, HENZE, HINDEMITH, HOLST, HONEGGER, IVES, JANÁČEK, KHATCHATURIAN, KODÁLY, LEHÁR, LEONCAVALLO, LIGETI, LOESSER, LUTOSLAWSKI, MARTINŮ, MASCAGNI, MENOTTI, MESSIAEN, MILHAUD, MOORE, NIELSEN, ORFF, PENDERECKI, PISTON, POULENC, PROKOFIEV, PUCCINI, RACHMANINOFF, RAVEL, REGER, REICH, RESPIGHI, RIEGGER, ROCHBERG, ROUSSEL, RUGGLES, SATIE, SCHOENBERG, SCHULLER, SCHUMAN, SCRIABIN, SESSIONS, SHOSTAKOVITCH, SIBELIUS, SONDHEIM, STILL, STOCKHAUSEN, RICHARD STRAUSS, STRAVINSKY, THOMPSON, THOMSON, TIPPETT, VARÈSE, VAUGHAN WILLIAMS, VILLA-LOBOS, WALTON, WEBERN, WEILL, WUORINEN, XENAKIS, and ZWILICH. The accompanying charts lists additional twentieth-century composers of note.

OTHER TWENTIETH-CENTURY COMPOSERS

Composer	Country	Musical Style
Laurie Anderson (1947–)	United States	Performance art.
Bülent Arel (1919–1990)	Turkey-U.S.	Electronic music.
Dominick Argento (1927–)	United States	Tonal vocal music, especially opera.
Robert Ashley (1930–)	United States	Electronic, multi-media, video opera.
Grazyna Bacewicz (1909–1969)	Poland	Neoclassic; mostly instrumental works.
Henk Badings (1907–1987)	Netherlands	Polytonal, later electronic; novel tunings.
Arnold Bax (1883–1953)	Great Britain	Impressionist, tonal.
Richard Rodney Bennett (1936–)	Great Britain	Serial symphonies, piano, chamber works, film scores, opera.
Arthur Berger (1912–)	United States	First neoclassic, later serial.
Lennox Berkeley (1903–1989)	Great Britain	Neoclassic.
Harrison Birtwistle (1934–)	Great Britain	Experimental, atonal; expressionist music theater, opera.
Boris Blacher (1903–1975)	Germany	Neoclassic; later serial.
Arthur Bliss (1891–1975)	Great Britain	Traditional romantic.
Karl-Birger Blomdahl (1916–1968)	Sweden	First neoclassic; later serial, electronic.
Henry Brant (1913–)	United States	Spatial arrangement of performers, multiple ensembles; electronic.
Earle Browne (1926–)	United States	Aleatory music; open forms, graphic notation.
Sylvano Bussotti (1931–)	Italy	Experimental; operas, ballet, chamber music.
Cornelius Cardew (1936–1981)	Great Britain	First serial, then aleatory; political music; later more conventional.

OTHER TWENTIETH-CENTURY COMPOSERS (*Continued*)

Composer	Country	Musical Style
Julián Carrillo (1875–1965)	Mexico	Microtones.
Alfred Casella (1883–1947)	Italy	Neoclassic; in all genres.
Chou Wen-Chung (1923–)	China-U.S.	Fusion of Chinese and Western idioms and style.
John Corigliano (1938–)	United States	Tonal; occasionally serial and atonal for contrast; instrumental works, operas.
Ingolf Dahl (1912–1970)	Germany-U.S.	Early expressionism; later diatonic, then serial.
Mario Davidovsky (1934–)	Argentina-U.S.	Electronic combined with acoustic instruments; emphasizes tone color.
Norman Dello Joio (1913–)	United States	Neoclassic, sometimes with jazz elements.
David Del Tredici (1937–)	United States	First atonal, serial; later neoromantic.
David Diamond (1915–)	United States	Traditional romantic, mostly tonal; eleven symphonies.
Charles Dodge (1942–)	United States	Computer music.
Marcel Dupré (1886–1971)	France	Traditional organ music.
Henri Dutilleux (1916–)	France	Early impressionist; later spatial, polytonal, polyrhythmic.
John Eaton (1935–)	United States	Electronic, microtonal; opera.
Werner Egk (1901–1983)	Germany	Neoclassic.
Herbert Eimert (1897–1972)	Germany	Early atonal, mechanical instruments, serial; later purely electronic.
Hanns Eisler (1898–1962)	Germany-U.S.-Germany	Political music, mostly in traditional diatonic style; many songs, film and theater music.
Morton Feldman (1926–1987)	United States	Aleatory; later long minimalist works with free rhythms,limited dynamics.
Brian Ferneyhough (1943–)	Great Britain	Complex counterpoint; unusual time signatures; personal serial style.
Irving Fine (1914–1962)	United States	Neoclassic; later serial.
Ross Lee Finney (1906–)	United States	Folk elements; serial; symphonies, choral music, much chamber music.
Gerald Finzi (1901–1956)	Great Britain	Mostly tonal; songs, choral music.
Carlisle Floyd (1926–)	United States	Operas in traditional style.
Wolfgang Fortner (1907–1987)	Germany	First neoclassic, then serial; instrumental and vocal works, operas; teacher of Henze.
Roberto Gerhard (1896–1970)	Spain-Great Britain	Personal serial style.
Alberto Ginastera (1916–1983)	Argentina	Serial with folk elements; quarter tones, polytonal, extreme vocal and instrumental effects.
Alexander Goehr (1932–)	Great Britain	Serial combined with modal, often cast in classical forms.
Henryk Górecki (1933–)	Poland	Mystic minimalist with neoromantic elements; choral works, symphonies, string quartets.
Sofia Gubaïdulina (1931–)	Russia	Individual experimental style; emphasizes tone color; expressionist vocal and chamber music.

OTHER TWENTIETH-CENTURY COMPOSERS (*Continued*)

Composer	*Country*	*Musical Style*
John Harbison (1938–)	United States	Largely tonal, neoromantic; choral music, songs, chamber works.
Lou Harrison (1917–)	United States	Highly original; Asian idioms and instruments; Greek, Elizabethan and other tunings; serial.
Karl Amadeus Hartmann (1905–1963)	Germany	Serial, expressionist; eight symphonies.
Pierre Henry (1927–)	France	Musique concrète, electronic; ballet music.
Lejaren Hiller (1924–1994)	United States	Electronic, computer music; music theater, mixed media.
Alan Hovhaness (1911–)	United States	Tonal; combines Eastern instrumental textures and modes with Western counterpoint and structure.
Karel Husa (1921–)	Czech-U.S.	Strongly rhythmic neoclassic; later serial; mainly instrumental works.
Jacques Ibert (1890–1962)	France	Mainly neoclassic; some impressionist elements.
Andrew Imbrie (1921–)	United States	Serial.
André Jolivet (1905–1974)	France	Polytonal, exotic modes; rich orchestration, electronic instruments.
Dmitri Kabalevsky (1904–1987)	Russia	Romantic, with folk elements.
Mauricio Kagel (1931–)	Argentina	Serial; electronic; aleatory elements; film and mixed media works.
Leon Kirchner (1919–)	United States	Atonal, expressionist.
Giselher Klebe (1925–)	Germany	Serial; later more romantic.
Oliver Knussen (1952–)	Great Britain	Atonal, quotation; set children's stories; symphonies, chamber works, songs, opera.
Barbara Kolb (1939–)	United States	Serial, electronic, aleatory.
Ernst Křenek (1900–1991)	Austria-U.S.	Atonal, neoclassic with jazz elements; later serial.
György Kurtág (1926–)	Hungary	Atonal with folk elements; mostly chamber and vocal music.
Ezra Laderman (1924–)	United States	Atonal, expressionist; symphonies, large-scale works.
Paul Lansky (1944–)	United States	Serial, electronic, computer music.
Libby Larsen (1950–)	United States	Atonal, drawing on serial, jazz, and popular styles; opera, vocal, chamber works, symphony.
Henri Lazarov (1932–)	Bulgaria-U.S.	Serial, sometimes live with tape; choral, instrumental works.
Rolf Liebermann (1910–)	Switzerland	Serial; later opera director, commissioned many avant-garde works.
Peter Lieberson (1946–)	United States	Atonal, influenced by Buddhist philosophy; instrumental works; monodrama.
Alvin Lucier (1931–)	United States	Live electronic music.
Otto Luening (1900–)	United States	Electronic pioneer; also some acoustic music.

OTHER TWENTIETH-CENTURY COMPOSERS (*Continued*)

Composer	Country	Musical Style
Elizabeth Lutyens (1906–1983)	Great Britain	Serial; works in all genres.
Tod Machover (1953–)	United States	Computer music; developed hyperinstruments.
Bruno Maderna (1920–1973)	Italy	Serial and electronic.
Gian Francesco Malipiero (1882–1973)	Italy	Neoclassic.
Frank Martin (1890–1974)	Switzerland	Atonal, serial, with mystic elements; choral and vocal works.
Donald Martino (1931–)	United States	Serial, dense but expressive polyphony; mostly instrumental works.
Nicholas Maw (1935–)	Great Britain-U.S.	Serial elements combined with expressive pantonalism; orchestral, vocal, opera.
Minoru Miki (1930–)	Japan	Combines Japanese and Western instruments and idioms.
Gordon Mumma (1935–)	United States	Electronic, live electronic, mixed media.
Thea Musgrave (1928–)	Great Britain-U.S.	Atonal, some serial; ballets, opera.
Bo Nilsson (1937–)	Sweden	Aleatory, electronic.
Akira Nishimura (1953–)	Japan	Experimental; structures based on tone colors and rhythms.
Luigi Nono (1924–1990)	Italy	Serial and electronic; expressing radical political ideas.
Per Nørgård (1932–)	Denmark	At first romantic; later minimalist, emphasis on tone color and rhythm.
Pauline Oliveros (1932–)	United States	Experimental electronic, live electronic, mixed media, improvisation, textless vocal works.
Andrzej Panufnik (1914–1991)	Poland-Great Britain	Atonal; ten symphonies, large choral works.
Arvo Pärt (1935–)	Estonia-Germany	Mystical minimalism; instrumental and large choral works.
Harry Partch (1901–1974)	United States	Microtones.
George Perle (1915–)	United States	Serial techniques with tonal elements; especially chamber music.
Goffredo Petrassi (1904–)	Italy	First neoclassic, later serial.
Tobias Picker (1954–)	United States	Atonal, serial; mostly instrumental.
Willem Pijper (1894–1947)	Netherlands	Impressionist, bitonal and polytonal; works grow from small group of notes.
Daniel Pinkham (1923–)	United States	Tonal, some serial; sacred choral music.
Ildebrando Pizzetti (1880–1968)	Italy	Tonal; operas and other vocal music.
Henri Pousseur (1929–)	Belgium	Serial, electronic, aleatory, some microtones, quotation.
Mel Powell (1923–)	United States	Originally jazz pianist, later electronic.
Shulamit Ran (1949–)	Israel-U.S.	Dense dissonant expressionism; mostly instrumental music.
Bernard Rands (1934–)	Great Britain- U.S.	Electronic, aleatory; virtuoso solo pieces.
Vittorio Rieti (1898–)	Italy-U.S.	Neoclassic; all genres.

OTHER TWENTIETH-CENTURY COMPOSERS (*Continued*)

Composer	*Country*	*Musical Style*
Terry Riley (1935–)	United States	Electronic, minimalist; later instrumental music drawing on diverse non-Western idioms.
Ned Rorem (1923–)	United States	Mostly tonal, some serial and impressionist elements; songs and song cycles.
Christopher Rouse (1949–)	United States	Early dissonance, fast tempos, pop (rock) influence; blend of tonal, atonal; quotation; instrumental.
Frederic Rzewski (1938–)	United States	Electronic, live electronic, collective improvisation; political works in more traditional styles.
Alfred Schnittke (1934–)	Russia-Germany	Polystylistic, drawing on serial, electronic, older styles.
Joseph Schwantner (1943–)	United States	Instrumental works, emphasizing sonority; also works for voice and instruments.
Humphrey Searle (1915–1982)	Great Britain	Serial.
Ralph Shapey (1921–)	United States	Dissonant, expressionist, some electronic; large forms.
Rodion Shchedrin (1932–)	Russia	Traditional tonal, folk elements.
Bright Sheng (1955–)	China-U.S.	Blends Chinese and Western elements.
Elie Siegmeister (1909–1991)	United States	Folk idioms, jazz, woven into largely romantic style; eight operas, eight symphonies, choral works, song cycles.
Nikos Skalkottas (1904–1949)	Greece	Serial music, folk idioms.
Roger Smalley (1943–)	Great Britain-Australia	Electronic, live electronic, rock elements.
Morton Subotnick (1933–)	United States	Electronic, live electronic; computer music.
Karol Szymanowski (1882–1937)	Poland	First romantic; then impressionist, atonal, polytonal, microtones, elaborate rhythms.
Toru Takemitsu (1930–)	Japan	Electronic, graphic notation, aleatory, mixed media; Western and Japanese instruments in Western forms.
Louise Talma (1906–)	United States	First neoclassic, later serial.
John Tavener (1944–)	Great Britain	Electronic, live electronic; later mystical minimalism.
Joan Tower (1938–)	United States	Atonal, experimental; mostly short instrumental works.
Joaquín Turina (1882–1949)	Spain	Impressionist, folk idioms.
Vladimir Ussachevsky (1911–1990)	United States	Electronic pioneer.
Judith Weir (1954–)	Great Britain	Music theater and opera, expressionist, drawing on older styles, folk elements.
Hugo Weisgall (1912–)	United States	Atonal; operas, vocal music.
Egon Wellesz (1885–1974)	Austria-Great Britain	Expressionist, romantic.

OTHER TWENTIETH-CENTURY COMPOSERS (*Continued*)

Composer	*Country*	*Musical Style*
Stefan Wolpe (1902–1972)	Germany-U.S.	First tonal with jazz elements; later highly individualistic serial; influential teacher.
LaMonte Young (1935–)	United States	Minimalist, electronic; elements of jazz, blues, Indian music; novel or older tunings.
Alexander Zemlinsky (1871–1942)	Austria	Late romantic, tonal; opera conductor.
Bernd Alois Zimmermann (1918–1970)	Germany	Atonal, quotation; theater and film music, opera.

two-step See under FOX TROT.

tympani See TIMPANI.

tyrolienne (tē rō lyen') *French.* A type of folk music popular in Tyrol, an Alpine province of Austria. It is usually in 3/4 meter and closely resembles the dance called LÄNDLER. The vocal part generally calls for some yodeling (see YODEL).

U

Übung (Y′bōōnk) *German*. **1** An exercise or étude. **2** The process of practicing a piece of music. Bach wrote a book of keyboard works for organ and harpsichord entitled *Clavierübung* ("Keyboard Practice").

u.c. An abbreviation for *una corda* (see under CORDA).

′ud (ōōd) *Arabic:* "wood." Also, *oud*. A lute played by various peoples of the Near East since the seventh century. It is the ancestor of the European lute, whose name is derived from it as well (see LUTE). Still used both as a solo instrument and in orchestras, the present-day ′ud has eight to twelve strings of gut, some of which are arranged in double courses (pairs tuned to the same pitch). Some instruments are provided with frets (to indicate stopping positions), but others are not.

ukulele (yōō″ kə lā′ lē; ōō″ kōō lā′ lā). A kind of small guitar that was developed in Hawaii, probably from a Portuguese guitar called **machete**, which was brought there by sailors. It is a different instrument, however, from the HAWAIIAN GUITAR. Shaped much like the classical guitar but only half as large, the ukulele has four strings, today usually of nylon, and a fingerboard provided with frets (see FRET). The strings, usually tuned either A D F# B or G C E A, are plucked with the fingers or with a small plectrum.

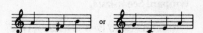

or

The ukulele is used almost wholly to accompany the singing of popular songs or folk songs. Music for ukulele is often written in a kind of tablature

that consists of a drawing of the fingerboard, showing the stopping positions required to produce the desired chords (see the accompanying illustration).

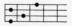

un, une For French musical terms beginning with *un* or *une*, such as *un peu*, see under the next word (PEU).

una, uno For Italian musical terms beginning with *una* or *uno*, such as *una corda*, see under the next word (CORDA).

union pipes See under BAGPIPE.

unis (Y nē'). The French term for unison (see UNISON, def. 1).

unis. An abbreviation for unison (see UNISON, def. 1).

unison 1 An indication that all the instruments or voices are to perform the same voice-part together, instead of performing separate voice-parts. It may mean sounding exactly the same pitches, or the same notes in different octaves. Often abbreviated *unis.* (See also DIVISI.) In figured bass, it means that no chords should be added. 2 Also, *prime.* The interval of two notes of the same pitch, the distance between them being zero. (See also INTERVAL, def. 2.) 3 In organs and harpsichords, the normal or eight-foot (8') pitch, that is, with the notes sounding in the same octave as played, instead of an octave higher (16') or lower (4'). (See also under ORGAN.)

unisono, all' (äl" ōō nē sô' nô). The Italian term for UNISON (def. 1).

unprepared A term used for a dissonance that appears without preparation (see PREPARATION).

unruhig (ōōn' rōō iḴH, ōōn' rōō ik) *German.* A direction to perform in a restless, agitated manner.

upbeat Also, *anacrusis, pickup.* A weak (unaccented) beat that begins a phrase or melody before the first bar line of the composition (or section), and occurs before the first accented beat (which is usually on the first beat after the bar line and is called DOWNBEAT). It is so called because it is indicated by an upward motion of the conductor's hand or baton. In the accompanying example, the beginning of the song "When Johnny Comes Marching Home," the first note is an upbeat.

When John-ny comes march-ing home a-gain, hur-
rah,___ hur- rah

up-bow See under BOWING.

upright piano A piano in which the strings and soundboard are vertical, that is, perpendicular to the floor. See under PIANO, def. 2.

urban blues See under BLUES.

ut In systems of naming the notes of the scale (see SOLMIZATION), another name for the first note, which today is commonly called *do* or *doh.* The word *ut,* first used by Guido d'Arezzo, is still used in France.

V. 1 An abbreviation for VIOLIN. 2 An abbreviation for VOICE. 3 An abbreviation for VIDE, def. 1. 4 In Gregorian chant, an abbreviation for verse, usually appearing as V̸.

va. An abbreviation for VIOLA.

vaghezza, con (kôn vä ge′ tsä) *Italian.* A direction to perform in an easy, graceful manner.

valse (vȧls) *French:* "waltz." A term that appears in numerous titles of instrumental works, among them Schubert's *Valses sentimentales,* op. 50, and Ravel's *Valses nobles et sentimentales* (1911), both for piano, and Sibelius's *Valse triste* ("Melancholy Waltz") for orchestra (1903). See also WALTZ.

value Also, *note value, time value.* The duration of a note. See under TIME.

valve A mechanical device used in brass instruments, such as the French horn, trumpet, and tuba. Without valves, these instruments could produce only a fundamental tone and its overtones (the HARMONIC SERIES). (See also BRASS INSTRUMENTS.) The valves change the length of the tube through which the player's breath travels (or the length of the air column the breath sets into vibration), and hence the pitch sounded. Valves were invented about 1815 and revolutionized brass instruments, which until then had been mostly limited to natural tones (the so-called "natural" instruments, such as the natural horn; see HORN). The only important modern brass instruments that lack valves are the TROMBONE, in which a slide mechanism performs the same function, and the bugle, which is confined to natural tones. —**descending valve** A valve that opens up an extra section of tubing, thereby lowering the pitch. Most brass instruments have three descending valves (a few have four), which make available a full chromatic scale (all twelve tones of an octave). In most instruments the first valve lowers the pitch one whole tone, the second lowers it one half tone, and the third lowers it one and one-half tones. The valves can be used alone or in combination. In combination, however, they tend to make a pitch slightly sharp (too high); this is particularly noticeable when all three valves are used together. The accompanying example shows how the three valves of the TRUMPET make available the entire chromatic scale from the C above middle C down to middle C. The numbers below the notes indicate which valves are used; no number means an open note, that is, the note produced without using a valve. Note that the E and A, produced by using valves 1 and 2 together, can also be

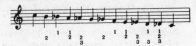

produced by using valve 3 alone; this is true because valves 1 and 2 together lower the pitch by one and one-half tones, and so does valve 3 alone. The fact that different valve combinations can be used for certain notes allows the player to select the most convenient fingering. —**ascending valve** A valve that closes off a section of the tubing, thereby raising the pitch. Today these are used only in the double horn (see FRENCH HORN) and in ordinary French horns built in France.

vamp 1 An improvised passage of chords to accompany a vocal soloist. **2** In popular music and jazz, a preparatory passage to fill in until a singer is ready to perform.

Varèse (vä rez′), **Edgar**, 1883–1965. A French-born composer who from 1915 on lived mostly in the United States, and who was one of the pioneers of electronic music. After early studies in Paris with d'Indy, Roussel, and Widor, Varèse organized and conducted several choral groups in Europe. Upon his arrival in America he founded the New Symphony Orchestra for the performance of modern music, and in the next few years he helped organize various groups to help contemporary composers. In his own compositions, Varèse worked out some wholly original ideas. Rejecting both traditional melody and traditional harmony, he combined pure sounds, creating music from texture, tone color, and strong, lively rhythms. There is no melodic or harmonic movement in the conventional sense: the music consists of blocks of sound, clarified by rhythm. This technique is evident in such early works as the octet *Octandre* (1924) and *Arcana* (1927), for a large orchestra. *Ionisation* (1931) is scored for percussion instruments (including a siren) and piano, and it

has been described as a combination of rhythm and wailing noises. *Density 21.5,* on the other hand, is for solo flute. Varèse was one of the first to experiment with MUSIQUE CONCRÈTE (taped real-life sounds); outstanding are his *Déserts* (1954), which combines live instruments with taped sounds, and *Poème électronique* (1958), presented over four hundred loudspeakers in a huge pavilion at the Brussels World's Fair.

variable meters The practice of using a new meter in every measure of a composition, employed by several twentieth-century composers (Boris Blacher was one of the first to do so).

variation A repetition of a subject (melody) or figure (motif) that differs in certain respects from its original presentation. The melody may be varied by being ornamented, or its key altered, the mode changed (from major to minor or vice versa), the rhythm altered, the voice-parts switched (the melody moved from the soprano part to the bass part, for example), etc. Moreover, such changes may occur singly or in combination. Variation has been a basic technique of composition for many centuries. An important musical form based on it is THEME AND VARIATIONS.

variations, theme and See THEME AND VARIATIONS.

vaudeville (vōd vē′yº) *French.* **1** In the early eighteenth century, a song whose text usually made fun of a current event or person and whose music was a popular melody. Such vaudevilles were often included in French comic operas (see OPÉRA-COMIQUE, def. 1). **2** In the nineteenth century, a type of French entertainment consisting of a short, humorous play and popular songs. **3** (vôd′vil). In the twentieth century, especially in the United States, a variety show consisting of songs, skits, and other light entertainment.

Vaughan Williams (vôn wil′yəmz), **Ralph** (rāf), 1872–1958. An English

composer who is remembered for his choral and symphonic works, which combine a variety of influences, ranging from impressionism to folk song. Notable among his works are *Fantasia on a Theme by Thomas Tallis* for string orchestra, the ballad opera *Hugh the Drover,* Mass in G minor, and Te Deum. Of his nine symphonies, *A London Symphony* (no. 2) and *Sinfonia antartica* (no. 7) are frequently performed. Vaughan Williams's music is particularly notable for his emphasis on melody and, influenced by Elizabethan and Tudor music, his interest in counterpoint and modal harmony (based on modes other than the major and minor). In his later works the harmony is quite complex, with free use of dissonance, although the forms remain traditional.

vcl. An abbreviation for CELLO.

velato (ve lä'tô) *Italian.* Direction to perform (usually sing) in a veiled, obscure manner, the opposite of clear and distinct.

vellutato (ve lo͞o tä' tô) *Italian.* A direction to perform in a very smooth manner.

veloce (ve lô'che) *Italian.* A direction to perform in a rapid tempo.

Venetian school A group of sixteenth-century composers who worked in Venice, Italy. Some were Italian and others were Flemish, that is, from what is now the Netherlands, northern France, or Belgium (see FLEMISH SCHOOL for an explanation). The most important members of the Venetian school were Adrian Willaert and Andrea and Giovanni Gabrieli (see WILLAERT, ADRIAN; GABRIELI). Others were Cipriano de Rore, Giovanni Croce, Claudio Merulo, Marc'Antonio Cavazzoni, and the theorists Gioseffo Zarlino and Nicola Vicentino. Although they belonged to the historical period called the Renaissance (1450–1600), the Venetian composers in some respects looked forward to the coming baroque period. Among their early achievements was the

increasing use of chromaticism (mainly through the use of many sharps and flats, as well as chromatic progressions, such as D–D#–E). Even more striking, especially with later composers such as Giovanni Gabrieli, was their development of the polychoral style (use of two choirs, singing in turn and together; see POLYCHORAL). They also introduced new instruments to their ensembles, especially wind instruments. In all these respects they influenced the early baroque composers, especially German ones (Hans Leo Hassler, Michael Praetorius, Heinrich Schütz—all of whom studied in Venice). See also RENAISSANCE.

Verdi (ver'dē), **Giuseppe** (jo͞o sep'e), 1813–1901. An Italian composer who is remembered principally for his operas, a number of which are among the finest of their kind and the most popular ever written. Such works as *Rigoletto* (1851), *Il Trovatore* ("The Troubadour"; 1853), *La Traviata* ("The Erring One"; 1853), and *Aida* (1871) are in the standard repertory of every opera company. Verdi's last two operas, *Otello* (1887) and *Falstaff* (1893), are in many respects his best, for throughout his long career Verdi continued to grow and develop, gradually turning from quite conventional treatments of form and orchestration to create highly dramatic, imaginative, and original works of art.

Beginning his musical education as a village organist, Verdi wrote his first opera (*Oberto, Conte di San Bonifacio*) at twenty-six, and it was performed with considerable success at Milan's La Scala, Italy's most important opera house. Discouraged by the failure of his next work, Verdi was nevertheless persuaded to try again, and his third opera, *Nabucco* (1842), was an enormous success. Thereafter he turned out one or two operas a year, and in 1847 came the first of a number of operas based on Shakespeare plays, *Macbeth.* Despite occasional setbacks, Verdi had enough income to con-

tinue composing, and in 1851 came his first masterpiece, *Rigoletto*, followed two years later by *Il Travatore* and *La Traviata*. There followed some lesser operas, all of which are still regularly performed—*Simone Boccanegra, Un Ballo in maschera* ("A Masked Ball"), *La Forza del destino* ("The Force of Destiny"), and *Don Carlos*. Up to this point, Verdi had retained the conventional form of the *opera seria* (see under OPERA). His popular success was due largely to his gift for writing fine melodies and his highly developed sense of drama. With *Aida*, written to celebrate the opening of the Suez Canal (1871), Verdi began to use the orchestra to enhance the drama instead of serving purely to accompany the singers. Also, he began to emphasize character and personality more than external events. These tendencies were carried even further in *Otello*, which has a remarkable libretto (based on Shakespeare's play) by Arrigo Boito. In his last opera (but only his second comic one), *Falstaff*, also to Boito's libretto (based on Shakespeare's *The Merry Wives of Windsor*), Verdi revealed, at seventy-nine, a masterful sense of comedy. Moreover, in *Falstaff* the orchestra supplies a kind of continuous melody, a treatment associated with Wagner's music dramas.

Although Verdi's music was immensely successful for most of his career, from the 1880s on his stature declined, largely owing to the growing popularity of Wagnerian opera. Today, however, he is generally regarded as the outstanding composer of nineteenth-century Italian opera, and some regard him as the greatest opera composer of all time.

Besides operas, Verdi composed some church music, most notably a Requiem Mass ("Manzoni Requiem," 1874) and *Quattro Pezzi Sacri* ("Four Sacred Pieces," 1898, which include a Stabat Mater and Te Deum).

verismo (ve riz′ mô) *Italian:* "realism." A term used for a type of late nineteenth-century opera that aims at pre-senting a realistic picture of life rather than concerning itself with myth, legend, or ancient history. The characters are everyday people instead of gods or kings, and the events, although often violent and melodramatic, supposedly could happen to anyone. The best-known examples of verismo are Mascagni's *Cavalleria rusticana* ("Rustic Chivalry"), Leoncavallo's *I Pagliacci* ("The Clowns"), Giordano's *Andrea Chénier*, and Gustave Charpentier's *Louise*. Some of Puccini's operas contain elements of verismo (for example, *La Bohème*), and in the twentieth century, Gian Carlo Menotti has continued the trend in some of his operas (*The Saint of Bleecker Street*).

Verschiebung, mit (mit fer shē′ bōōnk) *German.* In keyboard music, a direction to use the una corda (soft) pedal.

verschwindend (fer shvin′ dənt) *German.* A direction to perform more and more softly, as though the music were fading away.

verse 1 In songs with a poetic text, another word for stanza. **2** In popular songs or ballads, an introductory section, which is followed by the chorus, the main part of the song (see CHORUS, def. 3). This kind of verse is usually performed in free tempo and rhythm, and generally consists of an irregular number of measures. **3** In Gregorian chant, a verse of a psalm or some other scriptural text. In liturgical books it is usually indicated by ℣. The verse is always sung by the soloist. For this reason the Anglican church calls an anthem containing sections for soloists a **verse anthem** (see under ANTHEM). See also VERSET.

verse anthem See VERSE, def. 3; also under ANTHEM.

verset A short organ composition that is played instead of either a plainsong verse (see VERSE, def. 3) or some brief portion of the Mass. The music is based on the same melody that would otherwise be sung, but it is polyphonic (with several voice-

parts, as opposed to the single part of plainsong). From the sixteenth to eighteenth centuries versets were often used in Roman Catholic services. In the performance of psalms, the organ would alternate with the choir, each taking every other verse of the psalm. Later this practice was largely forbidden by the Church.

vertical texture See under TEXTURE.

Vespers See under OFFICE.

vezzoso (ve tsô'zô) *Italian*. A direction to perform in a smooth, graceful manner.

via (vē'ä) *Italian:* "away." A word used in such musical terms as *via sordini* ("away with [remove] the mutes").

vibes See VIBRAHARP.

vibraharp (vī'brə härp"). Also, *vibraphone*, *vibes* (slang). A tuned percussion instrument invented in the 1920s and used in orchestras, bands, and jazz ensembles. In appearance it resembles two of its relatives in the percussion section, the xylophone and the marimba. Like them, it has a pianolike keyboard, with two rows of aluminum bars instead of keys, which are struck with beaters. Under each bar hangs a metal tube, which acts as a resonator, strengthening the vibrations of the bar. Each resonator tube

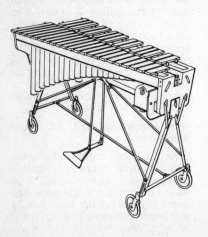

is also equipped with a small paddle-shaped fan. The fans, which are made to turn by an electric motor, alternately open and close the tops of the resonator tubes, thus producing a vibrato (wavering of pitch) in the sounds produced. In addition, the instrument has a pedal-operated damping mechanism, which can silence a note or chord when a new note or chord is to be played. Some vibraharps are also equipped with electronic amplifiers to strengthen the sound still more.

The vibraharp has a range of three octaves, the exact range varying with different makes of instrument. Although it was first used only for popular music and jazz, the vibraharp gradually attracted some serious composers who admired its sweet tone, harplike broken chords, and other special effects. The first important serious work calling for vibraharp was Berg's opera *Lulu*. Milhaud wrote a Concerto for marimba, vibraphone, and orchestra (1949); Messiaen and Stockhausen are among the other composers who have used it. Outstanding jazz vibraharpists include Lionel Hampton, Red Norvo, and Gary Burton.

vibraphone See VIBRAHARP.

vibrato (vē brä' tō) *Italian*. **1** A slight wavering in pitch, occurring so quickly that it resembles a vibration and sounds like a single pitch. **2** In stringed instruments (violins, cellos, lutes, etc.) vibrato is produced by rocking a finger very quickly back and forth while it is pressing down (stopping) a string. Formerly used only to obtain an effect of great emotion, vibrato today is used by string players on virtually all notes held long enough to permit it. **3** In some wind instruments vibrato can be obtained by manipulating the breath, rapidly alternating between greater and less wind pressure. To do so wind players use the diaphragm, throat, or, with reed instruments, even the jaw. **4** In the clavichord, vibrato is produced by repeatedly pressing a finger

against a key without ever releasing it entirely; the effect, generally known by the German term *Bebung,* is caused by slightly varying the tension of the string for that key. (See also CLAVICHORD.) 5 In the organ, vibrato is produced by a special stop called the **tremulant,** which quickly increases and decreases the wind supply to the pipes. 6 In singing, vibrato is the natural pulsation of the singing tone. A moderate vibrato in singing can be very effective; too much vibrato, however, sounds like poor intonation (singing off pitch), and, in fact, it frequently is caused by poor voice control.

Victoria (vik tôr' ē ä), **Tomás Luis de** (tō mäs lōō ēs' də), c. 1548–1611. Also, *Vittoria.* A Spanish composer who is remembered for his outstanding church music, including Masses, motets, and hymns, as well as two famous Passions. Along with Palestrina, under whom he may have studied, Victoria is considered one of the great masters of the late Renaissance. Victoria began his musical studies in Spain but he soon went to Rome. There he was organist and choir director in a number of churches. He also became a priest. Several collections of his works, published in Italy, were well received, but about 1581 Victoria decided to return to Spain, where he remained until his death. Unlike most Italian composers of his time, Victoria wrote no madrigals, nor any other secular (nonreligious) music. However, some of his motets, with five or six voice-parts, are as intensely expressive as many madrigals (see MADRIGAL, def. 2). Outstanding among Victoria's works are his Christmas motet, *O magnum mysterium* ("Oh, Great Mystery"), two Passions (which are still performed during Holy Week in the Sistine Chapel of the Vatican), the Mass based on his motet, *O quam gloriosum* ("Oh, How Glorious"), and his *Officium defunctorum* ("Office for the Dead"), written for the funeral of his patroness, the Empress Maria.

vide (vē'de) *Latin:* "see." Abbreviated *V.* 1 A term used in scores to mark a portion that the performer may omit if desired. The beginning of the section is commonly marked *Vi* . . . and the end . . . *de.* The performer may leave out the entire section. Frequently, a sign consisting of a circle with a cross through it ✚ is added to call attention to the section. 2 (vēd) *French:* "blank." See under CORDE.

video opera An opera created specifically to be seen on television and therefore composed on videotape. An example is the American composer Robert Ashley's *Perfect Lives* (1981).

viel (fēl) *German:* "much" or "very." Also, *vielem* (fēl'əm). A word used in musical directions like *mit viel Gefühl* ("with much feeling").

viele 1 (vyel). Another spelling of VIELLE. 2 (fēl'e). The plural of VIEL.

vielem See VIEL.

vielle (vyel) *French.* Also, *viele, viole.* A bowed stringed instrument of the Middle Ages that was used to accompany singers (minstrels). It began to be used during the twelfth century and was widely played, especially in France and Germany, until about the fifteenth century. The vielle was fairly small; the player held it under the chin, much like the modern violin, instead of over the knees, like other stringed instruments of the time. The vielle had three, four, or five strings. Pictures in Chartres, France, whose cathedral dates from the twelfth and thirteenth centuries, show three-stringed models. A treatise by Jerome of Moravia, dating from about 1250, describes the vielle as having four melody strings plus a fifth string used as a drone (continuously sounding one pitch). The earlier vielles had an oval-shaped body, which later gave way to a body with an indented waist, similar to the guitar's. In Italy the vielle appears to have developed into the LIRA DA BRACCIO sometime late in the fifteenth century, and it in turn was replaced by the violin.

vielle à roue (vyel A rōō). See under HURDY-GURDY.

Viennese classics A term sometimes used for the classic style of Haydn and Mozart; see CLASSIC.

vif (vēf) *French*. A direction to perform in a lively manner.

vigoroso (vē gô rô'sô) *Italian*. A direction to perform in an energetic manner.

vihuela (vē ōō el' ä) *Spanish*. Also, *vihuela de mano* (dā mä'nô). A small guitar strung and fingered like a lute, which during the sixteenth century was as important in Spain as the lute was in other European countries (see LUTE). Like the guitar, the vihuela had a flat back, long narrow neck, and fingerboard provided with frets (to indicate stopping positions). Like the lute, it had six double courses of strings (six pairs, with each string of a pair tuned to the same pitch; the guitar of this period had only four strings); they were usually tuned G, D, A, F, C, G. The vihuela was plucked with the fingers (*mano* means "hand") rather than with a plectrum.

Whereas the guitar was used for folk and popular music, the vihuela was used for court and art music. The repertory for vihuela, which includes both solo pieces and accompaniment for songs, was written in a tablature similar to that for the lute (indicating the strings and frets to be used instead of the pitches to be sounded; see TABLATURE). Some of the loveliest pieces for vihuela were written by Luis Milán, Luis de Narváez, and Miguel de Fuenllana, all contained in books published during the sixteenth century. In the seventeenth century the vihuela was largely replaced by the guitar.

vihuela de arco (vē ōō el'ä dā är'kô) *Spanish*. See under VIOL.

Villa-Lobos (vēl'läh lô'bôs), **Heitor** (ā'tōōr), 1887–1959. A Brazilian composer who, owing to the huge number of his works, his devotion to his country's folk music, and his reform of Brazilian music education, became his country's leading composer of the first half of the twentieth century. Many of his more than two thousand compositions are second-rate, but a few are outstanding. In general they reflect the influence of French impressionism and other contemporary French styles (introduced to Villa-Lobos by Darius Milhaud, who lived in Brazil for two years), the styles of Brazilian popular and folk music (itself influenced by African, Portuguese, and native Indian sources), and jazz. Among Villa-Lobos's most interesting works are some of his fourteen *Chôros*, which use the basic rhythmic and melodic elements of native Brazilian music. He also attempted, with some success, to link Brazilian rhythms with baroque counterpoint in his *Bachianas brasileiras*, of which the best known is no. 5, for soprano voice and eight cellos. He also wrote a great deal of piano music, including three suites called *Prole do bébé* ("Baby's Family"), and seventeen string quartets.

villancico (vēl" yän thē' kō) *Spanish*. **1** Today, a Christmas carol. **2** In the fifteenth and sixteenth centuries, a type of Spanish poem that was often set to music. It consists of several stanzas and a refrain, which is sung before the first stanza and repeated after each subsequent stanza. In general form the villancico is very similar to the Italian FROTTOLA and French VIRELAI. In the fifteenth century, villancicos were usually given polyphonic settings (with several voice-parts) and had purely secular texts (see also CANCIONERO, def. 1); in the sixteenth century they were sometimes treated as solo songs with instrumental accompaniment, usually provided by the vihuela, and, by the end of the century, often had sacred or devotional texts. Outstand-

ing composers of villcancicos were Juan del Encina (1468–1529), Cristóbal de Morales (c. 1500–1553), and Juan Vásquez (c. 1510–c. 1561). **3** In the seventeenth and eighteenth centuries, a choral composition similar to a cantata, for soloists, chorus, and instrumental accompaniment.

villanella (vē lä nel'ä) *pl.* **villanelle** (vē lä nel'e) *Italian.* Also, *villanescha* (vē lä nes'kä), *pl. villanesche.* A type of song that was popular in Italy during the sixteenth century. Less serious than the madrigal, with which it existed side by side, the villanella was also less complicated musically and often had a humorous text in strophic form. Although the music was for several voice-parts, generally three, they usually moved together, in chords, rather than weaving an elaborate polyphony as in the madrigal (see MADRIGAL, def. 2). The villanella probably originated in the city of Naples, and a common name for it was *villanella alla napoletana.* Composers of villanelle include Orlando di Lasso, Adrian Willaert, Luca Marenzio, and Andrea Gabrieli.

vina (vē nä') *Sanskrit.* One of the most important instruments of ancient and modern India. A stringed instrument, it is usually classified as a kind of zither (see ZITHER, def. 2), though it also bears some resemblance to a lute. In its simplest form, the vina consists of a long stick of bamboo or wood, over which are stretched seven metal strings; attached to the underside of the stick

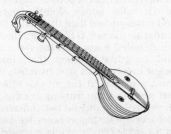

are one or two hollow gourds (vessels), which act as resonators (reinforce the vibration of the strings). In more elaborate forms, however, one of the gourds has become the body of the instrument and the stick has become its neck; the second resonator, if present, is largely decorative (see the accompanying illustration). Only four of the strings are used to play the melody; the other three serve as drones (sound a single pitch each, more or less continuously). The melody strings are stopped (held down) against high brass frets and are plucked with the fingernails, or with two plectra (picks) attached to the fingers; the drones are strummed with the little finger and sometimes with the thumb. For a very similar instrument, see SITAR.

viol (vī'əl). An important bowed stringed instrument of the sixteenth and seventeenth centuries. Made in various sizes ranging from treble (soprano) to bass, the viol was widely used, especially for chamber music. The viol developed not from the medieval fiddles (the rebec or vielle, ancestors of the violin) but from the VIHUELA, a small Spanish guitar strung and tuned like a lute. Like the vihuela, the viol had a flat back, a fingerboard with frets (in viols, pieces of gut tied around the neck at intervals to indicate where the strings should be stopped; see FRET), and six strings tuned in fourths around a central third (the accompanying example shows the typical tuning for the bass viol; all the intervals are fourths except for the interval C–E, which is a third). Another feature distinguishing

the viol is its sloping shoulders, that is, the body sloped downward from the neck, instead of being set at an angle to the neck (as in the violin). The bow used was curved, with the stick curving away from the hair, and

it was held with the palm of the hand facing up, not down. Originally the viol was held like a vihuela, slanting across the player's body. As larger viols were built, however, it was found more convenient to hold the instrument upright, resting either on the player's lap or between the knees, and soon all viols, large and small, were held in this way. This practice is the source of the bass viol's Italian name, **viola da gamba** ("leg viol").

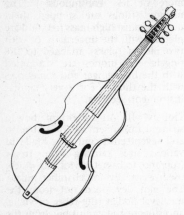

From Spain, where it was called **vihuela de arco**, the viol moved first to Italy and then throughout Europe. By the late 1520s it had reached England, where it became immensely popular. Numerous compositions were written for ensembles made up entirely of viols in various sizes (called a **consort of viols**, or *chest of viols*). For these the most important sizes were the **treble viol, tenor viol,** and **bass viol** (also called *viola da gamba*); a typical group consisted of six viols, two of each size. Late in the seventeenth century a fourth high-pitched instrument, called **descant viol**, was added. One kind of viol music was the division on a ground, that is, improvised variations on a bass theme (ground) performed by a solo instrument. The instrument used was often a small bass viol that came to be called a DIVISION VIOL. Another type developed was the LYRA VIOL,

slightly smaller than the division viol but still larger than the tenor viol. It usually included fifths in its various tunings, and its music was written in tablature. Still other developments were viols with sympathetic strings, such as the VIOLA D'AMORE and BARYTON. By the end of the seventeenth century viols had been largely replaced by violins. The only size that remained in general use was the bass viol (the kind illustrated here), which lived on through most of the eighteenth century.

In France works for one, two, or three bass viols and continuo were written by Antoine Forqueray (1671–1745) and Marin Marais (1656–1728), both virtuoso players, as well as by François Couperin and others. Later in the seventeenth century the French viol was given a seventh string, tuned to a low A. It is for this instrument that J. S. Bach wrote his bass viol sonatas and Jean Philippe Rameau his *Pièces en concert*. Early in the eighteenth century the cello replaced the bass viol as the bass violin in orchestras and chamber music. As a solo instrument the bass viol persisted somewhat longer, its last great virtuoso, Karl F. Abel, keeping it before the public until his death in 1787. Today the viols and their music, which for a century or more was often played by violins and cellos, if at all, have been revived along with other early instruments and can be heard in numerous ensembles specializing in Renaissance and baroque music.

viola (vē ō′lä). An important member of the violin family, slightly larger and lower-pitched than the violin. Its strings are tuned C G D A, a fifth (four whole notes) lower than the violin's, and considerably lower than one might expect for its size. Its music is usually written in the alto or viola clef (see the accompanying example, showing the tuning on two different clefs), except for higher notes, written in the treble clef. The viola is considered the alto or tenor member of the

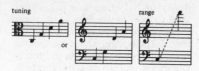

tuning range

or

violin group. Its tone in the higher register (higher pitches) is reedier and more nasal than the violin's; in the lower registers it is huskier and rougher. The viola looks almost exactly like a violin (it is pictured under VIOLIN for purposes of comparison).

Beginning about 1450, *viola* was the Italian name for a large variety of stringed instruments played with a bow. During the sixteenth century, a distinction was made between the name **viola da braccio** ("arm viol"), used for instruments held against the player's shoulder, and the **viola da gamba** ("leg viol"), used for instruments held on or between the player's knees. The former were violins of various sizes; the latter were viols (see VIOL). Later the name "viola da gamba" was used only for the bass viol, and "viola da braccio" for what today is called simply "viola."

Just exactly when the viola was developed is not known. It may well have preceded the violin. In any event, the early history of the two instruments is inseparable. Until the middle of the eighteenth century the viola was used only in the orchestra. Later in the eighteenth century, with the development of the string quartet, it became important in chamber music. However, except for a few isolated examples, the viola's possibilities as a solo instrument—and, in fact, as an important member of the orchestra—were not appreciated until the late nineteenth century. Among some notable works for solo viola, or with important parts for solo viola, are: Karl Stamitz (1745–1801), Concerto in D for viola and orchestra; Mozart, *Sinfonia concertante*, K. 364, for violin, viola, and orchestra; Berlioz, *Harold en Italie* (1834) for

viola and orchestra; Debussy, Sonata for flute, viola, and harp (1915); Bloch, Suite for viola and piano (1919); Walton, Concerto for viola and orchestra (1929); Hindemith (a renowned violist himself), *Der Schwanendreher* for viola and orchestra (1935) and several viola sonatas (1923, 1924, 1939); Bartók, Concerto for viola and orchestra (1945; finished after the composer's death by Tibor Serly); Martinů, *Rhapsody-Concerto* for viola and orchestra (1953); Piston, Concerto for viola and orchestra (1958); Druckman, Concerto for viola and orchestra (1978); Schnittke, Viola Concerto (1985); Schuller, Viola Concerto (1987); Kancheli, *Mourned by the Wind* (1989); Ligeti, *Loop* for solo viola (1991); and Lieberson, Viola Concerto (1993).

viola clef Another name for the alto clef (see under CLEF).

viola da braccio (vē ō′lä dä brä′ tchô) *Italian.* An earlier name for the VIOLA.

viola da gamba (vē ō′lä dä gäm′bä) *Italian.* Originally a name used for various viols and later confined to the bass viol (see VIOL). Sometimes abbreviated *gamba.*

viola d'amore (vē ō′lä dä môr′ e) *Italian:* "love viola." A treble (high-pitched) viol provided with sympathetic strings, that is, metal strings that were not played but that vibrated in sympathy with the bowed melody strings, reinforcing their sound. Shaped like a VIOL but lacking frets, the viola d'amore had either six or seven gut melody strings, tuned in a variety of ways, and an equal number of thin wire strings that ran directly under the fingerboard. Its name is thought to come from the fact that the scroll (at the top of the instrument) was often in the shape of a head of Cupid (or Amor), the god of love. Very popular during the eighteenth century, with composers such as Vivaldi, Bach, and Karl Stamitz writing for the instrument, the viola

d'amore virtually died out about 1800 but has been revived several times since then. It is called for in a number of nineteenth-century orchestral scores (by Meyerbeer, Puccini, and others). In the twentieth century, Charles Loeffler gave it a prominent solo in his tone poem *La Mort de Tintagiles* ("The Death of Tintagel"), and Paul Hindemith wrote both a sonata and a concerto for viola d'amore.

viole Another name for VIELLE.

violin The most important of the orchestral stringed instruments. It is widely used, both as a solo instrument and in ensembles, ranging in size from the string trio to the symphony orchestra. The smallest, highest-pitched of the modern stringed instruments, the violin is valued principally for its brilliant tone and its wide range of expression.

The violin consists of two main parts, a body and a neck, both made of wood. Both the top surface of the body, called the **belly** (or *table top*, or *soundboard*), and the bottom, called the **back**, are curved; together with the side walls, called **ribs**, they form a hollow box, which acts as a resonator (strengthens the vibrations of the strings). Generally a hardwood, such as maple, is used for the back and ribs, and a softwood, such as spruce or pine, for the belly. The overall shape of the body is curved, somewhat like the human body, so that it appears to have a waist. Inside the body are a **soundpost** and **bass bar**, which transmit the vibrations of the strings. The neck consists of a long, narrow piece of wood called a **fingerboard**. At its upper end are a **pegbox**, which holds the tuning pegs, and a small curved section called the **scroll**. Over the fingerboard and belly are stretched four strings made of gut. The strings, each wound around a tuning peg, pass over a small piece of wood called the **nut**, along the fingerboard, and over another piece of wood called the **bridge** and are attached to a third piece called the **tailpiece**, usually made of ebony and

sometimes equipped with small screw devices to help fine-tune the strings. When a bow passes over a string, the string is made to vibrate and hence to sound. The bridge, which touches the strings, is also made to vibrate, and its vibrations in turn pass to the belly and, to a lesser extent, to the back. Cut into the belly are two **sound holes**, today usually in the shape of an F (and thus called **F-holes**); they serve to let out the sound, and they also reinforce the vibrations of the upper part of the belly (near the neck). See BRIDGE, def. 1, for a drawing showing a cross-section of the body at the bridge. Violins today are made in seven sizes, depending on the length of the player's arm. The smallest size can be used by young children. (The accompanying illustration, however, shows the three different instruments of the violin family, violin, viola, and cello, for purposes of comparison.)

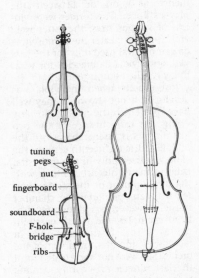

tuning pegs
nut
fingerboard
soundboard
F-hole
bridge
ribs

The four strings of the violin are tuned G D A E. Three of them are always made of gut (specially prepared sheep intestines); the E string, the thinnest, is usually made of steel wire or some other metal, and so has

a special tuner attached at the tail-piece (the ordinary tuning peg being inadequate for a metal string). The violin has a range of about four octaves, from the G below middle C to the E one octave above high C; in

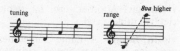

addition, the violinist can produce harmonics (overtones), which further extend the range upward. The basic technique of playing the violin consists of holding the instrument under the chin (most instruments have a **chin rest** for this purpose, a shaped wooden platform clamped to the upper edge of the instrument) and bowing with the right hand while stopping (holding down strings at various points to shorten their length) with the left. As in all stringed instruments, the pitches produced depend on the sounding length of the string. An open (unstopped) string produces the fundamental note to which it is tuned; stopping shortens the string, making it produce higher pitches. Some of the special ways of violin playing are listed under BOWING. (See also BOW; STOPPING, def. 1).

The violin was developed from one or another of the bowed stringed instruments in use about 1550, among them the vielle, rebec, and lira da braccio. Its exact history at this time is not clear, since numerous names were in use, among them viola, violino, rebec, and others. What is now called viola may have been the main instrument of this type in the sixteenth century (see VIOLA). By 1600 the viola was very much the instrument it is today, although it was still called a variety of names. The chief center of violin making was Cremona, Italy, where the great violin makers of all time worked. Unlike nearly all other instruments, the violin has remained basically unchanged in design, so

that instruments made by Amati, Stradivari, Guarneri, and Guadagnini during the seventeenth and eighteenth centuries can still be used today, and indeed are highly prized.

The violin and viola, whose early history cannot be separated, replaced the viols in the orchestra early in the seventeenth century. In fact, the most famous orchestra of this period, established by King Louis XIII of France in 1626, was named *Les 24 Violons du roi* ("The Twenty-four Violins of the King"). By the end of the baroque period (1750) the violin had attained its present high stature. It was important in chamber music; the chief form of baroque chamber music, the TRIO SONATA, was most often scored for two violins and continuo. Music for solo violin was written early in the 17th century; among the first composers to do so was Salomone Rossi (1587–c. 1630). Later, Biagio Marini (c. 1595–1665), Giovanni Battista Vitali (c. 1644–1692), Arcangelo Corelli (1653–1713), Giuseppe Torelli (1658–1709), and Heinrich von Biber (1644–1704), among others, contributed notable music for solo violin. These composers began to exploit the instrument's expressive powers, through the use of double stops, trills, and other special techniques and effects. In the seventeenth century these developments took place mainly in Italy and Germany; in France and England violins were used mostly for dance music. The eighteenth century saw further development. Italian composers such as Antonio Vivaldi, Giuseppe Tartini, and Pietro Locatelli wrote solo concertos for violin; Locatelli also wrote two dozen capriccios that required an unheard-of virtuosity for his time, and not equaled until another century (by Paganini). In Germany Bach wrote three beautiful violin concertos, as well as six sonatas for unaccompanied violin. Contemporary French composers, such as Jean-Marie Leclair (1697–1764), also wrote fine violin music. In the middle of the century two important books on violin play-

ing appeared, one by Francesco Geminiani in 1751 and another by Leopold Mozart (father of Wolfgang Amadeus) in 1756.

In the second half of the eighteenth century the violin became the orchestra's main melody instrument (see MANNHEIM SCHOOL), a position it continued to hold for at least 150 years. The modern symphony orchestra uses about thirty-two violins, more than any other instrument; they usually are divided into two sections (first and second violin). The violin remained a key instrument in chamber music, in string trios, quartets, etc., and grew in importance as a solo instrument. The nineteenth century saw the rise of great violin virtuosos, such as Niccolò Paganini, Henryk Wieniawski, and Pablo de Sarasate, as well as more widespread violin instruction in schools and homes. There were numerous highly influential violin teachers, beginning with Giovanni Battista Viotti (1755–1824) and continuing with Rodolphe Kreutzer (1766–1831; his études are still used today, and Beethoven dedicated his celebrated *Kreutzer Sonata* to him), Ludwig Spohr (1784–1859), Ferdinand David (1810–1873; student of Spohr, teacher of Joachim), Henri Vieuxtemps (1820–1881), Joseph Joachim (1831–1907), Eugène Ysaÿe (1858–1931), Leopold Auer (1845–1930), Carl Flesch (1873–1944; he also wrote an important book on violin playing), and Jacques Thibaud (1880–1953). The twentieth century has seen its share of great virtuosos and teachers, of whom one of the most outstanding was Fritz Kreisler. The next generations included Jascha Heifetz, Mischa Elman, Efrem Zimbalist, David Oistrakh, Isaac Stern, and Yehudi Menuhin, among others, and the teachers Ivan Galamian and Dorothy Delay. The violin also has attracted a few jazz musicians, notably Stéphane Grappelli of France.

Nearly every composer of note has written solo compositions for violin. (Some of the better-known violin concertos are listed in the chart accompanying CONCERTO, and a few famous violin sonatas are mentioned under SONATA, def. 1.) Others who have written fine violin sonatas are Schumann, Grieg, Reger, Debussy, Bartók, Bloch, Prokofiev, and Martinů.

violin clef Another term for treble clef (see under CLEF).

violin family A name sometimes used for the chief bowed stringed instruments of the orchestra—the violin, viola, cello, and double bass. The resemblance of the first three instruments to one another is seen in the illustration accompanying VIOLIN. Some authorities leave out the double bass on the ground that it is more closely related to the viols than to the violins. Others also include sizes of violin no longer in current use, such as the tenor violin, halfway in size between the viola and cello.

violino (vē ô lē′ nô). The Italian word for VIOLIN.

violon (vē ô lôɴ′). The French word for VIOLIN.

violoncelle (vē ô lôɴ″ sel′). The French word for CELLO.

violoncello (vē″ə lən chel′lō). The full name for the CELLO, which survives in the abbreviation for cello used in scores, *vcl.*

violone (vē ô lō′ne) *Italian*: "large viola." A name used in the seventeenth and eighteenth centuries for various instruments at various times, mainly a double-bass viol or a bass viol (especially the bass member of a consort of viols; see VIOL), a cello, or a double bass.

Viotti (vē ôt′ē), **Giovanni Battista** (jô vän′nē bä tēs′tä), 1755–1824. An Italian violinist and composer who is considered one of the founders of modern violin playing. Trained in the Italian tradition of violin technique, he became a brilliant performer. After concert tours throughout Europe, Viotti spent ten years in Paris, where he exerted a great deal of influence on the violinists of the day. The last

thirty years of his life he divided among London, Hamburg, and Paris, where he performed, conducted, taught, and ended by greatly raising the standards of performance. His compositions include twenty-nine violin concertos, of which the Concerto no. 22 in A minor is the best known, as well as violin sonatas, chamber music for strings, and a number of piano works.

virelai (vēr⁹ lā') *French.* An important form of fourteenth-century French poetry that was often set to music. It consisted of several stanzas (usually three) and a refrain of several lines, the refrain coming at the beginning as well as after each stanza. (See also REFRAIN, def. 1.) Notable virelais were composed by the great master Machaut, and, although the form was losing popularity by the fifteenth century a few were still written by Dufay and Ockeghem. A form of one-stanza virelai was called a *bergerette.* Almost identical to the virelai in form are the Spanish cantiga (thirteenth century), from which the virelai may have derived, as well as the Italian ballata (fourteenth century) and the Spanish villancico (fifteenth and sixteenth centuries).

virginal (vûr'jən ⁹l). Also, *virginals.* A kind of small harpsichord that was used from the fifteenth to seventeenth centuries, and in England gave rise to an important school of music.

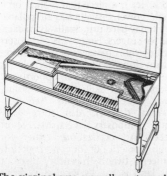

The virginal was a small, rectangular keyboard instrument. Often it was simply a rectangular box, placed on a

table or held in the player's lap, although some instruments had a larger case and legs. It had a single manual (row of keys). As in the larger harpsichord, pressing a key caused a string to be plucked; however, there was only one string for each key, instead of two or three, and the strings ran parallel to the keyboard instead of at an angle. It had a range of about four octaves.

Like the harpsichord, the virginal appears to have been quite popular as a home instrument in the sixteenth and early seventeenth centuries, especially in England. However, during this period the name "virginal" was used indiscriminately for several similar instruments—harpsichords, spinets, and virginals—so that it is not always possible to tell from historical accounts and scores exactly which instrument is being referred to. Nevertheless, a very rich repertory of music for the virginal (and/or its relatives) survives, and it is generally called virginal music. The most important of the composers, known as the **virginalists**, are William Byrd, Thomas Morley, John Bull, and Orlando Gibbons. Numerous collections of virginal music exist, all but one of them in manuscript (not printed). The most famous of them are the *Fitzwilliam Virginal Book,* containing 297 pieces by Bull, Byrd, Morley and others, and *Parthenia,* printed in 1611. The music includes dances, especially pavanes and galliards, sets of variations, preludes, fancies, transcriptions of madrigals, and some religious music. The best of these pieces make the most of the virginal's special qualities, particularly its agile keys and light, sweet, tinkling tone.

virginalists See under VIRGINAL.

virginals Another name for VIRGINAL.

Virginia reel See under REEL.

virtuoso (vûr choo ō'sō). **1** A highly skilled musical performer, particularly with regard to technical ability. **2** Describing a musical composition that requires great technical skill.

vite (vēt) *French.* Also, *vitement* (vēt mäN'). A direction to perform in fast tempo.

vitement See VITE.

Vitry (vē trē'), **Philippe de** (fē lēp' dª), 1291–1361. A French composer who wrote an important treatise, *Ars nova* ("New Art," c. 1320), in which he elaborated on Franco de Cologne's system of MENSURAL NOTATION. He declared that duple meters were as acceptable as the traditional triple meters, and he promoted the use of isorhythm, applying it to the upper voice-parts of his motets as well as to the tenor (see under MOTET for further explanation). A churchman and diplomat as well, he served the French court for many years and for the last decade of his life was Bishop of Meaux.

Vittoria See VICTORIA, TOMÁS LUIS DE.

vivace (vē vä'che) *Italian.* A direction to perform in a brisk, lively manner. Alone, it may mean a tempo about the same as or slightly faster than allegro but not as fast as presto. However, it is often used together with allegro (allegro vivace), meaning "quick and lively."

Vivaldi (vē väl'dē), **Antonio** (än tôn' ē ô), c. 1675–1741. An Italian composer and violinist who was one of the leading composers of the late baroque period (which ended c. 1750). For thirty years Vivaldi was employed in Venice at a girls' orphanage, for which he composed many works. He also traveled widely throughout Europe. His large output includes some forty operas and other theater pieces, and numerous choral compositions. It is his instrumental compositions, however, that have won Vivaldi lasting fame. His concertos, which include both concerti grossi and solo concertos (the latter mostly for violin), are among the finest of their kind. Particularly well known are his *L'Estro armonico*, op. 3, consisting of twelve concertos for one, two, or four solo violins, solo cello, strings, and continuo; *La Stravaganza*, op. 4, twelve concertos for solo violin, strings, and continuo; *Le quattro stagione* ("The Four Seasons"), op. 8, four concertos for solo violin, strings, and continuo; and *La Cetra*, op. 9, twelve concertos for solo violin, strings, and continuo. Vivaldi's solo violin concertos in particular, in which a fast and lively movement is often followed by a dramatic slow movement, influenced Bach, who transcribed several of them for harpsichord.

vivement (vēv mäN') *French.* A direction to perform in a lively, animated manner.

vivo (vē'vô) *Italian.* A direction to perform in a lively, animated manner.

vl. An abbreviation for VIOLIN.

vla. An abbreviation for VIOLA.

vlc. An abbreviation for CELLO.

vll. An abbreviation for violins (see under VIOLIN).

vocalese Reproducing jazz instrumental arrangements vocally. It involves singing in half-invented language and bending the voice to approximate the instruments' sounds.

vocalise See under SOLFÈGE, def. 2; VOCALIZATION.

vocalization Also, French, *vocalise* (vō kä lez'). A piece that is sung on a single vowel (usually *ah*) or syllable (*la*), today used principally as an exercise for singers. Numerous composers include short passages of vocalization within longer works, especially in operas, to give singers an opportunity to show their skill; these are sometimes called *coloraturas* (see COLORATURA, def. 1). Also, since early times, composers have written short pieces in vocalization, either for singing practice or for concert performance; a twentieth-century piece of this kind is Ravel's *Vocalise en forme d'habanera* ("Vocalization in the Form of a Habanera"; 1907).

vocal music Music for one or more voices. Music for solo voice is described under SONG, def. 2; music for ensembles is described under CHORAL MUSIC. In addition there is vocal part music, also called vocal chamber music, for two, three, four, etc. singers in which each has a separate part.

vocal score See under SCORE.

voce (vô′che) *pl.* **voci** (vô′chē) *Italian:* "voice." A term meaning either voice or voice-part (see VOICE, defs. 1, 2). —**colla voce** (kô′lä vô′che). An indication that the accompaniment is to follow the solo voice rather than keeping strict tempo. —**a due (tre, quattro) voci** An indication that a piece or section is written for two (three, four) voices or parts. (See also MESSA DI VOCE; MEZZA VOCE; SOTTO VOCE.)

voice 1 Another term for VOICE-PART. 2 A general term for the human apparatus that produces musical sounds (singing). Actually, singing involves a number of parts of the body, including the larynx ("voice box," into which project the so-called "vocal cords"), the lungs and other areas involved in breathing, the lips, tongue, nose, and various portions of the throat. Voices are usually classified according to their range, that is, the highest and lowest pitches they can produce accurately. The principal men's voices are (from high to low) TENOR, BARITONE, and BASS; the principal women's voices are SOPRANO, MEZZO-SOPRANO, and ALTO (or contralto). —**head voice** The upper portion of a singer's range (the highest pitches he or she can produce). In singing high notes the voice appears to resound inside the head. The tone tends to be light and clear in tone quality, with relatively few harmonics (overtones). See also FALSETTO. —**chest voice** The lower portion of a singer's range. In singing low notes the voice seems to resound in the chest. The sound tends to be deep, thick, and sometimes a little rough in quality.

voice-leading Also, *part writing.* In music with several voice-parts, particularly contrapuntal music (see COUNTERPOINT), the way in which the different parts are put together, how they move from chord to chord, and how the harmonies progress through dissonance to resolution.

voice-part In music with more than a single line of melody, the name used for each separate line or strand. The music may be either vocal or instrumental. Often the terms "voice" and "part" alone are used in this meaning. Thus one may speak of "four-part harmony," meaning music with four voice-parts, or of a "fugue in three voices" or "in three parts," that is, with three voice-parts. See also PART, def. 2.

voicing 1 In organs, making minor adjustments in the organ pipes in order to improve their tone quality; this process requires considerable skill. 2 In pianos, making minor adjustments in the felts that cover the hammers to improve the tone quality.

voix (vwA) *French:* "voice" or "voices." A term used both in the sense of human voice (singing) and in the sense of voice-part. A piece marked *à trois voix* ("for three voices"), for example, may mean it is for three singers or that it has three voice-parts.

volante (vô län′te) *Italian.* A direction to perform lightly and swiftly.

volta (vôl′tä) *Italian:* "time." 1 A term used in the directions *prima volta* ("first time") and *seconda volta* ("second time"), which mark the first and second endings for a section that is to be repeated. Sometimes the words are omitted, the first ending being marked with a long bracket and the figure 1, and the second ending with another bracket and the figure 2. In that case the performer first plays the section marked "1," returns to the beginning and plays the section over again, this time ending with the por-

tion marked "2." 2 Also, French, *volte* (vōlt); English, *la volta* (la vol'tä). A lively dance in 6/8 meter that was popular during the late sixteenth and early seventeenth centuries.

voltage control See under SYNTHE-SIZER.

volte The French name for VOLTA (def. 2).

volteggiando (vôl" te jyän' dô) *Italian.* In keyboard music, a direction to cross the hands.

volti subito (vôl' tē soo' bē tô) *Italian:* "turn at once." A direction to turn the page of the score quickly, warning the performer that the music is to continue without interruption. Often abbreviated *v.s.*

volume The loudness of a musical sound. (For a physical explanation of volume, see under SOUND.) The various gradations of loudness and softness in music are called DYNAMICS and are indicated by dynamic marks.

voluntary In Anglican church services, a solo piece played on the organ immediately before and imme-diately after the service. The name comes from the fact that in the early Anglican church (sixteenth century) such pieces were improvised ("at will"). In the sixteenth century the term was also applied to an impro-vised composition on another instru-ment; the most famous example is the *Trumpet Voluntary* of Jeremiah Clarke (long wrongly attributed to Purcell).

vom, von For German musical direc-tions beginning with *vom* or *von*, such as *vom Anfang*, see under the next word (ANFANG).

Vorschlag (for'shläg). The German term for APPOGGIATURA.

v.s. An abbreviation for VOLTI SUBITO.

vuota (vwô'tä) *Italian:* "empty." A word used in the directions *corda vuota* ("empty string"; of a violin, viola, and so on), meaning an open (unstopped) string, and *misura vuota* ("empty measure" [bar]), meaning a measure in which all the performers are silent (a measure-long rest).

vv. An abbreviation for violins.

W

Wagner (väg'nər), **Richard** (riĸн'ärt), 1813–1883. A German composer who is remembered entirely for his operas, in which he created not only a new kind of opera but a new kind of music. Particularly in his last operas— *Der Ring des Nibelungen* (comprising four operas, comp. 1854–1870), *Tristan und Isolde* (1865), *Die Meistersinger von Nürnberg* (1868), and *Parsifal* (1882)—Wagner created a new kind of work, which he called **music drama**. Until the mid-nineteenth century, serious opera was usually in the form of the Italian *opera seria,* consisting of arias (solo songs), recitatives (speechlike sections), choruses, and smaller vocal numbers (duets, trios, quartets, and so on), and with the orchestra serving mainly to accompany the singers and to provide an overture (see OPERA for a fuller description). Wagner, however, believed that music and story should be of equal importance, and the two should be closely linked, each enhancing the other. The music, too, should help tell the story; the orchestra should express feelings, convey ideas, etc. Moreover, instead of a story divided into songs and scenes, there should be one continuous line of story and music. In carrying out these ideas, Wagner was enormously assisted by his gift for lovely melody, his original uses of harmony, and his mastery of orchestration. His melodic gift helped

him carry out his idea of "unending melody," the continuous thread of music throughout the opera, as well as his idea of using short musical ideas to stand for elements of the story (see LEITMOTIF). His harmonies are often chromatic, sometimes bordering on the atonal. Wagner used the full resources of the orchestra, often enlarging it considerably and sometimes even devising new instruments for it (for an example, see WAGNER TUBA). All these features of his work had a profound influence on future composers.

Wagner wrote all of his own librettos (opera texts), using two main sources, medieval history and German myth and folklore. Although his detractors deride his plots as oversentimental and judge his operas far too long, none can deny that he was the most original and influential opera composer of the nineteenth century, and many consider him the most important musician of his time.

Educated at the University of Leipzig, Wagner turned to conducting and composing in his late teens. His first two major works were the operas *Rienzi* and *Der fliegende Holländer* ("The Flying Dutchman"), performed in Dresden in 1842 and 1843. While these two operas were still largely conventional in form, the next two, *Tannhäuser* (1845) and *Lohengrin* (1850), began to depart in new direc-

tions. Wagner had a stormy personal life, including trouble with politics, women, and money, as well as opposition from musicians and critics. A staunch supporter of Wagner's was Liszt, whose daughter, Cosima, became Wagner's second wife. Through Liszt's help Wagner was able to realize one of his fondest dreams, the construction of an opera house designed especially for his operas. The **Bayreuth Festival Theater** opened in 1876, and its annual productions continue to attract admirers of Wagner's operas from all over the world.

Wagner wrote very little of note besides his operas. Among his other works are the *Faust Overture* (1840), five songs to poems by Mathilde Wesendonck, and the *Siegfried Idyll* (1870) for orchestra, written in honor of his and Cosima's young son, Siegfried.

Wagner tuba A brass instrument devised at the request of Richard Wagner for his series of four operas, *Der Ring des Nibelungen.* It is not a tuba at all but has a bore (inside tube) midway between those of the French horn and saxhorn, is played with a funnel-shaped mouthpiece like that of the French horn, and is coiled into an oval shape like that of the orchestral tuba. Its tone quality is about midway between the French horn's and the tuba's. It is made in two sizes, a tenor pitched in B-flat and a bass pitched in F. The name is thought to come from a mistake made in translating into English the German word *Tube,* which means "tube" (not "tuba"). Although Wagner used these instruments only in the *Ring,* they have been used occasionally by other composers, among them Bruckner, Richard Strauss, and Stravinsky.

wah-wah (wä'wä). A special sound effect that resembles a baby's wailing. Originally it was obtained on brass instruments by waving a hat over the bell. Today a special wah-wah mute is available for trumpets and other brasses. On an electric guitar, wah-wah is produced by means of a foot pedal that sends an electric signal up and down from treble to bass and back. Wah-wah is used chiefly in jazz, rock, and other popular music.

walking bass See under JAZZ.

Walton (wôl'tən), **William,** 1902–1983. An English composer who became known mainly for his works in long forms—oratorio, opera, symphony, concerto—as well as for a number of fine motion-picture scores. His first major composition was *Façade,* a witty setting of poems by Edith Sitwell for reciter and orchestra; it was later made into a suite and a ballet. Other outstanding works of his are a Concerto for viola (1929), which was first performed by the composer Paul Hindemith (an excellent violist); his Violin Concerto, written for Jascha Heifetz; the oratorio *Belshazzar's Feast;* the opera *Troilus and Cressida;* a Te Deum written for the coronation of Queen Elizabeth II in 1953; Partita for orchestra; and film scores for *Hamlet, Henry V,* and *Richard III.* Walton's music is largely tonal, but there is free use of dissonant harmonies. His rhythms are lively and energetic, with frequent changes of meter and use of syncopation.

waltz (wôlts). Also, German *Walzer* (väl'tsâr), French *valse* (vAls). One of the best-known dances of the nineteenth century, which has appeared again and again, both in popular and in serious music. Basically a ballroom dance for couples, it is always in 3/4 meter, but the tempo may range from slow to moderately fast. The waltz originated in the late eighteenth century in Austria and Germany; it appears to have come from the peasant dance known as *Ländler* (which means "country dance") and perhaps also the dance form called *deutscher Tanz* ("German dance"). As one of the first dances performed by couples embracing one another, the waltz was considered very daring, and it immediately attracted composers. Some of the most famous waltzes were written by Viennese composers, most notably

FAMOUS WALTZES

Composer	Title	Description
Ludwig van Beethoven	*Diabelli Variations*, op. 120	1823; for piano
Johannes Brahms	*Liebeslieder* ("Love Songs"), op. 52	1868–1869; for piano duet and vocal quartet
	Neue Liebeslieder ("New Love Songs"), op. 65	1874; piano duet and vocal quartet
Frédéric Chopin	"Minute Waltz" from *Valses*, op. 64, no. 1	For piano
Franz Lehár	*Die lustige Witwe* ("The Merry Widow")	From operetta of same name, 1905
Franz Liszt	*Mephisto Waltz*	Originally for orchestra; three versions for piano exist
Maurice Ravel	*Valses nobles et sentimentales* ("Noble and Sentimental Waltzes")	1911, for piano; later revised for orchestra; inspired by Schubert (see below)
Franz Schubert	*Valses sentimentales*, op. 50	34 waltzes for piano
	Valses nobles, op. 77	10 waltzes for piano
Jean Sibelius	*Valse triste* ("Melancholy Waltz")	1903, for strings; a 1904 version for full orchestra
Johann Strauss the Younger	*An der schönen blauen Donau* ("The Blue Danube"), op. 314	1867
	Geschichten aus dem Wienerwald ("Tales from the Vienna Woods")	1868
Piotr Ilyitch Tchaikovsky	*Waltz of the Flowers*	From the ballet, *The Nutcracker*, 1891–1892
Emil Waldteufel	*Die Schlittschuläufer* ("The Skaters' Waltz")	1882
Carl Maria von Weber	*Aufforderung zum Tanz* ("Invitation to the Dance")	1819; first example of waltz in serious music

Johann Strauss the Younger (see STRAUSS, JOHANN), and in fact the dance is still largely associated with the city of Vienna. At the same time, serious composers such as Beethoven, Schubert, Weber, Chopin, Liszt, and Brahms wrote waltzes, mainly for piano but sometimes for orchestra and occasionally including vocal parts as well. Their waltzes, however, were not for the ballroom but for the concert hall. Often the waltz appeared within longer works, such as ballets (in Tchaikovsky's *The Nutcracker*) and operas (in Richard Strauss's *Der Rosenkavalier*), and sometimes even in symphonies (in Berlioz's *Symphonie fantastique*). Much of the waltz's appeal lies in its light, graceful melodies. The melody usually appears in the upper part (treble), while the lower parts (bass) carry out the *one*-two-three, *one*-two-three beat of the rhythm, with the accent always on the first beat. (In this respect the waltz differs from other dances in 3/4 meter, such as the mazurka, in which the accent often shifts to the second or third beat of the measure.) A few of the most familiar waltzes are listed in the accompanying chart.

water organ Another name for HYDRAULOS.

Weber (vā'bər), **Carl Maria von** (kärl mä rē' ä fon), 1786–1826. A German composer remembered mainly as the founder of German romantic opera. Breaking away from the Italian tradition, Weber turned to German folklore, nature, medieval history, and the supernatural for his subjects. His music, too, is based on folk idioms, so much so that some of his own melodies have become German folk songs. Weber was highly skilled in using the instruments of the orchestra to help tell the story. He was one of the first to use leitmotifs, short musical ideas that stand for a character or situation (see LEITMOTIF). These features had considerable influence on later composers, particularly Wagner.

Weber wrote his first opera at the age of fourteen; four years later he became a conductor at Breslau, the first of several conducting posts. His first great success came in 1821 with the opera *Der Freischütz* ("The Freeshooter"). It was followed by *Euryanthe* (1823), which was less successful but was to prove very influential, with its medieval legend for a story, continuous music instead of separate numbers, and use of leitmotifs. Weber's last notable work was *Oberon;* he died shortly after conducting its first performance, in London. Though he also wrote many instrumental and choral works, the only one still performed quite often is *Aufforderung zum Tanz* ("Invitation to the Dance," often translated "Waltz"), one of the earliest uses of a waltz in serious music.

Webern (vā'bərn), **Anton** (än'tōn), 1883–1945. An Austrian composer whose works, only thirty-one opus numbers in all, became the basis for later serial techniques (see SERIAL MUSIC) as well as other new developments of the twentieth century. Neglected during his lifetime, Webern was recognized shortly after his untimely death (he was shot by mistake, during the American occupation of Austria following World War II) as pointing the way to many important innovations.

Webern studied music from an early age. About 1904 he met Arnold Schoenberg, and along with Alban Berg he became one of Schoenberg's chief followers. Like Schoenberg, he began to write atonal music (see ATONALITY), meanwhile earning a living by conducting. Unlike Schoenberg and Berg, however, Webern's music was strictly atonal, containing no tonal elements whatever. Accepting Schoenberg's idea that music must constantly be varied, Webern never repeated any material, and this, together with his highly concentrated expression of musical ideas, resulted in very short compositions. Of his *Fünf Orchesterstücke* (Five Orchestral Pieces, op. 10, 1911–1913), the longest lasts a minute and the shortest consists of

fewer than seven measures (lasting about nineteen seconds). Webern's music is very precise in form and texture, very tightly controlled and symmetrical.

After World War I, when Schoenberg proposed the twelve-tone system of organizing music, Webern embraced it wholeheartedly. Eventually, he used it not only for pitches (the actual twelve notes of the series) but also for rhythms (patterns of beats and tempos) and tone colors (the notes of the series could be played only in certain patterns by the different instruments). This principle was later expanded by Boulez and Stockhausen, who extended the series also to dynamics (patterns of loud-soft) and densities (groups of instruments playing). More than half of Webern's works are for voice, consisting of songs with piano or other instrumental accompaniment as well as some choral works. His instrumental works also include *Sechs Orchesterstücke* (Six Orchestral Pieces, op. 6); *Concerto for Nine Instruments,* op. 24; Piano Variations, op. 27; String Quartet, op. 28; and Variations for Orchestra, op. 30.

Weill (vīl), **Kurt** (ko͞ort), 1900–1950. A German composer who is remembered for his sardonic ballad opera, *Die Dreigroschenoper* ("The Threepenny Opera," 1928). A modern version of an eighteenth-century opera by John Gay (see BALLAD OPERA), with a libretto by the playwright Bertolt Brecht, it became, in Weill's hands, a bitter satire on the Berlin underworld. It was very successfully revived in 1954 in an English version by Marc Blitzstein. Another collaboration with Brecht resulted in the opera *Aufstieg und Fall der Stadt Mahagonny* ("The Rise and Fall of the City of Mahoganny," 1930). When the Nazis began to persecute Jews in Germany, Weill left his homeland, eventually coming to the United States. There he wrote several musical comedies, among them *Knickerbocker Holiday* (with a libretto by Maxwell Anderson and containing the popular "Septem-

ber Song"), *Lady in the Dark, One Touch of Venus, Street Scene,* and *Lost in the Stars.* His other works include an opera for young people, *Down in the Valley.*

Weinachtslied (vī'näкнts lēd). The German word for Christmas carol (see CAROL, def. 1).

Western music 1 European and American music. **2** See under COUNTRY MUSIC.

whistle 1 A sound produced by blowing through slightly open lips. The pitch of the sound is controlled by the size and shape of the lip opening and of the mouth, which acts as a resonating cavity. **2** A small wind instrument consisting simply of a pipe with a flue-shaped opening (see FIPPLE FLUTE). See also PENNY WHISTLE.

white noise See under NOISE.

whole consort See CONSORT, def. 3.

whole note British, *semibreve.* A note, o, representing the longest time value in modern notation. The time value of all other notes—half, quarter, eighth, etc.—is based on the whole note. In the Middle Ages, however, the whole note was the shortest note. Its modern meaning has held only since the eighteenth century.

whole rest Also, *whole note rest.* A rest,▬, indicating a silence lasting the same length of time as a whole note.

whole step See WHOLE TONE.

whole tone Also, *whole step, major second.* The second smallest interval used in Western (European and American) music. It is equal to two half tones (a half tone being the smallest interval). See also INTERVAL, def. 2.

whole-tone scale Any scale that is made up entirely of whole tones, that is, containing no half tones, and therefore consisting of six notes per octave. In traditional Western (European and American) systems of tuning, there are two such scales: C D E F# G# A# and D♭ E♭ F G A B. Unlike the diatonic scales (the major and minor

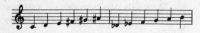

scales), the use of a whole-tone scale does not involve a tonal center (tonic). It is for this reason that the whole-tone scale attracted several composers of the early twentieth century who were rebelling against various features of traditional music, particularly traditional harmony. Chief among those who used the whole-tone scale was Debussy.

Widor (vē dôr'), **Charles-Marie** (shΛrl mΛ rē'), 1844–1937. A French organist, teacher, and composer who is remembered both for his organ music and his influence on young organists. Long a teacher at the Paris Conservatory, and later at Fontainebleau, Widor wrote ten long works for organ, which he called "symphonies." He also wrote several symphonies for orchestra, three operas, two piano concertos, a cello concerto, and numerous vocal and instrumental works. Of these, only the organ works, which continue the tradition established by CÉSAR FRANCK, are still performed to any great extent.

wie aus der Ferne See FERN.

Wieck (vēk), **Clara** (klä'rä). See under SCHUMANN, ROBERT.

Wieniawski (vyā nyaf'skē), **Henryk** (hen rēk'), 1835–1880. A Polish violinist and composer who was one of the great violinists of his age. He toured throughout Europe giving concerts, for a time together with the pianist Anton Rubinstein. He also taught at the Brussels Conservatory and composed two concertos and other works for violin, notable mainly for their technical difficulty. In addition, he wrote a book on violin playing.

Willaert (vē ler', vil'ärt), **Adrian** (ä drē än'), c. 1490–1562. A Flemish composer who is considered the founder of the Venetian school of composers. One of the most influential musicians of his time, Willaert served for the last thirty-five years of his life as musical director for St. Mark's Cathedral in Venice. He was among the most prominent to write for two choirs singing in turn and together (the famous polychoral style associated with Venice, although it was also practical elsewhere in northern Italy from about 1520 on). Aside from church music (Masses and motets), he wrote numerous fine madrigals and chansons (polyphonic songs), and he was one of the first to write ricercars (pieces in imitative counterpoint) for instrumental ensembles (see RICERCAR, def. 1; see also VENETIAN SCHOOL).

wind band A term used loosely for a brass band or a symphonic band. See under BAND.

wind chest In organs, a kind of chamber that holds the wind supply. Air (wind) is pumped into the wind chest by means of bellows. The air in turn passes from the wind chests to the pipes through grooves, which are controlled by stops. (See ORGAN.)

wind instruments A large category of instruments that produce sound when a column of air (inside the tube, or body, of the instrument) is made to vibrate. In BRASS INSTRUMENTS such as the French horn, the air column is set in vibration by the player's lips. In WOODWIND INSTRUMENTS, it is set in vibration either through a flue-shaped opening (flute) or by means of a reed (clarinet, oboe, bassoon).

The pitch sounded by any wind instrument—brass or woodwind—depends on the length of the vibrating air column; the longer the air column, the lower the pitch. The length of the air column can be varied by means of additional lengths of tubing (such as slides in the trombone, or valves that make available extra tubing in the French horn) or by finger holes, which cut off wind from part of the tube. The pitch pro-

duced also depends on whether the air column vibrates along all of its length or part of its length; in the latter case, harmonics (overtones of the fundamental pitch) are produced. The most important way of producing harmonics is OVERBLOWING.

The tone color of wind instruments—that is, the difference in sound between a trumpet and a French horn producing the same note—depends on the blend of harmonics produced along with the fundamental tone. This in turn depends on the shape of the instrument's mouthpiece (cup-shaped, funnel-shaped, an open hole), the presence or absence of reeds, the shape of the bore (inside) and bell, and other factors. See also TRANSPOSING INSTRUMENTS.

wind quintet See under QUINTET.

wobble An extreme vocal VIBRATO (def. 6).

Wolf (volf), **Hugo** (hoo'gō), 1860–1903. An Austrian composer who is remembered principally for his lieder (see LIED, def. 1). In the tradition of Schubert and Schumann, Wolf set to music poems of considerable literary merit. He also admired Wagner, whose influence is seen in the elaborate piano accompaniments Wolf provided for his songs. Wolf's most important collections of lieder are the *Mörike-Lieder* (1888), with texts by Heinrich Mörike; *Goethe-Lieder* (1889), to poems by Goethe; *Spanisches Liederbuch* ("Spanish Songbook," 1890) and *Italienisches Liederbuch* ("Italian Songbook," 1891, 1896), to German translations of Spanish and Italian poems. Of Wolf's other works, which include choral music, an opera, and various instrumental pieces, the one most often performed today is *Italienische Serenade* ("Italian Serenade," 1887), a string quartet that he later transcribed for orchestra.

wood block Also, *Chinese block*. An orchestral percussion instrument consisting of a rectangular piece of wood, $6^1/_2$ to 8 inches long, with a slit cut in one side to form a resonating cavity. Tapped with a wooden stick or mallet, it produces a high-pitched "toc-toc" sound, the exact pitch varying with the size of the block.

woodwind instruments A family of wind instruments in which sound is produced by the vibration of an air column set in motion by the player's breath through a mouth hole or reed. As in other wind instruments, the pitch of the note sounded depends on the length of the vibrating air column. This length depends in part on whether the pipe is open at both ends, as in flutes, or closed at one end, as in clarinets. The length of the pipe can also be altered, but in woodwinds, unlike brass instruments, the length can only be shortened, not lengthened. Shortening the air column, and hence raising the pitch, is accomplished by means of holes bored in the side of the instrument. The holes are opened and shut either directly by the fingers (finger holes) or by means of valves and keys. When all the holes are closed, the pipe sounds its fundamental tone; as the holes are opened, one by one, they successively raise the pitch.

The name "woodwind" comes from the fact that most of the instruments in the group were once made of wood. Today this is no longer true; flutes usually are made of metal, recorders sometimes of plastic, and saxophones are always made of metal.

The chief woodwind instruments of the symphony orchestra are the flute, piccolo, oboe, English horn, bassoon, double bassoon, clarinet, and bass clarinet. Also used occasionally are the saxophone, bass flute, heckelphone, and basset horn. The flute and piccolo consist of tubes open at both ends; the air is set in vibration by the player's breath through a mouth hole. The oboe, English horn, and bassoon are played with a double reed, which is set in vibration by the player's breath and in turn makes the air column inside

the instrument vibrate. The clarinet, basset horn, heckelphone, and saxophone are played with a single reed. (See also DOUBLE REED; REED.)

Woodwind instruments are among the oldest devised by man. The ancient Greeks used the AULOS, and practically every people who kept livestock had some kind of shepherd's pipe, ranging from PANPIPES to the SHAWM. Most of the woodwinds, however, remained fairly simple and limited, like the old FIFE and the RECORDER, operated simply by finger holes. Not until the development of keys could the player cover a wider range of holes, which until then had been out of reach. It is not known exactly when keys were developed—some apparently had been devised by the fifteenth century. They were not widely used until the seventeenth century, and they did not acquire their modern form until the late eighteenth and early nineteenth centuries. (See KEY, def. 2; BÖHM SYSTEM.)

woofer (wōō'fûr). In sound equipment, a speaker designed to handle low frequencies only. It is usually used together with a TWEETER and sometimes with a mid-range speaker.

word painting In vocal music, a term for various ways of making the music portray the meaning of the words. For example, when the text describes rising in the air or climbing a mountain, the music might rise in pitch; or when the words describe birds singing, the music might imitate birdcalls or birdsong. Although today word painting is generally regarded as a very obvious device, it was often used in earlier periods, particularly during the Renaissance and baroque periods, and by such masters as Lasso and Bach.

wuchtig (vōōKH'tiKH, vōōKH'tik) *German.* A direction to perform in a weighty manner, with heavy emphasis.

Wuorinen (wôr' i nən), **Charles,** 1938– . An American composer, pianist, and conductor known for his dissonant, highly chromatic scores, which include symphonies, a violin concerto, chamber music, piano pieces, and electronic music. His *Time's Encomium* (1968–1969), which won the Pulitzer Prize, is considered one of the finest works ever produced on the RCA Synthesizer; it uses both pure synthesized sound and processed synthesized sound (that is, further altered) so as to give both a foreground and background of musical ideas, much as live performers do. In his Piano Concerto no. 2 (1974), for amplified piano and orchestra, the soloist is pitted against the orchestra, but unlike the traditional acoustic piano, the electronically amplified instrument is able to drown out the entire orchestra. In Piano Concerto no. 3 (1984) the soloist performs nearly all the time, and in much of the half-hour work the orchestral sections supply an extension of the piano's tone colors and dynamics. Outstanding among Wuorinen's many other compositions are Symphony no. 3 (1959); Piano Variations (1963); two piano sonatas (1969; 1976); *On Alligators* (1972) for string and woodwind quartets; Two-Part Symphony (1978), a serial work in C; *Archaeopteryx* (1978) for bass trombone and ten players; *Reliquary for Igor Stravinsky* (1983) for orchestra, paying homage to a composer whose late, serially oriented works Wuorinen greatly admired, and *Bamboula Squared* for orchestra and tape (1993).

Würde, mit See WÜRDIG.

würdig (vyr'diKH vyr'dik) *German.* Also, *mit Würde* (mit vyr'de). A direction to perform in a stately, dignified manner.

Wurlitzer piano (wûr'lit sər). See under ELECTRONIC INSTRUMENTS.

XYZ

Xenakis (ze nak'əs), **Iannis** (yä'nəs), 1922– . A Greek composer who lived in Paris from 1947 on and wrote what he called **stochastic music,** a type of aleatory music based on mathematical formulas (see ALEATORY MUSIC). A pupil of Olivier Messiaen and also trained as an architect, Xenakis experimented with both musique concrète and electronic music, and occasionally used computers as aids to composition. His works include *Bohor,* consisting of sounds generated by Oriental jewelry and a wind instrument, *Metastasis* and *Pithoprakta* for orchestra (they also have been combined into a ballet), *Analogiques* ("Analogies") for strings and tape, *Eonta* for piano and brass instruments, *Strategy* for two orchestras and two conductors (who compete with one another), *Keqrops* for piano and large orchestra (with quadrupled winds), and *Okho* for three percussionists.

xylophone (zi' lə fōn"). A percussion instrument that consists of a set of wooden bars of different lengths, arranged in two rows like the black and white keys of the piano. When the bars are struck with a pair of beat-ers, they sound the chromatic notes of the scale (C C# D, etc.). The orchestral xylophone usually has a set of metal tubes fixed beneath the bars, which act as resonators. It has a range of three to four octaves, upward from middle C. The xylophone principle is a very old one. Stone slabs, bamboo tubes, and metal bars have been used in a similar way by ancient and primitive peoples in Asia, Africa, and America. In modern West Africa the **balafon,** with wooden keys and resonators, is still an important instrument, and various xylophones also are vital to the Indonesian gamelan (see GAMBANG; GENDER). In Europe the xylophone was being used by the sixteenth century, but generally only for special effects. Until the middle of the nineteenth century it was principally

a novelty instrument, used in concerts by entertainers. However, various refinements improved its tuning and tone, and in the second half of the nineteenth century it joined the

8va higher

percussion section of most large symphony orchestras. A particularly effective example of its use is in Saint-Saëns's *Danse macabre* ("Dance of Death"), where it is supposed to sound like a rattling skeleton. For a similar instrument, see MARIMBA.

yodel (yō'd°l). An unusual kind of singing popular in the Alps of Austria and Switzerland. It consists of sudden changes from a low-pitched (chest) voice to very high falsetto tones. Performed to vowel sounds (*ah, ee, eye, oh*) rather than words, it is usually added to a song as an ornamental chorus (in German, *Jodler*). Yodeling

is done by both men and women, usually as a solo but sometimes by two singers together. It also is occasionally used by country music performers, notably Jimmie Rodgers (1897–1933).

zampogna (tsäm pôn' yä) *Italian.* A bagpipe used in Italy. It has two separate chanters (melody pipes), one for each hand, pitched a third (two whole notes) apart. The player blows into the instrument through a blowpipe and fingers the melody on the chanters. In addition, there are two drones, each sounding a single note continuously; they are tuned an octave apart. (See BAGPIPE for a more detailed explanation of how such pipes work.) A shepherd's instrument, the zampogna was used particularly for Christmas music, played by shepherds coming to town for the holiday. Its sound is imitated by Handel in *Messiah* (at the opening of the instrumental section known as the "Pas-

toral Symphony") as well as by Bach in the *Christmas Oratorio* (in the instrumental sinforïia in Part 2).

zart (tsärt) *German.* Also, *zärtlich* (tsârt'liкн). A direction to play in a soft, delicate manner.

zärtlich See ZART.

zarzuela (thär thwä'lä) *Spanish.* A type of Spanish opera that includes spoken dialogue, which was important throughout the seventeenth century and was revived in the middle of the nineteenth century. The seventeenth-century zarzuela became an elaborate stage production. It included, in addition to spoken parts, recitatives, arias (solo songs), choruses written in the style of a madrigal (see MADRIGAL, def. 2), ballets, and other dances. Often the subject was from myth or legend. The earliest zarzuelas were written by Juan Hidalgo (c. 1600–1685), and the tradition was continued by Sebastián Durón (c. 1650–c. 1716) and Antonio Literes Carrión (1670–1747). Toward the end of the seventeenth century the zarzuela gave way to a new form, the **tonadilla**, which began as a kind of comic interlude performed between the acts of a play and grew into an independent comic opera. Serious opera in Spain, on the other hand, was dominated by the styles of the Italian OPERA SERIA.

In the middle of the nineteenth century came a renewed interest in national history and tradition, and the zarzuela was revived. A theater for zarzuela productions was built in Madrid, and numerous composers became attracted to the form. There are two kinds of modern zarzuela, a three-act serious form (*zarzuela grande*), corresponding to "grand opera," and a one-act humorous form (*zarzuelita*), which closely resembles a comic opera or operetta. An outstanding example of the former is Manuel Penella's *El Gato Montés* (1916), a version of the story of Bizet's opera *Carmen*.

zelo, con See ZELOSO.

zeloso (tse lô'sô) *Italian.* Also, *con zelo* (kôn tse'lô). A direction to perform energetically, in a fiery manner.

ziemlich (tsim' liҡн) *German:* "quite." A word used in such musical directions as *ziemlich schnell,* "quite fast."

Zimbel (tsim'b'l). The German word for CYMBAL.

zingara, alla (ä' lä tsin gä' rä) *Italian.* Also, *alla zingarese* (ä'lä tsin gä rä'ze). A direction to perform in gypsy style.

Zink (tsink) *German.* The old CORNETT.

zither (zith'ər) **1** A folk instrument of South Germany, Austria, and Switzerland. It consists of a flat, shallow wooden box with a large sound hole; over the box are stretched a few melody strings and several dozen accompaniment strings. The melody strings, usually five in number and made of metal, are on one side of the box, over a fingerboard provided with frets (to indicate stopping positions). The accompaniment strings, numbering anywhere from twenty-five to forty or more, are made of gut or nylon and are tuned in a variety of ways. The player stops the melody

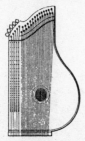

strings with the left hand and strikes them with a plectrum worn on the thumb of the right hand; the other fingers of the right hand strum the accompaniment strings. The melody strings are tuned in several different ways; two common tunings are A A D G C and A D G G C (shown in the accompanying example). **2** A general term for any instrument in which strings are stretched over a soundboard without a neck. Examples

include the various kinds of PSALTERY, whose strings are plucked, and the DULCIMER, whose strings are struck.

zögernd (tsœ' gernt) *German.* A direction to perform in a hesitant manner, holding back the tempo.

zoomoozophone (zoo moo' zə fon"). See under MICROTONE.

zoppa, alla (ä'lä tsôp'pä) *Italian.* A direction to perform in a syncopated rhythm, using the SCOTCH SNAP or a similar pattern.

zouk (zook) *Creole:* "party." A style of Caribbean dance music using synthesizers as well as traditional instruments, such as the Antillean horizontal log drum. Produced mainly in Paris, France by musicians from Martinique and Guadeloupe, it combines elements of Caribbean and African music in a sophisticated way.

zurückhaltend (tsoo rʏk' häl tent) *German:* "holding back." A direction to perform somewhat more slowly.

Zwilich (zwil' ək), **Ellen Taaffe** (täf), 1939– . An American composer who in 1983 became the first woman to win the Pulitzer Prize for composition for her First Symphony. Trained as a violinist, Zwilich wrote primarily instrumental music in traditional forms (symphony, concerto). Her harmonies, too, are largely traditional. Her music is dramatic, using instrumental tone color to convey emotion. Her works include a string quartet, three symphonies (1983–1993), and concertos for piano, flute, bassoon, French horn, and trombone.

Zwischenspiel (tsvish' ⁿn shpēl) *German.* **1** An instrumental interlude in vocal music. **2** A name for the parts of a concerto played by the full orchestra, which alternate with the soloist's parts.

zydeco (zī'di kō") A form of lively dance music originating in Louisiana

and Texas, combining elements of blues with Cajun (French) dance music. It is generally performed on accordion, guitar, and fiddle. The name is thought to come from a corruption of *les haricots* (French for "beans"), from a song title.

INDEX OF COMPOSERS

This index directs the reader to the **principal** information given about composers, and not to every mention of their works or names. For example, for Beethoven the reader is directed to the page with the main entry on Beethoven, and not to the charts of sonatas or symphonies or other places where his name also appears. However, an exception is made in a few instances where there is no main entry and several references are of equal use.

ABOUT THE AUTHOR

Christine Ammer, a lexicographer, served as executive editor of the *Harvard Dictionary of Music*, second edition, and is the author of *The A to Z of Foreign Musical Terms* and *Unsung: A History of Women in American Music*, as well as reference books in other fields. A contributor to the *New Grove Dictionary of Women Composers*, she has written and lectured about the role of women musicians and composers. Mrs. Ammer was born in Vienna and is a graduate of Swarthmore College. She is a member of the Sonneck Society and of the International Alliance for Women in Music.

ABOUT THE AUTHOR